1994

Narrative and Event in Ancient Art assembles new readings of several of the major monuments of antiquity, including the Pergamon Altar, the Apollo Belvedere, and the Francois Tomb, in the context of narrative representation. Focusing on an individual monument, each of the essays provides a model for construing ancient narrative structures through the application of methodological approaches relevant to the problems embedded in the distinctive objects produced by diverse societies. These essays also address the interplay between text and linguistic structure, style as a narrative force, time as a narrative clue, narrative through emblematic versus sequential images, and the observer as a necessary activator of the narrative.

The subjects addressed in this volume cover the scope of ancient artistic endeavor in a variety of media. As a volume, the essays demonstrate that visual images have an infinite capacity for verbal extension, forcing the viewer to take an active and creative role in a dialogue with an artwork and to become, essentially, both critic and narrator in order to reinvent the experience it communicates.

NARRATIVE AND EVENT IN ANCIENT ART

CAMBRIDGE STUDIES
IN NEW ART HISTORY AND CRITICISM

General Editor: Norman Bryson, *Harvard University*

Advisory Board:
Stephen Bann, *University of Kent*
Natalie Kampen, *Barnard College*
Keith Moxey, *Barnard College*
Joseph Rykwert, *University of Pennsylvania*
Henri Zerner, *Harvard University*

Narrative and Event in Ancient Art

Edited by
PETER J. HOLLIDAY
California State University, San Bernardino

CAMBRIDGE
UNIVERSITY PRESS

Published by the Press Syndicate of the University of Cambridge
The Pitt Building, Trumpington Street, Cambridge CB2 1RP
40 West 20th Street, New York, NY 10011–4211, USA
10 Stamford Road, Oakleigh, Victoria 3166, Australia

First published 1993

Printed in the United States of America

Library of Congress Cataloging-in-Publication Data
Narrative and event in ancient art / edited by Peter J. Holliday.
 p. cm. — (Cambridge studies in new art history and criticism)
 Includes Index.
 ISBN 0-521-43013-5
 1. History, Ancient, in art. 2. Art, Ancient. I. Holliday.
Peter James. II. Series.
N8210.N37 1993
704.9'4993—dc20

 93-24786
 CIP

A catalog record for this book is available from the British Library

ISBN 0-521-43013-5 hardback

CONTENTS

v

CONTENTS

ILLUSTRATIONS

CONTRIBUTORS

Joan Breton Connelly
Department of Fine Arts
New York University

Whitney Davis
Department of Art History
Northwestern University

Diane Favro
Graduate School of Architecture and Urban Planning
University of California, Los Angeles

Peter J. Holliday
Department of Art
California State University, San Bernardino

Ann Kuttner
Department of the History of Art
University of Pennsylvania

Nanno Marinatos
National Museum of Athens

John Pollini
Department of Art and Art History
University of Southern California

John Malcolm Russell
Department of Art History and Archaeology
Columbia University

CONTRIBUTORS Andrew F. Stewart
Department of the History of Art
University of California, Berkeley

Jane Whitehead
Department of Classics
Cornell University

PREFACE

Art historians are currently engaged in exploring a wide range of narratological problems in the visual arts. The genesis of this volume occurred when Thomas Reese asked me to chair a session at the 1988 annual conference of the College Art Association in Houston. For the sake of cohesiveness, that session, "Narrative and Event in Greek and Roman Art," was limited in scope to the art of fifth-century Athens and Augustan Rome; the additional restrictions peculiar to oral presentations at such conferences also curtailed the ability of the participants to explore fully the complex questions raised in their papers. In the discussion following the session, it became clear that there was a desire to see presented recent research on narrativity in other areas of ancient art, specifically including topics outside the "classical" world. The present volume represents an attempt to provide an appropriate forum for this continuing dialogue. Although a few of the papers originally presented in Houston have not been included here, several others have been added to amplify the discussion and expand its parameters.

Anthologies present a distinctive set of considerations. One may rightfully question why a set of papers is published together in the form of a book, as opposed to appearing separately as a series of articles in different journals. In the present instance, the following essays have been assembled both to underline the problems confronting art historians concerned with narratology (by no means limited to the art of antiquity) and to present a variety of possible approaches. A system of interesting issues crucial to pictorial narrative is embedded within the individual contributions; these points become apparent when the essays are studied as a collection. Significant issues include the interplay between text and linguistic structure, style as a narrative force, time as a narrative clue, narrative through emblematic versus sequential images, and the extent to which the observer is a necessary activator of the narrative. Each essay makes a unique and significant contribution to

the field; together they enrich our understanding of modes of communication in the visual arts.

Anthologies of essays written by groups of scholars, particularly if the authors are still living, are also notorious for their long gestation periods. This collection has proved no exception. Academia tends to attract people with a markedly independent streak, and it is often difficult to convince scholars to relinquish their cherished desires in exchange for some nebulous "big picture." It is especially difficult for a scholar to manipulate the presentation of ideas and arguments in order to cohere to a structure that may be incongruent with authorial intention. I am especially grateful to the authors represented here, who have been extremely patient during the drawn-out process of pulling this volume together. They have generally worked with me and Cambridge University Press to meet the criteria of the series this volume joins. Although each essay may no longer conform to the initial conception of the author, it still conveys the original and creative insights, expert scholarship, and ability to challenge the reader that first attracted my attention. I trust the authors will agree with me that in the end their efforts toward this endeavor have been worth it.

Throughout the volume, individual authors cite their debts to institutions, foundations, and other scholars who provided assistance during the course of researching and writing their articles. Similarly, many people have facilitated my job as editor. As both friend and colleague, Diane Favro has provided inspiration for many years; her contributions to this project are not limited to her essay on Augustan urban planning; rather, they can be found throughout the volume. Jeffrey M. Hurwit acted as discussant for the original College Art Association meeting in Houston. His thoughtful critiques of those papers not only aided the authors who present reworked versions here, but stimulated all who attended the session. Christopher Baswell, Claire Lyons, and Fikret Yegül have made important suggestions that have improved this volume. We are all indebted to Norman Bryson, the series editor for the Cambridge New Art History and Criticism, who has worked to provide a forum where received opinion can be questioned, original approaches are encouraged, and new voices heard. Each author has benefited from his advice and criticism, and his guidance was particularly valuable to me. The support and encouragement of Beatrice Rehl, the Fine Arts Editor at Cambridge, have proved immense. The commitment of Cambridge to furthering scholarly dialogue through its publication programs provides a hopeful sign in these times in which support for intellectual inquiry seems at best ambivalent.

NARRATIVE AND EVENT IN ANCIENT ART

INTRODUCTION

Peter J. Holliday

The traditional paradigm of representational art – a vehicle for rendering the world legible – has favored the evolution of art history as a means for reading objects. Every work of art, such an approach supposes, has meaning; and the role of the art historian is to read the work, to analyze and clarify its aesthetic complexity and density, and thereby interpret its meaning.[1] Yet recent study of visual narratives has raised a number of definitional and functional issues that challenge any historian's positivist view of knowledge or claims to truth of interpretation. The essays in this volume seek to reexamine a group of ancient monuments in the light of some of these studies.

Current debate within poststructural theory has centered on the arbitrariness of "truth" and the impossibility of anchoring meaning. Roland Barthes, to cite an influential instance, recognized that the prime challenge of any critical reading is to acknowledge the crucial role of audience and the absence of doctrinal certitude. He wrote of this difficulty:

I read texts, images, cities, faces, gestures, scenes, etc. These objects are so varied that I cannot unify them within any substantial or even formal category; I can find only one intentional unity for them: the object I read is founded by my *intention* to read: it is simply legendum, to be read, issuing from a phenomenology, not from a semiology (Barthes 1986: 34).

Following Barthes, one might say that an image becomes a visual narrative – an object of narrative reading – only when the intention of such a reading exists.

As they examine possible models for analyzing pictorial narratives, too, scholars must face the further challenge of overcoming the physical and temporal distance separating the contemporary viewer from the "real" image and thus stimulate a new audience's desire to experience it. Although experience can never be resurrected, it can be reinvented. The authors in this volume explore

the impact of recent theoretical discussions, and how they have moved our attention, as scholars and critics, away from a focus on single or definable meaning, the message assumed to lie behind a relatively stable, if ancient and thus arcane, semiological code.[2] Instead, they pay equal or often greater attention to the code itself, and to the systems of interpretive assumptions carried to pictorial narratives by the viewer. Thus, critical attention is less centrally pegged to the issue of absolute intention or meaning than to a shifting triangle of the ongoing process of negotiation between the work, its maker (artist or patron), and its audience (cf. Abrams 1953: 6–29). The essays here explore models for reinventing the experience communicated by ancient pictorial narratives. Each study proposes a narrative logic that might sustain such a reading and thus allow the viewer to infer, through that analysis, a chain of transmission of experiences. In this way, the reading of visual narratives becomes an active and exploratory exercise in which the viewer plays the crucial role enunciated by Barthes.[3]

The study of ancient visual narratives is not new. In 1955, the Archaeological Institute of America sponsored a symposium, "Narration in Ancient Art," that featured experts on different ancient cultures; their papers were published in the *American Journal of Archaeology* in 1957. Although those papers are still fundamental for the study of narrative in ancient art, the criteria they established now seem both too general and too limiting. The goals of the session were stated as follows:

The participants agreed further that they would exclude from intensive consideration the typical and casual material. . . . It has been assumed that narrative art, strictly speaking, could be identified as such only where the purpose of the artist was to represent a specific event, involving specific persons, an event, moreover, that was sufficiently noteworthy to deserve recording. (Kraeling 1957: 43)

Through the examination of some of the best-known monuments of antiquity, those scholars were given the objective of trying to typify narrative art for an entire culture, sometimes sweeping across millennia of fundamental historical and ethnic transition; in addition, most of those papers treated visual images as subordinate to verbal forms of narrative presentation. In contrast, the authors of a group of papers presented in Baltimore in 1984 and published in *Pictorial Narrative in Antiquity and the Middle Ages* (National Gallery of Art Studies in the History of Art 16 1985) concentrated on particular methodological approaches for studying the problems embodied in characteristic monuments.

In a similar manner, each author in this volume analyzes anew one of a set of rather well-known monuments – some commem-

orating specific historical events, but others depicting the typical and casual – specifically in the context of narrative representation. Narrative is but one of many representational codes employed by artists to transmit information to an audience, and any visual narrative will necessarily reflect the needs of a particular individual, period, or culture; the role of intentional ideology, therefore, is also critical (cf. Foucault 1975). New theories of narrative compel us to investigate individual linguistic and depictional practices at a very specific level. Although the authors here analyze their monuments in the context of larger historical traditions, focusing on a particular object (or class of objects) prohibits its assimilation to either earlier or later practices of representation; unlike the papers delivered in 1955, there is no attempt to summarize the narrative practices of an entire culture or historical period in any single essay.

The concept *ut pictura poesis* enunciated by Horace (*Ars Poetica* 361–5) already suggested the creative possibilities inherent in considering works of art as a literary topos (Trimpi 1973; Grabar 1979); in antiquity, artists took advantage of the analogous but inverse process to create works of art *ut historiam simulandum* (Brilliant 1984: 17). In developing paradigms to help us understand the creation of meaning in the visual sphere, art historians have found that models exist in the terminologies and methodologies of linguists, literary critics, and anthropologists. Whitney Davis prefaces his essay with an overview of some recent contributions to narrative theory and their potential applicability to studies in the visual arts. It is an essential principle of poststructuralist literary theory that the language of a narrative conveys the narrator rather than the narrative itself.[4] The role of the literary critic, therefore, is to reveal the narrator to the reader.

In recent literary studies of narrative, critics have also focused attention on the role of the reader in grasping verbal texts, and this concentration on the reader has now been taken up in critiques of representational strategies.[5] Indeed, the art historian confronts a situation in which multiple informational sources are embedded within an imagistic system (Bal and Bryson 1991: 203–4). A traditional model portrays the artist as the grand orchestrator of events, who provides clues indicating the relationships among the events and protagonists depicted in the artwork. This model is insufficient, for as Barthes indicates, it is the viewer who must change that imagery into some form of internalized verbal expression (cf. Brilliant 1984: 16). In ancient art, which often tends to abstract time and event, the observer must become more than simply a decoder of messages. The observer must assimilate and construct the material presented by the artist in order to produce

meaning: In a very real sense, the observer, both today as in an-
tiquity, must become the true narrator, connecting the discrete
images that have been brought into association with one another
through artistic convention.

The study of cultural context remains important, but it is in-
creasingly linked to an acknowledgment of the role of audience
and highly variable interpretive strategies in the creation of mean-
ing.[6] The art historian must give the fullest possible accounting of
the cultural experience (social, religious, philosophical, political,
and economic) conveyed by the artwork and within which it
necessarily stands and derives much of its significance. The lan-
guage of visual narratives is necessarily a part of that cultural con-
text; it informs the art object that serves as a medium or
intermediary between the maker and the observer, transferring
information from one to the other (cf. Derrida 1982; Bal and
Bryson 1991: 176–88). Artworks have the power to characterize
and to represent the cultural context in which they were created,
yet that cultural context is also determined by interpretive strat-
egies and is in need of elucidation (Culler 1988: xiv).

Although the essays in this volume explore the historical cir-
cumstances surrounding the artwork, then, the authors also ex-
amine the complex mechanisms whereby meaning is engendered.
Each essay attempts to produce readings that reinvent experience.
This process of reinvented experience suggests that the properties
of visual narratives are occasionally similar to those of verbal nar-
ratives. Several of the essays therefore take up fundamental issues
related to the interplay between text and linguistic structure
within pictorial narratives, including but not restricted to imagery
that apparently illustrates a textual source (cf. Bal 1991), inscrip-
tions that elucidate pictorial scenes, and rhetorical practices em-
bedded within the work of art.[7]

Several essays here analyze how artists adapted formulaic im-
agery, varying and manipulating it for the narratives at hand.
Using the theme of the rape of Kassandra, Joan Connelly dem-
onstrates how contemporary dramatic presentations directly af-
fected the imagery chosen by classical Greek vase painters. The
mythological and historical subjects illustrated in Etruscan tomb
paintings and the themes portrayed in the later Roman funerary
monuments discussed by Jane Whitehead were drawn from stan-
dard formulas, stock literary and visual topoi. Audiences already
familiar with the stories could reexperience them; their familiarity
would also allow observers to associate generic roles with specific
characters in individual works of art.

In his analysis of the reliefs Sennacherib commissioned for the
great palace of Nineveh, John Malcolm Russell compares the

inscriptions accompanying the people and events portrayed with the king's annalistic texts. Russell attributes the differences between the preserved sculptural and textual accounts of Sennacherib's campaigns to the different expressive potentials of the two modes: Visual narratives convey impact and detail, whereas verbal reckonings can communicate with breadth and economy. These differences in turn reflect the large and heterogeneous audience for the reliefs, literate and nonliterate, and a smaller audience of literate courtiers for the texts. Ann Kuttner demonstrates that during the Republican period, Roman honorific monuments were accompanied by inscribed texts analogous to panegyric, autobiographical, and other verbal historical narratives. As with the Neo-Assyrian reliefs, visual and textual narratives were interchangeable and determined by the mixed audience the artist sought to reach.

Yet the expressive details inherent in visual and verbal modes of communication are distinct. The captions accompanying the images at Nineveh anchor them, functioning like the labels on the paintings from the François Tomb that identify significant figures in the scenes (cf. Barthes 1977: 38–40). Inscriptions can also play an active role for the literate viewer by emphasizing the significant features of the action (cf. Barthes 1961). Diane Favro suggests that Augustan architects used names to link individual buildings with specific personages or ideas: Dedicatory and other inscriptions expressed what was not immediately evident in physical form and helped articulate an urban program for the literate observer. Petronius has the rich freedman Trimalchio inscribe epigraphs on his tomb; these are such clichés that they generalize and make banal the visual motifs described, ironically undercutting the very purpose of the imagery. The same manner of communication can engender tendentious meaning in one case and trenchant satire in another.

Andrew Stewart suggests that the painted inscriptions on the Great Altar of Zeus at Pergamon served as signs (*semeia*) that not only replicate the representational content of the monument, but also signal the choral nature of the program. Stewart argues persuasively that Baroque sculpted narratives were a distinctly rhetorical venture, and analyzes how the ancient terminology, like that found in ancient art theory, indicates a studied rhetorical association.

Classical education, grounded in the discipline of rhetoric, heightened the mnemonic skills of learned Romans and trained them to make mental links between disparate components and to synthesize the diverse meanings imparted by variations in sequence. (Stewart points out, however, that in antiquity, one did

7

not need formal schooling in order to assimilate the techniques of rhetoric, which were accessible daily in political debates, court cases, and speeches of praise.) Both Favro and John Pollini compare the structures of Roman visual narratives to ancient literary and rhetorical exercises; further, they investigate the similarities between the imagistic constructs of Roman monuments and the syntactic flexibility of the Latin language. And Kuttner demonstrates that the creators of Republican honorific monuments anticipated Augustan developments in their aims, methods, and vehicles for commemoration, for Roman commemorative monuments always implied the rhetoric of a life story in however abbreviated a form.

The similarities visual narratives share with verbal narratives make the former especially suitable for communicating ideological or rhetorical messages. Visual narratives are didactic, directive, and connotative. Although several of the monuments discussed here reflect literary traditions, visual narratives generally require of the observer less prior knowledge than do other codes, and are therefore particularly effective in coercing the observer to read the persuasive imagery toward a desired and seemingly inexorable conclusion (Winter 1985: 28). The Republican commemorative strategies and narrative programs Kuttner analyzes were deliberate and tendentious; the ideological significance Pollini construes in the miniature scale of the Gemma Augustea is also found within the Augustan plan for the capital. Stewart's exploration of rhetorical practice describes most techniques as examples of *technai* aimed at *psychagogia,* the swaying of the soul through emotional appeal. With what qualities can artists endow their visual narratives in order to achieve the persuasive effects sought by orators?

Each essay in this volume provides a careful description of the imagery portrayed by the artist or patron, but that examination is only preliminary to an analysis of the significance of the narrative structures developed by the artist. Although a proper iconographic interpretation is a necessary step in the reading of visual narratives, the two represent distinct means of communication. Iconography is basically a descriptive process of identification, whereas narrative is a process of organizational analysis, indicating "how" as opposed to "what" (Winter 1985: 27). Traditional iconographic interpretation can easily reduce the image to a question of treatment, for example, a connotation of style that necessarily confuses meaning and verbal denotation. Here it is shown that style itself can serve as a vehicle for narrative.

Stewart's discussion illuminates this crucial issue. The emotional appeal that is central to the Baroque style is often cited as a fault inherent in Baroque sculpture, a criticism that parallels both an-

cient and modern objections to Baroque rhetoric. Essentially, the Baroque was an historically conscious style, a discourse between the past and the present. Stewart analyzes the Nike of Samothrace and Pergamon frieze as monuments that make manifest a sense of their own history through their narrative forms, a level of meaning impossible to fathom through traditional iconographical accounts.

Kuttner argues that the stylistic disparities on Antonius's monument are the result of deliberate choice on the part of the maker (sculptor and patron) to convey a moral and didactic message to the audience. The awkward and stiff groupings on the Paris reliefs, sometimes interpreted as exhibiting a lack of artistic skill, contrast with the graceful rhythms of the Munich panels: Both were actually conditioned by ideas of decor. The purposeful manipulation of stylistic language served the aim of legibility, and Kuttner links the seemingly maladroit carving to the annalistic language used to describe religious ritual, whereas the appearance of a similar style on the Telephos frieze at Pergamon emphasized the historicity of that narrative. Sennacherib's celebrated developments in the carving of Neo-Assyrian reliefs – the creation of the new perspectival effects and unified field described by Russell – ensured maximum recognition through highly specific costumes and scenery, and thus made the imagery intelligible to a broader audience.

The Neo-Classical style used on the Gemma Augustea, calm and balanced, underlines the message of order brought to the world by the Augustan Peace. To provide an historical context for that message, the emperor's architects carefully juxtaposed monuments of opposing styles in the newly organized capital: The simplicity of the massive Mausoleum of Augustus contrasts with the gemlike precision of the Ara Pacis; such striking differences were governed by the rules of decor (in a manner that purposefully recalls the earlier Republican reliefs) in order to increase their evocative power. In the hands of Petronius's vulgarian, however, stylistic juxtapositions reveal ignorance rather than sophistication, undercut the pretensions of his *nouveau-riche* protagonist, and deepen the author's satiric observations. The effectiveness of Petronius's discourse depended on the awareness of his audience.

Reconstructing the intended audience for a visual narrative presents complicated problems for the art historian, but is essential for understanding the nature of the experience being communicated. Several of the monuments discussed here were public: The Nike of Samothrace, Great Altar at Pergamon, and Roman honorific statues, tomb complexes, and urban planning were visible to a large and diverse body of viewers. The frescoes decorating Etruscan tombs were less prominent, and the reliefs of Sennacherib were visible only to those with access to the court. Although

Egyptian palettes, Minoan daggers, Greek vases, and Roman gems
may be considered private objects, some were possibly the focus
of quasi-public rituals. In a process paralleling the original inven-
tion of the artist, the art historian must take into account the class
and educational background of the potential observer. Such an
exercise helps to explain why an artist chose to use a distinct
narrative mode – visual and textual (or as noted before, some
combination of the two) – on an object in order to communicate
effectively to the intended audience(s).

Indeed, the audience was frequently a necessary activator of
ancient visual narratives. Movement through a carefully plotted
cityscape provides a dynamic example of the potential for audience
participation in the creation of a narrative. Favro defines a process
in which the observer received characteristic orientations and sit-
ings within a particular built environment, the Augustan program
for the Via Flaminia. Similarly, Kuttner demonstrates that the lo-
cation of an honorific monument in the urban scheme enframes
the narrative: The placement of Antonius's monument in the Cir-
cus Flaminia enhanced its message of military achievement
through its association with other commemorative works in the
observer's field of vision. Nanno Marinatos shows that the for-
mulaic visual language of Minoan art defies a simple iconographic
interpretation. Her analysis indicates that the seal stones and dag-
gers decorated by Minoan artists with stock images of hunting and
warfare were themselves carriers of meaning. The relationship be-
tween those objects and the interchangeable signs of predation and
aggression adorning them engendered a narrative for their viewers
or owners (invariably male hunters and warriors), and thus made
the handlers active participants in the narrative discourse. Davis
effectively argues that the iconographic image of Narmer smiting
his enemy is both an element in and a symbol of the narrative in
which it is embedded, comparable to the imagery of Minoan art,
but in which the potential completion of the immanent blow of
the king's mace implies the conceptual penetration of real space.

Russell suggests that Neo-Assyrian artists used space as an an-
alogue of time, and that the progression of repetitive figures
through the continuous expanse of the figural ground expressed
a temporal sequence. Time is an important clue in visual narra-
tives. Most discussions of narrative structures try to determine the
temporal connection among the events described; linguistic and
speech act theories of narrative usually have linked events in one
of two fundamental ways: either simultaneously (synchronically)
or successively (diachronically) (cf. Banfield 1982; Prince 1982).
In visual narratives, however, temporal linkage is often achieved
through different emblematic and sequential strategies. The images

on the walls at Nineveh can be read in various sequences, unlike the textual accounts that demand a coherent story line to ensure continuity. The sculpted reliefs, therefore, lent themselves to a more episodic treatment of individual and select events, as opposed to the emphasis on the broad sweep of the campaign in verbal accounts.

Connelly describes how Greek black-figure vase painters compressed several successive actions into a single image: This "synoptic" or "simultaneous" method (cf. Weitzmann 1970) resulted in temporal ambiguity. Later red-figure artists developed an episodic method of representing independent yet related events side by side in a single picture field. Similarly, the exemplary emblematic or iconic images arranged within the confines of a tableau on the Gemma Augustea contain referential clues (symbols or scenes) that allow the informed observer to construe a narrative. The paratactic and conceptually related scenes suggest a complementary mode of narrative, comparable to the way vase painters had compressed and subordinated events or to the relationship between a central moment (sacrifice) and the synoptically complementary *census* and *lustrum* found on Antonius's base. Indeed, Kuttner shows that the compositional structure of the Republican reliefs not only describes the specific events commemorated, but also implies their temporal causality and succession.

Stewart demonstrates that the artist's synoptic treatment of the antitheses of storm and calm on the Nike of Samothrace not only creates a decidedly temporal effect, but effectually outflanks the Aristotelian critique of visual narrative and its privileging of verbal narratives and dramatic poetry over the visual arts. Yet regardless of its scale, any static artwork manifests a synchronic presentation vis-à-vis the viewer. Favro demonstrates that due to the different sequential positionings of its monuments, the urban fabric is necessarily dynamic and therefore presents itself diachronically. Augustan architects imposed clarity of order and a sense of progression through the repetition of individual phrases or characters, comparable to the markers in the Neo-Assyrian reliefs.

Marinatos shows that Bronze Age artists on Crete used a combination of diachronic and synchronic modes of presentation, and that their narratives derived from a significant combination rather than sequence of images. Meaningful juxtaposition can also engender the narrative force for groupings of paintings, such as those from the François Tomb that may also allude to larger temporal cycles. Indeed, the example of Petronius points out how a narrative can be read through the juxtaposition of a series of commonplaces; hackneyed funerary motifs from monuments like those Whitehead adduces as illustrations were combined to generate

narrative. Although many ancient visual narratives (e.g., Neo-Assyrian reliefs, Bronze Age objects, and Etruscan frescoes) make use of stock scenes or characters, Petronius's construction uses such imagery to emblematize time: His strategy suggests both chronology and achronology for ironic effects.

Although these essays explore the temporal potentialities of visual narrative structures, they also demonstrate that narrativity is not necessarily determined by temporal connections. Visual and verbal narratives may share similar characteristics, but they are not identical. Artists structure visual narratives in order to ensure clarity and comprehensibility and also to respond to the directives of their patrons. Individual artworks, therefore, do not reveal the same properties; certainly they are not manifest to an equivalent extent. In their attempt to reinvent the experience of ancient narratives, the authors demonstrate that linkage can also occur through typology, tropes, and any number of other strategies. Purely visual qualities, such as scale, setting and enframement, medium and style (including surface finish and technique), also convey narrative meaning. These essays avoid the view of language (signification) as reductivist, and present a system of issues that resists the privileging of verbal narratives over more purely imagistic strategies.

The uncertainty of interpretation alluded to before is not cause for despair or resignation; rather it results from the recognition of the multiplicity of meanings inherent in any work and the richness of their possible readings (cf. Foucault 1973; Searle 1980; Alpers 1983; Bryson 1983). It is not the purpose of this collection to set forth any single definition of narrativity or its workings in the visual arts of antiquity. Each of the essays in the volume is a separate exploration of an individual problem, providing the reader with a variety of potential accounts for construing ancient narrative structures. Each author has chosen a methodological approach suitable to the problems embedded in distinct objects produced by diverse societies, and thereby presents new readings of those objects that had seemed so familiar; the References not only indicate debts to other art historians, but also to scholars in other fields of enquiry, and serve as a guide for further investigation of narratological issues.

No single investigation of ancient visual narratives should hope to be exhaustive; many critical areas of ancient art – such as book illustration, ephemeral paintings for ceremonies, and programmatic interior decoration and garden design – are not investigated here. Nevertheless, the historical sweep of the subjects covered in this volume evokes the scope of ancient cultural endeavor and achievement, linked period to period, medium to medium. To-

gether the essays prove that visual images have an infinite capacity for verbal extension, forcing the viewer to take an active and creative role in a dialogue with an artwork, to become essentially both critic and narrator in order to reinvent the experience it communicates. These investigations lead to an enriched sensitivity not just to ancient pictorial narratives, but to the experience and discussion of any visual object, relevant to any period when a dominant cohort produces art conscious of ideological ends.

NOTES

1. Preziosi (1989) explores various models for the modern practice of art history; Davis (1990) and Marmor (1990) provide detailed critiques of his book.

2. The reader will find Bal and Bryson's (1991) overview of semiotics and its impact on recent art historical writing an accessible and useful introduction to many of the influential theoretical works reflected in this volume.

3. See also Bakhtin's (1981) theory of narrative, which focuses attention on the maker of the image, and Derrida's (1988) concept of dissemination.

4. In his semiotic conception of texts, Bal (1985) illuminates the true complexity of the situation, and distinguishes between three narrative agents: the narrator or speaker, the focalizer or source of the vision presented in the speaker's utterance, and the actor or agent acting out the sequence of events presented; he has elaborated these ideas further (1988).

5. Among many exemplary studies, Foucault's (1973) semiotic reading of Velázquez's *Las Meninas* and Searle's (1980) explanation of that interpretation through speech act theory stand out. See also Marin's (1980) influential reading of Poussin's *The Arcadian Shepherds*.

6. Riegl (1902) focused attention on the audience early in this century; Podro (1982) provides a useful analysis of his critical theory of spectatorship. More recently, the reception studies of Kemp (1983, 1985) and Fried (1980) have explored the issue of the observer's modes of involvement with artworks.

7. Cf. Garrard's (1982) provocative analysis of Atremisia Gentileschi's *Susanna,* in which the author discerns a critique of the theme of voyeurism depicted by and within the painting.

NARRATIVITY AND THE
NARMER PALETTE

Whitney Davis

The hypothesis of a rigorous, sure, and subtle form is naturally more
fertile. Derrida 1981: 67

In this essay, I consider one well-known example of ancient Egyp-
tian image making, the great carved schist cosmetic palette of
"King Narmer" (Fig. 4), probably made about 3000 B.C., from
the point of view of aspects of contemporary narrative theory. I
do not consider "narrative in Egyptian art" in general. Our un-
derstanding of the rules and practices of Egyptian image making
is not yet powerful enough to handle complex questions of meta-
phor, allegory, and narrative in the tradition as a whole. I prefer
to attend closely to one work. At any rate, narrative theory re-
quires us to investigate individual representational productions at
a very specific level. Indeed, the Narmer Palette poses special
problems. As an early, if not the first, "canonical" image in the
Egyptian tradition, it should not be assimilated to later Egyptian
practices of narrative representation. Instead, there are good rea-
sons to regard it as a typical "prehistoric" work, belonging to a
tradition of image making in the Nile valley dating back to the
eighth millennium B.C. and possibly before, for it clearly belongs
to a small group of decorated palettes made in the late fourth
millennium B.C. or "late prehistoric" period, such as the Oxford,
Hunter's, and Battlefield Palettes (Figs. 1–3), and some associated
works (for further references and discussions, see Davis 1989: chap.
6; 1992). The boundaries of this group of artifacts are not well-
defined. Some palettes usually included in it do not belong to the
pictorial system exemplified on the four palettes just mentioned;
thus, although they are tokens of an artifact type, the decorated
cosmetic palette, they are not tokens of the same *meaning* type.
Some of the objects, moreover, are probably forgeries; some are
too poorly preserved to interpret. Finally, relations among the

palettes within this group are, in themselves, disjunctive; and the Narmer Palette stands somewhat apart from the others.

NARRATIVITY AND
THE NARMER
PALETTE

DATE, CONTEXT, AND FUNCTION

Sometimes called "predynastic," "precanonical," or "Pre-Formal," late prehistoric Egyptian art – to which the Narmer Palette belongs – has a double historical relation with the "canonical" art of the dynastic "Great Tradition" of the third, second, and first millennia B.C. (for the terms, see Davis 1989: chap. 6; and Kemp 1989). On the one hand, the Tradition derived techniques and motifs from many prehistoric sources, tracing back to early rock art and to the material culture of the Nagada I period, about 4700–3700 B.C. (Davis 1989: 116–26), as well as to the pottery decoration and relief sculpture of the Nagada II/III periods, about 3700–3000 B.C. (Williams 1988; Davis 1989: 135–71). On the other hand, dynastic image makers and their patrons forged a new administrative apparatus and developed a mode of representation appropriate to it. The emerging bureaucratic, patrimonial state of the early Old Kingdom, about 3000–2700 B.C., approached the prehistoric legacy with actively selective interests. At the very least, in the emergence of the canonical tradition, some aspects of earlier image making were avoided or suppressed and others were adopted and refined (Davis 1989: chap. 6). These developments are important processes in their own right. However, neither the earlier prehistoric sources for nor the later canonical legacies of late prehistoric image making necessarily tell us anything about the meaning of individual late prehistoric representations in their own historical, cultural, and semiological contexts.

The striking homogeneousness of dynastic Egyptian art was probably produced by artists following a systematic set of sophisticated rules in an "academic" setting. By contrast, late prehistoric image making is characterized by considerable stylistic and iconographic heterogeneity. Many works cannot be associated now with academic contexts of production or even with elite contexts of patronage (although our lack of archaeological evidence does not prove that such contexts did not exist). It is not surprising, then, that the late prehistoric works are different both from canonical productions and among themselves.

The sequence of routine, mostly undecorated funerary palettes discovered in dated prehistoric graves establishes a relative chronology possibly applicable to the decorated examples (see Petrie 1920, 1921, 1953; Kaiser 1956, 1957; Kantor 1965). On these

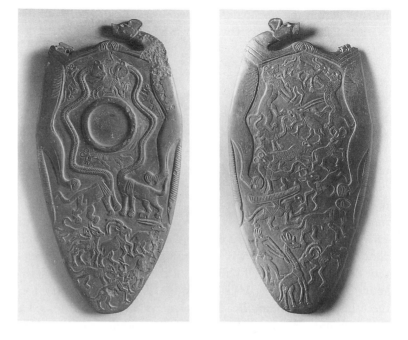

1 The Oxford Palette.
Late Predynastic Period
(Nagada IIc/d). Courtesy:
Ashmolean Museum, Oxford
University.

grounds, it seems likely that of the four decorated palettes mentioned above the Oxford Palette (Fig. 1) is the earliest (probably Nagada IId, about 3300 B.C.) and the Narmer Palette the latest (probably Nagada IIIa-b/early First Dynasty, about 3000 B.C.). The Hunter's and Battlefield Palettes (Figs. 2 and 3) may fall in between, although there is nothing in their pictorial systems that would prevent the Hunter's Palette from being contemporary with the Oxford and the Battlefield with the Narmer. Indeed, a chronology of the images should be based upon study of their pictorial systems rather than upon a typology imposed from the outside, in this case, from the series of routine funerary palettes. In this essay, however, I abide by the conventional dating (for further discussion, see Davis 1989: chap. 6).

Several of the canonical rules of image making were not fully codified until the Third and Fourth Dynasties. However, the most critical phase in the formulation of the canon was the Nagada III/ early First Dynasty period, the period in which the Narmer Palette was likely made. In this era, a potentially national state structure – with its associated administrative, military, commercial, and liturgical instruments – was emerging in Upper Egyptian polities like Hierakonpolis and perhaps Nagada, even though the activities of the earliest rulers of these polities presently cannot be documented in full detail (see Edwards 1972; Hoffman 1979; Trigger 1983). In itself, the chronology does not prove that the palettes

were made *for* the rulers by artists working for them, perhaps in the rulers' centers of residence, as some interpretations – such as those attributing a "propagandistic" function to the images (for example, Hoffman 1979: 299) – seem to require. Although court-affiliated artists can be identified in the early dynastic period (Davis 1983), we cannot say whether the late prehistoric palettes were manufactured by such specialists. Some of the palettes could have been produced in a traditional village craft economy by artisans unattached to the growing, if still small-scale, centralized administrations.

Unfortunately, then, the relative chronology of the late prehistoric palettes cannot be backed up by independent archaeological evidence about their contexts. Unlike routine funerary palettes from prehistoric graves, two of the larger, decorated palettes, the Oxford and Narmer Palettes (Figs. 1 and 4), were unearthed in the "Main Deposit" at Hierakonpolis, a much later collection of heterogeneous earlier artifacts deposited as late as the end of the Old Kingdom (Quibell and Green 1900–1; Adams 1974, 1975). As a "secondary" archaeological context, the Main Deposit provides no direct information about the "original" date, function, audience, or meaning of either palette. It tells us only that later viewers valued the earlier palettes – for whatever reason – and determined to deposit them, along with a number of other objects, perhaps in order to hide or preserve them (we do not know).

Earlier commentators on the palettes did not have access to the recent publication of the original fieldbooks of the Hierakonpolis excavations. They supposed that the Main Deposit was, in fact, a late prehistoric assemblage. In light of the objects found in it, they regarded it as a dedication at an early temple of Horus (for instance, a gold hawk was discovered in the Deposit) or Hathor (for instance, according to a common but disputable reading of the iconography of the Narmer Palette from the Deposit, the bovids' faces on its top edge depict the cow–goddess "Hathor"). Thus, they reasoned that the palettes were temple dedications to divinities made by "royal" patrons, for the iconography of both Horus and Hathor were later associated with the pharaoh (Baumgartel 1955; Asselberghs 1961: 259). However, although it is logically possible that the objects had a dedicatory or votive function in a temple, we now know that we have no actual evidence to this effect for the two palettes from the Main Deposit. Therefore, I will not assume a connection between the palettes from the Main Deposit and temple cult, temple furniture, or temple dedications – even though my interpretation will not be incompatible with such a connection if it were to be established through evidence yet to be discovered.

Contextual information on the other late prehistoric palettes and associated objects usually grouped with the Narmer Palette is equally hard to come by. The Hunter's and Battlefield Palettes (Figs. 2–3), the two images most closely related to the theme of the Narmer Palette, have no reliable recorded provenances. In view of this, it is surprising that assertions about the function, audience, or meanings of the palettes can be found throughout the literature.

Some scholars (e.g., Petrie 1953) have confidently assumed the "ceremonial" or "liturgical" use of the palettes, implying that they were set up for display in a residence, temple, or public place or were stored and used on special ritual occasions. It is logically possible that the Narmer Palette had a "ceremonial" nature; my interpretation will not be logically incompatible with the thesis. But there is not a shred of independent evidence in the matter. Even if correct, the hypothesis of "ceremonial" function is not helpful when we do not know what the "ceremony" itself was all about. Perhaps some late prehistoric images document ceremonies known from later textual sources, although the anachronism is dangerous. For example, for Siegfried Schott (1950) and Jacques Vandier (1952), the Narmer Palette commemorates a celebration of victory over defeated "northern" enemies or a royal jubilee celebration later known as the *Sed*-festival. Nicholas Millet (1990) has interpreted the decorated macehead of Narmer – an object closely related to the Narmer Palette – as depicting, or even documenting, a festival of the "Appearance of the King of Lower Egypt" stated on the Palermo Stone (a Fifth Dynasty annal describing earlier "history") as having occurred in the First Dynasty. But even if the images do, in fact, depict or document particular ceremonies, it does not necessarily follow that the objects or images themselves were also used in or made for those very ceremonies. (Although the reliefs on the Ara Pacis Augustae in part depict a ceremony conducted at that altar, J.-L. David's *Tennis Court Oath* was not produced for the swearing of the oath itself.) And certainly nothing at all is discovered about the way in which the images, qua images, represent the supposed ceremonies – that is, about the particular metaphorical or narrative way in which they "document" or otherwise imagine them.

Possibly contradicting the "ceremonial" hypothesis, other writers have urged that the decorated palettes had a "magical" function. The palettes could have promoted success in the hunt or battle or secured the favor of a totem or divinity, rendered "magically" efficacious by the images themselves, by "ritual" use of the object, or by both together. The diversity and vagueness of these accounts (see Capart 1905; Baumgartel 1955, 1960) indicate that

they are implausible. There is no archaeological evidence that the palettes or the images carved on them had a "magical" function. Although some Egyptologists have cited the "magical" properties of funerary statues or liturgical implements in later dynastic art and cult, it is gross anachronism to suppose that meanings so closely tied to the canonical theology and iconography of the hierocratic state were present in the late prehistoric context.

Finally, some recent writers have argued that the palettes might have served, as Michael Hoffman (1979: 299) puts it, as "symbols of power generated as political propaganda." However, the possibility that the objects were literally used as "propaganda" does not exhaust the ways people could have attached sense to images with the pictorial system I identify in what follows. This functional specification, like any other, needs to be secured on independent archaeological grounds. Unfortunately, the evidence is not compelling. "Propaganda" is usually addressed by a particular, often elite group to an outside, often mass audience. But we do not find the palettes in wide circulation, mass production, or public display, or in any contexts of nonelite or popular reception, consumption, and use, as we would expect to do if they functioned literally as elite "propaganda" aimed at the population. Perhaps the evidence is simply unavailable, as it is for the other hypotheses I have noted; but if this is so, we should not simply assume the possibility as the very basis for an historical interpretation.

We cannot determine whether the objects were viewed by a wider public circle than that of the maker and his or her immediate or initial beholder. Of course, because we have no direct evidence for elite or other patronage, even these identities could have been the same individual – for "maker" and "beholder" are simply positions within the field or scene of representation, which anyone, who may not literally or physically possess that position, can potentially imagine himself or herself to occupy. Despite their sometimes unwieldly bulk, even the largest palettes were made, we might suppose, to be inspected by at least some viewers, however few in number or restricted their access to the viewing situation. As we will see, the images seem to be organized, as images, to be "read" in a specific way, if not by actually handling the object, then at least by moving around it, possibly just in the mind's eye. The physical reality of this situation and activity of beholding is totally unknown. Did it transpire in a ritual setting? Was the object set up for display so people could see its two sides, or could one actually take it in his or her hands? Could people see what the palette depicted, or, like stained glass windows high in the wall of a medieval cathedral, was the image largely unreadable in its details?

All of these questions about possible functions and uses are somewhat beside a point that, surprisingly, still needs to be made; although they are not irrelevant questions, we need to address a prior consideration. Irrespective of the possible votive, ceremonial, commemorative, ritual, magical, documentary, exchange, propagandistic, or other functions of the decorated objects, they have a *representational* function. In some ways, this conclusion is obvious. However, it is both broader and more penetrating than the specifications I have noted – for all of these must be seen as specifications of a possible function of what is already functioning as representation. In fact, most of the specifications I have noted are too general. Other activities or artifacts apart from images, as well as other sorts of images, could have served successfully in ceremonial, ritual, magical, or propagandistic ways, and probably did. Therefore, we still have to offer an account of *these* objects as fulfilling *these* functions by way of *these* images. How could we expect to determine what the function, social use, or cultural meaning of the images might have been if, as I suspect, we have not even identified the properties or system of representation in the images themselves?

Along with the Oxford, Hunter's, Battlefield, and possibly several other decorated palettes, the Narmer Palette, I suggest, functions as a complex narrative representation.[1] Because, as we have seen, we have no independent archaeological information about this, or any other, function and meaning of the images, this hypothesis can be evaluated only by examining its power to account for the images better than the competing hypotheses. A narrative analysis is compatible with any of the general functional hypotheses I have already noted; a "ceremonial," "ritual," or other image can certainly also be a narrative one. In particular, then, the narrative analysis must account for the properties of the images more adequately than the most popular interpretive method adopted in the literature. This method claims to identify what an image "means" by comparing its motifs with motifs in other, earlier, or later images, some of which supposedly can be deciphered on the basis of independent evidence or associations. And indeed, the narratological analysis, whatever its own flaws and uncertainties, fares much better than this crudely "iconographical," source-hunting, and parallel-quoting method – for this procedure fails not only on empirical, but also, and more important, on theoretical grounds.

Several writers have investigated the possible sources of and parallels for the decorated palettes in earlier and contemporary media like rock art, pottery design, wall painting, or textile decoration (see especially Williams and Logan 1987; Williams 1988).

Because these were, apparently, ancient and rich traditions, it is not surprising that we can discover apparent antecedents and analogs for many elements of the late prehistoric images, for they form just part of a larger, longer history of production in the Nile valley. This tradition might even have derived some mannerisms and motifs from older or contemporary Near Eastern sources, perhaps mediated by small Mesopotamian seals, although to date such seals found in late prehistoric Egyptian contexts do not themselves actually document the diffusion of the motifs in question (see further Boehmer 1974, 1975; Teissier 1987).

However, it is not at all clear what any of this painstaking research really manages to discover. Because all cultural practices necessarily have some kind of cultural heredity (just as biological individuals have a biological heredity), in principle we can always find a stylistic or iconographic "source" for an element of an image. We could continually extend the parallels to other and yet further associations. But to identify a source or a parallel is not thereby to understand the role of the element in any one of its immediate semiological contexts. Although an image maker derives a motif from another's work or even from another culture, it might be put to quite independent use, altering its established meaning by inserting into a new formal or semantic setting. For example, some commentators have suggested that the intertwined "serpopards" on the Narmer Palette symbolize the "unification" of Upper and Lower Egypt (Gilbert 1949) – a signification that presumably had nothing to do with the "original" Mesopotamian prototype of serpent-necked beasts. Source hunting alone will not expose such disjunctions. Indeed, unqualified by attention to the formal (e.g., compositional) and semantic (e.g., metaphorical or narrative) coherence of each image, source hunting based on ramified comparison among the disparate elements of many images, taken out of their immediate contexts, distracts attention from the meaning of any single image. The possibility of an earlier origin for some late prehistoric Egyptian motif tells us nothing one way or another about the symbolic function – for example, the metaphorical or narrative status – of this motif *as it was replicated by a late prehistoric image maker.* It would be interesting to find that the image maker expected viewers to recognize the earlier instances as an aspect of the motif he uses, and thus as an element of its connotation; but we can only establish this pictorial possibility by scrutinizing the entire mechanics of the image, not just by identifying the earlier analogue. A sign made according to the criteria of one symbol system is a different sign than that made according to different criteria, even if the morphology of the two signs is formally indiscernible. But only scrutiny of each image, as a se-

miological whole, will tell us what kind of symbol system it might be (see Goodman 1949, 1971).

Exactly the same considerations apply when we consider the replications of late prehistoric motifs in later, canonical art. By definition, the late prehistoric images form one part of the context for this subsequent production. But the late prehistoric image maker could hardly have intended all of the selections canonical image makers would make from particular aspects of his production (for example, they drew what I [1989: chap. 4] have called the "core motifs" of canonical iconography from the prehistoric repertory). To use George Kubler's (1961) term, the late prehistoric image maker could not have been fully aware at the time of the "serial position" he or she occupied in a continuous art history. But despite the obvious anachronism, it has been extremely tempting for many writers to take what we know of canonical art, hieroglyphic script, or Egyptian ritual, mythology, and cult and apply it back to images produced in an almost wholly preliterate, less complex prehistoric society. The procedure is completely unsound methodologically. In every case, independent evidence would be required to show that the earlier and the later images did refer to their objects, as images, in the same or very closely similar ways, but in most cases, the only evidence adduced for this is the "parallel" itself. Luckily, it turns out that little of real interest hinges on information gleaned from canonical iconography. Here or there a motif might be more precisely identified or a glyph deciphered. But by and large, and as we would fully expect, the late prehistoric image maker's practices were intelligible in their own terms. In fact, these terms were strikingly disjunct – Erwin Panofsky's (1960) term for the most important feature of an iconography in its historical dimension – from the terms ultimately adopted in canonical representation. Late prehistoric narrative images, including the Narmer Palette, cannot be assimilated easily either to what came before or to what came after.

LATE PREHISTORIC NARRATIVE IMAGES

Whatever their order of manufacture may have been, and despite their common status as the background for the canonical tradition, close scrutiny of major late prehistoric palettes – the Oxford, Hunter's, Battlefield, and Narmer Palettes (Figs. 1 to 4) – reveals that they are related to one another in Panofsky's (1939, 1960) "iconographic" sense. That is, they are related disjunctively: Although certain motifs might be morphologically constant through-

out the series, comparable with instances in earlier or later art production, each image exhibits a distinctive metaphorics; thus, although visual form remains relatively stable, textual meaning is disjunct from one image to the next. Although each image depends upon, or "works with," it also "works away from" earlier images in an evolving discourse, what Panofsky meant by an "iconography" as a continuous history of repetition and revision. The specific meaningfulness of each image is a matter of its own coherence within its own particular context of manufacture and use, what Panofsky meant by its "iconological" context. Unfortunately, although considerable attention has been paid to "iconographical" constancies in prehistoric and canonical Egyptian art, little attention has been paid to the defining disjunctiveness of iconography in its "iconological" contexts. Late prehistoric Egyptian images are disjunct from earlier prehistoric and from later canonical representation precisely in the fact that they seem to require a particular form of narrativization as the condition of their iconological intelligibility.

Here I cannot consider the disjunctive metaphorics of the two dozen or more late prehistoric images constituting the Narmer Palette's immediate iconographical and iconological context (for the principal examples, see Petrie 1953; Asselberghs 1961). Many of the works are simply too fragmentary to permit a properly detailed analysis of their pictorial structure. However, in order to understand the specific dynamics of the Narmer Palette, we must look briefly at the general characteristics of the Oxford, Hunter's, and Battlefield Palettes (Figs. 1 to 3). Despite their textual variety, all four palettes evidently project a common fabula. In various ways, each depicts the human hunter's or ruler's presence in and mastery of the natural and social worlds. The hunter on the Oxford Palette (Fig. 1, reverse bottom left) and the Hunter's Palette (Fig. 2) disjunctively becomes a lion on the Battlefield Palette (Fig. 3) and the human person of the ruler himself on the Narmer Palette (Fig. 4); in the latter two images, human enemies replace wild animals as the ruler's antagonists. At the most general level, this fabula of the ruler's mastery will become the central concern of canonical representation as well (see Hall 1988; Davis 1989: chap. 4).

More important for our purposes, no matter how each image relates a common, general fabula, at the levels of both story and text each image masks the blow of the hunter or ruler. In every case, the viewer does not directly behold the ruler's decisive violence; it is not presented in the pictorial text for the story related although it is logically required in its fabula. Instead, the viewer sees certain of the preconditions of the blow, like a hunting expedition (Fig. 2), or certain of its consequences, like a battlefield

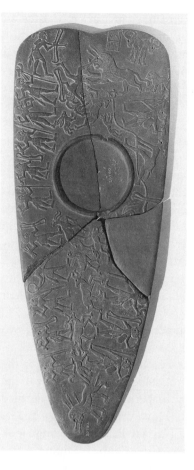

2 The Hunter's Palette.
Late Predynastic Period
(Nagada IId?). Courtesy:
British Museum.

strewn with corpses (Fig. 3). Nevertheless, despite this ellipsis, the
pictorial story and text take the viewer as close as possible to this
logically central event in the fabula without literally presenting it.

To take a simple example, on the Hunter's Palette (Fig. 2), the
viewer encounters a hunter at the top and "beginning" of the
image. Possibly the leader of the hunting expedition (he is taller
than all of the other figures), he is fitting an arrow to his bow,
about to shoot a lion attempting to protect its cub. But we do
not literally behold the flight of the arrow – that is, the fact that
in the fabula, the logic of events, the hunters succeed in hitting
the lion several times, an event leading from one state of affairs
to another, namely, the death of the lion after being struck by six
arrows, presented at the bottom of the image. In fact, this ellipsis
in the pictorial text is even greater than might first appear. At the
top of the image, the hunter seems to stand in front of the lion
to shoot directly at him. The confrontation of the pair is face to
face. However, at the bottom of the image, we discover that the

lion has been struck by one arrow in the anal-genital region (according to modern big game hunters, this is the ideal "kill" shot: it does not overly damage the beast's hide). In order to synthesize the story and fabula from the text of the image, then, the viewer must reconstitute the moment of the kill itself as having involved the hunter's sneak attack from behind. In unfolding this narrative, the viewer goes back — in the light of a later passage of depiction (the dead lion) — to an earlier passage of depiction (the lion about to be killed) in order to discover its incompleteness; the viewer experiences the movement or filling out of the story by interpreting what fabula must be implied in the material presented, or elided, by the pictorial text. All four palettes (Figs. 1 to 4) work in this fashion. On first glance, the Narmer Palette seems to present a full pictorial textualization of the fabula of victory. But even here an ellipsis between story and text and the logic of the fabula itself has a central role to play in the Narmer Palette's construction of narrative meaning.

As the example of the Hunter's Palette suggests, it would be misleading to isolate individual figures, groups of figures, motifs, or signs and try to identify their meaning independent of their metaphorical and narrative context within a particular image. By definition, an image is a concatenation of passages of depiction functioning for a viewer as a referential whole; no detail in or compositional zone of the pictorial text can be ignored. In the example of the Hunter's Palette, if a viewer ignores the arrow plunging into the lion's anal-genital region, then it is not possible to reconstruct the developments in the fabula (for instance, the sneak attack) that, once the viewer realizes their necessity, alters any understanding of the entire story and its textualization: The sequencing of episodes in the story has been set up to create a textual surprise, a communication of transformation in what is otherwise just the "static" depiction of states of affairs. Thus, although the lion on the Hunter's Palette (Fig. 2) may be formally comparable to the lion on the Battlefield Palette (Fig. 3), his narrative "meaning" is specifically constructed in relation to other figures in the image in their particular compositional arrangement. Taken out of this context, the lion "means" nothing — and certainly does not mean what it seems to signify on the Battlefield Palette (Fig. 3), where, for instance, the beast is not the antagonist and victim of the ruler.

In order to understand all of these images, the viewer must observe several general conditions that render them pictorially intelligible. First, each image requires the viewer to begin with the "top" of the "obverse" side of the palette — namely, the zone of pictorial text above the cosmetic saucer. Although we have no

independent archaeological evidence about the actual handling, use, or display of the palettes, it is reasonable to suppose that the "obverse" – or "first" or "beginning" – side of the image is specified as the side for carrying the cosmetic grounds, which would spill if and when the palette is turned over. The only one-sided image in the group, the Hunter's Palette (Fig. 2), has this saucer on its decorated side; and in the whole corpus of predynastic palettes (Petrie 1920, 1921), there are no palettes with saucer on one side and images on the other. The "top" – or the "beginning" in the top-to-bottom axis of the story – is specified by the fact that the routine funerary palettes from which the decorated palettes typologically derive oppose an emphasized, sculpted edge – often ornamented with double birds' heads, or "heraldic" animals in our group (Figs. 1 and 4) – to a plain, tapering edge. The cosmetic saucer (Figs. 1, 2, and 4) is usually closest to the sculpted edge, which, in predynastic graves, usually faces in the same direction as the head of the dead body (e.g., Petrie and Quibell 1896). Note, however, that "top" and "bottom" are always relative to a viewer's orientation, which need not be constant. Because the palette can be turned in the hands, "top" can become "bottom" and vice versa. A narrative can unfold through this reorientation. Note too that the narrative experience as a whole would not be greatly compromised if a viewer begins with the

3 The Battlefield Palette. Early First Dynasty (Nagada IId/III?). British Museum (large fragment) and Ashmolean Museum, Oxford University (small fragment).

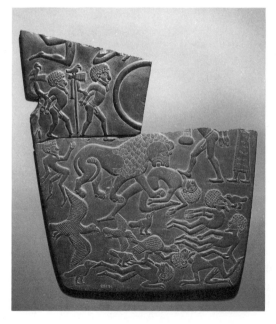
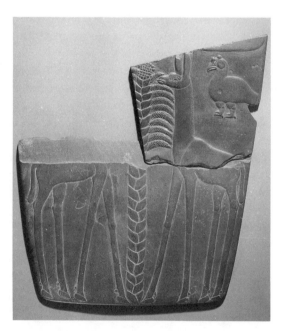

"bottom" or the "reverse" rather than with the "top" or the "obverse." As we have seen, the fabula can be reconstructed from the story sequence however it is ordered (for instance, in the "normal" or the "inverted" versions of Forster's specimen plot sentence[1]). Of course, as distinct from the interpretation of the fabula, the viewer's experience of the story and text varies with the point of entry, for example, at the "top obverse" and "beginning" or the "top reverse" and "half-way through." As we will see, pictorial narrative can play on this fact. On the Narmer Palette, it is only by "reading through" all of the pictorial material that the viewer will discover that, in the logic of the fabula, the "beginning" of the story on the "obverse top" is actually the logical *end* of the fabula.

Second, on either side of the palettes, the image presents either three or four distinct groupings of figures arranged in visually discrete zones or bands of depiction. In canonical representation of the dynastic period, register lines and other independent framing devices will be used to distinguish such zones. By contrast, in late prehistoric images, the zones are distinguished by the fact that each typically contains one or more pairs of actors – the several animal or human figures in the whole image – engaged in some kind of mutual action or interaction. (The Narmer Palette uses both the canonical and the late prehistoric means of dividing and sequencing the story.) These zones form the several episodes of the story from which the fabula can be projected. They tend to have quite different textual qualities one from the next (for example, in compositional arrangement, pictorial detailing, or use of complementary "hieroglyphs"), but they are all linked with one another as the episodes in the story of the narrative, or the poles of a metaphor, in particular top and bottom, left and right, side to side, or obverse to reverse relations.

Third, within each story zone or band, the nature of the mutual relation between the individual actors in the narrative is established in three ways, working together simultaneously: first, by the animals' or human figures' placement – at the sides or in the center (or bottom or top, right or left) of the zone; second, by their bodily orientation – moving toward, moving beside, or moving away from one another, from or toward an edge of the zone, from or toward the center of the palette, and so on; and third, by the directions of their glances – looking at one another or looking elsewhere (for the dynamics of "focalization" in narrative, see further Vitoux 1982; Bal 1983). These relations may be repeated or revised (for example, reversed or inverted) in other zones on the palette. In other words, the placement, orientation, and directionality of zones establish the mutual relations among

story episodes just as the placement, orientation, and directionality of figures establish the mutual relations among actors within a story episode. Such infrazonal interrelations generally establish that two zones should be taken together as a continuous segment of the story, whatever its chronological arrangement (for example, as before to after).

Fourth, in order to identify and inspect all of these relations within and between zones, the viewer is generally required to twist, rotate, or flip the whole palette in order to obtain a series of views of its surface. For example, the viewer can twist the object from "left" side up to "right" side up or flip it from obverse to reverse. Many of these views could also be generated by the viewer moving around the object placed, displayed, or held in a fixed position. In fact, such movement could be carried out in a viewer's imagination. For convenience of exposition, I will write as if the beholder's action on the palette was physical. Depending, then, upon where the viewer's hands grasp the object, upon what can be seen as upright in holding it from that angle, upon what disappears from view, and so on, the individual figures within the zones and the relations both within and between zones will have changing aspects in the activity of viewing. The viewer narrativizes the depictions by moving and scanning them in a particular order.

This concept of the active narrativization of an image through its real or notional manipulation and transformation is central to an understanding of late prehistoric Egyptian image making (see further Davis 1992). Unfortunately, as we have seen, we have no independent information about the way in which the palettes were actually manipulated or displayed. If they were "ceremonial" objects, then they might have been handled infrequently; people's access to them might have been quite restricted. If exhibited in a "liturgy" (in later periods, eye paint ground on palettes was applied to cult statues), then they could have been carried or displayed by handlers in such a way that viewers could see both sides of the image. For simplicity, I will suppose that the palette could be, in principle, handled by one person examining the several zones of depiction in a sequence of twists, rotations, or flips – whether or not anyone actually did so. At least one person did indeed handle the object this way: its maker's conceptualization of his or her visual and physical position in relation to the image articulated the narrative in the first place.

Whether or not we can suppose that people physically rotated or flipped the palettes, the plain fact of the matter is that with the exception of the Hunter's Palette (Fig. 2), the objects present depictions on both sides (Figs. 1, 3, and 4). Any interpretation of

the images must accommodate this property. Indeed, we may suppose it to have been a constitutive one in late prehistoric pictorial notation, differentiating it, for example, from morphologically similar symbol systems like the slightly later system of hieroglyphic script (for the general terms, see Goodman 1971; and compare Baines 1989, Millet 1990, and Fairservis 1991, all of whom overly assimilate or conflate depiction and script in late prehistoric and early dynastic Egyptian representation). In theory, it is not incidental but intrinsic to the significance of a visual narrative that it requires that "transposition" or "mobility of its internal elements," some "summation in time" of a "combination of an initial stable state with a subsequent movement," which Juri Lotman (1975) has identified as the essential feature of narratives in nondiscrete texts such as pictures.

One might object that if the palettes were used, in practice, to grind eye paint, then they could not have been rotated or flipped without spillage. It would follow that the palettes either were not actually flipped or were not actually used for their ostensible practical purpose. However, it is risky to proceed as if we know what late prehistoric Egyptian viewers would have regarded as practical given their own understanding of the functions of their images. To suppose that the images could not be rotated or flipped for practical reasons implies that any narrativization of the images derived from these motions was an impractical action. But we have no grounds for this supposition because we have no independent evidence for the function of the objects or the images on them. In fact, the representational function of the images is not incompatible with, and is actually required by, the functional hypotheses themselves. Consider the parallel of a decorated chair. When a person is sitting on the chair, using it for its literal or practical function, any decoration applied to the back of the chair cannot be seen without great difficulty, the chair cannot be tipped over, and the sitter cannot simultaneously move around it. But none of this implies that the decorations on the chair cannot be systematically structured as narratives or other complex representations. It certainly does not entail that the images are unrelated to the "practical" function of the chair – for example, as symbols of the person displayed on the chair or as metaphors for "sitting" (being settled, being in the seat, and so on). In fact, the representations both specify and universalize the merely practical function of an otherwise inert object by symbolically stating what its ostensible practical function "means," deploying the natural, social, cosmic, or other terms of an iconography: One can say that "sitting in the seat" is as much a metaphor as a use. So, too, with the Narmer Palette: Both the practical and the representational dimensions of

the object are interconnected aspects of the use and meaning of a complex artifact that also happens to be an image, an artifact representing something, and of a complex image that also happens to be an artifact, an image to be handled.

NARRATIVITY AND THE NARMER PALETTE

The Narmer Palette (Fig. 4) takes the general structure and conditions of intelligibility of late prehistoric image making to an extraordinary level of complexity, ingenuity, and calculation. It can hardly be understood except as the product of several generations of cultural practice. As I have already stressed, however, despite its continuities with earlier examples of prehistoric art in Egypt, the Narmer Palette is disjunctively related to these origins.

The top edges of both sides of the Narmer Palette are decorated with two frontal heads of bovids. (In some commentaries, the bovids are identified as Hathor, divine mother of the Egyptian pharaoh, or as the cow–goddess Bat, but they could be equally

4 The Narmer Palette. Early First Dynasty (Nagada IIIa/b or Horizon A/B). Courtesy: Cairo Museum.

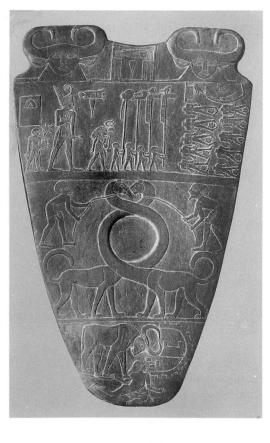
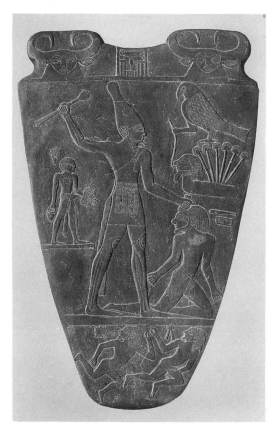

heads of the bull that stands, in the main image, for the ruler himself.) They flank a "palace facade" or *serekh* containing the *nar*-fish and the *mer*-chisel, signs also attached to the largest figure on the top zone of the obverse, apparently naming the ruler himself. This decorated top edge is sometimes interpreted as depicting a roof or canopy for a (palace) facade with bucrania. Although not necessary for our purposes, the reading is not incompatible with other features of the image. The top edge is divided from the zones below it by a thin register line.

Below the decorated top edge, the two sides of the palette are each divided into three horizontal zones. Excepting the "rebus" (reverse top right), each zone on the Narmer Palette containing a representation of the ruler has been provided with a register groundline – namely, the obverse top, with the ruler and his retainers and standards inspecting the corpses of enemies; the obverse middle, with the ruler's retainers mastering "serpopards"; the obverse bottom, with the ruler-as-bull vanquishing an enemy; and the reverse middle, with the ruler smiting his enemy. By contrast, zones depicting enemy personages do not possess a groundline – namely, the obverse top right, the obverse bottom, and the reverse bottom. In each of these zones, the enemies are depicted as defeated, twisted on, and from their baselines and upright axes. The special place of the enemy chieftain on the ruler's groundline in the reverse middle zone will concern us later.

The registers therefore mark the different status of figures within the image either as being part of or associated with the ruler or as being outside or not associated with the ruler, two different grounds. However, in addition to maintaining distinctions indicated in earlier images in the group, on the Narmer Palette the registers also divide each zone from the others on that side of the palette. As elements of composition, passages of visual text, they separate the zones – and thus presumably the elements of the story – in a way never presented on the preceding late prehistoric narrative images (Figs. 1 to 3).

Each side of the palette presents a zone depicting the aftermath, at the top, and the beforehand, at the bottom, of the ruler's blows of victory, with the obverse depicting the aftermath and the reverse the beforehand of the ruler's most decisive blow, the killing of the enemy chieftain. Thus, the story is arranged in the four top and bottom zones, top-to-bottom/obverse-to-reverse, as consistently after-to-before (Fig. 5). A few commentators (e.g., Vandier 1952: 596) have almost recognized this structure; otherwise, however, the Narmer Palette is usually described in very general non-narrative terms as a symbolic or allegorical image (e.g., Schäfer 1957; Finkenstaedt 1984; Kemp 1989) and is even reproduced

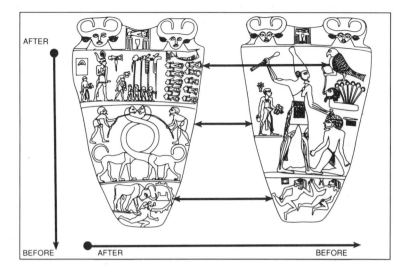

5 Story structure of the
Narmer Palette. Drawing:
Jandos Rothstein.

incorrectly – for example, as if the obverse side with saucer should
"come after" the reverse side with its picture of Narmer smiting
(e.g., Janson 1991: 99), and sometimes showing just one side (e.g.,
Trigger 1983: Fig. 1.8), equivalent to reproducing one-half of a
narrative painting sliced down the middle. As distinguished from
the fabula and story, the pictorial text also includes elements re-
lating material in the other temporal direction, from before to after
(strictly speaking, a counternarrative), as well as elements breaking
out of the narrative sequencing altogether. In view of this com-
plexity, it will be useful to go through the zones one by one
before considering their metaphorical and narrative interrelations.

Beginning with the obverse top, flanked on the left by his
sandal bearer and on the right by a "priest" bearing scribal equip-
ment, the victorious ruler (wearing the Red Crown of Lower
Egypt) is preceded by four standard bearers. The whole group of
ruler and followers inspects two rows of five decapitated enemies,
each spread on the ground, without groundlines, at right angles
to the progress of the victors. Signs or "hieroglyphs" above this
group – it is not clear whether they should be understood in
the way later canonical hieroglyphs can be – depict or designate
a door on its pivot (= the hieroglyph "great door"), a falcon
(= the ruler?) carrying or vanquishing a harpoon (= the enemy
on the reverse side, labeled with a harpoon?), and the "sacred
bark" of the ruler (see further Williams and Logan 1987; Fairservis
1991). The pictorial text on the Narmer Palette begins, then, with
the final achievement of the king, the celebration of his victory.

The beforehand of this episode is related in the top zone on
the reverse of the palette. Here, a "rebus" depicts the "enemy"
or enemies brought to the ruler by a falcon – an aspect, double,

or representation of the ruler's identity or perhaps his divine protector. (On the basis of an anachronistic comparison with canonical Egyptian iconography, we could conclude that the falcon is the god Horus; but this inference is methodologically unsound.) The falcon inserts a hooked cord into an enemy's nose in order, it seems, to prepare him for the beheading whose aftermath is related in the obverse top zone, where the ruler inspects decapitated corpses. The papyrus stalks growing from the enemy's body probably denote the enemy's home territory, "Papyrus Land." However it should be interpreted, in a general sense, the rebus indicates that the ruler – in his aspect as or with the protection of "Falcon" – has defeated his enemies and prepares them for their judgment and destruction.

On the obverse bottom, the beforehand of this episode – storying backwards in the fabula – is related. Here, a great bull uses its horns to break down the walls of a fortress evidently inhabited by the enemies, one of whom is thrown to the ground, facing away from the bull, and trampled. We can take the bull as an aspect, double, or representation of the ruler, although he should not be identified with the human person of the ruler as such. This zone seems to depict the moment in the battle itself when the enemies' defeat was secured. In his aspect as or with the protection of "Bull," the ruler enters their citadel.

Finally, on the reverse bottom, the beforehand of this episode is related; in the storying of the narrative, the "beginning" of the fabula comes at the "end" of the text. Here, two enemies are depicted as fleeing toward the right, that is, if one looks back through the text to the preceding stage (obverse bottom), toward the citadel in which they plan to take refuge (without avail, as even later episodes in the story have already told us in the text). They look back over their shoulders; they are being pursued by the ruler. Although the ruler does not appear in the pictorial text of this zone of the image, the text of the image as a whole is quite clear about his presence: The viewer already knows (obverse bottom) that "Bull" will break down the enemies' citadel, a building that the text depicts as a broken and inverted version of a sign labeling the left enemy figure. Furthermore, the enemies' glances over their shoulders are directed "up" to the figure of the ruler smiting his enemy presented immediately above this zone. Although coming last in the story, the fabula "begins," then, with the ruler pursuing his enemies.

Almost all commentators agree that the sign labeling the left enemy depicts or denotes a fortress with bastions. The denotation of the right sign is more obscure. In one interpretation, the signs label the Delta towns of Memphis and Sais (Kaiser 1964: 90; Kap-

lony 1966: 159). If all three signs labeling the enemies on the Narmer Palette, in the obverse and reverse bottom zones, refer to their actual hometowns, then the Palette could document a contest between "Nar-Mer" of Upper Egypt and a Delta coalition in which the principal "Enemy," Buto or the "harpoon" of the enemy on the reverse middle (Newberry 1908) was assisted by Memphis and Sais.

But I doubt that trying to force the Narmer Palette into serving as a document for actual historical events can be justified. At any rate, it cannot be the end of the matter in understanding the image. Even if a specific reference for the whole image could be found in actual events, this possibility is not, in itself, enough to show why they are represented in the particular symbolic, metaphorical, or narrative fashion that they are in the image as such. For example, the maker decides to use "Bull" to stand for the ruler, an intention probably determined in part by earlier or other representations of the ruler in the aspect of a great animal (see Fig. 3).

If we invert the order in which the image arranges it as a story, the four episodes of the fabula can be reconstituted as follows (Fig. 6):

1. Enemy resists and flees Ruler (Episode One, reverse bottom).

2. Ruler pursues and conquers Enemy (Episode Two, obverse bottom).

3. Enemy is presented to Ruler (Episode Three, reverse top).

4. Ruler celebrates death of Enemy (Episode Four, obverse top).

In turn, although not literally presented in any of the relevant passages of depiction, each of these episodes in the story must be linked one to the next, in the chronological and causal logic of the fabula, by the success of a direct blow by the ruler. Reading from the "beginning" of the fabula (as we have seen, the "end" of the pictorial text), between the first two episodes of the story the ruler must successfully track the fleeing enemies, locate their citadel, and scale or undermine its walls; we behold the enemies fleeing (Episode One) and the citadel, already taken, with the enemies already being trampled (Episode Two). Between the second and third episodes of the story, the ruler or his army must round up the conquered inhabitants and prepare them for judgment and imprisonment; we behold the town being overrun just

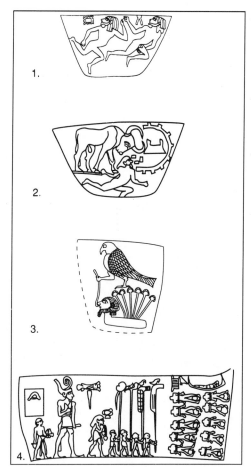

6 Episodes of the story
on the Narmer Palette.
Drawing: Jandos Rothstein.

after the walls have been demolished (Episode Two) and "Falcon"
already mastering the captives taken (Episode Three). Between the
third and fourth episodes of the story, the ruler or his executioners
must lop off the heads of the enemies condemned to die or to be
sacrificed in the victory ceremonials; we behold "Falcon" lifting
an enemy's head (Episode Three) and the ruler already inspecting
the decapitated corpses (Episode Four).

The ruler's decisive blow, then, occurs several times or
throughout the fabula. It is that transition, the event or process,
that takes the story inexorably from one state of affairs to another.
In the text, when viewers flip the palette from obverse top to
reverse top (Episode Four to Episode Three), despite the expec-
tation and requirement that we inspect the rebus (reverse top
zone) we cannot help initially noticing the picture of the king
smiting his enemy occupying the reverse middle zone. Here, ac-
companied by his sandal bearer and wielding the mace, the human

person of the ruler himself – wearing the White Crown of Upper
Egypt and other regalia – is about to strike an enemy labeled
"Harpoon" (or coming from "Harpoon Land"). The figure of
Narmer is presented at larger scale than any other figure in the
composition of the image; in fact, he appears at larger scale than
any other figure in the whole known group of late prehistoric
images of the ruler's victory. The rebus in the reverse top zone is
almost squeezed in beside him. In the flip from reverse top to
obverse bottom (Episode Three to Episode Two), that picture is
removed from view but replaced, in the same compositional po-
sition, by what seems to be its metaphorical equivalent – namely,
the picture, in the obverse middle, of the ruler's two retainers
mastering two serpopards. Finally, in the flip from obverse bottom
to reverse bottom (Episode Two to Episode One), the picture
of Narmer smiting his enemy, removed from view after the first
flip, reappears. Thus, no matter how the viewer flips the palette
to determine the relation between the zones of depiction spread
across it, reconstructing the fabula on the basis of the story
sequence, Narmer smiting his enemy continually appears in the
text.

The text provides the viewer with a key to the cipher of the
narrative image at exactly the place where the palette itself would
be both grasped and flipped, namely, the depiction of the ruler's
two retainers mastering the two serpopards. As well as represent-
ing the ruler's, they represent the viewer's own blow in viewing
the image: The two serpopards are the two sides of the palette to
be twisted around one another in the viewer's own two hands.[2]
Whatever their role as metaphors for the ruler's victory, the figures
of the retainers, textually associated with the viewer's own hands,
are depicted as moving in a clockwise circle (from obverse flipping
right hand over left hand toward reverse), gradually twisting to-
gether the long necks of the beasts from their heads down to their
bodies. The palette, then, must be viewed by starting with the
obverse top scene and always flipping the palette right hand over
left in the same direction (that is, obverse to reverse to obverse)
and always scanning top to bottom.

If the viewer adopts and without interruption continues to fol-
low this means of reconstructing the narrative fabula, then a sim-
ple, continuous twist will be generated. It can be summarized as
follows (Fig. 7):

OBV TOP	to	OBV BOTTOM (flip)
REV TOP	to	REV BOTTOM
(complete top-to-bottom scan for each side)		
REV TOP (flip)	to	OBV TOP

7 Reading the text of the Narmer Palette. Drawing: Jandos Rothstein.

OBV MID (flip) to REV MID
REV BOT (flip) to OBV BOT (flip)
(complete side-to-side scan, top-to-bottom for each side)
REV TOP (flip) to OBV MID
OBV MID (flip) to REV BOT
(complete side-to-side, top-to-bottom, one strand twist)
OBV TOP (flip) to REV MID
REV MID (flip) to OBV BOT
(complete side to side, top-to-bottom, other strand twist)

The full twist takes the viewer through all the available sequences of all zones of the depiction. On completing this twist at the obverse bottom, the viewer could only repeat the twist all over again. Therefore, this simple, continuous twist allows the viewer to construct what I will call the basic form of the narrative image available in the Narmer Palette. The basic narrative incorporates all possible forms of sequencing available within the context of the general conditions of intelligibility of late prehistoric image making (see the foregoing third section), and apparently leaves nothing out and nothing in excess. Returned to the obverse side whence the construction of the narrative began, in the progress through this basic pictorial narrative, the viewer makes ten complete flips of the two-sided palette, metaphorically equivalent to the two rows of five decapitated enemies, ten in all, depicted in the obverse top zone where the text "begins."

I have been looking so far, of course, at the arrangement of the fabula in the story presented by the image simply in terms of the sequencing and connectedness of the four episodes it logically requires. But the properties of the pictorial text invest the basic sequence with particular accumulating properties, a textual "tone," such as the continual reappearance – as it were, the underlining – of the ruler standing firm on his groundline and stabilizing the center of the image on a horizontal axis, the place of pictures of the ruler's blow, as the palette continually rotates around its vertical axis. Moreover, although the top and bottom zones on the two sides are all episodes in the story, they are not all, of course, textually alike.

For example, consider the textual qualities of and relation between just the first two logically closest episodes in the image's inverted storying of the fabula (that is, Episode Four, obverse top, and Episode Three, reverse top [Fig. 6]). In the inverted storying of the fabula, Episode Four precedes Episode Three. In fact, in the basic form and any other sequencing that still obeys the general rule of beginning with the obverse, Episode Four, the obverse top zone, "begins" the text, and Episode Three, the reverse top, turns up later and necessarily after a flip of the palette. Already, then,

the text of Episode Four, the depiction on the obverse top zone, must prepare the viewer for the text of Episode Three, the rebus on the reverse top. In the text of Episode Four, the ten decapitated enemies, depicted frontally, and the ruler's retinue, depicted in profile, literally and jointly ground the viewer's point of view: The viewer has been placed above and looking down on the enemies while being on the same level as and at the side of the ruler's group. The picture itself is highly descriptive. It graphically depicts the human person of the ruler with crown, costume, and regalia, his chief retainers, and his standards or army, as well as the specific fate of the enemies, with all attributes of costume, individual gesture, and so forth, carefully rendered. Some of this ekphrastic detail has a narrative status. For example, the decapitated heads of the enemies must be connected with the depiction in the rebus – "later" in the viewing of the narrative, if "earlier" in the fabula – of "Falcon" lifting up an enemy's head in order for him to be executed. However, some of the description is superfluous for the purposes of the narrative. Just compare the textualization of quite similar narrative material in the rebus, pictorially the least explicit of all the zones of the image. Here ekphrasis is at a minimum. To represent the "many enemies," the maker uses a single enemy head, without details of body, and plants possibly symbolizing the enemy homeland, "Papyrus Land." In fact, as a rebus, in this passage of the image pictorial textuality has been modulated into another species of textuality altogether, quite close to if not identical with ideographic script.

Other zones in the depiction stand somewhere in between these two relatively extreme possibilities of greater or lesser descriptive richness in the pictorial notation. Three "hieroglyphic" zones of pictorial textuality (the obverse middle, obverse bottom, and reverse top) can be readily distinguished from three "descriptive" zones (the obverse top, reverse middle, reverse bottom): The descriptive zones supplement pictorial text with the addition of actual symbolic labels ("Nar-Mer," "Harpoon," left and right enemy "towns"), that is, with nonpictorial text, but the "hieroglyphic" zones (cipher key, "Bull" and citadel, rebus) do not need to do so, for they are already quite close to or have completely modulated into nonpictorial text anyway.

These and other textual differences among passages of depiction play out in the way the narrative image will be interpreted by the beholder. For example, in the basic form of the image, the viewer encounters Episode Two, in the obverse bottom, *after* the descriptive Episode Four, the obverse top, and *before* the "hieroglyphic" Episode Three, the reverse top (Figs. 6 and 7). In this midway position, the obverse bottom seems pictorially more descriptive

than a group of hieroglyphs or a rebus: Its figures of "Bull" and
enemy are visually separated one from the other, and the hiero-
glyphs labeling the home towns of the enemies on the reverse
bottom are treated here as actual pictures of their citadel itself.
But the obverse bottom is less pictorially descriptive than the pic-
ture on the obverse top. Therefore, in this first segment of the
basic sequence (obverse top to obverse middle to obverse bottom
to reverse top), the narrative image begins with a very graphic,
vivid look at the "end" of the story (obverse top), gives the viewer
the key required for unfolding the story leading up to it (obverse
middle), goes back in some sketchy detail to a much earlier epi-
sode, the taking of the town (obverse bottom), quickly telegraphs
the connection between the taking of the town and execution of
prisoners should the viewer fail to infer it and simultaneously an-
chors further material it will introduce (rebus), and so forth. To
use the (possibly misleading) parallel of many modern novels and
films, the viewer–reader progresses through paragraphs of dense
description for and briefer summaries of events nested in an ar-
mature of foreshadowings and recapitulations – the montage ed-
iting of long or short takes in closeup, deep focus, zoom, and so
on, with greater or lesser clarity, color, and the like.

It would consume all of my space to describe all of the textual
properties of every possible segmentation and sequencing of the
narrative image on the Narmer Palette. However, we should, at
least, take note of the way in which the four episodes of story at
the top and bottom of the two sides of the palette are related to
the two central passages of text, the obverse middle and the re-
verse middle. As we have seen, both of these passages have the
narrative function of seeming to picture the ruler's blow that the
fabula requires must be taking place throughout the story – from
pursuing the enemies to taking their town, to rounding up pris-
oners, to executing them – even though the former adopts a more
"hieroglyphic" and the latter a more descriptive textualization.
Both zones have been singled out textually, appearing at larger
scale and in the center of the composition on either side, precisely
because of their relatively greater narrative significance, that is, the
fact that they continue to reappear in the image. But neither zone,
of course, literally denotes or describes the very moment of the
ruler's blow. Consistent with the overall organization of the image
obverse-to-reverse/top-to-bottom as after-to-before (Fig. 5), the
obverse middle depicts the moment just *after* the decisive blow
has fallen (here, the serpopards have just been caught and their
heads begun to be twisted together) and the reverse middle depicts
the moment just *before* it (here, Narmer throws back his right arm,
carrying his mace, just about to smite his Enemy down). The blow

itself as it strikes its target, after the beforehand of the blow and before the aftermath of the blow, is not depicted as such. It must be *in the center of the middle of the image* – namely, in the cosmetic saucer, where the beholder, a holder or user or even the owner of the palette, reaches down to mix the eye paint.

As they twist together the necks of the serpopards, the ruler's retainers are also depicted as tightening a noose around the cosmetic saucer, where the ruler's blow at the instant it strikes its target must be placed in the center of the middle of the image. In continually flipping the palette to retrieve the image caught and recaught up in its twist (Fig. 7), the viewer, then, seems to come closer and closer to beholding the falling of the blow, to pulling the noose tight around it with his or her own two hands.

But in fact, although the picture of Narmer raising his mace reappears again and again in the basic form of the image (Fig. 7), the blow escapes depiction and the image continues to mask it. Although there is no need to describe all of its textual properties and relations (we have looked briefly at the first segment), the full viewing sequence through all ten flips gives the narrative image on the Narmer Palette a complete text of eighteen zones – that is, the three sets of possible ways of scanning the six zones on the two sides according to the general conditions of intelligibility of late prehistoric image making, these sets sequenced in turn to accord with the same conditions and with nothing left out, no overlap, and no excess. This complete text can be mapped as follows:

1. obv top (Episode Four)

2. obv middle (cipher/after the blow)

3. obv bottom (Episode Two) – FLIP

4. rev top (Episode Three)

5. rev middle (before the blow)

6. rev bottom (Episode One) [completes top-to-bottom set]

7. rev top (Episode Three) – FLIP

8. obv top (Episode Four)

9. obv middle (cipher/after the blow) – FLIP

10. rev middle (before the blow)

11. rev bottom (Episode One) – FLIP

12. obv bottom (Episode Two) [completes side-to-side set] – FLIP

41

NARRATIVE AND
EVENT IN
ANCIENT ART

13. rev top (Episode Three) – FLIP

14. obv middle (cipher/after the blow) – FLIP

15. rev bottom (Episode One) – FLIP

16. obv top (Episode Four) – FLIP

17. rev middle (before the blow) – FLIP

18. obv bottom (Episode Two) [completes double-twist set]

Several features stand out in this text. First, the rate of flipping "speeds up" as the text progresses. In fact, it literally becomes three times faster at the end of the text than at the beginning. By the end of the text, casual viewers may long since have abandoned it; but viewers accepting the general conditions of intelligibility and following the whole narrative will experience its accumulating excitement as a physical sensation to be something like a roller-coaster ride that begins slowly and rockets through the final stretch.

Second, in the first set of flips (top to bottom, zones 1–6), the enemies' execution (Episode Four) and the enemies' flight (Episode One) begin and end the segment or "chapter" (as zones 1 and 6). In the fabula, these episodes are separated by the greatest temporal span, namely, between the very beginning and the very end of the war or conflict (on the concept and problems of narrative "span," see Bal 1985: 61–3). In the next and second set of flips (side to side, zones 7–12), the enemies' capture (Episode Three) and the taking of the town (Episode Two) begin and end the segment (as zones 7 and 12). In the fabula, these episodes are separated by a lesser temporal span (namely, as episodes within the war). In the center of this segment, and of the text as a whole (zones 9 and 10), the viewer seems as close temporally to the blow as it is possible to get insofar as the blow itself is not directly depicted (zones 9 and 10 = after the blow followed by before the blow, the least temporal span of all). But in the third and final set of flips (double twist, zones 13–18), that temporal closeness is forced open again. The enemies' capture (Episode Three) and the taking of the town (Episode Two), as they had earlier (for zones 13 and 18 = zones 7 and 12), enclose the after of the blow and the before of the blow (zones 14, 17 = zones 9 and 10); but they, in turn, enclose the *greatest* temporal span in the fabula, namely, the enemies' flight (Episode One) and the enemies' execution (Episode Four) (zones 15 and 16). In sum, despite the increasing pace of the viewing, or precisely because of it, the image relates the greatest possible temporal span of the fabula as entirely caught up within the king's blow, the central, focal moment. The viewer,

then, cannot be led closer and closer to the blow, for the blow is outside and around whatever the viewer's viewing unfolds. In the way it interrelates the many details and zones of the image, the storying works to establish the image's principal metaphor, an expression of the continuousness of the ruler's blow.

Third, the viewer, in fact, does not only fail to behold the ruler's blow. The ruler's blow also comes at the viewer from precisely the direction in which the viewer is not looking. Whereas in the pictorial text (obverse middle), the ruler's retainers are twisting the serpopards together clockwise in the ten obverse-to-reverse flips of the palette, the ruler with his mace raised to strike (reverse middle) is poised to begin precisely on the other side of the place from the viewer's place of beginning. In the flips of the palette, Narmer is always about to strike counterclockwise in the reverse-to-obverse direction. Therefore – like the lion on the Hunter's Palette (Fig. 2) – the viewer fails to see the ruler coming up around "behind" him. The noose will twist off the head of the viewer before it is ever tight enough to capture the ruler's blow; in the viewer's cumulative and dizzying viewing of the image, the ruler pulls the noose tight *as* his blow and it is the viewer who becomes its victim. At the beginning of the text, then, the viewer has been invited by the image to enter the scene like the ruler executing his enemies (obverse top, zone 1): The viewer marches beside the ruler and looks down upon the decapitated corpses. But at the end of the text (by zone 18), the viewer understands the real import of the scene initially viewed, for it was, after all, the "last" scene (Episode Four): The viewer leaves the text as yet another victim caught up in the ruler's blow.

In sum, it is not surprising that although in viewing the image the viewer may seem to unmask the ruler's textual appearances and come ever closer to seeing the blow taking place throughout the fabula, in the ten flips of the palette the ruler is finally remasked. The ruler is always escaping the depiction of the identity the viewer thinks to behold wielding the actual blow. As we have seen, the six zones of the two sides of the palette (eighteen in all in the basic form of the image) are presented in two quite visibly different modes of pictorial textuality, a descriptive or ekphrastic mode (D) and a "hieroglyphic" (H) mode. In the basic form of the image, the sequence of appearance of these these modes can be mapped as follows:

D H H H D D (top to bottom set, zones 1 to 6)

H D H D D H (side to side set, zones 7 to 12)

H H D D D H (double twist set, zones 13 to 18)

As we have seen, the viewer begins with a graphic description of the final episode, Episode Four, the enemies' execution (zone 1). In the first set of flips (top to bottom), the preceding episodes are presented in less descriptive, "hieroglyphic" pictorial text (zones 2 to 4) only to be reviewed again in more descriptive terms (zones 5 and 6). For the viewer setting out to view the image, it would seem that the "masked" depictions of the ruler – as "Bull" and "Falcon" – are going to be unmasked, and his human person smiting down his Enemy revealed.

The lure of unmasking the ruler, and of finding the real climax of the fabula, sets the viewer off on a further series of flips, only to be caught up in the ruler's noose (zones 7 to 18). A parallel device can be found in other late prehistoric images – for example, on the Oxford Palette (Fig. 1), a victim moves toward the lure of the hunter's presence only to be attacked from behind – but the Narmer Palette, disjunctively related to the earlier work, handles this arrangement as a metaphor in its own turn: The viewer is now a "victim." After a dizzying exchange of maskings and un-maskings (zones 7 to 12), in which the viewer can never be certain who or where the ruler really is in the narrative (although he appears to be throughout it), the viewing ends with the three most descriptive depictions of the ruler (zones 15 to 17) enclosed by the three most "hieroglyphic" (13, 14, and 18). Because the arrangement of episodes of the story embeds the greatest temporal span within the least temporal span, the textualization of this story embeds descriptive specificity within "hieroglyphic" generality. In other words, it turns what would ordinarily be a simple inversion of spatiotemporal and causal logic for the purposes of presenting a story into a metaphor for the narrative, an expression of the universality of the blow paralleling its continuousness.

The depiction of the ruler about to smite his Enemy (reverse middle zone) is insistently repeated. In the fabula, it appears between Episodes One and Two, Two and Three, and Three and Four. In the basic form of the narrative story as constructed in the ten flips of the palette, it turns up as zones 5, 10, and 17. Finally, the pictorial text strongly highlights it by magnifying its compositional scale. The picture of Narmer smiting his Enemy is strongly visible every time the viewer flips to the reverse side of the palette (Flips 1, 3, 5, 7, and 9); it is therefore textually present in a full half of the narrative.

For these reasons, the picture of Narmer smiting his Enemy becomes not only an element in (to be sure, a major, focal element) but also a symbol of the narrative in which it is embedded. In fact, it advances into a single passage of text (reverse middle zone) the pictorial dynamics of the whole narrative image as it is

spread out in or spread over a whole series of passages of depiction segmented and sequenced in various ways. In other words, the reverse middle zone directly depicts the metaphor that is not directly depicted in any one of but rather constructed by the complete concatenation of all the zones: It is the pictorial symbol of the metaphorical content of the narrative.

In what Heinrich Schäfer (1957) called the main "symbolic image" of the Narmer Palette, the rebus (reverse top right zone) is not divided from the picture of the ruler smiting his Enemy by a register line like those separating the zones elsewhere on the palette. Whereas the late prehistoric narrative image on the Narmer Palette constructs the reverse top and the reverse middle zones as distinct passages of pictorial narrative text, the pictorial symbol of the narrative – a second, complementary text readable in the whole text of the Narmer Palette – does not so distinguish them.

As we have seen, the rebus indicates that "Falcon" rounds up and presents the enemy captive or captives to the ruler. In the symbolic image, in which reverse top and reverse middle zones are not separated, the depiction explicitly shows that "Falcon" lifts the enemy's face to gaze directly at the face of the human figure of the ruler Narmer. Unlike the fleeing enemy on the Battlefield Palette (obverse, third zone), who looks behind him to see and acknowledge the victorious lion–ruler facing away from him (Fig. 3), here Narmer's enemy, already subdued by "Falcon," faces the master who takes possession of his town.

However, just below, a less compliant Enemy is depicted, grasped by Narmer himself: Although his body faces away from Narmer, the ruler twists his head completely around. Narmer stands fixed to a solid groundline drawn below the group from side to side of the whole palette. But the blow he is just about to strike, of course, cannot actually curve in or on the picture plane indicated by that groundline to land on top of his Enemy's skull or between his eyes. Because the end of the mace points up, rather than down, and considering the way in which Narmer's arm, wrist, and hand are rendered, in the moment of smiting itself the blow must swing forcefully to the side of the Enemy's head, caving it in or knocking it off. The ten decapitated enemies on the obverse top zone are the aftermath of such a blow. Narmer's decisive blow, then, must arc through a wild, unrepresented space – an ellipsis in the image's specification of "place" – from the point of view of the figures ranged along the depicted groundline. The ruler's deadly force enters the world from outside, where it cannot be seen. In this case, his force enters directly from the place – like the cosmetic saucer on the obverse – where the real viewers of the palette must be standing, invited to view the nar-

rative image as followers of the ruler, and where the ruler himself must be standing behind, for his blow, in the full unfolding of the narrative, will take them too. In the depiction, the doomed Enemy seems about to slump on the groundline. As the ruler is holding him up by the topknot of his hair, when the blow falls – the aftermath of this before – his broken body will collapse forward along the groundline or at right angles to it, in any case "falling off" the groundline and "out of" the picture into one or more unrepresented place. But, again, in the full unfolding of the narrative image, all of these places, in "back," "beside," or "in front of" the palette, have already been mastered by the ruler in the counterclockwise direction of his blow.

In addition to the rebus (reverse top right zone) and the figure of Narmer smiting "Harpoon" (reverse middle zone), the symbolic image also contains a third element (reverse left zone). Behind the ruler and placed on his own small solid groundline, the ruler's personal and evidently favored servant waits on the sidelines to perform his services. The viewer has already met him in the introduction to the narrative image (obverse top zone), where he comes up "behind" Narmer. In both passages, he carries the ruler's sandals, a water jug, the ruler's seal in a case around his neck (?), and slung around his waist what seems to be a bowl with two long hanging flaps of cloth for washing. Above his head, two "hieroglyphs" – a "royal" rosette and what is probably the bulb of the lilieacious plant that produces the flower – give his title as "sandal bearer of the ruler" (see further Schott 1950: 22).

In the obverse top zone, the sandal bearer has a relatively straightforward place in the highly detailed description of the enemies' execution. On the reverse of the palette, matters are by no means as clear. Because he stands "below" the ruler's upraised right arm clutching the mace, he appears to be part of the reverse middle zone; he appears to be accompanying the ruler just before the moment of his decisive blow. And yet, because he has his own groundline placed in the left portion of the composition, he could also belong to the reverse top zone, facing and completing the group of the rebus. On this view, the whole passage of pictorial text above the principal groundline on the reverse (reverse middle *and* reverse top zones) presents a "closeup" but also more "hieroglyphic" view of the scene depicted on the obverse top – that is, the ruler, accompanied by his personal servant and other companions (represented by "Falcon"), executing his enemies.

Why, then, should the sandal bearer be the only one of the ruler's retainers, of the several depicted in the introduction to the narrative image (that is, at the end of the fabula), to stand near the ruler just before the decisive blow? Although on the obverse

top he has an obvious, if limited, place in the narrative image by filling out the ekphrasis at the beginning of the story, why should he be included in the text that symbolizes the narrative as a whole? Why, in the symbolic image, does he occupy the place walking "beside" or "behind" the ruler that the viewer initially occupies in the beginning of the narrative and by its end discovers as being struck by the ruler's blow? Finally, if we treat the whole reverse side of the palette as part of the symbolic image, then why do the fleeing enemies below the groundline look over their shoulders not only at the ruler, but also at him, with no other such glances "across" register lines appearing on the Narmer Palette? Are we looking simply at the compositional and iconographic ambiguity necessarily inherent in a passage of text that functions simultaneously as part of a narrative image and as a symbol of the narrative whole? Or are we looking at the maker's, or viewer's, difficulty in extracting a symbolic whole out of a narrative image?

If the symbolic image on the reverse of the palette extracts the same metaphor for the sandal bearer as it extracts for the group of ruler and Enemy, then the sandal bearer's position as "coming up behind" spatially might be interpreted as his continuous, universal temporal place. Like the ruler smiting his Enemy, he too must be before, after, and throughout the story of the blow – with the difference that throughout he is masked from the sight of the Enemy, for Narmer stands before and between them. On these grounds, the sandal bearer might, I think, be regarded as Narmer's own son and successor. There is no independent evidence, of course, to back up this iconographic hypothesis. The sandal bearer does appear in another image of approximately the same date, the Narmer macehead, below and to the right, but facing or moving toward the seated ruler (Adams 1974: no. 1); the rosette labels the ruler himself on the so-called Scorpion macehead (Baumgartel 1955: 116).

The pictorial text places the sandal bearer directly below the ruler's raised arm, clenching its mace. In the text, then, after the blow falls, he will be given a place to grow. With the text of the symbolic image placing the heir apparent on the left and "future" or after side of the blow, the two enemies depicted "below" Narmer's groundline (reverse bottom zone) are correlatively placed on the right, forward side of the ruler, looking back in the very direction the blow will be coming toward them. Like the son of the ruler, in the symbol they too seem to have a place in both the befores and the afters of the ruler's blow. In the before of the blow – in the forward direction of the narrative image – they flee the ruler's deadly wrath, are pursued, and are destroyed (Fig. 6). In the after of the blow – and in the message of the

narrative image extracted by its symbol – they acknowledge Nar-
mer's heir: While the left enemy raises his left hand and looks
back over his right shoulder, the right enemy reverses direction,
raising his right hand and looking back over his left shoulder. In
either case, the pictorial text depicts them as only able fully to see
what is behind them, the power and danger of the ruler, with a
firm twist of their heads back even further to their left (that is,
twisting off their heads) or completely around to their right (that
is, changing their "point of view").

Considering its place in the composition of the narrative and
its composition as an independent text, the symbolic image on
the reverse side of the palette presents the continuity of the blow,
plaited through and tightening a noose around history, an order
both outside and a precondition of that history as a continuous
cycle of afters-to-befores and befores-to-afters. In all of history
itself, the ruler – and his dynasty – is always coming around in
the other direction from his enemy.

Henceforth, this pictorial mechanism and ones like it will be-
come the canonical narrativity of the art of the dynastic Egyptian
state, which literally subordinates the viewer of its representations
to and by those representations themselves (see further Davis 1989:
192–224). Despite the two sides and several zones of depiction,
and the possibility of different ways of scanning, segmenting, and
sequencing them, the insistence of the image on the Narmer Pal-
ette cannot be ignored: In the text, it regulates the story sequence
by the use of register lines and repeatedly introduces or inserts
and magnifies the scale of the ruler; in metaphor, it expresses the
continuousness and universality of his blow; and in symbol, it
represents and reduces the narrative. One cannot look away when
the ruler is always there, everywhere. In fact, it is possible that
many viewers of the Narmer Palette did not, in fact, pursue the
narrative image all of the way through its complex, complete
form, despite the fact that the palette derives from and replicates
the established conditions of intelligibility of late prehistoric nar-
rativity. Instead, the symbolic image on the reverse side of the
palette – the choice of a single striking picture to stand for the
whole narrative image – became the dominant meaning in reading
the pictorial text. Singled out by its compositional scale and
framed by register groundlines, the symbolic image of Narmer
about to strike his Enemy literally pushes the other zones of de-
piction to the side. In the constitution of the canonical tradition
in the early dynastic period, later artists selected the symbolic im-
age for replication as such, that is, as an independently meaningful
visual text that could be applied in new scenes of representation
the image maker of the Narmer Palette could never have antici-

pated. Moreover, as far as we can tell, these later image makers also suppressed the replication of the late prehistoric narrative image from which this symbol derived and in which it was initially embedded (Hall 1988; Davis 1989: 64–82, 159–71, 189–91).

In summary, considering both the narrative image and the symbolic image metaphorically related to it, the pictorial text on the Narmer Palette – the viewer's experience of the representation of the ruler's blow – has become the homologue of the fabula itself. Beholding the Narmer Palette is, in itself, an example of the ruler's victory.

NOTES

1. As I have stressed, we have no independent archaeological evidence about the function or meaning of the Narmer Palette. My hypothesis that it functions as a narrative representation, then, is based upon some of the predictions of systematic narratological theory (see especially Barthes 1977; Bal 1985). Because my terms are somewhat different from those of others who have written about pictorial narrative in ancient arts (for example, I adopt a tripartite analysis rather than the simple bipartite distinction between "story" and "discourse"), I sketch them in this note for those readers who wish to follow up the terminology and conceptual framework I have used to interpret the Narmer Palette.

As understood by semiologists and narratologists, narrative is conceived as the verbal designation or the graphic, sculptural, or other kind of depiction – broadly, the discursive "recounting" – of a transition from one state of affairs to another state of affairs. The transition entails and requires change in some but not necessarily all of the properties that events, actors, times, and places in the story are initially represented as having.

A reader or viewer interprets the narrative's presentation of states of affairs, properties, and transitions on several levels. In part, he or she proceeds at the level of the logic of the case, determining "what must be so in" or "what is true of" the world of the story if it could logically have the states, properties, and transitions it is related as having. Generally, we assume that at least some laws of spatiotemporal order and cause and effect, as they apply our "real" world, also apply in the fictive world of the narrative. But as my quotation marks have just implied, the "real" world – the world of the reader or viewer of the narrative – might be produced at least partly by narrative itself. Thus, if an image like the Narmer Palette has any kind of narrative dimension at all, it would be a mistake to attempt to understand it wholly as a "document" of some reality, whether it is a document of events themselves (such as the king's defeat of his enemies) or of "stories for" fictive events preexisting the production of the narrative image itself (such as a legend of the king's defeat of his enemies). The narrative image in part constructs the fictive worlds that it is "about" rather than merely takes over such worlds from previous discourse (on depictive aboutness, see further Goodman 1978; Wolterstorff 1981; Walton 1990).

For this reason, the popular distinction (e.g., Barthes 1977; Chatman 1978) between "story," the narratable material that preexists the narration

itself, and "discourse," a particular narrative representation, is inadequate, although it is frequently used by art historians who hope to take narrative images as "about," as narrating, preexisting events or stories (e.g., see Kessler and Simpson 1985). *Both* story *and* discourse are constructed by the narrative text itself, which, often enough, implicates no preexisting narratable material. And even if such preexisting stories can be found (such as the verbal or written texts that are often juxtaposed with pictures as providing the pre-existing story material for pictorial narrative), the narrative projects its own construction of the story, embedding this within the pictorial image. For example, although the written text narrates events in one temporal order, the pictorial image might relate them in another order; here, the image's representational activity occurs not only as its "discourse" about a preexisting story, but also produces the story itself, because stories are defined by temporal orderings. (By the same token, the preexisting text is, itself, a narrative, with its own relationship, as a story, to its own relevant narratable material.) Modern narratology conceives any preexisting written text as the "fabula" for the construction of a story and text accomplished in the narrative image. But there is no logical reason why the narrative image cannot project its own fabula as well: a fabula requires only the community's general under-standing of cause-and-effect, chronological, and other elementary relations, providing the conditions of intelligibility for any possible narrative in that community (see further Cros 1988; Coste 1989).

The narrative text itself might not present all of the elements a reader or viewer will tend to assume in reading and viewing the story as presented. For example, an event transforming one state of affairs into another might not be directly related, even though the story logically requires it. It will probably be "filled in" by the reader or viewer in his or her "imagination" in the "act of reading" or beholding (Sartre 1949; Iser 1978). Similarly, two states of affairs linked as cause and effect by a specific process related in detail in the narrative text may not be themselves presented. The reader or viewer reconstructs them as preconditions and consequences. Any explication of narrative must handle such logic and the interpretation of the narrative "in the reader's head" and "outside" the text itself as well as what the text itself literally appears to relate. Narratological analysis, then, refers to the reader or viewer's perception and interpretation of a narrative text rather than merely to different grammatical or compositional parts of the text *qua* text.

E. M. Forster (1927: 31, 82) has provided a classic example of a simple narrative relating:

The king died, then the queen died of grief.

As a single English sentence of two clauses, the statement appears to be quite simply composed; it has a straightforward grammar. But its narrative logic – in terms of a reader or viewer's perception and interpretation – requires close scrutiny.

First, consider the intrinsic logic of the case, the state of affairs in flux that this statement narrates. At one point (the initial state of affairs), the king is dead, but the queen is alive. At a later, causally related point (the following state of affairs), the king is (still) dead, and the grieving queen dies (or the queen dies of grief). A finer-tuned analysis might distinguish more than two states of affairs within this logic. For example, the narrative relating tells us about the death of the king (initial State of Affairs, 1), the grieving of the queen (a second State of Affairs, 2), and the resulting death of the queen

"of grief" (the final State of Affairs, 3). On this understanding, the narrative text – the grammar of the sentence itself – causally links State of Affairs 3 to 2, for the queen's death is caused by her grief, but it says nothing one way or another about the causal link between State of Affairs 2 and 1, for it does *not* directly state that the queen's grief, and consequently her death "of grief," was caused by the king's death, only that it chronologically succeeds the king's death. Some readers will infer this causal link if no other possibility is hinted at; but other readers, perhaps more alert, might be cautious. As we will see, attention to ellipsis and causal ambiguity is at the heart of late prehistoric Egyptian narrative image making.

At any rate, at the level of "states of affairs," we look at the world of narrated situations and events in their chronological and causal logic, "what is so in" as well as "what must be true of" the situations and events the narrative relating requires, what I call the *fabula*. As I have already stressed, this fabula need not preexist the narrative text as any particular existing representation of the world available in any other medium. It is the logic projected by the narrative text itself.

Second, our sentence – "the king died, then the queen died of grief" – presents the relevant logic of affairs in a particular fashion. For example, the sentence relates the king's death before it relates the queen's death. But preserving the underlying logic of the fabula, it certainly could have inverted this sequence of presentation – for example, "the queen died of grief after the king died." We can recover the same fabula from the second, inverted sentence as from the first, uninverted version. Nevertheless, we might be interested in the second level itself, the different sequences themselves, what I will call the *story* – namely, the particular arrangement of the chronological successions and causal links of the states of affairs related by the narrative. More simply, the story is the fabula as it is presented in a particular fashion.

Third, the sentence relates the properties of the agents and events in the fabula and story in a particular manner. Preserving the underlying logic as well as its sequential presentation, it could have offered other words in another grammatical array – for example, "the king passed away, and his grief-stricken queen followed him to the grave." This sentence preserves the chronology and causal relations of the fabula as well as the manner of presentation of one story version, the "uninverted" version, but it puts this information into words quite different from those making up the sentence written by Forster for the same fabula and story, namely, "the king died, then the queen died of grief." (An alert reader will also be cautious about constructing the Forsterian fabula and story from this text, for the words "followed him to the grave" might mean something other than the presumed fact that the queen actually dies.) This level of the narrative *text* is the particular manner of relating the story as its particular manner of relating the fabula.

The words, phrases, and sentences relating a story of the fabula can be but are not necessarily identical with the words making up what is often colloquially understood as a "text," the total concatenation of everything brought together in a piece of writing like a "poem," "story story," or "novel." In writing, the *narrative text* as such can combine with other forms of text, for example, passages that describe the appearance of characters or the aspect of settings (Klaus 1982 is a perspicuous discussion). These do not affect the fabula and story themselves one way or another. However, such passages strongly affect the reader's experience of the text, the writing out of the fabula and story. For example, they may slow down the reader's

reading one episode of the story or, through word choice or syntax, make it more difficult for the reader to recover the facts of chronology and cause and effect in the fabula. It can be extremely difficult, and sometimes pointless, to distinguish between the textual presentation, or writing out, of what is specific to the fabula and story and what is not.

Here again, the common distinction between "story" and "discourse" fails to capture the phenomena of narrative. According to this binary scheme, although description might be present in discourse, the story is, as it were, a pure narrative logic cutting through it. However, it is the discursive writing out, the written text or pictorial image itself, that might be the reader's only avenue toward the story and its fabula. Rather than speaking of "story" *and* "discourse" or even "story" *in* "discourse," we should refer, then, to the "discourse *of* story." Of course, the risk of ignoring the phenomenology of narrating – the reader's production and interpretation of a narrative from the material of a written or pictorial text – is also inherent in the triadic distinction among fabula, story, and text adopted here. As Gerard Genette (1988: 14) puts it, the triad "corresponds to no real or fictive genesis." Working for expository purposes from fabula to story to narrative text, or from narrative text back through story to fabula, encourages one to believe that the narrative text is just the reproduction of a story or fabula somewhere "in the writer's head" or "out there" in the collective consciousness or myth system of a culture. In addition to reifying culture as the origin of meaning (see Herbert 1991), this approach reinforces a debilitating literalizing tendency to look for the "meaning" of a narrative image in preexisting "texts" like religious scripture, fables and legends related in writings of mythology, annals or chronicles of the deeds of sovereigns, and so on. On this view, the narrative image becomes merely an illustration of another text. Its own specific pictorial organization may be ignored.

Thus, I must stress, yet again, that my analytic distinctions refer to narrative phenomenology – in the case of the Narmer Palette, to the visual experience of its viewers. In psychological experience, fabula and story can only be known by the viewer "in" or "by" the image. To that extent, the textual dimension of the narrative is experientially primary. "The prime reality is that of the text, which does not reproduce a model that might be fictive or real, but which, more precisely, *produces a narrative*. The narrative itself does not organize a *story* [and fabula] which would be prior to what it says, but on the contrary, it allows itself to be reduced to the story [and fabula]" (Cros 1988: 95). As active, experientially primary processes operating at the level of the reader's reading or the viewer's beholding of the text, the image involves what we should properly call the viewer's "fabulation," "storying," and narrative "textualization," his or her narrativization of the image. As we will see in looking at the Narmer Palette, the viewer's actions in projecting a narrative are, literally, actions, although we know little about their physical realization; they are something the viewer performs on and with the text in a given spatial setting and temporal duration (compare Lotman 1975, an account that has strongly influenced my own; Ricoeur 1983 is a sophisticated analysis of relations between the "fictive time" related in a narrative text and the reader's own temporality). Taken out of the spatial and temporal context in which the image is actually beheld and regarded merely as a static picture – a "composition" of motifs that is similar to other motifs or "decipherable" according to a dictionary of pictorial meanings – the narrativizability of the Narmer Palette, like that of any other text or picture, is not readily apparent.

Unfortunately, many investigations of "pictorial narrative" in ancient art studies and elsewhere frequently seem narratological neither in their premises nor in their results. Too often, they do not even address themselves to the pictorial narrative dimensions of ostensibly narrative images; conversely, they completely miss narrative images that should be identified, understanding them as "decorative," "emblematic," allegorical, or symbolic or as belonging to some supposedly nonnarrative genre like "portrait" and "still life" (for a provocative reconsideration of the last mentioned, see Bryson 1990: chap. 1). Often they concern themselves with matters like the representation of motion, of elapsed time, or of "historical" or "actual" events, with the sequencing of pictures of events, with degrees of realism or spatiotemporal naturalism, and so forth. Although some aspects of some of these topics may be relevant to understanding a pictorial narrative as such, many of them are red herrings.

For example, despite H. A. Groenewegen-Frankfort's insights into predynastic, protodynastic, and canonical Egyptian representations of "space and time" in her superb book *Arrest and Movement* (1951), in a later discussion of Egyptian "narratives" (1970) she works with an overly narrow conception of pictorial narrative. As many Egyptologists have done, she regards Egyptian images as "static," including the vast majority of temple and tomb paintings and reliefs. However, in her view, Egyptian image making occasionally attempts to create "dramatic actuality," as in images produced by artists working for King Akhenaten at Tell el-Amarna in the Eighteenth Dynasty (see Davis 1979) or by Ramesside artists in the Nineteenth Dynasty (see Smith 1965). But the problem of narrative as such totally cross-cuts Groenewegen-Frankfort's distinction between the static and the "dramatic" or "dynamic" properties of images. For instance, a pictorial narrative, such as the Narmer Palette might be, can use several "static" images to depict the individual states of affairs of the fabula as it is related in the story. Just because the pictures are "static" says nothing one way or another about the available modes of fabulation, storying, and textualization that might narrativize them. In fact, it is impossible to reconcile Groenewegen-Frankfort's comments about the narrative possibilities of "dramatic" images with her statement – incorrect, as it happens – that the juxtaposition of separate pictures is the only means of creating a pictorial narrative. Along with "drama," as one of the two criteria for identifying narratives Groenewegen-Frankfort lists "actually"; because she finds "dramatic actuality" in Ramesside art, she must also find narrative. Indeed, for some Egyptologists (e.g., Gaballa 1977) the "actuality," or documentary value, of an image is the sole test of its narrativity. But the "actuality" of an image is an entirely independent matter with no immediate bearing on pictorial narrative as such. Narratives may relate actual or nonactual events, stories about ahistorical, suprahistorical, or unreal situations; to look for narratives only in the depiction of actual, historical takings place would be to rule narrative out of all religious or mythological images, among many others. The upshot of Groenewegen-Frankfort's analysis, from our point of view, is that for her the Narmer Palette has no narrativity: As a composition of "static" images that evidently have no "actuality," she argues that it is, quintessentially, a "symbolic image." As we will see, however, although its "symbolic" status is important, the Narmer Palette is probably one of the most ingenious narrativizable images in the Egyptian prehistoric and canonical traditions.

2. For a fuller discussion of this aspect of the image, see Davis 1992; apparently, there are several examples of cipher keys – guides to the active narrativization

of the otherwise static or inert image – in late prehistoric Egyptian art, including various animal figures on the Oxford Palette (Fig. 1) and the "shrine" and "double bull" signs at the top of the Hunter's Palette (Fig. 2). (Later register composition can also be regarded as a way of regulating the viewing of the image by segmenting it into ordered parts; the Battlefield Palette [Fig. 3] and the Narmer Palette [Fig. 4] are initial efforts in the chain of replications leading to the full-scale elaboration of the canonical system of register composition [see further Davis 1989: chap. 1].) On the Oxford, Hunter's, and Narmer Palettes, these signs need not be regarded as hieroglyphs; although they might have independent denotations, they also function as depictions – as pictures of the very activity of viewing in which the narrative is constructed. The relationship between pictorial narrative and the nondiscreteness (Lotman 1975), hypoiconicity (Peirce 1932), or density (Goodman 1971) of visual text is too large a topic to explore here. Suffice it to say that pictorial narrative requires some mechanism by which the wholeness of the image, its textual continuity or even instantaneity, can be segmented into a sequence for scanning it in a particular order in both the time and the space of the viewer's viewing of it. Although such mechanisms can be provided in natural language text, such as captions, they can also be provided in the visual text of the image itself – and, of course, must be so provided in a largely non- or preliterate society. Here I do not take up the complex question of the emergence of Egyptian hieroglyphic script from late prehistoric traditions of pictorial narrativity.

SENNACHERIB'S
LACHISH NARRATIVES[1]

John Malcolm Russell

Sennacherib's great "Palace without Rival," built in Nineveh at the beginning of the seventh century B.C., was excavated between 1847 and 1851 by the youthful British adventurer A. H. Layard. Of the nearly two miles of sculptured slabs he found lining the walls of this edifice, none stirred more excitement among his contemporaries than those decorating a small inner chamber he designated Room XXXVI (Fig. 8). According to their cuneiform label, the reliefs in that room depict Sennacherib's conquest of the Judean walled city of Lachish. The story is also recorded in II Kings 18:13–14:

> In the 14th year of the reign of Hezekiah, Sennacherib, king of Assyria, attacked and took all the fortified cities of Judah. Hezekiah, king of Judah, sent a message to the king of Assyria at Lachish: "I have done wrong; withdraw from my land and I will pay any penalty you impose upon me." So the king of Assyria laid on Hezekiah, king of Judah, a penalty of 300 talents of silver and 30 talents of gold. (*New English Bible* 1971)

Layard's excitement at this discovery – the first independent confirmation of an event from the Bible – comes through clearly in his book *Nineveh and Babylon,* where he wrote: "Here, therefore, was the actual picture of the taking of Lachish, the city, as we know from the Bible, besieged by Sennacherib. . . . They furnish us, therefore, with illustrations of the Bible of very great importance" (Layard 1853: 152–3).

In addition to this visual account of the victory at Lachish, the colossal guardian figures in the main doorway of the throne room carried a text that included a description of Sennacherib's siege of Jerusalem (Russell 1991, Figs. 124–5). Layard observed that the Assyrian and biblical accounts agreed not only on the unsuccessful outcome of the siege, but even on the amount of gold paid as tribute by Hezekiah – Sennacherib's text states: "With 30 talents of gold . . . he dispatched his messenger to pay the tribute" (Luckenbill 1924: 70: 31–2).[2]

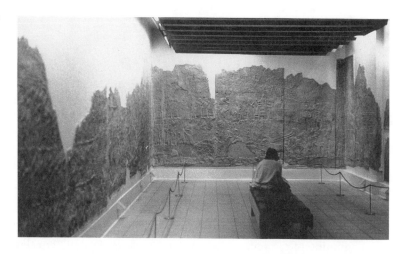

8 The siege of Lachish as installed in the British Museum, Room XXXVI, Southwest Palace, Nineveh. British Museum, WAA 124904–124915. Photo: J. M. Russell.

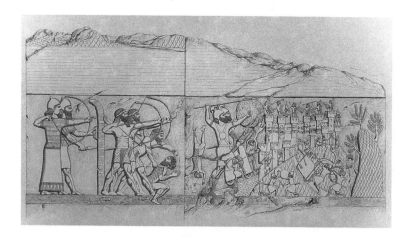

9 The siege of Pazashi, engraving of Slab 2, Room 14, Sargon's Palace, Khorsabad. From Botta and Flandin (1849–50, vol. 2, 145).

The Lachish relief series and the texts associated with it are the subjects of this essay. It focuses on three distinctive features of these sculptures. First, the structure of the relief series is considered in light of Sennacherib's innovations in the depiction of perspective. Next, Sennacherib's use of captions as labels for people and events in the composition is discussed and the narrative content of the captions is compared to that of the king's annalistic historical texts. Finally, the considerable differences between Sennacherib's textual and sculptural accounts of his campaign to Judah are analyzed. It is proposed that these differences may be accounted for by considering both their audience – a large heterogeneous audience of literates and nonliterates for the reliefs, a small group of literate courtiers for the texts – and the different expressive potentials of visual (impact, detail) versus verbal (breadth, economy) narratives.

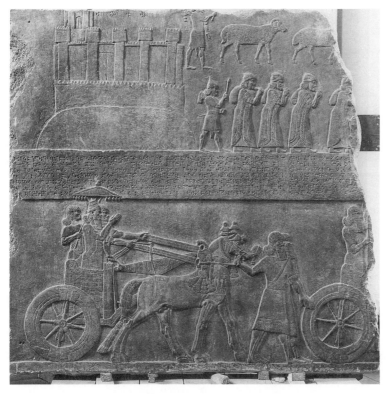

10 Relief of Tiglath-pileser III showing the booty of Astartu, Central Palace, Nimrud, w. 195 cm. British Museum, WAA 118908. Photo: Trustees of the British Museum.

For viewers accustomed only to the visual conventions of his predecessors, the narrative reliefs in Sennacherib's palace, including the Lachish series, must have appeared astonishingly innovative – never before had there been anything quite like them. One of their most remarkable features is their perspective. Although not mathematically coherent like Renaissance linear perspective, it nevertheless often provides an effective suggestion of depth.[3]

The narrative relief slabs of Sennacherib's predecessors are divided horizontally into two registers by a raised band of inscription. In the resulting long, relatively narrow pictorial field, spatial relationships could be indicated by either of two conventions. The most common was to place all figures on a single groundline, depth being indicated by having closer figures overlap more distant ones (Fig. 9). In compositions organized this way, the flow of the narrative within the register is horizontal and – to appropriate a term from music – monophonic. Because all figures are arranged on a single horizontal, the direction of the narrative must be horizontal as well, and because there is only a single row of characters in a register, only a single story may be occurring in any given vertical segment of the register.[4]

With the other convention, used infrequently before Sennacherib, figures could be placed anywhere in the field, and higher

"horsemen and charioteers"

0 1 2 3m

11 The siege of Lachish as reassembled by the author, Room XXXVI, Southwest Palace, Nineveh.

figures are understood to be more distant than lower ones (Fig. 10). This system provides a more satisfying suggestion of depth, at least to our eyes, and at the same time permits much greater complexity: The narrative may flow vertically and diagonally, as well as horizontally, and – to borrow from music again – it can be harmonic, with figures above and below the primary ones contributing additional information, or even polyphonic, with several rows of characters arranged one above the other, each telling its own story.

The cramped register height in the reliefs of Sennacherib's predecessors, however, permits only very small-scale figures to be juxtaposed vertically in this manner. Figures this small are difficult to recognize from a distance, an especially serious shortcoming in

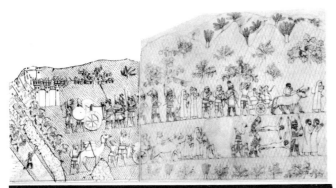

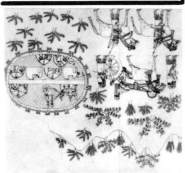

the case of the all-important figure of the king. Sennacherib, or
his artists, must have been unsatisfied with the limitations imposed
by the two register format, for he eliminated the central text band
from all of his wall reliefs, thus opening the entire surface of the
slab to perspectival and narrative exploitation. To this expanded
surface, his artists applied the second type of perspective.

The Lachish relief series, the best preserved narrative sequence
from Sennacherib's palace, serves as an excellent illustration of
Sennacherib's perspective construction. Room XXXVI was a rel-
atively small room and the Lachish episode occupied all four walls
(Fig. 11). The setting is a wooded mountainous landscape, indi-
cated by the traditional scale pattern covering nearly the entire

12 Assyrian army
approaching the city of
Alammu, nineteenth-century
drawing of Slabs 4–6, Room
XIV, Southwest Palace,
Nineveh. British Museum,
WAA, Or. Dr., IV, 57.
Photo: Trustees of the British
Museum.

13 The siege of Lachish,
Layard's drawing of Slabs 5–
6, Room XXXVI, Southwest
Palace, Nineveh. British
Museum, WAA, Or. Dr., I,
58. Photo: Trustees of the
British Museum.

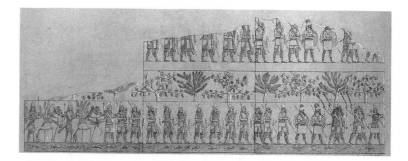

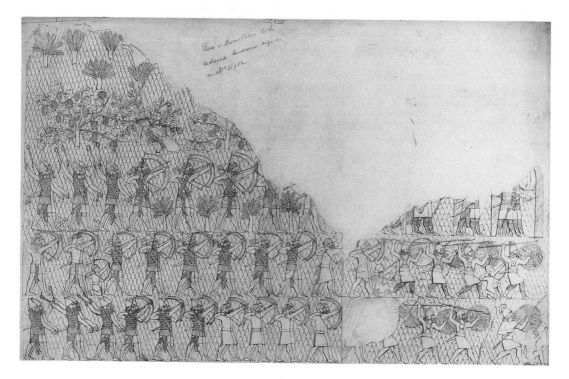

height of the slabs. The scale pattern is bounded at the top by an undulating line that defines the contours of the mountains in the background. This upper contour, which functions as a horizon, is something new in Assyrian reliefs. In "correctly" constructed perspectives, the horizon defines the level of the viewer's eye, and here too the high horizon serves for the viewer as a confirmation of the high viewpoint implied by the sharply rising ground plane below it.

The majority of figures here are arranged on a series of ground lines, which serve to organize the recession vertically. Unlike the inflexible register divisions in the reliefs of his predecessors, however, Sennacherib's ground lines are never allowed to assume an

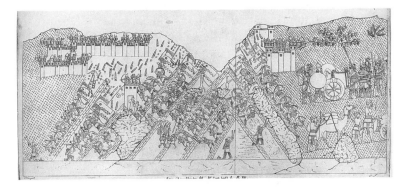

14 The siege of Lachish, Layard's drawing of Slabs 7–8, Room XXXVI, Southwest Palace, Nineveh. British Museum, WAA, Or. Dr., I, 59. Photo: Trustees of the British Museum.

15 The siege of Lachish, Layard's drawing of Slabs 9–10, Room XXXVI, Southwest Palace, Nineveh. British Museum, WAA, Or. Dr., I, 60. Photo: Trustees of the British Museum.

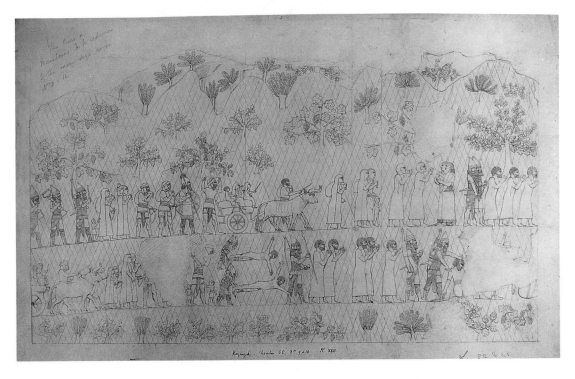

identity independent of the figures, and they may slant, shift, or terminate to suit the requirements of the figural arrangement. The figures themselves are relatively small, their height rarely exceeding one-fifth of the height of the slab. Most figures are roughly the same size. The soldiers who man the siege ramps and the defenders of the city are somewhat smaller than the figures on neighboring slabs, but the visually disruptive effect of the scale pattern that separates the larger and smaller figures makes this discrepancy less noticeable than it might be otherwise.

The composition is read from left to right. The first four slabs at the left were not drawn or removed, but Layard reported that they showed "large bodies of horsemen and charioteers," that is, the approaching Assyrian army (Layard 1853: 149). The equivalent scene from a similar narrative series in Room XIV of Sennacherib's palace gives some idea of what the lost Lachish version probably looked like (Fig. 12). The preserved portion of the Lachish relief series commences with three files of Assyrian attackers, each occupying a ground line (Fig. 13). This pattern of horizontals is then interrupted by the dramatic diagonals of the siege ramps, where the Assyrians push their siege engines to the top of the city

16 The siege of Lachish, Layard's drawing of Slabs 11–12, Room XXXVI, Southwest Palace, Nineveh. British Museum, WAA, Or. Dr., I, 61. Photo: Trustees of the British Museum.

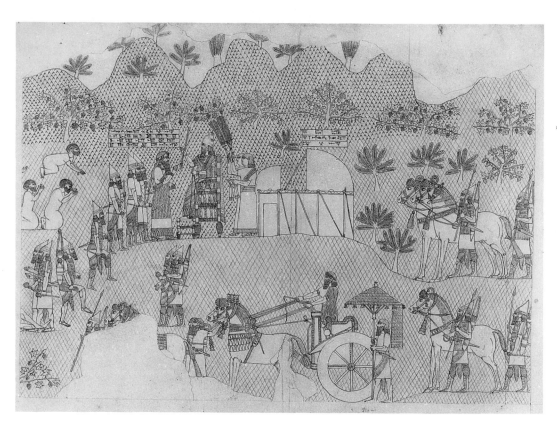

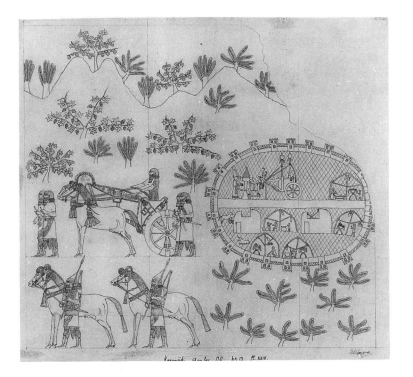

17 The Siege of Lachish,
Layard's drawing of Slab 13,
Room XXXVI, Southwest
Palace, Nineveh. British
Museum, WAA, Or. Dr., I,
62. Photo: Trustees of the
British Museum.

wall amidst a hail of fire and arrows from the defending Lachishites
(Fig. 14)

To the right of this are two files of prisoners being marched
away from their now-fallen city (Fig. 15). These files slant grad-
ually upward and eventually converge on a hillock, represented
by a single ground line located midway up the slab (Fig. 16). Atop
this is Sennacherib, further elevated above his surroundings by the
high throne on which he sits. Also setting the figure of the king
apart from the rest is a pair of captions, which horizontally bracket
his head and signify to literate and nonliterate alike that *this* figure
is someone special. The king emerges as the single most prominent
figure in the composition, not by being shown physically larger
than his fellows, as would have been the case in Egypt, but rather
because he occupies a visually privileged space. The composition
concludes with the king's attendants and chariots, and the walled
Assyrian camp (Fig. 17).

In this relief series, space is used as an analogue of time. The
progression of figures through the continuous space represented
in the reliefs is used to express temporal sequence. This in itself
is not an innovation of Sennacherib's artists — the same usage
occurs in the reliefs of his predecessors. There are two features,
however, that distinguish Sennacherib's temporal sequences from
those that came before. First, in Sennacherib's reliefs, the vertical
expansion of the picture field permits the artist to include greater

narrative detail without extending the horizontal length of each episode to the point where the coherence of the narrative is in danger. Second, the more expansive landscape patterns of Sennacherib's reliefs provide a strong visual link between episodes, emphasizing the continuity of location from one episode to the next and thereby strengthening the unity of the narrative.

Recent excavations at Tell ed-Duweir, ancient Lachish, have provided convincing evidence that Sennacherib was concerned with spatial verisimilitude not for its own sake, but rather as a means of constructing the image of a very particular place. Those excavations showed that in the Assyrian period, Lachish was a double-walled city high atop a mound (Ussishkin 1982). Its only approach was via a ramp that ran diagonally up the side of the mound to a towered gate in the outer wall. The Assyrians breached the inner wall by building against it a massive siege ramp, portions of which still survive, at the southwest corner of the mound.

The double walls and the locations of the approach ramp, towered gate, and siege ramp all correspond closely to Sennacherib's picture of the event in Room XXXVI. Ussishkin suggested that the Assyrian relief artists attained this degree of accuracy by working from drawings made on the spot during the campaign, but I think an alternative possibility is equally likely. The only evidence for such drawings is the apparent accuracy of the finished reliefs in details such as costume, topographical details, and architecture. In the Lachish reliefs, however, there is a significant difference between the excavated outer city wall, which appeared to be only a low unfortified retaining wall, and the outer wall as represented in the reliefs, shown fortified with regularly spaced towers full of defending Lachishites (Ussishkin 1982: 119–26). This is the sort of discrepancy one would hardly expect to find in a drawing made on the spot, but which might occur in a written description of the city translated into visual terms. In this latter scenario, it is easy to imagine "wall" in a written description being translated into its most familiar (and formidable) visual form, that is, a towered fortification, even if this convention does not in fact correspond to the appearance of the original.

The details that do exist in the reliefs could, I believe, have been drawn wholly from written campaign accounts and interviews with participants from both sides. In this context, two things should be remembered. First, many inhabitants of captured cities were deported to Assyria, so it should not have been difficult to locate Lachishites to interview. Indeed, Barnett observed that men wearing the costume of the Lachishites were shown among the laborers in the bull-hauling scenes of Court VI and in the royal

bodyguard in the Ishtar Temple procession (1958: 164). Second, Sennacherib's palace was being built and decorated at the same time as the first few campaigns were being conducted. The relief designers could draw on recent memories, unclouded by time, to ensure the accuracy of their images. Thus, we might expect to find greater accuracy in the early campaign reliefs of Sennacherib than in those of Assyrian kings whose palaces date to the later part of their reign.[5]

Whatever the explanation for this accuracy, it is clear that the Lachish shown in the relief is intended to be recognizable. Indeed, its combination of topography, costume, and architectural features is so specific that it seems probable that anyone who had seen the city itself would recognize its image in the reliefs, whether or not that viewer could read the captions. This degree of visual specificity is without precedent in Assyrian reliefs, and is largely made possible by the expanded pictorial field available to Sennacherib's artists.[6]

The primary Assyrian source for Sennacherib's third campaign is the "Rassam Cylinder" (British Museum, WAA, 80–7–19, 1; dated 700 B.C.), discovered in the palace walls by Hormuzd Rassam, who succeeded Layard as excavator of Nineveh (Luckenbill 1924: 29–34, 60–1, 68–70; Borger 1979, I: 64–5, 68–77; Reade 1986: 33–4; Russell 1991, Fig. 6). This text survives in numerous duplicates, including the throne room colossus inscription that so excited Layard. As summarized by Na'aman, the third campaign, of 701 B.C., fell into three phases (1979: 64–70). First, Sennacherib's army marched down the Phoenician coast, collecting tribute along the way (Fig. 18). Next came the recapture of Philistia, in the course of which Sennacherib defeated an Egyptian army at Eltekeh. The final phase was an apparent attempt to subjugate Judah, where Sennacherib's offensive succeeded in capturing a number of Judean fortified cities, but failed to conquer the capital city Jerusalem.[7] Interestingly, the only Judean city mentioned in Sennacherib's "official" account of the third campaign is Jerusalem – neither Lachish nor any other captured Judean city is mentioned by name. Instead, there is the generic statement: "As for Hezekiah, the Jew, who had not submitted to my yoke, 46 of his strong, walled cities and the cities of their environs, which were numberless, I besieged, I captured, I plundered, as booty I counted" (Luckenbill 1924: 70: 27–8). I will return to this point later.

The only Assyrian textual reference to Lachish is the caption carved in front of the enthroned Sennacherib on the relief series being considered here (see Fig. 16). It reads: "Sennacherib, king of the world, king of Assyria, sat in a *nēmedu*-throne and the booty

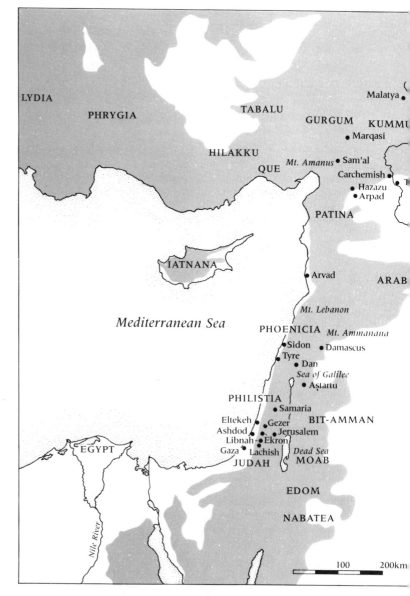

LYDIA

PHRYGIA

TABALU

Malatya

GURGUM KUMMU

Marqasi

HILAKKU

Mt. Amanus Sam'al

QUE

Carchemish

Hazazu

Arpad

PATINA

IATNANA

Arvad

ARAB

Mt. Lebanon

Mediterranean Sea PHOENICIA *Mt. Ammanana*

Sidon Damascus

Tyre

Dan

Sea of Galilee

Aṣtartu

PHILISTIA

Samaria

Eltekeh Gezer BIT-AMMAN

Ashdod Jerusalem

Libnah Ekron

Gaza Lachish *Dead Sea*

EGYPT

JUDAH MOAB

EDOM

NABATEA

Nile River

100 200km

18 Map of the ancient
Near East at the time of
Sennacherib. Drawing:
D. L. Hoffman.

of Lachish passed in review before him" (Russell 1991: 276). An-
other caption is located over the tent behind the king at right:
"Tent of Sennacherib king of Assyria" (ibid.: 277).[8]

Assyrian artists were among the first to employ labels in con-
junction with images as a means of particularizing and explaining
subject matter. These captions – called "epigraphs" by Assyri-
ologists – are the ancestors of the modern news photograph cap-
tion and comic strip balloon. Although the epigraphs in the
palaces of Sennacherib's predecessors, Tiglath-pileser III and Sar-
gon II, were reserved solely for enemy cities and captives, Sen-

nacherib's are often placed near his own image and commence with his name and titles, serving primarily to identify the king, and only secondarily the defeated enemy. In the Lachish relief series, the name of the king appears twice in epigraphs located near his enthroned image. Even though there is no long text carved across the middle of these reliefs, as was the case for earlier kings, there is no danger of mistaking the identity of the hero of this story.

Sennacherib's epigraphs are also more informative than those of his predecessors. Epigraphs of Tiglath-pileser III consist only of

the name of the enemy city (see Fig. 10). Some of Sargon II's epigraphs are of this same form, but others augment the city name with the statement "I besieged, I conquered," which, however, is already abundantly clear from the accompanying images (see Fig. 9). The Room XXXVI epigraphs, by contrast, include more narrative detail, such as the information that the king sat in a *nēmedu*-throne, that the tent belongs to the king, and that this procession represents booty from Lachish.

For Sennacherib, therefore, the epigraph is no longer simply a passive label containing the name of the enemy, but now serves a much more active role in the narrative, identifying the participants on both sides and giving a descriptive summary of the action depicted. To employ Roland Barthes's terminology, Sennacherib's epigraphs both "anchor" the images, ensuring the correct identification of the subject, and "quicken" them, emphasizing for the literate viewer the significant features of the action (Barthes 1977a: 25; Barthes 1977b: 38–40; Winter 1981: 25).

The Lachish relief series in Room XXXVI was given unusual prominence by its architectural setting. The room occupied the third, inner, rank of rooms in the suite west of Court XIX (Fig. 19). Access to Room XXXVI from Court XIX was gained by passing through a series of three monumental portals. Each of these doors was decorated with a pair of bull colossi, which decreased in size from 18 feet high in the outer door, to 12 feet high in the door of Room XXXVI, the Lachish room. Because these doorways were all located on a single axis, the visual effect when standing in Court XIX and looking in toward Room XXXVI was an accelerated perspective, a sense of dramatic convergence toward the scene depicted on the rear wall of Room XXXVI, namely, the image of the besieged city of Lachish (Ussishkin 1982, Fig. 60). Because the distance (130 feet) and lighting differential between Court XIX and Room XXXVI would probably have made the image of Lachish invisible from the courtyard, the colossi serve simultaneously to focus the viewer's attention on the reliefs and to mark the pathway to them. Nowhere else in the preserved portion of the palace were colossi used to highlight a room in this way.

The Lachish room was located in a suite – Rooms XXIX to XLI – that seems to have been decorated almost exclusively with scenes of Sennacherib's third campaign, to the west (Russell 1991: 161–4, 172–4). Because its combination of central location and perspective effects makes the Lachish room the focal point of the entire suite, a visitor might justifiably conclude that the surrender of Lachish was the high point of the western campaign. What a surprise, then, to turn to the annalistic account of that same cam-

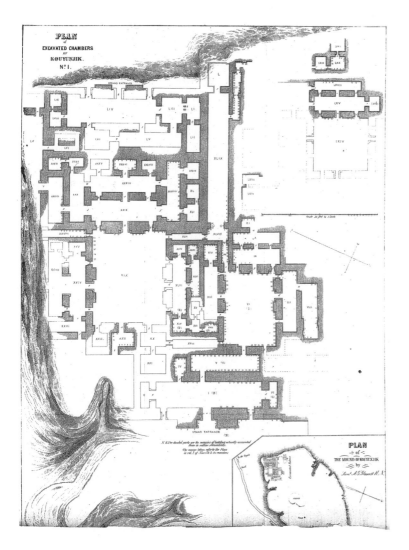

19 Layard's second plan of the Southwest Palace, Nineveh. From Layard (1853, opp. 67).

paign, inscribed on the bull colossi at the throne-room entrance, and discover that Lachish is not mentioned at all!

It appears that Sennacherib has here taken advantage of the strengths of two greatly different narrative media, image and text, to tell what is essentially the same story in two very different ways. An extended verbal narrative requires a "story line," that is, a series of links that relates each episode to the one that follows, and a coherent overall sequence, that is, an intelligible temporal relationship between episodes. In these terms, the campaign against Judah, which included the capture of Lachish, does not make a very inspiring story because its apparent objective, the capture of the capital city Jerusalem, was not attained.[9] A reasonably full written account of this phase of the third campaign would have to described the capture of Lachish, and perhaps other im-

portant cities as well, and then culminate with the account of the
unsuccessful siege of Jerusalem. This climax would be anticlimac-
tic at best, and risks making the considerable effort that went be-
fore appear wasted. Sennacherib chose instead to make the written
narrative of this portion of the third campaign very brief, men-
tioning only that a number of cities – which are not named
– were captured, and that Jerusalem was not captured but paid
tribute anyway. The importance of this part of the campaign
is minimized, both by treating it in vague terms and by permit-
ting it to occupy only a minimal amount of space in the overall
narrative.

In this context, it is necessary to consider the audience for these
written narratives. It must be remembered that at this time, lit-
eracy was confined almost exclusively to the scribes. Sennacherib's
colossus texts are so lengthy and specialized that they probably
could be read with facility only by the Assyrian court scribes who
composed them. Any outside visitor would face at least five sub-
stantial difficulties in interpreting them. First, most outsiders
would not be literate. Second, even if they could find someone
to read the text, most foreigners – and even many Assyrian visitors
– could probably not understand Akkadian, which was gradually
being supplanted by Aramaic as the primary spoken language of
the empire. Third, even Assyrian visitors who understood Akka-
dian might have difficulty understanding the palace inscriptions,
which were almost always written in the Babylonian dialect rather
than in the Assyrian. Fourth, few visitors, even if they passed the
first three obstacles, would have the time required to read these
texts, which are very long and involved. Finally, very few people
outside the court would have the cultural background necessary
to comprehend fully even the titulary, which presuppose a high-
level familiarity with Assyrian imperial ideology. The annalistic
portions of the texts might be somewhat easier for the unindoc-
trinated to understand, but the technical language of the building
accounts would probably also be incomprehensible to those un-
familiar with Assyrian palaces (Liverani 1979: 302).[10]

Consequently, it is unlikely that a visitor to the palace, even a
literate one, could have the time or expertise to wade through
the tremendous number of Assyrian victories recorded in these
texts in order to discover that the Judean campaign was less than
successful. The verbal narrative of the Judean campaign, therefore,
must have been intended mainly for the Assyrian administrative
elite, a group that would have been thoroughly familiar with the
story without even needing to read it. For this audience, whose
loyalty was essential to the king's continuing rule, the seemingly
unbiased written account of this campaign establishes the credi-

bility of the text, and by extension, of the king who ordered its composition and display.

In this way, the written narratives in Sennacherib's palace serve to confirm the confidence of the courtiers in their king, thereby helping to maintain the fidelity of this important group. For in this period, at the height of Assyrian imperial power, the greatest threat to the king of Assyria was not Judeans on the fringe of the empire. Rather, the real threat was at home in the king's own palace, a fact amply demonstrated by the fate of Sennacherib himself: The victim of a palace conspiracy, he was murdered by one of his sons (Parpola 1980: 171–82).

The visual narratives in Sennacherib's palace, by contrast, lend themselves much more readily to an episodic treatment. This is a matter of both spatial scale (the reliefs are large-scale; the inscriptions, small-scale) and relative economy. No image can hope to match the narrative economy of an annalistic statement of the form "the cities of W, X, Y, and Z, I besieged, I conquered, I carried off their spoil." Such a statement carries both a description of each episode (the capture of each city), and an implied sequence (the order in which the cities are listed). A visual image, to convey the same amount of information, would require four separate episodes, which in the wall-relief format could fill a large room. Whereas extended visual narrative consisting of a number of consecutive linked episodes is possible in the larger rooms of Sennacherib's palace, the smaller rooms often have space for only a single episode.

Although it was apparently desirable for visual narratives within a single room to display some degree of continuity, there is little apparent necessity for requiring this sort of continuity to extend between rooms. Unlike texts, where the writing system fixes the order of the narrative, it is difficult to ensure that a narrative spread throughout a suite of rooms will be read in the correct sequence. Without guidance or prior knowledge, a visitor to the suite cannot know which rooms to visit and in what order. There are universally acknowledged rules for reading a text, but the route one takes when walking through a building is often determined by the circumstances of the moment.[11] The primary emphasis in the verbal narratives, therefore, is on the broad sweep of an entire campaign, whereas that in the visual ones is on the detail of individual, and presumably select, episodes.

Faced with these considerations, Sennacherib's artists seem to have adopted overall subjects for certain suites of rooms – in this case, the western campaign – but not to have attempted a complete sequential narrative. Instead, their treatment of the decoration was episodic, a display of "highlights" from the campaign.

The capture of Lachish probably in fact was one of the highlights of the third campaign, and must have been *the* highlight of its final phase, against Judah. It is of interest here that in the biblical account of this campaign, only Jerusalem, Lachish, and Libnah were considered worth mentioning (II Kings 18:13, 17; 19:8). Recent excavations at Lachish, concentrating on the city walls and the remains of the Assyrian siege ramp, taken together with the picture of the siege in Room XXXVI, show that Sennacherib concentrated immense resources and expended tremendous energy in its capture (Ussishkin 1982: 50–4).

Furthermore, the Rassam foundation cylinders and the eponym canon, or year–name list, indicate that the walls of the palace were being built in 700 B.C., the year after the western campaign.[12] Assuming that the relief carving was carried out shortly thereafter, the victory at Lachish may well have been the last great triumph in Sennacherib's most recently completed campaign, and might thereby have gained the place of honor in this suite. Whereas in a written narrative, the glory of the capture of Lachish might have been overshadowed by the disappointment of the apparent failure at Jerusalem, in Room XXXVI, the visual account of this single episode is unencumbered by concerns for the sequel, and the success at Lachish is permitted to shine forth untarnished.

The visual record of this success was presented in a way that would ensure maximum recognizability, through highly specific costumes and scenery; and verisimilitude, through exploitation of perspective effects in a unified field. This visual narrative would have been intelligible to a much broader audience than would the written one, including not only literate courtiers, but also nonliterate foreign visitors, some of whom may have recognized their own people and land in this highly specific image.[13] There is no hint of failure here: The Assyrian victory is conclusive and unalloyed. The image of the fall of Lachish confirms for foreign visitors and subject peoples what they already know – or at least what the Assyrian king wants them to believe – namely, that Assyrian might is invincible and that the price of resistance is inevitably defeat. For courtiers, by contrast, these images would have been a pleasing reminiscence of an Assyrian victory, as well as a cautionary reminder of the forces at the king's command.

Thus, the campaign against Judah was commemorated quite differently in the verbal and visual accounts. This difference is not – to cite John Barth's formulation of the elements of narrative – in the "tale" (Judah campaign), nor the "teller" (Sennacherib), but rather in the "told," that is, the way of telling (1969: 118). The differing forms of this "told," I have suggested, are a function both of the strengths of two types of narrative vehicle – image

and text – and of the audience for each narrative type: literate courtiers for the texts, a wide range of palace visitors and residents for the images.

NOTES

1. I am grateful to The University of Chicago Press for permission to reprint here portions of chaps. 7, 9, and 11 of my book *Sennacherib's Palace Without Rival at Nineveh,* © 1991 by The University of Chicago. All right reserved.
2. Sennacherib's account gives the amount of silver as 800 talents, however.
3. For a discussion of the differences between Renaissance perspective *construction* and ancient perspective *representation,* see Panofsky (1953, I: 3–12). For studies of Assyrian spatial conventions, see Groenewegen-Frankfort (1951: 170–81), Reade (1980: 71–4), and Russell (1991: 191–222).
4. It should be noted, however, that there may be vertical narrative connections between the images in the upper and lower relief registers, as in Slabs 17–20 in the throne room (B) of Assurnasirpal II's palace at Nimrud (Winter 1981: 14, Figs. 4–9).
5. An observation I owe to Nadav Na'aman (personal conversation).
6. The idea of specificity in narrative reliefs is a well-established Neo-Assyrian tradition, beginning with the reliefs of Assurnasirpal II (Winter 1981: 14–15; Reade 1985: 212–13). What is different here is the much greater *degree* of specificity, which should have made the subjects of Sennacherib's reliefs more readily recognizable than those of his predecessors.
7. Concerning his apparent lack of success in Judah, one could argue that Sennacherib was not really interested in capturing Jerusalem itself, but rather used this campaign to reduce Judean border forts and to bring the area into the Assyrian sphere of influence as a buffer state between Assyria and Egypt, as he apparently also did with Ellipi in the second campaign. On the third campaign and Egypt, see Yurco (1980: 221–40).
8. Though the picture shows exactly what such a throne looks like, it is not clear whether *nēmedu* here refers to the throne's arms, height, or footstool (*Assyrian Dictionary, N* 1980: 156).
9. Both the Assyrian (Luckenbill 1924: 70) and biblical (II Kings 19:35–36; II Chronicles 32:21) accounts agree that Jerusalem did not fall.
10. These observations do not apply in the same degree to epigraphs, which are sufficiently short and simple to be readily interpreted for visitors by whomever is serving as their guide.
11. It is possible that for at least some suites of rooms, the sequence of passage through space would have been governed by a particular ceremonial function, now unknown, which that suite regularly served.
12. The Rassam cylinders, dated 700 B.C., were immured in the walls during their construction (Reade 1986). The entry for the year 700 in Eponym Canon Cb7 reads: "[the foundations/walls(?)] of the palace in the city [of Nineveh . . .]," and then continues with a list of the same rare building materials that are described in Sennacherib's later palace building accounts (Ungnad 1938: 435). See also Luckenbill (1924: 117: 7) and Postgate (1973).
13. Concerning the audience for Assyrian palace reliefs, see Russell (1991: 223–40, 251–2).

SOME REFLECTIONS
ON THE RHETORIC
OF AEGEAN AND EGYPTIAN ART

Nanno Marinatos

Although the present volume is dedicated to pictorial narrative, it is not narrative but rhetoric that I would like to explore in this essay.

First, a definition is necessary. According to *Webster's New Collegiate Dictionary,* rhetoric is "skill in effective use of speech." Art, too, like language, employs devices that make artistic statements more effective, more graspable, and more immediate. These visual strategies will be explored here and, although this study is by no means *exhaustive,* it will at least introduce an approach that may be useful in analyzing images.

Some of the devices of artistic rhetoric are too banal to merit discussion here. I am referring to variables such as size and position in the visual field. For example, it is well known that if the artist wants to emphasize the importance of an object or a person, the figure is placed either in the center or on the edge of the composition. Manipulation of size also helps focus attention on the emphasized visual element. Finally, rhythmic repetition of figures or objects will help intensify the effect. I am thinking of processional scenes in particular, although the multitude of workers and offering bearers, so frequently depicted in Egyptian art, serve the same purpose.

Here, I am concerned with some less well-explored "rhetoric," which may involve juxtaposition of entire scenes as well as interlinking of images.

PICTORIAL SIMILES

A pictorial simile involves two dissimilar figures involved in a similar situation; the juxtaposition forces a comparison. Most common is the comparison between humans and animals. In such

20 Two scenes on an
inlaid dagger from Grave
Circle A, Mycenae. After
Morgan (1988, Fig. 34).

21 Dagger from Lasithi,
Crete. Drawing: P. Rehak,
after Evans (1930) (*PM* I,
Fig. 541).

similes, the bravery or strength of the animal is compared and thus
transferred to the human.

One of the inlaid daggers from Shaft Grave A at Mycenae has
already been discussed by L. Morgan as a pictorial simile (Morgan
1988: 163). There, human hunters are engraved on one side, lions
on the other (Fig. 20). Being on the same dagger, the scenes invite
comparison, and by being compared, the human and lion hunters
are implicitly equated with each other.

A similar man/animal comparison is suggested on a Minoan
dagger from Lasithi, Crete (Fig. 21). On side A, a human hunter
confronts a wild boar. On side B, two wild bulls confront each
other frontally (Long 1978: 34–56). That the two scenes have a
thematic unity can be argued on many grounds. They both appear
on the same object. The same vegetation motifs, acting as signs
of a landscape setting, appear in both. The pairs of contestants,
man and boar on side A, bull and bull on side B, are depicted in
a typical antithetical position denoting "combat." Most important:
in both scenes, the visual language suggests a contest between
champion and adversary. On side A, we suspect that the human

75

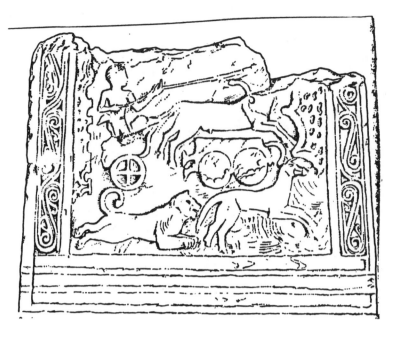

22 Stele from Grave
Circle A, Mycenae. After
Hood (1978, Fig. 81).

hunter (on the right) will win. On side B, it is made very clear
that the right bull will be the eventual victor, because he exhibits
more bodily control and has caused his opponent to slip. Thus,
the figures to the right are the victors; the ones to the left are the
defeated (Marinatos 1989: 20–1).

Let us now move to another medium: Mycenaean funerary
stelai of the period of the Shaft Graves. Remembering that the
function of such monuments should have been display of the
prowess of the deceased, it is likely that the representations will
have some "propaganda" value.

A pictorial simile of the type we found on the dagger from
Grave Circle A is to be found on a stele from the same Circle
(Fig. 22). In what appears to be a unified scene, there are actually
two different representations, distributed in two zones. On the
upper zone, a warrior in a chariot is riding over his fallen enemy
(only his eight-shield and feet are visible). On the lower, a lion is
chasing a horned animal (a deer?) (Mylonas 1955: 142–7; Sakel-
lariou 1985: 307). At first glance, the two scenes seem to be un-
related and yet coherence is guaranteed by the unified space. In
fact, they constitute a pictorial simile: A warrior and his fallen
enemy are compared to a lion and his victim. The warrior is thus
implicitly equated with the lion.

Compare with Egyptian representations of Ramses III at his
mortuary temple at Medinet Habu. In one scene, the king is
shown at war, his prowess being stressed by a visual intensifier: a
lion that, next to him, also hunts the enemy (Keel 1978: 86, 103).

23 Axe of king Ahmose,
Egypt. Drawing: P. Rehak,
after William Stevenson
Smith (1981, Fig. 216).

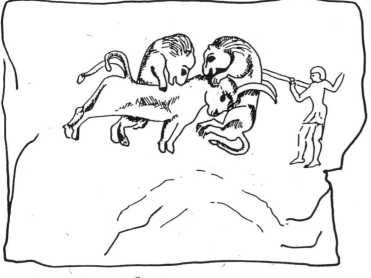

24 Stele from Grave
Circle B, Mycenae, slightly
simplified and restored.
Drawing: N. Marinatos and
L. Papageorgiou, after
Mylonas (1972, Fig. 12b).

On the exterior walls of the first pylon, the king hunts wild bulls.
Below, soldiers with bows and shields march in an orderly fashion:
Hunting and war modes are blended in unified imagery (W. S.
Smith 1981: 372, fig. 366).

On a ceremonial battle axe from Egypt belonging to king Ahmose
(Fig. 23), the pharaoh is depicted as smiting an enemy. Below, in a
different zone, is a griffin. The latter acts as an "intensifier," a symbol
of power and aggression and the two scenes function as a pictorial
simile (W. S. Smith 1981: 221; for additional examples, see also L.
Morgan 1988: pl. 63; Davis 1989: 79, fig. 4.12).

We now consider the device of the "double attack." On a

Mycenaean stele from Grave Circle B, human and lion hunters are combined in a single scene in what seems to be a double attack (Fig. 24). Lions attack bulls, and humans attack the lions. Here we have more than a pictorial simile. What is presented is a "pecking order" with the human hunter on top, the lion below him, and the bull further below. What more appropriate way to glorify the dead than by showing his prowess in hunting?

Paintings from Egyptian tombs use the exact same visual rhetoric of the double attack, bull, lion, man. In the Old Kingdom tombs of Mereruka (Fig. 25) (Duell et al. 1938) and Ptahhotep, there are hunting scenes in which a bull is attacked by a lion, whereas the lion is itself hunted by humans. This can be clearly inferred by the presence of a net that frames the scenes on the right and left (Davis 1989: 75–6). The reason for the pictorial rhetoric here, as on the Shaft Grave stele from Mycenae, is to make the human hunter look superior. In general, the main purpose of the hunting scenes either in Egyptian tombs or on temple walls is to represent the human hunter (tomb owner or pharaoh) as dominant over the animal kingdom. It is interesting that both the Egyptians and the Aegeans used the same subtle devices. I wouldn't exclude the possibility of transmission, although it is also possible that these visual modes were invented independently.

PICTORIAL CONTRASTS

25 Scene of hunt from the mastaba of Mereruka. After Duell et al. (1938, Fig. 25).

Whereas the simile establishes meaning through comparison, the "contrast" achieves meaning by means of polarity. This strategy

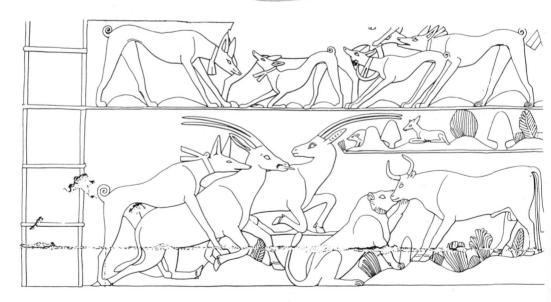

was explored by Egyptian artists in their tomb paintings. In the Old Kingdom tomb of Ptahhotep, two registers with hunting scenes are depicted (Fig. 26) (Davis 1989: 75, fig. 4.9b). What is interesting is that whereas the bottom register depicts hunted animals (I might add that there is emphasis on the death of the victims), the top register includes two mating scenes. The hunting thus takes on a new meaning. Death is contrasted with the beginning of life implied by copulation shown on the upper register. The concept underlying the polarity is probably not unrelated to the Egyptian preoccupation with the cycle of life and death.

FUNCTION AND DECORATION

Each spatial unit has a specific function, and the ancient viewer bore that function very much in mind when looking at its decoration. The study of the interplay between the image(s) and the function of the object could yield interesting results.

We have already discussed Aegean daggers, which are instruments of aggression, but also status symbols of the male aristocrats. The predominant figures are animals whose main characteristics are aggression or speed. Thus, we find birds, horses, and dolphins, all notable for their speed, together with the most powerful of predators, such as lions and griffins (Laffineur 1984: 134–6). Similar motifs appear on the pommels of the daggers or swords: lions, griffins, and scenes of predation. In one case, drowning enemies are depicted on the dagger blade (see Fig. 31) (Hood 1978: 176–86 with figs. 174–83).

Speed is necessary for the dagger to inflict a wound; it is therefore evident why animals that are both swift and aggressive are chosen as appropriate emblems. But it should also be remembered that there is an underlying presupposition at work here: The animal kingdom has certain qualities envied by humans. The owner of the dagger admires the speed of the dol-

26 Scene of hunt from the mastaba of Ptahhotep. Drawing: P. Rehak, after Schäfer (1974, Fig. 151).

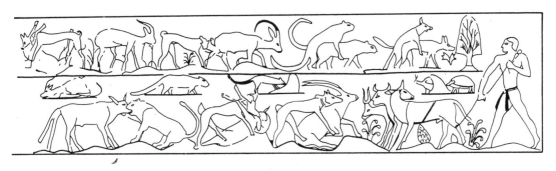

79

phin or the power of the lion and griffin; he wishes to be identified with these animals, or at least partake of their abilities. By depicting them on the dagger, the function of the object is enhanced.

Egyptian daggers have similar iconography of aggression. A dagger found at the tomb of Tutankhamun, for example, depicts scenes of predation (Seton-Williams 1980: 138.) Axes also are instruments of war and we have already discussed the battle axe of Ahmose (Fig. 23) showing the pharaoh with an enemy as well as a griffin. Another axe dating to the eighteenth dynasty represents a lion attacking an antelope (W. S. Smith 1981: 242, pl. 237).

From Tutankhamun's tomb come several objects with iconography relevant to our discussion. On the back of one of his thrones, the king is shown seated, anointed by his young wife. The scene on the throne presents the king, not in a heroic mode, but in a quiet, more private moment. Yet, we should not see it only as an idyllic scene of blissful home life, for in the interaction of the couple is implicit the superior ceremonial status of the *enthroned* king. Once more there is a projection of an ideal image, but it is well chosen as decoration for a throne (Seton-Williams 1980: 128)

On smaller personal items, Tutankhamun is depicted as "heroic." On a ceremonial shield, which, of course, is a war implement, he is depicted as a sphinx treading over a fallen enemy; on another shield, he is shown as being about to kill a lion. Here the warrior and the hunter are clearly associated on the same medium, which itself is a hunting and war implement.

A wooden footstool is decorated with captive enemy peoples (Seton-Williams 1980: 135) Thus, when the king rested his feet on it, he symbolically stepped on the subjugated enemies. This pictorial formula of "enemies trampled underfoot" is a very common one in Egyptian art since the Old Kingdom (Davis 1989: 77–82). It is worth noting that the objects chosen to be decorated with this theme have one feature in common: they are stepped upon. Thus, we find the iconography of defeated enemies on statue bases (Davis 1989: 168, fig. 6.19) as well as door sockets in addition to footstools (Davis 1989: 175, fig. 6.26).

On Tutankhamun's fan, there is a representation of the king on an ostrich hunt. (Seton-Williams 1980: 131). Because fans are often made of feathers, a relationship between object and representation is suggested once more. More than that: The fan becomes symbolically a trophy of the hunt celebrating the triumph of its owner.

We have seen that the function of an object can be enhanced by its decoration. In the majority of cases, the enhancement is achieved by imagery appropriate to the gender. Mycenaean mirrors with ivory handles, which are articles of female toilette, are decorated with elaborately dressed women holding flowers (Poursat 1977: 94, 105–6, pls. XXXII and XXXV). On the other hand, thrones of Egyptian kings normally have appropriate "male" imagery of aggression or of political power.

In this section, we explore the opposite case in which an object associated with a woman appropriates "male" imagery to enhance her status.

I will not discuss the best known example of Egyptian history, Hat-shepsut, who actually appears as a male. Rather, I will concentrate on two less obvious examples in which visual rhetoric is employed in order to add the prestige of male status to the public persona of a woman.

From the eighteenth-dynasty tomb of Kheruef comes a scene in which the queen Tiye is seated on an elaborate chair (Fig. 27). Its decoration is derived from a distinctively male domain as it depicts a sphinx trampling enemies as well as bound captives. The captives seem to be women to judge from the pendulous breasts (Nims et al. 1978: pl. 47).

Another example comes from the Amarna period. On a *talatat*, there is a representation of the ship of Queen Nefertiti. Painted on the cabin of the ship is the queen, represented as a king, clobbering enemies (Aldred 1973: 136, no. 57). Here again, however, the queen's enemies are women. Thus, although Tiye and Nefertiti appear in the role of a man, the assimilation with the male gender is not absolute.

In both the foregoing cases, the decoration of the object would probably shock the viewer with imagery of obvious norm inversion (the effectiveness of the rhetoric would partly be due to the shock). The latter is deliberate because it challenges the viewer's expectations as regards gender role. The result would be that something like a reevaluation of roles was achieved. It is as though the queen stated: "I am a woman but my political power is of such a nature that I could well have been a man."

Nothing like this exists in the Aegean. Although females with swords are known (see, for example, a Minoan seal *CMS* II. 3, 16), these have been generally interpreted as goddesses or priest-

27 Seated king
Amenhotep III and Queen
Tiye, from the tomb of
Kheruef. After Nims et al.
(1978, pl. 47).

esses. Their role seems to be cultic rather than political. The ostensible gender appropriations with political overtones remain distinctive to Egypt.

THE ICONOGRAPHY OF CHAOS VS. THE ICONOGRAPHY OF ORDER

Already in Predynastic times, the Egyptians developed an iconography of battle scenes in which the enemy is shown as fallen bodies in utter disorder (Schäfer 1957: 168–76). Characteristic of their posture is the chaotic arrangement in the field and the lack of body control of the individual figures. Thus, on an ivory knife from Gebel-el-Arak (?), ships are depicted and, below them, drowning enemies (Fig. 28) (Williams and Logan 1987, 245–84; Davis 1989: 128, fig. 6.6). It is worth noting that the medium bearing this decoration is the handle of a knife, an instrument of aggression (see the third section). This iconography of defeat is carried on through early dynastic times (on the Narmer palette, for example) and finds novel expressions during the New Kingdom (for the development, see Davis 1989: 73ff.). A good example is a painted stucco relief from the chariot of Tuthmosis IV. The pharaoh is riding his chariot triumphant; the enemy in total disarray is trampled underneath (Fig. 29).

The iconography of chaos is also transferred to the hunt, however. Hunted animals, like the human enemy, are shown fleeing in all directions under the threat of the triumphant hunter. In such cases, the artists of the New Kingdom were even willing to abandon the organizations in registers. I believe that this type of composition was chosen to emphasize chaos rather than merely unity of space. The best example is furnished by the tomb of Rhekmire (Fig. 30) (Davies 1943: pl. XLIII). There, the registers have been supplanted by undulating lines denoting hillocks. Leaping animals, overlaps, and multidirectional motion all contribute to a sense of confusion.

In Aegean art, the same type of iconography is used to denote chaos, especially defeat. I will confine myself to two examples only, which are quite characteristic.

The first is an inlaid dagger from Vapheio (Fig. 31). There, human figures are depicted that have been identified as swimmers (Evans 1930: 127, fig. 81). In fact, they must be drowning enemies because they have a lifeless posture that indicates lack of bodily control (L. Morgan 1988: 150–4). Although the victor is seemingly missing, he is implicitly there as the owner of the dagger.

The second example is a miniature wall painting from Akrotiri,

28 Predynastic ivory knife
handle from Gebel-el-Arak.
Louvre. Drawing: P. Rehak,
after Davis 1989, fig. 6.6)

29 Scene on the chariot
of Thutmosis IV. After Davis
(1989, Fig. 4.7).

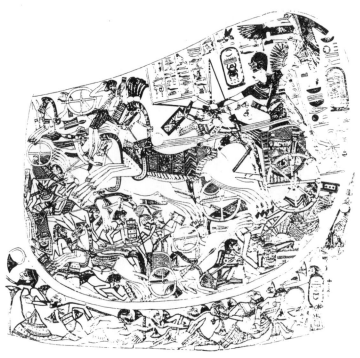

Thera found in room 5 of the West House (Sp. Marinatos 1974: 40–1). On the North frieze, the composition is divided into two halves (Fig. 32). On the upper section, we see a file of marching warriors and the people of a town settlement going about their daily business (N. Marinatos 1984: 38–40). This is a composition with an "iconography or *order*" accomplished by the paratactic arrangement of the marching troops. Below, in the sea, we see naked figures. Their bodies are in disarray, but they also display a conspicuous lack of bodily control. For this reason, I have argued that they are not swimmers but drowning enemies (N. Marinatos 1984: 40). Compare with the bodies of drowning enemies on the predynastic ivory handle, Fig. 28. The conventions of "defeat" apparently persisted for a very long time.

To return to the Theran fresco: The contrast between order and chaos in the upper and lower sections of the scene would have alerted

30 Scene of hunt from the tomb of Rhekmire. After de Garis Davies (1943, pl. XLIII).

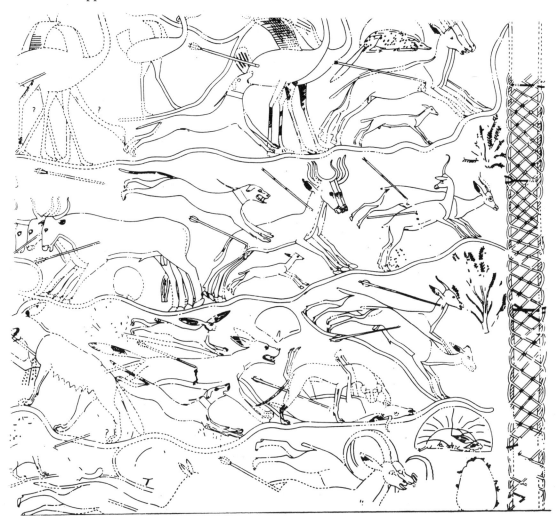

31 Dagger from Vapheio. Drawing: P. Rehak, after Evans (1930, Fig. 81).

32 North Wall frieze from Room 5, West House, Thera. Drawing: P. Rehak, after Marinatos (1974).

the ancient viewer to the meaning of the iconography: The pictorial rhetoric would have been automatically recognized.

Apart from the paratactic arrangement, there exist other devices also that result in an iconography of order. Antithetical and flanking groups come to mind and it is obvious that such compositions are emblematic and useful for the expression of state ideology. This cannot be pursued further here. Suffice it to say that we need to revise our criteria for distinguishing between Mycenaean and Minoan artworks. It is commonly held that there is a predilection

86

for heraldic compositions in Mycenaean art, and that such arrange-
ments are scarce in Minoan compositions. This is hardly true.
Both cultures used heraldic arrangements to create emblematic
images: Flanking griffins and lions are most common (the natu-
ralism that often characterizes Minoan art is reserved for
nonemblematic subjects). Thus, the formulas or rhetorical devices
can be multiple and diverse within the one and same culture.

Still, it is worth asking some questions. What does the use
of similar visual rhetoric imply for the *mentalities* of the
Aegeans and Egyptians? (I am more concerned with this question
than with diffusion because a culture borrows only that which fits
its own cognitive or visual schemata.) By the same token, what
do the differences – such as the absence of gender inversion in
the Aegean – imply?

These issues are better left for a more extensive study. In this
essay, I have only scratched the surface by investigating strategies
that I have termed visual rhetoric. Two aspects have been dis-
cussed. One is the variety of pictorial formulas that are used to
express ideas, either singly, or by way of contrast and comparison.
The second type has been the implied three-way conversation
between the viewer, the object viewed, and its decoration. Al-
though this is not narrative per se it comes close to telling a story.
But it is a story of cultures and norms, and in this respect, Egypt
and the Aegean seem to have been close.

NOTE

I wish to thank my colleague P. Rehak for reading various drafts of this paper.

NARRATIVE AND IMAGE
IN ATTIC VASE PAINTING
Ajax and Kassandra at the Trojan Palladion

Joan Breton Connelly

The image of Ajax and Kassandra at the cult statue of Athena changes drastically from traditional Attic black-figured vase painting to the later, Attic red-figured repertory. Although this development has been recognized,[1] the full scope of the change has never been examined and the reasons for the change have remained unexplained. The system of developing images is examined here in order to understand better the role of narrative intent in the image-creation process. As the reasons for retelling the Kassandra story changed from the sixth century to the fifth century B.C., so, too, did the means by which the story was retold.

During the chaotic night of the sack of Troy, Priam's daughter Kassandra fled to the temple of Athena and clung to the wooden image for safety. The Lesser Ajax followed her there and, trying to drag her away, carried off the image as well, so tightly did the princess embrace the statue. Thus, Ajax defiled the sanctuary and incurred Athena's wrath. The earliest recorded account of the episode is that from the lost *Iliupersis* of Arktinos, as retold by Proklos (*Chrestomathy,* 3); this may have served as the inspiration for Alkaios' poem.[2] Later poets[3] and mythographers[4] retell the story in fuller versions with sometimes conflicting details. Whether or not Kassandra was actually raped by Ajax remains unclear; this is generally regarded as an invention of the ever wiley Odysseus, who wished to discredit Ajax and please Agamemnon, who wanted to take Kassandra for his own.

Many factors influence the image-creation process: Developments in the pictorial tradition, changing narrative methods, historical events, religious and social influences, literature and drama are but a few. I will argue that the representation of Ajax and Kassandra in the presence of Athena entered the Attic black-figured repertory at the end of the second quarter of the sixth century because it presented an opportunity to celebrate the might of Athena, the sanctity of her cult statue, and her triumph in the Gigantomachy at a time when her worship was intensified by the

reorganization and expansion of the Panathenaic festival. From the late sixth into the fifth century, the motivation for narrative changed. In light of the Persian threat and subsequent devastation of the Akropolis in 480, the Kassandra episode was used as a metaphor for the brutality of war and its effects on society. During the fifth century, the story was retold not only on vases, but on stage, and the representational tradition faced an audience well informed by theatrical images. Kassandra probably appeared on stage taking refuge at the Palladion in Sophocles' lost *Locrian Ajax,* a play that dealt with the crime and subsequent punishment of the Lesser Ajax.[5]

The transformation in the image tradition is all-encompassing. It affects scale, placement, and representational schemata as well as the choice of shapes on which the image occurs, the moment in the action depicted, and the narrative method employed. The wide scope of this change calls for investigation from a variety of angles, utilizing a number of different approaches. Those methods best suited to examining each aspect of the change will be used as tools for studying the comprehensive process of image creation and evolution. Some of the methods may be considered "traditional" and others "new." On the one hand, we will seek to define and explain the nature of changes in shape, design, and authorship following a system of analysis defined by the work of Sir John Beazley (Beazley 1922: 85; Kurtz 1985: 237–50). In keeping with traditional analysis, we will also consider the impact of historical events on the image-creation process.[6] On the other hand, we will read the representational schemata as part of a discrete system or "language of images" on its own and as part of the greater social, cultural, and historical context in which it was created.[7] We will attempt to analyze the relationship of narrative method to narrative intent (Snodgrass 1982: 5–16; 1987: 136–47). Finally, we will consider the motivation of the artist and the response of the audience in creating and receiving the images.[8]

Both traditional and new lines of questioning are afflicted by the peril of uncertainty inherent in the study of antiquity. The fragmentary nature of the evidence and the fragmentary nature of our understanding of the greater context from which it survives allow for a dangerous latitude in the application of any single method, old or new. Adherence to a single line of inquiry can cause distortions in interpretation. It can also lead to the manipulation of evidence in order to support preconceived conclusions. The utilization of several approaches simultaneously perhaps can provide a safeguard against these pitfalls.

Mindful of the obstacles inherent in this work, I will begin with the examination of the vases and the images they carry (com-

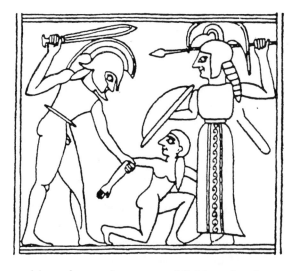

33 Shield strap. Olympia,
Olympia Museum B 1891.
Drawing after Touchefeu
(1981).

position, shape, placement of field, authorship, iconography, representational code, and narrative method) and then consider their contexts (historical, social, and cultural). Avoiding the exclusive use of any single method, I will attempt to employ a construction of methods as tools for examining and illuminating multiple aspects of the problem.[9] As questions asked significantly determine answers reached, it is desirable to ask as many questions as possible in as many ways as we know. Perhaps this will lead to fuller understanding of the fundamental question: What motivates the selection of images for narrative and how does narrative intent shape the images through which a story is told and retold.

SIXTH–CENTURY BLACK FIGURE

Composition

The conventional composition comprises three principal figures: Ajax at left with sword drawn, advancing to the right; Athena at right with spear and shield raised, advancing to the left; and Kassandra at center, fleeing right toward Athena, kneeling or crouching low beneath or behind Athena's shield (Fig. 33). Although the story calls for the conflict to take place at the *statue* of Athena, that is, at the famous Palladion of Troy, Athena is shown here as an activated agent rather than as an inanimate statue. She charges at Ajax from the right, occupying the same groundline as the attacking Greek and the fleeing Trojan princess. This visual ambiguity in the reading of Athena's role as living adversary or inanimate icon is central to the representation of the scene in black figure.

The composition is essentially that already established in the

90

bronze shield straps from Olympia (Fig. 33),[10] dating ca. 590–580, and from Delphi,[11] dating ca. 560, with some significant changes. Although the shield straps show the three characters with almost equal emphasis, the representations on Attic black-figured vases stress the conflict between Ajax and Athena, relegating Kassandra to a subordinate role. The shield straps show Kassandra somewhat smaller but essentially in the same scale as Ajax and Athena; her body is completely visible beneath Athena's shield, which is shown in the profile view. Ajax looks directly down at Kassandra and grabs her forcefully by the arm. The roles of antagonist and victim are clearly depicted. In contrast, the Attic black-figure repertory often shows Kassandra with diminutive proportions (Figs. 36 and 38 to 40); her body is partially hidden beneath or behind Athena's shield, which is shown frontally, frequently reducing Kassandra to no more than a headless body (Figs. 38 to 40). Ajax seems to be wholly involved in fighting Athena; most often, he neither looks at Kassandra nor touches her.

Only one image in the Attic black-figured sequence stands apart from the standard compositional scheme. This comes at the very beginning of the ceramic sequence on Lydos' fragmentary belly amphora in the Louvre (Fig. 34).[12] Here, Athena is shown at left and Ajax at right, an arrangement attested on one of the shield straps from Olympia.[13] Lydos paints Athena with her shield held in the profile view, just as on the shield strap. He places her spear diagonally against her shoulder rather than brandished high over her head. She is without a helmet. In short, she does not at all resemble the agressive, attacking Athena of what is to become the canonical black-figured tradition. Lydos also gives us the only occasion in black figure where the attack on Kassandra is paired

34 Amphora, Lydos. Paris, Musée du Louvre F 29. Drawing after Touchefeu (1981).

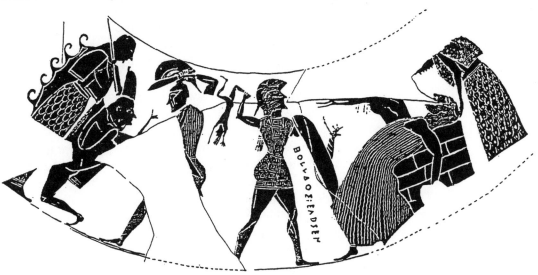

with the deaths of Astyanax and Priam in a single composition on the same side of a vase.

The standard black-figured image of the Ajax and Kassandra episode from the midsixth century onwards shares compositional models with a number of narrative themes involving attack, escape, and counterattack. The most significant of these is the Gigantomachy from which the attacking giant/fallen giant/attacking Athena composition is easily adapted to the attacking Ajax/crouching Kassandra/attacking Athena formula. Evidence for the sharing of these image formulas is shown in the work of the Princeton Painter and his circle. The clash of the giants on his Madrid Gigantomachy[14] compares closely with his rendering of the Palladion episode on his amphora in Geneva (Fig. 36).[15] His amphora in Tampa,[16] which shows a warrior fighting Athena, may represent a Gigantomachy or, as Beazley suggested, a scene of Ajax and Athena from which Kassandra has been omitted.

A similar sharing of compositional matrices can be seen in the work of the Swing Painter. Comparison of his Palladion scene in the Villa Giulia[17] with what has been identified as his Gigantomachy in Frankfurt[18] illustrates the closeness of the compositional schemata shared by the two themes. The Gigantomachy composition can be easily adapted for a Palladion scene by the addition of a tiny, half-hidden Kassandra beneath Athena's shield. Interestingly, the Swing Painter shows Athena wearing her aegis in the Palladion episode, but without it in the Gigantomachy. The presence of the aegis may underscore the protective nature of the Palladion, perhaps linking the image with that of a statue on the Athenian Acropolis. We know that the cult statue of Athena Polias was endowed with a special protective power. The feast of the Plynteria on 25 Thargelion when the temple of Athena was closed and her statue bathed and wrapped in a shroud was considered a "polluted," dangerous, and inauspicious day in Athens.[19]

Whereas Ajax and Athena are systematically portrayed according to strict pictorial formulas, there is considerable variety in the pose of Kassandra. Further borrowing from the Gigantomachy formula can be observed. The Princeton Painter's Madrid Gigantomachy shows a defeated giant squatting with knees pointed toward Athena and head averted. The same pose is utilized for Kassandra in the Palladion scene of the Group E amphora in the Metropolitan Museum of Art (Fig. 37).[20] As on the neck amphora in Philadelphia, Kassandra is generally shown with her body facing Athena and her head turned back to look at Ajax.[21] However, on an amphora in Wurzburg (Fig. 38),[22] the Painter of Berlin 1686 exceptionally turns Kassandra's body to face Ajax rather than her protectress Athena. This may be due to a conflation with the

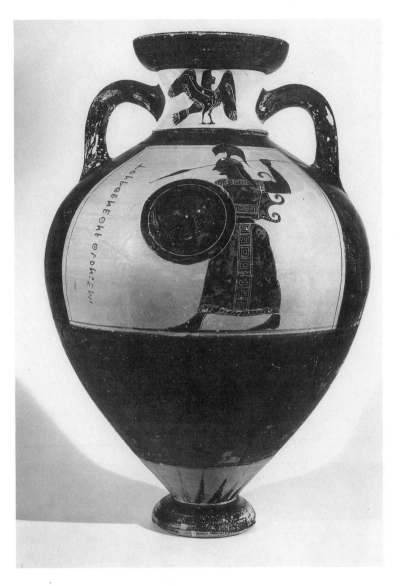

35 Panathenaic Amphora,
London Group. London,
British Museum B 130.

Gigantomachy in which a fallen giant turns away from the at-
tacking Athena.[23] Or perhaps the painter is thinking of a similar
composition frequently used for the Amazonomachy, substituting
Ajax for the standing male figure at left, and Kassandra for the
Amazon who kneels facing her assailant at lower right.[24]

A neck amphora in Berlin[25] shows what appears to be a Pal-
ladion scene, although there is some confusion. Kassandra is almost
unrecognizable, resembling a generic suppliant figure draped in a
mantle and sitting quietly beneath the clash of Ajax and Athena
above. The ambiguity with which her function in the composi-
tion is understood diminishes her significance in the action. She
plays a somewhat detached, supporting role, plugged into a pre-

93

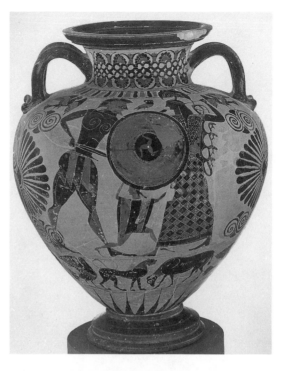

36 Amphora, Princeton
Painter. Geneva, Musée d'Art
et d'Histoire HR 84.

37 Amphora, Group Ea.
New York, Metropolitan
Museum of Art 41.162.143
(Rogers Fund).

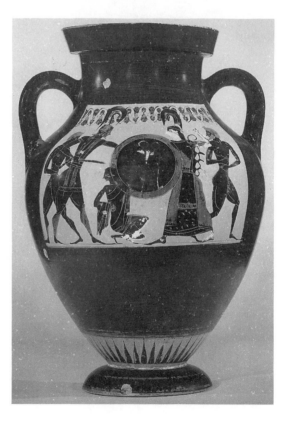

determined composition like an attribute identifying the setting as that of the Athena precinct at Troy.

The compositional differences seen between the representation of the Palladion episode on early archaic shield straps and that on Attic black-figured vases are significant. The Attic repertory shows the spotlight focused on Ajax and Athena whereas Kassandra's role is considerably reduced. A different narrative message is created through these changes in composition: It is the conflict between mortal and god that is paramount, not that between man and woman. This tendency to look beyond the human level to the interaction between man and god or man and his own fate is well attested in Greek literature. In the pictorial tradition, the basic composition shown on the early archaic shield straps is later integrated into a larger network of images known in Attic black-figured vase painting. Their compositional formulas are shared by a variety of narrative themes; the Palladion scene and the Gigantomachy thus share the same image matrix. The one constant is the figure of Athena, who is unmistakable regardless of the context.

Shape

Is there a relationship between vase shape and the image that it carries?[26] Can patterns be recognized in the frequency with which a certain image is used repeatedly on a certain shape? The representation of Ajax and Kassandra at the cult statue of Athena appears in Attic black-figured vase painting toward the end of the second quarter of the sixth century and is continued on nearly forty surviving vases until ca. 500 B.C. The amphora is overwhelmingly the shape of choice, providing the field for roughly 60 percent of all the representations of the subject. Twenty-five amphorae carry the Palladion scene, as opposed to five cups, four lekythoi, three olpai, two kraters, one hydria, and one plate.[27] The amphorae begin early in the sequence, most between 550–540, and last longest, whereas the other shapes appear somewhat later in the century. What is the reason for the popularity of the amphora shape as a field for this scene and why is there a concentration of amphorae showing this scene at the beginning of the sequence? Can an association with the Panathenaic amphorae of midcentury possibly account for patterns recognizable in the repetition of the Athena's image?

Shape and image come together to present a strong visual connection between the Athena of the Ajax and Kassandra scene and the Athena of the Panathenaic series. Both show Athena at the right of the picture field, advancing to the left with a round shield

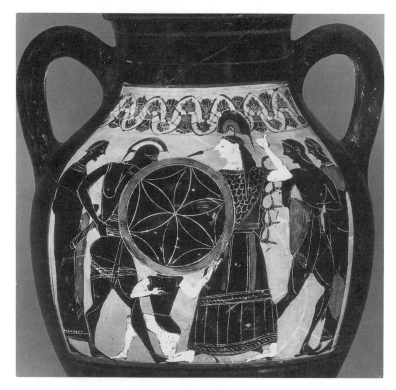

38 Belly Amphora,
Painter of Berlin 1686.
Wurzburg, Martin v.
Wagner-Museum 249.

39 Olpe, Dot Ivy Class.
Leiden, Rijksmuseum PC 54.

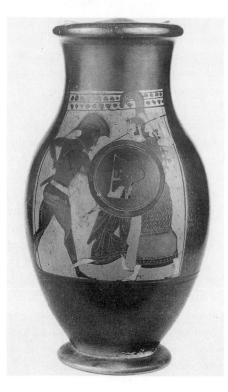

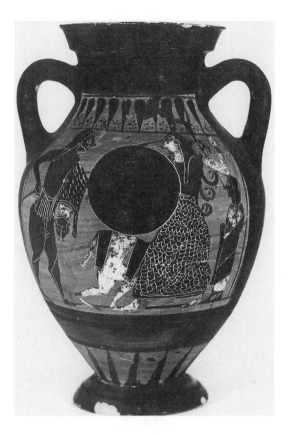

40 Belly Amphora.
Trieste, Civici Musei di
Storia ed Arte di Trieste S.
454.

in front view and raised spear. The Burgon amphora (Fig. 35),[28] placed at the very beginning of the Panathenaics (ca. 560), shows an Athena very similar to that of the Ajax and Kassandra scenes that follow a decade or so later (Figs. 36–40). Repetition of this well-known Athena in the same position on the amphora shape helps to associate the Palladion scene with the Panathenaic image.

The choice of shape and image links the Athena vs. Ajax episode with another popular series first appearing around 560: Athena in the Gigantomachy. It is hard to get an accurate count for all vases showing the Gigantomachy, but some idea of the number of amphorae relative to other shapes showing the scene can be gathered from the listing compiled in the *Lexicon Iconographicum Mythologiae Classicae*. For the period between 560–500, representations of Athena fighting a giant or giants are listed for at least thirty-four amphorae as opposed to ten lekythoi; nine cups and hydriai; three each for skyphoi, olpai, and pelikai; and a scattering of one or two examples for other shapes.[29]

An image of Athena very similar to that seen on Panathenaic amphorae is pictured frequently in religious scenes,[30] some of

97

which show her as a cult statue receiving the attention of her worshipers.[31] Athena's pose and attributes are usually identical to those of the Panathenaic Athena. Sometimes her stance is altered, exchanging the striding pose for one with feet placed together giving a more statuelike appearance.[32] It is perhaps not by accident that the amphora shape is a most popular field for these religious scenes, reinforcing the visual association with the Panathenaics and reaffirming the might of Athena at Athens.

Placement of Field

Shape and placement of the picture field, determined by vase shape and handle position, play an important role in determining the limits of the image composition and the narrative method employed. The series of amphorae dating to the second half of the sixth century show a nearly square or trapezoidal field stretching between the handles from just below the neck to just below the greatest width of the belly (Figs. 37, 38, and 40). This space allows for the main three-figured composition, as well as the addition of onlookers. The picture frame narrows to fit the tall slender shape on olpai of the last quarter of the century (Fig. 39),[33] thus limiting the composition to the three principal characters. The trapezoidal picture panel positioned on the belly of the vase confines the narrative field to a single view of the action. Perhaps it is in part due to the restriction of space that the black-figure artist endeavors to tell as much of the story as possible in a single image, employing what has been termed the "synoptic" method (Snodgrass 1982: 5–16; 1987: 135–57).

The picture panels on the column krater in Basel,[34] ca. 530, and the hydria in the Vatican,[35] ca. 515–500, are broader and the compositions show an increase in the number of onlookers to four and five, filling the field. A cup in Munich[36] shows six onlookers, three to each side of the central action. A cup in Madison, Wisconsin, shows Hermes added as an onlooker.[37] These shapes and compositions are, however, exceptional for the Kassandra episode in black figure and may reflect developments in the contemporary red-figured repertory.

The Priam Painter could have used the curving field of the shoulder on his Vatican hydria (*LIMC* I, 340, no. 38), but he located the Palladion scene in its usual position on the body, a placement inherited from the amphorae that predate it by up to 30 years or so. His composition and narrative method, however, appear to have been influenced by representations of the Palladion scene on new shapes in contemporary red figure. The addition of Aeneas and Anchises at the far left of the field may have been

inspired by works such as Oltos' nearly contemporary cup in Malibu,[38] which shows the Kassandra episode within the context of the Iliupersis cycle. The curving field of the kylix wall is well-suited to compositions made up of multiple images presenting a narrative cycle. Combining two scenes within a single rectangular frame on the hydria is, however, problematic. On the Priam Painter's hydria, Aeneas and Anchises appear crowded in at left as onlookers, their own story taking a subordinate position to that of Kassandra's plight. The Priam Painter may be seen to look both backwards and forwards, marking a transition between the black-figured and red-figured representations of the scene, not only in the composition and narrative method employed, but, as we will see, in his conception and portrayal of the roles of Kassandra and Athena.

The conventional three-figured composition of the black-figure repertory is, in effect, the composition established on the amphora shape and restricted by the dimensions of the amphora's metopelike picture panel. As is the case with other subjects, the Palladion scene's cast of characters grows to fill the space when it is painted on shapes with broader fields, thus expanding the compositional, iconographic, and narrative possibilities. Shape and placement of the picture field thus play an important role in the presentation of the image.

The Painters

The fortuitous nature of the survival of ancient vases makes generalizations about favorite themes of painters and groups of painters hazardous. Yet the record of surviving vases suggests certain moments of intensity for the repetition of the Palladion image by certain related painters. The impact of Group E on the formation of the conventional black-figured image is considerable (Fig. 36). Three surviving amphorae from Group E show schemata that differ from the earlier arrangement seen on shield straps from Olympia (Fig. 33) and Delphi and on the amphora by Lydos (Fig. 34). Group E (ca. 550–540) developed the image with a specifically Attic flavor and established a representational formula maintained over the next half century.[39]

The "Other Pot Painters" grouped by Beazley (1956: chap. XX) embraced the subject with enthusiasm during the third quarter of the sixth century. The count now includes one vase by the Princeton Painter (Fig. 36) and three in his manner,[40] one by the painter of Berlin 1686 (Fig. 38)[41] and one by the Swing Painter.[42] The sharing of this theme may serve as new evidence of contacts among this group of painters who have received increased recognition in recent years (Chamay and von Bothmer 1987: 62).

Dietrich von Bothmer has pointed out that members of this group are primarily painters of amphorae and neck amphorae (Böhr 1982: 53; Chamay and von Bothmer 1987; Shapiro 1989: 35). Though they did not paint prize amphorae, the Swing Painter and the Princeton Painter favored Panathenaic shapes and were fond of the "Panathenaic Athena," which they applied to cult scenes and Gigantomachies. The Painter of Berlin 1686 similarly has no extant Panathenaics, but painted scenes that may reflect the Panathenaic festival, as his name vase illustrates so well.[43] It is perhaps not by accident that these related painters, wishing to use repeatedly Athena's image, saw an opportunity for this in the representation of the Kassandra episode. This, combined with the fact that none of these painters is particularly involved in painting Iliupersis themes, suggests that their primary interest in the Palladion scene was prompted by Athena rather than by the Trojan War. Or, perhaps, they were prompted by the job of painting amphorae and took the easiest and most familiar model available.[44]

The Leagros Group played a very important role in the repetition of the Palladion scene toward the end of the sixth century and, once again, the amphora shape carries the familiar scheme. The Painter of Munich 1519 has three surviving examples to his name.[45] M. Hart has recently pointed out the particular fascination the Leagros Group had for scenes of the Iliupersis (1991: 323). Several of the examples from this group give images that diverge from the canonical black-figure formula, showing a good deal of inventiveness and creativity in the rendering of the familiar scene.[46]

Iconography

Two significant features distinguish the Ajax and Kassandra scene portrayed on early archaic shield straps from that shown on Attic black-figured vases. In the Attic repertory, the shield of Athena is turned from the profile to the frontal view and Athena's feet spread from their closed position to a striding, active pose. Both changes help the image to conform to that of the Athena shown on the Panathenaic prize amphorae.

The earliest examples in black figure reflect a transition between the shield straps and the new Attic mode of representation. The Siana cup in London[47] (*LIMC* I, 339, no. 16) shows Athena standing rigidly with feet together as on the shield straps. Her shield is turned to the frontal position and it is held at her side, rather than out in front in the fighting pose of the "Panathenaic Athena." Similarly, the Lydos amphora (Fig. 34) shows a precanonical representation of the Palladion scene, before Athena acquires her "Panathenaic" pose.

The popularity of the "Panathenaic Athena" on vases around the middle of the sixth century has been widely discussed. The association of the image with that of a new cult statue on the Acropolis as part of the reforms of the Panathenaic festival in the 560s seems possible. The precise identity of the statue represented is widely debated with proposed candidates including Athena Polias, Athena Promachos, Athena Nike, and Pallas Athena.[48] We will continue to refer to this image as the "Panathenaic Athena" type in order to prevent confusion with the fifth-century Athena Promachos statue and to avoid unnecessary entanglement in the problem of precise identification.[49]

Scholarship is generally divided between those who read the image as a living Athena and those who see it as a statue.[50] Perhaps this distinction was not so critical to the ancient audience as it is to us, and we would do well here to attempt a view of the image through "ancient eyes." Sources suggest that, in antiquity, statues of the gods had the same meaning as the gods themselves. They could assume divine powers as well as human qualities and could seduce, murder, be punished, and even be put to death (Schnapp 1988: 568–74). It is therefore not impossible to read the Athena image both as a statue and as a living opponent to Ajax. The black-figure image of Athena plays multiple roles in the Palladion scene: It represents the statue from which Kassandra was torn, the object against which the offense was most directly committed, and the goddess herself who was offended by Ajax and who will take action to avenge the sacrilege.

The significant point here is that, statue or no statue, this is a purely Attic Athena and has nothing to do with the cult statue at Troy. Homer suggests that the Trojan statue was seated. In *Iliad* VI. 297–311, the priestess Theano places the beautifully woven peplos on the statue's lap as part of the ritual in which the women of Troy pray for the death of Diomedes. Whereas the epic suggests that the Trojan statue was seated, Attic black-figure vase painters created their own image of the famous statue (Kroll 1982: 65–76).

Whether the Athena of the Ajax/Kassandra scene is a statue or the goddess herself is of less importance than the reasons for which she appears to be a living protagonist. First of all, she embodies the might of Athena in a well-known image that may have been inspired by an actual statue on the Akropolis. Second, her combative pose suggests the punishment subsequent to the actions of pursuit and sacrilege. Synoptic narrative calls for the compression of several actions into a single image. This cannot be achieved with an inanimate statue and so Athena comes to life.

41 Plate, attributed to
Paseas. New Haven, Yale
University Art Gallery
1913.169. Gift of Rebecca
Darlington Stoddard.

Two of the latest images in the sequence show significant
changes in the representation of Athena. The Priam Painter's hy-
dria (*LIMC* I, 340, no. 38) presents a striding figure of reduced
scale in an elevated position resembling that of a statue, as Susan
Matheson reminds us (1986: 106). The identification of the image
as a statue is further supported by the traces of the bottom step
of a high base, which has previously gone unnoticed, preserved
just to the lower right of the large central lacuna. An amphora
from the Leagros Group shows a similarly high base with a striding
Athena statue on top.[51] Both images seem to be under the influ-
ence of iconographic changes introduced in the contemporary
red-figure sequence and can be compared with the striding Athena
statue on Onesimos' cup in the J. Paul Getty Museum (Fig. 42),
(Matheson 1986: 105, 106). The Athena of the Leagros Group
amphora, however, stretches her aegis out over her arm brandish-
ing a raised snake head and is without a shield. This arrangement
breaks with the traditional shield-bearing Panathenaic Athena and
recalls Euphronios' Athena battling Kyknos on the calyx krater
now in the Shelby White and Leon Levy Collection (von Both-
mer et al. 1983: 58–60). These images of the "brandishing-aegis"
Athena may have been inspired by a highly visible source in

monumental sculpture, namely, the Athena from the Giganto-
machy pediment of the Old Athena Temple.[52]

The representation of Ajax follows strict iconographic formulas
throughout the sequence. His Corinthian helmet is worn down
covering his face, he draws his sword in his right hand, and ad-
vances toward Athena looking straight at her. This image con-
forms to the black-figure formula for showing an assailant on the
attack: Achilles pursuing Troilos and Menelaos pursuing Helen
utilize a similar image matrix.[53] Ajax's attack is more directly fo-
cused on Athena than on Kassandra.

The painter of the Trieste amphora (Fig. 40)[54] gives us a rare
departure from the standard image of Ajax. Lacking the conven-
tional helmet and sword, the assailant carries a spear rather awk-
wardly and stretches out a panther skin draped over his left arm.
One might suppose a confusion with Herakles, but the reverse
side of the vase shows that the painter knew how to depict a true
Herakles wearing the lion's skin and battling the hydra with his
scythe. The panther skin worn by Ajax may recall Dionysos, who
is not unknown in the role of a warrior (Lissarague 1987a: 111–
20), but who is altogether strange in this context. Perhaps we have
a confusion with the old Gigantomachy formula, as animal skins
can be worn by giants, reinforcing their role as wild creatures
endowed with exotic "otherness."[55] Or perhaps the painter's mo-
tive in introducing the panther skin was to elicit a visual connec-
tion between the two sides of the vase: Herakles and Ajax are
thus associated by animal skin and scythe/spear, just as their op-
ponents, the hydra and Athena, are connected by the shared scale
pattern of skin and skirt. The artist, uncertain of his story and its
iconographic details, is clear on one thing, the role of Athena and
her Panathenaic image.

While Ajax and Athena follow strict representational schemata,
the image of Kassandra shows a great deal of variation: She runs,
she kneels, she squats, she sits; she is nude, seminude and, some-
times, dressed in a short tunic; she is shown hidden, half-hidden,
or in full view. The reasons for the variations in her image are of
greater interest than the details of the differences themselves.
When she runs with arms and legs spread, she resembles the fright-
ened women fleeing from the fountain house where Achilles sur-
prises Troilos.[56] When she sits helplessly at the feet of Athena, she
resembles a generic suppliant figure.[57] Her nudity may be a ref-
erence to the erotic nature of the pursuit, as Furtwängler and
Reichhold noted (Furtwängler and Reichhold 1904: 85; Davreux
1942: 141) or rather a mark of her vulnerability, as Larissa Bon-
fante (1989: 560) has suggested, or, perhaps, a bit of both. Still, it
is the violation of Athena's sanctuary that is the preeminent crime,

not the attack on the little figure running toward the statue. Analysis of iconographical choices thus bears out the same conclusions reached in our discussion of compositional choices before: Emphasis is not on the conflict of man and woman, but on the conflict of man and deity.

The choice of a diminutive scale for Kassandra may be in part compositional, in part thematic, in part conceptual. The limitations of space leave her no room except that beneath Athena's shield; her petite proportions underscore her vulnerability as childlike, innocent victim; she plays the supplementary role of an attribute identifying the conflict as that of Athena and Ajax.

However, not all examples show a tiny Kassandra. Amphorae in Berlin[58] and New York (Fig. 37), both belonging to Group E, as well as neck amphorae in Naples[59] and London,[60] show her as a young woman on a scale comparable with Ajax. Compositional considerations play a role in the scale utilized. On these examples, either Kassandra kneels, thereby taking up less space, or the shield of Athena is moved right of center, thereby providing more room for Kassandra's body. On the tall, slender, olpe shape, in contrast, crowded conditions force Athena's shield to the center of the composition, leaving Kassandra nowhere to go but down, and diminutive (Fig. 39).[61] When Kassandra is shown running, which requires more space than kneeling, she regularly has a childlike size, as on the amphorae in Geneva (Fig. 36); Krefeld, Rome, and Trieste (Fig. 40); and on the olpai in Paris[62] and Leiden (Fig. 39). These examples demonstrate that Kassandra's scale is dependent on compositional factors. It is possible that her diminutive scale was introduced for compositional reasons early on and maintained as a convention in later works, long after the original reason was forgotten.[63]

A fragment in Orvieto (*LIMC* I, 340, no. 39) suggests that Kassandra's scale may be dependent on other factors as well.[64] Here, Kassandra is placed in front of Athena's shield, a rare position for her in black figure, one used by the Priam Painter, who, as we have seen, may already be under the influence of red-figure work. Although the painter of the Orvieto fragment has emphasized the nude form of Kassandra by placing it in the foreground of his composition, he has chosen to depict the princess with childlike proportions. Diminutive scale, combined with the spread arms and legs of her running pose, and the added white used to indicate nudity cause this Kassandra figure to resemble the running nude or semiclad girls on the krateriskoi found at Artemis sanctuaries in Attica. These votive vessels, which show the "bears" participating in girls' initiation rites, have been found at Brauron, Mounychia, Halai, and Athens and date from the late sixth to the

first half of the fifth century B.C.[65] Feminine nudity is rare enough in black figure, but, when combined with running pose and diminutive scale, the correspondence between Kassandra and the Brauron girls is striking. Kassandra's running nude figure may allude to the nudity and footraces that played such an important role in these transitional rituals (Dowden 1989: 31, 32; ritual nudity, Bonfante 1989: 554). I will argue in what follows, under the discussion of code and gesture in the red-figure sequence, that the association of Kassandra with girls' initiation rites is strengthened by the running figures pictured on Athena's peplos in the Palladion scenes shown on Onesimos' cup (Fig. 42) and on a fragment from the Athenian Akropolis (Figs. 43 and 44).

In the black-figured tradition, Kassandra is reduced to a mere attribute within the image formula. The arbitrariness with which her little figure is placed in different poses and dress wherever it fits best into a preexisting compositional formula diminishes her role in the action at hand. Reduced size means reduced importance: She is included simply to identify the conflict as that of Athena vs. Ajax rather than Athena vs. a giant.

42 Kylix, Onesimos: painter, Euphronios: potter. Malibu, J. Paul Getty Museum 83.AE.362.

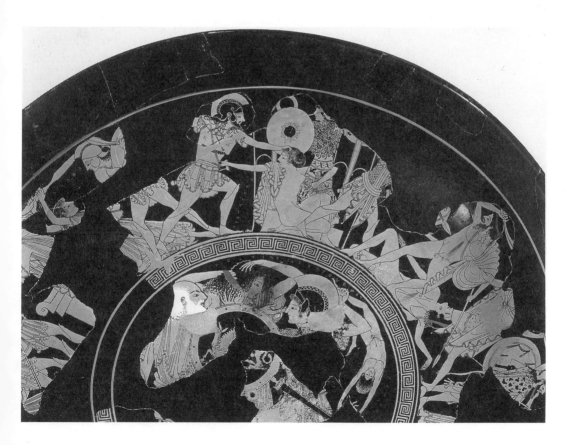

Code and Gesture

The structure of the composition comprises two opposing vertical forces moving toward each other with a dominating circular form at center under which a powerless entity takes refuge. The center of the composition, marked by the circle of the shield, serves a dual and paradoxical function: It is both the center of intensity for two conflicting forces and a neutral zone of protection for the victim who cowers beneath. The language of pose and gesture makes the image intelligible even to the viewer who may not be familiar with the specifics of the Kassandra story. It is clear that the figure at left threatens the figure at center who seeks help from the figure at right who fights back at the figure at left.

Many of the problems that cannot be answered through traditional iconographic examination can be more clearly understood through semiotic analysis. The cases of the diminutive Kassandra and the Panathenaic Athena are troubling for the literal-minded reader who wishes to understand how Kassandra can be at once a child and a woman, or how Athena can be at once a statue and a living adversary. When read in terms of code, these problems seem without importance. Gombrich maintains that the purpose of narrative in the visual arts is "not to tell a story but to allow those who already know the story to re-experience it" (Gombrich 1982: 88). The ancient viewer could read the actions of assailant, victim, and protector through the language of code and gesture. Familiarity with the Palladion story would allow the viewer to associate these generic roles with the specific characters of Ajax, Kassandra, and Athena.

Ajax advances toward Kassandra from left to right according to the archaic convention that has the victor face right and the vanquished left (Fittschen 1969: 159, n. 780; Pinney 1988: 468). Kassandra assumes the position of the defeated, falling down as she flees to the right, looking back over her shoulder at Ajax. This formula has many parallels, including that of Achilles pursuing Troilos on shield straps from Olympia, dated roughly to 600 B.C.[66] Achilles draws his sword and charges right as does Ajax in the Palladion scene. Troilos sinks to one knee, grabbing a tree at right just as Kassandra falls to the right, seeking sanctuary at the statue of Athena. A metope from the Heraion at Foce del Sele (ca. 550), generally thought to show Orestes pursuing Aegisthos, gives a similar compositional formula in which the roles of assailant and victim are codified.[67] Orestes draws his sword and moves toward right after Aigisthos, who flees toward the column of a temple or house at far right. Ajax, Achilles, and Orestes fall into the same codified images embodying the role of assailant, just as Kassandra,

Troilos, and Aigisthos assume the conventional position of victim. Statue, tree, and column are a shorthand for sanctuary. Only slight variations in the formula need to be played in order to adapt it to the narrative at hand.[68]

The representation of the Kassandra episode in black figure shows different choices in code and gestures than those employed in the earlier tradition. The shield straps showed Ajax grabbing Kassandra by the arm, conforming to a code of domination/submission also seen in Achilles/Troilos scenes and scenes of Menelaos/Helen or Paris/Helen.[69] In vase painting, this gesture is used in abduction scenes, particularly those with erotic intent. Menelaos grabs Helen by the wrist in black figure as well as in red figure.[70] But Ajax rarely touches Kassandra in black figure, and the few examples showing this fall early in the sequence. Ajax holds Kassandra by the upper arm on the Siana cup in London (*LIMC* I, 339, no. 16) and grabs her by the wrist in only one example, that of the olpe (*LIMC* I, 340, no. 36) in the Cabinet des Medailles. In the vast majority of representations, he neither touches her nor looks at her, greatly reducing the erotic content of the image. The choices made concerning gestural codes deemphasize Kassandra's role and shift the spotlight onto Ajax and Athena.

Whereas Ajax and Kassandra assume generically codified roles of assailant and victim, Athena is both image and icon. Her image is a code for herself and only herself: Pose, attributes, action and function are one and uniquely hers.

Narrative Method

If we attempt to read the images in terms of our notions of time, space, and story, we must address their apparent inconsistencies and contradictions. We have confronted the problem of interpreting Athena both as statue and living combatant and Kassandra as both child and woman. These contradictions can be reconciled through a reading of narrative according to the "synoptic" method as defined by Snodgrass (1982: 5–10; 1987: 135–57) or the "simultaneous" method, as it is called by Weitzmann.[71] The apparent temporal ambiguity in the Palladion representations is explained when they are read as a compression of several successive actions into a single image. The attraction, the pursuit, the seeking of sanctuary, the violation of the temple, and the subsequent punishment of Ajax are all contained in a single image. Read in this way, we understand the choices made in the representation of Ajax as a generic warrior consumed in combat, Kassandra as a seminude child frozen in flight, and Athena having come to life to avenge the violation of her temple. A single image

tells the full story, the evil of hubris and sacrilege, the inevitability
of divine retribution. Again, it is Athena's story and not that of
Kassandra that is paramount.

Narrative Context

The popularity of Attic vases bearing the image of Athena in the
middle of the sixth century has been linked to the intensification
of her worship under Peisistratos. The reorganization of the
Greater Panathenaia, traditionally dated to 566/5 B.C., elevated the
festival's status to one of Panhellenic acclaim. It is perhaps not
surprising that the Palladion theme, up to this time seen only on
shield straps from the international festival sites of Olympia and
Delphi, was adopted into a new Attic repertory. This allowed for
the repetition of Athena's image in the specifically Attic form of
that shown on the Panathenaic prize amphorae.

It is possible that the Panathenaic Athena represents a new cult
statue set up on the Akropolis in the midsixth century, perhaps
the ancestor of the fifth-century Promachos. A number of vases,
some of Panathenaic shape and others not, seems to show the
Panathenaic image (or a variation of the Panathenaic image with
feet placed together) as an actual statue, sometimes attended by
worshipers.[72] Shapiro (1989: 29–32) believes that the image may
represent the goddess herself, but showing the influence of an
important statue somehow connected with the Panathenaia.

The Kassandra episode provided an opportunity to repeat this
image within the context of a story warning against sacrilege. Per-
haps the episode can also be read as a metaphor for the violation
of Athena's sanctuary by Megakles in the 630s B.C. After all, the
curse on the Alkmeonid family began when Megakles trapped
Kylon and his men in Athena's temple on the Akropolis. Herodo-
tos (5.71) tells us that Kylon took refuge at the statue of Athena.
Thucydides (126) says that Kylon and his brother escaped, but that
their followers stayed at the altar of Athena, where they were
starved out and finally slaughtered. This sacrilege against the sanc-
tuary of Athena brought pollution on the whole state; the guilt
of the Alkmeonids was not easily forgotten (Parker 1990: 16–17).
For those who like to connect the popularity of certain themes
from the artistic repertory with developments in contemporary
Athenian politics,[73] the Palladion episode may be read as a warning
to the Alkmeonids. Such a reference to their family shame might
be well-timed by Peisistratos in the course of reorganizing Athe-
na's worship and the setting up of a new statue of the goddess on
the Akropolis. Viewed in this light, the representation of Ajax's

attack on Kassandra and his violation of Athena's sanctuary takes on a new and timely meaning.

The Kassandra episode may also have held special interest for a contemporary society increasingly concerned with the individual's responsibility to the community. Ajax, the soldier who brings ruin on his army by virtue of a personal crime, illustrates the Solonian precept that the suffering of man is caused by his own presumption. The sixth-century interest in themes of crime and punishment met with the ongoing expansion of Athena's cult worship to propel the old Palladion story to a new significance and prominence. What better warning against individual hubris, against placing personal desire above the collective good, against impiety and sacrilege? Athena, who among other things and in some ways in Athens personified, protects her devoted citizens and punishes those who dare to put themselves above divine law. Kassandra is incidental to this message; her story is simply a vehicle through which the might of Athena can be celebrated.

ATTIC RED-FIGURED VASE PAINTING

Composition

The red-figured sequence presented two basic compositional arrangements. One reproduced the Ajax/Kassandra/Athena formula of the black-figure tradition (Fig. 42); it was employed on red-figure cups and hydria early on, ca. 510–480. The other compositional scheme, first tried by Paseas ca. 520–510 (Fig. 41)[74]; but not adopted as the conventional form until the middle of the fifth century (Fig. 45), placed Athena at left, Kassandra at center, and Ajax pursuing from the right.

Paseas' work stands on its own. What appears to be a radical change in composition is in fact an ingenious change of perspective. We view the same traditional lineup, but now from the other side, looking at the action from behind Athena's shield. This gives us an unobstructed view of Kassandra, who takes a new position of prominence at center stage.

The cup painters who followed did not adopt this composition or perspective, yet they managed to keep the focus on Kassandra by placing her in front of a newly diminutive image of Athena striding atop a statue base. Athena's shield no longer hides Kassandra, but highlights her like a halo from behind (Figs. 41 and 42), an arrangement paralleled in black figure by the Priam Painter's hydria (*LIMC* I, 340, no. 38). The Kleophrades Painter (*LIMC*, 341, no. 44) turned the shield of his static Athena in

profile,[75] a view not seen since the archaic shield bands (Fig. 33) and Lydos' amphora (Fig. 34). This compositional change allows Kassandra's head to be silhouetted against the black background rather than against Athena's shield. This same effect is suggested by the examples seen on an Akropolis fragment (Fig. 43),[76] in the work of the Eleusis Painter[77] (Fig. 44), and on a cup in Boston.[78]

The pot painters of the midfifth century made several important compositional changes. They almost always reversed the order to Athena/Kassandra/Ajax, keeping the statue of Athena on a base and turning it to a frontal view. This position reinforces the role of Athena's statue as an inanimate stage property or setting element, detached from the action. When the Altamura Painter showed the rape of Kassandra alongside the death of Priam on his calyx krater in Boston (Fig. 45),[79] he broke with the traditional rendering of the Iliupersis in distinct units and integrated the two episodes into a compositional whole. Kassandra beckons to her father Priam, who reaches out to return her gesture, creating a visual and psychological link between the two scenes. The mirror image of pose and gesture allows father and daughter to participate in a single convergent composition that fills the expansive field of the krater's wall.

Two vases at the end of the sequence adopted the earlier composition of Ajax/Kassandra/Athena. Polygnotos' volute krater[80] shows the old arrangement with a frontal statue of Athena and, most interestingly, a living Athena standing beside her own statue. The Marlay Painter (Fig. 46)[81] reverted more faithfully to the older tradition by showing his Athena statue in profile view and in the striding pose, yet now with a profile shield and standing on a base.

43 Fragment. Athens, National Museum, Akropolis Collection 812. Drawing after Davreau (1942).
left bottom

44 Fragment of cup, Eleusis Painter. Vienna, University of Vienna 53.C.23.25.20. Drawing after Davreau (1942).
right bottom

45 Kalyx-krater,
Altamura Painter. Boston,
Museum of Fine Arts
59.176 (William Francis
Warden Fund).

The red-figured sequence shows a great deal of variety in the
compositional arrangements that, in part, reflect the variety of new
shapes on which the scene appears. The number of supporting
characters flanking the central actions depends on the space avail-
able. The dominant compositional change from black figure is the
new prominence of Kassandra and the reduction of Athena's role
to that of an inanimate statue, often diminutive and always de-
tached. There is no longer any question of whether Athena is a
living goddess or statue.

Shape

The earliest representation of the Kassandra episode in red figure
is that on Paseas' plate (Fig. 41). The choice of shape shows a
significant departure from the amphorae that regularly carried the
scene in black-figured work. In the course of the fifth century,
the repertory of shapes bearing the theme increased dramatically.
For the period 520–425, twenty-four vases survive, including ten
cups, seven kraters, two amphorae, one plate, one hydria, one

46 Kylix, Marlay
Painter, exterior. Ferrara,
National Archaeological
Museum T 264.

kantharos, one oinochoe, and one fragment. Cups are the dominant
shape for the period 510–480 (representing roughly 40 percent of all
vases carrying the subject), with the larger shapes (kalpis, krater, and
amphora) clustered in the 480–450 range. The break with the black-
figured tradition is significant: Only two amphorae show the scene
in red figure and these fall late in the sequence, ca. 450.

Placement of Field

The expanded repertory of shapes introduced a multitude of new
forms for the picture field and thereby new possibilities for com-
position and narrative method. The tondo of plate and cup, the
curving field of the kylix wall and the kalpis shoulder, and the
broad belly of the krater opened up new spatial dimensions for an
image previously restricted to the more or less trapezoidal picture
panel of black-figure amphorae.

The placement of the image on Paseas' plate involves a dramatic
departure from the black-figured tradition, not only in the shape
of the picture field, but in composition and conception. A circular
field had not served for the scene since the early example of the
black-figured Siana cup in London, ca. 575–550. While a lotus
chain decorates the area beneath the exergue line on the Siana
cup, the letters KATANDRA are inscribed beneath the exergue
line on Paseas' plate.[82]

The curving fields of the cup wall and the kalpis shoulder are ide-
ally suited for a series of images representing a sequence of related
events. Oltos is the first red-figure artist to show the attack on Kas-
sandra in combination with the murder of Priam and Astyanax and
the recovery of Helen by Menelaos.[83] The portrayal of the Kassandra

47 Kylix, Marlay
Painter, tondo. Ferrara,
National Archaeological
Mueum T 264.

episode within the greater context of the Iliupersis cycle had not
been attested since Lydos placed it alongside the death of Priam on
his amphora in the Louvre (Fig. 34). Oltos' arrangement was fol-
lowed by Onesimos' full-scale Iliupersis raging around the walls of
his cup in the Getty Museum (Fig. 42).[84] The whole cast of relevant
characters is shown combining a series of distinct episodes into a cy-
clic whole. Kassandra is featured front and center at the Palladion.
Fragments of pots in Athens (Fig. 43) and Vienna (Fig. 44) show very
similar arrangements for Kassandra and Athena and may well have
belonged to an extended multiepisodical composition. The Kleo-
phrades Painter adapted the sprawling composition used on the
curved wall of these cups for the similarly elongated field provided
by the shoulder of his kalpis in Naples.[85] Following the example of
the cups, he filled his field with images depicting the cumulative
events of the night of the sack of Troy.

The large shapes of the midcentury maintained the narrative
cycles formalized by the cups, but now spread out across the big
broad fields of their bodies.[86] Among the new characters intro-
duced to fill the ever-widening picture fields, the fleeing priestess
and attendants were most popular.

In the third quarter of the fifth century, the theme again ap-
peared on cups, most significantly that of the Marlay Painter who
shows the rape of Kassandra on the exterior and the death of
Kassandra on the tondo, giving the first and only representation
of two events in the life of Kassandra combined on a single vase
(Figs. 46 and 47).

With the introduction of different shapes and the integration of the episode into the full narrative cycle of the Ilioupersis, identifying inscriptions became a regular part of the decoration. They were used by Paseas, Oltos, Onesimos, the Eleusis Painter, and a painter from the Group of Polygnotos.[87] This new interest in naming the chief players contributed to Kassandra's emergence from the anonymous child of black figure to the compelling woman of red figure.

The Painters

The Palladion scene seems to enter the red-figured repertoire through the bilingualists and their pupils, in particular, through the cup painters. Our earliest examples are on cups by the bilingualist Paseas and by Oltos, who may have been a pupil of the Andokides Painter (Boardman 1975a: 57). The great cup painter Onesimos (Fig. 42) seems to have played a very significant role in shaping and canonizing a red-figured image repeated in the work of the Eleusis Painter (Fig. 44), the Tyszkiewicz Painter,[88] and the Kleophrades Painter. The special relationship between Onesimos and the Eleusis Painter was recognized long ago by Beazley.[89]

A second series of painters can be associated with the theme at midcentury. The Altamura Painter and his "younger brother" the Niobid Painter[90] seem to have shared an interest in the scene along with those that followed, the Painter of London E 470[91] and Polygnotos. Susan Matheson has shown how Polygnotos' rendering of the subject on his krater in Malibu places his work securely in the tradition of the Niobid Painter,[92] as Beazley recognized before.[93] At the very end of the sequence, two classic cup painters associated by Beazley,[94] the Eretria Painter,[95] and the Codrus Painter,[96] both paint Kassandra, although the Eretria Painter shows her with Apollo rather than with Ajax.

It was noted earlier that the black-figured artists who painted the Kassandra episode were more interested in repeating the image of the Panathenaic Athena than in showing scenes from the Iliupersis cycle. In contrast, the red-figured painters presented the Kassandra episode within the greater context of their special interest in Iliupersis scenes. Oltos, the Kleophrades Painter, the Tyszkiewicz Painter, and the Niobid Painter were particularly fond of Trojan themes. This bears out the overall shift from the black-figured interest in Athena to the red-figured interest in Kassandra.

Iconography

The red-figured Athena is unmistakably a statue, nearly always set upon a base.[97] There is a great deal of variety in the details of her

image. Early on she is shown striding in profile view and later with feet together in frontal view; she can be dressed in a peplos or in a chiton and himation, and can hold her shield in profile or in frontal view. Paseas presents his full-scale Athena in right profile, standing on the same groundline with Ajax and Kassandra (Fig. 41). Though her scale and placement suggest she may be living, several features confirm her identity as a statue. Her feet are together in direct contrast to the black-figure arrangement.[98] Though she is equipped with the arms of the Panathenaic Athena, she has changed the traditional peplos for chiton and himation and is without an aegis. The elaborate swallowtail folds of her dress and her long wavy locks of hair cause her to resemble an Akropolis kore, particularly that sculptured by Antenor.[99] Kassandra passes her right arm behind and over Athena's left forearm and tugs at her mantle, bracing herself against the pull of Ajax. Ajax no longer looks at Athena, but turns his undivided attention to Kassandra.

Onesimos leads the way in presenting a small-scale striding Athena statue upon a base (Fig. 42). This arrangement can be seen in two contemporary black-figured works, that of the Priam Painter (*LIMC* I, 340, no. 38) and a painter of the Leagros Group as well as on a red-figured fragment from the Akropolis (Fig. 43). Onesimos shows Athena with the pose and equipment of the old Panathenaic Athena, but he gives her an elaborate woven peplos decorated with figural and patterned designs (Fig. 42). The Akropolis fragment (Fig. 43) similarly shows Athena wearing a costume decorated with running figures.

The Kleophrades Painter (*LIMC* I, 341, no. 44) follows Onesimos by setting his Athena up on a base. But he abandons the rushing attack pose for a static posture with feet placed close together. This pose, combined with the diminished scale and "archaizing" smile make Athena once and for all an inanimate cult statue. If Paseas' Athena recalls Antenor's kore, then the Kleophrades Painter's statue surely recalls the Peplos kore.[100] However, whereas Paseas shows a statue of roughly contemporary style to that of the other figures in the scene, the Kleophrades Painter shows a statue with a sculptural style at least a quarter century out of date. This, of course, enhances its identity as the venerable Palladion of Athena's precinct at Troy.

The turning of the Palladion to frontal view on the large vases of midcentury serves to detach Athena from the central action even more (Fig. 45). The masklike frontal face of the static image denies even the slightest visual interaction between statue and suppliant. The inanimacy of the Palladion is underscored in Polygnotos' interpretation of the scene, where Athena stands beside her own statue.[101] This visual device is later employed in South Italian

vase painting showing the Trojan Palladion in the context of the Ajax and Kassandra episode as well as the reunion of Menelaos and Helen, and the theft of the statue by Odysseus and Diomedes.[102]

The reduction in Athena's role from the chief protagonist of black figure to the detached setting element of red figure comes to its full conclusion on a red-figured amphora (*LIMC* IV, 550, no. 358) by the Dwarf Painter[103] on which a frontal statue of Apollo is substituted for the Palladion. Though this scene is sometimes identified as showing Menelaos and Helen,[104] it is more likely that we have a mutation of the Palladion scene showing Ajax and Kassandra (Clement 1958: 58, 59; Simon 1969: 123). Kassandra and Ajax maintain their standard iconographies though the setting has apparently changed to the temple of Apollo. This example confirms Kassandra's new dominance of the scene. In black figure, the artist's interest in the Palladion episode started with Athena; in red figure, the artist starts with Kassandra. The Dwarf Painter thinks first of Kassandra's relationship with Apollo, confusing the iconographic formulas, and leaving out Athena altogether. The new focus on Kassandra's role is complete.

The representation of Ajax undergoes significant changes in red figure, transforming his action from that of attack to that of erotic pursuit. Changes in pose, costume, and gesture communicate this new image, which, again, serves to place the spotlight on Kassandra. Ajax now moves toward Kassandra from right to left, diminishing the old vanquisher at right/victim at left formula seen in black figure. His Corinthian helmet is now pushed up onto his head; he no longer needs to be protected from Athena's counterattack, but wishes to look more freely on the object of his pursuit, Kassandra. The early transitional work of Paseas is the only red-figure example to show the helmet down, but a new conception is already at work as Ajax looks at Kassandra rather than Athena and, for the first time, grasps the girl with both hands.

Ajax regularly makes physical contact with Kassandra in red figure, grabbing her arm, wrist, head, or hair. In early examples, he grabs her with his left hand and holds his drawn sword in the right (Figs. 42 and 44), but by midcentury, he uses the right hand to catch her hair, holding spear and shield unthreateningly in the left. Changes in Ajax's pose and equipment can be read in response to the diminished threat of the agressive "living" Athena, now replaced by a statue.

Kassandra bursts onto the stage of red figure liberated from her black-figured iconography. Assuming adult proportions and a feminine voluptuousness to match, she dominates the image, confronting the viewer with her sexuality and terror. The early paint-

ers show her completely nude or with a mantle thrown over her shoulders, exposing her shapeliness in full view. The pot painters of midcentury show her in varying states of dress and undress, with the flying mantle as the most popular arrangement.

Again it is Onesimos at the forefront, solving a number of compositional and conceptual problems (Fig. 42). He has Kassandra squat in the foreground overlapping the Palladion. With her left arm around Athena and right arm stretched out toward Ajax, her shapely torso is fully exposed, stretching across the composition. Her gaze and beseeching gesture are answered by Ajax whose eyes and outstretched arm parallel her own as he grabs her by the forelock. Onesimos' arrangement of the two parallel arms is followed by the painter of the Akropolis fragment (Fig. 43), the Eleusis Painter (Fig. 44), and the Kleophrades Painter (*LIMC* I, 341, no. 44). It reinforces the immediacy of the conflict between man and woman in its full physical and psychological dimensions.

Code and Gesture

The structure of the composition shows much variation in red figure. As we have seen before, the victor left/victim right formula of black figure and early red figure was reversed in the middle of the fifth century by the Altamura Painter, who introduced the frontal Palladion at far left (Fig. 45). This remained the most popular arrangement throughout the third quarter of the century: Niobid Painter,[105] Painter of London E 470, Ethiop Painter,[106] and Codrus Painter (*LIMC* I, 344/264, no. 67). The reversal of the composition tends to deemphasize the combative quality of the scene, moving away from the Ajax/Athena battle, and focusing anew on the Ajax/Kassandra story.

In early red figure, assailant and victim confront one another directly: Ajax points his sword at Kassandra, who answers with a beseeching gesture (Figs. 42 and 44). By midcentury, Kassandra no longer engages in eye contact with Ajax, but turns to look at her father Priam (as shown by the Altamura Painter, Fig. 45), at the ground (as in Polygnotos), or, most frequently, toward the statue of the divinity. The sequence ends with the popular arrangement of Kassandra facing the cult statue and Ajax pulling her hair from behind.[107]

During the course of the red-figure sequence, Ajax undergoes a transformation in which he surrenders his hoplite iconography for that of an ephebe. He carries a sword, but is without a shield in black-figure and in the red-figure repertoire from Oltos to the Kleophrades Painter. However, from the Altamura Painter's work onwards, Ajax is most often shown carrying a spear or spears rather

than a sword. The Niobid Painter adds a chlamys over the cuirass and, eventually, the cuirass is abandoned altogether. Ajax is shown nude with a chlamys draped about his shoulders. Gone is the soldier of the Homeric epics, having given way to the ephebelike image of a youth.

Christiane Sourvinou-Inwood (1987a, 1987b) has defined differences in iconography and meaning for scenes of attack and scenes of erotic pursuit. She has pointed out that attack scenes, showing the warrior with drawn sword, reflect an image matrix that existed long before it was made famous by the Tyrannicides. This is the formula employed for the representation of Ajax in black figure and early on in red figure (Fig. 42). Erotic pursuit scenes, on the other hand, show the antagonist as an ephebe, dressed in a chlamys and carrying spears. These attributes are precisely those that Ajax acquires during the course of the fifth century. The newly adopted codes thus emphasize the role of Ajax as a "hunter" and Kassandra as a "wild girl."[108] The physical, psychological, and sexual interaction, wholly absent in the black-figure image of Ajax and Kassandra, is thus potently presented through changes in pose, gesture, costume, and composition.

We have already seen in our discussion of black-figure iconography that Kassandra's racing nude figure resembles the "bears" shown participating in initiation rites on krateriskoi found at Artemis sanctuaries in Attica (Kahil 1977: 86–98, pls. 18–21). Could the slipping of Kassandra's mantle and exposure of her body be a visual reference to the shedding of the *krokotos,* the culminating act that seems to signify the rite of passage to womanhood (Sourvinou-Inwood 1988: 119–35)? The iconographic connection with girls' initiation rites may be reinforced in the red-figure repertoire by the woven decoration of racing figures on Athena's peplos, as shown in the work of Onesimos and on the fragment from the Akropolis (Figs. 42 and 43). Is there an intentional connection between the running figures on Athena's peplos and the nude or seminude Kassandra who has raced to the cult statue for protection? Though Kassandra's image may recall that of a girl participating in initiation rites, her nude race is an involuntary one that may result in an unwanted initiation into womanhood through rape.

Thus, in red figure, the images of the three principal players each evoke a full range of new associations and meanings beyond the specifics of the Palladion story. As an inanimate statue, Athena serves as a setting element included only to identify the location of the erotic pursuit at hand. Ajax is portrayed as an ephebelike hunter/pursuer, evoking associations with the generic youths who

participate in the chase and subsequent killing/sexual initiation of the prey/female. Kassandra is the victim, the animal/woman who is meant to be caught and killed/tamed through sacrificial/sexual initiation. The newly adopted semiotic system reflects the semantic shift behind the retelling of the story, thereby intensifying the new emphasis on the conflict of Ajax and Kassandra.

Narrative Method

The red-figure sequence reflects experimentation with a number of different narrative methods that reject the old-fashioned synoptic method of black figure and explore new temporal and spatial dimensions. Athena's departure from active duty eliminates any allusion to the ensuing punishment of Ajax as well as to the broader tragic consequences for the Greek expedition as a whole, consequences that were to some extent implicit in the active response of the black-figured Athena. Now, Athena's true Palladion serves merely as a setting element, locating the scene within her precinct on the Trojan akropolis and establishing a unity of place. The physical and psychological connection between Ajax and Kassandra makes for a new unity of time: the climactic moment of truth in what has been a chaotic sequence of events. The traditional three-figured composition thus achieves a unity of time and space, employing what has been called the "monoscenic" method (Weitzmann 1970: 14–17).

The placement of the Kassandra scene within the context of related episodes from the Iliupersis cycle (such as the death of Priam, Menelaos' recapture of Helen, and the escape of Aeneas) presents another new dimension for narrative. We have seen this system employed on cups (Fig. 42) and the shoulder of a kalpis; both shapes present a relatively narrow continuous curving surface ideally suited for showing a sequence of events.

There is no existing terminology to describe this placement of independent yet related events side by side in a single picture field. It cannot be called cyclic narrative, as that definition requires the repetition of a certain individual, comic-strip fashion. It cannot be called "simultaneous" as that is the term used by Weitzmann (1970: 13–14) to describe "synoptic" narrative. It is not purely synchronic narrative, as these events did not necessarily occur simultaneously at a given moment but over at least one day, maybe even more. I will describe it as "episodic" narrative because it portrays several distinct episodes within a single larger story. This new method is one of the most important developments in visual narrative of the late sixth century and persists into

the fifth century as a popular and effective means of telling the whole story through the juxtaposition of independent episodes.[109]

The only example of true cyclic narrative is that presented by the Marlay Painter on his cup in Ferrara. Here, the Palladion scene is shown on the exterior of the cup and the murder of Kassandra in the tondo (Figs. 46 and 47). The appearance of the murder of Kassandra at the hands of Klytaimnestra is most interesting, as it has not been attested in the artistic tradition since a seventh-century bronze relief panel from the Argive Heraion.[110] The emergence of this scene in the red-figure sequence may be a response to theater. By the middle of the fifth century, performances of Aischylos' *Agamemnon* brought the subject of Kassandra's death before the Athenian audience, though the actual murder apparently took place off stage. The Marlay Painter took this subject from the theatrical canon and gave it a visual representation drawn from the long tradition in vase painting: the attack on Kassandra at the Palladion. He substitutes Klytemnaistra for the assailant Ajax, and has Kassandra fall at the altar of Apollo rather than the Palladion of Athena. On the exterior of the cup, the familiar Palladion scene is repeated and, thus, two events from the life of Kassandra were combined in a single work.

Narrative Context

From Oltos onwards, red-figured vase painting shows the Kassandra episode combined with other scenes from the Ilioupersis, suggesting an understanding of the full cycle of events described in the epic. This new development may be attributed to the introduction of Homeric recitation in the Panathenaic festivals of 526 or 522 B.C. The testimony of Pseudo-Plato's *Hipparchos* (228 b) says that Hipparchos was the first to bring the Homeric epics into the country and forced the Panathenaic rhapsodes to "go through them." This may have resulted in a new prominence and broader familiarity with the Homeric stories (Friis-Johansen 1967: 223–43). Shapiro (1989: 43–6) has cautioned us to remember that vase painting seems more influenced by its own long pictorial tradition than by changes in Iliadic recitation. Still, the concept of presenting an image within the greater context of pictures from other related stories may reflect changes in the perception of time and events as governed by new developments in narrative method and greater familiarity with the stories as a whole.

Another impetus for the popularity of the Kassandra episode in early red figure may be found in historical developments. In face of the Persian threat, the Iliupersis cycle took on a whole new importance as a metaphor for the brutality of war (Boardman

1975a: 94). The great Persian massacres in the wake of the Ionian revolt of 499/98 brought stories of death, destruction, and captivity home to Athens. John Boardman has shown that Iliupersis scenes make up 75 percent of all Trojan themes shown in archaic red figure. In time, the sack of Troy came to be equated with the Persian sack of the Akropolis (Boardman 1976: 3; Davreux 1942: 15). Thus, the Kassandra episode took on a reality of its own independent of the old Palladion story. As part of a cycle that represented the full effect of war on all members of society, Kassandra represented the particular plight of young women in wartime.

As the focus shifted to the individual suffering of Kassandra, it is not surprising that her character received closer attention in poetry and drama from the middle of the fifth century onward. Pindar gives us the first specific reference to Kassandra as a prophetic maiden, the *mantis kora,* in *Pythian XI* (dated either 474 or 454).

It is Aischylos who brings the prophetess fully and unforgettably to life in his *Agamemnon* of 458. The emphasis on Kassandra is consistent with her treatment in the contemporary image tradition: Center stage and full scale, she commands the attention of the viewer and dominates the stage. She is presented, perhaps not surprisingly, as a wild, untamed creature, like a bird possessed of a "barbarian" tongue (1050). The gripping scene in which she is entranced in her prophetic vision concludes with her flinging off her oracular vestments: "See Apollo stripping me!" she cries. We are reminded of the climactic moment of girls' initiation rites: the shedding of the *krokotos.*

Kassandra was a very familiar character to Greek audiences by the end of the fifth century. She must have played a major role in Sophokles' lost play, the *Locrian Ajax;* his *Lacaenae* must have dealt with her story as well. She has major roles in the first and third plays of a Euripidean trilogy, the *Alexandros–Palamedes–Trojan Women* of 415 B.C. Her short but powerful scene in the *Trojan Women* again shows her psychologically separated from the other characters. Now costumed, not as a prophetess but as a bride, she acts out her delirium on stage in a perversion of preparations for her "marriage" to Agamemnon. But she does not leave the stage without stripping off her garlands and adornments (450–454), an act that recalls her devestment scene in the *Agamemnon* and, once again, the initiatory ritual of the shedding of the *krokotos.*

In the *Trojan Women,* Kassandra's character presents a perfect foil for Helen. Both are beautiful royal women, much admired by men; both are abducted and carried across the sea by members of the enemy's royal house. But Kassandra resists sexual advances

at every turn, in contrast to Helen who succumbs. Thus the farce in Kassandra's perverted bridal scene. The princess maintains that she will be for Agamemnon "a more fatal wife than Helen" was for Menelaos. In fact, although Helen is "every man's" wife, Kassandra is wife to no man, but ever the priestess of Apollo. South Italian vase painting juxtaposes the Kassandra/Ajax and Helen/Menelaos stories within a single image, reinforcing the contrast between the two women.[111] For Euripides, Kassandra is ever the virgin priestess just as Iphigeneia; both maidens are slain before the culminating act of marriage. It is significant that Euripides (Hamilton 1985: 55–66) refers to both women as "keybearers" of the temple, *kleidouchoi*: Iphigeneia as priestess of Artemis (*Iphigeneia at Tauris* 132, 1463) and Kassandra as priestess of Artemis' brother, Apollo (*The Trojan Women* 256).

Theater may be responsible for developments in narrative content as well as narrative method during the third quarter of the century. The tondo of the Marlay Painter's cup (Fig. 47) shows Kassandra falling to her knees before the altar of Apollo, laurel tree behind and tripod overturned at the side. She raises both hands in supplication to Klytaimnestra who rushes toward her wielding an axe. Kassandra's pose, kneeling with her left leg on the step of the altar and arms raised toward her assailant, and the slipping of her costume borrow directly from the traditional iconography of the Ajax/Kassandra episode. We are again reminded of Aischylos and the powerful scene from the *Agamemnon* in which Kassandra cries: "Instead of my father's altar, a chopping block awaits, blood red with the hot sacrifice of me, the one who has been butchered" (1277–8).

The imagery of sacrifice is key in the Marlay Painter's rendition: Klytaimnestra is dressed as one who sacrifices, with himation slung apron fashion across her waist (Connelly 1988: 51). But here she takes on the male role in sacrifice, the actual killing of the victim (Detienne 1989: 142–3). The transformation is complete. Klytaimnestra assumes the position of Ajax while Kassandra falls toward the altar rather than toward the safety of the Palladion. The Klytaimnestra/sacrificer/murderer equation replaces the Ajax/hunter/sexual assailant role. Kassandra is left to be the consumate sacrificial/violated victim. By combining his innovative murder scene with the well-known Palladion scene from the old representational tradition, the Marlay Painter achieves a new dimension for narrative and the unique exploration of two episodes in Kassandra's compelling story.

The fifth-century audience would have seen Kassandra not only on stage and on vases, but very prominently pictured in wall paintings, at Athens as well at the great Panhellenic centers of

Delphi and Olympia. Polygnotos' monumental wall paintings in the Stoa Poikile at Athens (Pausanias 1.15.3) showed the Achaean kings discussing Ajax's crime, with Ajax and Kassandra pictured nearby. Numbers of pilgrims passing by the Lesche of the Knidians at Delphi (Stansbury-O'Donnell 1989: 211, 212; Kebric 1983) must have admired the scene showing Kassandra holding Athena's image and Ajax standing beside an altar taking an oath (Pausanias 10.26.3). The painting of Kassandra was apparently so striking that Lucian commented on it in his discussion of ideal portraiture (*Imagines* 7). Inside the temple of Zeus at Olympia, a wall painting by Panainos showed the Ajax and Kassandra episode, once again. Thus, the new emphasis on the character of Kassandra experienced in the poetry and drama of the fifth century had a lasting effect on her popularity in the image tradition. As foreign princess, beauty, bride, victim, war prize, prophetess, priestess, and finally, in Euripides, as bacchante, Kassandra evoked a broad range of ever-evolving associations in a developing society searching for a greater understanding of the individual.

CONCLUSIONS

The comprehensive nature of the change in the Palladion scene's image tradition illustrates just how interconnected are shape, design, composition, authorship, iconography, code, gesture, and narrative method. The shift in focus from the conflict of Ajax and Athena to the conflict of Ajax and Kassandra embraces nearly every aspect of the presentation of the image. By examining the full scope of these developments and then asking *why* they occurred, we come to a fuller understanding of how story and image interact in the creation and communication of meaning.

Reconstruction of narrative intent is a dangerous business. The best we can do is to bring together the existing evidence for the historical, cultural, and social setting in which the minds of the ancient artist and audience interacted. The episode of Ajax and Kassandra at the Palladion provides a specific case study through which the larger question of changes in the collective consciousness can be examined. The shift in emphasis from Athena to Kassandra can be read as a shift in interest from the divine to the human, from the generic to the individual, from the symbolic to the psychological, from epic to tragic. By examining the changing reasons for retelling the story, we may shed new light on the interests and concerns, hopes, and fears of the artists who retold it and the audience that watched and listened.

NOTES

For their critical readings of this essay, I am grateful to Richard Hamilton, François Lissarague, Anne McKay, Sir Hugh Lloyd-Jones, Rush Rehm, Brunilde Ridgway, Alan Shapiro, Christiane Sourvinou-Inwood, and Dietrich von Bothmer to whom I owe additional thanks for allowing me to consult his photographic archive and for drawing my attention to several vases previously unknown to me.

Much of the research and writing of this paper was done in Paris and at Oxford during the spring and summer of 1989. I am indebted to the following individuals and their institutions for facilitating my research and for valuable discussions of content and method: Prof. Lily Kahil, *Lexicon Iconographicum Mythologiae Classicae*, Institut d'Art et d'Archéologie; Prof. Alain Schnapp and Prof. François Lissarague, Centre Louis Gernet de Recherches comparées sur les sociétés anciennes; Dr. Annie Caubet, Département des Antiquités Orientales, Musée du Louvre; Dr. Donna Kurtz, The Beazley Archive, the Ashmolean Museum, Oxford University; Mr. Michael Vickers, the Ashmolean Museum, Oxford University.

1. Davreux (1942) attributes the difference in iconography to a difference in literary sources followed by the artists; Moret (1975); Bell (1977: 392) connects the proliferation of Palladion scenes at midcentury with the setting up of a new cult statue on the Akropolis; Touchefeu (1981: 350); Matheson (1986: 103–7).

2. P. Colon, inv. n. 2021; Merkelbach (1967: 81) (translated by Lloyd-Jones 1968: 125); Lloyd-Jones (1991: 306–30).

3. Lycophron, *Alex.* v. 357; Propercius *Eleg.* IV(V) c. I, 118; Ovid *Ars Amatoria* I, 7, 17, *Metamorph.* XIV, 468; Tryphiodorus, *Sack of Troy 647*; Quintus of Smyrna *Posthomerica* XIII, 422.

4. Apollodoros, *Epitome* V 22; Hyginus *Fabula* CXVI, 20.

5. Haslam (1976: 1–26); S. Radt (1977: 8); Pearson (1917: 8); Sutton (1984: 7–9). Webster (1967: 146) has associated a number of scenes from a fourth-century vase painting showing Kassandra and Ajax and the Palladion and the priestess Theano fleeing with Sophocles' *Ajax Locrus*. Kassandra's story was probably also taken up in Sophocles' *Lacaenae, Teucer,* and *Antenoridae;* see Sutton (1984: 21–3, 66–8, and 132–9).

6. Boardman (1985: 239, 240) gives a summary of this approach.

7. Following methods that view images as part of signifying systems of representation. See Bérard et al. (1985, 1987); Bérard (1983: 5–37); Lissarague and Thélamon (1983); Lissarague (1987b: 266).

8. This line of inquiry is derived from that set forth in the works of Vernant and Vidal-Naquet (1972) and those who apply this approach to the study of ancient representations. See n. 5, and esp. Sourvinou-Inwood (1987b: 41–55). For the study of myth through hearer/viewer response and reception patterns, as borrowed from methods in contemporary literary theory, see Parker (1990: 188).

9. In this, I follow Sourvinou-Inwood (1979: 2), who defines a multimethodological approach and calls for the use of "many different approaches and methodological tools" in order to "diminish the risk of distortion and illuminate as many aspects as possible."

10. Olympia B 1801: Kunze (1950: 161, Ie, pl. 2.4.7) and *LIMC* I, 342, no. 48; Olympia B 1654: Kunze (1950: 161–3, pl. 18); Olympia B 975: Kunze (1950: 161–3, pl. 56).

11. Delphi 4479: Perdrizet (1908: 123, no. 674); *LIMC* I, 342, no. 49.

12. Paris, Louvre F 29: *ABV* 109.21, 685; *Paralipomena* 44; *LIMC* I, 342, no. 50.

13. Athens, National Museum: Davreux (1942: 149, no. 78, pl. 25, fig. 47); Furtwängler (1890: no. 705, pl. 39).

14. Madrid, Archaeological Museum 10925: *ABV* 298, 11; *CVA* Madrid I, pl. 2 (18) 16; *LIMC* I, 221, no. 178.

15. Geneva, Musée d'art et d'Histoire HR 84: Chamay and Bothmer (1987: 58–68).

16. Tampa, *ABV* 308, 70 bis. I thank Dietrich von Bothmer for drawing this vase to my attention.

17. Rome, Villa Giulia 56099: *LIMC* I, 340, no. 21; Böhr (1982: pl. 9, A; 10 bis); Davreux (1942: 144, no. 66, fig. 39 [drawing]).

18. Frankfurt, Collection Neumann: Böhr (1982: 7, 31–2, pl. 46 A).

19. No public or private business was conducted on that day; see Mansfield (1985: 371–8, 388–96); Simon (1983: 46); Brulé (1987: 105–6); Parker (1990: 26).

20. New York, Metropolitan Mueum of Art 41.162.143: *ABV* 134, 25; *Paralipomena* 55; *CVA* New York 3, pl. 14 (546); *LIMC* I, 340, no. 19.

21. Philadelphia 68-36-4. I thank Dietrich von Bothmer for drawing this vase to my attention.

22. Würzburg 249: *ABV* 296, 10; *Paralipomena* 128; Davreux (1942: no. 1, 143, no. 64, fig. 37); *LIMC* I, 340, no. 23.

23. Aberdeen University 634: *ABV* 278, 29, *LIMC* IV, 223, no. 226 (Antimenes Painter or his Group); Princeton 33.42: *ABV* 279, 99 (Antimenes Painter).

24. For example, his own Amazonomachy on Bologna Museo Civico PU 192: *ABV* 296, 7; *LIMC* I, 589, no. 28., showing Herakles vs. an Amazon who is not kneeling but faltering. Closer examples from contempory black figure are provided by other painters: Near Group E, Paris, Louvre F 218: *ABV* 139, 9; *LIMC,* I 589, no. 28; Group of Toronto 305, Naples, Museo Nazionale 2750: *LIMC,* 589, no. 33; Leagros Group (near Group of Munich 1501 and London B 272) Bochum University, Coll. Julius and Margot Funcke S 486: *LIMC* I, 589, no. 35.

25. Berlin 1863, near the Painter of Villa Giulia M 482: *ABV* 590, 1; Davreux (1942: 147, no. 75, pl. XXIII, fig. 43); Moret (1975: 20, n. 5); *LIMC* I, 340, no. 24.

26. This question has been taken up recently by Shapiro (1990).

27. This count is based on the list given in Touchefeu (1981: 339–42), supplemented by: a cup on loan to the Elvehjem Museum of Art, University of Wisconsin, Madison, ca. 520, Moon and Berge (1979: no. 5); amphora, Musée d'art et d'Histoire, HR 84, by the Princeton Painter, Chamay and von Bothmer (1987: 58); neck amphora, Philadelphia 68-36-4; neck amphora, Vulci Antiquarium, Leagros Group, *ArchCl* 23 (1971), pls. 37–9.1 (A, B); several neck amphorae that have appeared on the art market, including one by the Painter of Munich 1519 (attributed by von Bothmer), Leagros Group, ex Bechina, *Christie, Manson and Woods,* sale catalogue 5.5.1979, pl. 22, no. 63 (A, B); neck amphora, New York Market, Antiquarium 1986; neck amphora, Ariadne, Bec. 1983 754; neck amphora, *Munzen und Medaillen, A.G.,* Basel, sale catalogue 63 (1983): 11, fig. 27; neck amphora *Sotheby's* sale catalogue 10.7.1989; neck amphora, Basel market (Palladion) *Apollo* 107 (March 1978): 88 (A).

28. London, British Museum B 130: *ABV* 89, *Paralipomena* 44; *CVA* British Museum, III, He, Part III, pl. 1, 1 a–b(25); *LIMC* II, 969, no. 118.

29. This count is based on list given by Vian and Moore (1988: 218–26). The

Beazley Archive database shows that sixteen out of fifty-two Gigantoma-chies in black figure occur on the amphora shape, fourteen of these are neck amphorae and two are of type A or B. This count, however, is only for vases not attributed in *ABV*.

30. Demargne (1984: 969, nos. 381–8, 514, 517–18, 574–7, 582–6).

31. Berlin, Staat. Mus. 1686: *ABV* 296.4; Paris Bibl. Nat. 243; Florence MS 3941: *ABV* 110.33; Amphora by the Swing Painter, *Paralipomena* 135, 92bis; Böhr (1982: 222, S28f 94, pl. 89, A). For recent discussion of Athena's identifi-cation in these scenes as goddess or statue, see Shapiro (1989: 27–36).

32. Berlin 1686: *ABV* 296.4; *Paralipomena* 128.

33. Leiden, Rijksmuseum P6 54.

34. Basel, sold *Munzen und Medaillen, A.G.,* cat. no. 56.19.2 (1980): 31, no. 70, pl. 25; *LIMC* I.1, 33a.

35. Vatican, ex-Astarita 733: *ABV* 333, 30; *Paralipomena* 147, 30; *LIMC* I, 340, no. 38.

36. Munich, Antikensammlungen 2017 (J 506): Davreux (1942: no. 41, fig. 40); *LIMC* I.1, 40, no. 258.

37. Madison, Elvehjem Museum of Art: Moon and Berge (1979: 504, no. 59).

38. Malibu, The J. Paul Getty Museum 80.AE.154: Westcoat (1987: 58–61).

39. Berlin F 1698: *ABV* 136, 54; Davreux (1942: 141, no. 62, fig. 36). New York, Metropolitan Museum of Art 41.162: *ABV* 134, 25; *Paralipomena* 55; *CVA* Fogg and Gallatin Collections, pl. 35 (383) 2; *CVA* New York 3, pl. 14 (546) 1. Munich 1380 (J. 617): *ABV* 135, 34; *CVA* Munich I, pl. 14 (108) 1 and pl. 15; Davreux (1942: 145, no. 70).

40. Oxford 1965-124: *ABV* 300, 6; *Paralipomena* 130; *CVA* Oxford 3, pl. 31 (646), pl. 33 (648) 1, 2; *LIMC,* I 340 no. 27; Davreux (1942: 144–5, no. 67–8). Krefeld: *ABV* 300, 7. Warsaw 138487: *ABV* 300, 14bis; *Paralipomena* 131; *CVA* Warsaw, I, pl. 9 (138), 1–2, pl. 10 (139).

41. Würzburg 249: *ABV* 296, 10; *Paralipomena* 128; Davreux (1942: 143, no. 64, fig. 37); *LIMC* I, 340, no. 23.

42. Rome, Villa Giulia 56099: *LIMC* I, 340, no. 21; Böhr (1982: pl. 9, A; 10 bis); Davreux (1942: 144, no. 66, fig. 39 [drawing]).

43. Berlin, Staat. Mus. 1686: *ABV* 296.4; Bothmer (1953–4: 54–5); Shapiro (1989: 30, pl. 9 c–d).

44. I owe this suggestion to Richard Hamilton.

45. Painter of Munich 1519: London, British Museum B 242, Vulci: *ABV* 393, 2; *CVA* BM I, pl. 59 (204) 29; Davreux (1942: 146, no. 73); Moret (1975: 20, no. 5, 515–510 B.C.); Vatican G 22, Vulci: *ABV* 393.1; *LIMC* I.1, 340, no. 35. Neck amphora, *Christie, Manson and Woods,* sale cat., 5.5.1979, pl. 22, no. 63 (A, B). Leagros Group: neck amphora, Vulci, Antiquarium: *ArchCl 23* (1971): pl. 37–9, 1.

46. Christie's sale catalogue 5.5.1979, pl. 22, no. 63.

47. British Museum B 379, Manner of the C Painter, 575–550 B.C.: *ABV* 60, 20.

48. Athena Polias: Bothmer (1953–4: 52–6); Herington (1955: 41–42). Athena Nike: Hurwit (1985: 246). Pallas Athena: Pinney (1988: 464–77). For a useful overview of the problem, see Shapiro (1989: 27–36).

49. Gloria Pinney's suggestion (1988: 464–77) that the image shows Pallas in her victory dance after the Gigantomachy is of interest, insofar as we have noted above the sharing of compositional formulas between the Palladion scene and certain Gigantomachies. The Athena of the Kassandra episode is certainly not dancing, nonetheless the connection between the Panathenaic festival and Athena's victory in the Gigantomachy is critical to our under-standing of the "Panathenaic" image.

50. The scholarly debate is summarized by Matheson (1986: 105–6); also see Shapiro (1989: 27–36).

51. Christie's sale catalogue (1979): pl. 22, no. 63.

52. Traditionally dated to ca. 520 B.C., but possibly dated as late as 505 B.C.; see Stähler (1972: 101–12).

53. Sourvinou-Inwood (1987b) differentiates between the formula for attack and the formula for erotic pursuit. The Ajax of black figure conforms to the attack matrix: advancing from left to right wielding a sword, dressed as a warrior.

54. Trieste S 454: CVA Trieste I, pl. 2 (1910) 3; LIMC I.1, 340, no. 22.

55. Examples can be seen in sculpture, Siphnian Treasury at Delphi and Temple F at Selinous, and vase painting, Meidias Painter: Naples, Museo Nazionale 2045: ARV² 1338, Paralipomena 481.

56. LIMC I, 87–9, nos. 293, 295, 297, 301, 303, 322.

57. Berlin 1863, near the Painter of Villa Giulia M 482: ABV 590, 1; LIMC I, 340, no. 24.

58. Berlin F 1698: ABV 136, 54; Davreux (1942: 141, no. 62, fig. 36); LIMC I, 340, 18.

59. Naples H 2621: Davreux (1942: 143, no. 65, fig. 42); LIMC I, 340, n. 29.

60. London, British Museum B 242, Painter of Munich 1519, Leagros Group: ABV 393, 2; CVA British Museum I, pl. 59(204) 29; LIMC I, 340, no. 34.

61. Leiden PC 54, Dot-ivy class: CVA Leiden 2, pl. 82(176)1–3; Davreux (1942: 145, no. 69, fig., 38); LIMC I, 340, no. 37.

62. Paris, Cabinet des Médailles 181, Honolulu class: Paralipomena 193, 4; CVA Bibliothèque Nationale I, pl. 34(318)7, pl. 35(319)1; Davreux (1942: 149, no. 79, fig. 58); LIMC I, 340, 36.

63. I thank Dr. Jacques Chamay for his helpful insights on this point.

64. Orvieto, Museo Civico 7034: LIMC I, pl. 258, no. 39.

65. Kahil (1963: 13, 14, pl. 6, 1–2; 1965; 1977; 1981).

66. Olympia B 988, B 1801, and B 1802 (Troilos takes refuge at tree), and B 4962 (youth takes refuge at altar); LIMC I, 89, no. 376; Künze (1950: 140–2, pls. 3, 5).

67. LIMC I, 374, no. 20, pl. 290.

68. In accordance with the fluidity necessary for the domination/submission formula in the visual arts, as described by Gombrich (1982: 83).

69. Shield bands: Olympia Mus. B 969, Kunze (1950: II, V, 11b, pl. 20); LIMC VI, 529, no. 163; Olympia Mus. B 1803, Kunze (1950: 20, XV, 27d, pls. 41, 43); LIMC VI, 529, no. 164; Olympia Mus. B 1883, Kunze (1950: 16, XI, 17d, 166 pls. 34–57); LIMC VI, 542, no. 314.

70. In black figure, Edinburgh Painter: Swiss Collection: ABV 478, 8; LIMC IV, 549, 335. In red figure: Oltos, Paris, Louvre G3: ARV² 53, 1; Paralipomena 139, 168; LIMC IV, 540, no. 237; Malibu, J. Paul Getty Museum 80.AE.154: LIMC IV, 376 bis. The Centaur Painter: Paris, Louvre, Camp. 10268: ABV 189, 6; LIMC IV, 539, no. 235.

71. See Weitzmann (1970: 13–14), where a summary of earlier scholarship on narrative method is given. See also Himmelmann-Wildschutz (1967) and Meyboom (1978: 55–62).

72. Berlin 1686: ABV 296.4; Bothmer (1953–4: 54–5). See also Florence 97779: Shapiro (1989: 27, 28 n., pl. 8a); Munich 1727: ABV 397, 33; JdI 52(1937)39, fig. 6; Athens, National Museum, Akropolis 2298: ABV 216, 8; Graef and Langlotz (1937: pl. 96); Shapiro (1989: 30, pl. 10a); Athens, National Museum, Akropolis 1220: Graef and Langlotz (1937: pl. 67); Shapiro (1989: 30, pl. 10b); Paris, Cabinet des Médailles 243: CVA Biblio-

theque National 1, pls. 88, 89, 1–2; Shapiro (1989: 33, pls. 12c–d); once Basel Market, *Munzen und Medaillen* 56 (1980): 69; Böhr (1982: pl. 91); Shapiro (1989: 33, pl. 12b); New York, Metropolitan Museum of Art 53.11.1, Princeton Painter: *CVA* New York 4, pl. 13; Shapiro (1989: 34, pl. 14b).

73. Following an approach first set out by Boardman (1972), continued in Boardman (1975b, 1978b), and summarized in Boardman (1985).

74. New Haven, Yale University 1913.169: *ARV²* 163, 4; *LIMC* 342, no. 51.1260.

75. Naples, Museo Nazionale 2422, 81669: *ARV²* 189, 74 (66); 16321: *Paralipomena* 341; *LIMC* I, 341, no. 44.

76. Athens, National Museum, Akropolis 212: Davreux (1942: Fig. 63); Graef and Langlotz (1937: 212, p. 17, ca. 500 B.C.).

77. Vienna University 53, C, 23.35, 20: *LIMC* I, 341, no. 45.

78. Boston, Museum of Fine Arts 08.30a.

79. Boston, Museum of Fine Arts 59.176: *ARV²* 590.11; *Paralipomena* 394; *LIMC* I, 263, 344 no. 60.

80. Malibu, J. Paul Getty Museum 77.NA.198: Matheson (1986: 101–3, fig. 1a).

81. Ferrara T264: *ARV²* 1280.64, 1689; *LIMC* I, 345, no. 75.

82. This is the last surviving vase to show the attack on Kassandra placed in the tondo. The Marlay Painter's cup, ca. 430 B.C. (Fig. 47) shows the death of Kassandra in this position.

83. Malibu, J. Paul Getty Museum 80.AE.154: Westcoat (1987: 58–61).

84. Malibu, J. Paul Getty Museum 80.AE.362: Matheson (1986: 106, fig. 4).

85. Naples Museo Nazionale 81669: *ARV²* 189, 74 (66); 16321: *Paralipomena* 341; *LIMC* I, 341, no. 44.

86. Boston 59.176, the Altamura Painter; Bologna 268, the Niobid Painter: *ARV²* 598, 1; *CVA* Bologna 5, 97, pl. 87 (1471); *LIMC* I, 344, no. 61; Davreux (1942: 159, no. 42, fig. 54).

87. Neck amphora, Cambridge, Corpus Christi College: *ARV²* 1058; *LIMC* I, 343, no. 54; Davreux (1942: 152, no. 83, fig. 49); Moret (1975: 12, no. 9).

88. Akropolis 813: *ARV²* 294, 67; Graef and Langlotz (1937: 73).

89. *ARV²*, 313–15.

90. Bologna, Museo Civico C 268: *ARV²*, 598; *Paralipomena* 394; *LIMC* I, 344, no. 61; Beazley referred to the Niobid Painter as the Altamura Painter's "little brother," *ARV²*, 598.

91. London, British Museum E 470: *ARV²* 615, 2; Davreux (1942: 163, no. 98, fig., 60); Moret (1975: 14, n. 2).

92. Matheson (1986: 108–11).

93. *ARV²*, 1027.

94. *ARV²*, 1247.

95. Taranto, Museo Nazionale 8063, kantharos type D; Lezzi-Hafter (1988: 285bis, p. 352); *LIMC* II, pl. 261, 874.

96. Paris, Louvre G 458: *ARV²* 1270, 11; *LIMC* I, 344/264 no. 67; Davreux (1942: 158, n. 91, fig. 55); Moret (1975: 14, n. 2; ca. 430 B.C.).

97. With the exception of Oltos' fragmentary kylix in the J. Paul Getty Museum showing Athena striding on the same groundline with Ajax and Kassandra, and Paseas' tondo (Fig. 43) that shows a statuelike Athena without a base. These early examples look back to the black-figured tradition with Athena's frontal shield extended. Kassandra, however, is now placed well in front of the shield.

98. This has not been seen since the C Painters's cup in London and Lydos' amphora (Fig. 34) prior to the formulization of the Palladion schema in black figure.

99. Athens, Akropolis Museum 681: Richter (1968); identified by Ridgway (1990: 603) as Athena.

100. Acropolis Museum 679: Hurwit (1985: 349). Interestingly, both korai have been interpreted as statues of divinities, the Peplos kore as Athena or Artemis and Antenor's kore as Athena; see Ridgway (1977, 1990: 603, 610).

101. Malibu, J. Paul Getty Museum 80.AE.362; Matheson (1986: 106, fig. 4).

102. Kassandra and Ajax: Taranto 52.665: Moret (1985: pl. 3); Naples H 3230: Moret (1985: pl. 4); Helen and Menelaos: British Museum F 160: Moret (1985: 8); theft of the Palladion: Stockholm 1963: Moret (1985: pl. 29). See also the north metopes of Parthenon.

103. London, British Museum E 366: *ARV²* 1010, 4; *CVA* British Museum Fasc. 5, III,1,C, pl. 65, 2a; *LIMC* IV, 550, no. 358.

104. *ARV²* 110, 4; Kahil (1955: 96, no. 82); *LIMC* IV, 550, no. 358.

105. Bologna, Museo Civico C 268: *ARV²* 598, 1; *CVA* Bologna 5, pl. 97 (1471) 1–2 and pls. 98–100 (1472–4); Davreux (1942: 159, n. 97, fig. 54); Moret (1975: 14, n. 5); *LIMC* I, 344 n. 61.

106. New York, Metropolitan Museum of Art 56.171.41: *ARV²* 666.12; *Paralipomena* 404, 521; *LIMC* 344, no. 63.

107. The hair-grabbing scenario is known from a number of narrative contexts. See Moret (1975: 193–225, 234–40).

108. See Sourvinou-Inwood (1987a: 152).

109. Shapiro (1990: 136–8) refers to this as "unified" narrative. See also Froning (1988).

110. Athens, National Museum 15131: Neumann (1965: 101, fig. 46).

111. London, British Museum F 160, Ilioupersis painter: *RVAp* I, 193, n. 8; Davreux (1942: 152, n. 84, fig. 50); Moret (1975: 11, n. 2, pl. 8 and pl. 10, 1; *LIMC* I, 343, n. 59. Zurich, Galerie Nefer: *RVAp* Suppl. 1, 151, 21a, pl. 29, 4; *LIMC* IV, 551, no. 361 (Baltimore Painter).

NARRATION AND ALLUSION
IN THE HELLENISTIC BAROQUE

Andrew Stewart

Hellenistic narratives are peculiarly difficult to pin down. Dates, historical contexts, and functions are often hard to specify, and rarely it is easy to discern the reasons for this or that choice on the part of their makers. This essay focuses upon two central monuments of the "Baroque" style: the Nike of Samothrace and the Gigantomachy frieze of the "Great Altar" of Pergamon (Figs. 48–51, 55–7). The Nike seems to represent a relatively early stage of the Baroque, still in touch with the traditions of the fourth century (Fig. 5), the Gigantomachy a relatively late one. They are also utterly different in genre and type: One is a single-figure personification that conjures up a real event; the other a multifigured ensemble that ostensibly illustrates a mythological tale. Yet each encodes narrative values that prompt one to look for subtextual meanings and allusions: In each case, metanarratives are implicit in the rendering, lurking beneath and beyond its surface.

The Nike and Gigantomachy are among the most impressive of all Hellenistic sculptures, and have inspired an extensive scholarly literature. To paraphrase some words by Rosenmeyer (forthcoming) on another Hellenistic masterpiece, the "Argonautica" by Apollonios of Rhodes, there are a number of ways to tackle works like these. One can look backward at their antecedents in the early Hellenistic and classical periods; one can look forward at their impact upon the numerous later Hellenistic and Roman monuments that perpetuate or revive the Baroque; one can look laterally, and attempt to integrate them into their respective social, cultural, and political contexts; and one can look inward, exploring and analyzing structure, themes, motifs, and much else, or deconstructing the presentation to do justice to the challenges of the style's unease. Other approaches are possible, and two or three of the foregoing can be made to overlap. Such inferential criticism (Baxandall 1985), working between a description of the work in question and a description of mid-Hellenistic culture, seeks to identify what makes it interesting, and to match these observations

with particular developments in the culture. In doing so, it implicitly seeks to specify causes for it, to pinpoint the necessary conditions for its creation. "Necessary" but not sufficient, for no amount of criticism can ever exhaust a work of art.

In our case, both monuments have often been linked with specific historical events, and even with specific personalities. Though suggested dates for the Nike range from Demetrios Poliorketes's annihilation of the Ptolemaic fleet in 306 off Salamis in Cyprus to Augustus's triumph at Actium in 31, her architectural setting has yielded pottery dated by the excavators to around 200–180, lending welcome support to those who had long argued for an early second-century date for the dedication on stylistic grounds (Charbonneaux 1952; Lehmann 1973: 181–9; Lehmann 1975: 85–6). Anticipating these finds, Thiersch (1931) had even conjectured a sculptor and patron for her in exactly this period: In his opinion, the Rhodians commissioned her from their fellow citizen Pythokritos in order to celebrate their naval victories of Side and Myonnessos over Antiochos III of Syria in 191/190.[1] His case rested upon a multilated inscription reading **[. . .]s Rhodios [. . .]** that had been found nearby, and upon the Rhodian stone used for the ship. These Rhodian victories had helped to turn the tide of the Syrian War in favor of the Romans and their allies, Pergamon and Rhodes herself, and led directly to the defeat of Antiochos on land at Magnesia in 189. In 188, the humiliating peace of Apameia forced him to pay a huge indemnity and banished him and his successors forever from Asia west of the Tauros Mountains. Rhodes and Pergamon were amply rewarded with territory and tribute, and the next 30 years saw both states at the peak of their power and prosperity. Yet the Nike's connection with these events is by no means proven or provable, the pottery is problematic, and a date around 250–200 is still argued by some (Smith 1991: 78–9).

As to the "Great Altar," the dedicatory inscription (Fränkel 1890: no. 69), though again mutilated, proves that it was constructed during the reigns of either Eumenes II (197–159) or Attalos II (159–138). The monument has been variously explained as a Pergamene counterpart to the Nike for the Syrian victory, as a thank offering for Pergamene prosperity around 180–170, or, most recently, as a celebration of the final defeat of the Macedonians in 168 and/or the Celts in 166 (Kunze 1990; Schmidt 1990). Those who date it this late ascribe its unfinished state to Prousias of Bithynia's devastating raid in 156, which presumably caused a massive diversion of resources into the task of reconstruction. An alternative theory sees the "Altar" as a heroon for the city's founder, Telephos, and specifies no single historical event

as the catalyst (Stähler 1978). Menekrates of Rhodes, a name known both from the literary sources and the signatures inscribed below the Gigantomachy, has sometimes been suggested as the monument's designer (cf. Bieber, 1961: 114; contra, Börker 1986; Goodlett 1991: 673). More recently, Simon (1975) has argued that the program of the Gigantomachy is the work of the Stoic Krates of Mallos, who was head of the Pergamene library under Eumenes, and that he derived it from Hesiod's *Theogony,* which he edited. She proposes that it is heavily indebted to Stoic philosophy in general and Krates' geographical theories in particular.

Confronting these issues directly might be salutory, for as remarked before, in no case is the chain of inference secure (cf. Smith 1991: 78–9, 157–64). Yet because the Nike and her setting are presently being restudied for definitive publication,[2] and new observations have thrown considerable doubt upon Simon's reading of the "Altar" (Pfanner 1979; Wenning 1979; Meyer 1983: 66–72), it might be prudent to take a somewhat different route.

Here, one may usefully start with T. J. Clark's insight, prompted by the writings of Mikhail Bakhtin (e.g., Bakhtin 1981), that like literary texts, works of art are *utterances.* "All utterances anticipate answers, provoking them, eluding them, orienting themselves toward an imagined future in which something is said or done in reply; and works of art, being especially elaborate, pondered cases of utterance, are most of all shot through with such directedness" (Clark 1990: 177). They take the observer into account from the very beginning; their relationship to him/her is as basic to their construction as it is to the construction of literary discourses. Just as texts design a Model Reader, they design a Model Spectator, an individual who is foreseen by the artist and explicitly addressed by him, and whose responses are anticipated in the work itself. This Model Spectator can be extrapolated from the work by analyzing its form, by charting its place amid the similarities and differences revealed by looking at its genre and artistic context. The analogy may be taken further. "Many texts aim at producing two Model Readers, a first level, or a naive one, supposed to understand semantically what the text says, and a second level, or critical one, supposed to appreciate the way in which the text says so. . . . [They offer "clues" that] seem to work exactly as self-focusing appeals: the text is made in such a way as to attract the attention of a critical reader" (Eco 1990: 55).

The present essay attempts to explore these "clues." Questions to be addressed include the following: What kind(s) of Model Spectator do the Nike and Gigantomachy construct, and what responses do they seek to provoke, to anticipate, and to elude? Do they encode narrative values that might reveal an ulterior pur-

pose? How far do they manifest a specific historical consciousness, and to what end?

My starting point will be the Baroque style itself, or rather (given the thrust of this volume), the Baroque as a medium of sculptural narration. The ancient critics of Baroque rhetoric will serve as guides: What do their criticisms reveal about its history, audience, and aims? Then I will return to the Nike and the Gigantomachy, looking for evidence that their sculptors were aware of and even sought to anticipate these criticisms by couching their utterances in an authoritative way, so that each monument could manifest a sense of its own history and worth through its narrative form. In the case of the Nike, questions about the motif of the composition – what, exactly, is she doing? – awake the suspicion that more lies behind it than currently meets the eye. In the case of the Gigantomachy, the clue is the striking way in which it mixes wholesale evocation of the past with equally thoroughgoing innovation. What is the purpose of this mixture, and what does it tell us about Pergamene engagement with past, present, and future? This understanding of the Baroque as a hybrid and therefore historically conscious style will lead to a concluding look at its nature as a discourse with present and past, and particularly with the classic style of the fifth and fourth centuries B.C. and its Hellenistic revivals.

THE HELLENISTIC BAROQUE AS A NARRATIVE STYLE

If the prime duty of inferential critics of Hellenistic art is to explain historically what makes the subjects of their enquiry special, it follows that they must begin by describing them, by identifying categories of visual interest within them. Description of this kind is "ostensive" (Baxandall 1985: 9–10). Mediating between object and explanation, it both calls to attention what is interesting about the former, and stimulates us to reflection and explanation on the causes of this interest. To determine these causes, however roughly, requires that the critic attempt to reconstruct historical circumstance, however broadly. S/he must seek to learn what the ancient artist thought he was doing when making the choices he did. S/he must seek the understanding of a participant in the process, suppressing his/her own concepts and knowledge in order to take up those of the Hellenistic Greeks. And because Hellenistic Greeks spoke Greek, thought in Greek, and used Greek to specify and categorize these choices, it becomes peculiarly important to locate Greek explanatory terms for the phenomena we isolate.

Such contemporary terminology is "super-ostensive" (Baxan-

dall 1985: 111–16). It is at once *necessary,* in order that we may
give an adequate account of things now remote from our culture
and language; *strange,* because it shakes us out of our false sense
of familiarity with this remote culture and its artifacts; and *super-
ostensive,* in that our new unfamiliarity makes us work harder be-
tween word and image, and so leads us to a closer perception of
the latter.

The characteristics of the Baroque style – its grandiloquence,
theatricality, emotionalism, energy, floridity, obsession with
extreme contrasts, penchant for surprises, and passion for novelty
– have often been described, and this is not the place for an ex-
tended reprise. It is even fairly easy to turn some of these obser-
vations into Greek. *Auxesis* (stylistic amplification), *makrologia*
(extended treatment), *deinosis* (emphasis on the terrible), *ekplexis*
(surprise), *antithesis,* and *pathos* are terms that come immediately
to mind. Unfortunately, though, these terms cannot be directly
connected with the sculpture itself. For whereas we are fairly well
supplied with instances of the application of Greek critical vocab-
ulary to particular works of classical Greek art (Pollitt 1974), the
oblivion to which the later Greek and Roman Neo-Classical crit-
ics consigned Hellenistic sculpture in general, and the Asian Ba-
roque in particular, leaves us with nothing direct to go on.

Two factors help to mitigate this dismal situation. First, ancient
art theory was almost entirely rhetorical, and Baroque sculptural
narrative invites categorization as a rhetorical utterance of a very
particular kind (Robertson 1975: 540). As Marrou has remarked,
"Hellenistic culture was above all things a rhetorical culture . . .
and the categories of eloquence were imposed upon every form
of mental activity" (1982: 195). And, second, all the Greek de-
scriptive terms mentioned before do in fact have specific meanings
within the context of Aristotelian and Hellenistic rhetoric. In par-
ticular, they characterize those rhetorical techniques that flour-
ished in Hellenistic Asia Minor from the third through the first
centuries B.C.: the "Asiatic" style that was so vilified by Cicero
and others (*Brutus* 51, 286, 325; *Orator* 25, 231; *de Oratore* 2. 58;
Dionysios of Halikarnassos, *On the Ancient Orators* 1–4, and *de
comp. verb.* 18; Quintilian 12.10.16–19; cf. von Wilamowitz-
Moellendorf 1900; Norden 1958: 131–49; Kennedy 1963: 301–3,
330, 334n, 337–8; Gabba 1982).[3] Its earliest practitioner was He-
gesias of Magnesia at the beginning of the third century (of whom
Cicero cuttingly remarked that "once you knew him, there was
no need to look further to find a man of bad taste"), and its latest
was Aischines of Miletos, Cicero's contemporary (fragments, Ja-
coby 1923–58: nos. 142 F 1–24 and 566 F 1–158). There is also
a considerable overlap with the practices of the so-called "tragic"

historians (some of whom were also based in Asia), whose histrionic approach is roundly condemned by Polybios (2.56.11).

Rhetorical education was readily available to the children of the comfortably off (Marrou 1982: 194–205), and an increasing number of Hellenistic sculptors fell into that category (Stewart 1979: 105–11; Goodlett 1991: 676–78). Indeed, the public offices held by quite a few of them presuppose speaking ability. Yet one did not need to go to school to assimilate rhetorical techniques: One would hear them used every day, whether in political debate (deliberative rhetoric), in courtroom arguments (forensic rhetoric), or in publicly sponsored encomia of benefactors and others (epideictic rhetoric). Just like the local Phrygian, Lydian, and Mixolydian modes of Asian music, all these *technai* aimed at *psychagogia,* the swaying of the soul, at convincing their audiences by aural pyrotechnics and emotional appeal (Plato, *Republic* 398c–402a; *Gorgias* 453a; *Phaedrus* 261a, 271c).

To connect rhetorical "Asianism" in general with the Baroque art of Hellenistic Asia Minor is not particularly new. This had been essayed long before Margarete Bieber boldly used the term as a chapter heading in her encyclopedic study of Hellenistic sculpture, which first appeared in 1955 (cf. Bieber 1961: 171).[4] Yet though many historians of Hellenistic art have echoed the ancient critics' disapproval of this sculptural "Asianism," very few, to my knowledge, have asked how it functions as a narrative device. Description and analysis tend to stop with awe at its virtuosity, and disapproval at its extravagance; little if any attention is given to what these artists thought they were doing when they set out to carve in this style. For clues, one may begin by investigating the statements of the ancient rhetoricians.

They condemn the Asian style for the following faults:

1. It abandons the direct vocabulary, clear subordination, and measured periods of Demosthenes and the Attic orators for either a choppy, disjointed diction based on short sentences made up of one or two clauses, or a "rich and fatty" style using long, rolling sentences.

2. In the "choppy" style, these units were each so strongly rhythmical and clearly cadenced that any larger structure was lost; in the "fatty" style, the effect was that of a prose poem. Enslaved to rhythm, Asianism all too often resorted to "padding" solely to preserve it.

3. Not only was Asian syntax "unhealthy" and too far from normal speech, but its imagery was strained and bizarre, and

its wordplays were chosen more for their assonance and their shock value than for their utility in enhancing meaning.

4. Lacking subordination and confined to "bite-sized" sentences, the "choppy" style was rapid and flashy, lacking depth, weight, and refinement of thought, whereas the "fatty" style was turbulent, bombastic, and redundant, "full of sound and fury, signifying nothing."

This uniformly hostile critical reception can be summarized thus: The Asiatic style was too distant from normal speech for comfort. It was both untraditional and artificial. Whereas the Attic orators maintained contact with reality, it abandoned their naturalism (*aletheia/veritas*) of expression and sought dramatic effects instead, breaking the connection of "appropriateness" (*to prepon/ decor*) that should always link event and description. Suggestively, this is also the implication of the dismissal of the art of the entire early and mid-Hellenistic period by Neo-Classical critics like Quintilian and Pliny (*Inst. Or.* 12.10.9; *N.H.* 34.52; cf. Pollitt 1974: 125–38, 201–4, 430–4). They felt that whereas the artists of the fourth century had generally managed to balance the demands of beauty and likeness, and their successors in the later second century attempted to return to this ideal, those in between produced work that could not be termed "art" at all.

Though these ancient art critics greeted the Hellenistic Baroque with a resounding silence, their modern counterparts have been less restrained: The abuse they heap upon the Gigantomachy of the "Great Altar" sometimes appears to be lifted word for word from Cicero and Dionysios on Asiatic rhetoric. This is both suggestive and revealing of the extent to which, reinforced by historical circumstance, ancient prejudice still dominates modern criticism. For like their ancient counterparts, many early modern historians of Greek art also developed their theories in reaction to the Baroque: Neo-Classicism was their creed, and the Baroque a kind of heresy. Their consensus is that as a *narrative* style, the Baroque fails dismally, for even as it strives to heighten the effect of the narrative, it destroys its coherence by its chaotic rhythms and empty bombast. As Carpenter succinctly remarked, "there is too much to see and too little formal help to seeing it" (1960: 199). Yet as he goes on to note, "single statues worked in such a style of emotional excitation might be less exhausting, because less exacting if so complicated an appeal were confined within formally intelligible boundaries. The Victory of Samothrace is a case in point" (1960: 201).

Now, it would be surprising if the Asian sculptors had not

anticipated such criticisms before they began to carve. Indeed, on one level, they must have done so. As remarked before, modern studies of literary narrative take it as given that the relationship between author and audience is a reciprocal one, that is both prior to the creation of the work and incorporated within its utterances. "Every word is directed towards an answer and cannot escape the profound influence of the answering word that it anticipates. . . . This relationship toward the concrete listener, taking him into account, is a relationship that enters into the very internal construction of rhetorical discourse. This orientation toward an answer is open, blatant, and concrete" (Bakhtin 1981: 281). Considered from this point of view, narrative sculpture emerges as a very particular kind of utterance, a distinct mode of discourse between its makers (the sculptor and his patron) and its audience.

On some level, then, Hellenistic Baroque sculptors surely anticipated these charges of artificiality and empty bombast – charges that may be summed up as a lack of *authority* for their utterances. Now in Greek culture, such authority was usually mobilized by presenting a general truth in a new and arresting way, by invoking a privileged source, and/or by following an accepted style of discourse. So how far and in what ways do the works in question seek to meet these charges? In particular, how far if at all do they attempt to invoke authority, and what do they make of it? What clues, what self-focusing appeals, attract our attention as critical readers?

THE MOTIF OF THE NIKE OF SAMOTHRACE

In the early 1950s, excavation revealed that the Nike of Samothrace (Figs. 48 and 49) was set slightly on the diagonal in a small precinct with a low retaining wall at the sides and back. The floor was paved with rippled marble, which was furnished with dowel holes to fix objects in bronze, perhaps dolphins or other sea creatures. Traces of pipes led the excavator to reconstruct the ensemble as a fountain (Fig. 50), with water pouring from an upper basin set within the precinct into a lower one; two huge rocks that were found in the lower basin completed this pictorial, quasi-maritime setting (Lehmann 1973). Furthermore, he discovered what should be the right hand of the Nike in the basin, and fitted finger fragments in the reserves of the Kunsthistorisches Museum in Vienna to it (Fig. 51); these had been found on the Nike terrace by the Austrians in the nineteenth century.

The hand was open and its fingers were slightly splayed. This finally disproved the old theory that – although Nike's head was

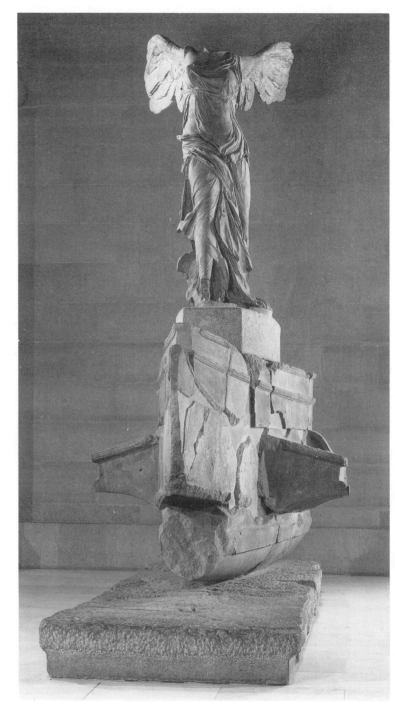

48 Nike of Samothrace.
Paris, Musée du Louvre.
Photo: Service photogra-
phique de la Réunion des
Musées nationaux 87
EN2196.

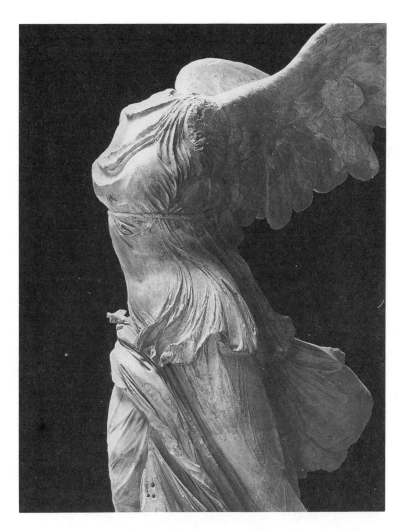

49 Detail of the Nike of
Samothrace. Paris, Musée du
Louvre. Photo: Bulloz 8731
bis.

50 Reconstruction of the
Nike "Fountain,"
Samothrace. After Lehmann
(1973, fig. 5).

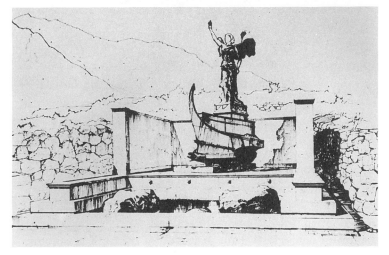

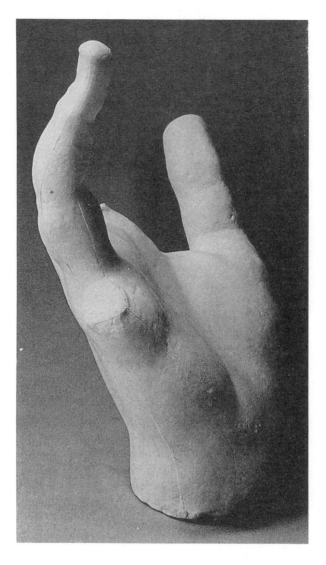

51 Cast of the right hand of the Nike of Samothrace. After Charbonneaux (1952, pl. 1).

52 Tetradrachm of Demetrios Poliorketes. Boston, Museum of Fine Arts, Harriet Otis Cruft Fund. Photo: MFA C39775.

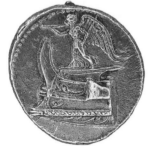

patently turned a little to her left, toward the spectator – she was blowing a fanfare on a trumpet just like her sister on the victory coinage of Demetrios Poliorketes (Fig. 52). This issue was struck to commemorate Demetrios's great victory over Ptolemy I Soter of Egypt at Salamis in Cyprus in 306, and was long held to justify a late fourth-century date for the Samothracian Nike, which some even turned into a dedication by Demetrios himself. Disputed on stylistic grounds by many German scholars, this association was most seriously challenged by Lehmann's ceramic evidence, which supposedly confirmed a date around 200 B.C.

Lehmann suggested a Samothracian, not a Rhodian, commission and authorship for the statue on the grounds that the Rho-

dian inscription commonly associated with it was too small to belong, warships on the island's coins attested to the existence of a Samothracian navy, and the Rhodian stone of the ship and base could well have been imported by Samothracian sculptors. One such individual was working on Rhodes in the 220s (Lehmann 1973: 192, n. 14). What the Nike held in her left hand is another matter: a *stylis* (enemy naval standard) seems the most likely, as on Demetrios's coins, or perhaps a palm branch; a trophy would only be appropriate to a land battle.

Lehmann died before he could produce a full publication of the Nike monument, but this is now in preparation.[5] In particular, the evidence that the complex was a fountain is less specific than one would like, and there was probably no difference in levels; the date of the pottery, too, is uncertain (cf. Smith 1991: 78–9). Yet the evidence of the hand still seems secure, and it is to this that we now turn.

Lehmann's view that it was empty is surely correct. Yet despite his observation that an attribute would have required a closed fist (or at least a thumb pressed to the index finger) and/or a dowel, commentators still do not feel comfortable with the notion of an open hand. Thus, Charbonneaux, in his original publication of the hand, suggested a loosely held *taenia* (Charbonneaux 1952: 44–6); Robertson writes that "the right arm was up and forward, perhaps with a wreath, the left down and slightly back" (1975: 535); and Pollitt is even more emphatic, seeing her arriving on the ship "in order to crown its victorious commander and crew" (1986: 113). Lehmann, however, visualized the scene quite differently: "Nike alighted on the ship extending her arm forward against the enemy in a great gesture of command" (1973: 184).

A moment's reflection on the role of Nike in antiquity will reveal a strange paradox. For while those who restore an attribute in the outstretched hand are almost certainly wrong, the assumption behind their judgment, that Nike is not an active figure in a battle but a messenger come to confirm victory, is most definitely right. Lehmann's reconstruction of the motif, on the other hand, is absolutely in accordance with the archaeological evidence, but seriously misunderstands Nike's true nature and function. Nike is a go-between, a messenger of Zeus, not a figure of command: she makes no decisions herself, but only transmits those of Zeus (*RE* s.v. "Nike": col. 287).

A second look at Demetrios Poliorketes' coins (Fig. 52) may help to clarify matters. The prow of the ship on this coin is broken, so it must be a captured *enemy* ship (Newell 1927: 31–8; cf. Lehmann 1973: 191, n. 13; Mørkholm 1991: 77–8; in general, Bellinger 1962). Demetrios's Nike is therefore heralding his vic-

tory as she brings his prize to port: This and other examples (Neumann 1965: 41–8, figs. 19–22) suggest that the motif of the Samothracian Nike is *homecoming,* and that her sweeping, triumphant gesture is one of greeting. As with the turn of her head toward us, the object of this gesture is presumably the spectator.

What of the ship? Newell took his argument from the coin further, to suggest that the Samothracian ship, too, was an enemy prize. Accepting the current identification of her as a *diploia,* or swift-sailing bireme, used to carry messages, he remarked: "Nike is winged and so the question naturally arises why should she need the aid of so mundane an object as a boat, however, swift, to bear her to land?" (Newell 1927: 35). More recently, however, Casson has argued that the ship is not a *diploia* but a heavy battleship, one of the quadriremes that formed the backbone of the Rhodian navy at Side, Myonessos, and many other battles (Casson 1971: 102–3; cf. Livy 37.22–4 and 30). The implication of his remarks is clear: that she is one of the victor's ships, not a prize. In fact, prizes were normally towed ignominiously into port, as actually happened at the battle of Side (Livy 37.24.3, 9), for they were usually damaged and waterlogged; in any case, the victors would not have had the extra manpower to row them. For ship and crew to be captured intact was a real rarity.

Demetrios's issue seems to have been unique in its attention to the prizes, for the simple reason that at Salamis their numbers were almost unbelievable: 100 transports, 40 warships with their crews, and 80 that were damaged and waterlogged, so were towed in (Diodoros 20.52). Other celebratory coin issues, like the Macedonian tetradrachms struck two or three generations later by Antigonos Gonatas or Antigonos Doson (Mørkholm 1991: 135, nos. 436–7; Smith 1991: fig. 287) certainly show the victors' ships. The undamaged ship carries Apollo, who holds his bow, and is inscribed *Basileos Antigonou,* "of King Antigonos," on the outrigger. The date and motivation for the issue are both desperately uncertain: Gonatas's victory over the Ptolemaic fleet off Andros, apparently in the 240s, or Doson's Carian campaign of 227 both have their advocates among historians, though most numismatists prefer to attribute them to Doson. These coins might well reproduce an actual dedication, for warships were often dedicated in sanctuaries. Gonatas celebrated his decisive defeat of the Ptolemaic fleet off Kos in 261 by dedicating a ship to Apollo (Athenaios 5.209e), and the ship–monument on Delos known as the Monument of the Bulls has often been linked with Demetrios and Salamis (Bruneau and Ducat 1983: 138–40; Anne Stewart 1984: 113–18; Tréheux 1987). To place a bronze or marble Nike or

Apollo on the deck of a dedication like this would not be a large step to take.

The Nike of Samothrace, then, begins where the coins and their putative models left off: She invokes tradition and adapts it in a highly dramatic and authoritative way. She takes the motif of the victorious return of the fleet, a narrative that must have been repeated a thousand times in Greek history, and develops it thus: A great sea battle has taken place, and we, the citizens, wait anxiously on the shore for news. A ship pulls into view: Is it one of ours or an enemy? Suddenly, Nike alights on the ship, rushes forward, and throws out her arm to greet us with the news: The battle is won![6] All this goes well beyond the late fifth-century Nike of Paionios (Fig. 53), whose wet and windswept drapery alludes to victory at sea but does not make it explicit; she stands on a pillar and is supported by Zeus's eagle, who could be flying over land or sea. By contrast, the sculptor of the Samothracian Nike sets his figure in a carefully crafted environment, replete with props that turn the work into a full-scale narrative that now includes the spectator – for we are the focus of the entire composition.

In adopting this strategy, he involves us in an ongoing scenario, a dramatic recreation of reality, or *mimesis physeos,* as ancient critics of literary narrative would say. By making his extraordinarily vivid and mobile Nike alight on the returning ship, fling out her hand to us, and turn her head to look us in the eye, he literally "sets the scene before our eyes," making it present by representing the situation "as if in a state of actuality." "Since the objects are represented as animate," this in turn "gives life and movement to all, for actuality is movement" (Aristotle, *Rhetoric* 3.10.6, 1410b33; 3.11.2, 1411b24–5; 3.11.3–4, 1412a3–10).

These passages are taken from Aristotle's discussion of the dynamic role of metaphor in invigorating literary narrative – an issue that has attracted much attention in literary circles of late (Richards 1936: 89–138; Black 1962; Ricoeur 1977; Lakoff and Johnson 1980; Johnson 1987: 65–100; and for Greek poetry, Silk 1974). I quote him at this point because, despite the obvious applicability of his observations to the Nike, she presents us with a problem of logic. Although her ship is almost home, and the waters around it (whether represented by the rippled marble slabs found there or by real fountain water as well) are calm, perhaps even frequented by dolphins,[7] she is fighting a veritable hurricane. Critic after critic has commented upon this. "The chiton is thrown against her body by a strong wind and the violent movement. Some parts therefore . . . appear as if nude, while folds waving like

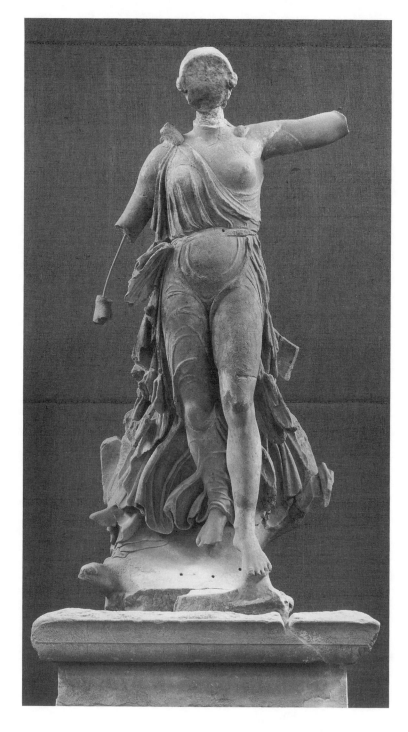

53 Nike by Paionios,
dedicated by the Messenians
and Naupaktians at Olympia.
Olympia Museum. Photo:
Hirmer 561–0636.

foam, with unruly lights and shades, cover the other parts. The rhythm is rather choppy . . . but the effect of stormy movement and gale on the drapery has hardly ever been more gloriously handled" (Bieber 1961: 126). "The sea wind rushes all around her, filling her wings like sails, beating back her cloak, and in a quieter moment, tossing the edges of her overlap" (Havelock 1981: 137). "A flowing panel of cloth . . . flares behind the Nike like a rudder to her airborne flight" (Carpenter 1960: 201). Yet ancient sea battles were not fought in gales, and storm-tossed drapery is definitely not standard among Hellenistic Baroque Nikai: The Nike of the "Great Altar" (Pollitt 1986: fig. 99; Stewart 1990: fig. 694) is a case in point. This peculiarity of the Samothracian Nike, violating both what is and what ought to be, invites explanation.

Is this lapse in realism simply another example of the turbulent bombast of the "fatty" style of Asiatic rhetoric? Some ancient viewers would surely have thought so, and would have promptly moved on. Yet the visitor who stopped to consider it in connection with the gesture of the right hand might perhaps have seen it differently, as a tell-tale sign, or *semeion:* a self-focusing appeal addressed to him as a critical spectator. For the Hellenistic world was much interested both in realism and in signs, in evident but puzzling facts that lead one to other, nonevident facts (Liddell and Scott, s.v. "*semeion,*" with Long 1986: 21–30, 123–31; Long-Sedley 1987: index s.v. "signs"). At this point, the alert reader, or *kritikos,* often looked for an allegorical interpretation (cf. Pfeiffer 1968: 5, 9–11, 69–70, 140, 237–42). A strong explanatory drive was basic to Greek culture, and a problematizing approach and the proposal of solutions in terms of "hidden" generalities was simply instinctual to it.

Another "sign," different in kind, but pointing in the same direction, is presented by the Nike's relation to her context: the Samothracian cult itself. The Great Gods were patrons of seafarers, to be sure, but in a very particular way: They protected them from shipwreck. Initiates could pray to the Dioskouroi, and, if they were lucky, the storm would subside and the sea grow calm. The Argonauts were saved in this way by Orpheus, the lone initiate among the crew, and subsequently put in to Samothrace for mass initiation; numerous others, both mythical and historical, followed their example. The popularity of the cult with Greek sailors is evident from inscriptions (Fraser 1960), and from a variety of literary texts such as the following fragment of New Comedy (Page 1950: no. 61; Lewis 1958: no. 233):

> Storm, gale, rain, mountainous seas,
> Lightning, hail, thunder, seasickness, night!
> And yet every sailor awaits the gleam of Hope

And despairs not of the future. One grabs the ropes
And watches the sail, another prays the Samothracian Gods
To help the steersman, and hauls in the sheets. . . .

These lines could almost be a commentary on the Nike monument itself. Yet this mass of evidence from and about the cult only complicates matters further, for battle dedications are otherwise completely unknown in the Samothracian sanctuary, and its devotees believed that the Dioskouroi, not Nike, piloted ships safely through storms. Indeed, the Nike *cannot* be doing this, for as Fig. 51 demonstrates, she is definitely not pointing with just her index finger, as a pilot would do (cf. Newmann 1965: 17–37, figs. 7–13; Tersini 1987: 145–52, figs. 9–12): She is addressing us, her audience. As the problems multiply, the signs of allegory grow more compelling: The puzzlement that they generate makes us, like the Greek *kritikoi,* sit up and look for answers in a realm other than the obvious.

If the Samothracian monument strongly invites a reading as a "continuous metaphor" or allegory (Cicero, *Orator* 95; Quintilian 8.6.44 and 9.2.46; cf. Hinks 1939: 4; in general, Fletcher 1964), then this allegory is most likely to be the famous literary image of the ship of state. The dedicator would presumably have been one of the many Aegean cities who patronized the sanctuary (see Fraser 1960); one of the Antigonid kings of Macedon (the only major dynasty interested in the cult; so, Smith 1991: 79, suggesting the Koan victory of 261); or the Samothracians themselves – perhaps the most likely possibility, but so far only advocated by Lehmann (1973: 192, n. 14). The occasion remains unknown, and perhaps will always remain so, though peace achieved through victory at sea remains the obvious motive.

In antiquity, the invention of the ship of state metaphor was placed in the sixth century and attributed to Alkaios (fr. 18/A6 Z2 Page); fragments of the poem in question are still extant, but the allegorical reading is disputed. Its presence is indisputable, however, in Aischylos's *Seven Against Thebes,* where its numerous occurrences have inspired a veritable critical industry (Kahlmeyer 1934: 231–4; van Nes 1963; Pöschl 1964: s.v. "Schiff"; Petrounias 1976: 33–51; and on the medieval and later use of the image, Fletcher 1964: 77–80). In these images, not only is the attacking host likened to the pounding breakers that threaten to swamp the ship (63–4, 114–15, 758–61), but these are driven on by the "blasts of Ares" (63–4, 115); terrified citizens are like seamen fleeing "from stern to prow" (208–10), while Eteokles is the stalwart helmsman (652, 1080–4). Because of his self-sacrifice, the ship reaches calm seas, having taken on no water in the storm (795–6,

1080–6), while the chorus mourns him, beating their heads in unison like the rowers of Charon's ferry-boat across the Styx (854–60). After Aischylos (*Agamemnon* 1005; *Supplices* 470; *Eumenides* 553), this image became a *topos,* appearing in Sophokles (Ajax 1081–3; *Antigone* 162, 187), Euripides (*Troades* 102; *Medea* 278; *Herakles* 837, etc. – extending it to encompass the whole voyage of human life), Aristophanes (*Wasps* 29; *Frogs* 361), Anaxandrides (fr. 4), Demosthenes (18. 194), and (most famously of all) in Plato (*Republic* 488a; *Laws* 758a). A long passage in Polybios (6.44) shows that it had not lost lost its vitality in the Hellenistic period, and in Augustan literature it is alleged by Quintilian (8.6.44) to be the point of Horace, *Odes* 1.14 (see esp. Anderson 1966). Interestingly, he uses this very poem to illustrate the concept of allegory as a metaphorical chain.

In his study of the Nike of Samothrace and ship fountains, Lehmann (1973: 207) placed the first appearance of the ship-of-state allegory in late Republican Rome, chiefly (it seems) because he was not aware that it occurred in poetry before Horace, and because his archaeological evidence was restricted to the numerous Roman coin pictures of an oared galley carrying the symbols of Rome – Roma's head, a fortress, the she-wolf, the fig tree of the forum, and so on. Yet not only do the passages cited previously prove that Greek poets had invented it long before, but the image of a company of revellers progressing from storm to calm appears in Greek sympotic verse and related vasepainting as early as the sixth century (Slater 1976; Davies 1978). From Exekias's splendid cup in Munich with Dionysos drinking on his ship to a late fourth-century Campanian bell-krater with a water picnic featuring Silenos and company (Fig. 54), Greek art offers numerous versions of this nautical sympotic metaphor.[8] Since the symposium was regularly considered to be a microcosm of life and a haven from the storms of care that raged outside, this *topos* and that of the ship of state may have been connected. At any rate, these pictures show that Greek artists and their customers were alert to the metaphorical potential of storm and calm centuries before the Nike of Samothrace was commissioned and carved.

Vases offer no certain instances of the ship of state motif itself: Overt political allegory of this kind was not their province. Yet though they may fail us, another sphere of material culture turns out to be unexpectedly helpful. A late fifth-century Attic inscription bears the names of a number of ships in the Athenian navy. Among names like *Aglauros, Alkmene, Leonte, Naukratis,* and *Salpinx* appears [*Eleu*]*theria,* "Freedom" (IG ii² 1604a, on p. 811). By the time of Alexander, names that identified warships with qualities supposedly possessed by the city and citizens that they de-

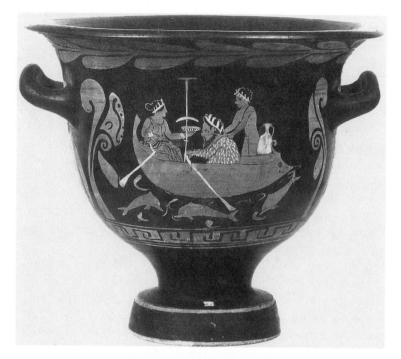

54 Campanian bell-krater
with a symposium at sea.
Melbourne, National Gallery
of Victoria D14/1973. Felton
Bequest, 1973. Photo: A. C.
Cooper 761653, for Christie,
Manson, and Woods, Ltd.

fended were very common (Schmidt 1931; corrected and supplemented by Casson 1971: 348–58). Besides *Eleutheria*, inscriptions give us *Eunomia*, "Law and Order"; *Themis*, "Right"; *Demokratia*, "Democracy" (a particular favorite); *Dikaiosyne*, "Justice"; *Eirene*, "Peace"; *Pronoia*, "Foresight"; and *Sophia*, "Wisdom." Others bore names like *Sosipolis*, "Saving the City," geographical names such as *Sounias, Eleusis, Amphipolis,* and *Delias,* or names of local nymphs and heroes. It is not surprising, then, to find fourth-century coins of Euboian Histiaia bearing a ship's stern with the ivy-crowned head of the city's eponymous nymph on one side and the nymph herself on the other, seated on a ship's stern and holding a *stylis* on which is inscribed **ATHANA** (Newell 1921, 1927: 35; Kraay 1976: 93–4, pl. 15, 280). The reference is to Athens' naval and military operations of 341–338, which freed the city from Macedonian rule; Histiaia is reading the watchword of the fleet that freed her, and so brought her *polis* to calm waters.

With the collapse of Athenian naval power around 320, our evidence for ships' names drops off drastically. Yet *Eleutheria* and *Eunomia* are still found, together with geographical names like *Korkyra* (on a Corfiot ship), and *Nika* herself. Hieron of Syracuse named his great grain carrier-cum-battleship *Syrakousia*, but when he sent it off as a present to Ptolemy III, he renamed it *Alexandria* (Athenaios 5.208f, 209b). Ships were also named after the kings

themselves: We hear of a *Demetrias,* a *Ptolemais,* and an *Antigonis.* This, in turn, might lead one to understand the "of King Antigonos" inscription on his victorious ship (Mørkholm 1991: 135, nos. 436–7; Smith 1991: fig. 287) as indicating not only the king's ownership of the vessel, but also the identification of the fleet's success with the success of king and kingdom alike.

So whoever dedicated the Samothracian monument and why, a reading of it as an example of the ship of state returning victorious to port is historically plausible. Indeed, given that warships had been identified with the virtues and mission of the *polis* for over two centuries before it was carved, it seems most unlikely that it was not meant to be read that way at the time. If the rocks in the Samothracian precinct were a part of the original composition, as Lehmann argues, and not simply debris fallen from the hill above, then they would signally strengthen this reading. Quite gratuitous in a scene of simple homecoming, they had been integral to the ship-of-state allegory ever since Aischylos, who draws a vivid picture of mariners drowning in the tide while the storm dashes their ship to pieces on a rocky headland (*Eumenides* 553–65).

Can this reading be supported by evidence from the Nike herself? Here, we must return to the problem of her drapery. In contemplating the great masses of cloth blown to and fro across her body, the ancient spectator might well have been reminded of the poets' figure of the "blasts of Ares" and the great waves they whip up, all threatening to overwhelm the state. Yet looking at the huge and totally fantastic "rudder" of cloth behind her (Fig. 49), he might also have deduced that the storm of opposition was being safely traversed, a hint that would have been much reinforced by the tranquility of the setting. This motif was not only popular with the poets, as we have seen, but was again specifically evoked in real warships' names such as *Aura,* "Fair Wind"; *Kratousa,* "Conquering"; and *Euploia,* "Bon Voyage."

Such evocative use of textures and surfaces to place a personification in a context had some precedent in classical and Hellenistic art. As Harrison (1982: 62) has remarked, the Nike of Paionios's wet and windswept drapery (Fig. 53) specifically suggests a victory at sea, and in the early third century, the river Eurotas by Eutychides is said to have been "wetter than water" (Pliny, *Natural History* 34.78). Yet only by resolutely abandoning the mundane requirements of simple truth to natural appearance, or (as the critics would have put it) of *aletheia/veritas,* could the Nike's sculptor fully realize the potential inherent in this approach. His massively enhanced techniques of amplification, *auxesis,* now enable him to take up where Paionios had left off. They give him

complete freedom to use style to signify, opening it up to a whole range of metaphorical expression that his late classical predecessors, wedded to beauty and concrete truth (Quintilian 12.10.9), had tended to deny themselves. For as the rhetoricians constantly remind us, *auxesis* is appropriate to *epideixis*, to praise for great deeds.

Aristotle, in particular, is adamant that in epideictic rhetoric, which was soon to dominate all other Hellenistic rhetorical genres (Marrou 1982: 195), amplification is particularly effective in proportional metaphors, and most powerful when kept concrete (Aristotle, *Rhetoric* 1.9.38–40, 1368a10–30; 3.6.7–7.5, 1408a1–28). In the case of the Nike monument, the metaphor may be dissected as follows: As the ship conquers the gale, so does the state conquer the "blasts of Ares." The crucial factor is that the metaphor's "vehicle" (Richards 1936: 96) should be visually concrete, appropriate to the subject, and not "mere noise" – a test that by common consent, the Nike seems to pass with flying colors.[9] And once again the rocks, if intentional, would greatly enhance the effect.

If the Samothracian monument truly alludes to the salvation of the ship of state from the stormy blasts and breakers of war, it would fit snugly into a development of personification and allegory in Greek art that can be traced back to the Shield of Achilles and the Chest of Kypselos (*Iliad* 18.535; Pausanias 5.18.1–2; cf. Hinks 1939: 76–7, 106–23; Webster 1954; Shapiro 1977; Onians 1979: 95–118). On the Shield, Strife, Panic, and Deadly Fate took part in the fighting, and on the Chest, Night was shown mothering Sleep and Death while Justice throttled Injustice. In these cases, the personifications were adjuncts to the narrative scenes, pedantically helping to clarify the figurative potential of the central message for the viewer. They see that s/he gets the point. Archaic and classical vases continue the trend, using these and other personifications to illuminate individual mythological contexts. By the end of the fifth century, the Meidias Painter could depict Aphrodite and Phaon surrounded by all the personified pleasures that she could bestow on him for aiding her in her hour of need: Health, Happiness, Love, Springtime, and even All-Night Partying (Beazley 1963: 1312/2, etc.; see esp. Burn 1987: 32–40, pls. 27–9). Yet none differs in any obvious sense from the others: They are individually distinguishable only by the names painted beside them.

A century later, Lysippos's Kairos, or "Opportunity," was much more sharply characterized, but our lack of a specific context hinders interpretation: Was it Lysippos's artistic testament, was it Alexander's talisman, or was it simply a clever exposition of the proverb "seize time by the forelock?" (Stewart 1990: 187–8, fig. 555; contra, Pollitt 1986: 53–4). The "Calumny" of Apelles,

if really by him and not a fiction of Lucian (the supposed protagonists in the tale lived a century after the painter), put this personification into a firm narrative context, whereas the Tyche of Antioch by Eutychides eschewed narrative altogether, opting for a strong evocation of place (Lucian, *Calumniae non Temere Credendum* 4; Pausanias 6.2.6–7; John Malalas, *Chronographia* 11, p. 276 (ed. Bonn); cf. Onians 1979: 95–9, fig. 101; Pollitt 1986: 3, 55–6, fig. 1; Stewart 1990: 201–2, figs. 626–8; Smith 1991: 76, fig. 91). She sits on Mt. Silpion, while at her feet swims the River Orontes: The two still dominate the topography of the city. Meanwhile, the nautical symposium pictures (Fig. 54) explore the mode's possibilities from the opposite direction, allegorizing specific figures from mythology. In all these cases, the central communication is the allegorical figure(s) or narrative as a whole, which the spectator must now decode in order to get the point. Intellectually demanding and directly involving the viewer in the work of art, this approach seems to have attracted late classical and Hellenistic artists. It also demanded much sharper characterization if the allegory were to be intelligible.

Strong characterization, then, and a firmly established context are the main desiderata of developed Greek allegory. The Nike of Samothrace, if truly allegorical, would satisfy both. As a *continua metaphora,* or allegorical narrative, she would answer the demand that for clarity of exposition the personification itself should reveal an experiential similarity, and collaborate with a specific environment (Hinks 1939: 119; Fletcher 1964: 70–2; Lakoff and Johnson 1980: 154). She would evoke the authority both of a solidly based mimesis of reality and of a general truth (the ship-of-state metaphor) grounded in experience. For her sculptor's expertly managed technique of *auxesis* or amplification simultaneously encourages three complementary but quite distinct illusions: that his Nike is a real *daemon,* a flesh-and-blood creature of irresistible power,[10] that she is battling the "blasts of Ares" as she lands on the prow, and that she is specifically a goddess of the sea, whose crisscrossing waves, "flashing and frolicsome under the sun," are the real gift she brings to the victor from Zeus. Whereas Paionios's Nike was all transparent artifice, this sculptor dissembles his extraordinary *techne* behind a mask of solid corporeality. His figure thus appears to be as concretely real as its base and setting, announcing a victory that is no mere rodomontade, but irreversible, tangible, and lasting.

This effect is achieved for the most part by the authority of the rendering itself, of the sculptor's extraordinary command of marble, and of the vocabulary of illusion. In this respect, his Nike answers to the most fundamental demand of a public monument,

that it should be exciting and accessible to all. Swept away by her declamatory power, we simply have no choice but to take her seriously. Yet for the critical spectator who pauses to ponder, her double appeal has its costs: The antithesis of storm and calm itself presents a visual and logical problem, as I described earlier. Though her sheer bravado masks the inconsistencies to a certain degree, they do not go away. Investigate them, and the puzzle deepens.

On the surface, the Nike answers to the Aristotelian prescription for the perfectly popular rhetorical style: that "one should aim at three things: metaphor, antithesis, and actuality" (Aristotle, *Rhetoric* 3.10.6, 1412b30; 3.11.9, 1412b20). As he remarks a few pages later: "The more concisely and antithetically sayings are expressed, the greater is their popular appeal. The reason is that instruction is more powerful through antithesis, and more rapid through concision. . . . The more special qualities an expression possesses, the smarter it appears, for instance, if the passage contains a metaphor, particularly one of a special kind, antithesis, balance, and actuality" (*Rhetoric* 3.11.10, 1412b21–30). At first sight, the Nike seems to meet these demands directly and cogently. The metaphors she evokes are powerful, diverse, and venerable: "Victory is beautiful," "Victory is hard," "Victory is salvation," "Life is a journey," "Life is a battle," "Life is a storm of ills," and so on (cf. Lakoff and Johnson 1980). All can be read into her with ease, and all have ample precedent in Greek writing and thought.

Through the concision of his address, the sheer quality of his carving, and his sensitivity to the metaphorical potential of the Baroque, the sculptor both convinces us of the cosmic power of the being he represents and the forces she battles, and anticipates the objection that the victory she brings is impermanent or unimportant. Indeed, his synoptic treatment of the antithesis of storm and calm even creates the effect of narrative time. He thus seems to outflank the Aristotelian critique of visual narrative and to confound the philosopher's privileging of verbal narrative and dramatic poetry over art: Artistic *mimesis* can now proceed in time, so "philosophic" achievement is no longer ruled out.[11]

Yet the price is high: The more metaphorical and "philosophic" one gets, the more the antithesis sharpens, but the more the authority of the rendering, of this splendid evocation of nature's energy, is undercut. The deeper one probes, the more the abstraction takes hold; the more one deconstructs the rendering, the more one's sense of the monument's concrete actuality weakens. Here is the paradox: Out of context, at the head of the grand staircase in the Louvre, the rhetoric is direct and compelling; in context, at the sanctuary of the Great Gods on Samothrace, it

suspends us teasingly between two worlds, irreconcilable and for-ever in tension. Sculptural *mimesis,* credible narrative, rhetorical amplification, and metaphorical allusion may indeed be incompatible in some fundamental way (cf. Fletcher 1964: 147–50).

ALLUSION AND INNOVATION IN THE GIGANTOMACHY
OF THE "GREAT ALTAR"

As remarked before, critics of the baroque regularly describe the Gigantomachy of the "Great Altar" (Figs. 55–57, 61) as the apotheosis of "mere noise," a kind of sculptural ancestor to Haydn's "Representation of Chaos" at the beginning of his oratorio "The Creation." Yet even Haydn's overture is by no means completely formless, and others have responded by claiming that the Gigantomachy's extensive borrowing and reworking of classical motifs and types are a Pergamene attempt to meet this charge, to invest this otherwise "formless" and "chaotic" monument with borrowed authority (Carpenter 1960: 199). Pfanner (1979) has even alleged a complex system of underlying symmetries between the friezes: groups on the North side echoing those on the South, and so on. Correspondences of this kind would appeal to Hellenistic viewers as confirmation that a divine rationale or *logos* underlies even the most chaotic of events, reinforcing the generally allegorical thrust of the conflict. Some, going further, have situated the "Altar" in the context of an overall Pergamene cultural strategy of setting up their city as a bastion of civilization against chaos and barbarism, as the "Athens of the East" and a rival to the pretensions of Ptolemaic Alexandria (e.g., Pollitt 1986: 81–2, 105).

Yet the most extended attempt to establish the authority of the frieze takes quite another route. Simon (1975) has tried to demonstrate not merely that the Gigantomachy was entirely based upon the genealogies presented in Hesiod's *Theogony,* but that the frieze is shot through with the Stoic creed of the philosopher Krates of Mallos. Krates, a Stoic fellow-traveller and literary critic, was certainly resident at Pergamon in the reign of the "Altar's" dedicant, Eumenes II (197–159), and may have been head of the king's library (cf. Hansen 1971: 409–18), which makes him an obvious candidate for the "Altar's" design consultant.

Simon argues for her Stoic reading as follows (1975: 56–9):

1. Though their works are lost, the Stoics Kleanthes and Krates both wrote upon themes that are germane to the frieze: Kleanthes on both gods and giants, Krates on Hesiod. Like their writings, and like the contemporary panels on the tem-

ple to Eumenes' mother Apollonis at Kyzikos (known from a series of Hellenistic epigrams: *Anth. Pal.* 3; Brilliant 1984: 35–7; von Hesberg 1988: 362–3), the frieze is allegorical and didactic.

2. Krates made a globe to illustrate his theories, which are described by Strabo (reconstruction, Fig. 60). The organization of the frieze in four parts, with Eos, goddess of the dawn, on the South and Nyx, goddess of Night, on the North, echoes what we know of his geography.

3. In the Stoic Kleanthes' *Hymn to Zeus,* written about two generations earlier, Zeus is the omnipresent prince of rational order who punishes lawlessness through his thunderbolt. On the frieze, he is presented in just this manner: His arsenal of thunderbolts is formidable, and his eagle also appears on the East frieze, the South frieze, and (twice) on the West frieze, to either side of the steps. Only on the North is it absent: This is Hades, so not his realm.

4. The frieze has the Titans fight on the side of the Olympians. Although it is true that Stoic doctrine tended to conflate the

55 Frieze of the Great Altar of Pergamon: Artemis' opponent. Berlin, Pergamonmuseum. Photo: A. F. Stewart.

56 Frieze of the Great Altar of Pergamon: Sea-horse from Poseidon's chariot. Berlin, Pergamonmuseum. Photo: A. F. Stewart.

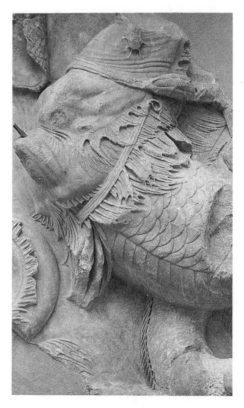

154

two (Krates allegorized Zeus as Ouranos and also as Helios), and the frieze does not, it is entirely in the spirit of Stoicism to mobilize the Titans in defence of cosmic order.

5. The giants of the frieze are physically abnormal. Deformed, bestial, and uncontrolled, they replicate the Stoic insistence that passion is a deforming disease.

6. Several aged demigods fight on the side of the Olympians: The Stoics took a positive view of old age.

7. Would the Baroque be anathema to Stoics, who preferred a plain, unadorned style of presentation? Not necessarily: The Stoics Krates, Apollodoros, and Panaitios show a greater flexibility in such matters.

Simon's reviewers attacked some of her identifications, implicitly and sometimes explicitly casting doubt upon her Hesiodic thesis (Wenning 1979). The most serious challenge was mounted by Pfanner (1979). Identifying the object at the end of the pigtail of "Nyx" as a pomegranate, he argued that she must be Persephone. He also proposed that the main compositional principle was

57 Frieze of the Great Altar of Pergamon: Apollo and opponent. Berlin, Pergamonmuseum. Photo: Pergamonmuseum PM 208.

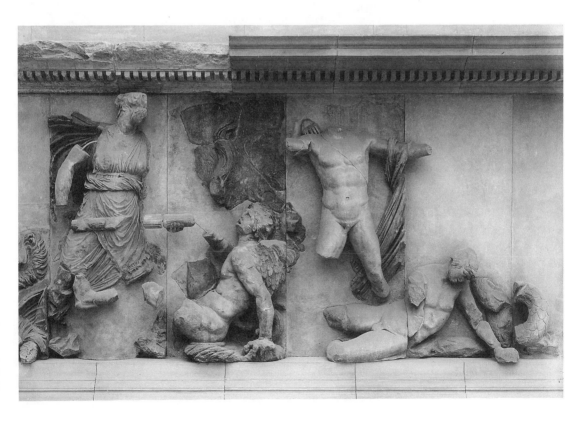

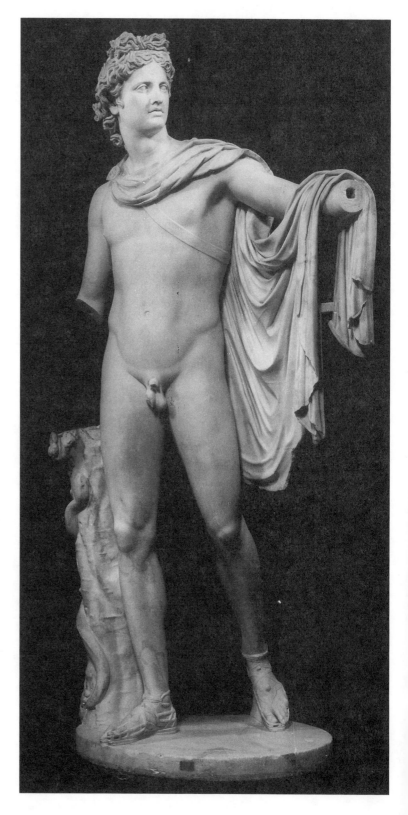

58 Belvedere Apollo.
Vatican Museums. Photo:
Musei Vaticani xxxiv–32–75.

geographic, not genealogical: the Olympians on the East, gods of
Day and Night on the South, Asian and marine divinities on the
West, and chthonic and Underworld divinities on the North.
Though he makes no mention of Krates or Stoicism, this reo-
rientation of the frieze would potentially do some violence to
Simon's conclusions.

In fact, the geography of the frieze is less straightforward than
either Simon or Pfanner allow. The identification of "Nyx" as
Persephone is by no means secure, and indeed, the designer's ob-
vious desire to keep close relatives together might lead us to ex-
pect her not on the North frieze but on the East, next to her
mother Demeter, whose position in the gap between Apollo and
Hera is secured by the discovery of an inscription naming her
opponent, Erysichthon, on this side (Fränkel 1890: no. 114; omit-
ted in Pollitt 1986: 96, fig. 98). All this, in turn, thrusts the in-
terpretation of the North side back into the realm of conjecture.
As to the other sides, whereas the sun, moon, and stars (South
frieze) face their actual locations in the southern sky, the Olym-
pians (East frieze) and the gods of Asia (West frieze) have their
backs to their respective homes. Here the spectator is presumably
expected to provide the link, as s/he faces the friezes and looks
beyond them to the regions in question. As for the gods of the
sea, their presence on the North–West, a location unrelated to
any but the Black Sea, would be compatible with the conventional
view of a world girdled by the stream of Ocean, but so would
any other position on the "Altar." Yet Krates's geography was not
conventional: His globe was not ringed by Ocean in the normal
way, but divided into four quadrants by it (Fig. 60), and Asia,
Europe, and the Ethiopians occupied but one of these. The "or-
der" of the frieze, then, is aesthetic, not scientific: It neither rep-
licates reality nor any known theoretical scheme, Krates's
included.

Furthermore, some of Simon's assumptions about Krates, Sto-
icism, and the Baroque style do not stand up to scrutiny either.
For Krates was not an orthodox Stoic at all, but a grammarian
with Stoic leanings, and what little we know about his views on
stylistics and theology does not bode well for a positive attitude
to the frieze. For though the Stoics indeed cared little or nothing
for style, regarding rhetoric as totally subordinate to dialectic
(Dionysios of Halikarnassos, *de Comp.* p. 21.6–22.13 Us; Atherton
1989; Porter 1989: 150, n. 8), he wrote a book on Atticism, and
extolled euphony and beauty as supreme poetic virtues (cf. Porter
1989). One imagines that if he thought about art at all, he would
have preferred Classicism to the Baroque. His theology was more
orthodox, but equally unpromising. For because he agreed with

the Stoics that the gods were natural forces, one presumes that he also shared their opinion that traditional Greek anthropomorphism – in art as in literature – was absurd.

If the standard tests of the legitimacy of an interpretation are external decorum, internal decorum, and parsimony (Baxandall 1985: 120), then Simon's seems to fail on at least two of these counts. Though what little we know of Hellenistic planning suggests that it is historically legitimate to propose Krates's Stoic and Hesiodic studies as informing the Gigantomachy's program, the Stoic part of her proposal seems both at variance with what we now understand of the frieze's composition, and redundant in that the number of qualifications necessary to make it work now hinder, rather than promote, our understanding of the monument. Hesiod's genealogies fit better, but perhaps only because many of them had long since become entrenched in the literary tradition. If one must hunt for sources, the old suggestion that the frieze may draw on a lost epic poem seems as good a solution as any: Kleanthes's *On Giants,* written in the later third century, is a prime candidate (Pollitt 1986: 109; Stewart 1990: 212; cf. Smith 1991: 164).

Yet all is not yet lost: Stoicism and Krates may be waning rapidly as the moving forces behind the frieze, but a Stoic audience might still have found much food for thought in it. For Stoics had long been accustomed to finding authentic "fossils" of ancient wisdom in what they regarded as the fictional perversions of Homer and Hesiod, even in works of art (Pfeiffer 1968: 237–8; Long 1992). Chrysippos (ca. 280–206) even went so far as to allegorize a picture of Hera fellating Zeus (Diogenes Laertios 7.187, etc.; von Arnim 1903–5: nos. 1071–4)! So a Stoic *kritikos* could have seen the thunderbolts on the East frieze and in the claws of the eagle on the South frieze as a reference to the *ekpyrosis* or cylical torching of the earth by Zeus, and the eagles themselves as signs of his universal power.[12] The open mouths, distended chests, extreme muscle tension, and prominent veins of the figures would neatly confirm his belief that a *tonos* ("tension") of *pneuma* ("breath") pulses through the veins of all living things. The omnipresent eagles, the stoically determined expressions of the gods, the deforming passion of the giants, and the numerous aged allies of the Olympians (including the Graiai themselves) would not have escaped his notice either. And, finally, the logic of the various groupings would certainly have appealed to him as confirmation that a divine rationale or *logos* guides even the most seemingly chaotic of events (Long 1986: 144–9, 155–8, 168; Long and Sedley 1987: nos. 46, 47). Indeed, not the least interesting aspect of the frieze is that it literally deploys its own *logos* in the

form of inscriptions: the names of the gods on the epistyle above, those of the giants on the socle of the monument, and the sculptors own signatures directly below them (Fig. 61).

Though Greek vase painting and frescoes regularly employed both clarifying inscriptions and signatures, they are extremely rare in Greek architectural sculpture. The sixth-century Sikyonian and Siphnian friezes at Delphi used inscriptions both on the background of the relief and on its base molding, and the fourth-century temple of Athena Alea at Tegea included names on the architrave below the porch and pronaos metopes; in addition, the sculptor of the North and East friezes of the Siphnian Treasury signed his name on the shield of one of the giants (Dugas, Berchmans, Clemmensen 1924: 35, pls. 58E, 88A; Stewart 1977: 57; Stewart 1990: figs. 78, 194). Painted labels may have been more common, but the programmatic nature of the Pergamene inscriptions is essentially unprecedented in the genre. Here, they serve as signs (*semeia*) that replicate the representational content of the monument, and signal the choral nature of the undertaking. Calling attention to the frieze's content, dualistic structure, and authorship, they invite us to consider it in these terms.

First, the two opposed sets of names signal that the gods are "up," the giants "down" – a spatial metaphor that is fundamental

59 Copy of a Dying Celtic Trumpeter attributed to Epigonos of Pergamon. Rome, Capitoline Museum. Photo: A. F. Stewart.

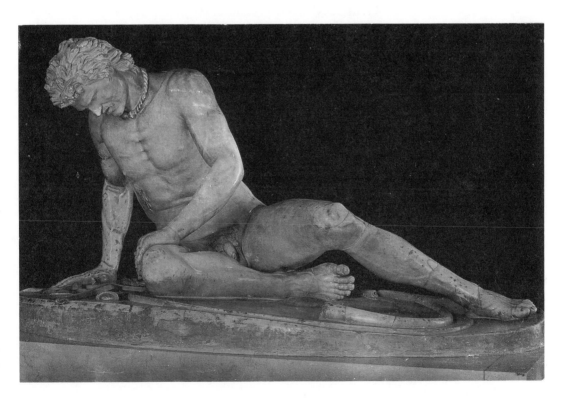

to human experience (Lakoff and Johnson 1980: 14–21), and is neatly encapsulated in the Greek word for what the giants are suffering: "downturn" or *katastrophe* – ruin, subjugation, and death (Figs. 55 and 57). For not only do they have to struggle "up" to Olympos, but the snake legs of many of them automatically ensure that the gods tower over them, giving their divine opponents the upper hand from the start; not surprisingly, then, most of the giants are already going down to defeat – the outcome is a foregone conclusion. This suggestive confrontation of inscriptions and images inevitably calls other, equally deep-rooted metaphors to mind: virtue/good (*arete*) is up, vice/badness (*kakia*) is down; reason (*logos*) is up, emotion (*pathos*) is down; order (*nomos*) is up, chaos (*chaos*) is down; beauty (*kallos*) is up, ugliness (*aischria*) is down; and so on (cf. e.g., *Iliad* 2.211–77; Hesiod, *Erga* 289–335; Simonides fr. 579 Page; Aristotle, *E.N.* 4.2–3, 1122a18–1125a35; etc.).

As to the signatures, their unprecedented stress on the maker's share, complete with the use of the assertive aorist form of the verb *epoese/epoesan* (Pliny, *N.H.* praef. 26–7; Donderer 1988: 65), suggests a marked degree of originality: To a Hellenistic Greek, they would enunciate the sculptors' role as *efficient causes* in the Gigantomachy's creation, and ask that he consider material, formal, and final causes too (Aristotle, *Physics* 2.3, 194b16–195b30). This frieze is no longer "the anonymous product of an impersonal craft," to quote Rhys Carpenter's famous dictum about Greek sculpture in general (1960: v), but is a most articulate and personalized enterprise.

A sculptor's relation to his materials is by no means straightforward. The posture of the romantic artist, locked in tragic combat with his materials, was foreign to the Greeks, as was the modern concept of "truth to materials." Instead, the Greeks considered their materials as resources to create illusions. *Ars est celare artem:* the ideal was the "cunning" of the Homeric artisan who makes his work so lifelike that it can no longer be told apart from the real thing. Both Paionios's Nike and the Nike of Samothrace (Figs. 48 and 53) dissemble their virtuoso technique behind a finish so perfect that one forgets that they were made by men using tools on a material that is little suited to such daring flights of fancy.

Yet on the Gigantomachy, tool marks are ever present, acting both as signs of the tools that made them and as "notional" representations of texture (Figs. 55 and 56; cf. Wollheim 1987: 17–25; Alpers 1988: 14–33). The address is a double one, a teasing duality of realistic illusion and manifest artifice, of nature and representation. As a barrage of hair, fur, hide, scales, feathers, cloth,

leather, seaweed, and even fire assaults the senses, the spectator is greeted with unprecedented tactile stimulation from the marks of chisels, drills, rasps, and abrasives in endlessly varied combination. The drill is king of them all: Whether cutting teeth or shredding hair, burrowing under folds or creasing flesh, its channels are normally left conspicuously raw. But as insistently as these sculptors innovate in technique, the ethnics and patronymics studiously appended to their signatures locate them firmly within the sculptural traditions of family and polis, and the strictly uniform placement and syntax of the inscriptions places the credit with the team as much as with the individual. And the more insistently they thematize their virtuoso relationship with their tools and materials, the more they problematize the mimetic truth of their work.

It is certainly tempting to see all this as a kind of ironic running commentary upon representation as such, an assertion that even as the *techne* of sculptural *mimesis* attains its ultimate goals, so do appearances become infinitely deceiving. Many ancient philosophers would have agreed – but perhaps this explanation is too modern, even postmodern. It is certainly insufficiently appreciative of another "cause" of the monument: its purpose or "final" cause. But first to the workshop's handling of form.

The sculptors of the Gigantomachy are as innovative formally as they are daring technically. As with the Nike of Samothrace, it is instructive to analyze this aspect of their work in terms of the rhetoric of the image, an area where ancient notions of innovation are well understood (Cairns 1972: 98–126).[13] Comparing it with rhetorical (especially epideictic) practice, and considering its compositional units as equivalent to the *topoi* of rhetoricians and poets, one finds that these sculptors innovate both in style and in most of the available iconographical categories too.

First, they introduce elements and notions not hitherto associated with the genre. From the Titans to the Graiai – though probably not Alexander the Great (Radt 1981) – a host of new actors occupies the stage, and the battle even extends to the Ocean (Fig. 56) and the Underworld. Zeus's omnipresence, too, is a novelty, as is the mixture of hybrid and humanoid giants. Second, they present an artful combination of both new and traditional motifs. As we have seen, characters are carefully juxtaposed in order to emphasize genealogies and functions, and larger groupings are often arranged topographically. Third, and most obviously, they modify standard stylistic formulas and standard iconographies in a myriad of ways. Indeed, if the first two categories are largely the work of the monument's planner, then this one, above all, is what the spectator would most naturally connect with the individual signatures below each segment. The two are

mutually reinforcing: The signature is an index of originality in the form, and the form is an icon that validates the message of the signature.

This skillful mixture of innovation and allusion is the frieze's most salient and most problematic feature, for although it initially accounts for much of the Gigantomachy's extraordinary fascination, it also tends to freeze the narrative as the spectator turns to pursue each borrowing to its source. These sculptors innovate stylistically by vigorously and inventively reworking the classic formulas for postures, drapery, anatomy, and physiognomy, producing an effect of unceasing motion and pulsating life, and continually stimulating the eye by stark contrasts of texture. The drapery in particular constantly cites classical authority, quoting liberally from fifth- and fourth-century precedents. Its segmentation into individual rhythmical units strongly recalls the rhythmical, individually cadenced cola of the "choppy" style of Asiatic rhetoric (Cicero, *Orator* 230–1; cf. Falkener 1946: 36–42), and has attracted much the same censure from critics.

Yet as in the Nike, these turbulent cross-rhythms are not merely gratuitous bombast, but have a specifically narrative and metaphorical function. They act out the drama of the event, the elemental violence of the conflict. The sculptor uses them to enhance both the chaotic features of the giants, and the poised movements and concentrated, self-possessed faces of the gods. These *antitheses,* derived from the theme itself and made explicit in the clarifying inscriptions (gods above, giants below), once again serve as a mode of *auxesis,* emphasizing the *aretai* of the gods by pointing up the *kakia* of the giants (cf. [Aristotle,] *Rhetorica ad Alexandrum* 3, 1426a32).[14] Another important mode of *auxesis* is *deinosis* or exaggeration of the terrible ("Longinus," *On the Sublime* 11–12, with Quintilian 6. 2. 24), in this case by means of aggressively realistic details such as distorted facial expressions, pulsing veins, even armpit hair (Fig. 55). These sculptors enthusiastically embrace all the attention-getting devices known to Hellenistic painting and sculpture in order to emphasize the horror and quasi-Manichaean dualism of the conflict. Iconographic innovation includes double and triple hybrids among the giants; unexpected motifs, startling twists, and dramatic antitheses in the narrative; and the adaptation of familiar types and groups from other monuments and genres.

The hybrids – *deinosis* personified – are everywhere, though to point up their insane polymorphy, several of the giants are completely human and composed of feature. Given the thrust of the frieze as a whole, it is suggestive that these wear armor that would have been standard equipment in the armies of Pergamon's Greek

rivals, and startling that one has a shield embellished with the Macedonian starburst (Winnefeld 1910: pls. 5, 8, 10, 15, 17, 28; Kähler 1948: pls. 6, 7, 14, 30, 34, 36; Simon 1975: pls. 7, 16, 19, 24; Smith 1991, figs. 195, 196.4).[15] As for other unexpected twists or *peripeteiai* in the narrative, we are surprised to see Ge supplicate Athena directly, instead of trying to hold on to her progeny; shocked to find a giant with a conspicuously broken neck; and amazed to come across one or two gods who seem to be losing (Winnefeld 1910: pls. 12, 15; Simon 1975: pls. 9 and 15, also text Fig. 3; Meyer 1983: 66–72; Pollitt 1986: figs. 100, 109; Stewart 1990: fig. 695; with Haynes 1972). Finally, by way of *antithesis,* draped figures usually fight nude ones, humanoid giants are attacked either by hybrid gods or by their animal companions, old age and youth are starkly juxtaposed, and so on.

Iconographic allusions are manifold and varied. Besides the giant with the Macedonian shield, the frieze may target other enemies of Pergamon as well. "Nyx" wields a pot with a snake around it against a humanoid giant wearing a Macedonian helmet – a motif that some see as a reference to the use of snake-filled jars as a secret weapon in a sea battle with the Bithynian fleet in 183 (Hansen 1971: 99, n. 90; Kunze 1990: 137; cf. Winnefeld 1910: pl. 17; Kähler 1948: pls. 15, 26; Simon 1975: pl. 17; Stewart 1990: fig. 704; Smith 1991: fig. 196.5; Nepos, *Hannibal* 10–11; Justin 32. 4. 2–8).[16] If so, it would announce that the tables were now decisively turned, for in the battle it was the Bithynians, led by the ever-resourceful Hannibal, that used the jars against the Pergamenes, routing them in panic. And finally, the repeated stress on family solidarity (Apollo, Leto, and Artemis; Hera, Herakles, and Zeus; Nereus, Doris, and Okeanos; and so on) may be intended to evoke the almost legendary closeness of Eumenes and his three brothers (Schmidt 1990: 153–4), not to mention their mother Apollonis, who was explicitly named in the "Altar's" dedicatory inscription (Fränkel 1890: no. 69; Smith 1991: fig. 194). Famous sculptures are quoted too. The very particular twist that they put on the narrative is particularly clear in the case of the Apollo group (Fig. 57) and Hera–Zeus–Athena groups of the east frieze.

The Apollo quotes the late fourth-century Apollo Belvedere, and his opponent is a version of the Dying Celtic Trumpeter (Figs. 58 and 59).[17] One version of the Belvedere type stood at Synaus in Phrygia, a Pergamene possession from 188 (Deubner 1979: 231, fig. 5), and the Trumpeter, attributed on Pliny's authority (*N.H.* 34. 88) to Epigonos of Pergamon, must be taken from a late third-century Pergamene victory monument. As *alexikakos* (averter of evil) and *Pythios,* Lord of Delphi (Deubner 1979: 231–5; Hedrick

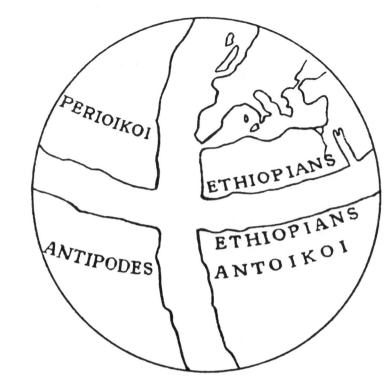

60 Reconstruction of
Krates of Mallos's terrestrial
globe. After Dilke (1985, 36–
7, Fig. 5.

61 Selection of
inscriptions from the
Great Altar. Berlin,
Pergamonmuseum. From
Fränkel (1890, no. 70).

164

1988: 185–210), Apollo mimics his role in repelling the Celts from Delphi in 279, and his dying opponent points us in the direction of that most decisive of all Pergamene victories over the Celts, at the sources of the river Kaikos in or around 237 (Allen 1983: 198). This battle, often dubbed the Pergamene Marathon, was commemorated by several monuments on the Akropolis of Pergamon itself (one of which was copied in the Trumpeter), and by another set of sculptures dedicated on the Athenian Akropolis (Pausanias 1. 25. 2; Plutarch, *Antony* 60. 2). Though the date is in dispute, there are strong reasons to date it to the year 200, and to ascribe it to the Pergamene king Attalos I (so Pollitt 1986: 90–5, figs. 89–94; Stewart 1990: 210, figs. 685–91; Smith 1991: 102–4, figs. 123–32). Visiting the city in that year, he offered the Athenians an alliance against the brutal and vengeful Philip V of Macedon, and the Athenians accepted it with joy and relief. The group included Persians, Amazons, and Giants for good measure, implying that Philip and his army were little better than barbarians. One of the dying Celts attributed to it is the mirror image of the Trumpeter, and a prime candidate to be the immediate model for Apollo's opponent.

Meanwhile, the quartet of Hera, Herakles, Zeus, and Athena quotes liberally from the Parthenon, Athens' supreme votive offering for the defeat of the Persian barbarian (Demosthenes 22. 13 and 76). The Gigantomachy of the east metopes is the main source, accounting for details as the actions and relative positions of Zeus and Hera, the flying Nike behind Athena's back, and so on, though the explosive, V-shaped composition of Zeus and Athena is lifted from the temple's west pediment (Brommer 1979: figs. 9–10, 23; Stewart 1990: figs. 345–55). There, Athena conjured the olive tree out of the ground in the famous contest with Poseidon; here, she tears the giant Alkyoneus, Earth's wayward son, from the earth itself.

The critical spectator's response to the narrative is channelled by these allusions, which tend to disrupt the progress of the story and to divert one into abstract reflection upon its meaning. Of course, evocation of this kind is also to be found in both classical and early Hellenistic art (Stewart 1990: 93, 166, 193). Yet never before, as far as we can tell, had it been so all-pervasively and programmatically deployed. By turning the Gigantomachy into a kind of thesaurus of masterpieces of Greek art, of *endoxoi eikones* or *nobilia opera* as the Roman critics were later to call them (cf. Pollitt 1974: 167–9, 406–9), citations of this kind make it a vehicle for a particular conception of history, for the Attalid monarchy's resurrection and appropriation of the mythical and historical past, and for a bundle of abstract ideas about the eternal struggle be-

tween civilization and barbarism, between order and chaos. Nostalgia for a vanished era, for the glories of classical art and of Periklean Athens; pride in Pergamon's own military, political, and cultural achievements; concern to project an overarching moral message; and anxiety at the increasing power of Rome and the limitations that this power placed upon Greek freedom of action – these are the subtexts that a reading of this kind reveals.

Of course, not one of these issues was unproblematic at the time, and the very stridency of the Gigantomachy's rhetoric may register this. Pergamon herself had no past. Founded only in the third century and lacking a mother city, her links with Old Greece were tenuous at best. Their fragility is clear from the myth of Telephos that embellished the Altar's interior: Born at Tegea, and cast up on the shores of Mysia only by happenstance, Telephos was notable only for his battle with Achilles and the Greek army, who had mistaken the country for Troy, and for the festering wound that he suffered in consequence. This is hardly the stuff of which strong cultural bonds are forged. And as for the city's pretensions to be a second Athens, everyone knew that here the prize went to Alexandria. Alexandria, not Pergamon, had the Library and the Mouseion; Alexandria, not Pergamon, hosted the greatest scholars and poets in the Greek world. Alexandria, in short, was the Queen of the Mediterranean, and nothing the Pergamenes might say, do, or build could change this.

Finally, Pergamon's military history is particularly revealing of the monument's unease. She was never more than a second-rank power, and was continually forced to hire mercenaries on a very large scale to maintain her position. Furthermore, apart from her victory over the Celts on the river Kaikos and her defeat of their great revolt of 168–166, her successes were achieved largely in alliance with Rome. The Romans were not Greeks by race and did not speak Greek: They were therefore to be classified as *barbaroi,* barbarians – and by the second century, the Gigantomachy had a long and distinguished history, at Pergamon as elsewhere, as a paradigm for the defeat of invading barbarians (cf. Stewart 1990: 47).

Yet on the "Altar," the terms of the equation are reversed, for Pergamon and Rome had been allies since first the two nations met, and the armor of those giants that carry it is Greek (Macedonian), not "barbarian." Indeed Eumenes and Attalos before him had been spectacularly successful in securing Roman intervention against the Macedonians and Syrians in 200, 192, and 172, and profited hugely thereby. Between 188 and 172, however, the same maneuver failed more or less dismally when repeated against Macedon, and in 168 failed against the Celts as well: The Romans

were not to be relied on. Indeed, Roman capriciousness in peace and brutality in war had alternately puzzled and shocked the Greek world since their first appearance in Greece in 229. The sword of Rome was two-edged, and to embrace the Romans certainly meant siding with barbarian against Greek, could mean the unleashing of a terrible fate upon one's fellow Greeks, and might lead to unexpected consequences for oneself. If the "Altar" is really to be dated after the decisive defeats of the Macedonians in 168 and of the Celts in 166, as some now believe (Callaghan 1981; Kunze 1990; Schmidt 1990), it is no wonder that the Gigantomachy is so fraught with tension. For the first of these victories was achieved on the coattails of Rome; the second in the face of her total indifference. The mainland Greeks were not unaware of this situation, and responded accordingly: As Polybios sagely remarked (31. 6), their esteem for Eumenes increased as the Romans' distance from him grew.

In this tense situation, then, the Gigantomachy's stylistic and iconographic allusions attempt to establish a pedigree for it and the culture that created it, to narrate Pergamon's history and achievements as the culmination of those of the Greeks as a whole. Simultaneously, they overtly anticipate the inevitable charges of "mere noise," of lack of authority for the narrative's utterances. These turn upon the various modes of *auxesis* (amplification), by means of which these sculptors both strive to outdo all their predecessors: *makrologia* (extended treatment), *antithesis, deinosis* (exaggeration of the terrible), and dramatic *peripeteiai* (reversals of fortune) that generate *pathos* and *ekplexis* (surprise). Yet, once the spectator has recognized and appreciated these innovations, the allusions (like the patronymics and ethnics of the signatures) inevitably pull him back to the past. In this heightened atmosphere, tradition and originality, narration and allusion, myth and history, allegory and reality are in continual and unresolved tension, and the pendulum of interpretation swings unceasingly between them. What, one may ask, was the purpose of it all?

The belief that every action had an end (*telos*) and was somehow determined by that end was deeply rooted in Greek thought. "Look to the end," Solon's famous injunction to Croesus, echoed undiminished down the centuries. Aristotle's "final cause," then, was far more in tune with everyday Greek thought than the Stoics' (and others') attempts to downgrade it. In terms of the present subject, though the monument's basic function (an altar for the Olympians or a heroon for Telephos?) remains clouded, the immediate purpose of the Gigantomachy is clear: To praise the *arete* of the gods. Yet it also glorifies the Attalid regime and locates its achievements within the age-old struggle of civilization and bar-

barism: The two functions, overt and implied, are complementary. An inscription once again makes the link between them explicit: Though mutilated, there is just enough left of the dedication on the epistyle to show that it included the word "queen" in the genitive, and the words "for good things befallen [us]" (Fränkel 1890: no. 69; Smith 1991: fig. 194). It therefore must have included the king's full title, and read more or less as follows: "King Eumenes, son of King Attalos and Queen Apollonis, [for . . . and?] for good things befallen [us dedicated this monument] to. . . . " It is at this level of explanation, in terms of purpose, that these sculptors' thematization of the strategy of allusion-plus-innovation in *techne* and form converge. It will be convenient to discuss these political and religious functions of the narrative in this order, exactly as they occurred in the dedication.

Together, the signatures and allusions signify the universality of the Pergamene reach, and the city's cultural status as magnet for talent like Athens. In this regard, it is significant that each sculptor signs his work in exactly the same place on the base molding, and employs a standardized word order, syntax, and script (Fig. 61). These inscriptions, in other words, are more like labels than true signatures. Furthermore, regardless of where the carvers came from, they uniformly employ the Attic dialect form for the word "made" (*epoesen* for *epoiesen*), and they take their most important borrowings from Attic sculpture. Their *techne* is a common one: Style and technique alike are homogenized to a degree that recognizing individual hands among the surviving slabs is most difficult. The implication of all this is clear: The individual sculptor is only important *insofar as he belongs to the team*. It makes explicit the situation that obtained on the "Altar's" model, the Parthenon, which like the rest of the Periklean building program was also a magnet for sculptural talent from all over the Aegean.

Yet neither Perikles nor his team left their names on his buildings, and the Periklean sculptors' skill is concealed by carefully removing all tool marks from visible surfaces. Eumenes, on the other hand, loudly proclaims both the panhellenic nature of his team, and the homogenization of its individual and local *technai* into a specifically Pergamene one, all for the greater glory of his city and its dynasty. Paradoxically, then, in the final analysis, the signatures celebrate neither the individual sculptor's triumph nor that of the team as a whole, but the king's in creating this "Athens of the East," while they simultaneously anticipate the charge that the Gigantomachy they grace is "mere noise," empty bombast with no authority to back it.

As to religion, the inscription on the "Altar's" epistyle and the cult performed regularly within its precinct explicitly offered this

entire achievement to the gods, classically authoritative images of
whom were openly incorporated into the frieze (Figs. 57 and 58).
This strategy openly builds upon Attalos I's practice of taking cult
and votive statues from the cities he had conquered and rededi-
cating them in the sanctuary of Athena Polias Nikephoros, located
on the terrace immediately above the "Altar" (Fränkel 1890: nos.
136–44; cf. Hansen 1971: 316–18). By the early second century,
statues by the great Myron and Praxiteles were displayed there, as
well as ones by lesser masters like Xenokrates of Athens. One
would like to think that some of these figures were actually quoted
in the Gigantomachy, but because all of them are lost, we will
never know.

Yet although the Olympians' favor would have been all too
evident in the "good things" (past and present) that one saw all
around – these dedications included – the extraordinary volatility
of the international scene meant that this happy situation could
change at any moment. As king Perseus of Macedon had reflected
after his defeat and capture at Pydna in 168, lady luck now ruled
the world, and owed no one a quiet life (Polybios 29. 21. 3–6).
So the "Altar" not only celebrated current success, but also ex-
pressed the fervent hope that the gods would continue to smile,
and that the city's current good luck would hold. How sensitive
were its sculptors to this all-important but notoriously unpredict-
able final cause? All that remains to speak for them is the Gigan-
tomachy itself, whose restless turmoil and clangorous stridency
eloquently betray their unease.

CONCLUSION: ALLUSION, NARRATION, HYBRID STYLES,
AND THE BAROQUE AS OPEN DISCOURSE

It will be evident that the Hellenistic Baroque's recourse to met-
aphor and allusion as both preemptive and propagandistic devices
not only accounts for much of its power and interest as a narrative
style, but also for much of its ambivalence. Viewed in these terms,
the Baroque style of the Nike and the Gigantomachy is not merely
an utterance, but a provocation. Whether "fatty" or "choppy," it
provokes us to reflect and comment, holding in readiness a
second-order, factitious, or intrusive authority that is revealed and
acknowledged only after dialogue with the spectator has begun.
This strategy embraces and unites what we conventionally divide
into iconography and style: It suffuses the presentation through
and through. Both of the monuments considered here make use
of traditional subject matter, but invigorate it in a very particular
way: the Nike with a sophisticated blend of visual metaphors in

order to narrate the triumphant progress of the ship of state, and the Gigantomachy with a mass of quotations in order to narrate Pergamon's place in world history. Recent work on Hellenistic narrative (von Hesberg 1988) has pointed to an increasing preoccupation with the abstract as the period advances, and these two works are no exception. Progress and battle being the two fundamental patterns of western allegory (Fletcher 1964: 151–61), the Nike and the Gigantomachy deserve to be considered as paradigms of this change.

While the Nike's appeal to an abstract *logos* is quite subtle and understated, the Gigantomachy is decidedly more vociferous. Evoking the manifold achievements of both the classic and the Hellenistic, it has become a blatant hybrid, "a mixture of two social languages within the boundaries of a single utterance" (Bakhtin 1981: 358). This hybrid represents the classic in the light of the Hellenistic, self-consciously mobilizing the past for Eumenes' own narrative purposes. It is therefore explicitly doublevoiced, both commenting upon the classic and being judged by it: Parrying the present by coopting the past, it immediately lays itself open to a critique from that quarter too. This doubling goes beyond mere matters of form, for what is represented here are two socioartistic consciousness that are very different in kind. In the frieze, as in the texts studied by Bakhtin, these "two epochs . . . come together and consciously fight it out on the territory of the utterance" (Bakhtin 1981: 360). Viewed in this respect, the frieze is not merely the locus for a collision of gods and giants, but for a collision between two differing world views: Style and iconography here take on a concretely social character, becoming uneasy allies in the clash of epochs.

This dichotomy extends to the very core of the image, to the representation of cosmic violence itself. For even as these sculptors mobilize every persuasive device in their repertoire, their thematization of technique, their constant use of allusion, and their allegorizing of the theme itself simultaneously tend to undercut and displace the violence and sadism of the conflict. While the tool marks stress the fictiveness of the image like a consistent counterpoint to the rhetorical blasts of the narrative, the allusions direct the observer's attention back toward the past (particularly to the classical masterpieces of Old Greece), and the insistent dualism of absolute Good versus absolute Evil expands his frame of reference to the cosmos itself. The pleasure of both maker and observer, then, is interstitial: It lies not in the violence itself, but in the rendering and displacement of that violence (cf. Bersani and Dutoit 1985: 108, 122–3). As on the level of culture, this tension on the level of nature remains unresolved. Here, the purposes of

Asiatic rhetoric and of the frieze ultimately diverge: For whereas the rhetorician aims to persuade one at all costs of the literal truth of his message, the sculptor is deeply ambivalent.

Unfused, disjunct, and therefore characterized by massive internal tension, this hybrid is both historically contingent and artistically unstable. Too defensive and self-reflexive to be a rounded, internally consistent, and finished construct, it is thereby incapable of presenting a new and independently viable world view. Yet this is not to say that the end product was either vacuous or infertile. Quite the contrary. For stability and closure, it substitutes raw energy, acute historical awareness, and a distinct open endedness that is evidenced by its extreme longevity and extraordinary popularity both in Asia and, later, in Rome. In both areas, it sired a remarkably varied progeny that ranged from the so-called "Rococo" to the imperial Baroque of the Antonine period. Herein, perhaps, lies one reason why it was anathema to the Neo-Classicists: For the Neo-Classic style of works like the Kallimachean maenad reliefs (Pollitt 1986: 169–72, figs. 175–7; Stewart 1990: 166, 271, figs. 436–7), though thoroughbred to perfection, was ultimately sterile.

As a mimetic mode, then, the Baroque is both peculiarly complex and peculiarly protean. This is why the handbooks can describe it, sometimes in the same breath, as superrealistic, theatrically contrived, and part of a classic revival.[18] For because *mimesis* itself is inevitably double-imaged, being simultaneously a representation of reality and a commentary upon it, it follows that the Baroque of the Gigantomachy is actually double double-imaged. This may require a word of explanation. The archaic and classic present both an image of the world "out there," so to speak, and an image of the artist's understanding of it: To that extent (but to that extent only), they are "simple" styles. This duality, intrinsic to *mimesis* as such, explains much of the confusion in discussions of it from Aristotle to the present, including the endless battles over whether it should be translated as "imitation" (which privileges the first term of the equation) or "representation" (which privileges the second). In fact, both are necessary and neither is sufficient, for within the boundaries of the image, both the world itself and the artist's commentary upon it vie for our attention.

In drawing so heavily upon the classic, then, the late Baroque of the Gigantomachy not only becomes a historically conscious style, but a style that is complex where the archaic and classic were "simple." For at the same time as the frieze's sculptors engage classic "reality" and classic interpretations of that reality, they offer their own version of contemporary reality too: the world

"out there" as it appeared to second-century Pergamenes. This tense internal discourse between past and present mobilizes both the classic and the contemporary world to narrative ends: These sculptors express the complex and somewhat fragile historical consciousness of the Pergamene kingdom through a studied manipulation of narrative form. Indeed, they go further, for their own mastery of the rhetorical techniques of *auxesis,* particularly *antithesis* and *deinosis,* keys up the tensions to breaking point, and their thematization of sculptural *techne,* from the techniques of tooling to the techniques of iconographic and stylistic adaptation, leads to an eventual thematization of the act of imaging itself.

In contrast to other authentically hybrid and historically conscious styles, such as the Augustan, or to stylizations, such as the Neo-Attic, the Baroque of the Gigantomachy is quite open about all this. Though it shares with the Augustan style a clear sense of history as narrative context, it debates the issues openly, making no claims to internal consistency or smoothly managed synthesis. The Neo-Attic style, on the other hand, is a closed mimetic system. A product of the same turmoil that convulsed the Hellenistic world with the coming of Rome, it is all but totally insulated from the world and oblivious to any goal but that of making the style of Pheidias and his pupils present to a nostalgic audience of Hellenistic and Roman connoisseurs. Against it, the Baroque emerges as an open system, eternally engaged in narrative discourse with other systems and with the world itself. It is also wonderful sculpture, both visually exciting and intellectually stimulating. One can hardly ask for more.

NOTES

I am most grateful to to Svetlana Alpers, Carol Benson, Anthony Bulloch, Tim Clark, Mark Griffith, Erich Gruen, Huberta Herres, Peter Holliday, Max Kunze, Anthony A. Long, Ira Mark, Mary McGettigan, Jim Porter, Thomas G. Rosenmeyer, and two anonymous readers for Cambridge University Press for their advice and assistance in preparing this chapter. Parts of it were given as lectures at Berkeley and at Johns Hopkins University in April 1989: I thank Virginia Altman, Alison Futrell, Chris Hallett, Martha Hollander, and Gretchen Umholtz (at Berkeley), and Yves-Alain Bois, Elizabeth Cropper, Charles Dempsey, Herbert Kessler, and Bill Tronzo (at Johns Hopkins) for their comments and suggestions for improvement; any errors of omission and commission that remain are, of course, solely my own.

1. Thiersch's conclusions were strongly challenged by Lehmann (1973: 192, n. 14); on Pythokritos, see most recently Goodlett (1991: 676). In turn, Smith (1991: 78–9) challenges Lehmann's date, preferring the 250s or even 306.
2. By Ira S. Mark.
3. Cicero and the others, however, stress that the Rhodian style was more

moderate, closer to the Attic; yet whether the Nike is truly Rodian or not, one cannot expect literary and artistic tastes always to coincide.

4. She simply assumes the term's applicability, without definition or further comment. For early discussions of the relationship between the two, see, on the philological side, von Wilamowitz-Moellendorf (1900: 48–9), and on the archaeological, Brunn (1905: vol. 2, 457). The most thorough treatment of the issue is by Falkener (1946).

5. By Ira S. Mark, whom I thank for sharing some of his preliminary views on the Nike "fountain" with me.

6. On Nike as a popular ship's name, see Thiersch (1931: 374) and Casson (1971: 352, 355).

7. Cf., e.g., Apollonios of Rhodes, *Argonautica* 4. 933–6.

8. The krater, formerly at Nostell Priory and now in Melbourne (inv. D 27/1979; ht. 37 cm.), is reproduced here by permission of the National Gallery of Victoria. It is the namepiece of the "Boating Painter": Trendall (1967: 246, no. 139); Christie, Manson, and Woods, Ltd. (1975: no. 242); Trendall (1980: 3–11). On connections between the ship of state, the ship of life, and the ship of love, see Anderson (1966), and on progress as a central theme of allegory, see Fletcher (1964: 151–7).

9. For important remarks on particular techniques of *auxesis* see [Aristotle,] *Rhetorica and Alexandrum* 3, 1425b36–1426a32. Cf. Robertson (1975: 535): "This is the grandest of Greek victories, and reminds one of the rashness of such generalizations that the old themes had lost their power in the new age; but it is true that Victory is always well thought of, certainly at least at this epoch."

10. On the daemonic agent and allegory, see Fletcher (1964: 39–69).

11. On time and poetry's consequent superiority over art, see Lucas (1968: 267), with *Poetics* 1, 1447a1–26 (mimetic media); 3, 1448a19–29 (narrative genres – epic, tragedy, and mixed – with the visual arts now left out); 6, 1449b24–8 (definition of tragedy by temporal and other means), 1450a3–5 (importance of plot structure), and 1450a23–34 (no tragedy without action, but as in painting, there can be tragedy without character drawing); 7, 1450b21–25 (plot structure, development, and length); 9, 1451b3–7 (of the truly narrative media, poetry is more philosophical than history). In general, Aristotle's parallels with the visual arts, frequent at first, lessen and then disappear as the time-dependent elements of tragedy come to the fore.

12. Though the *ekpyrosis* burned up everything except Zeus, the other gods included: It was Zeus in a state of supernova.

13. Cf. Russell and Wilson (1969: xi–xxxiv) on Menander. Our most complete ancient textbook on epideictic, he would presumably classify the Gigantomachy among "encomia of gods," as a "mythological hymn." His rules for the genre, which are heavily classicistic, are set out in Book 1, 331. 21–332. 2.

14. The only extended analysis of the frieze in terms of Asiatic rhetorical terminology is Falkener (1946: 36–42), though a comparison will reveal that her approach is somewhat different than mine.

15. The starburst decorates Macedonian shields on two monuments that are approximately contemporary with the Gigantomachy: the tomb of Lyson and Kallikles and the base of Aemilius Paullus at Delphi: Markle (1982: figs. 16 and 20).

16. First suggested by Roscher in the nineteenth century: see Hansen (1971:99 n. 90) and Pfanner (1979: 55) for the earlier literature. Pollitt (1986: 82),

on the other hand, argues that the preponderance of snake-legged giants is intended to recall this incident. Yet, in both cases, it seems odd that Eumenes would want to advertise his own humiliation, and one wonders whether these serpentine motifs are not being misread; the snake, by the way, is not emerging from the pot, but is merely wrapped around it. Schmidt (1990: 148–50, 157) argues for the presence of anti-Roman motifs on the Telephos freze, and anti-Roman undertones on the Gigantomachy. This is to misread the political situation, for as Gruen (1984: 561–3, 576–84) shows, the evidence only proves that from 168, Eumenes was cold-shouldered by the Romans for a while, not that he reciprocated by being hostile to them – he needed them too much. In 164, the Senate rallied to his support against Prousias: The chill had passed (Polybios 31. 1. 2–5; Diodoros 31. 7. 2).

17. For the types, see Stewart (1990: 191, 205–6, 283, 301, figs. 573, 667–70).

18. So, e.g., Lawrence (1972: 228): "The [designer] had obviously made an intensive study of fifth- and fourth-century sculpture. . . . The frieze as a whole gives a realistic impression of a writhing mass of figures engaged in a desperate struggle. . . . Throughout the Gigantomachy, every face registers the utmost possible emotion, . . . yet the scenes fail to horrify because they are clearly unreal." Carpenter (1960: 199) recognizes the problem, and is far more sophisticated about it.

NARRATIVE STRUCTURES IN THE FRANÇOIS TOMB

Peter J. Holliday

Etruscan artists drew from a rich repertoire of forms and themes, sometimes derived from native Italic traditions, but often Greek in origin. When appropriating from those traditions, artists worked with a knowledge of both local conventions and the physical setting for their creations, which were also essential for their final form. The Etruscan process of making art was therefore fundamentally deductive and extractive (Brilliant 1984: 23). Ancient viewers (which for Etruscan tomb paintings included visiting relatives and participants in subsequent burial parties), on the other hand, used an inductive method of analysis, dependent upon memory, in order to recognize the subjects represented and interpret their significance (cf. Brilliant 1984: 23; cf. Iser 1978).[1] The challenge is even greater for the modern viewer, who must also overcome the problems of interpreting images removed from their original context. This is particularly true for the programs of paintings that decorated Etruscan tomb chambers. There, once the correspondences among the diverse painted motifs are discerned, the imagery can acquire deep narrative qualities.

The François Tomb at Vulci is particularly rich in its painted decorations.[2] The tomb, discovered in 1857 and named for its principal excavator, Alessandro François, contained burials dating from the midfifth to the early second century B.C.; the paintings themselves have been variously dated, most convincingly to the transitional period between the late classical and mature Hellenistic periods.[3] Although he wrote a summary report, François primarily described the various objects found in the tomb, including some vases and a great quantity of goldsmith work (François 1857: 98–104; cf. Buranelli 1987: 23–46).[4] Another excavator, A. Noël des Vergers, provided a fuller account of the actual discovery:

At the last blow of the pickaxe, the stone which sealed the entrance of the crypt gave way, and the light of our torches lit those hollow rooms whose silence and darkness had not been troubled for more than twenty centuries. Everything was still the way it had been on the day the en-

trance had been closed, and ancient Etruria appeared to us just as when it was in its glory. On their funeral couches warriors, covered by their armor, seemed to be resting from the battles they had been waging against the Romans and our ancestors the Gauls. Shapes, garments, cloth, color, all were clearly distinguished for some minutes, then everything disappeared as the outside air came into the underground chamber, where our flickering torches were almost blown out. The past which had been conjured up lasted no longer than a dream, and disappeared, as though to punish us for our foolhardy curiosity.

While these frail remnants turned to dust upon contact with the air, the atmosphere around us was becoming more transparent. We then saw that we were surrounded by another group of warriors created by the artists of Etruria. Paintings decorated all the walls of the tomb and seemed to come to life in the trembling light of our torches. Soon I became completely absorbed looking at them, for they seemed to me to be the most beautiful part of our discovery. On one side, the paintings recalled Greek myths, and the Greek names written in Etruscan letters left no doubt as to their subject. They had been inspired by the poems of Homer. Under my eyes, one of the bloodiest events of the *Iliad* was taking place, the sacrifice, by Achilles, of the Trojan prisoners over the tomb of Patroclus. In contrast the fresco which formed a pendant to it no longer had anything Greek about it, except for the sophistication of the art, the modelling of the naked bodies, the bulging muscles, the expressiveness of the faces, animated by violent passions, and the skill with which the lights, shadows, and the half-tones were rendered. As to the subject, it was obviously a local theme, as was shown by the names, completely Etruscan in character, inscribed above each figure.[5]

Although fancifully romantic in its tone, Noël des Vergers's account indicates that the inhumations were mostly on benches, seemingly intact on discovery; more important, it is accurate in its description of the paintings.[6] His report provides crucial evidence for their disposition, for only a few sections of the frescoes remain in situ, the rest having been detached in 1862 and removed to the Museo Torlonia (formerly the Villa Albani) in Rome.[7]

The François Tomb was entered through a deep *dromos* over eighty feet long; three small rooms were added off the sides of the dromos for later inhumations. The important paintings are in an older, T-shaped chamber comprised of two sections. An entrance doorway with architrave leads from the dromos into an oblong vestibule that forms its cross-bar; at either end, six additional rooms were added, symmetrically arranged three to each side. Opposite the doorway into the vestibule was an almost square area, called the *tablinum* by analogy with that room in a Roman house. Indeed, the grandiose layout of this multichambered hypogeum probably imitated the interior disposition of an aristocratic house,[8] and differs from similar underground chambers only in the complexity of its architecture (Fig. 62). The *tablinum*

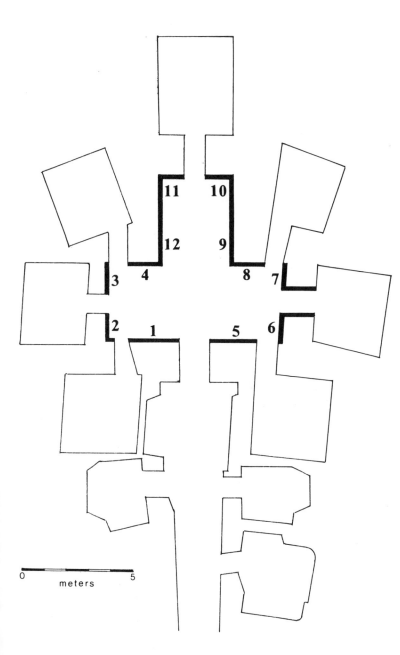

62 François Tomb, plan and disposition of wall paintings. 1: Ajax and Cassandra. 2: Phoenix. 3: Nestor. 4: Eteocles and Polyneices. 5: Sisyphus and Amphiaraus. 6: Thanchvil Verati. 7: Vel Saties and Arnza. 8: M. Camitlnas and Cn. Tarchunies. 9, 10: Mastarna, the Vibennae and their Opponents. 11, 12: Achilles Sacrificing the Trojan Prisoners. Drawing: R. Reif.

served as an antechamber to the back burial chamber, which features a pitched ceiling and walls painted to imitate marble inlay.

The paintings described by Noël des Vergers decorated the vestibule and *tablinum* (Fig. 62). The vestibule frescoes depict, clockwise around the room from the entrance, Ajax slaying Cassandra; Achilles's tutor Phoenix and Nestor; the duel of Eteocles and Polyneices; a fight between Marce Camitlnas and Cneve Tar-

chunies; the proprietors of the tomb, who are identified as Vel
Saties and Thanchvil Verati; and Sisyphus and Amphiaraus in the
underworld. The long side walls of the *tablinum* are decorated with
more complex scenes: on the left, the sacrifice of the Trojan pris-
oners before the shade of Patroclus, and on the right, an episode
from Etruscan lore in which Vulcian heroes overcome warriors of
other ethnic origins.

The architectural members below the figured scenes are painted
in perspective; a meander pattern, also in perspective, runs above
them and formally connects the various tableaux. (In the vestibule,
the meander is separated from the figured scenes by a frieze of
real and fantastic beasts attacking fauns and horses; on the ceiling,
women's heads appear among floral motifs.[9]) Yet closer analysis
suggests that a series of sophisticated formal and thematic analogies
further link the images. The figures scenes are designed to make
subtle correspondence in image and subject, linking wall to wall,
counterposing figures from Greek myth and epic with figures
from Etruscan history.

At their discovery, Noël des Vergers noted that the paintings
were clearly labeled with painted inscriptions in Etruscan char-
acters, which allowed him to correctly identify the subjects por-
trayed. Those inscriptions also indicated a clear plan for the
arrangement of the scenes in the vestibule and *tablinum:* Greek
episodes to the left, Etruscan to the right.[10] (This strict axial sym-
metry is broken only on the front wall by the images of Amphi-
araus and Sisyphus.) Not only did Noël des Vergers properly
identify this basic arrangement, but he also described the juxta-
posed paintings in the *tablinum* specifically as pendants. But are
discrete images of episodes drawn from larger narrative cycles,
even if displayed as pendants, enough to constitute a new visual
narrative? If so, how should the viewer "read" the assembled
scenes to discern the message of that narrative? A fuller description
of the painted scenes will not only secure their relationship as
pendants, but also indicate additional associative meanings among
all the paintings of the program, and thereby point the way to
distinguishing a narrative structure in which episodes of Greek
victory at Troy allude to ancestral triumph over a present-day
enemy.

The most impressive and best preserved painting in the tomb
is the sacrifice of the Trojan warriors (Fig. 63). In the presence of
his companions, Ajax and Agamemnon, a wrathful Achilles leans
forward to slash the throat of the young Trojan captive seated on
the ground before him; appropriately, blood gushes from the
opening wound like that of a sacrificial animal.[11] The central pair
is enframed by two purely Etruscan figures evoked to witness the

slaughter: at the left, the female angel of death, Vanth, looks on compassionately; her left wing shadows Achilles, fated to follow in death soon; to the right, the death demon, Charun, raises his hammer, his expression sneering, his complexion the color of rotting flesh.[12] With their legs hacked to prevent escape (Poulsen 1922: 52), two other Trojans await their fate. Sheltered by Vanth's right wing, the shade of Patroclus stands by, his bandages indicating the wounds from which he died.[13]

The composition of this episode is probably derived from another painted source, perhaps an original painting from Magna Graecia. The same subject appears in a number of contemporary works, including Faliscan painted vases, bronze cistae from Praeneste, chests, and sarcophagi (Sprenger and Bartoloni 1983: 143).[14] Greek origins for the scene are also suggested by the more pictorial quality of its execution – the vivid chiaroscuro achieved by hatching and successive thin layers of paint – as compared with the scenes from Etruscan lore, which certainly drew upon local traditions. Nevertheless, the addition of the demonic figures from

63 Achilles Sacrificing the Trojan Prisoners. Photo: Alinari 43936.

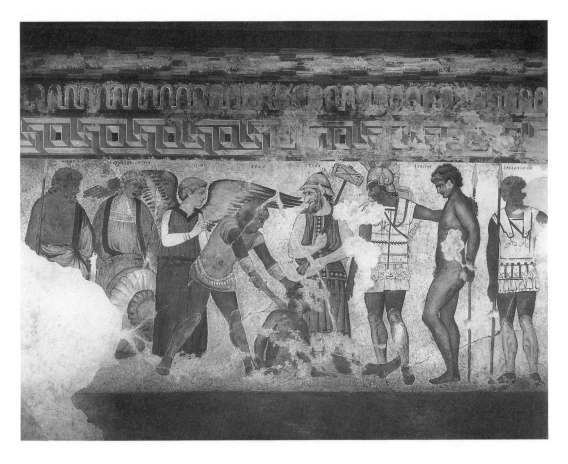

the Etruscan underworld indicates that the painting is not merely a slavish copy; rather, it represents an assimilation of a Greek source by an artist sensitive to the peculiarly Etruscan needs of his patron. The presence of Charun and Vanth not only grounds the Greek story more closely to a local interpretation, but also integrates it with the corresponding Etruscan combat motifs.[15]

A series of four epic confrontations makes up the scene on the facing wall (Fig. 64). The artist depicts the successful surprise attack on the Etruscan allies of Rome by an opposing group of Etruscan warriors. The heroes, identified as Larth Ulthes (Lars Voltius), Rasce (Rascius), and Aule Vipinas (Aulus Vibenna), overcome warriors of other ethnic origins: Laris Papathnas Velznach (Lars Papatius, or Fabatius, a Volsinian), Pesna Arcmasnas Sveamach (Sovanese), and a third whose name and origins are difficult to decipher due to the mutilated condition of the inscription (Venthical . . . plsachs, who may be Faliscan or Falerian). Still wrapped in their mantles, as if surprised in their sleep, the helpless enemies are quickly overcome; blood spurts from their wounds with a violence similar to that visited on the hapless Trojans.

64 Battle of Etruscan Heroes. Photo: Alinari 43939.

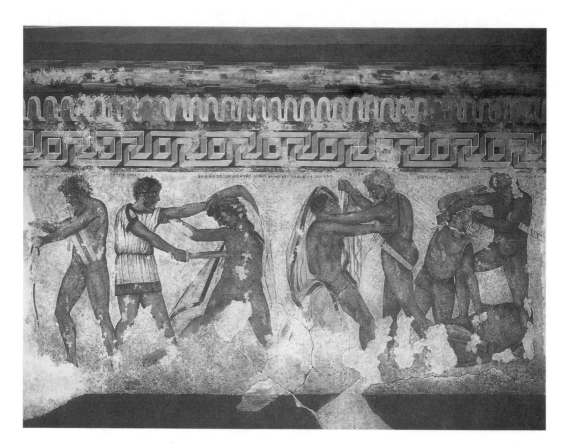

The climax of this mission concerns Rome itself. To the far left of the composition, a figure labeled Macstrna (Mastarna) liberates the Etruscan hero Caile Vipinas (Caelius Vibenna), Aulus Vibenna's brother, from the bonds imprisoning him. Festus tells us that the Vibenna brothers were from Vulci, and that they were friends of Macstrna (*CIE* 5267). According to the emperor Claudius, an amateur Etruscologist of some renown, Macstrna was the Servius Tullius of Roman legend.[16] Each of the protagonists was connected with Rome, and specifically its occupation, for the Caelian Mount was said to have been named after Caelius Vibenna, and the Capitolium after Aulus Vibenna: *caput oli*, "head of Olus," or "Aulus," according to some etymologies (Varro, *Ling Lat* 5.46; Tacitus, *Annals* 4.65).[17]

The two *tablinum* scenes share a similar compositional structure. Each starts at the edge of the vestibule and, on either side of the door to the back chamber, reaches a climax with two mirror images: the bound figures of the Trojan prisoner and Caelius Vibenna. While the doomed Trojan is led to the tomb of Patroclus to be sacrificed with his fellow captives, Caelius Vibenna, when freed from his chains, will rejoin his victorious companions. The symmetrical balance between the left-to-right and right-to-left ordering on the facing walls may reflect similar aesthetic concerns found in smaller-scaled works. For example, although Etruscan is written from right to left, inscriptions on Etruscan vases occasionally read from left to right, changing direction for decorative or other reasons as they also do on Greek vases (cf. Small 1987). The carefully ordered directional structures here also suggest a purposeful, tendentious choice that heightens their resonance.

The close compositional parallels between the two scenes have led scholars to seek likenesses between the subjects as well; some have seen a comparison between the victory of the Greeks over the Trojans and that of the heroes of Vulci over the men of Rome and her allies (Zevi 1970: 70; Coarelli 1972: 102; Torelli 1975: 85). A severely symmetrical structure is sometimes expressed with the formula Greeks:Trojans = Vulcians:Romans. Like the later Romans, the people of Vulci believed in their own Trojan origin[18]; other scholars, therefore, have seen contrasts rather than parallels between the scenes. According to this interpretation, the fatal condition of the original Trojans after their capture is contrasted with the miraculous escape of the Trojan descendants from the same hopeless situation (Alföldi 1965: 224). Any association, however, does not stem merely from compositional resemblances or similarities in subject matter; rather, there are also deep analogies between moralizing and political themes. The typological correspondences therefore serve both to impose a formal structure on

the tomb paintings and to inspire the viewer to read a narrative among them in the process of deciphering their multilayered relationships.

Around the corner in the vestibule, a naked bearded warrior, Marce Camitlnas, grabs the hair of his enemy and thrusts his sword into the cringing Cneve Tarchunies Rumach, Gnaeus Tarquinius (Tarquin) of Rome (Fig. 65).[19] Tarchunies wears a white toga with the red border of the *toga praetexta,* and seems to have been roused from his sleep like the vanquished warriors in the *tablinum.* The composition for this scene was obviously derived from the image of the epic duel between Eteocles and Polyneices on the opposite wall (Fig. 66). There Eteocles leans over the crouching body of his brother, painted under the corner of a door jamb, and thrusts his sword into Polyneices' throat; Polyneices, in turn, stabs upwards at Eteocles. Both figures are nude and bleed profusely; the twisted body of Eteocles combines with their interlaced legs and arms to create a closed, spiral composition.[20] The heroic exploits

65 (*bottom left*) Marce Camitlnas and Cneve Tarchunies. Photo: Alinari 43928.

66 (*bottom right*) Eteocles and Polyneices. Photo: Alinari 43934.

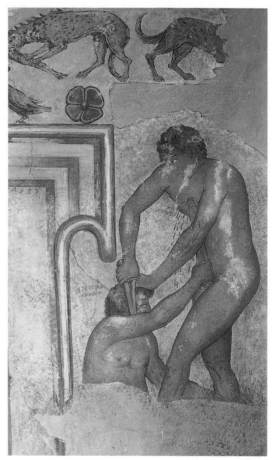

of Macstrna and the Vibenna brothers are also portrayed as a series of epic duels, indicating their derivation from the related Eteocles and Polyneices composition.[21] Despite the praise lavished on them by Noël des Vergers, however, none of the Etruscan pairs of warriors is as well composed or as evenly matched as the corresponding Greek model; the unified pattern of the Trojan prisoners contrasts sharply with the choppy sequence of pairs of figures in the Etruscan scene.[22]

The compositional similarities among the combined Etruscan episodes are so striking that some scholars have interpreted the duel between Marce Camitlnas and Cneve Tarchunies as the opening skirmish in a single conflict that is continued in the adjacent *tablinum* composition.[23] Although some of the figures portrayed in the tomb are mentioned by Roman sources, the particular event depicted is not recorded in any Roman sources that have come down to us. In fact, these paintings represent the sole evidence – significantly an Etruscan source – celebrating the achievements of Etruscan military leaders during the sixth century B.C. Although modern viewers tend to see a reference to Etruria's legendary past of two centuries before the commission of the paintings, the scenes also have definite historical value (Alföldi 1965: 212–31; Ridley 1975: 147–77; Torelli 1981: 175–6, 234–7; Carandini 1985: 37; Pallottino 1987: 225–33). Indeed, their historicism would have been fundamental to their original context.

The couple who commissioned the paintings was portrayed on either side of the door to the right-hand chamber, or, following the analogy with the plan of a Roman house, the master bedroom (Fig. 67). Vel Saties stood to the left of the door; the portrait of his wife, Tanaquil, unfortunately destroyed, stood to the right (*CIE* 5278, 5279).[24] Vel Saties wears a crown and ceremonial purple robe, similar to the Roman *toga picta,* which was worn by generals who had been awarded a triumph[25]; he was probably awarded a triumph for the victories he won for Vulci over Rome. Images of warriors armed with shields and lances and engaged in some kind of ceremonial dance decorate the robe, making a further allusion to triumphal celebrations.[26] Vel Saties's actions indicate that he also held priestly offices, for he follows the tradition of the *etrusca disciplina* of augury and bird lore. A servant, identified by the inscription as Arnza, attends Vel Saties. This figure has a large head and hands; his stunted legs support a fleshy body, and he carries a leashed bird perched on his left hand. Vel Saties reads the public omens, or *auspicia,* from the flight of the birds already released by the dwarf Arnza, omens that might even refer to the battle in which he won the triumph.[27] Vel Saties's dress and attitude indicate his honors and titles as if in an honorary inscription

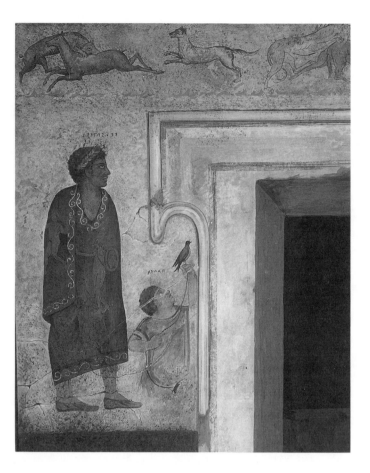

67 Vel Saties and Arnza.
Photo: Alinari 43929.

or epitaph; such an allusion to some kind of laudatory theme, akin
to a Roman *elogium,* is historically based and befits a distinguished
personage.[28] It is surely no coincidence that the first paintings in
Rome of men in triumphal dress and the first painted battle scene
set up on the wall of a public building date to the first quarter of
the third century, shortly after these Etruscan works.[29]

The spectator would have been struck first by the formal and
compositional similarities among the paintings. Once the individ-
ual subjects had been deciphered, thematic and moral associations
among the scenes became more vigorous: The spectator moved
back and forth between the pendants, noting deeper layers of the-
matic meaning in the paired images. In addition to those pendant
relationships already discussed – that between the mutual fratricide
of Eteocles and Polyneices and the duel of Marce Camitlnas and
Cneve Tarchunies, and that between the sacrifice of Trojan pris-
oners and the paired combat motifs of Vulcians and their Etruscan
enemies – several others can be distinguished among the remain-

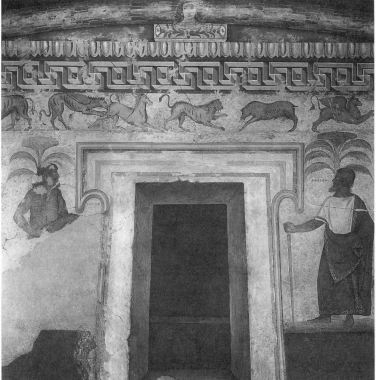

68 Phoenix and Nestor.
Photo: Alinari 43933.

ing scenes. The paired portraits of the owners of the tomb, Vel Saties and Tanaquil, belong to a long-standing tradition in south Etruscan cities (Bonfante 1978: 138). It is novel, however, to show the patron reading the auspices, and ties him with the paired images of Phoenix and Nestor on the opposite wall (Fig. 68). Themes of hubris and retribution connect the depiction of the Greek prophet Amphiaraus watching the punishment of Sisyphus with the scene of Ajax slaying the prophetess Cassandra.[30]

A pendant relationship functions effectively when the events depicted are believed to represent comparable states of affairs: The images exemplify analogous types. In classical literature, Stoic writers had long employed the force of correspondence through comparison. Later Plutarch would use a typological structure for his *Lives* (cf. Todorov 1969: 70–6); the author's moral didactics were emphasized through the use of historical parallels dependent upon a flexible view of the present and a projective view of the past.[31] The typological system of inconography developed in the François Tomb also requires a flexible view of temporality, for in the tomb scenes from both past and present are encompassed at the same moment by the viewer. The artist has brought the paint-

ings together through the compatibility of their subject matter, thereby developing his theme through the use of visual similes in the form of parallel pendants (Brilliant 1984: 33). The artist developed a form of typological narrative that set up the past as a metaphorical anticipation of the present whereby the Greek motifs on the left "served as a resonating gloss for the scenes from Etruscan history" (Brilliant 1984: 34).

Within the larger context of the entire tomb, therefore, the painter turned individual scenes into vehicles for metaphor. Quintilian (*Inst. Orat.* 8.5.35 and 8.6.4) described a process of rhetorical alteration that converted a form from its proper, given meaning to another, which he defined as a trope. In his discussion of the poetic technique involving the application of tropes, Quintilian argued that the extraction of elements from their cohesive narrative contexts and their subsequent employment to represent themes of varying degrees of abstraction is an exercise in modal forms (*Inst. Orat.* 8.6.1–59). The reliance on analogy among the figured scenes in the François Tomb implies a metaphorical connection among the constituent elements out of which some central meaning emerges. Quintilian stated explicitly that "metaphor is designed to move the feelings, give distinction to things and place them vividly before the eye."[32] It is evident that this exercise in modal forms, the trope, can be expressed in visual as well as linguistic terms.[33] Tropes play a major role in the programmatic decoration of the François Tomb, where overt narrative implications served the needs of symbolic association for the edification of the viewer. Thus, the removal of the duel between Eteocles and Polyneices from the Theban saga, or the illustration of the sacrifice of the Trojan prisoners outside its original epic context, suggests that the artist purposefully chose these specific images for the force and power they would engender within their new setting. The sacrifice of the Trojan prisoners no longer merely illustrates an incident from a particular legendary cycle, it also offers a commentary on the corresponding Etruscan images: A new relationship emerges.

The rhetorical language of tropes can elucidate apparently strong contrasts among themes, such as those between the Greek and Etruscan images. The metaphorical constructions of synecdoche and metonymy, for example, may point the way to an appropriate interpretation (cf. Brilliant 1984: 73–4; White 1973: 31–8; Schofer and Rice 1977: 121–49). Metonymic relationships do not require a precise equivalence in all respects; for example, metonymy can serve to reduce the narrative gap between scenes by indicating their intimate relationship in cause and effect (cf. Quintilian *Inst. Orat.* 8.6.23–7). An appreciation of ancient rhe-

torical practices therefore appears to help articulate the selection and arrangement of the pendants; the trenchant possibilities of integration are a feature of rhetorical and poetic tropes: "they are the very substance of narrative."[34] Therefore, the linking of episodes of diverse mythological and historical material has been achieved through analogy.[35]

Although each scene is obviously self-contained and rich with descriptive matter, its place in the ensemble is justified by those very nontemporal connections asserted in the mind of the viewer. Aristotle (*Poetics* 1459b) had suggested that literary narratives were preferable to scenic representation, because literary narrative is able to treat several actions simultaneously.[36] In the decorative program of the François Tomb, however, that advantage disappears: The apparent disjunction of the scenes emphasizes the synthetic power of the viewer's imagination. The very fact of projection and deliberate association of pendants in an affective relationship serves to break the frame of the individual scene and replace it by the larger enframement of the chamber as a whole.[37] The development of this system of references, moving from one scene to another, requires the interpretation of one panel in terms at least partially defined by another, and sets up the real possibility of defining a quasi-narrative by analogy (Brilliant 1984: 78). Seeing the duel of Marce Camitlnas and Cneve Tarchunies in terms of the struggle between Eteocles and Polyneices, for example, forces one to define those relationships: One consequence is that the actions of historical personages appear raised to mythic proportions (cf. Alföldi 1965: 223–7). Chronological disjunctures among the pendant episodes cast them together (by their connected thematic echoes) into mythic space and time, *in illo tempore,* and thus attract the more immediately historical (and chronologically linked) Etruscan figures into that same space and time of mythic grandeur.

The juxtaposition of historical events with scenes from myth and legend enjoyed a long tradition in classical antiquity, and is unique neither to the François Tomb specifically nor to Etruscan art in general. Greek artists had employed the device of pendant composition to develop reciprocating programs of imagery in the design of sculpted friezes and pediments and in the arrangement of paintings in public buildings.[38] For example, Pausanias (1.15.3) saw four paintings in the Stoa Poikile in Athens:[39] Polygnotos's *Troy Taken,* Mikon's *Athenians and Theseus against the Amazons,* the *Battle of Oinoe,*[40] and the *Battle of Marathon.*[41] Descriptions of the last painting list several inscribed portraits of historical personages, including the Greeks Kallimachos, Aeschylus and his brother Kynegeiros, and Miltiades, and the Persians Datis and Artaphernes. It seems evident from the literary descriptions that the program

of paintings in the Stoa Poikile made a deliberate association be-
tween the historical and mythological events portrayed.[42]

The later Romans also structured monuments using pendant
relationships to compare the worlds of myth and history. The Ara
Pacis, for example, presents a typological narrative in which recent
historical events are equated with scenes from the mythical past.[43]
The artist portrayed Augustus, recently returned to Rome from
abroad, conducting a religious rite; the emperor's pose, gestures,
and dress purposefully imitate those of his ancestor Aeneas shown
sacrificing on an adjacent panel to their shared family gods upon
his arrival in Italy. As the viewer was led to interpret the duel
between Marce Camitlnas and Cneve Tarchunies in relationship
to the epic struggle between Eteocles and Polyneices, so he must
consider the actions of the founder of the Roman empire in terms
of those of the founder of the Roman race. The program of the
Roman monument thereby endows the historical event with
mythic qualities by placing it in a series of metaphoric contexts.[44]

Similar relationships occur elsewhere in that Roman art that
drew so heavily on Etruscan traditions. Karl Schefold was the first
scholar to explore the possibilities of programmatic connections
among groups of painted panels in the rooms of Pompeian houses
(1952: 12–51; 1972)[45]; in his studies, he distinguished between
cycles and pendants as the constituent elements of such programs:

By the term cycle we mean the interrelated motifs of decoration, ar-
ranged along the walls, while the term pendant pictures refers to the
specific meaning that governs their association. Such pendants might
even be taken from cycles, but they constitute more significant relation-
ships than mere association in the course of the narrative.[46]

The inscriptions in the François Tomb not only identify the
characters depicted in the paintings, they also guide us in the un-
derstanding of the particular iconography worked out for scenes
from local Etruscan history.[47] Marce Camitlnas and the Vulcian
heroes hail from the same city as Vel Saties, and may even have
been among his ancestors: The Etruscan motifs therefore all illus-
trate events from interrelated cycles of city and family history. Ajax
and Cassandra, Phoenix and Nestor are each drawn from the same
Trojan cycle that also contains Achilles's sacrifice of the Trojan
prisoners; the artist removed these images from their original nar-
rative cycles to create the pendant relationships in the new,
Etruscan context of the tomb. The resulting structure of the dec-
orative program is not limited to a series of pendant relationships,
however; indeed, it is also possible to read all the scenes – Greek
and Etruscan – in order, as an integral cycle.[48] Filippo Coarelli

suggested that an ordered cycle began at the main entrance to the principal chamber where the ancestors of Vel Saties were buried and led to the door of his burial chamber, where Vel Saties, the triumphator who commissioned the decorative ensemble for the family tomb, was portrayed with his wife.[49] The cycle was therefore structured to follow a chronology opening with motifs from the Homeric past, move on to the period of the heroic exploits of the Etruscan warriors, including the conflict between Vulci and Rome, and culminate with the triumph of Vel Saties (Bonfante 1978: 138). This arrangement would emphasize the achievements of Vel Saties, who had just brought new distinction to his family, while reflecting back on the glory of previous generations.

Another set of temporal correspondences develops this cyclical structure further. The considerable number of Etruscan representations of figures reading omens shows their concern for this ritual element, which was linked whenever possible to a specific city (like Vulci) or family (like that of the Saties in the François Tomb) (Bonfante 1978: 148–50).[50] As has been shown, in an Etruscan cosmology, local history incorporated the heroic past within a religious – or here, more specifically funerary – context. The Etruscans believed that each city had its own fated *saecula* (Sordi 1972; 781–93; Pfiffig 1975: 159; Massa Pairault 1985: 66, 77–82). Censorinus (*De die natali* 17.5) wrote:

But though the truth is not clear, still it seems that the ritual books of the Etruscans teach, in each city-state, what its real cycles were. . . . [51]

Elsewhere in the same passage, Censorinus states that:

[t]hese omens the Etruscans carefully observed, thanks to the skill of the science of the haruspex and of their own learning; and they recorded them in their books.[52]

In the François Tomb, therefore, the artist appears to have depicted episodes pertaining to the *saecula* of Vulci. But such *saecula* also had a human dimension, for "a *saeculum* is the longest possible human life span, between the limits of a birth and a death" (*De die nat.* 17.2).

It is therefore significant that any cyclical reading of the paintings opens with figures from the ancient past who have the ability to foresee future events. In the funerary context of the François Tomb, the intrusion of the Greek motif of Sisyphus and Amphiaraus on the "Etruscan" side of the chamber not only reflects the image of the prophetess Cassandra, but also appropriately suggests the inevitability of death, a matter that all can predict. The cycle closes with the present generation, whose wealth and power permitted the commission of these paintings in the family tomb, tak-

ing the auspices for their futures as well. Past, present, and future become inextricably bound in a thematic argument of heroic achievement.

These depictions were surely linked to an aristocratic tradition followed by the tomb's proprietors.[53] It has already been noted that the elaborate layout of the tomb chambers suggests the disposition of rooms in a substantial house. In addition, however, the triumphal paintings decorating the atrium are similar to those tokens of honor displayed in an aristocratic Roman house along with the funerary *imagines* of the family's ancestors.[54] In the tomb itself lay the actual bodies of those Etruscan warriors whose remains Noël des Vergers saw, resting on their funeral couches after their strenuous efforts.

These were the ancestors of Vel Saties, and perhaps even included some of the Vulcian heroes depicted in the *tablinum*. Their noble actions continued to bring esteem to their descendants, and added to the family's authority (*auctoritas*). Insofar as they were inheritors of Etruscan tradition, we know that for the Romans, the acquisition of *auctoritas* was cumulative; for them, it elevated citizens up through the *cursus honorem* that dictated public offices in ascending order of importance, which began with military service. In fact, the desire for glory (*cupido gloriae*) motivated actions of men and was the driving force behind many wars. Writing in the late 40s B.C., Sallust (*Bellum Cat.* 7.3–6) explained the quest for glory as one of the primary motivations for Roman imperialism (cf. Harris 1978: 17–20, 24–7). In the first century B.C., Cicero (*Leg. Man.* 19–21) explained that the Roman people "have ever been, beyond all nations, seekers after glory and greedy of praise." Military achievement was a ready road to *gloria* among the Italian people; a large percentage of the monuments in Rome attested to individual prowess on the battlefield.[55] Significantly, the famous triumphal parades that allowed generals to bring their distant achievements before the eyes of their fellow citizens had their origins in Etruscan rituals (Bonfante Warren 1970: 49–65); and the Roman practice of carrying *imagines* of worthy ancestors from the house to participate in public funeral ceremonies also had Etruscan precedents.[56]

Both Greeks and Italians sought the founders of their cities and families in what we would consider the world of myth, but what was for the ancients their common prehistory (Bickerman 1952: 65–81)[57]; this realm also provided prefigurations of historical events. From the seventh century on, a family's ancestors were shown in tombs as images of the heroized dead (Rebuffat and Rebuffat 1978: 98–101).[58] In Etruscan tombs, men and women were pictured feasting at banquets held in their honor. Indeed,

some scholars have even seen an allusion to mythical Greek an-
cestors in the figures of Nestor and Phoenix or Sisyphus and Am-
phiaraus, which would be in keeping with the triumphal context
of the paintings in the atrium.[59]

Triumph is the primary theme tying all the diverse scenes to-
gether. Triumph is implied by the wise Homeric generals, un-
derscored by the paintings of the *tablinum;* it is brought down to
local historical traditions with Vulci's victory over Rome and her
allies, and it culminates in the figure of Vel Saties in the *vestis picta.*
The use of pendants as a structural device accentuates the theme.
Corresponding to the figures of Vel Saties and his wife are those
of the two wise counselors, Nestor and Phoenix, standing by their
palm trees across the hall. As previously noted, the artist has em-
phasized the relationship between Vel Saties and Nestor in dress
and pose. The venerable Greek general, too, wears a purple robe,
though his *himation,* draped in the Greek manner, is not decorated
like the triumphal *vestis picta.* Both their gazes are turned upwards:
Nestor, like Vel Saties, seems to be reading the omens.[60] Such a
depiction would result in the further telescoping of time if Vel
Saties were, in fact, seeing his own war's victorious end, to be
celebrated by his triumph. Even the palm trees behind Nestor and
Phoenix might be read as symbols of the triumph, the recent
Etruscan achievement being thus cast into Greek terms (Bonfante
1978: 139).

The emphasis on the spilling of blood, both in the scene of the
sacrifice of the Trojan prisoners and in the animal frieze running
above the figured scenes in the vestibule, further conjoins the
worlds of funerary and triumphal ritual (Cristofani 1967). Two
famous cases of sacrificing enemy prisoners in Etruria are recorded
in the fourth century B.C. in the course of the fierce struggle
between the Etruscan cities and Rome.[61] Related rituals in honor
of the dead continued in the gladiatorial games the Romans took
over from the Etruscans, and in the celebration of the Roman
triumph, basically a ceremony to cleanse the army from blood
guilt.[62] The ritual connotations of such bloody scenes as the
slaughter of the Trojan prisoners and the deaths of Eteocles and
Polyneices probably explain their frequent representation in Etrus-
can art during this period.

It is through the synthesis of these two compositional modes,
pendant and cycle, that the artist has created a meaningful struc-
ture for the figured scenes. The designer of the François Tomb
manipulated the motifs borrowed from Greek epic to fit the spe-
cific needs of his Etruscan patron, who wanted to commemorate
the role his family had played in the history of Vulci. This process
of assimilation created a form of typological narrative that, on one

level, set up the past as a metaphorical anticipation of the present. The Greek material functioned as a complementary analogue to the political struggles of the Etruscan present. It reinforced and ennobled the historical meaning of the Etruscan subjects, and also brought the remote past, represented by the age of Troy and the less remote history of the sixth century B.C, into equivalence with the context context of the fourth-century commission. Although modern viewers relegate these scenes to the separate worlds of classical myth, local legend, and family history, such distinctions probably held little force for ancient viewers. For the Etruscans, past and present belonged to different periods, but not necessarily separate realms; rather they correlated to different phases of a temporal cycle, the *saeculum*.[63]

The artist deliberately blended this diverse cultural and ethnic material to create a new narrative cycle. Analogous relationships became apparent and articulated the thematic implications of the composition as a whole. Prior knowledge, or folk memory, stimulated by the explicit character of the individual episodes makes the narrative line of the frieze intelligible. The frequent allusions to death and the underworld are appropriate to its funerary context, and the suggestions of death and transportation also ensure family *gloria*. The narrative cycle unifies and transcends the otherwise fragmentary nature of the legendary and quasi-historical episodes. This is all made possible because the scenes face inward and were therefore visually accessible, separately and in combination, at or almost at the same time. This stands in marked contrast to the physical situation with temple friezes and other types of large-scale works.[64] Nonetheless, there is a similarity in the compositional structure that emphasizes salient episodes bounded by weak connectives, dependent in turn on the architectural context for its overall organization and on the familiarity of the pious historical tradition for the teleological authority of its narrative.

NOTES

1. Winter (1985: 12) noted that ancient Near Eastern historical reliefs frequently demand "the viewer's prior knowledge and correct identification of the scene – a process of 'matching' rather than 'reading' of the imagery itself qua narrative."

2. The scholarly literature for the François Tomb is extensive. Among the most important sources are Körte (1897); Messerschmidt and von Gerkan (1930); Pallottino (1952); Cristofani (1967); Dohrn (1972); Bonfante (1978); Bianchi Bandinelli (1982); Sprenger and Bartoloni (1983); Steingräber (1984); Buranelli (1987); Cristofani (1990: 18–19).

3. Stylistic comparisons with Apulian art indicate that the paintings belong to the second half of the fourth century, roughly about 340 B.C. The François

Tomb paintings also compare well with the painted Sarcophagus of the Amazons from Tarquinia (Museo Archeologico, Florence), dated to the third quarter of the fourth century B.C.: see Bianchi Bandinelli (1950: 142–5); Pallottino (1952: 93–6); Sprenger and Bartoloni (1983: 139–40).

4. The erroneous assumption that the celebrated François Vase, the volute krater by the potter Ergotimos and decorated by the painter Kleitias (570–565 B.C., now Museo Archeologico, Florence inv. no. 4209) came from the François Tomb has entered both popular and scholarly accounts of the tomb: for example, see Sprenger and Bartoloni (1983: 142–3). In actuality, François found the vase in separate excavations at Chiusi (cf. Marzi 1980: 27–50).

5. Noël des Vergers, 1862–4: 47–8. Quoted by Dennis (1883: 508); Bonfante (1978: 136–7); Bonfante's translation is used here.

6. Körte (1897: 61–3) criticized Noël des Verger's account and its appeal to the popular imagination. One wonders if such an account might have influenced Federico Fellini: In one highly evocative scene from the great director's *Roma* (1971), modern engineers come upon ancient Roman paintings during the construction of the Metro, only to watch them fade and crumble before their eyes as modern, polluted air rushes in from their tunnel.

7. The lower portion of Vel Saties portrayed as a triumphator, for example, remains visible on the end wall of the right-hand side of the atrium: see Moretti and Maetzka (1970: pl. 105); Moretti (1982: pl. 30). Copies were made of the paintings before their removal and are now in the Vatican: cf. Messerschmidt and von Gerkan (1930: 111); Boitani (1986: 26–9); Blanck and Weber-Lehmann (1987: 207–15).

8. For the relation of Etruscan tomb planning to domestic architecture, see Prayon (1975); Boëthius (1978: 75–94).

9. These motifs suggest a connection between the tomb's decorative friezes and iconographical and stylistic trends in Apulian ornamental painting. Cristofani (1967) argued that these friezes were made from cartoons rather than representing the artist's free invention.

10. This has been a basic precept for understanding the layout of the tomb from the earliest scholarly literature: cf. Körte, 1897: 58; Messerschmidt and von Gerkan (1930: 13); Dohrn (1972: 205).

11. Bonfante (1978) is one of the few scholars to fully appreciate the crucial importance of sacrificial imagery throughout the tomb. I am indebted to her analysis for the discussion that follows.

12. On Charun and Vanth, see Pallottino (1952: 118). On Vanth, see also Richardson (1964: 146–9); Rallo (1974: 50–3).

13. Similar bandages are worn by the ghost of Agamemnon in the Tomba dell'Orco II at Tarquinia, dated to the last quarter of the fourth century B.C.: see Steingräber (1984: 334–7, pl. 130).

14. Messerschmidt and von Gerkan (1930) claimed seven similar illustrations of these scene were all taken from a single original; cf. Beazley (1947: 8–9, 89–92).

15. Brilliant (1984: 33, 173 n. 26) compares this to the assimilation of Greek models seen on the Ficoroni Cista; cf. Höckmann (1982: 78–87).

16. *ILS* 212, lines 22–3. See Momigliano (1932, 1934: 11–16); Bonfante (1978: 147).

17. Cf. Radke, s.v. "Vibenna," *RE* 8 A 2 (1958): cols. 2545–7, with additional references.

18. Indeed, many have argued for an Etruscan origin for the Roman Aeneas

legend: Bömer (1951: 39–40) (early fifth century B.C.); Alföldi (1957: 19–20) (sixth century B.C., for Alba); Galinsky (1969: 103–40, with references), believes that "Aeneas was known in Rome ... as the hero of the Etruscans" in the sixth century B.C., but that "in the first part of the fourth century the Romans had not yet come to consider themselves as Trojans." For those scholars who do not believe that the Trojan legend existed in Rome before the third century B.C., see Perret (1971: 39–52); Weber (1972: 213–25); Gagé (1976: 7–30); Cornell (1977: 77–8).

19. This Tarquin is unattested in any of the literary sources passed down to us.

20. On the popularity of the Theban saga's Eteocles and Polyneices in Etruscan art, see Ronzitti-Orsolini (1971); Small (1974: 49–50).

21. Alföldi (1965: 227–8) suggests that the artist deliberately chose to depict the heroic feats of the Vibenna brothers as a series of epic duels because this style reflected the way the oral tradition narrated their deeds; indeed, it was a preferred narrative structure for commemorating military feats: "Niebuhr observed long ago that the description of the battle at Lake Regillus in Livy does not give the clash of two armies but a series of heroic duels, as in the *Iliad* of Homer."

22. In addition, the Etruscan duels share an uncertainty in the chiaroscuro and a clumsiness in the gestures and movements, though the heads, all in profile, are effective and seem to have had the painter's full attention, notably in the expressive areas of chiaroscuro in the hair and beards and the shading of cheekbones and under the jaw. Significantly, there is a difference in the execution of mythological figures, and the technique used for the local Vanth and Charun.

23. Cristofani (1990: 18–19) sees little connection between the episodes of the Vibenna brothers and of Marce Camitlnas on the grounds that they are in different rooms, one facing the scene of the Trojan prisoners, the other independently related to the scene with Eteocles and Polyneices.

24. Messerschmidt and von Gerkan (1930: 136–7) doubt Noël des Vergers's attribution to this figure of an inscription referring to a "Tanchvil Verati," or Tanaquil Verati. After Vel Saties was buried in this chamber, another portrait representing him dressed in his triumphal finery was painted on the door; a fragment still remains in situ.

25. Dohrn (1972: 213) called the crown a *Totenkranz;* see Torelli (1975: 65) on the *corona graminea.* On the *vestis picta,* see Torelli (1975: 65); Coarelli (1972: 102); Bonfante Warren (1970: 64–5).

26. On the armed dance in Etruria, see Ryberg (1955: 7); Bloch (1958: 7–37); Poursat (1968: 550–615); cf. Servius, *ad Aen.* 8.285. Messerschmidt and von Gerkan (1930: 133–4) think the dancing figures on Vel Saties's mantle represent gladiators rather than armed dancers, while Bonfante (1978: 155 n. 17) points out their close resemblance to dancing Curetes on Augustan monuments. On the Salii, the warrior priests of Rome, see Bonfante Warren (1973: 588–9), with references.

27. Goidanich (1935) identifies the bird as a female picus, the bird traditionally used for the *auspicia;* the male has presumably already been released, and his flight is being closely watched by Vel Saties. See also Rebuffat and Rebuffat (1978: 88–104, esp. 101–3); Bonfante (1978: 139). Some scholars interpret the bird instead as a bantam falcon, in an aristocratic hunting scene: Pallottino (1952: 120); Bianchi Bandinelli and Giuliano (1973: 258). On birds in archaic Etruscan art as representing omens, see Brendel (1978: 146).

28. On elogia in the Republican period, see Ann Kuttner's essay in this volume.

29. Festus *de sig. verb.* 228: portraits of M. Fulvius Flaccus and T. Papirius Cursor. Pliny *N.H.* 35.22: M. Valerius Maximus Messala's victory over the Carthaginians and Hieron. See Vessberg (1941: 25–6, nos. 83 and 84); also Holliday (1980: 3–10). In this context, the fragmentary painting from a tomb on the Esquiline (now Palazzo dei Conservatori, Rome) is relevant. The Roman painting, dated to the early third century B.C., records events related to the Second Samnite War: Coarelli (1976b: 13–21); Felletti Maj (1977: 145–52); Bonfante (1978: 149–51).

30. Cf. Joan Connelly's discussion in this volume of the theme of the rape of Cassandra in Greek vase painting.

31. For the importance of *prolepsis* in Epicurean and Stoic thought, see Goldschmidt (1978: 155–69).

32. Nam translatio permovendis animis plerumque et signandis rebus ac sub oculos subiiciendis reperta est.

33. Keuls (1978: 121–34) suggests that, in addition to introducing descriptions of paintings into their discourses (*Bildeinsatz*), ancient rhetors may actually have used visual aids; on the term *Bildeinsatz,* see Schissel von Fleschenberg (1913: 83–114). According to Pliny (*N.H.* 35.23), Mancinus, the first Roman commander to breach the walls of Carthage, stood beside his triumphal paintings to explain details to spectators, whom he so pleased that he was elected to the next consulship; cf. Holliday (1980: 6–7).

34. Brilliant (1984: 73–4) also observes that in other contexts (specifically, Pompeian paintings), rhetoric allows for the possibilities of contrast and opposition, and of change in condition.

35. Ovid utilizes a similar narrative device in the *Metamorphoses,* where analogies alternate with continuities in the variations of fortune as an organizational device; cf. Otis (1970: 45–90).

36. See Genette (1976: 1–13), who emphasizes the distinction in Aristotle between *diegesis* (narrative) and *mimesis* (imitation) in *Poetics* 1448a. Cf. Andrew Stewart's discussion in this volume of Aristotelian aesthetics in relation to the Nike of Samothrace, and also Whitney Davis's discussion regarding theories of visual narrative emphasizing the unity of vision in the single field.

37. In his analysis of the narrative structure of Pompeian paintings, Brilliant (1984: 78) similarly described the enframement offered by a Pompeian room as "a hermeneutic field;" cf. also his discussion of Epicurean concepts of vision, 76–8, and Lee (1978). Ann Kuttner's discussion in this volume of the enframement of Antonius's monument in the Circus Flaminius is also relevant.

38. See Thompson (1961: 36–77) for a survey of the sources.

39. The site of the Stoa Poikile was recently discovered: cf. *AJA* 86 (1982): 285–6; for the literary testimonia, see Wycherley (1957: 31–45, nos. 47–98).

40. The Battle of Oinoe was unascribed and is a subject of uncertain interpretation; it may have represented an historical event or it may have been mythological: cf. Jeffrey (1965).

41. There is some confusion over the authorship of the Battle of Marathon, an odd circumstance for such a famous painting from historical times. The earliest sources fail to ascribe it to an artist. Later it is sometimes given to Mikon or Polygnotos; both Pausanias and Pliny give it to Panainos, the brother or more probably the nephew of Pheidias. Polygnotos is sometimes referred to in general terms as the author of the paintings in the Stoa; Robertson (1975: 244) suggests that he may have had some supervisory standing similar to Pheidias's position on the Periklean Acropolis.

42. For the testimonia, see Harrison (1972).

43. Among the recent literature that addresses this aspect of the program, see Moretti (1938); Simon (1967); Torelli (1982: 27–61); Zanker (1988); Holliday (1990b).

44. Petronius lampooned the pretensions of such programs in lower-class funerary art in his *Satyricon*, in which the tomb of the wealthy freedman Trimalchio features scenes from his life juxtaposed with motifs from Homeric epic; cf. Jane Whitehead's essay in this volume.

45. Cf. Thompson (1961: 36–77) and Brilliant's analysis of Schefold's contribution (1984: 62–8).

46. Brilliant's translation of Schefold (1962: 186). Schefold's premise that the paintings that decorated the rooms of Pompeian houses were intentionally combined into meaningful associations, often of allegorical as well as of narrative significance, was first suggested by Trendelenburg (1876: 1–8, 79–93).

47. Cf. Bonfante (1978: 148), who suggests that such inscriptions are an indication of Etruscan historicization in the visual arts.

48. As will be shown, the conception of cyclic organization in Etruscan tomb painting is broader than the method defined by Weitzmann (1970: 17–33) in which a coherent series of images represents stages within a *single* "text."

49. Coarelli first presented this reading in "Le pitture della tomba François – struttura e significato," a paper delivered at the American Academy in Rome in 1977; cf. Bonfante (1978: 138, 154 n. 13). See also Coarelli (1983b: 43–69).

50. Nancy T. de Grummond has begun to investigate more fully the depictions of augury on Etruscan mirrors.

51. "Sed licet veritas in obscuro lateat, tamen in una quaque civitate quae sint naturalia saecula, rituales Etruscorum libri videntur docere. . . . " Hubaux (1945) analyzed the difficulties and uncertainties that the Romans later faced in calculating the potential life of their city.

52. "Haec portenta Etrusci pro haruspicii disciplinaeque suae peritia diligenter observata in libros rettulerunt. . . . "

53. Most Etruscan tombs were decorated with motifs related to some aspect of an aristocratic life, and the themes frequently alluded to warfare. For example, cf. the late fourth-century Giglioli Tomb belonging to the influential Pinie family at Tarquinia; its frieze of arms probably refer to the last episodes of the war between Rome and Tarquinia in 308 B.C.: Steingräber (1985: 314–15).

54. For ancestral portraits in the atrium of a Roman house, see Zadoks Josephus Jitta (1932: 32); Rebuffat and Rebuffat (1978: 92–3). On *elogia* and *imagines*, see Hanfmann (1953: 39); Bianchi Bandinelli (1961: 172–88); Torelli (1975: 45–56).

55. Cf. Ann Kuttner's essay in this volume.

56. On the Roman custom of carrying ancestral portraits at the funeral ceremony, see the famous description in Polybius 7.53, 54.

57. See Torelli (1975: 45–56) on the *elogia* and divinization of members of the Spurinna family, portrayed in the fourth-century Tomba dell'Orco I and II in Tarquinia; Torelli contrasts the Greek custom of attributing divine ancestors to a family with the Roman aristocrats' emphasis on their famous historical ancestors, whose deeds were recorded in their *laudationes funebres*. See also Torelli (1983: 7–17); Steingräber (1985: 334–7).

58. On the ancestor cult: Prayon (1974); Dohrn (1976); Mansuelli (1968: 17 n. 48).

59. Nestor and Phoenix: Dohrn (1972) and Höckmann (1982); Sisyphos and Amphiaraus: Coarelli (1983b).

60. Bonfante (1978: 139, 156 n. 20) suggests that for the Etruscans this might be an appropriate convention for representing a "wise man."

61. In 356 B.C., 307 captured Roman soldiers were sacrificed by the men of Tarquinia (Livy 7.15.9–10); the following year the Romans retaliated, killing 358 noble Tarquinian prisoners. Both mass executions were carried out publicly, as rituals, in the forum of each city. See Heurgon (1961: 263, with references); Torelli (1975: 84–5).

62. For the gladiatorial games, see Heurgon (1961: 263–4); Pallottino (1978: 101). For the triumph as a purification rite, see Ryberg (1955: 33); Bonfante Warren (1970: 53–7). To be eligible for a Roman triumph, a general had to have commanded a war in which at least 5,000 of the enemy had been killed.

63. For the multivalent possibilities of historical time in antiquity, see Momigliano (1966: 1–23). For the reflection of Etruscan beliefs in the cyclical nature of time in Roman thought, see Holliday (1990b).

64. Von Blanckenhagen (1957: 78), for example, did not include such monuments as the Basilica Aemilia reliefs in his category of "continuous narrative" because he excluded "the sequence of coherent but separate, independent scenes representing one story, legend, tale or narrative . . . since each scene is a unit in itself and must be thus interpreted."

SOME NEW GROUNDS FOR NARRATIVE

Marcus Antonius's Base (The Ara Domitti Ahenobarbi) and Republican Biographies

Ann Kuttner

This study originated in a paper presented in 1985[1] about the "Altar of Domitius Ahenobarbus," which identified the patron who commissioned that monument with Marcus Antonius the grandfather of Antony the triumvir, a great Republican statesman and orator who was active in the late second and early first century B.C. Although Antonius had been linked to this monument before, my inquiry found new grounds for the identification. The reliefs in Munich and Paris[2] (Figs. 69 and 70), which once decorated the "Altar," represent triumphal booty and commemoration of a magistracy (censorship), respectively, and the pair is cognate to standard Roman biographic and panegyric structures that emerge by the beginning of the first century B.C., the period to which the monument should be dated. Since then, I have come to view this "Altar" – in fact, the base for a commemorative statue – as one of a class of such monuments, oblong commemorative statue bases with a figural frieze zone celebrating the patron, in evidence from the early second century B.C. on. The famous relief panels of the "Ara Domitii" now emerge as a deliberate collage of plundered Greek art and a panel cut in Rome to match, a collage whose intrusive stylistic disparities turn out the result of deliberate choice; this esthetic stance has its own moral and didactic weight.[3]

I move from a detailed discussion of the physical structure and setting of Antonius' monument to the stylistic and iconographic structure of its figured frieze zone. My emphasis is on commemorative strategies and narrative programs, and their relationship to concepts of narrative attested elsewhere in Republican culture, by texts (rhetorical theory, oratory, history and autobiography, panegyric in prose and poetry) and by other monuments and monument complexes. The base analyzed here and its genre expand our potential understanding of the ways in which Roman commemorative statuary was understood to imply a narrative; style itself can be seen in this period to be capable of holding narrative significance. Such a study widens our knowledge of what sort of

stories the Roman elite wished to tell through images, about their
own achievements and about the Republic they claimed to serve;
their aims, methods, and vehicles for commemoration anticipate
developments usually seen as Augustan.

MARCUS ANTONIUS' MONUMENT AT THE
CIRCUS FLAMINIUS

The *Ara Domitii Ahenobarbi* consists of two friezes that revetted
one tier of a monumental basis (5.65 × 1.75 m) that stood *in circo
Flaminio* before the *aedes Martis* and *aedes Neptuni:* (1) (Fig. 70) a
sea-thiasos (Glyptothek, Munich), the wedding of Poseidon and
Amphitrite, recut to revet one long and two short sides of the
basis; (2) (Fig. 69) a frieze panel (Louvre, Paris) for one long side
of the basis, whose central scene shows a *censor* in the company
of Mars about to celebrate the sacrifice closing a *lustrum.* Where
are the Paris and Munich friezes from, and how can we know
what they decorated?

The modern circumstances in which these friezes were found,
made known to artists and antiquarians, and dispersed to end in
their present locations, have been well-documented. Dug up
when foundations were laid in 1637 for the church of San Sal-
vatore in Campo, the friezes were built into the wall of the Palaz-
zo Santa Croce cortile while it was being decorated for the Monte
di Pietá. This installation involved the removal of marble from
the back of the slabs and along their top, destroying most of the
once-prominent "architrave" (ca. 12 to 14 cm) over the corner
pilasters of the friezes, which are now ca. 80 cm tall, with about
8 to 10 cm missing (Kähler 1966: 7f., 12; Coarelli 1968b: 305f.).
The church of Santa Croce was built over the site of a Roman
temple at the northwest end of the Circus Flaminius (Fig. 71);
some, led by Coarelli, identify it with the Temple of Neptune,
erected by 206 B.C. (cf. Wiseman 1976: 159, plan at 160), others
(cf. Wiseman 1976, 1987: 214; Zevi 1976),[4] with the Temple of
Mars built by Brutus Callaicus in 132 B.C. This end of the Circus
lay by the Navalia, the shipyards of Rome (Coarelli 1968b: 317–
18, 1970–1: 245f.; Olinder 1974: 42–5).

The two different friezes actually are made of two sorts of mar-
ble, a fact publicized only recently. The *thiasos* blocks are of some
kind of East Greek marble (whitish with blue streaks, similar to
Proconnesian), but the *census* frieze is made of a different marble
described as "a grain serré, plutôt fin" with no streaking observed.[5]
The *thiasos* frieze shows signs of having been recut in antiquity to
fit its use in Rome; this recutting, and the use of two different

sorts of marble in one set of friezes,[6] means that the *thiasos* is *spolia* removed from another context. The friezes did not once form part of an actual building, or they would not have been supplied with their own moldings or especially with corner "pilasters"; instead, given their scale, they must have ornamented some monumental construction that was not a building. This core probably stood about three Roman feet high (ca. 90 cm), and with revetments in place, it was about about 1.75 × 5.65 m on the sides. Thus, it was an oblong structure accessible to view on four sides. It was certainly not any kind of ancient altar; European scholars generally speak now of the Paris–Munich reliefs, but in English texts, the monument still keeps the misleading nickname "Altar of Domitius Ahenobarbus."

Once San Salvatore was identified with the temple of Neptune, the friezes were drawn into a different art–historical vortex, the continuing discussion of the group of Poseidon in a thiasos with Thetis and Achilles by "Skopas," which Pliny says was put into the Temple of Neptune built/restored by Gn. Domitius Ahenobarbus in the 40s B.C. (*NH* 36.26). There has been a natural temptation to associate the group described in texts with the thiasos friezes in Munich, and so to identify them with a base for these statues, set up either in or in front of the Temple of Neptune (Lattimore 1976: 16–81). When it was recognized that this structure could hardly have held all the figures named by Pliny as belonging to Skopas's group, authors reverted to calling it an altar (Lattimore 1976: 18), or made it the base for the cult statues that stood in the temple (Coarelli 1970–1: 248; Wiseman 1976).[7] Recently, a few scholars have commented in an offhand manner that it might simply have been a base for a votive or anathema (Zevi 1976: 36; Torelli 1982: 8; Simon 1986b; Zanker 1988: 22), probably outside the temple (Wiseman 1976, 1987: 214).[8] While the

69 Census scene, with Marcus Antonius. Paris, Musée du Louvre inv. 975.

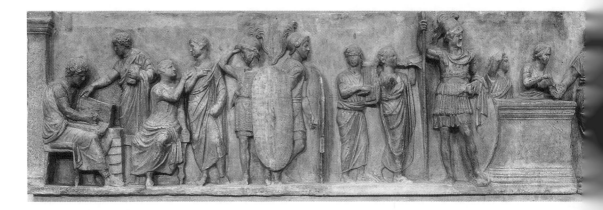

monument is universally recognized to be a Republican piece, dates have ranged through the last two centuries B.C. (Strong 1988: 337).

The dimensions of the reconstructed rectangular mass are those of an intermediate member in a taller rectangular structure, whose surface was given architectural definition. Certainly, it was not any kind of Roman altar; the eccentric proposition (Hafner 1987) that it was a Late Imperial-type sarcophagus for a Republican Roman general is easily dismissed (e.g., by Lattimore 1976). Just as surely, this cannot have been a cult statue base: In all of Greco–Roman antiquity, at the court of the most megalomaniac Hellenistic king, there is no parallel for a cult statue base on which was depicted the career of a human patron. Rather, it must have been the base for some large piece of commemorative statuary, set up as a votive; its proportions and dimensions accord fully with such an hypothesis.[9] It was obviously meant to be viewed as easily from one long side as another; this and its dimensions show that it cannot have stood actually *in* the 8 × 10 m cella of the Aedes Neptunis, as often claimed, nor in the cella of the Aedes Martis (Simon 1986a), but rather must have stood out in front of it, where all four sides could be seen. This is a typical way of setting up votive statuary in the Republic.[10] Compare the bases excavated from in front of the temples of the Largo Argentina and the S. Omobono precincts (Coarelli in *Roma medio-rep.,* 1973: 100ff., 117ff.), areas where temples put up *de manubiis* accreted as they did (Coarelli 1970–1: 176f.) around the Circus Flaminius, or the placement of the Heracles Olivarius base (CIL VI.33936) before the round temple on the Tiber (Mummius' T. Heracles Victor) rather than inside it (Ziolkowski 1988: 323).

Once this mode of siting is recognized, one can resolve a major iconographic crux, that is, the religious double nature of the Paris–

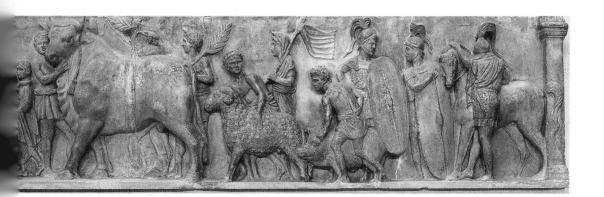

Munich assemblage, which honors both Mars and Neptune, one on either long side. Scholars have worried over *which* divinity the base was devoted to[11]; the answer is, both. The Temple of Neptune stood near the Temple of Mars erected by Brutus Callaicus in 132 B.C., and our monument will have been set up so as to be in significant range of both temples at once.[12] That such a joint dedication was possible is shown by the fact that a unified act of worship could be directed toward the two neighbors:[13] in the last quarter of the first century B.C., the Arval Brethren are on record sacrificing jointly to *Mari Neptuno in Campo*.[14] This line of reasoning, by the way, establishes 132 (dedication of the T. Mars) as a *terminus post quem* for the Paris–Munich base. There was certainly a sacred area demarcated before the Temple of Neptune in which such a votive could have been put, for Pliny called it a *delubrum,* and Varro defines such a temple as one with an *area assunta*.[15] A parallel is the siting of votive statuary before the twin temples of Fortuna and Mater Matuta in the Area Sacra of S. Omobono. Here M. Fulvius after taking Vulci in the fourth century B.C. set up two separate bases for bronze statue groups, presumably one in front of each temple; another, probably later, votive was a splendidly articulated round base for a bronze group set up on the axis of the passage between the two temples, so as to serve both at once (Torelli in *Roma medio-rep.* 1973: 100f., cat. 89, pl. 23).

What would have been carried by such a basis? Plainly, in terms of basic commemorative function, our four-sided base was constructed to have a primary face, that depicting the censorship. This long side, carved in Rome, is framed by the other three like a ring bezel in its setting[16]; it is also the side on which the patron himself is depicted, holding central place. This main face will have confronted a spectator approaching on the most obvious route. A later analogy is the siting of the Altar to Vespasian in its precinct off the Forum at Pompeii (La Rocca 1976: 118 [view altar], plans 103, 105, 121, descr. 120); the main, narrative face (Vespasian at sacrifice) confronts the viewer who enters the compound, framed by three sides filled with symbolic objects and backed by the temple facade. The *titulus honorarius* of the original monument then

70 Seathiasos, the wedding of Poseidon and Amphitrite. Munich, Staatliche Antikensammlungen. Glyptothek inv. 239.

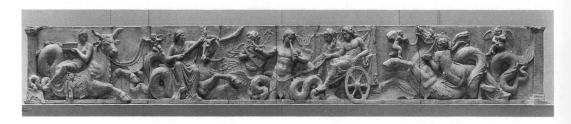

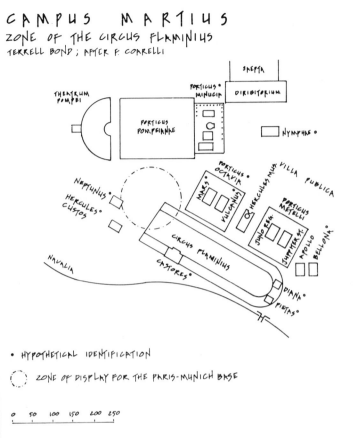

CAMPUS MARTIUS
ZONE OF THE CIRCUS FLAMINIUS
TERRELL BOND; AFTER F. COARELLI

• HYPOTHETICAL IDENTIFICATION

ZONE OF DISPLAY FOR THE PARIS-MUNICH BASE

0 50 100 150 200 250

71 Plan of the Campus
Martius, Zone of the Circus
Flaminius. Drawing: Terrell
Bond, after Coarelli (1977).

will have been set upon this side, and in its direction will have
faced whatever stood on top.

The base is quite large,[17] far too roomy for a single portrait
statue on foot (*statua pedestris*). Its dimensions of ca. 1.76 × 5.65
m might suggest an equestrian statue, as documented for other
bases of 4- to 5-m width. However, these equestrian statue bases
typically have a small side as the principal face bearing the *titulus*
(Eck 1984a: 210–11, 1984b: n. 127 at 162), for such statues face
down the long axis of their bases (cf. the base with with hoof
holes at Kaunos for the Republican *imperator* Murena (Tuchelt
1979: pl. 5.1.)). The contrasting basis format here indicates an
alignment of the crowning statuary on the short axis of the base,
ruling out an equestrian figure. The shallow depth of this short
axis also rules out another option in the honorific statue repertoire,
a chariot group. Most plausible is a statue *group* of some three to

five figures,[18] paratactically disposed to front the viewer of the
Paris frieze,[19] with a strong central accent. Such a group could
have included the patron and other members of his family, per-
sonifications like Victory or Ocean, or emblems such as trophies
or captives. The three-beat structure of the long panels (see infra)
further suggests a group with a strong central accent and comple-
mentary flanking figures and/or objects. This typical Republican
and Imperial honorific scheme[20] was already in use by 91 B.C. for
Sulla's victory monument on the Capitol, depicted on coinage of
57 B.C. (Crawford 1974: no. 426.1; cf. Schäfer 1989; Plutarch *Mar-
ius* 32, *Sulla* 6).[21] By midcentury, the sculptural scheme occurred
naturally to the designer of the Villa dei Mysteri Dionysiac hall,
as model for the painting of a contemporary bride flanked by
Amores on separate "pedestals" (ill. Simon 1986b: 177f.; Andreae
1973: fig. 32). Because our Mars is singled out on the primary
face, and the sea *thiasos* reliefs are *manubiae* (a triumphator's booty),
the crowning group probably had an overtly military and trium-
phal theme. The setting is also suggestive—every known monu-
ment at the Circus Flaminius, starting with the Circus itself, was
built to celebrate military achievement (Coarelli 1976a: 27f.).

The base is clearly meant to honor a particular person. As Late
Republican censors are not all that thick on the ground, many
have tried to name this patron. What transforms the whole dis-
cussion is Wünsche's observation that the *thiasos* (Fig. 70) is not
Roman at all, but rather something taken away from Asia Minor.[22]
The fact that this thiasos is a piece of recut *spolia* is key to the
understanding of the monument (contra Torelli's statement, 1982:
22 n. 2, that "Wünsche's conjecture if true would not alter the
problem of the conception and meaning of the whole monument
in its final, Roman appearance"). Its patently Hellenistic origin,
highlighted by the stylistic contrast with the Roman slab that it
was recut to frame, would have made very plain to a contem-
porary observer that it was reused booty. The reliefs were dis-
played in one of the favorite locations in which Republican
generals not only spent cash from converted booty, but also re-
dedicated stolen works of art; a Roman would naturally guess at
triumphal spoils. Finally, the fact of seizure would also have been
spelled out explicitly ("*X cepit . . . dedit*") by the inscription that
once graced these reliefs in their Roman *publicatio,* a text that
might even have named the exact city of origin; witness here are
extant dedications, for example, by M. Claudius Marcellus (211
B.C.),[23] Flaminius (192 B.C.),[24] M. Fulvius Nobilior (after 189
B.C.),[25] and the most famous extant Republican display of *spolia*,
Aemilius Paullus' column monument at Delphi (197 B.C.).[26]

Manubiae were typically dedicated at Rome itself by someone

who had been granted a triumph. Such a man would have had vast quantities of spoils from which to choose to construct a public monument. The patron must have known when he choose the *thiasos* frieze that it would immediately suggest a triumph for victories *at sea*. The other panel commemorates the successful completion of a full 5-year censorial term, a *lustrum,* culminating in the lustral sacrifice (*suovetaurilia*) shown at its center. Only one man in the last two centuries of the Roman Republic held a censorship that included a *lustratio,*[27] and also celebrated a triumph for victories at sea: Marcus Antonius M.f. M.n., *praetor* with proconsular imperium 102–100 B.C., celebrated a triumph in late 100 for victories over the Cilician pirates, was consul in 99 and censor 97 B.C. He was killed by Marius in 87 B.C.[28]

Antonius's name has been championed before, especially by Coarelli. This chapter is concerned, however, with the phrasing of questions as well as with the generation of answers. Previously, scholars worked to show that a *thiasos* belonging to the wedding of Poseidon and Amphitrite would have been understood, purely on iconographic grounds, to refer to a sea triumph. The reading put forward here recognizes that it is the status of the Munich frieze *qua* booty that makes it a legible vehicle for triumphal proclamation; this legibility, of course, was augmented by the general associations of the specific subject with the idea of triumphal celebration. At Pergamon and other Hellenistic courts, tritons and sea thiasoi had become symbolic of triumph and sovereignty in a general sense; in the Late Republic, this iconographic theme became for Romans linked specifically to triumphs won in sea battles and over pirates, as in the commission by an early first century B.C. *imperator* at Miletos, slightly later than our monument (Waelkens 1987: 96 n. 15; La Rocca 1986: 94; Meyer 1983: 88; Hölscher 1979: 339; ill. Hanfmann 1975b: Figs. 84–5; Tuchelt 1979: 113–14).[29] If the marble of Antonius's *spolia* is indeed from the Asia Minor coast, his area of *imperium,* would this in itself have been noticed at the time? In the case of temples[30] or of large lots of stone, such as columns installed in one's house, this could be so, but for a mere statue base, it is less probable.

The implications of this reading are various. First, because the Greek frieze (Fig. 70) is a piece of art made for a completely different purpose, none of whose details was altered, its cast of players cannot be interpreted to refer in any way to subtleties of Roman religious belief or aristocratic genealogical claims (Wiseman 1974/87).[31] Instead, it is legible at an extremely basic level; although a highly educated spectator contemplating the basis might enjoy reciting appropriate lines of Greek poetry to himself during his meditation, the meanest member of the city rabble

could comprehend it at once as a beautiful prize, alluding to victory at sea. The monument of Marcus Antonius, then, belongs with the large body of evidence on triumphal display of booty, and its relevance for those seeking further, civilian office. In the Late Republic, a very good road to the censorship lay through a successful campaign. A general who wanted a triumph and then a censorship had an observable advantage in the elections if he brought rich booty to Rome, vowed, for example, a temple, put a lot of art on display, and seemed disposed in the light of his disbursements to be able and willing to conduct a censorship in which he would materially benefit and beautify the city (see Pape 1979).[32] Booty or its lack was not a single deciding factor in any such election, of course, but the advertisement of its possession belonged to the general strategy of running an efficient campaign for an office connected with public works.

The outlining of an individual *cursus honorum* on the Paris–Munich base, that of *triumphator–censor,* is, one might say, explanatory as well as annalistic. It is at once a promise, and a fulfillment of a promise: "I possess great resources in the form of *manubiae* which I will spend on you, fellow Romans, as censor, paying for building projects and putting my artistic spoils on display for all of you." The record shows that Marcus Antonius as *censor* did indeed leave his mark on the city. Even more interesting here is that the chief project he undertook as *censor* made quite specific reference to his triumph, and to the fact that it had been won in Neptune's domain. In the Forum Romanum, Antonius spent his *manubiae* to refurbish the great speakers' platform, the Rostra (Cicero *De Orat.* III 3, 10); this platform was called "the Prows" (*rostra*) because it was faced with the trophy beaks from the crucial early Republican naval victory at Antium. Antonius surely added prows from the pirate fleets he had himself defeated (Murray and Petsas 1989: 118–19); the commission itself, with its consequent inscription, will have shown off his naval victories as equal to the Battle of Antium in saving the state from a foreign menace.[33] (And how apt that a man passionately committed to the cause of public oratory (see what follows) should have devoted his attention to the most important oratorical platform in Rome!) Antonius also repaired and improved the Navalia (Cic. *De Orat.* I 14, 62), the state shipyard and military port located on the Tiber in the Campus Martius near the end of the Circus Flaminius, where the temples of Mars and Neptune were located, though it is not clear whether he did this in 102 B.C. (setting out for Cilicia) or after 97 B.C. (as censor). In any case, he was active in the physical vicinity of the monument here attributed to him.

Before moving on, it is worth asking some questions about the

aedes Neptunis. One would expect Antonius to have concerned himself with this very temple, especially for a sea triumph. In fact, it is very probable that he was responsible for the temple's rebuilding in this period. To reconstruct the Navalia, Antonius turned to the architect Hermodoros of Salamis (Cic. *De Or.* I 14, 62), who also built the Temple of Mars for Brutus Callaicus out of his spoils (Nepos fr. 13). At some time in these years – texts are lacking – the temple of Neptune was rebuilt on a purely Greek plan that looks "Hermodoran" (peripteral, no podium). The hypothesis arises that both temples were designed by Hermodoros, and is strengthened because their interior (cult) statuary was by the same Skopas, a second-century Greek artist established in Rome[34]; Hermodoros and Skopas were both involved too with Mummius's Temple of Hercules built *ex manubiis* (Ziolkowski 1988). It would indeed be astonishing if Antonius had not concerned himself with building or restoring an *aedes* with his *manubiae.* Surely, the late second-century Temple of Neptune is this obligatory temple project, carried out by an architect who worked for Antonius in other contexts also, and who was in demand among Roman triumphators for their commemorative monuments. Skopas's *thiasos* of Thetis bringing arms to Achilles should then be considered Antonius's commission as well, though disassociated from the Paris–Munich basis to which it is so often linked; its overt triumphal message needs no explication. Antonius's involvement with the Temple of Neptune receives indirect confirmation from Gn. Domitius Ahenobarbus' documented involvement with the same temple decades later. Ahenobarbus was a close ally to Antonius's famous grandson, Antony the triumvir; just as Antony's old admiral Sosius when ally to Augustus rebuilt (ca. 20 B.C.) the Temple of Apollo *in circo* with his *manubiae,* but decorated it to compliment his leader Augustus (La Rocca 1985a; 1988: 121–9), so perhaps Ahenobarbus may have concerned himself with the Temple of Neptune because the genealogical link with Antony's grandfather made it a compliment to Antony.

I have hardly discussed yet the actual images upon this base; where does narrative come in? The web of reasoning and inference before is based on reconstructions of the ways in which Roman aristocrats tried to tell important stories about themselves and what they had done, by exhibiting and commissioning public monuments to their deeds. Much of the narrative potential in any such physical record resided in aspects that are often forgotten, or obscured, by a narrow focus on specific artistic or architectural details. One aspect cannot be stressed too much: Any tangible honorific commission was accompanied by an inscribed text. This

is why it is legitimate to expect that a spectator might try to "read" other parts of a monument; familiarity with the basic formulas of such dedicatory inscriptions teaches the modern detective what seemingly recondite physical information might in fact have been made verbally explicit. Both epigraphers and art historians need a better grasp of one another's material if they are to be faithful to the task of understanding an ancient monument (Eck 1984a: 201).[35] Roman dedicatory inscriptions, wherever room permitted, gave not just the patron's filiation, but the details of his public *cursus;* Roman commemorative monuments, therefore, always implied a life story in however abbreviated a form. In looking for textual analogues to illuminate artistic program and style, one does not have to confine oneself to such condensed dedicatory narratives; however, it has to be recognized that the genre immediately analogous to a commemorative monument is that of panegyric commemoration and historical narrative, which includes such texts (see what follows).

Second, one needs to be aware that a good deal of story was narrated simply by the physical existence of the honorific artifact. In the highly charged natural and man-made geography of Rome, where a monument stood was very much part of its story. This is why one can use knowledge of physical context to try to answer questions that did not vex the original viewers; for them, contextual associations would have acted simply to condition and deepen their response. Thus also it is legitimate to reconstruct details of location from iconographic aspects of the honorific monument itself. This base, for instance, comes from a location where triumphal dedications were traditionally set, around the Circus Flaminius, where triumphal processions were prepared and booty displayed. What it did, in effect, was to put on permanent display a piece that would have been temporarily exhibited in the same place several years previously. In itself, it became part of the accreted series that would frame future dedications *de manubiis.* And its census depiction would be just as apposite; on the one hand, it would stand as an inspiring *exemplum* for any future triumphator, a promise of what was possible for him and also an injunction as to how to conduct himself in such an office. The great assemblies of the *plebs* held in this *circus* would see such a monument, too, not just as an *exemplum* and piece of successful individual propaganda, but as an exhortation to military service and a hint of its rewards. In its own small way, a monument like this is not entirely dissimilar from the appeals Marius made (possibly in this very area) for recruits and votes, as depicted by Sallust (*BJ* 84.5ff.).

Finally, knowledge of sacred topography and its customary function might be used, as here, to construct apt puns on the

typical sequence of episodes in political ritual. The fact that a frieze
full of nymphs frames on three sides an image of censorial record
taking, puns on the reality that the censorial tablets prominent
here were kept in the Temple of the Nymphs[36] down at the other
end of the Circus,[37] about 200 yards from the Altar of Mars shown
in the middle of the panel. This matches the more explicit and
oft-noted topographic reference to the Campus Martius (Field of
Mars) made on the census slab, by the depiction at its center of
the *Ara Martis in Campo*.

THE PARIS AND MUNICH FRIEZE PANELS

The final aspect of this base's identity is, of course, the figured
decoration of its frieze zone (Figs. 69 and 70).

The story of the Munich reliefs (Fig. 70) was inherited by the
Roman patron ready-made, and the details of their iconography
belong rather to a discussion of Hellenistic art; their artistic worth
is self-evident. The perception of this excellence was evidently the
motive force for Antonius's seizure of these reliefs in Asia Minor
and his transport of them to Rome, and for his installation of
them at Rome in public. It has long been noted that these reliefs,
in conjunction with the Skopaic *thiasos* immediately adjacent in-
side the Temple of Neptune, seem to have spawned direct imi-
tations in the decorative arts, for example, in mosaic[38] and
decorative marblework[39]; these borrowings support the assertion
that the basis stood in the open air where the *thiasos* was freely
visible. The Munich reliefs are assumed here to speak at a very
basic level, as a divine wedding with triumphal overtones, a sea
story, a lovely and appealing sensuous depiction in a recognizably
East Greek stylistic mode.[40] The wedding of Neptune, as the Ro-
man spectator would have named him, already had triumphal con-
notations in the Pergamene sphere[41]; if it did not already have
them in Rome, then this inscribed display of *manubiae* will have
easily established the link. Romans were also already used to as-
sociating Amor with the victorious aftermath of war, either in the
company of Venus, the consort of Mars, or appearing on his own;
the Amorini who here rein in the plunging horses of the sea
would have been read easily as metaphors for the prosperity fol-
lowing the "taming" of the sea lanes by Antonius's defeat of the
Cilician pirates.

I mentioned before the surprising fact that nymphs are icono-
graphically appropriate to censorship, because the censorial records
were stored in the *aedes Nympharum*. The specific subject of this
nymphikos thiasos (the wedding of Poseidon and Amphitrite) might

have suggested the Temple of the Nymphs even more strongly, if its cult rituals around 100 B.C. included ceremonies described by the later, imperial writer Johannes Lydus (*de mensibus* 4.154); the *dies natalis* of the *aedes Nympharum* was December 1, and Lydus says that December opened with a salute to Poseidon, Amphitrite, and Aphrodite. This evidence has been cited to prove that "the mythical scene has just one unequivocal meaning – the wedding of the two great gods of the sea and therefore their close association in cult" (Torelli 1982: 7). The thiasos image seems rather to have a broad range of meanings; and the implication of my *manubiae* theory is the Munich panels were not created to have a Roman message for a Roman context involving the specifics of a Roman cult. Finally, neither their iconography nor Roman setting justifies reading them as a theological primer for religious practice at a temple where they were not dedicated. In a very important aspect, the Munich panels conflict with Lydus's information. Venus, stressed by some scholars (Torelli 1982: 7–9; Simon, 1986b), is in fact absent from the basis friezes, though she could easily have been introduced, and would fit well as being also Mars' consort. The nymphish and matrimonial aspects of Neptune's epiphany flesh out his characterization, but this characterization is secondary within the whole set of friezes to his apposition to Mars, which is primary. Lydus's text does show how the base's reference to the *aedes Nympharum* (through the censorship) might perhaps have been poetically extended by particular overtones of that cult, but no more.

As for the Paris census slab (Fig. 69), the procedural details of the *census* image are not at issue here. Much has been made of small details of armament, in an attempt to read very specific political and historical messages; I believe, rather, that the panel was meant to be read at a quite basic level as showing the knights, the light-armed and heavy-armed infantry. Claims have been made that the relief cannot postdate the Marian reforms, after which the census lost its military significance (Torelli 1982: 13f.; Simon 1986b), but this is not historically correct. Marius's innovations had nothing to do with the forms of censorial enrollment and these traditional forms survived Marius (E. Gabba in *Hellenismus in Mittelitalien,* 1976: 36). The textual sources up through the reign of Augustus (at least) unite in attributing to the censorship as a primary function the guardianship of military strength by means of military registration, and they continue to be especially fascinated by the spectacle of the knights' parade with their horses. One can claim that these processes did not in fact materially contribute to the functioning of the state; what matters for the interpretation of a commemorative monument is that Romans *thought*

that the censorship *was* a potent force for imperialism.[42] The censor appears here precisely as the steward of Rome's military might, as magistrate and priest. He also appears as the colleague and companion (*comes*) of Mars; there is a rich tradition that associates men with gods in the last century of the Republic,[43] and this is one of its earliest examples. Mars on this frieze in fact displaces Antonius's censorial colleague.[44] The panel is not simply meant piously to transcribe *lustratio* and *census* rite but to celebrate the censorial tenure of a *particular* noble individual. (Compare how Scipio put his name alone on the Pons Aemilia that he and Flamininus had in fact built together as censorial colleagues (Ziolkowski 1988: 329).)

Compared to the Munich *thiasos,* the Paris *census* relief initially seems so different in technique as to be the work of an artist who simply could not carve very well, an example of the first fumbling steps of Roman craftsmen toward the glories of historical relief exemplified by the Ara Pacis. This is how the Paris census figures all too often in surveys of Roman art. Rome, with the rest of central Italy, in fact had been familiar with Hellenistic depictions and techniques for the past 200 years. One should remember, for instance, that the standard terra-cotta architectural sculptures of the Middle Republic, whose disappearance was so piously mourned by moralizing pundits at the Republic's end, did not look in the least like the stiff stylized figures of High Archaic Veii. As surviving architectural and votive terra-cottas from Latium and Etruria show, they would rather have exhibited the same characteristics of intense flamboyance, dramatic emotional expression, and technical brilliance in composition, anatomical modeling, and surface treatment observable in marble and bronze in the eastern Mediterranean; extant friezes that "document" civic rites assimilate this vivid figure style to a slightly sobered compositional structure (e.g., Pensabene 1982). It is clear, too, that accomplished Hellenistic battle depictions in relief were well within the reach of Central Italian stone carvers at this period; the Mantua frieze (Strong 1988: 88, Fig. 40, n. 28), probably from a basilica, has long been known, and now such a battle frieze has turned up in the atrium of a magnificent aristocratic residence at Fregellae (Coarelli 1987: s.v. Fregellae).[45]

Why, then, the seemingly stiff and "awkward" groupings of the Paris census? The use of this stylistic mode is conditioned by notions of *decor* in regard to two aspects: the status of this frieze as a base molding, and its narrative content and function. First, in the Greek East as well as in Rome, sculptors carving subordinate sculptural elements would often deliberately subdue their style in the interests of architectural decor. This kind of decorative sub-

ordination is a well-known characteristic of Hellenistic architectural friezes, as at the temples of Lagina (Havelock 1981: cat. 159–60; *LIMC* s.v. Ares no. 109 (Simon)) or Magnesia (Havelock 1981: cat. 158).[46] The battle frieze atop the Column Monument of Aemilius Paullus of 167 B.C. at Delphi, made by Greek sculptors, is another good example (Pollitt 1986: 155f., figs. 162–4). The same phenomenon, of decorative austerity or "primitivism" practiced by artists capable of quite different illusionistic styles, gave rise to a whole genre of "small friezes" in Roman commemorative art, from the Augustan friezes of the Temple of Apollo Sosianus (La Rocca 1985a: figs. 22–7; 1988: 136–48) and the inner altar of the Ara Pacis (sacrifice, personifications) (Ryberg 1949; Simon 1975; Torelli 1982: chap. 2; La Rocca 1988: 400–26; Smith 1988; Viscogliosi 1988) to the friezes of the Arch of Titus (Pfanner 1983), Forum Transitorium (von Blanckenhagen 1940; Girard 1981), and beyond.[47]

There is still the "awkwardness" and seeming simplification of single figures and their groupings. Figures do not overlap, their gestures are exaggerated, and their postures are expressive rather than graceful. Yet this style does serve the aim of legibility, making quite clear the steps in a complicated series of civic and religious rituals associated with the *census;* one can link this style to the language actually used to describe religious and legal ritual (Torelli 1982: 9f., 19f.). It had been evolved already by the third century to serve the same function of annalistic record as here, witness the registers of painted military annals on the facade of the Esquiline Tomb (Strong 1988: 40, fig. 11; La Rocca 1986); late second-century/early first-century coinage shows that it was considered the appropriate style also for depictions of civic rite.[48] Expressive "awkwardness" in the depiction of single figures, after all, was also in the Hellenistic repertoire by this point; it was used to notable effect to give a kind of everyday vividness to a number of the scenes on the Telephos frieze (Havelock 1981: cat. 166–7; Pollitt 1986: 198f., schema fig. 213), as if to bolster their claim to historicity.[49]

The distinctive flavor of the Paris *census* is the result of artistic choice, not of artistic ineptitude. Its style seems to have been chosen to fit notions of *decor* that can be reconstructed, not just from the material record (subordination of "molding" friezes), but also from known moral and rhetorical canons of Republican Rome. The character to which every Roman noble was supposed to aspire was one of *gravitas* and *dignitas;* such rhetorical forms as annalistic history, deliberative and analytic oratory were held to demand a style with the same characteristics. Deliberate archaism, the evocation of styles considered more primitive, was one means

to this end; austerity of style, insofar as it suggested an earlier age, was held to to evoke the stern *mores* that Romans habitually attributed to a previous generation. Just so, Mummius put a Latin verse inscription in the vigorous, rasping Saturnian meter (CIL I2 626 = VI.331; ILLRP 122) on the front of his temple of Hercules, which had been faultlessly constructed in a Greek style in Greek marble by the Greek architect Hermodoros.[50]

Style is used here, therefore, as a carrier of meaning, to describe the character of the patron responsible for this image, as well as to imply a grave virtue and probity to his exercise of censorial office. The Paris census is in fact an extremely carefully crafted composition, which employs recognizable Roman conventions for narrative order. The slab actually depicts two distinct events, which the viewer is meant to read right/left/center:[51] the *census* of military *classes*, featuring the *transvectio equitum*, is carved at left and at right to frame the central episode, the censor's performance of a lustral sacrifice (*suovetaurilia*) to Mars, who stands in front of one end of his altar.[52] (One can compare Mars on the Civita Castellana Base (Ryberg 1955: 27; Andreae 1973: figs. 201–4; La Rocca 1988: 382–3, cat. 213; Strong 1988: 50–1, Fig. 18, n. 35) or Apollo on the "Ara Borghese" (Felletti Maj 1977: pl. 22, Figs. 59 (a–d), 170f.; Strong 1988: 50, n. 35).[53] Established Latin figural compositions supplied the basis for both the altar group (compare the Via S. Gregorio terra-cotta pediment,[54] ca. 130–100 B.C. (Dohrn 1972: II, cat. 1605, 408ff.; Felletti Maj, 1977: 140f., fig. 41; Coarelli 1968a: 345, figs. 20–2)) and the census composition (compare the third-century Villa Giulia Praenestine cist (Kuttner 1991)), and so both compositions would have been immediately legible. At the same time, the artist went to great pains to make this slab, at first sight so different from the *thiasos*, harmonize with it in style and composition.

The faces of the Paris figures are actually not so very different in treatment from faces on the Munich slabs, as Kähler (1966) showed long ago. Persistently frontal self-presentation also characterizes both friezes. In composition as well, the Roman master took the preexisting *thiasos* into account and adapted his depiction to it. The most telling detail is the Paris altar group, which consists of a lyre player and a flutist immediately to the left of Mars, the presiding divinity at the *lustratio*. Flute players appear in most Roman altar groups, as they did in actual cult, although this one is very unusual in that he dances forward with his head thrown back, flutes up, spiraling on one foot; Roman *tibicines* usually stand still, flutes decorously lowered, immediately behind or next to an altar. The lyre player is also somewhat anomalous – indeed, lyre players are not documented as part of the Roman sacrificial apparatus in

any ritual text. The paired *tibicen* and *citharoedus* do turn up from the fifth to second century B.C. on Etruscan funerary reliefs that paraphrase real civic processions, magisterial,[55] triumphal,[56] and (n.b.) equestrian[57]; and there seems to be a *citharoedus* right of the flute player behind the altar on the Late Republican "Ara Borghese" (see before), the only other (possible) example I know of such an altar group. Comparison with these examples, however, shows quite clearly how the Roman artist of the Louvre *census* constructed his musical group to echo the arrangement in the marine *thiasos,* where to the left of the presiding divinity (Neptune) is a pair of matched (triton) musicians, first a puffing flute player[58] and then a lyre player busy strumming. Just like the *census* players (though their relative positions are reversed), these triton musicians look in opposite directions, one in profile, the other turning his face out to us.[59]

The Paris composition echoes the Munich slab throughout. To begin with, there is the structure of the whole face: a central group with divinity and companion (Amphitrite/censor), flanked by figure groups moving/facing toward the center; each god leans an elbow over a large circular object in three quarters view (wheel/shield). This similarity is underlined by the correspondences between the most prominent flanking figures at either end: The twisting Nereid at right, the only figure in this slab shown from the back, corresponds directly to the similarly sited knight; her sister's elegant cross-legged sprawl and turned head are mirrored by the seated magistrate in Paris. The remaining points of correspondence are worth listing to establish the validity of my re-vision; the artist's attention to detail throughout is itself noteworthy. The great bovine mask on the Munich frieze, facing Neptune and eyeing us, is echoed on the Paris panel by the great bull head swung out toward us in Mars' direction; the Munich sea bull's tail at left overlapping a pilaster is mirrored in the Paris horse's tail at right; less directly, the Paris horse head swung out to face us in Paris is reminiscent of the sea-horse head in front of Neptune. The flag flown on the Paris slab (right) has a very odd texture: It can only be meant to echo the similarly ribbed and scooped-out fins and tail of the chariot tritons, just as the two palms prominently waved at the sacrifice answer to the two torches next to the tritons. Although the reliefs have completely lost their original coloring, the torch flames certainly would have been tinted scarlet: They will have been echoed by the scarlet helmet plumes of the Roman soldiers and Mars. Finally, the odd rendition of helmet plumes in the census, a split tail flattened like two wings, is evidently meant to pick up on the pattern of the wings of the Amores perched along the top of the *thiasos.*

It is significant also that the Paris artist made individual figures as muted versions of standard Baroque types, and this is true not only of the twisted magistrate and knight who correspond to the flanking Munich Nereids. The censor has the shifting stance and uneasy weight shift of post-Classical draped portraits, and the patterning of his drapery is typically late Hellenistic. The musicians, in particular, are soberly glossed versions of typical performers who appear in painting and in sculpture. The twisting *auletes,* flutes up, is readily recognizable as a standard sculptural type for female entertainers and satyrs (Shapiro 1988). The lyre player's stance, straight back leg and flexed front leg, and body leaned forward from the hips, typifies New Comedy cymbalists (male or female) step dancing to their own beat; see the cymbalists in, for example, a terra-cotta troupe in Athens (NM 5060, ex Misthos coll. 543) (*Cambridge Ancient History VII.1 Plates* 1984: 156–7), and in compositions from Pompeii like the famous Dioscourides mosaic (Naples M.N. 9985, copy of ca. 100 B.C.) from the "House of Cicero" (Pollitt 1986: 227, fig. 241; Havelock 1981: col. pl. xii) or the pinax from the midfirst century B.C. Casa del Criptoportico, here following a twisting *auletes* (Robertson 1975: pl. 184c).

To return to the correspondence between figures in the two friezes, these significant analogies could be attributed to a process of simultaneous creation, except for two things. One is that material facts indicate the *thiasos* to have existed prior to the *census,* and to have been recut to make a frame of *spolia* for it. The second is the composition of the altar group; this rare or unique alteration of Roman altar group iconography, in a relief that deliberately reeks so of *mos maiorum,* seems best accounted for by the circumstances of this specific commission – to make an image to match a preexisting Greek work of art. The total effect of these correspondences is to bind the two friezes together. It helps to stress the partnership of Mars and Neptune, so relevant to this commission's votive nature. It helps to underline relations within the census depiction itself: that the censor is meant to have Mars as his divine *comes* (which is sometimes doubted) is verified by the fact that Mars and the censor are made analogous mirror images to the group Neptune–Amphitrite in the *thiasos.*

The disparate nature of these two friezes was relished by their Roman audience (and such juxtapositions occur elsewhere in Roman art); the subtle correlations of shape and surface between the two sections convey to a viewer the subliminal sense that they do really belong together. This sense of an underlying formal correspondence serves an expository, didactic end. The whole narrative thrust of the basis program is to set up a series of conceptual

linkages. The juxtaposition of visual and iconographic elements invites perception of appositions and oppositions: Greek/Roman, female/male, land/sea, war/peace, military/civil, *virtus/pietas, otium/negotium,* florid/austere, and mythic/historic. Duality, double nature, and reversal are the structural principles on which this base frieze zone seems, literally, to be constructed. These themes and aspects invite comparison to developments in rhetoric and textual forms in the Late Republic, although this is not to say that the narrative strategies used here are identical to those of written and spoken discourse. Very much in evidence on this base is a peculiar genius of Roman artistic composition: the use of structural and visual characteristics to appeal to the intelligence, in order to compass the expression of abstract concept, the description of event, the implication of temporal succession and of causality, and the statement of relation and intention.

Many of the complementary pairs listed before refer simply to standard metaphors and descriptive categories. For instance, the apposition of land and sea, characterized by their respective animal denizens, is typical of triumphal and imperialistic rhetoric; the Paris–Munich complex is cognate in this respect to the many triumphal texts that proclaim the establishment of *pax terra marique* ("peace by land and sea"), and is precursor to the conceptual framework of late first-century monuments like the Ara Pacis Venus panel or the Augustan Cherchel cuirass portrait (Simon 1986: s.v., pl. 8). The apposition of atemporal myth, the gods' time, and specific historical performance, human time, will later typify Augustan complex visual assemblages, such as the panels of the Boscoreale Augustus cup (Strong 1988: figs. 43–4; Kuttner forthcoming: chap. 1),[60] or the panels of the Ara Pacis (Simon, 1967, 1986b; Settis 1988; Zanker 1988).[61] These pairings and others in the list act to make the frieze band around Antonius's votive into a microcosm of the physical and social cosmos, which contains both sexes, every sort of being, the bonds of family, friendship, citizenship, military service, celebration, and duty. Other conceptual dyads have to do directly with narrative, and in fact to a Roman would specifically have suggested a biographic narrative.

The chariot and altar at the center of the long sides are legible emblems of *pietas* and triumph, respectively. Their relationship in Roman thinking is causal as well as complementary, implying a chronological sequence of action and result. Piety earns the divine favor that grants victory, giving triumph, and in gratitude, the successful triumphator gives again to the gods, keeping the cycle going. The world of *negotium,* active engagement in the *res publica,* and *otium,* the world of feasting, music, and art suggested by the *thiasos,* are paired with one another in good Late-Republican fash-

ion; these worlds are interdependent and mutually sustaining.[62]
Such concepts again suggest alternating stages and events in the
life of the patron. (Indeed, it is tempting to wonder whether the
patron's own marriage is hinted at by his choice of booty, which
would give the base a spice of *epithalamium* – our Antonius did
reproduce, but no facts or dates about specific marriage(s) survive.
The grouping of images of triumph, magistracy, and marriage
would be very like the episodic structure of later imperial sar-
cophagi.) Most obviously, the whole structure of the base frieze
narrates specific honors and offices held in chronological (if not
also causal) sequence. The base frieze, in other words, is a biog-
raphy, or rather an autobiography, cognate to the *titulus honorarius*
under each *summus vir* in Augustus's Forum. A better parallel yet
is a *titulus* written by the honorand himself, like Sulla's inscriptions
for victory monuments at Rome and at Aphrodisias (Appian *BC*
1.97) – the latter indeed described Venus fighting at Sulla's side
in battle as his *comes,* like the relationship stated visually between
Antonius and Mars.

What is known of biography and biographic characterization
in this period accords well with the observed features of this base.
The late second and early first centuries B.C. witnessed the estab-
lishment of memoir and biography as recognized literary genres
in Rome, practiced by successful statesmen on their own account;
the Paris–Munich base is itself a part of this phenomenon, its *pub-
licatio* equivalent to Sulla's circulation of his Autobiography.[63] The
pairing off of censorship and triumph is highly significant in this
regard: These represent the pinnacle of achievement available in
either of the two fundamental Roman categories of achievement,
that is, military activity and civilian magistracy. Thus, the basis
frieze itself can be seen to assess its patron's life in terms of this
categorical pairing. In this regard, the structure of the base is di-
rectly analogous to literary as well as epigraphic forms, which tend
to sum up potential and activity under the interchangeable head-
ings *in bello et pace, domi militiaeque, in foro et campo,* and *in toga et
armis.*[64]

The delineation of an essentially moral excellence in these
spheres prefigures later tendencies explored by, for example, N.
B. Kampen. The Paris–Munich base becomes one of the "lost
sources" for the typological panegyric narratives she analyzes on
imperial funerary monuments, asserting their kinship to rhetorical
structures with fluency and point (1981a: 49, and n. 15, 50–1).[65]
This annalistic and biographic structure is typical, for instance, of
the histories of Livy, who lived and wrote in the first century
B.C.[66]; his programmatic preface (chap. 9) stated his subject to be
"quae vita, qui mores fuerit, per quos viros quibusque artibus *domi*

militiaeque et partum et auctum imperium sit."[67] The aim of life was to be like Livy's Publicola (II.16.7) a *princeps belli pacisque artis* ("chief statesman in the arts of war and peace"); a great and honored orator like Cicero could be driven by this ideal to make himself ridiculous chasing (unsuccessfully) after the award of a triumph to round out his *cursus*. The office of censorship itself, as Livy characterized it when describing its foundation by Servius Tullius, was of peculiar benefit in both spheres.[68] This structure occurs in the prose and oratory of Cicero[69] and in the histories of Sallust,[70] in encomium and in denigration. It seems to have served Ennius already in his *Annales* describing great men of the Republic[71]; later it served the poets Propertius[72] and Tibullus.[73] These texts are intimately linked to the Roman practice of funerary biographic panegyric, the *laudatio funebris*. The biographic structure described here is implicit in the lists of office that characterize the analogous funerary inscriptions, as in the series from the Tomb of the Scipios, whose tomb facade evidently bore annalistic paintings similar to those on the Esquiline fragment mentioned before (CIL I.2; Felletti Maj 1977: 153–5, pl. 19, fig. 44; Lauter-Bufe 1982; Brilliant 1984: 26–7).[74]

Antonius's base *as* a decorated base belonged also to a recognizably Roman genre. Its proportions are typical of Roman honorific bases, and it seems to have been a very Roman practice to revet commemorative bases with figural narratives and designs. Bases with figural friezes occur sporadically in the Greek tradition, with clusters in Late Archaic Athens for commemorative monuments,[75] and in the High Classical age for cult statue bases (e.g., Pheidias's Athena Parthenos and Zeus Olympios, Agorakritos's Nemesis),[76] but not many survive in proportion to the number of undecorated bases.[77] Romans from the second century B.C. onwards, on the other hand, seem to have favored such bases very much. The first in the series is the elevated basis frieze of Aemilius Paullus's column monument at Delphi, early in the second century (167 B.C.), which has a continuous battle frieze (Pollitt, 1986: 155–8, figs. 162–4). For the first century B.C., one can name the "Sullan" basis friezes from near the Forum Boarium (see above n. 21; Strong 1988: figs. 16–17), the round base from Civita Castellana (see before; Strong 1988: fig. 18), and, especially, the rectangular base of (?) Antony the Triumvir from Praeneste (Hanfmann 1975b: fig./cat. 100; Hölscher 1979: 342–5, figs. 1 and 2). Both later rectangular bases exhibit the same deliberate mixing of styles as seen on the Paris–Munich base; the "Sullan" base mixes archaistic Victories, a Roman tabula ansata, plump flying Amores, illusionistic garlands, and variously stylized or illusionistic armor decorations; the Praeneste basis combines a Neo-Attic depiction

of a cavalry procession, with a vivid "small frieze" depiction of
Antony riding the flagship of his armada on the main long side
(the so-called Vatican Liburnica relief). The Paris–Louvre basis
turns out a Roman type of monument, then, to carry a Roman
iconographic structure; it is especially Roman as a stylistic collage
exploiting Greek forms and styles.

Let us sum up Antonius's autobiography, as narrated by the
base of his monument in the Circus Flaminius. This *pater* of Latin
eloquence, represented by Cicero as master of the appropriate
choice of style and (*Tusc. Disp.* 5.55) outstanding for his *virtus
domi militiaeque,* shows himself as being at once a cultivated man
appreciative of Hellenic culture and an exemplary *civis Romanus,*
a man who *in foro* shows himself deeply versed in *res militares* (Cic.
post red. in Sen 6.13 vs. Calventius), a general of outstanding skill
who is equally adept at the arts of peace. An *imperator* who gives
the state the supreme gifts of *salus* (well-being), *otium,* and *dignitas*
(Cic. *post red. ad Qu.* 16 on Pompey), Antonius spends his spoils
in the Forum and in the Circus Flaminius in such a way as to
make military achievement frame and support the orderly rituals
of civic life. As triumphator, Antonius employs the most skilled
Greek artists available, to construct traditionally Roman votives at
a traditional triumphal location. A connoisseur of Greek art, he
avoids the imputation of *luxuria* by sharing his treasures with the
people[78]; like Paulus, Africanus, and Mummius, he prefers with
his spoils *Italiam ornare quam domum suam*[79] (Cic. *de off.* 2.18.76).[80]
The way in which Greek art here is used to frame a Roman
depiction of Roman civic virtue, and Greek artistry is used subtly
to enhance the evocative power of Roman compositional struc-
tures, is a comment upon Rome's historical progression toward
mastery of the Mediterranean as well as an explication of Anto-
nius's own philhellenism.[81] The styles of either portion of the
frieze seem chosen with excruciating correctitude to conform to
rhetorical notions of *decor* (appropriateness) and *pulchritudo*
(beauty), which established complementary categories of esthetic
appeal: *venustas* (sensual appeal) and *dignitas, lepos* (charm, light
heartedness) and *gravitas* or *severitas.*[82] Indeed, these strictures ex-
actly suit the divisions of style, theme, and iconography on the
Paris–Munich base. In the *Orator* 69, Antonius himself is made to
define the three styles that suit the three ends of oratory – a plain
style for proof, a vigorous style for persuasion, and for pleasure,
the middle style. This last, rich, and charming (91) is characterized
by (94) a continuous stream of metaphors, *allegoria.* The Munich
thiasos certainly qualifies as a visual example of the middle style,
the Paris frieze as an example of the plain style. . . .

All of this corresponds with what we know of Antonius's char-

acter from Cicero (cf. *Or.* 77, 138): that he was a consummate rhetorician deeply versed in Greek learning who was careful to subordinate his philhellenism publicly to a purely Roman image[83]; indeed, Cicero's exaggerated, propagandistic portrait of Antonius and other *boni* of the period as unlearned in Hellenistic culture is patently belied by the existence of this *censor*'s base. Whatever stood on top of Antonius's base must have displayed an equally faultless conformity with Roman tradition on the one hand and Hellenistic technical and esthetic standards on the other, and above all will have conformed to the votive and biographic narrative tone of the basis below; some possibilities have already been suggested.

The base frieze seems to be like the *titulus honorarius,* which resembles it in purpose, content, and location within the monument, to be a peculiarly Roman genre. Such friezes were used to expand, add, or comment upon the major visual focus of a Roman honorific dedication, the statuary carried by such a base; ideally, one would like to see a full study of such basis friezes. The dialectic between forms, styles, and iconographic content, which occurs so often within such frieze zones, would have been constituted also by the juxtaposition of frieze and statue, in the same way that *titulus* and statue could work together to enable the spectator to construct a biographic narrative in his mind. The basis frieze as outlined here was often directly analogous to verbal forms of panegyric, and the verbal and visual must often have seemed to Romans as to us to be fully interchangeable. At other times – and Antonius's base provided such an occasion – the language of form and physical presence was exploited to provide messages that take pages to unravel, presented with an impact no text could rival, to give us (as Yeats wished to) "character isolated by a deed / to engross the present and dominate memory."

NOTES

I would like to thank those whose interested response and timely criticisms helped me to refine this chapter in its various drafts; errors that remain are my own. My special gratitude goes to Erich Gruen, Richard Billows, Brian Rose, Alison Keith, John Pollini, and Peter Holliday; Francois Baratte generously supplied photographs of the Paris *census,* and Raymund Wünsche of the Munich *thiasos.*

1. "Marcus Antonius and the so-called Altar of Domitius Ahenobarbus"; the Annual Meeting of the American Philological Association, December 1985, Washington, D.C.
2. Paris, Louvre inv. 975. Munich, Staatliche Antikensammlung, Glyptothek inv. 239. Separated in 1816 by Klenze; their nineteenth-century history,

Wünsche (1985: 45, 47, 49–51, figs. 30–1). Henceforth, the Paris frieze or census, and the Munich frieze or thiasos; their original state, joined as one monument, called the Paris–Munich monument or basis.

3. The essential bibliography on this monument is Coarelli (1968b); Wiseman (1974, 1987); Zevi (1976); Hölscher (1979, 1984); Torelli (1982: 1–3, 5–25); Meyer (1983: 87–8); Simon in LIMC II (1986: s.v. (Ares)/Mars no. 282, and cf. no. 15); Zanker (1988: 22–4, figs. 10a–b); the basic monograph (with plates) is Kähler (1966); more recently, see Torelli (1982: chap. 1) and Gruen (1992); ill. Andreae (1973: 360–1, figs. 199–200). Critical bibliography, Ling in Strong (1988: 337, n. 36, s.v. figs. 19–20). On the Latin sketchbook tradition behind the Paris frieze, see Kuttner (1991).

 On the Late Republican context, see *Roma medio-repubblicana* (1973); Olinder (1974); Coarelli (1968a, 1970–1, 1976a); Pape (1975); Lattimore (1976); Noftes (1988); Ziolkowski (1988). I was unable to consult the texts of Pietilä-Castren (1987) and Gruen (1992).

4. Wiseman (1974: n. 13) thought Coarelli's arguments flawed because the Paris–Louvre basis is not a third-century B.C. piece contemporary with the original temple, but Gros and Coarelli in fact note that the S. Salvatore building is a Late-Republican (re-)construction.

5. Paris census: François Baratte, curator of the Department of Greek, Etruscan and Roman Antiquities at the Louvre, in a letter of January 12, 1989. Munich thiasos: Andrew Stewart (University of California, Berkeley), in consultation with its curator R. Wünsche, whose investigations can now be cited via Meyer (1983: 87, n. 3). Torelli (1983: chap. 1, n. 22) dismisses Wünsche without mentioning this major premise. Greek/Asia Minor workshop source posited by Zanker (1987: 23) but without mention of the marble used. Strong (1988: 51) and von Heintze in Kraus (1967) call both sections "Pentelic."

6. Whatever one thinks of the origins of the two marbles, their difference remains a fact. Yes, large statues and friezes were typically pieced from multiple sections of stone, but even in works of poor quality, these are one marble when executed at one time. Yes, Greeks and Romans might combine different stones deliberately, but only for visual color effects, or to augment soft stones (like limestone) with, for example, fine marble for heads; all sections here are one sort of stone (marble), nor do they differ visually from each other to an extent such that this difference could have been chosen for esthetic effect.

7. To Coarelli, the circumstances of finding indicated that the friezes originally stood within the temple cella. However, even if the traces of building work in 1637 imply that this is where they were found, they may already have been stripped from their base and moved slightly from their original site, as is the case for many inscriptions and reliefs found at Rome. As Wiseman (1987: 214) points out, Coarelli has backed off and now assigns the base simply to the temple area ("questa zona": 1980a: 279).

8. Torelli, however, in a lecture given at the American Academy in Rome in 1985 reverted to the Skopas-group thesis. Although Zevi disposes well of the notion that it held Skopas's group, he mistakes its dimensions as appropriate only for objects (e.g., trophies) not figure statues.

9. Coarelli commenting on Zevi (1976) at the conference proceedings noted a base of similar dimensions used to hold several statues in the temple (of the Nymphs) on the Via dell' Botteghe Oscure (see n. 37), citing also the proportions of the Late-Hellenistic basis at Lykosoura, several of whose statues survive.

10. This mode of siting was used in portico-and-temple complexes for some quite large portrait votives. The *equus Caesaris* of the Forum Julium (a votive before the Temple Venus Genetrix) and the triumphal *quadriga* group of Augustus in the Forum Augustum (before the Temple Mars Ultor) are in this regard good Republican-style commemorative monuments; so also are Augustus's votives in the Greek East, before the Parthenon (miniature tholos with statues of Rome and Augustus) and by the Temple of Athena Polias on Pergamon's Acropolis (Augustus inserted on the round Attalid base for Athena).

11. For example Wiseman (1987: 214) still thinks one has to pick one or the other. Lit., Lattimore (1976: 17).

12. Castagnoli (1945) stated the "problem" – either the monument is dedicated to Neptune, but for personal reasons depicts a census; or it is dedicated to Mars, but devotes most of its space to a marine theme. Kähler (1966) simply gave up and decided Mars was not a focus, only the censor.

13. A general performs a double sacrifice to two divinities on a Late-Republican Luna marble relief in the Vatican from Castel Gandolfo, which with a companion fragment (battle) narrates scenes from Rome's legendary history (Mus. Greg. 2916); the *imperator* (probably Romulus) at center stands between two altars, one lit, one with fruits, a bull facing center behind each altar, at each side a pedestal with cult statue, left Mars, right(?) (foot only). Felleti Maj (1977: 191, Fig. 67); Simon in Helbig4 I, cat. 1122; Kleiner (1983: 298–9); Hafner (1987: 241–60, pl. 116–17).

14. *Fasti Arvalium* = CIL I2, pp. 214–15; Olinder (1974: 26–7, further on the Temple of Neptune at 42–3, 45, 51–2, on the Temple of Mars at 40, 52). Compare Octavian's thanks for victory in sea battle at Actium to Neptune and Mars, with Apollo Actiacus, on the great victory monument decorated with Antony's prows he set up at Nikopolis overlooking the Actian gulf; Ehrenberg and Jones (1976: no. 12: *[Nep]tuno [Marti]* . . .). On this monument, see Murray (1989). Already in the Middle Republic, Plautus (*Amph.* 42f.) had apostrophized Neptune and Mars as joint military patrons, with Victoria and Virtus.

15. Varro *res diuinae* = Macrobius *Sat.* 3.4.2, Serv. *ad Aen. 2.225*.

16. For a similar formal and conceptual framing structure, see the noted Iliac Tablet (later first century B.C.); its center narrates Aeneas's flight from Troy, within a ring of densely packed little frames and texts that "tell" the Iliad and Ilioupersis. Brilliant (1984: 55f., fig. 2.1). Greek epics are subordinated to the Roman story and Roman-style depiction of the central panel, framing it literally as well as figuratively.

17. Eck (1984b: 144) mourned "the widespread absence of measurements" and "the inadequate descriptions in many *corpora* of inscriptions" and hoped for a systematic investigation, to aid in determining what sort of statue one might reasonably posit for a given size and shape of base. Tuchelt's paradigmatic collection has so far gone unimitated.

18. The measurements of Eck's nine-figure bases for Rufus (CIL VI 1508) and for Aelius Lamia, as well as the tablet measurements given in his 1984 tables, allow ca. 75 to 125 cm width per figure in a multifigure group. The number should be an odd one, to allow for a central portrait symmetrically flanked, and the 5.65-m width of our base would be well suited by a five-figure group. Eck (1984a: 205f., tables at 212f.;, 1984b: 146f.). Schäfer (1989: 74–5, n. 20) restores the Bocchus monument (San Omobono Base; see n. 21) as ca. 6 m long, comparing it to our base (5.65 × 1.75 m) and Eck's monuments of 8–9-m length.

19. Greek precedents for such groups go back at least to fourth-century Athens; a good example, and certainly paradigmatic in antiquity, is the "short" Attalid dedication in the precinct of Athena Polias. Tuchelt (1979: 51–4) gives Republican honorific examples from the Greek East.

20. La Rocca points out that the Vienna cameo, of Octavian *triumphans* drawn by acclaiming Tritons, prefigures the noted Commodus and Triton group from the Horti Lamiani and must paraphrase contemporary Augustan free-standing commemorative groups; La Rocca (1986: 94). (On a Pergamene sea-victory votive with Poseidon flanked by tritons, see n. 41.) Some of R. Smith's Claudian panels from the Sebasteion at Aphrodisias document such panegyric schemes: (1987: cat. 2, pl. vi, and cf. cat. 1, pl. iv; 3, pl. viii; 5, pl. xii). See also the "statues" depicted on the Augustan Vicus Sandaliarius altar (Gaius, Augustus, Livia ?) and compare Augustan portrait groups, for example, from Corinth (Gaius–Augustus–Lucius); Simon (1986b: Figs. 87, 84). As a format for relief depictions, this three-beat centralized composition is the most common schema for Augustan art; for its general currency in Roman statue arrangements, cf. also Bartmann (1988).

21. Sulla enthroned receives the homage of Bocchus kneeling at his right, and Jugurtha bound kneeling at his left; connected by Hölscher (1984; 1988b: 384, Fig. 177) with the Conservatori base from S. Omobono, mentioned in what follows.

22. See n. 7. Wunsche's observation is based on style and (see n. 6 before) on differences in marble type; originally reported to me by Andrew Stewart of Berkeley, his views were described accurately by Meyer (1983: 87–8). Hölscher (1984: 16–17, fig. 20) considered the *thiasos* Roman work; Zanker (1988) recognizes it now as East Greek work reused, but (like Wiseman) thinks it aimed to establish a mythological genealogy for the censor/patron.

23. CIL I2 608, on a stone pedestal, dedicating from the Sicilian wars: *M. Claudius M.f. /consol/Hennad cepit.*

24. CIL I2 613, on a fragment of molding from Praeneste, from his Greek campaigns: *[L. Quinctius L.f. Le]neado cepit/[eidem conso]l dedit.*

25. CIL I2 615–16, pedestals from Rome and from Tusculum, spoils from Ambracia and Aetolia: *cos . . . cepit.*

26. CIL I2 622, the inscribed tablet on the column monument taken over from the fallen king of Macedon, *L. Aemilius L.f. inperator de rege Perse/ Macedonibusque cepet;* discussed in what follows. Compare also CIL I2.2.48 (ILS 3142 = ILLRP 221), a base from Tusculum, to Mars (ca. 200 B.C., M. Furius as military tribune from his booty): *M. Fourio C. f. tribunos/ militare de praidad Maurte dedet;* Broughton (1986: 96). I thank R. Billows for this reference.

27. Thus, I reject the otherwise tempting P. Servilius Isauricus, *tr.* 74 B.C. for victories over the Cilician pirates, *cens.* 55–54 B.C. – he did not successfully close his *lustrum.* Bibliography to this candidate: Platner and Ashby (1929: 329); Pape (1975: 75).

28. The sources on Antonius: Broughton III (1986: 19); I (1951: 568, s.v. 102 B.C., 572, s.v. 101 B.C.); II (1951: 1, s.v. 99 B.C., 6–7, s.v. 97 B.C.).

29. The sculptural fragments are addorsed tritons with rudders; Hanfmann (1975b: 41) does compare the Munich frieze (fig. 86) to his reconstruction.

30. Ziolkowski (1988: 328) discusses patrons using marble from their area of *imperium* (e.g., Metellus's and Mummius's use of Pentelic marble from Attica). The Paris slab may also be Pentelic (n. 6), a status symbol in Rome at the time; Antonius, of course, did pass through mainland Greece himself.

31. Thus Meyer (1983: 88) excludes the thiasos from detailed Roman narrations

of Greek mythological themes; "der allgemeine Sachverhalt eines Meer-thiasos als das Primä "re gesehen worden ist" (after it's been robbed out).

32. See Pape (1979: 70–1) on the censorships held by T. Quinctius Flamininus (189 B.C.), M. Fulvius Nobilior (179 B.C.), L. Aemilius Paullus (164 B.C.), Q. Caec. Metellus (131 B.C.), and L. Mummius (142 B.C.), and also the consular elections of L. Quinctius (192 B.C.), Cn. Octavius (165 B.C.), and Metellus again (143 B.C.). Consider, too, Caius Flaminius's censorship, when in 220 B.C., he established the Circus Flaminius over the erstwhile Prata Flaminia, and multiplied its associations with triumphal rite; Coarelli (1970–1: 241f.). A recent fine discussion of competitive patronage is in Ziolkowski (1988: 325f.).

33. This illuminates why Octavian remodeled the Rostra podium, and chose to mount opposite the Antonian Rostra the *rostra* from his defeat of Antony the Triumvir at Actium on the podium of the Temple of Divus Julius, now made an alternate speaker's platform for the Forum. Hence, also Antony the Triumvir's appropriation of the Rostra for the display of his enemies' heads. On Antony, Octavian, and the Antonian Rostra, see Murray (1989: 120–2).

34. Coarelli (1970–1: 245–55), surveying censorial munificence, brings together the evidence for these workshops and projects, and suggests a link with Antonius through the Paris–Munich base. Mars and Venus by Skopas in the Temple of Mars: Pliny *NH* 36.26. Skopas at the Temple of Neptune: see before.

35. "Das Monument, also eine Statue, eine Säule, ein Bauwerk oder ein Bogen, war zumindest so bedeutend wie die dazugehörige Inschrift, war mit Warscheinlichkeit sogar in vielen Fällen das eigentlich Entscheidende, während der epigraphische Text eher eine erklärende Funktion hatte." Eck's published work stands out for its attempt to synthesize textual and visual evidence to achieve valid cultural and political history of Republican and Imperial Rome.

36. The key text is Cicero *pro Milone* 73: *qui* [sc. Clodius, 57 B.C.] *aedem Nympharum incendit, ut memoriam publicam recensionis tabulis publicis impressam exstingueret;* Cicero also refers to this arson in the *par. Stoic.* 31 and *de har. resp.* 57, which alludes to the nymphs' watery nature.

37. Identified with remains visible on the Via delle Botteghe Oscure: Coarelli (1968c: 365–73 at 372f.); Torelli (1982: 12). The cella's large base would easily house these plural goddesses (Coarelli, 1968c: 372, fig. 2).

38. The Pompeian mosaic (ca. 100–50 B.C.) with an analogous chariot group of Neptune and Amphitrite from the Casa del Granduca di Toscana IX.2,27 [triclinium d], Naples M.N. inv. 10007: Ferrari et al. (1986: 118–19, cat. 25); Settis (1970–1). Contra Settis, the cithara-playing triton is not left-handed, nor is the Munich Poseidon, whose trident is cradled casually in his left arm because he is using his right to drive the chariot. Another Pompeian mosaic *emblema* quotes a famous sculptural work from Rome: the Lion and Amorini tondo from the Casa del Centauro (*Coll. Napoli* (1986: 159–61, cat. 21)) draws on Arkesilaos' group made in Rome before the midcentury; on that group, Pliny *NH* 36.41, cf. Pollitt (1983: 88–9).

39. R. Paris surveys comparanda and literature s.v. the sea-thiasos of the great Late-Republican marble basin, Terme inv. 113189: *Museo Nazionale Romano. Le Sculture* I, 1 (1979: 255–7, cat. 159).

40. On an interesting Neronian bronze issue from Corinth, two tritons draw Aphrodite in a chariot (*LIMC* sv. Aphr. 1211a–b). The coin composition shows that the core motif of the Munich friezes stayed current in the Greek

East as a triumphal epiphany scheme at least through the Julio–Claudian period. See n. 59 on the use of this scheme for Hellenistic and Roman Dionysos epiphanies.

41. Paris (supra n. 39); Meyer (1983: 88); La Rocca (1986: 94). Paradigmatic "triumphant" tritons will have been the the Pergamene triton pair from the Great Altar terrace, whose arched-back torsos indicate that they once brandished instruments and/or emblems of victory. Formerly installed as akroteria on the roof of the Great Altar at the Pergamon Museum in Berlin, cf. Radt (1988: 196, fig. 78); current reexploration of the roof sculptures by M. Kunze (the former Museum director) has moved the tritons to a free-standing votive on the terrace, flanking the well-known Poseidon, which seems to have been produced by the same workshop, and the tritons have been removed from the Altar facade to the gallery floor.

42. Continuing admiration for the perceived military *dignitas* of the equestrian order and the continuing popularity of enrollment (i.e., our censorial ceremony): Wiseman (1970, 1987: 68f.). On the Augustan Livy's view of the census, see n. 70, which follows, citing 1.42, .45.

43. See Kuttner (forthcoming, chap. 2).

44. Gruen (forthcoming) will identify the patron's colleague in the veiled figure with a vexillum in the procession episode at the right of the altar, in connection with texts describing the rite. I thank him for informing me of his conclusions. This identification seems to me quite plausible. It does not destroy my main thesis, that Antonius' role is the point of formal stress on the frieze, to the subordination of his colleague in the paired office.

45. Unpublished except for this excavator's note. I thank W. Harris for bringing this frieze to my attention.

46. Compare these vigorous, simplified narrative friezes to the complex renderings on the friezes of the Pergamon Great Altar; Pollitt (1986: 95ff.).

47. There are many other examples of "small-frieze" design, as one can see perusing any good Roman art handbook. The genre is usually recognized in reference to Roman imperial arches.

48. For example: 115 B.C. denarius of P. Laeca; Kent (1978: no. 41, pl. 13). 113/12 B.C. denarius of P. Nerva; Strong (1988: Fig. 3R (Crawford RRC 30, 292.1, pl. 40)). 100 B.C. denarius of Piso and Caepio; Kent (1978: no. 77, pl. 13).

49. I mean the episodes where Telephos is greeted by Teuthras (esp. the beautifully vivid bagged-out tunic across the soldier's buttocks), the Flight of the Argives, Telephos's reception in Argos, the founding of cult at Pergamon, and Telephos's deathbed.

50. And so will have Callaicus on his own Hermodoran temple of Mars, for Cic. *Arch.* 27 says he had the poet Accus write *carmina* for all his temples and monuments. On these dedications, see Ziolkowski (1988: 316–17).

51. The Ostia oracle relief honoring Pompey reads right–center–left; see Meyer (1982: 268–71, fig. 13) and Kuttner (1991: 153 n. 43). The Domus Uboni Thetis room at Pompeii (IX.5.5.(n)) reads center–right–left (Scyros-Hephaistos's forge–Thetis bringing the arms to Achilles); Brilliant (1984: fig. 2.6). Roman narrative order is often right to left; on the West face of the Ara Pacis, the sacrifice of Aeneas is right of the finding of Romulus and Remus. This order is observable in episodic sequences on Roman sarcophagi, as soon as they begin to take narrative decoration: cf. the Louvre sarcophagus Ma 459 from Torre Nuova, where Diana discovered at her bath is right of the death of Actaeon (Herdejürgen 1989: 23, pl. 8.1); Baratte and Metzger (1985: 49f., cat. 15). On the A.D. second-century "gen-

eral's" sarcophagi, the sacrifice at the start of a campaign is always shown in the center of the main face, typically to the right of a scene of submission by captives marking the end of the campaign.

52. It is sometimes doubted that the figure to the left of the altar is the god Mars, rather than a human general. Why is this a god? He is the tallest figure in the entire frieze, patently cognate to Poseidon on the other slab, and his panoply and stance mean that he cannot be a human. There are a few, rare depictions of the sacrifice in armor in Roman art, but in none of these does the general sacrificing have a shield with him or leaning on his lance as here. If this were a human, he would be wearing a wreath, like the other members of the sacrificial party. Finally, Mars has his foot upon a (half-) globe before his own altar, a gesture that asserts ownership made by no human sacrificant in the Greco–Roman repertoire.

53. On this small round altar, two goddesses, a naked Heracles and Apollo *citharoedus,* stand to the left of a great altar, their heads touching the top of the field; musicians behind the altar are visible before a break in the stone. Toward the altar are led a calf and a pig. Cf. the Civita Castellana round base, where also a line of deities await their worshiper across an altar. If, indeed, Venus Genetrix appears on the Borghese piece, making it Caesarian or later, then it might well be a garbled version directly derived from our monument.

54. On temples in Rome *etrusco more* with terracotta sculpture, see Helbig[4].

55. On the second-century urn Florence Mus Arch. 8680 and an identical piece in Volterra, these musicians and a *tubicen* head a procession of lictors and magistrates; Felletti Maj (1977: 95–6, 172, s.v. fig. 10). The pair already figure in the procession on the main face of the fifth-century sarcophagus from Caere, Vat. Mus. Greg. Etr. 14949; Holliday (1990a: fig. 1, 76–8, and n. 19); Brendel (1978: 324–5, fig. 246, n. 40).

56. As on the urn Volterra Mus. Guarnacci 173; Felletti Maj (1977: 80, fig. 2); Holliday (1990a: 86–7, n. 71, fig. 13).

57. Felleti Maj (1977: fig. 12) is an urn in the British Museum (Coll. Forman), a procession of knights and mounted lictors riding to sacrifice, led by a lyre and flute player.

58. The right hand with conch is modern; Kähler (1966: 13). His arm posture and puffed cheeks are typical of an exuberant aulos player with long double flutes.

59. The motif, of fantastic beings drawing a god's matrimonial chariot and playing aulos and lyre, is a Hellenistic creation of the second century B.C.; it seems to have characterized also lost Hellenistic versions of the wedding thiasos of Dionysos and Ariadne, prototypes for the Dionysiac sarcophagi of the middle and late Empire. See Matz (1968: I, 79; II, 88 (list), 189–91, 245–7, 286f., and esp. cat. 83 and 89–93). Antonine sarcophagi "butterfly" the motif, into facing chariots drawn by a single musical centaur each, often flanking a *clipeus.* Matz (1975: IV, 452–4) is very brief; see his cat. 265, 270. Facing musical centaurs with lyre and flutes, and Amorini, appear already on the midfirst-century A.D. grave altar of Amemptus; Simon (1986b: fig. 230).

60. One side is an allegorical tableaux of Augustus, gods, and personifications; the other side shows the emperor receiving Celtic chieftains, in illusionistic perspective, with no gods present.

61. The long friezes document a procession ca. 13 B.C., the four panels framing the doorways on the short sides show two scenes from Rome's legendary history (Aeneas sacrificing the Lavinian Sow; the finding of Romulus and

Remus), and two epiphanies, of Roma and of Venus. See before on the inner altar.

62. Sallust *In Cat.* 52.5 has Cato the Younger discuss *otium* as a primary good to the *res publica*. On *otium,* cf. André (1966).

63. Autobiographies are known for Scaurus, Rutilius Rufus, and Sulla; cf. Coarelli (1970–1: 172).

64. There is no literary or historical study to date of these essential panegyric structures. The survey of texts here can certainly be expanded.

65. "The *laudatio funebris, res gestae,* panegyric and written biography made subjects and narrative method accessible to literate and illiterate alike and gave artists the structure into which to fit commonly known visual motifs. The source for the biographical monument is ultimately to be found in biography itself; whether spoken, written, acted, carved, or painted, the conceptual method and themes were part of the cultural heritage of Romans from the Republic on." See in this volume, Whitehead.

66. For example, in the first four books: I. 8 animum vel *bello* vel *paci* paratum [of Aeneas and his people] (a spirit ready for war as for peace); 15.6 Romulus's *domi militiaeque gesta* (deeds at home and on campaign), and (concilium) *bello ac pace* firmandae (for what should be done in war and peace), preceding the list of specific religious, legislative, and military activities in .7–.8; Numa – cf. 19.1, 21.6; Tarquin Priscus – 34.12; Ancus – 35.1; Servius – 42, 45; Tarquin Superbus – 53.1; and cf. II. 16.7 (Publicola), 33.5 (Coriolanus), 31.10, 34.1, 49.4 and 50.11 (the Fabii), 52.2, 54.2, 60.4; III. 11.6–7 (Caeso), 19.5 (Cincinnatus), 24.11, 30.2, 31.1, 42.1, 41.9 (Fabius), 44.2 (Verginius), 43.1, 65.6, 66.1; IV. 1.1, 3.16 (Numa, Servius, etc.), 11.2, 10.8, 12.1, 35.3, 19.1 (Cossus), 34.5.

67. "What kind of life, what sort of *mores* there were, and through what men and by what talents *at home and on campaign* the empire was given birth and increase." Compare 2.1.1: *Liberi iam hinc populi Romani res pace belloque gestas,* "the things achieved by the now free Roman people in peace and war."

68. I.42: Servius founds the *census* as: *rem saluberrimam tanto futuro imperio, ex quo belli pacisque munia . . . pro habitu pecuniarium fierent; tum classes centuriasque et hunc ordinem ex censu discipsit, vel paci decorum vel bello:* "the thing which was most health-giving for such a great empire as was to come, by means of which sufficient resources would always be maintained for war and peace; he (Servius) then set up the *classes* and centuries and that ordering established by the census, which is so appropriate either for peace or for war." Its effect, .45: *Aucta civitate magnitudine urbis, formatis omnibus domi et ad belli et ad pacis usus, ne semper armis opes adquirerentur,* "their society was built up to the greatness of an *urbs,* with everything set up at home to fit the needs both of war and of peace, lest a wealth of resources for arms ever be lacking."

69. *De off.* 1.28.116 comments on complementary achievements by known fathers and sons, either in *ius ciuilis* (civil law) or in *res militaris* (military affairs), and notes those extraordinary persons who combined both, like Africanus who *eloquentia cumulauit bellicam gloriam* (by eloquence added to his store of soldierly fame). *Pro Archia* 27 pairs *imperatores . . . armati* (generals in arms) and *togati iudices* (judges in the *toga*). *De off.* 2.18.84 notes that good leaders try to augment the *res publica* however they can *vel belli vel domi* (whether at war or at home). A young man should seek *gloria* (fame, reputation) in *bellica res* (military occupations) and then by association with wise and famous men in politics (*de off.* 2.12.45).

70. *Beillum Jug.* 63.2, Marius's *animus belli ingens, domi modicus* (spirit hugely apt for war, less so for home affairs); 85.3, the duty of a consul is *domi forisque omnia curare* (to have a care to all things at home and abroad); 95.3 examines conduct in *otium* and in *negotium. In Cat.* 2.3 discusses individual *virtus* (prowess) *in pace* or *in bello;* 3.1 *vel pace vel bello clarum fieri licet* (one can be eminent either in peace-time business or at war); 9.1 the fortune of the Roman people *in bello/ in pace;* 52.21 Cato on conduct *domi/foris* (at home vs. abroad), .22 *publice/privatim;* 53.1 the Roman people *domi militiaeque, mari atque terra* (at home and on campaign, by sea and land). The *ep. ad Caesarem* (sometimes attributed to Sallust); 13.2 names the *honestamenta pacis et praemia belli* (pickings of war and the earned honoraria of peace); 13.5 Caesar's deeds are *domi militiaeque praeclara* (outstandingly famous, performed at home or on campaign).

71. (Warmington 1935) frag. 268 contrasts civil and military careers: *spernitur orator bonus, horridus miles amatur* (the worthy orator is despised, the repellent soldier is adored); frag. 271 assesses someone *qualis consiliis quantumque potesset in armis* (by their quality in deliberation and their potential achievement under arms); frag. 368 praises Hannibal as *suasorem summum et studiosum robore belli* (outstanding as a persuasive counsellor and most learned in the demanding exercise of war).

72. Propertius 3.9.19–26, about Maecenas – *hic satus ad pacem, hic castrensibus utilis armis:/ naturae sequitur semina quisque suae* . . . (this man is fitted out for peace, this man is of service in the camps and under arms; every man follows the seeds of his own being). Compare also 3.22.21–2 – we Romans *nam quantum ferro tantum pietate potentes / stamus* . . . (dominate thanks as much to our *pietas* as by the sword).

73. Tibullus's panegyric on Messalla, 3.7 at .39 *nam quis te maiora gerit castrisve forove?* (for who will do greater things than you in the camps or in the forum?); .45 f. describes M.'s skill as statesman in the art of words; .82 f. his *belli artes.*

74. Esquiline history friezes, see before. Also on the Esquiline, the "Sepolcro Arieti" had simple paintings in this genre; Brilliant (1984: n. 16 to n. 26; Felleti Maj (1977: 155–8, pl. 19, figs. 45a–c); Holliday (1990a: 89–90, fig. 14, n. 90); Schäfer (1989).

75. Athens N.M. 1464 (boys leading horses) is a rare Classical example; M. Robertson (1975: pl. 130d; 1981: fig. 44). The Archaic bases took a commemorative male statue (*kouros,* or warrior), and their images portray by description and metaphor (e.g., animal combat) the noble citizen's "typical" character and activities. Such a statue on its relief-decorated base is depicted on the grave stele, N.Y. Met. 36.11.3; Boardman (1978a, 1985: fig. 234). Some examples: Athens Ker. Mus. P 1001, ca. 550–40 – Boardman (1978a: fig. 240); Robertson (1975: pl. 31c). Athens Ker. Mus. P 1002, ca. 510 B.C. – Boardman (1978a: fig. 243). Athens N.M. 3477 – Boardman (1978a: fig. 241); *The Human Figure in Early Greek Art* (1988: cat. 63). Athens N.M. 3476, ca. 510 – Boardman (1978a: fig. 242); Robertson (1975: pl. 74a; 1981: fig. 94).

76. These are known from texts (esp. Pausanias) and some Roman decorative reliefs that quote portions of the depictions. As with the earlier commemoratives, the stories and tableaux on these bases said something about the feats and/or nature of the divinity honored.

77. Post-Classical Greek examples are the base at Mantinea for a votive statue of Apollo by Praxiteles, Athens N.M. 215–17, depicting Apollo and the Muses – Robertson (1975: pls. 128a–c; 1981: figs. 195–7). The Acropolis

"Lysippan" base for an athletic statue, Athens Acrop. 3176, showing athletes after exercise – Robertson (1975: pl. 148c); Havelock (1981: cat. 148). The base at Messene, connected with a hunting group at Delphi of Alexander and some followers (Louvre, Paris); Pollitt (1986: 38, fig. 31).

78. *Luxuria* consisted, not of Philhellenism as such, but of too great private indulgence in material luxury that included, of course, a great deal of Greek art; public dedication and display of plunder could vitiate the accusation of *luxuria*. On evidence for attitudes to the ownership of art and the hoarding of booty, read Wardman (1976: 50–60), and see Gruen (forthcoming) in his chapter on Republican art. Cato as censor, for instance, was not so much an anti-Hellene as he was against selfish, private, material enjoyments, although his attitude is often misunderstood.

79. "[T]o furnish Italy rather than his own house." Temple spoils in a *domus*: Naples M.N. 145070 and 145080 are superb Late-Classical Nereid and dolphin akroteria reused as fountain ornaments in an aristocratic villa at Formia.

80. Scipio dedicated from spoils the Apollo Caelispex, Plut. *Flam.* 1; Ziolkowski *Phoenix* 42–4 (1988: 329). A first-century B.C. *imperator* rededicated at Ostia a bronze priestess robbed from Delphi: *EAA* suppl. s.v. Phradmon. Other references on statue bases and plundered art, Reynolds (1981a: 123).

81. Archeology is beginning to document the specific esthetic appetites of other Late-Republican *imperatores*. Cicero (*Verr.* II 1.17.44) tells how Cornelius Dolabella (procos. in the early 1970s) tried to plunder the art treasures of Delos; sealings there from his signet show a warrior on a rearing horse seen from behind taken straight from the established Hellenistic pictorial tradition, going back to the Vergina hunt paintings. See Boissac (1988: 317, figs. 17a–b).

82. Cf. Cic. *de off.* 1.36.130: *pulchritudinis duo genere sint, quorum in altero uenustas sit, in altero dignitas.* He goes on to say that *uenustas* is *muliebris*, and *dignitas* is *uirilis.* And *de off.* 1.37.134: in *sermo* (i.e., public discourse), style should suit subject – *si (de) seriis, severitatem adhibeat, si iocosis, leporem; Orator* 138 notes as a principal aspect of the search for the *proprium* in language the choice between *lepos* and *pondus,* charm and weight.

83. Thus, he celebrated the technically arduous transfer of his fleet over the Isthmus at Corinth with the inscription there of a *Latin* poem in elegiac couplets; CIL I2 2662 = ILLRP 342; Sherwin-White (1976: 4–5). (Cf. n. 50 on Callaicus.)

READING THE AUGUSTAN CITY

Diane Favro

When Augustus came to power in the late first century B.C., he surveyed his capital city. Republican Rome was unordered in appearance, unruly in temperament, and decaying in form. The city did not present a positive image. During a long political life (44 B.C.–A.D. 14), Augustus expended great sums and great effort to improve Rome's appearance.[1] He restored over eighty temples, funded dozens of new structures, encouraged the patronage of others, and established municipal boards to undertake urban maintenance (Zanker 1988; Favro 1992). So comprehensive was Augustan intervention, the emperor boasted, "that he had found [Rome] built of mudbrick and left it in marble" (Suet. *Aug.* 28). With equal justification, Augustus could also claim to have found the capital an indecipherable jumble and left it an engrossing urban narrative.

The Augustan narrative is most legible in the remains of the Campus Martius, the northern floodplain of Rome. Before turning to this case study, we modern observers must retool our urban reading skills. Today, chambers of commerce explain cities with promotional slogans or official icons. We experience cities at high speed and from removed vantage points such as tall skyscrapers or airplanes. We are comfortable with cityscapes that change rapidly, where entire blocks of buildings are replaced with different structures almost overnight. Faced with rapidly changing environments, we rely primarily on signage, numbering, and names to identify urban buildings, and only secondarily on form, ornamentation, location, or semiotic content (Lynch 1960; Cullen 1961; Gottdiener and Lagopoulos 1986). Accustomed to speed reading modern cities, modern observers are not trained to catch the subtleties of urban encoding evident in ancient urban environments.

Roman urban observers had both the opportunity to read city environments in depth and the capability. As pedestrians or passengers in animal- or human-powered conveyances, they passed through cities at slow, modulated speeds. This more leisurely pace

allowed them to examine a city closely and to draw subtle connections. In addition, the relative constancy of ancient environments allowed observers to read and reread the urban narratives many times.[2]

Furthermore, compared to modern urban observers, the Romans of the late first century B.C. were far more visually literate. Drawing on Greek sources, Republican authors proclaimed sight as the most potent of the senses.[3] In a society in which few could read, visual imagery functioned as a literal text legible to all. Rome's inhabitants relied on images as much as verbal sources for everyday information. For example, they learned about political dealings not only from speeches and graffiti, but also from artwork, buildings, and places. Cicero wrote, "One's emotions are more strongly aroused by seeing the *places* that tradition records to have been the favorite resort of men of note in former days, than by hearing about their deeds or reading their writings."[4] A century later, Plutarch restated the connection between urban environments and human achievements: "we deem it only proper that a city, . . . retaining its identity, should be involved in the disgraces of its forebears by the same title as it inherits their glory and power" (*Mor.* 559C).

Urban texts share certain conventions with paintings, sculptures, reliefs, and other artistic narratives. For example, large scale is equated with greater import, items in the foreground are more significant, and repeated images are mentally linked by the observer (Torelli 1983; Brilliant 1984). In addition, urban texts also possess unique characteristics. A work of art is a consciously selected moment or moments in time captured in a singular image. Observers can view artwork from various angles (literal as well as psychological) and under different conditions of lighting and placement, yet the image itself does not change. In contrast, an urban environment is dynamic. Appearances are transformed by different climatic and functional conditions. An empty forum in the rain is markedly different from the same space filled with people and animals on a sunny day. In addition, urban places are constantly altered. New buildings, the growth of trees, and demolitions all transform urban set pieces. Furthermore, observers interact directly with city environments. Their movements, angles of viewing, and very existence affect the urban experience and shape the urban narrative.

The scripting of urban environments is complicated. The patron and designer of an individual architectural monument or grouping can directly control the story presented; authors of urban narratives have to consider many factors beyond the specific structures they construct. All components of a city have to support, or

231

at least not detract from, the primary narrative. Preexisting struc-
tures and messages have to be counteracted or incorporated; new
additions have to interrelate physically and/or conceptually. Al-
though observers can look at a single monument or work of art
from many angles, they experience it as the focus of a synchronic
presentation. The urbanistic experience is quite different. Observ-
ers see city locales both from many vantage points and in greatly
different sequential positions. Diachronically experienced urban
elements have different contents, depending on what the readers
see before and after. In effect, observers manipulate the narrative
through their path selection.[5] Urban authors can exert some pres-
sure through the arrangement of their text, yet they can never
totally determine the paths taken by readers. To maintain control
over their narrative, authors must develop a text that is legible
regardless of the sequence followed.

Authors of urban narratives in antiquity relied heavily on their
readers. Unlike most modern observers, Roman readers had well-
honed mnemonic skills. In particular, educated patricians, the
most desireable audience for any propagandistic message, were
trained to make mental links between disparate components and
to synthesize the diverse meanings imparted by variations in se-
quence. The education of every upper-class Roman included
rhetoric, the art of persuasive speaking.[6] Because the Romans con-
sidered it bad form to rely on notes, memorization was an essential
skill for all orators. In the 80s B.C., an anonymous teacher of rhet-
oric in Rome fully described a mnemonic system based on places
in his textbook known today as *Ad Herennium* (3.16–24). He ad-
vises speakers mentally to associate ideas with architectural forms
and localities.[7] In each created environment or *locus,* orators place
different *imagines,* simulacra of what they wish to remember.[8] By
imagining they are moving through the conceived environments,
orators recall the parts and sequences of a speech. Once estab-
lished, the same mental environment could be used to memorize
different orations.

Orations, like peregrinations, can vary in sequence.[9] Because
the placement of the *imagines* was based on relationships, orators
could start from any point in the *locus* and move either backwards
or forwards and still maintain the sense of the speech. The author
of *Ad Herennium* explains, "If these [*loci*] have been arranged in
order, the result will be that, reminded by the *imagines,* we can
repeat orally what we have committed to the *loci,* proceeding in
either direction from any *locus* we please" (3.17.30).

For the best effect, the same author advises orators to imagine
loci of workable size and variety with evocative sensory detail.
Diversity aids remembrance. If *loci* have too many similar forms,

such as intercolumnar spaces, the "visitor" becomes confused. Orators could provide further clarity by placing the *imagines* at moderate intervals of approximately 30 feet and giving each fifth one a distinguishing mark. The anonymous author further recommends the *loci* be well lighted and devoid of distracting people. Relying on familiar images, orators frequently created mental environments based on the locale most familiar to them: the single-family residence (*domus*) preferred by upper classes.[10] Quintilian, a rhetorician in the first century A.C., describes other memorable models, "What I have spoken of as being done in a house can also be done in public buildings . . . or in going through a city" (*Inst.* 11.2.21).

Unfortunately, ancient authors do not discuss fully the city as a mnemonic model. An individual building such as a house is a well-structured whole with obvious spatial continuity. For mnemonic purposes, this clarity in turn reinforces the sequential logic of any associative content, thereby making compact structures powerful memory tools for rhetoricians. A real city as a conveyer of content is significantly more complex. Because authors of urban narratives cannot control all construction in a city, they must present their stories in episodic form and rely on the reader to make the connections. For greatest effect, Roman authors imbued elements in the city with the actual narrative to be conveyed, in contrast to rhetoricians who used imagined *loci* as receptacles of a text. In effect, real urban components did not merely hold the meaning, they were the meaning.

Fortunately, Romans of all classes were accustomed to reading a content in buildings. Every structure conveyed a message about its patron (Favro 1989; Kuttner in this volume). Vitruvius writing in the late first century B.C. affirmed the link between status and private residences (*De arch.* 6.5). In the same period, Cicero noted that the achievements of individuals brought fame to specific environments and, conversely, that a notable structure could enhance a person's status. Describing an imposing *domus* in Rome, he wrote, "Everybody went to see it, and it was thought to have gained votes for the owner" (*Off.* 1.39).

The tying together of disjointed individual urban messages required pretraining. Again, rhetorical education established the framework. Roman orators, like elegiac poets, combined elements from different sources to explicate a single theme.[11] Orators did not explain their extended metaphors and analogies in detail, assuming the listener would translate and recombine them into a cogent content. In effect, the Romans applied hermeneutics to the creation of a logical narrative. Given this training, urban authors addressed a proleptic, preconditioned audience. Even the

slightest associative link between urban projects, stimulated edu-
cated urban observers to discover a uniting narrative.[12]

The lower classes could not draw upon rhetorical training to
help them comprehend the urban narrative of ancient Rome. Cic-
ero noted that the half-educated "find it easier to deal with matters
that they cannot grasp in their entirety if they split them up and
take them piece-meal, and . . . separate words from thoughts as
one might sever body from mind" (Cic. *De Or.* 3.6.24). However,
the thousands of anonymous, uneducated observers in the capital
had developed excellent visual mnemonic skills on their own. In
a large metropolis with few street names and no numbering, res-
idents needed good visual and spatial memory simply to move
about.[13] Because they received most of their information visually,
uneducated urban residents associated ideas with the images before
them. Patrons acknowledged this by incorporating explicit, easy-
to-read messages on all monuments. Sculptures, paintings, plant-
ings, and architectural materials and forms all projected a legible
text. For these individual phrases to have greater meaning, they
had to be linked together. Whereas the educated relied on their
rhetorical training to make associations, the unsophisticated drew
connections between urban projects with similar visual traits or
related meanings.

Hundreds of content-laden places and images filled Rome dur-
ing the Republican era. Individually, they told stories about sig-
nificant events and individuals; collectively, they presented the
history of the state. Yet these *loci* and *imagines* did not form a
coherent narrative. The discrete messages were disjointed and dif-
fused. They remained episodic. Too many authors had created
these vignettes over too long a time for them to hold together by
anything more than superficial proximity and a shared history.
The short stories of Republican Rome did not coalesce into an
urban narrative.

During the first century B.C., powerful individuals dominated
the political stage, creating a context for conscious urban scripting.
Sulla, Pompey, and Caesar claimed overscaled power; they re-
quired overscaled monuments.[14] Yet single buildings or com-
plexes, even such grandiose projects as Pompey's theater, could
not convey the scope of power wielded by these men. A trans-
formed city could. The Romans acknowledged the potent asso-
ciation of cities and dynasties in the eastern Mediterranean. They
freely discussed the great palace and tree-lined streets of Cleopa-
tra's Alexandria and the choreographed compositions of Attalid
Pergamon.[15] Inspired by such examples, the powerful men of the
late Republic developed not only residences suitable to their
status, they began to reshape the capital city.

Julius Caesar made the most comprehensive plans to rewrite Rome's urban text. He envisioned numerous gigantic individual monuments, including a new forum "distinctly more beautiful than the Forum Romanum" (Dio Cass. 43.22) and a Temple of Mars "greater than any in existence" (Suet. *Iul.* 44). In addition, the Dictator considered altering the revered Tiber River to suit his projected narrative. By straightening this liquid thoroughfare, he could impose orthogonal order upon the capital and enhance the status of his own projects and property.[16] Cicero complained, "What a shame! [Caesar's planner] is enlarging the city, ... he thinks it too small to hold the great man alone" (July 13, 45 B.C., *Att.* 13.35.1). Though these Caesarean undertakings were not realized, their scope and purposefulness convey the Dictator's desire to rescript the entire city.

With Caesar's adopted son, Augustus, Rome acquired an author who possessed not only the motivation, but the resources, the power, and above all the endurance to script an explicit text from the entire cityscape. As *triumphator* over Egypt, Augustus had a vast personal wealth at his disposal. By the 20s B.C., he had acquired enough power to undertake large alterations personally and sufficient authority to direct the urban projects of others. Beyond *auctoritas,* the *princeps* had time. In power for over 50 years, he lived to see the majority of his urban projects completed.

Augustus consciously rewrote Rome's urban text in his own words. Addressing the first emperor, Vitruvius noted, "I observed that you cared not only about the common life of all men, and the constitution of the state, but also about the provision of suitable public buildings" (*De arch.* 1.Pref.2). Augustus made adjustments throughout the capital. However, his text can best be read in the Campus Martius.[17] This floodplain to the northwest of the city center was ideally situated for maximum exposure. The Via Flaminia cut a wide swath along the eastern edge of the plain; this main northern highway into the city provided a well-defined path and viewing platform. Spreading westward from the Via Flaminia, the ancient Campus was geographically distinct (Fig. 72).[18] To the East, rose garden-covered hills; to the North and West, the turbulent Tiber formed a liquid border; to the South, a dominating closure was provided by the fortified escarpment of the Capitoline hill towering approximately 30 meters above the Campus.

In the first century B.C., the Campus Martius was a *tabula rasa* awaiting a determined author.[19] Although this plain had long been used for large communal gatherings, such as festival celebrations and military maneuvers, generally, these activities had taken place outdoors or in temporary structures. The Republican Campus had

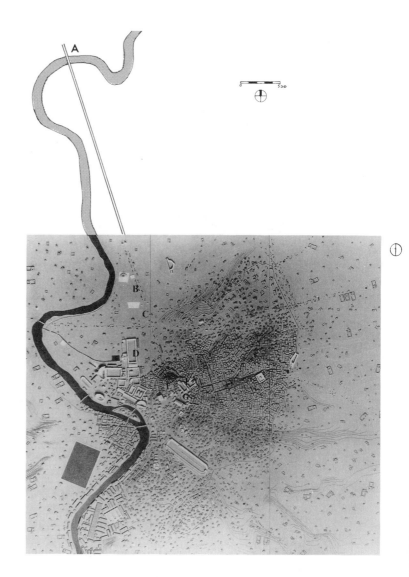

72 Model of Augustan
Rome; overlay extends map
to the Mulvian Bridge.
A. Arch of Augustus on the
Mulvian Bridge.
B. Mausoleum Augusti and
Ustrinum. C. Horologium
Augusti and Ara Pacis. D.
Saepta Iulia. E. Capitoline
Hill. F. Fora of Julius Caesar
and Augustus. G. Forum
Romanum. Courtesy:
Antikenmuseum Berlin,
Staaliche Museen Preussicher
Kulturbesitz. Photo:
J. Laurentius.

few large, permanent buildings. Only the great stone Theater of
Pompey (ca. 55 B.C.) made a monumental, permanent statement.[20]
Programmatically, the Campus was also unencumbered. Outside
the city proper, the Field of Mars was free of the restrictions
imposed on activities within the city's sacred boundary, the *pom-
erium* (Oliver 1932). For example, in the Villa Publica of the Cam-
pus Martius, foreigners waited for official approval to enter the
city center. Armed troops, similarly barred from entering Rome
proper, marshalled in the great plain; soldiers participating in the
magnificent parades for military triumphs gathered first in the
Campus. The sprawling, open plain also provided ample space for
the large tribal assembly (*comitia centuriata*).[21] Furthermore, the

public ownership of much property in the Campus Martius facilitated development by the state (Oros. 5.18.27).

After Caesar's death in 44 B.C., several alterations to the Campus Martius further prepared the area for scripting. In 43 B.C., a vote of the Senate decreed the large Naumachia Caesaris be covered over. Unmaintained, this artificial lake for mock naval battles had become a center of disease (Dio Cass. 45.17). The following year, the *triumvirs* compelled rich senators to spend money reworking roads, presumably including the Via Flaminia (Dio Cass. 47.17). In 33 B.C., Augustus' right-hand man, the admiral and general Marcus Agrippa, assumed the lowly office of aedile and repaired Rome's decaying drainage system, thus making the flood-prone Campus Martius relatively safe for construction. In addition, he constructed a new aqueduct, the Aqua Virgo (completed in 19 B.C.) to supply the area with an ample supply of potable water. Augustus himself cleared and widened the Tiber bed and in 27 B.C. repaved the Via Flaminia (Suet. *Aug.* 30; Dio Cass. 53.22).

Beginning in the late 30s B.C., the first emperor and his supporters imposed a directed text upon the Campus Martius. They erected approximately twenty-five structures and restored or reworked at least seven preexisting buildings. In effect, Augustan patrons created a legible epitome district, a zone of concentrated emotions, layered symbols, and intense energy and meaning.[22] In so doing, they established a plot line to be embellished by succeeding generations.

The Campus Martius served as a public forecourt to Rome, an area integral to the city proper, yet distinct. The most obvious contemporary analog is the atrium of the Roman house. Significantly, foreign ambassadors waited in the Campus for official admittance into the *pomerium* of the city proper just as visitors waited in an atrium for admittance into the private areas of a *domus*.[23] Also like the semipublic atrium, the Campus Martius provided visitors entering from the north with impressive background information on the primary residents of the city/house within. In a *domus* atrium, visitors found sculptures of family members, shrines to the family spirits, and treasures. In the Field of Mars, urban observers saw representations of imperial family members, revered state ancestors, and patron deities; monuments commemorating Augustan achievements; and displays of expensive and refined objects.[24]

In both atria and the Campus Martius, the narrative is shaped by the path of the observers. An atrium's proscribed area limits kinetic options; the city multiplies them. Although many ancient texts describe the city moving from the center outward, others describe internal paths or external approaches.[25] Rhetorical texts

confirm the importance of creating a legible text regardless of the path followed. Given the importance of the Campus Martius as a forecourt to the capital, this chapter explores the urban narrative experienced by an observer moving from outside Rome toward the city center.[26]

The Augustan narrative first becomes legible far to the North, at the point where the Via Flaminia crosses the Tiber River (Fig. 72). In 27 B.C., Augustus repaved the Via Flaminia at his own expense. To celebrate this achievement, he placed an arch on the Mulvian Bridge surmounted by a representation of himself looking down on all who approached the capital.[27] Passing through this symbolic doorway, ancient observers assumed three roles. Looking at new Augustan projects, they were passive readers. Varying their route through the Campus and their length of stay, observers became commanding storytellers called upon to connect diverse, nontangential messages. Furthermore, by being physically in the Campus Martius, observers became active participants in the Augustan narrative, for their very presence affected the narrative reading of others.

In reality, the self-determination of urban observers was limited. Throughout the Campus Martius, Augustus as urban author exploited the Via Flaminia as an organizational device (MacDonald 1986). He and his supporters located all major features in relation to this linear viewing platform. The Campus with its great buildings lay slightly lower than the highway. After moving for miles through the countryside, observers naturally were attracted to the active urban scene to the West rather than the more rural eastern view of the Pincian Hill with its scattering of villas and gardens.[28] The Via Flaminia made the narrative comprehensible and, equally important, ensured that the majority of viewers read the same text in the same order. Any reading away from the primary story line identified by the highway required a determined effort and was immediately perceived as ancillary.

Along the Via Flaminia, observers first encountered a series of tombs dating back to the early Republican period.[29] Romans of import vied for burial along major roads into the capital. Even more prestigious was the honor of a funerary monument in the Campus Martius. The Republican Senate had awarded this distinction to such notables as Sulla and Julius Caesar.[30] Just on the northern edge of the great Field of Mars loomed the Mausoleum Augusti. Rising dramatically from the low-lying plain to a height of over 40 meters, the human-made mountain literally overshadowed all earlier tombs (Pollini in this volume: Fig. 86). The scale of the new structure was appropriate to the desired stature of Augustus and to the mausoleum's place within his urban narrative.

Great size was identified as an admirable trait in the Hellenistic period. Although Romans of the late first century B.C. believed enormous structures appealed primarily to the unsophisticated, they nevertheless continued to equate great size with great importance.[31] Augustus began his monumental tomb in 28 B.C., shortly after his acclaimed restoration of the Republic and triple triumph for the conquest of Illyricum, victory at Actium and annexation of Egypt. The huge memorial was appropriate for a man of such achievements. Furthermore, the form of the tomb linked the *princeps* with other greats. Romans associated the tumuli of Etruria and Anatolia with their mythical ancestors from Troy and with Alexander the Great, believed to be interred in a mound near his namesake city in Egypt.[32] Diodorus Siculus described the Macedonian's large funerary sanctuary as "worthy of the glory of Alexander in its size and elaborateness" (18.26). After visiting Alexander's tomb, Augustus constructed a monumental mausoleum worthy of his own elevated place in history. Such projects, as Vitruvius noted, served as "a memorial to future ages" (*De arch.* 1.pref.3).

Observers easily read the Mausoleum's simple, natural shape from a great distance. Formal conventions in ancient painting called for elements seen from afar to be larger and less detailed. Similarly, Cicero told orators the best results could be had by selecting mnemonic images "that are effective and sharply outlined and distinctive, with the capacity of encountering and speedily penetrating the mind" (*De Or.* 2.87.358). Today, even without its earthen mound, the centralized form of the tomb and its gigantic scale still impress visitors to Rome.

On drawing closer to the Mausoleum, ancient observers found an even more detailed text. Atop the earthen mound stood a large bronze statue of the first citizen. Expensive marble ashlar encircled the tomb's base with a sparkling ring. The whiteness of the marble stood in marked contrast to the evergreens planted on the mound and the greenery of the surrounding public garden.[33] To the East, observers saw another relatively large funerary building, the Ustrinum Domus Augustae, composed of an iron fence surrounding a wall of white stone and grove of black poplars.[34] In conjunction with the tomb, the Ustrinum formed a viewing gate toward the South. Between these two constructs, observers on the Via Flaminia had a carefully orchestrated view of the central Campus Martius (Fig. 73, viewpoints A and B). On a clear day, they could see two Agrippan projects, the original Pantheon (27 B.C.) and, as they moved southward, the short end of the voting enclosure, the Saepta (dedicated 26 B.C.).

Already with these few structures, the Augustan narrative began

73 Plan of Augustan
Campus Martius showing
viewing points along the Via
Flaminia. A. View between
Mausoleum and Ustrinum to
north façade of Saepta Iulia.
B. View between
Mausoleum and Ustrinum
broadening to include north
elevation of the Agrippan
Pantheon. C. View with
obelisk of Horologium as
directional guide. D. View
from Ara Pacis toward screen
of Aqua Virgo.

1. Mausoleum Augusti.
2. Ustrinum.
3. Obelisk of Horologium Augusti.
4. Ara Pacis.
5. Ara Providentiae [?].
6. Aqua Virgo.
7. Porticus Vipsania.
8. Divorum.
9. Saepta Iulia.
10. Agrippan Pantheon.
11. Euripus.
12. Thermae Agrippae.
13. Temple of Mars.
14. Theater of Pompey.
15. Theater of Balbus.
16. Porticus Octaviae.
17. Theater of Marcellus.
18. Temple of Juno Moneta.
19. Temple of Jupiter Optimus
 Maximus.
20. Forum Romanum.
21. Porta Fontinalis.
22. Campus Agrippae.
 Drawing: R. Reif.

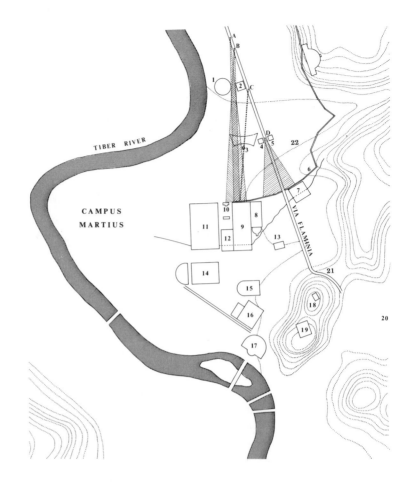

to take shape. The form of the Mausoleum associated Augustus
with famous heroes; its size proclaimed his import. The surround-
ing public gardens affirmed the *princeps'* love of nature and his
paternal concern with providing recreational space for urban res-
idents. The projects by his partisan Agrippa further clarified the
primary themes of the Augustan narrative.[35] Agrippa completed
the large Saepta for tribal voting as a tangible monument to Au-
gustan support of Republican institutions. In addition, the Saepta
affirmed familial piety for Augustus's adopted father, Julius Caesar,
who had begun the project. Agrippa attempted to glorify the Au-
gustan family further with the new Pantheon to the West. He
initially wished to name the structure after Augustus and to place
a statue of the mortal *princeps* inside. When Augustus wisely de-
murred, Agrippa dedicated the temple to all the gods, but em-
phasized Mars and Venus, the ancestral deities of the gens Iulia.
In the porch, he placed statues of Augustus and of himself as a
member of the Julian family through marriage.[36]

The power of the Augustan narrative in the Campus Martius intensified as observers continued South along the Via Flaminia. Once past the Ustrinum, they saw a collection of new monuments. Immediately, their eyes were drawn to a tall Egyptian obelisk. This red granite needle acted as a sight line directing the observers' view once again toward the Saepta and Pantheon in the central Campus Martius (Fig. 73, viewpoint C). Drawing nearer, observers realized the obelisk was part of a large ensemble. Directly North of the stone monolith lay an expansive paved area measuring approximately 160 × 75 m (Fig. 74). Bronze lines inlaid in the travertine paving described a familiar dovetail-shaped form associated with solar timepieces. Observers readily identified the obelisk as the gnomon of a grand sundial, the Horologium Augusti (10 B.C.). Looking down from the slightly higher level of the Via Flaminia, they saw the obelisk's shadow point to bronze lines and words marking the hours of the day, months, signs of the zodiac, and seasonal winds.[37] The obelisk of the Horologium Solarium Augusti was so visually powerful, it became an identifying attribute of the personified Campus Martius, as seen on the base of Antoninus Pius' memorial column (Vogel, 1973: n. 117) (Fig. 75).

Only after they had absorbed the dramatic first impression of the Horologium Augusti did observers notice the small, jewellike Ara Pacis to the East (13–9 B.C.).[38] From a distance, this exquisite marble enclosure read as a rectangular solid with an embossed exterior wall. Dedicated on the birthday of Livia (January 30), the Ara Pacis specifically commemorated the victorious return of her husband Augustus from Spain and Gaul. The small altar also provided a more global interpretation; it celebrated the gift of peace bestowed on the residents of Rome and all the Empire. After a century of unrest, Augustus enshrined Pax in the field of the war god Mars.

Executed in human scale, the Ara Pacis invited closer inspection. The surface of the altar's exterior enclosure had two horizontal registers of carved relief. Stylized acanthus tendrils encircled the altar in the lower zone; figural reliefs embellished the upper. As with most passages in the urban narrative, the altar could be interpreted on many levels. Observers could read the figural carvings on the long sides simply as a depiction of the ceremonies associated with the dedication of the altar itself, or as an advertisement of Augustan religious piety. They could enjoy the mythological reliefs of Rome's origins on the East and West as celebrations both of Rome's illustrious history and of the divine heritage and achievements of the Julian clan. Similarly, observers could enjoy the lower register as a straightforward depiction of stylized nature, or as a container of more complex meaning. For

74 Plan of Mausoleum
Augusti, Horologium
Augusti, and Ara Pacis.
Drawing: F. Yegül.

75 Relief from base for
column of Antoninus Pius.
Lower left corner shows the
personified Campus Martius
holding an obelisk. Courtesy
of the Archivo Fotografico
Vaticano, Monumenti Musei
e Gallerie Pontificie.

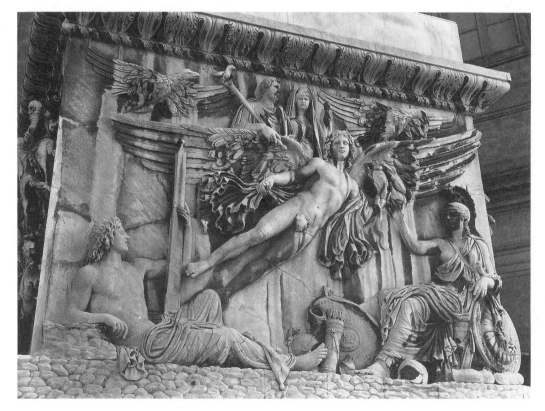

242

example, the representations of swans, sacred to Apollo, called to mind the close ties between Augustus and the sun god who brought him victory at Actium.[39]

From the Via Flaminia, observers first saw the northern face of the Ara Pacis. Above the floral band, a row of patricians marched in solemnity away from the Via, encouraging observers likewise to move West toward the altar's facade. This directional ploy was repeated with the figures on the southern exterior wall. Here, facing the city, observant urban readers identified carved depictions of the first family. Near the head of the procession stood Augustus himself, directly in line with the gnomon of the Horologium. The processional figures are approximately life-size, humanizing the urban narrative and thereby drawing observers directly into the plot. In effect, the figures on the relief mirrored and directed the peregrinations of the urban readers. Both real and carved pedestrians strolled around the altar enclosure toward the paved area of the Horologium[40] (Pollini in this volume: Fig. 86).

The sundial's enormous travertine piazza allowed a pause in the urban narrative. From this vantage point, observers could reexamine passages already read and preview passages to come. To the East, they saw the facade of the white Ara Pacis before a verdant backdrop of *horti*-covered slopes. To the North, the huge Mausoleum filled the horizon. The Augustan tomb was linked to the sundial formally; the centers of both stood the same distance from the Via Flaminia. Previously hidden from the observers' view, the Mausoleum's entrance facing the city now shouted for attention.[41] Placed before the entry, observers discovered an urban text in the traditional literary form of funerary *elogia*. At Augustus's order, his numerous achievements (*Res Gestae*) were inscribed on two bronze tablets and displayed before his family tomb.[42]

Within the plaza of the Horologium Augusti, observers found further overt textual material. The towering obelisk with its exotic and illegible hieroglyphs reinforced the victorious association of Augustus with Egypt. On the base, the *princeps* made the message more explicit in a Latin inscription proclaiming his subjugation of Cleopatra's Egypt (*CIL* 6.702). The Horologium also celebrated another Roman triumph. With this sundial, the designer, mathematician Novius Facundus, demonstrated the Roman conquest of Greek science by basing his calibrations on Greek models and using the Greek alphabet for the words inlaid in the pavement.[43]

Kinetic and temporal in focus, the Horologium presented different readings at different times of the day and year. Everyone could understand the association of the sundial with Augustus's patron, the sun god Apollo. Only the most learned observers could read the complex program in full. On key dates, the shadow

from the obelisk–gnomon literally pointed to the Augustan monuments of the northern Campus, linking them all together programmatically and visually. For example, a shadowy finger pointed directly at the door of the Ara Pacis on the autumnal equinox (September 23; Buchner 1982; Bowersock 1990: 386–9). Such staging was made explicit to urban readers who gathered in the northern Campus on this day to celebrate a simultaneous event, the birthday of Augustus[44] (Fig. 74). With the aid of Apollo, Augustus conquered Egypt and brought peace to Rome.

From the piazza of the Horologium, the view toward the city was likewise carefully scripted. No known Augustan buildings graced the area directly south of the sundial. In all probability, this open zone was preserved to accommodate the exercises, games, and spectacles traditionally associated with the Campus Martius.[45] Across the unencumbered plain, Romans standing by the obelisk Augusti again saw the northern faces of the Saepta and Pantheon. Looking toward the unruly Tiber, observers read an increasingly pastoral urban text. Here were grassy areas, carefully tended shrubs, and other plantings associated with Rome's first grand public bathing establishment, the Baths of Agrippa just South of the Pantheon.[46] The baths and lush greenery received water from the Aqua Virgo. This new Agrippan aqueduct also served other projects. At a distance, observers could see light reflecting off the surface of an artificial pond, the Stagnum Agrippae, and a canal, the Euripus (Coarelli 1977: 830–7).

After reading the complex urban text visible from the Horologium, observers were drawn back to the well-ordered story line viewed from the Via Flaminia. Just past the Ara Pacis, the view opened eastward across the public parkland of the Campus Agrippae.[47] Observers now experienced the full impact of the dramatic Aqua Virgo, known in its own day as the Aqua Augusta (Dio Cass. 54.11.7) (Fig. 73, viewpoint D). Observers marching down from the eastern hills saw the arches of the aqueduct grow ever taller until they terminated at the northern end of the Saepta (Frontin. *Aq.* 1.22). This scenographic device drew the eye directly into the center of the Campus to the most elaborate, largest, and most impressive structures: the grand Saepta and the temple to all the gods, the Agrippan Pantheon (Coarelli 1983a).

Agrippa's aqueduct performed as a dividing line between the relatively open northern section of the Campus Martius, an area that actually deserved the designation of "campus," and the heavily developed zone to the South. Directly North of the aqueduct, East of the Via Flaminia, lay the Campus Agrippae associated with the son-in-law of the *princeps*. This field, along with the northern Campus Martius on the other side of the highway, held the most

explicit monuments to the dynastic aspirations of Augustus. Moving toward the city center, observers faced an increasingly dense and increasingly Republican cityscape. After they passed through the powerful urban line formed by the Aqua Virgo, observers encountered a narrative interwoven with a range of diverse themes. To the left stood the large Porticus Vipsania begun by Agrippa's sister and completed by Augustus (ca. 12 B.C.); inside the portico, a map of the world affirmed Roman domination (Dio Cass. 55.8.3–4). Across the Via Flaminia to the West, observers saw the exotic religious center devoted to the extrapomerial worship of Isis and Serapis.[48] Behind the temple to Egyptian deities, they spied the long, uniform flank of the Saepta and the adjoining hall for the counting of votes, the Diribitorium (ca. 26 B.C.). These two structures associated with the voting of the assemblies attested, at least on the surface, to the outward continuation of the Republic. However, as real control moved from the popular assemblies into the hands of the emperor, these facilities accommodated alternative uses. For example, Augustus held gladiatorial combats in the Saepta, initiating the imperial program of *panem et circenses* designed to divert the populace from acknowledging their diminishing political power.[49]

Looking at the central Augustan Campus, observers read a story of ample leisure time and group-pleasing patrons. In addition to the public gardens and baths, they saw many other buildings dedicated to entertainment. South of the Agrippan baths and Saepta, the curving forms of two theaters rose above the urban infill. To the far West stood the majestic Republican theater and portico erected by Pompey (55 B.C.). Closer to the Capitoline hill was the smaller, yet more opulent theater complex of Balbus (13 B.C.).[50] Too distant to be seen clearly, but known to all observers, the area of the great Circus Flaminius (erected 221 B.C.) nestled on the Tiber bank.[51] Loudly and clearly, the text of the Augustan Campus conveyed a light-hearted satire of gladiatorial games, verdant parks, relaxing baths, and theatrical performances.

The urban narrative became muddled as observers faced the congested construction at the base of the Capitoline Hill. Several important Republican buildings graced this area, including the Villa Publica and an altar to Mars, the namesake deity of the Campus. Yet the numerous shops and residences minimized the visual impact of the individual structures. Observers did not find a clear story line. With views to either side of the Via Flaminia greatly constricted by diverse construction, observers found their attention drawn upward to the Capitoline Hill. The Temple of Juno Moneta on the Arx stood almost directly on axis with the Via Flaminia. However, its placement away from the edge of the

hill meant that observers could glimpse the temple only from a distance.[52] Far more impressive was the Temple of Jupiter Optimus Maximus perched high above the plain on the northern edge of the Capitolium. From the Via Flaminia, observers saw the rear corner of this magnificent structure with its prominent roof sculpture silhouetted against the sky. Augustus restored the temple in the mid-20s B.C., noting in his *Res Gestae,* "I rebuilt the Capitolium . . . [at] great expense, without any inscription of my own name" (20.4.9). This act of modesty was calculated to attract attention and to underscore his piety and personal association with the temple as triumphator and member of all the great priestly colleges.[53]

Continuing southward, observers followed the Via Flaminia as it rose and curved to the East. At a high point just below the Arx, they faced a second threshold, the Porta Fontinalis.[54] Like the Mulvian Bridge at the edge of the Campus Martius, this urban gateway identified a transition. Passing through the remnants of the Republican fortifications, the great highway became an urban street, the Clivus Argentarius. At this point, the Campus Martius chapter of the Augustan urban text also came to a close.

Like any good narration, the Augustan urban text in the Campus Martius had several recognizable, all-pervasive themes. Visitors stood in awe at the enormity of Augustan projects. For example, Dio Cassius marveled that the Diribitorium with its beams 100 feet long was "the largest building under a single roof ever constructed" (55.8). Similarly, the mountainous form of the Mausoleum Augusti overshadowed all other tombs in the Campus Martius, and in Italy. Agrippa's bath complex with its surrounding parklands introduced a new building type, the grand imperial *thermae* joining characteristics from Greek palestra with those of Latin baths. Other constructs represented outsized ideas. The Ara Pacis celebrated the great gift of peace after many decades of foreign and civil unrest. Overall, the huge extent of Augustan intervention in the Campus Martius itself was notable. The entire ensemble of buildings recalled the stately palace–park–gymnasia complexes of Hellenistic rulers (Coarelli 1983a: 44). Few observers could read this text without being impressed, or without equating the immense projects with the enormous power and fame of the *princeps* himself.

Similarly, the very arrangement of the urban text presented another major theme. The orthogonal configuration of the central zone was memorable; the grid explicitly reflected Augustan rationality and organizational skill.[55] This thesis was further supported by the overall health of the region's infrastructure. Only a few years before, visitors to the Campus Martius and the rest of

Rome had found derelict public buildings, unsafe streets, and marshy lowlying plains. In contrast, observers moving through the Augustan Campus enjoyed well-maintained marble structures, a newly paved highway, safe pedestrian passage, and opulent recreational complexes standing on reclaimed urban land.[56] The programming of the Campus emphasizing entertainment purposes acknowledged both the existence of leisure time and a paternal concern for users. Reading between the lines, observers discerned an author who cared about the well-being and enjoyment of the capital's residents.[57]

On the microurban scale, individual elements, like individual words, clarified the Augustan narrative and left little room for ambiguous readings. Sculptures, paintings, and inscriptions celebrated specific events, personages, and myths supporting Augustan propaganda. Thus, the world map on display in the Porticus Vipsania proclaimed the extent of Augustan conquest.[58] Certain architectural forms had their own specific content. The numerous obelisks of the Campus affirmed over and over Augustus' subjugation of Egypt. Individual building names linked complexes with specific people (Saepta Iulia, Thermae Agrippae; Porticus Vipsania) or with all-encompassing ideas (Ara Pacis, Pantheon). Inscriptions expressed what was not immediately evident in the physical form of the urban text. Lengthy written passages, such as the *Res Gestae,* carefully articulated the Augustan program for literate observers.

To clarify the order and progression of the urban narrative, individual elements, like individual phrases or characters, were repeated. For example, obelisks occurred at the Horologium and the Templum Iseum et Serapeum. Selected opulent materials and decorative elements also reoccurred frequently, linking structures separated by distance. Extravagant white marble, formerly rare in the Republican capital, identified major projects as Augustan. Similarly, laurel trees, symbols of Apollo and victory adopted by Augustus, appeared within the Campus Agrippae and at the Mausoleum Augusti.[59] Following the format of contemporary painted and sculpted narratives, the most commonly reiterated image was that of the primary character.[60] At the center of each urban vignette in the Campus Martius stood a literal representation of Augustus. He welcomed observers from atop the arch over the Via Flaminia; he reigned over the entire Campus from the great height of his mausoleum; he piously performed in religious rituals on the Ara Pacis; with Agrippa, he proudly occupied the porch of the Pantheon.

Representations of the *princeps* physically placed him in the Campus Martius in the reality of the moment. Other urban pas-

sages projected the First Citizen into an extended environment. The altar of Peace and the Egyptian obelisks expanded his sphere of action far outside the city on the Tiber. The Pantheon related Augustus, the Campus, and the Roman state to the cosmos. Similarly, individual associations expanded time outward in contrasting directions, often simultaneously. In particular, the Mausoleum Augusti offered multiple readings. To some urban observers, this large tumulus recalled the burial mounds of mythical figures in Rome's distant past; to others, it sparked memories of the tumulus of Alexander the Great. At the same time, both groups could read this impressive structure as a paean to Rome's glorious future, a future to be shaped by the descendants of Augustus.

The urban choreography of the narrative in the Campus Martius directly drew upon rhetorical models. The anonymous author of the *ad Herennium* advised orators carefully to choreograph their mental *loci*. He recommended objects be placed at moderate intervals of about 30 Roman feet explaining, "for like the external eye, so the inner eye of thought is less powerful when you have moved the object of sight too near or too far away" (3.19.32). Augustus staged his narrative with equal care. His enormous Mausoleum was appropriate in scale for distant viewing. This great tomb was first seen as observers moved southward from the Mulvian Bridge over 3,300 m to the North.[61] The interval between the next three Augustan groupings was fairly equal, measuring approximately 400 m. Such ample urban spacing maintained a uniform rhythm and allowed the large buildings of the central Campus to be viewed at distances appropriate to their scale.

As a good author, Augustus varied the impact of various urban phrases within his text. According to the *ad Herennium,* the "unusual, great, unbelievable . . . the striking and the novel stay longer in the mind" (3.22.35; cf. 37). The *princeps* filled the Campus Martius with many memorable images. The Mausoleum was magnificent in scale, the Ara Pacis exquisite in execution, the Horologium marvelous in its scientific precision, the Diribitorium unique in its construction, and so on.[62]

Just as orators carefully crafted their speeches to be understood at various levels by different listeners, Augustus provided an animated text legible for urban readers of all types and classes. However, his primary audience was obviously the receptive educated elite (Hölscher 1984). Full appreciation of his narrative could only be had by observers with the skill and knowledge to read the complex tale. Significantly, most members of the patrician class had training in the architectural mnemotechniques of rhetoric. Furthermore, this group alone had access to the best view of the Campus Martius. Only the rich resided on the Pincian Hill to the

West. From their opulent villas and gardens, these privileged ob-
servers could read the entire Augustan text in a single glance.[63]
Other classes could comprehend the urban narrative, but with less
clarity. Uneducated plebeians moving through the Campus Mar-
tius could readily identify representations of the *princeps,* marvel
at his wealth and power, and admire his paternal attitude toward
Rome and her residents even if they may not have understood
the subtleties of the text or been able to interweave the different
isolated messages into a true narrative.

In antiquity, *memoria* meant both the capacity for remembering
and actual remembrance. The *princeps* choreographed Rome with
great structures not merely to help residents find their way, but
to secure his own place in the collective memory of the Roman
people. Quite simply, he wanted his influence, his *memoria,* to
endure for beyond a single lifetime. Augustus constructed nu-
merous marble projects in Rome as lasting memorials to his
achievements. Yet he knew narratives lived even longer than
physical monuments. His contemporary Vitruvius explained, "An
architect ought to be an educated man so as to leave a more lasting
remembrance (*memoriam*) in his treatises" (*De arch.* 1.1.4). To
heighten the memorability of his urban projects, Augustus wove
them together into a recognizable, unambiguous narrative.[64] Only
then was his architectural propaganda able to direct the energies
and thoughts of urban observers (Brilliant 1988: 110).

The Campus Martius presented observers with a clear intro-
ductory chapter. The story of Augustan Rome continued within
the city proper. Passing through the Porta Fontinalis, urban ob-
servers carried memories of the plots and subplots, phrases and
vocabulary presented in the first installment of the capital's mul-
tivolumed narration. Just within the Porta Fontinalis, atop the rise
of the Clivus Argentarius, observers commenced the next chapter.
The city center had a complex, layered, labyrinthine plot. There
Republican themes exerted themselves more forcefully than in the
northern plain. Yet after reading the text of the Campus Martius,
urban observers could readily identify Augustan passages. Looking
down on the two imperial fora to the East, they drew immediate
parallels with projects in the Campus. In effect, the experience of
the Campus Martius "trained" urban observers to read the rich
materials, well-defined form, and overall grandeur of the Forum
Iulium and Forum Augustum as characteristically Augustan.

Despite such careful scripting, the Augustan urban text did not
endure. Observers in the early first century easily followed the
story line provided by projects enormous in scale and shockingly
rich in material. Those who visited the late imperial city found
an urban text so encumbered and overwritten that legibility was

extremely difficult. Following Augustus, subsequent imperial authors wrote their own urban narratives on top of the preexisting text. With each new scripting, earlier story lines became obscured and new urban narratives became difficult to read. Key syntactical conventions lost their effectiveness. For example, with the addition of more and more grand structures, opulence and large size became commonplace (and thus unmemorable) characteristics. As a result, neither the earlier Augustan narrative nor the new imperial story could be readily discerned. By the midfirst century A.D., the Augustan narrative was largely illegible; the individual monuments of the first emperor reverted to episodic, unconnected vignettes.

A capital city is the physical container of collective aspirations, or rather of elite aspirations collectively imposed. All architecture in a capital has significance beyond its utility. Augustus exploited this phenomenon to create a city worthy of his stature. During his many years of power, building by building, ensemble by ensemble, he crafted an urban narrative conveying select information on the state, the citizens, and himself. On the *tabula rasa* presented by the Field of Mars, he wrote a text that was well-orchestrated, easy to follow, and focused. Strabo compared the Campus of his day specifically to contrived stage paintings. After describing the great Augustan colonnades, sacred precincts, theaters, monuments, and temples, he concluded that any sensible observer would consider the rest of Rome a mere appendage (5.5.8). In the well-formed Campus Martius building forms, compositions, materials, decorations, iconography, and scale all supported a clear narrative: Through the foresight and beneficence of the *princeps,* the disjointed, unruly Roman world was ordered, educated, tamed, entertained, and united. By A.D. 14, the Campus Martius presented a narrative readers could paraphrase in a single word: Augustus.

NOTES

1. After his adoption by Julius Caesar in 44 B.C., C. Octavius was recognized as C. Julius Caesar Octavianus. In the following years, he avenged his adopted father's murder and acquired power through force and alliance. In 28 B.C., he enrolled himself in the Senate as *princeps senatus;* the following year, he was awarded the honorary title *Augustus.*

2. This chapter focuses on the reading of Rome's urban environment. Recent works explore the multiple (and repeatable) readings of Augustan art, including Kellum (1985); Leach (1988); Zanker (1988). On the visual impact of urban forms in the Roman empire, see the inspiring work by MacDonald (1986: esp. 266–70).

3. Aristotle wrote, "the soul never thinks without a mental picture;" *De An.*

432a 17; cf. 431b 2. Similar statements occur in the works of Roman authors; e.g., Cic. *De Or.* 2.87.357; Yates (1966: 32–4).

4. My emphasis, Cic. *Fin.* 5.2. Similarly, when Marcus Antonius rebuked Julius Caesar in early 44 B.C., he drew upon the power of specific sites, noting that he selected the locations for their meetings in order, "that Caesar might be made ashamed by the very *places*" (my emphasis); Dio Cass. 46.19. The Romans believed each location had its own attendant, enduring spirit or *genius loci;* cf. Servius comp. *ad Aen* 5.95; *DarSag* s.v. Genius.

5. Of course, the individual reader plays a major role in determining how and in what sequence individual elements are read in all visual narratives as Brilliant has demonstrated in relation to Roman reliefs (1984: 16–17). Kevin Lynch discusses paths as one of the five main components of cognitive mapping (1960: 49–62, 91–9).

6. All educated Romans studied rhetoric, though not all became rhetoricians; Carcopino (1971: 122–7); see also the references to ancient rhetoric in the essays in this volume by Pollini, Kuttner, and Stewart.

7. The *Ad Herennium* has in the past been mistakenly credited to Cicero. In 55 B.C., Cicero himself completed *De Oratore,* a work on oratory in which he discussed the rhetorician's art of memory in a more entertaining and succinct manner. The *Institutio Oratoria* written by Quintilian in the first century A.C. is the third major ancient source describing the architectural mnemonic system. On these three sources, see Yates (1966: 1–26). Although Roman texts describe other memorization techniques, the use of *loci* was especially popular because it was thought to be based on nature; *Ad Her.* 3.22.35. This system did have one major drawback: The creation of an imagined environment actually increased the amount of information to be remembered; cf. Quint. *Inst.* 11.2.23–26.

8. *Imagines* could represent actual objects, individual words, or underlying ideas; *Ad Her.* 3.20.33; cf. 3.23.38.

9. An orator might vary the order of points in his speech in response to his audience and site of presentation; Quint. *Inst.* 11.1.47.

10. Due to the high costs of urban land in Rome, single-family homes were affordable only by the very rich. In the first century A.C., Juvenal noted that one could buy an entire house in other Italian cities for the same price as the yearly rental on a dark garret in Rome; 3.223–225.

11. Brilliant makes an analogy between the episodic compositions of Roman painting and the combinatory nature of elegiac poetry (1984: 72).

12. The personal, mental creation of narratives was furthered in the Augustan Age by the gradual supplantation of the oral tradition by individual, private readings. Without a speaker to consult, readers had to draw upon their own hermeneutical skills (Macrob. *Sat.* 1.pref.5; Brilliant 1984: 15, 72–4, 123). Barthes considers the intention to read as a potent shaper of narrative: "I read texts, images, cities, faces, gestures, scenes, etc. These objects are so varied that I cannot unify them within any substantial nor even formal category; I can find only one intentional unity for them: the object I read is founded by my *intention* to read: it is simply *legendum,* to be read, issuing from a phenomenology, not from a semiology" (1986: 34).

13. Locational disorientation must have been common in ancient Rome. Unlike planned Roman colonial cities, the capital had neither an orthogonal layout nor an organizing primary street that observers could use to orient themselves. In antiquity, only a few significant streets within the greater city (e.g., the Sacra Via) and highways (e.g., the Via Flaminia) had names (Homo 1971: 357–84).

14. Sulla held the extraordinary position of dictator from 81–79 B.C. He planned two great architectural projects on the Capitoline Hill: the rebuilding of the Temple of Jupiter Optimus Maximus after a fire in 83 B.C. and a record office, the Tabularium. He also reworked the Forum Romanum (Van Deman 1922). Sulla, in turn, acknowledged the military prowess of his general Pompey by dubbing him *Magnus* (the Great) after triumphal campaigns in Africa (81 B.C.). Pompey constructed a portico and Temple of Venus Victrix along with a great theater complex in the Campus Martius completed in 55 B.C.; Cic. *Off.* 2.60; Sauron (1987). Caesar was dictator in 49, 47, and 45 B.C., and finally was appointed dictator for life in 44 B.C.; Syme (1939). Though he planned many large alterations to Rome, these were curtailed by assassins' knives on the Ides of March, 44 B.C.

15. In the first century A.C., Quintilian succinctly stated, "Cities are praised after the same fashion as men" (*Inst.* 3.7.26). The tradition of urban panegyrics can be traced back to the fifth century B.C. (Hartigan 1979). Strabo writing in the Augustan Age provided lengthy descriptions of both Pergamon (bk. 13) and Alexandria (bk. 17).

16. Cicero, *Att.* 13.33a. The proposed Tiber alteration would have increased the value of Caesar's property along the Via Portuensis on the right bank; Hor. *Sat.* 1.9.18; Cic. *Att.* 15.15. In addition to reworking Rome's physical fabric, Caesar drafted new municipal laws. Incomplete at his death, these laws were subsequently passed on the motion of Marcus Antonius. Known today as the *Lex Iulia Municipalis,* they included a provision restricting urban traffic during the daylight hours; Hardy (1911: 136–63); Favro (1992).

17. Due both to its position nestled among the hills and to its sprawling suburbs, Rome did not present a powerful external view, a major contrast to Hellenistic capitals according to Bek (1985: 146). Augustus attempted to redress this planning flaw by placing impressive constructions associated with his family at every major approach. The Via Flaminia entering Rome from the North through the Campus Martius was an especially important route as demonstrated by subsequent imperial building; Boatwright (1987: 87).

18. The Campus Martius encompasses approximately 140 hectares on the West side of the Via Flaminia; the distance from the Pons Mulvius to the Capitoline along the Via Flaminia is about 4.5 km. In 7 B.C., when Augustus established fourteen administrative regions in Rome, he designated the Campus Martius as Region IX, second in size only to the large peripheral region across the river; Homo (1971: 102–4); Castagnoli (1946: 93–193).

19. The metaphor of a wax tablet was used frequently in discussions of memorization. The author of the *Ad Herennium* wrote, "For the *loci* are very much like wax tablets or papyrus, the *imagines* like the letters, the arrangement and disposition of the images like the script, and the delivery is like the reading" (3.17.30).

20. Before the Theater of Pompey, the most notable structures in the Campus Martius were religious. For example, beginning in the fourth century, a series of four East-facing temples created a notable ensemble in the Area Sacra del Largo Argentina. Nearer the walled city proper, at the point where triumphal processions gathered before entering the city proper, generals erected temples to commemorate their successes; as a result, they created what Stambaugh dubs an area of "prestige urbanism"; Stambaugh (1988: 29–30); Coarelli (1977). Undeveloped public land in the northern Campus Martius was sold during the upheavals of the early first century B.C.; Oros. 5.18.27. Pompey himself purchased property and created a large garden estate near his theater; Vell. Pat. 2.60.3; Coarelli (1984: 86). Agrippa

apparently owned land in the central Campus; Coarelli (1977: 815–16). Little is known of the urban infill (houses, shops, shacks) of the Campus, yet because a large portion of the field was state property, we can presume that few unrecorded structures disrupted the views and relationships between major monuments. On the public ownership of the Campus, see Cicero, *Leg.Agr.* 2.31.85.

21. The Villa Publica (435 B.C.) was the main permanent public complex in the Campus Martius proper in the Early Republic; Livy, *Epit.* 4.22.7. A coin issued in the 50s B.C. indicates the Villa Publica was restored by Fonteius Capito in the same era; *BMCRR* 1.479, 3856–60; Agache (1987). The *comitia centuriata* voted in an impermanent enclosure known as the Ovile, later replaced by the Saepta Iulia; Serv. *Ad Ecl.* 1.33; Juv. 6.529; Gatti (1937).

22. Clay coined the term "epitome district" in his discussion of American cities (1973: 38–65).

23. Ambassadors gathered at the Villa Publica awaiting permission to enter the *pomerium;* Livy, *Epit.* 30.21.12; 33.24.5; Coarelli (1965–7); Morgan (1973).

24. In addition to new representations of himself, Augustus transferred statues of important citizens from the sacred Capitoline Hill to his new development in the Campus Martius (Suet. *Calig.* 34). Unfortunately, the appearance of the Augustan display is unknown. The Porticus ad Nationes built by Augustus, probably in the vicinity of the Theater of Pompey, had statues of the fourteen nations Pompey conquered (Serv. *ad Aen.* 8.721). The Romans used the porticos of the Campus for the display of many curiosities; in the Saepta they exhibited one of the huge timbers required for the Augustan Diribitorium (Pliny *HN.* 16.202; cf. 9.11; 116; 12.94; 16.200; Suet. *Aug.* 43).

25. Among Augustan authors, Strabo describes Rome's physical form chronologically, starting with the settlements on the Capitoline, Palatine, and Quirinal hills. However, he gives experiential details only for the Campus Martius (5.3.7–9). Strabo's route through the Campus meanders: He examines the southern section, the Mausoleum to the North, and then returns to the city proper to point out Augustan constructions at the Forum Romanum, Capitoline, Palatine, and Esquiline. From his exile, Ovid recalls the memorable structures of Rome, moving mentally from the city center to the Campus (*Pont.* 1.8.33–8; cf. *Tr.* 3.1). Horace describes walking from the city center to a garden across the river in order to avoid a bore (*Sat.* 1.9.17–78). For a fabricated walk from the city center to the countryside in the midfirst century A.C., see Purcell (1987).

26. The reverse path shows an equally powerful narrative, tracing the evolution of Augustus's life, from birth on the Palatine to burial at the Mausoleum Augusti; see the essay by Pollini in this volume and Coarelli (1983a: 42).

27. Unfortunately, Dio Cassius does not describe in detail the arch or statue erected by Augustus on the Mulvian bridge (53.22). A coin minted in Spain depicting an arch with Augustus in a chariot drawn by two elephants has been linked with the Mulvian Bridge; *BMCRE* 1.75, Nr. 432, Table 10.6.

28. Among the expansive gardens (*horti*) East of the Via Flaminia were those belonging to Lucullus and Pompey, the latter subsequently given by Caesar to Marcus Antonius (App. *BCiv.* 3.14). Wealthy Romans cultivated so many gardens on the hill above the Campus Martius, it became known as the Collis Hortulorum (Suet. *Ner.* 50; cf. Strab. 5.3.8).

29. On the honor associated with burial along the Via Flaminia, see Stat. *Silv.* 2.1.176.

30. Following the death of Caesar's daughter Julia, the Roman people insisted she be interred in the Campus Martius. The senator Domitius declared such an action to be sacrilegious without a special decree (Dio Cass. 39.64). Among other tumuli in the Campus was the unused mound of Agrippa, whose location and disposition are unknown (Dio Cass. 54.28; Boatwright 1985: 492).

31. Hellenistic authors and artists had often praised great size or *megethos*. Augustan writers continued to equate largeness with fame (Ov. *Fast.* 5.553–4), though with the usual caveats (Vitr. *De arch.* 7.pref.15; Onians 1979: 121–3, 133–4, 144).

32. The tumuli form harkened back to the tombs of Ionia and the burial mounds of the Etruscans associated with the heroes of Rome's past (Verg. *Aen.* 2.849; Hor. *Carm.* 3.29.1). Augustus may also have chosen a tumulus in emulation of the Tumulus Iuliae in the Campus Martius, the most likely burial spot of Julius Caesar (Dio Cass. 44.51; Suet. *Iul.* 84). Because the specific site of the Caesarean mound is unknown, it cannot be included in the Augustan narrative described here. The symbolism of the Mausoleum Augusti is examined by Kraft (1967); Eisner (1979); Coarelli (1983a); von Hesberg (1988b); Zanker (1988: 72–7).

33. Strab. 5.3.8. Recent reconstructions represent the figure atop the Mausoleum as Augustus triumphant in a quadriga; Hofter (1988).

34. The Ustrinum of Augustus is described by Strabo in a very confusing passage; 5.3.8; Boatwright (1985: 492; 1987: 224–5, 229–30).

35. When ill in 23 B.C., Augustus gave Agrippa his signet ring, a clear sign he considered the general his political heir (Dio Cass. 53.30). Once recovered, the Princeps identified other, closer family members as his successors. In the early 20s B.C., Agrippa married Marcella, niece of Augustus, whom he divorced in 21 B.C. to marry Julia, daughter of Augustus. On the life of Agrippa, see the works by Shipley (1933) and Roddaz (1984).

36. Dio Cass. 53.27. The exact form and orientation of the Agrippan Pantheon are still a subject of debate; see de Fine Licht (1968: 172–6, 191–4); MacDonald (1976: 77–84); Loerke (1982); Boatwright (1987: 36–7, 43–6). On the symbolism of the Pantheon in relation to Augustus, his family and to Rome's founder, see Coarelli (1983a).

37. Pliny *HN*. 36.72. During the time of Augustus, the Ara Pacis apparently stood at a slightly higher elevation than the obelisk of the Horologium Solarium Augusti. The great sundial has been thoroughly studied by Buchner in two major articles combined into a single publication (1982). His excavations and calculations indicate this large sundial underwent several subsequent alterations; see also Buchner (1988).

38. Possibly, the Ara Pacis was mirrored across the Via Flaminia by another altar, the Ara Providentiae Augusta; Coarelli (1983a: 43). Dedicated to the personification of imperial care over the entire Roman empire, this altar stood in the Campus Agrippae. The date of the altar remains uncertain. It is shown on coins from the reign of Tiberius, yet may have been erected in A.D. 4 at the time of his adoption by Augustus; Coarelli (1980b: 304); Martin (1982: 115–20); Scott (1982: 439). Later in the Imperial period, the so-called Arco di Portogallo over the Via Flaminia further accentuated the location of the Ara Pacis; Nash (1968: 83–7); Hannestad (1986: 206–8).

39. The iconography of this important monument has been explored in several publications; Simon (1967); Pollini (1977); Torelli (1983: 27–61); Hannestad (1986: 62–74); Holliday (1990b).

40. The Ara Pacis had two openings in the outer marble enclosure. Given the

orientation of the interior altar and directional movement represented in the figural reliefs, the West was the primary facade.

41. Two obelisks flanked the entrance to the Mausoleum in antiquity. Because Augustus' contemporary Strabo did not mention them, they may have been erected at a later date (5.3.8; cf. Amm. Marc. 17.4.16; Boatwright, 1987: 68).

42. Although sections of the *Res Gestae* indicate the text was written before A.D. 14, the document was not placed on urban display until after Augustus's death (Suet. *Aug.* 101.4). This blatantly promotional list of "deeds accomplished" paralleled the form and content of funerary *elogia* in all but one aspect: It was written by the subject himself. On funerary *elogia,* see Brunt and Moore (1967: 2–3).

43. The form and orientation of the Augustan Horologium indicate a Greek model; Buchner (1982: 12–19); Coarelli (1984: 90–1). Writing in the Augustan Age, Vitruvius refers to the Greek inventors of sundials (*De arch.* 9.8.1).

44. The rituals of daily and specialized use greatly enlivened the Augustan narrative. The plain continued to be a popular place for exercise (Strab. 5.3.8). For example, the gymnastics of Roman youths focused on the Horologium; Coarelli (1984: 90). Among the many celebrations held in the Campus were the Circensian games of 28 B.C. and the Ludi Saeculares of 17 B.C., as well as other religious events and funerary ceremonies; Dio Cass. 53.1; *CIL* 6.32323, Boatwright (1987: 225–6); Palmer (1990: 26, 60). Unfortunately, without more data on the specific location of these activities, they cannot be incorporated into an analysis of the Augustan narrative in the Campus Martius. Nevertheless, the importance of controlled spectacles in shaping ancient urban narratives must be acknowledged; de Kuyper and Poppe (1981: 85–96); Brilliant (1988: 111).

45. Coarelli speculates that the tombs of Julius Caesar and Agrippa may have been in this section of the Campus; Coarelli (1983a: 43–4). Ancient sources, however, support the existence of ample unencumbered space. Strabo remarks on the green space in the Campus Martius (5.3.8); Suetonius describes a purifying sacrifice (*lustrum*) at which a large crowd gathered around the Pantheon (*Aug.* 97); Boatwright (1987: 37).

46. Strab. 5.3.8. The Baths of Agrippa united features of Roman private baths, or *balnea,* with Greek facilities for exercise, namely, gymnasia and palaestra; Huelsen (1910); Coarelli (1984: 86–90); Roddaz (1984: 278–82).

47. Agrippa bequeathed his Campus to Augustus who made it public property in 7 B.C.; Dio Cass. 55.8; cf. Aul. Gell. 14.5.1; Roddaz (1984: 291–2).

48. In 43 B.C., the Senate voted approval for a Temple to Serapis and Isis, though there is no evidence that it was built immediately (Dio Cass. 47.15.4). Describing the year 28 B.C., Dio Cassius wrote that the Princeps "did not allow the Egyptian rites to be celebrated inside the *pomerium* [of Rome], but made provision for the temples" (53.2.4). In the Augustan Age, the Temple to Isis and Serapis probably stood on the same extrapomerial location as the later shrine (Iseum Campense) East of the Saepta; Gatti (1943–4). Other Egyptiana also was evident in the Augustan Campus, including several obelisks and pyramidal tombs; these, however, often were associated with conquest; Lambrechts (1956); Coarelli (1977: 88–91).

49. Suet. *Aug.* 43; Juv. 10.77–81. Romans also flocked to the Saepta to buy luxury goods on sale there; Boatwright (1987: 36). The long flanks of the complex were known as the Porticus Argonautarum and Porticus Meleagri.

50. Both theaters were oriented East/West, with the cavea for seating on the

West. The theater of Marcellus planned by Caesar and completed by Augustus stood below the Capitolium and was not readily visible from the Via Flaminia; its orientation was Southwest/Northeast (Fidenzoni 1970). On the Theater of Balbus, see Gatti (1979); Manacorda (1982). The amphitheater of Statilius Taurus of 34 B.C. also stood in the Campus Martius, though the exact location remains uncertain (Suet. *Aug.* 29).

51. In the time of Augustus, the Circus Flaminius may have been an open, paved area; Coarelli (1984: 93). Wiseman proposes the Via Flaminia itself may have served as a race course (1979: 133).

52. Few late Republican or Augustan sources refer to the Temple of Juno Moneta (Ov. *Fast.* 6.183). This structure may have declined with the moving of the mint at the end of the first century; Nash (1968: 515–17).

53. *Mon. Anc.* 7.3. Augustus magnanimously allowed Lepidus to continue to hold the position of head priest or *Pontifex Maximus* until his death in 13 B.C.; Brunt and Moore (1967: 49–50, 52–3).

54. Though part of Rome's Republican fortifications had been dismantled during the construction of the Forum Iulium, the Porta Fontinalis apparently remained, for it is mentioned in several imperial inscriptions (*CIL* 6.9514, 9921, 33914). Less certain is the status of the porticus constructed in 193 B.C. connecting the Porta Fontinalis to the Ara Martis in the Campus (Livy, *Epit.* 35.10.12).

55. The basis for orthogonal planning was established by the orientation of the voting precinct (Ovile) to the cardinal points, perhaps as early as the sixth century B.C. Subsequent structures, such as the temples of the Area Sacra di Largo Argentina, had the same alignment, yet their small scale and discontinuous placement minimized the impact of the grid; Coarelli (1984: 95). Only with the large, numerous, tangent structures of the Augustan Age did the orthogonal layout become fully evident. Vitruvius emphasizes the memorability of balanced, orthogonal forms in his discussion of cubes (*De arch.* 5.pref.4).

56. The new lake (Stagnum Agrippa) and canal (Euripus) collected runoff water and worked together with other Augustan hydraulic projects to help limit flooding in the Campus Martius; Lloyd (1979); Boatwright (1987: 36).

57. Augustus did much to improve city services. He reorganized Rome into fourteen regions, provided an organized police and fire department, and established several curatorial boards to maintain Rome's roads and buildings (Suet. *Aug.* 37); Homo (1971: 73–92); Strong (1968: 101–9); Favro (1992). In addition, he paternally manipulated the composition of Rome's population (Suet. *Aug.* 42). On Augustus's paternal relationship to the city and state, see Storoni Mazzolani (1972: 133–5).

58. Pliny *HN.* 3.17; Roddaz (1984: 291–3). If displayed on the portico wall, the world map may not have been visible to pedestrians moving through the unroofed central space (Pliny *HN.* 3.2.17; Moynihan 1985: 149–62).

59. H. von Hesberg reconstructs the Mausoleum of Augustus with laurels flanking the entry; Zanker (1988: 74); cf. Strab. 5.3.8. Martial describes the Vipsanian laurels in the Campus Agrippae portico (1.108; for a full discussion of laurels, their use and symbolism, see Alfoldi, 1973). On the Palatine Hill in the city center, laurels identified the entrance to Augustus's own house and embellished the nearby new complex honoring Apollo (Dio Cass. 53.16; Ovid *Tr.* 3.1.45–46; *Am.* 3.389). Two laurels also stood near the official residence of the Pontifex Maximus in the Forum Romanum; Hannestad (1986: 40–1).

60. As Richard Brilliant points out, the repeated figure is the "actant" or pro-

tagonist who links together different scenes (1984: 30, 104).

61. A distant and equally important view of the Mausoleum was had by Romans approaching the city by boat (Verg. *Aen.* 6.874). Aristotle explored viewing distance as a metaphor for rhetoric stating, "the bigger the thing, the more distant is the point of view; so that in the one and the other high finish in detail is superfluous and seems better away" (*Rh.* 3.12.5).

62. Yates considers the irregular places and asymmetrical architectural forms recommended by teachers of mnemonic techniques to be unclassical in spirit (1966: 16). In reality, irregularity and asymmetry are also characteristic of classical architecture and urban planning as shown by MacDonald (1986).

63. On bird's-eye views, see Trimpi (1973: 9); Leach (1988: 82–3).

64. In this context, *memorability* can be defined as the power of an urban object or environment to evoke a lasting connotative response. In contrast, *imageability* as described by Lynch (1960) focuses on the denotative aspects (i.e., appearance) of urban form (Gottdeiner and Lagopoulos 1986: 5–12). In her essay in this volume, Kuttner demonstrates how the Romans used relief sculptures likewise to describe events, imply temporal succession and causality, and convey relationships and intentions.

THE GEMMA AUGUSTEA
Ideology, Rhetorical Imagery, and the
Creation of a Dynastic Narrative

John Pollini

Among the most important contributions of Roman art are visual narratives celebrating the achievements and status of the leader of the Roman State. The most representative works of art in which the imperial story is told in a continuous series of images arranged in a seemingly logical diachronic sequence are the columns of Trajan and Marcus Aurelius.[1] However, this manner of depicting imperial accomplishments is quite rare in Roman art. More commonly, we encounter exemplary emblematic, or iconic, images arranged as staccatos, as on the Ara Pacis Augustae, or within the confines of a tableau, as in the Gemma Augustea (cast: Fig. 76; original: Kähler 1968, pl. 3 [black and white]; Simon 1986b, pl. 11 [color]). Although images of this sort do not constitute a true narrative, they often have narrative qualities or a narrative potential that might have induced the highly educated ancient observer to create for himself a narrative of sorts and thereby become, in effect, a "viewer–narrator."[2]

In the case of narratives of a purely literary nature, Gerald Prince recently pointed out in his book (1982: 161) that some of the many different types of literary narratives may have minimal narrativity and that certain nonnarratives, which may adopt various narrative trappings, may achieve a high degree of narrativity. An ancient example of the latter is Ovid's *Metamorphoses*. In view of the variability in narrative and nonnarrative structures, imagistic constructs like the Ara Pacis and Gemma Augustea might profitably be considered *quasi-narratives,* or perhaps better, *inferential-narratives.*[3] They can be viewed as narratives only insofar as an informed observer can recreate the narrative from referential clues – be they symbols or scenes – encoded in the imagistic construct.

At a fundamental level, the cognitive processing of visual *disiecta membra* into a form of narrative would not have been difficult for a mind accustomed to the syntactic flexibility of the Latin language. This flexibility, or "dystactic" structure,[4] is especially manifest in Latin poetry and rhetoric, in which words, phrases, and

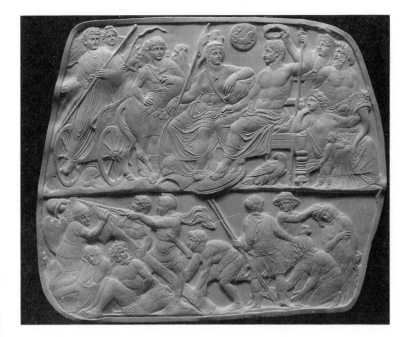

76 Gemma Augustea
(cast). Photo: J. Pollini.

clauses are held in suspension until a thought is completed. At
times, these word or clause relationships can be quite complicated,
as in long periodic sentences with several subordinate clauses or
in certain figures of speech, most notably *hyperbaton,* an unusually
disjointed word order of poetry.[5] In the highly oral Greco–Roman
culture, educational training – emphasizing as it did prodigious
memorization[6] – would also have aided the viewer in creating a
narrative out of an ensemble of visual images. From an early age,
children were urged to learn and expand upon simple story lines
of fables, using their imagination and training their descriptive
powers in extending a narrative (Nicolaus Sophiste 3.454; Theon
75.16).[7] At a later stage of their education, students were required
to repeat a story from different starting points: either beginning
somewhere in the middle, returning to what preceded, and then
concluding; or beginning at the end and then working back over
the events that led to the conclusion (Quint. *Inst.* 2.4.15; Theon
86.7).[8]

One of the narratives that a highly educated Roman observer
might have created for himself out of a collection of visual images
is what I would term a "dynastic narrative," a form of narrative
in which the representation of or allusion to two or more dia-
chronically and/or synchronically linked events or situations in-
volves a dynasty of individuals.[9] Scenes that focus in particular on
ceremonial display and achievements are often replete with sym-

bols, formulaic gestures, and personifications that underscore imperial virtues and values. Such referential elements may help not only to complement and/or clarify an imagistic message, but also to extend an explicit or implicit narrative in the manner of a subplot or paranarrative.[10]

In this chapter, I focus on the symbolic, ideological, and rhetorical imagery, temporal aspects, and narrative possibilities of the Gemma Augustea. This spectacular sardonyx cameo is one of the most important private artistic creations of the Augustan Age, the seminal period in the development of imperial art and ideology.[11] Free of the constraints of official ideology, which held that the *Princeps* ("First Citizen") was first among equals, private works of art like the Gemma might employ a rather different artistic *koiné* – one that owed much to the rhetorical traditions of Hellenistic encomium. The syntax and vocabulary of this artistic language often presented divinely chosen leaders like gods or heroes who might enjoy the company of various deities or superhuman figures (Fears 1977; Pollini 1978: 256–63, 1989: 333–63). Reflecting the desire for a type of power incompatible with the official ideology of the Principate, the Gemma expresses the underlying monarchical tendencies in the Augustan regime.

By reading the images on this elaborate cameo in a new way, I show that even future accomplishments, with concomitant benefactions, are presented as foregone conclusions. Reference to the future may even shed some light on the function of the Gemma and the identity of its intended recipient.[12] In order to establish the events commemorated and their temporal sequence, as well as to decode the explicit and implicit messages by which the narrative could be extended, it is first necessary to understand clearly – and in a historical context – the symbolic and conceptual language of the Gemma's complex ideological program. It is only through such a hermeneutical approach that the rhetorical dynamics and narrative implications of its visual imagery can be fully appreciated.

IMAGISTIC SIMILES AND PARADIGMS OF POWER

In the Gemma Augustea, the principal protagonist, Augustus, appears in heroic seminudity, enthroned with the goddess Roma, reflecting no doubt the cult worship of Roma and Augustus in various parts of the Roman world.[13] In this cult, most of the seated statues of Augustus were probably based on the Sullan cult figure of Jupiter Optimus Maximus in the Capitoline temple in Rome.[14] Like Hellenistic seated figures of Zeus, the Capitoline image of

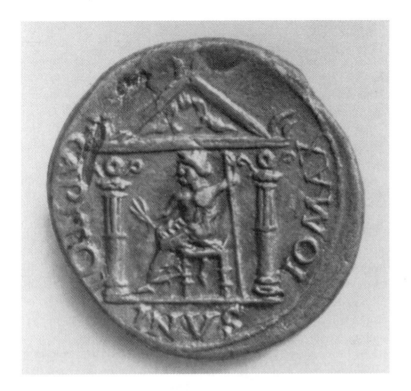

77 Denarius of A.D. 68–
69 representing the Sullan
statue of Jupiter Capitolinus.
London, British Museum.

78 Bronze statuette
of Jupiter. New York,
Metropolitan Museum
of Art.

the supreme god of the Roman pantheon was undoubtedly ulti-
mately influenced by the world-renowned Pheidian statue of
Olympian Zeus (cf. Zadoks Jitta 1938: 52, 55; Maderna 1988:44–
5). The appearance of the Sullan statue of Jupiter Capitolinus is
known from numismatic representations (Fig. 77)[15] and probably
a bronze figurine in the Metropolitan Museum in New York (Fig.
78).[16] Like the image of Augustus on the Gemma, this Jupiter type
is presented as seminude with mantle draped around his lower
body.[17] Jupiter's right leg is crossed behind his slightly advanced
left leg; his raised left hand grasps his long scepter; and his right
hand, which bears the thunderbolt, rests on his raised upper right
leg. As in the case of the statuette, Augustus leans back somewhat,
thus conveying a sense of self-assurance. As we shall see, Augus-
tus's relaxed pose belies the reality of the potentially disastrous
military situation at the time the Gemma was presumably carved.
If the Capitoline cult image were the direct source of inspiration
for the figure of Augustus on the Gemma, the engraver of this
cameo omitted the draping of the mantel over the left shoulder.
This minor alteration of *schema* probably was necessary because
the body of Augustus was to be seen in a three-quarter view from
the right rather than frontally like the cult image of Jupiter.

To the right of Augustus appear divinities of earth and sea, most
likely Tellus (Italiae) and Oceanus.[18] Here they would be the vi-

sual equivalents of the common Latin expression *terra marique* (by/
on land and sea), the domain over which Augustus brings peace
through victory (Pollini 1978: 187).[19] Augustus himself expressed
this concept best in his *Res Gestae: cum per totum imperium populi
Romani terra marique esset parta victoriis pax . . .* ("when throughout
the entire dominion of the Roman people peace had been estab-
lished by victories on land and sea . . . ") (*Mon. Anc.* 13). In a
relief from the Julio–Claudian Sebasteion at Carian Aphrodisias,
the deified Augustus is graphically represented as the bringer of
peace and prosperity on land and sea (Smith 1987: 103–6, pls. 6
and 7).[20] In another relief from the Sebasteion, Oceanus appears
in the context of imperial victory throughout the Roman Empire
(Reynolds 1981b: 325 [no. 13: Ὠκεανός). On the Gemma, Oi-
koumene, the inhabited civilized world personified, holds over
Augustus's head the *corona civica* (civic crown) awarded for the
saving of the lives of the citizenry. Because it is Oikoumene who
crowns Augustus, the metaphor is extended so that Augustus be-
comes the *conservator* (savior), *custos* (protector), and *benefactor* of a
united, civilized world. Pliny the Elder echoes this sentiment
when he states (*HN* 16.8) that Augustus *coronam . . . civicam a ge-
nere humano accepit ipse* ("he himself received the civic crown from
the human race"). The idea of the Oikoumene as the united peo-
ples of the civilized world, the citizenry of one great *polis* (city–
state) governed by one νομός (law), owed much to the early
Stoics, who were themselves undoubtedly inspired by eastern
thought and by the achievements of Alexander the Great in the
East.[21] The long scepter that Augustus grips and the Roman eagle
by his feet further emphasize his hegemony over the Roman
world as the vice regent of Jupiter on earth.

Although it has often been suggested that Augustus appears here
as Jupiter,[22] the *lituus* that he holds in his right hand demonstrates
his subordination to the supreme god of the Roman Pantheon:
The short crooked staff of the augur defines Augustus's role as
interpreter of Jupiter's will on earth and mediator between gods
and man (Pollini 1978: 189–90).[23] If Augustus were meant to be
seen *as* Jupiter, he probably would have been represented holding
the thunderbolt.[24] The absence of this Jovian attribute is, more-
over, a good indication that Augustus was still alive when the
Gemma was created.[25] A thunderbolt in the hand of a Roman
Princeps, especially in this early period, would indicate that he had
passed on to the realm of the divine (cf. Lucan 7.457–59).[26] Au-
gustus is therefore represented on the Gemma not *as* Jupiter, but
like Jupiter – a small but very significant difference.

The *lituus,* which is crucial in interpreting the scene, not only
alludes to Augustus's specific augural powers but also – in a
broader sense – symbolizes peace and victory, salvation and re-

birth.[27] Imperial salvation was usually stated in the historical context of military victory and implied in the concept of a religious refounding of the State. Because Romulus had founded Rome by august augury (*augusto augurio*), the *lituus* here also casts Augustus in the role of *alter conditor* ("Second Founder") of Rome.[28] In fact, Suetonius tells us (*Aug.* 7.2) that the very name *Augustus* had been carefully chosen for its sacral and augural associations, especially in connection with the founding of Rome by augury.[29] Furthermore, Ovid records the religious and specifically augural significance of the name Augustus and its special association with Jupiter. This information is included in the *Fasti* for January 13, the day on which Octavian received the name Augustus and on which annual sacrifices were offered by the Flamen Dialis in the Capitoline Temple of Jupiter for Augustus's restoration of Rome's provinces to the Roman people (cf. *Mon. Anc.* 34). Ovid associates Augustus with Jupiter because of the special sacral status of his name, an honorific title far greater than those bestowed on any other great Roman (*Fast.* 1.607–616):

> sed tamen humanis celebrantur honoribus omnes:
> hic socium summo cum Iove nomen habet.
> sancta vocant augusta patres, augusta vocantur
> templa sacerdotum rite dicata manu;
> huius et augurium dependet origine verbi,
> et quodcumque sua Iuppiter auget ope.
> augeat imperium nostri ducis, augeat annos,
> protegat et vestras querna corona fores,
> auspicibusque deis tanti cognominis heres
> omine suscipiat, quo pater, orbis onus!

Yet all these [great Romans] are honored with human titles; Augustus [alone] has a name associated with mighty Jove. The Fathers [i.e., senators] call holy things "august," and "august" are called sacred precincts [*templa*] dedicated with proper ceremonies by priestly hands. And from this very word augury derives, as well as whatever else Jupiter augments with his power to aid. Let Jupiter [therefore] augment our leader Augustus' command [*imperium*], let him augment his years [on earth], and let the oak crown protect the doors of your [i.e., Augustus's] home, and under the auspices of the gods let Augustus, heir of so great a name, undertake the burden of the world with the [same] omen as did his father [i.e., Julius Caesar].

On the Gemma Augustea, the augural *lituus* also visually underscores the fact that Augustus holds superior *imperium* (military command), and that under his *auspicia* (auspices), victories over barbarians were won by Tiberius, who descends from the chariot of Victory.

A nexus of ideological concepts and symbols proclaims the Roman belief that victory is achievable *auspicio, imperio, felicitate, ductuque* (by auspices, legal authority, good fortune, and military leadership) (cf., e.g., Livy 40.52.5).[30] *Felicitas* – that is, "success" or "good fortune/luck" with its attendant fertility and prosperity – is critical to the charismatic leader, especially as a manifestation of the working of Fortuna through the leader for the benefit of society (cf. Versnel 1978: 361–84). His ability to achieve victory is, in fact, largely due to his *felicitas* and *virtus.* These elements together form the basis of the leader's *auctoritas,* a word whose root meaning is related to *augēre* (to increase), as are the words *augur* and *augustus.*[31] Besides bringing victory, therefore, the *felix imperator* (divinely blessed commander) or *felix vir* (divinely blessed hero) is responsible for increase in human and agricultural fecundity as part of the fruits of peace – a message implied in the Tellurian goddess and her two offspring in the upper register of the Gemma.

Augustus's Jupiterlike appearance in the Gemma is, to be sure, an imagistic simile[32] for the idea that as Jupiter reigns in heaven, so Augustus serves as his vice regent on earth. Horace expressed this concept well in two odes:

> *Caelo tonantem credidimus Iovem*
> *regnare; praesens divus habibitur*
> *Augustus adiectis Britannis*
> *imperio gravibusque Persis (Carm. 3.5.1–4)*

> We believe that Jupiter reigns in heaven because we
> hear him thundering; Augustus will be regarded
> as a divinity present on earth after adding the Britons
> and the dreaded Persians to our dominion.

and

> *gentis humanae pater atque custos,*
> *orte Saturno, tibi cura magni*
> *Caesaris fatis data: tu secundo*
> *Caesare regnes.*

> *ille seu Parthos Latio imminentes*
> *egerit iusto domitos triumpho,*
> *sive subiectos Orientis orae*
> *Seras et Indos,*

> *te minor latum reget aequus orbem (Carm. 1.12.49–52)*

> O father and guardian of human kind, offspring of
> Saturn, to you the Fates have given the tutelage of
> mighty Caesar: may you rule with Caesar next in
> command.

Whether he led in just triumph the broken
Parthians who now threaten Latium or the Seres and
Indians who border on the East,

as your vice-regent Caesar will justly govern the broad
earth.

These rhetorical *comparationes* intentionally recall similar Hellenistic models in which Zeus and Alexander the Great are compared, as in an epigram said to have been added to a statue of Alexander by Lysippus:

αὐδασοῦντι δ' ἔοικεν ὁ χάλκεος εἰς Δία λεύσσων,
Γᾶν ὑπ' ἐμοὶ τίθεμαι· Ζεῦ σὺδ 'Ὄλυμπον ἔχε.
(Plut. *DeAlex. fort.* 2.2.335B)

Gazing up at Zeus the bronze statue seems ready to
proclaim "I have placed earth beneath me; you, O Zeus,
retain Olympus!"

In past discussions on the Gemma some of the implications of Augustus's Jupiterlike imagery have often not been fully appreciated. Here, Jupiter is established as Augustus's direct celestial paradigm (παράδειγμα, or *exemplum*): Augustus is represented, for example, as *custos,* an epithet associated with Jupiter.[33] As Jupiter is his *custos,* Augustus in turn is *custos* of the Roman world. Suetonius (*Aug.* 94.8) relates that Catulus, who dedicated the Temple of Jupiter Optimus Maximus,[34] once dreamed that Augustus as a child was seated in the lap of Jupiter Capitolinus, who declared that the boy was being reared to be the savior of his country. Interestingly, this very story may have been the ultimate inspiration for a statue of Jupiter with Domitian in his lap set up by Domitian in his Temple of Jupiter Custos on the Capitoline (Tac. *Hist.* 3.74; Suet. *Dom.* 5).

Implied in the Jovian imagery of the Gemma, finally, is another imagistic simile that extends the narrative: As Jupiter with the assistance of the gods once saved the universe from the giants who threatened universal order, so Augustus with the assistance of Tiberius and other family members now delivers the civilized world from the threat of barbarians, who appear in the lower register of the Gemma. The barbarians are themselves the "spiritual" descendants of the giants and the very incarnation of disorder. Within even the most ordered societies, there are elements of disorder that constantly need to be controlled. For this reason, metaphors like that implied on the Gemma are created. Rulers are thereby able to cast themselves in the role of archetypal divinities and/or heroes, who in personifying the principles of social order have already successfully waged war on and conquered the

enemies of that order. From a sociological point of view, it is important for leaders who wish to retain power, or for those seeking power, to control symbols that are already powerful (cf. Duncan 1968: esp. 63–6). This rationale accounts for the popularity in political art of the metaphorical reenactment of the defeat of the forces of chaos, the enemies – real or imaginary – of ordered society. Psychologically, these potent images are designed as much for the leaders, who must convince themselves of the righteousness of a course of action, as they are for the led. Such thinking is at the root of the concept of a *bellum iustum* (just war).

The theme of the victory of civilization over barbarism, of order over chaos, is further emphasized on the Gemma by the presence of Oikoumene crowning Augustus and by the bearded figure of Oceanus, the venerable Titan who had assisted Jupiter in the battle against the giants.[35] By siding with the gods and the forces of good, Oceanus became a bulwark against the external world of chaos and darkness that lay beyond earth's encircling waters.[36] His appearance on the Gemma also helps to underscore the paternal and patronal aspect of Augustus as Pater Patriae, because Oceanus was considered the father of all things, in Vergil's words *pater rerum* (G. 4.382). Supporting the identification of Oceanus on the Gemma is his resemblance to a figure associated with the inscribed name ΩΚΕΑΝΟΣ (Okeanos) in the gigantomachy frieze of the Great Altar of Zeus at Pergamon (Kähler 1948: 49–51, pl. 19; Rohde 1982: 114, fig. 97), as well as his position at the extreme edge of the Gemma's composition, as if to signify the waters that encircle the edge of the world.[36a] His location functions, in effect, as an attribute. Because the theme of the gigantomachy had long been used in Greek literature and art as a metaphor for the triumph of the forces of civilization over barbarism,[37] the implied allusion to the gigantomachy on the Gemma Augustea[38] further magnifies the achievements of Augustus and his heirs. As already noted, the *lituus* indicates that Augustus holds superior *imperium* and that under his *auspicia* victories over barbarians were won by Tiberius, his intended successor, who descends from the chariot of Victory. Directly below in the lower register of the Gemma, a military trophy is being raised over barbarians vanquished in battle by Tiberius. His natal sign Scorpio (for detail: Kähler 1968: pl. 16), emblazoned on the trophy's shield, visually and symbolically testify now to Tiberius's rising fortunes.

The line that separates the two scenes is perhaps more than a simple device to "registrate" images in the manner of an exergue on a coin; it is a symbolic line of demarcation separating the rational and ordered world of the Augustan State from the periph-

eral and chaotic world of barbarism. The same ideology of the
line, known in earlier art (cf. the Narmer palette: Fig. 4), will be
found again in Roman imperial art on the spectacular Julio–Clau-
dian Grand Cameo.[39] Such a binary composition of oppositional
forces ultimately derives from thinking grounded in magic and
"primitive" religion.[40] In the Gemma Augustea, the antithetical
juxtaposition of the two spheres – order and implied disorder –
also serves to accentuate the virtues of Rome's leaders and Roman
hegemony (cf. Rodenwaldt 1943: 53).[41]

Interestingly, no frenzied battle is depicted on the Gemma. Bar-
barian chaos is only hinted at in the disheveled hair of the defeated
and of those already yielding to the might of Rome. The *Bild-
sprache* of the Gemma reflects a new rhetoric that sharply contrasts
with the old Hellenistic formula, regarded as overdramatized and
bombastic by Augustan contemporaries partial to the Neo-
Classical style. Instead of the wonderfully exuberant, pathos-
oriented Baroque style of Hellenistic conflict like the Pergamene
gigantomachy frieze, in which gods and giants clash in a death
struggle of twisted and tormented forms, the Neo-Classical style
of the Gemma Augustea conveys in its balanced forms an almost
harmonic calm – the imperial "symphony," so to speak, of a new
world order.[42]

DYNASTIC DISPLAY

In the upper register of the Gemma Augustea, dynastic succession
is proclaimed in the language of hereditary monarchy. Augustus
is clearly the principal figure: In the upper zone, all heads turn
toward him and his head alone is in strict profile.[43] Augustus's
directed gaze at Tiberius and the shorter scepter that Tiberius
holds[44] signify Tiberius's subordinate position, while marking him
out as Augustus's destined successor. In his extended right hand,
Tiberius holds a small foreshortened *rotulus* (book roll) (Fig. 79),
symbolizing his charge (*imperium*) to carry out the war under the
auspicia of Augustus.[45] Dynastic display and orderly succession are
further emphasized by the individuals flanking Tiberius. The fig-
ure that once stood to the left of Tiberius is now discernible only
from the traces of his toga and shoes behind and to the left of the
left wheel of Victory's chariot (Fig. 79).[46] Presumably, because of
damage to the cameo long after its creation, attempts were made
to eradicate this figure, perhaps at the time the Gemma was placed
in its nonancient gold setting (Oberleitner 1985: 42–3). The
youthful figure in armor to the right of Tiberius can be identified
on the basis of portraiture as Augustus's great-nephew Germani-

79 Left border of Gemma Augustea showing rotulus and togatus with boots (detail of cast). Photo: J. Pollini.

cus, who served with Tiberius in the Illyrian (Pannonian) wars.[47] In A.D. 4, the year in which Tiberius was adopted by Augustus, Tiberius in turn adopted Germanicus at the behest of the *Princeps*. Ostensibly, it was Augustus's hope that succession would eventually pass to Germanicus, a blood relative. Given the importance of dynastic display in Augustan and Julio–Claudian art in general, it is likely that the largely obliterated togate figure to the left of Tiberius is his natural son Drusus Minor (Pollini 1978: 211–12).[48] The representation of Drusus in toga would have been particularly appropriate: Although he had played no role in the Illyrian wars celebrated in the register below, he was accorded – because of his father's victory – the special honor of attending meetings of the Senate before actually becoming a senator himself. As a matter of protocol, because Germanicus was of the blood of Augustus and Drusus was not, it is Germanicus who stands closer to Augustus in the scene. With the representation of this dynastic trio – the future hope of the Roman State – the message of *concordia familiae* (familial concord) is reified as it had been in other Augustan programs, most notably in the representation of the extended Augustan family on the Ara Pacis and in the dedication of the Temple of Concordia Augusta by Tiberius on January 16, A.D. 10, just

before his departure for Germany to avenge the loss of Varus's legions (Pollini 1978: 212 and n. 145).[49] In the Gemma, the implications of *concordia familiae* and dynastic succession in the context of victory serve, then, to extend the narrative.

HISTORICAL AND METAPHORICAL CONSTRUCTS

The paratactic and conceptually interconnected scenes in the upper and lower registers suggest a complementary mode of narration. But before this issue can be addressed, it is necessary to identify and reevaluate the Gemma's depicted historical events and/or situations, as well as to consider the implications of its metaphorical messages. Because of the combination of preserved historical figures in the upper register, the majority of scholars have interpreted this scene as referring to Tiberius's triumph in A.D. 12 for his victory over the Illyrians.[50] However, Tiberius is not represented here as *triumphator:* He is not attired in the *tunica palmata* (tunic with palm patterns) and the *toga picta* (embroidered toga); he does not carry the *triumphator's* attributes – the eagle-topped *scipio* (scepter) and the laurel branch; the chariot in which he rides is not the *currus triumphalis* (triumphal chariot); and Victoria does not crown him.[51] Finally, it has been consistently overlooked that military dress like that worn by Germanicus is by custom forbidden within the *pomerium* (sacred boundary) of the City on a day of triumph. Had this scene alluded to the triumph of A.D. 12, Germanicus would in all probability be represented in the *ornamenta triumphalia* (triumphal regalia) awarded to him and worn on the actual day of the triumph (cf. Vell Pat. 2.121.3).[52] A more satisfactory interpretation was restated in recent times by H. Kähler following the seventeenth-century scholar–antiquarian Albert Rubens, son of the famous Flemish painter. According to Rubens's long-overlooked idea, the Gemma Augustea commemorates Tiberius's return to Rome after his victories in Illyricum (Rubens in Kähler 1968: 14).

Although Tiberius's ceremonial *adventus* (arrival) and *salutatio* (greeting) are generally dated to the beginning of A.D. 10, my reevaluation of the primary written sources indicates that this ceremony took place instead late in A.D. 9.[53] Because of the devastating loss of Varus's three legions in Germany and the impending threat of a German invasion, Tiberius postponed the triumph that had been voted to him for his victory in Illyricum (Suet. *Tib.* 17). Instead, he entered Rome wearing the *toga praetexta* (purple-bordered toga) and crowned with laurel – as he appears on the

Gemma. He then proceeded to the Saepta Iulia in the Campus
Martius (Figs. 72 and 73), where he took his seat on the tribunal
beside Augustus and between the two consuls. From here, Ti-
berius was officially greeted by the people. The seated personifi-
cation of Roma on the Gemma, in fact, embodies the concept of
Senatus Populusque Romanus. This ceremonial *adventus* into Rome
and public *salutatio* should be read as a psychological reaffirmation
of the military might of Rome in time of crisis: Surely Tiberius,
acting under the military auspices of Augustus, would expedi-
tiously bring new victories over the barbarous Germans, thus re-
storing the military pride of Rome. The message of the Gemma,
however, should not be used as evidence that Augustus planned
to launch a full-scale war of subjugation against the Germans in
A.D. 10. Indeed, Rome's retaliatory forays into Germany after the
disaster of Varus were rather restrained (Cass. Dio 56.24.6, 25.2–
3; Suet. *Tib.* 18–19). The scene on the gem indicates only the
clear intention to avenge the loss of Varus's legions through mil-
itary action that was expected to have a victorious outcome.

In the upper register of the Gemma, the historical ceremony
in the Saepta Iulia has been figuratively transformed into a scene
of dynastic display, cloaked in the language of metaphor and al-
legory. Preparedness for the coming campaign in Germany is in-
timated in the upper register by the representation of the goddess
Victory with reins and whip in hand, ready to depart for fresh
conquests once Tiberius has returned to the chariot. Germanicus,
who was to accompany Tiberius to the front, stands ready to
depart, as signified by his armor and left hand clasping the hilt of
his sword. Behind him appears the *bellator equus* (war horse),[54]
symbolic of the coming conflict and of victory. We may recall
here the horses that Aeneas saw when he first beheld the promised
land of Italy and that his father Anchises immediately recognized
as a double omen: one of coming war and one of future concord
and peace (*Aen.* 3.537–543).[55] In addition, the closely linked, an-
tithetical Roman concepts of *domi . . . militiae or togatus . . . ar-
matus*[56] – which, figuratively speaking, can mean "at peace and at
war" – are suggested by the dress of the flanking figures of Ger-
manicus and Drusus: the civilian toga and the military cuirass.

The resolution of the future conflict with the Germans finds
visual expression in the lower register of the Gemma, although
this scene has invariably been interpreted as having reference only
to Tiberius's past victories. In this "predella," ideal types and per-
sonifications assist in victory.[57] The group of seven figures in the
left half of the lower zone appears to recall Tiberius's recent suc-
cesses in Illyricum.[58] Raising a trophy over three seated barbarians
are four ideal figures.[59] In the interest of variation, two of these

ideal types are represented in different types of armor worn by
Roman officers (Pollini 1978: 205)[60]; the other two, in only kilt-
like loincloths.[61] The group of four figures to the right in the
lower zone I suggest alludes to Tiberius's anticipated victories over
the Germans.[62] Several factors indicate that two separate and se-
quential events are referred to in this predellalike register. First of
all, the two central figures are turned back to back with heads
facing in opposite directions – a common artistic device that can
signify two separate actions (cf., e.g., Weitzmann 1970: 29).[63] Also,
the seated barbarians on the far left are shown as already con-
quered, and those on the right are being brought into submission
in the direction of those figures alluding to past victory. The pose
of the female barbarian to the far right even conveys reluctance.
Unlike the ideal types raising the trophy on the left, the victors
on the right appear to be definable personifications.[64] The male
figure, wearing a Greek *exomis* (one-armed tunic) and a stylized
*petasus*like helmet, may symbolize Thracians troops in particular,
because the *petasus* (broad-brimmed hat) was especially associated
with Thracians. And Thracians, we know, served with Tiberius
in the German campaign (Pollini 1978: 208–9).[65] More difficult to
identify has been the female figure with hair bound up in a scarf.
She wears military boots and a cuirass over a short *chiton* (tunic)
and carries two spears.[66] It had not been noticed that iconograph-
ically this figure most closely resembles personifications of His-
pania, who often carries two spears, the common weapon of the
Iberian peoples (Pollini 1978: 207–8).[67] On *aurei* of the Civil War
period (A.D. 68–9), Divus Augustus is shown on the observe, and
Hispania (so labeled) is represented on the reverse with hair bound
up, dressed in a *chiton,* wearing military boots, and carrying among
other things two spears (Fig. 80).[68] In one coin type, she even
wears a cuirass over a short *chiton.*[69] This type may have been based
on some Hispania type already known in the Augustan period.
Hispania was undoubtedly represented among the statues of var-
ious *nationes* (peoples) in the Augustan *Porticus ad Nationes* in
Rome (Pliny *HN* 36.39; Serv. *ad Aen.* 8.721) and among the
images on the podium of the Ara Pacis (cf. most recently De
Angelis Bertolotti 1985). In any case, a figure representing Spain
with two spears is known as early as 46/45 B.C. on *denarii* of
Gnaeus Pompey minted in Spain (Crawford 1974: 479 [no. 469/
1a]). Because of the manpower shortage after the loss of Varus's
legions, military forces from various parts of the Empire were
called upon to serve in the coming war against the Germans. In-
cluded among these forces was a large contingent of Spanish aux-
iliaries (Cheesman 1914: 72; Parker 1958: 86–7, 92; Webster 1969:
56, n. 3). Because the forces of Spain were not to our knowledge

80 Aureus of A.D. 68–9
representing Hispania. Paris,
Bibliothèque Nationale.
Courtesy: Bibliothèque
Nationale.

involved in the Illyrian conflict, their representation in the personification of Hispania on the Gemma would have proleptically signified the future victory over the Germans. The personified Thracian and Spanish warriors would therefore by extension be visual synechedoches symbolizing the important role that the combined auxiliary forces of the eastern and western halves of the Empire would play in bringing victory in Germany. As such, they would be visual metaphors for East and West. These antithetical geographical references are to be found also in Augustan literature and art.[70] In his *Georgics* (3.33), for example, Vergil refers to Octavian's twofold conquest of the peoples of the East and West – *bisque triumphatas utroque ab litore gentes;* and Horace in his Odes (*Carm.* 4.5.15–16) speaks of the Latin name, the might of Italy, and the fame and majesty of the Roman *imperium* spreading *ad ortus / solis ab Hisperio cubile* ("from Hesperia's bed to the rising of the sun").

The notion of a future victory may also unriddle the visual oxymoron of the empty "horn of plenty" held by the seated earth goddess in the upper register,[71] as well as the meaning of the hand gesture of the child directly behind her. From A.D. 5 to 9, Italy repeatedly suffered from famine, in large measure because of war.[72] By implication, the "fruitless" cornucopia will be filled by the future fruits of victory – *pax et felicitas*. The generally overlooked hand gesture of the child behind has been interpreted at least by one scholar as apotropaic (Kähler 1968: 25).[73] If so, it would have served to ward off any evil from the coming campaign. It has not been noticed, however, that the combination of extended thumb, index, and middle fingers of the left hand (as opposed to the right hand) is the Roman computational gesture for the number two. In this context, the child might also be signifying a double victory, once for the past Illyrian war and once for the coming German campaign. Victory, as already noted, brings society not only *pax* but also *felicitas,* in the specific sense of prosperity and fertility. The children themselves are metaphorical expressions of the hope for an abundance of future citizens, much needed especially to fill the ranks of the army.[74]

The depiction of two children with an earth goddess, most likely Tellus Italiae, may signify the importance of a strongly united Rome and Italy in Augustan politics. It was, after all, the Italian municipal aristocracy who supported Augustus in his struggle with Antony and who replaced the old moribund Roman nobility as the new upper class. Italian manpower also made up the bulk of the legions, the backbone of the Roman Empire (Pollini 1978: 183–85).[75] Vergil presents the concept of a closely united Rome and Italy in his memorable phrase *sit Romana potens Itala virtute propago* ("let the Roman race be strengthened by Italian

valor") (*Aen.* 12.827). As early as 70 B.C., Italia carrying a cornucopia is paired with Roma in a symbolic gesture of *iunctio dextrarum* (joining of the right hands) in representations on *denarii* of the mint of Rome (Alföldi 1956: 87, 95; Crawford 1974: 413 [no. 403/1]). On the obverse appear jugate heads of Honos and Virtus, signifying that the alliance of Rome and Italy was under the auspices of these military virtues, a point that Vergil likewise echoed in his *Itala virtute*. In the Gemma Augustea, the Tellurian figure wears a wreath of ivy sacred to the god of wine – perhaps here a direct reference to Italy, rich in viticulture.[76] The ivy-shaped *bulla* (amulet) around her neck may also be interpreted as a symbol of fertility, especially human *fecunditas,* as indicated by the two children who accompany her.[77] She is the personification of the land of Italy, assuring the abundance of the *aurea aetas* ("Golden Age") brought about by Augustus. We should not, however, think of this figure as representing only peninsular Italy (as we think of it today), but an "expansive" Italia, that is, *solum Italicum* (Italian terrain) wherever it existed throughout the *imperium Romanum* as legally defined by the *ius Italicum* ("Italic rights"), a special privilege that granted a non-Italian land the legal status of an Italian city (Pollini 1978: 183–4).[78] If the seated earth goddess on the Gemma were a personification of the land of Italy (broadly defined), she would complement the figure of Oikoumene, who crowns Augustus for saving the lives of the citizenry throughout the civilized world. It was Augustus who in effect created the *ius Italicum* and set up the majority of *coloniae* (colonies) with *ius Italicum* in the Empire as part of his politics of reconciliation in keeping with the establishment of the Principate.[79] These colonies, made up of the dispossessed and the veterans of the Civil Wars, were also largely responsible for supplying recruits for the legions and therefore for the safety of the Empire. If the seated female with children is Tellus Italiae, then she would also be a suitable pendant to Roma, who in a similar way not only personifies the city of Rome, but also collectively embodies Roman colonies and municipalities throughout the Empire (Pollini 1978: 184–5).[80] In short, Tellus Italiae is a composite goddess joining the concepts of Tellus and Italia in much the same way the genitive *Italiae* is used to modify *Tellus* in the compound expression *Tellus Italiae.*

TEMPORAL ASPECTS OF NARRATION

In order to determine the narrative qualities or narrative potential of the Gemma Augustea, its temporal frames of reference must be compared to other glyptic or pictorial representations. It is often

difficult to establish whether a future event is illustrated because of the problems encountered in determining specific points of time in various forms of Roman glyptic art. For comparanda alluding to future accomplishments, Roman coinage – which can often be closely dated – is particularly helpful. Interest in representing future achievements is found in coinage from the Republic on.[81] But because of the small size of the field in numismatic art, the presentation of events or situations is usually rendered in a shorthand or symbolic fashion. For example, on the reverses of *aurei* and *denarii* from a mint traveling with Sulla in 82 B.C. (Crawford 1974: 386–7 [nos. 367/1–5], 732), Sulla is shown in triumphal *quadriga* (four-horse chariot) crowned by a flying Victory. Significantly, these coins were struck a year before his actual triumph in Rome. At this time, Sulla had not only been denied the right to triumph for his Eastern victories, but had also been declared a *hostis* (public enemy) by the Roman Senate. In fact, in 83–82 B.C., Sulla's opponents in Rome had issued their own coinage presenting the goddess Victoria with victory wreath and palm branch driving her *quadriga*[82] – a proleptic reference to their expected victory over Sulla. Similarly, in the period of the Second Civil War, Antony had issued *quinarii* (43–42 B.C.) portraying Victoria, a reference to a victory hoped for rather than achieved (Crawford 1974: 498–9 [nos. 489/4–6], 740). Symptomatic of this proleptic thinking were the notorious "donations of Alexandria" when Antony allotted to one of his sons by Cleopatra certain territories, some of which had not yet been subdued: Ἀλεξάνδρῳ μὲν Ἀρμενίαν ἀπένειμε καὶ Μηδίαν καὶ τὰ Πάπθων, ὅταν ὑπαγάγηται (and to [his son] Alexander he [Antony] assigned Armenia, Media and the holdings of Parthians, *when[ever] he would have subjugated* them) (Plut. *Vit.Ant.* 54.4).

Under the Principate, Roman coins continued the tradition of expressing the hopes or expectations of the leader (Mattingly 1960: 139–44, esp. 140). The representation of a future event or situation as already accomplished or effectuated – a "predeed" as it were – can in certain cases be interpreted as a form of sympathetic magic, that is, the willing into being of a desired outcome or effect through mimetic representation.[83] In addition, gems in antiquity were generally considered to have special magical powers, some of which were curative, some beneficial for those going into battle, and some even influential in matters of human destiny. For example, in books dedicated to King Mithridates VI of Pontus, a noted collector of gems (Pliny *HN* 37.11), Zachalias of Babylon attributed man's destiny to the influence of gem stones: *Zachalias Babylonius in libris quos scripsit ad regem Mithridatem gemmis humana fata adtribuens* (Pliny *HN* 37.169). Above all, the Gemma Augustea

is a visual testament to the fate, fortune, and destiny of Augustus and his dynasty. From the ancient record, furthermore, it is clear that Augustus and Tiberius were not only great believers in *Fatum* and *Fortuna,* but were also quite superstitious (e.g., Suet. *Aug.* 90–2, 94.12; *Tib.* 69).

Proleptic imagery figures in Augustan literature, especially in prophetic contexts. We have already seen this idea expressed in Horace's prediction that Augustus will become a *divus praesens* after he has conquered the Britons and Persians. Another literary parallel to the way the Gemma anticipates victory is found in a passage of Ovid's *Ars Amatoria* (1.177–228): Here the poet momentarily digresses from his precepts of love making to speak clairvoyantly of Gaius Caesar's future victories over easterners and his anticipated triumph, in which the conquered barbarians are described as already being paraded before the *triumphator*'s chariot.[84] Tibullus (2.5113–118) had expressed a similar thought when he sang of the future triumph of his patron. Vergil, too, represents the effectuated future in his famous prophetic passage in Book 8 of the *Aeneid* (626–731): Here he describes scenes on the shield of Aeneas that depict events that, from Aeneas's point in time, have not yet come to pass. All these literary vignettes function like visual *futura praeterita* (past times set in the future) or *futura perfecta* (accomplishments set in the future). In broader terms, the emphasis on the future in Augustan literature and art was in part symptomatic of the new optimism that the *Pax Augusta* brought after a century of foreign wars and civil strife.

In Roman art, the representation of the future can be found in a number of other circumstances, most notably in planned monuments shown as already completed on Roman coinage (Prayon 1982: 319–30) or mythological stories told on sarcophagi (e.g., Brilliant 1984: 124–65). A particularly interesting form of proleptic imagery occurs on some children's sarcophagi, such as the late second-century example from the Via Portuense in the Museo Torlonia in Rome (Fig. 81).[85] The Torlonia sarcophagus shows several scenes in a continuous biographical narrative of a child's

81 Child Sarcophagus. Museo Torlonia. Photo: DAI neg. 33.11.

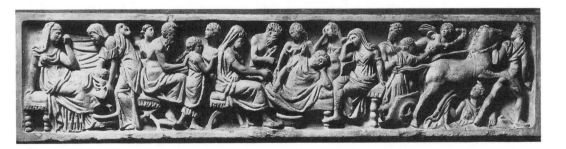

life from birth to death and apotheosis. Noteworthy here is the representation of the child as a bearded adult in a scene of *prothesis* (the laying out of the corpse), the penultimate vignette of the series. However, in the final scene, that of apotheosis, the child is portrayed as physically being a child again. The presentation of the child on this sarcophagus as an adult in one proleptic moment of time in a temporal sequence is a graphic way of stating what the child would have become had he lived — in short, his un-realized potential. This sentiment is expressed by Quintilian in reflecting on the death of his son (*Inst. Orat.6. Pr.* 10–13) and by Vergil in his famous passage about what Augustus's nephew Mar-cellus might have become had he lived:

> *Heu, miserande puer, si qua fata aspera rumpas,*
> *tu Marcellus eris! (Aen.* 6.882–3)

> Alas! Child to be pitied, if you break the
> harsh bonds of Fate, you will be Marcellus!

Although the future tense is used in this particular instance, an unfulfilled potential (in grammatical usage) would normally be conveyed by a future perfect. In art, an unrealized potential can likewise take form in different ways depending on what the artist and/or patron wished to convey.

Essential in assessing the narrative possibilities of the Gemma Augustea as a whole is an appreciation of the temporal relationship of the events or situations depicted or implied. The principal scene of Tiberius's victorious *adventus-salutatio* in the upper register is conceived as taking place in the present, and the two groups of figures in the lower register, as I have suggested, refer to two different events — a recently accomplished victory and one that is anticipated. The latter is treated like a future perfect, a tense that is far more frequently and vividly employed in Latin than in Eng-lish. I believe, therefore, that the two groups of figures in the lower zone have symbolic value and together serve as a gloss on the principal narrative "bit" — a means of complementing and further explicating the action of the principal scene above. The temporal *schema* of the double register composition is conceived as a pyramid, with the present (the main event) forming the apex of the pyramid. In this way, the present visually binds together the past and future; in turn, the present both validates and is val-idated by the past and future. Without accompanying text, this temporal *schema* might seem difficult for the modern viewer to perceive; but the complexity of the imagery and the nature of this costly *exemplum* of "court art" presuppose a highly literate viewer–

narrator knowledgeable about the events and situation that the
Gemma commemorates.

As far as can be determined, the creation of such a hierarchical
temporal pyramid in two registers is something quite new in Ro-
man art. There may, however, be some compositional inspiration
from the East, because it was not uncommon for an eastern ruler
to be represented with divine trappings in a main scene, with
minor figures, especially the conquered enemy, in a separate reg-
ister below. The tradition for such hierarchic, iconic tableaux
extends as far back as the famous palette of Narmer from Hiera-
konpolis, a work dating to ca. 3000 B.C. (Fig. 4).[86] Here different
temporal events are represented in a grand emblematic display of
kingly prowess. On the principal side of the palette, the king,
wearing the crown of Upper Egypt, stands on a groundline about
to dispatch an enemy leader in what has been interpreted as a
ritual slaying. Below the groundline, marking the boundary be-
tween the civilized and barbarian worlds, are two other defeated
enemies. Like the conquered barbarians on the Gemma, these
frenetic figures represent the forces of chaos. Even the notion of
the leader having a divine paradigm to imitate (implied on the
Gemma by the Jupiterlike appearance of Augustus) is graphically
represented in the figure of the king's divine protector, the falcon–
god Horus, standing victorious upon a man-headed hieroglyph.
This pictograph, out of which grow papyrus plants, alludes to the
conquered land of Lower Egypt. Behind the king, on his own
groundline, appears a sandal bearer, who may very well be the
king's son.[87] If so, this figure would serve as an implicit reference
to the future succession, an essential element in the creation of a
dynastic narrative.

In the East, representations of victory usually modify previously
established compositional motifs and ideologies to serve new or
at least somewhat different political needs. For example, the fa-
mous late sixth/early fifth-century monumental relief of the
Achaemenid king Darius at Behistun compresses historical events,
which are symbolically conveyed by representations of captured
rebel leaders; as a result, the relief illuminates, rather than illus-
trates, in a detailed way its accompanying text (Cool Root 1979:
182–226, pl. 6).[88] By contrast, the Gemma Augustea, lacking any
text, depends on the clarity of its own referential imagery and its
viewer–narrator's familiarity with the context and events to which
allusions are made.

The importation from the East of sardonyx (the material out
of which the Gemma is carved) (Pliny *HN* 86–9), the existence
of large cameo compositions in Ptolemaic Egypt,[89] and the Hel-

lenistic encomiastic language of the Gemma presuppose a strong
Eastern tradition (Vollenweider 1966: 81). It is likely that the
Gemma Augustea was created by some outstanding Greek gem
carver, who, I suggest, may have come from Alexandria or been
trained by an Alexandrian master. Such artists certainly worked
for the Ptolemaic court and are likely to have come to Rome
either as slaves or as free agents in search of commissions after the
fall of Alexandria in 30 B.C., when Ptolemaic power came to an
abrupt end.[90] The particular temporal *schema* of the Gemma, on
the other hand, may simply reflect the need to refer to an unusual
combination of events and circumstances. In any case, similar
compositions with strong dynastic constructs expressed in the vo-
cabulary of eastern kingship certainly lived on in Roman art, as
in the already mentioned Julio–Claudian Grand Cameo.

In its temporal and referential approach to narrative and absence
of repeated figures, the Gemma Augustea suggests a "comple-
mentary" method of narration,[91] that is, scenes are built around a
central moment (the *salutatio* of Tiberius in the Campus Martius),
which is synoptically complemented by the subsidiary actions.[92]
The large statuary base commonly (but incorrectly) known as the
"Altar of Gn. Domitius Ahenobarbus" (Fig. 69) provides an im-
portant Roman example of "complementary" narration in its rep-
resentation of a *census-lustrum* ceremony. On one side of this
monument, several distinct moments represented or referred to in
this two-part ritual appear to be occurring simultaneously. At the
same time, they have been compressed and subordinated to the
central scene, the sacrifice to Mars (Kähler 1966; Torelli 1982: 5–
16; Pollini 1983).[93]

This synoptic form of visual narration had been particularly
popular in earlier Greek art, especially in the Archaic period
(Meyboom 1978: 59–65; Snodgrass 1982; Hurwit 1985: 170–2,
174, 263, 296) but declined thereafter, probably largely due to its
seemingly illogical manner of representing time and event.[94]
Somewhat analogous to the Gemma in its temporal and referential
approach to narrative is a friezelike composition depicting the de-
parture of Amphiaraos on a Corinthian krater of the mid-Archaic
period (Fig. 82) (Hanfmann 1957: 75–6; Schefold 1966: 80–2, pl.
67a; Himmelmann-Wildschutz 1967: 90, 98–100, fig. 8; Mey-
boom 1978: 60, pl. 29, fig. 13).[95] In the center of the scene, the
Argive hero mounts his chariot while taking leave of his son Alk-
meon, who was later to avenge his father's death. To the far left
stands Amphiaraos's wife Eriphyle, holding in her hand an over-
sized necklace – the fatal adornment of Harmonia. Because this
ominous necklace was the cause of Eriphyle's treachery to her

husband, it is a symbolic reference to the past. Seated on the ground to the far right is the seer Halimedes, mourning the imminent death of Amphiaraos. Above his head appears a coiling spotted snake, a chthonic symbol signifying the future spirit of the deceased.[96] In this composition, the adjunct figures do not merely complement the situation of the moment (the departure of Amphiaraos): They refer to and even explicate the cause and the result of his departure, much in the same way the two groups of figures in the lower register of the Gemma explain Tiberius's arrival and implied departure. In both works, different figures and even symbols are used metaphorically to refer to specific past, present, and future events. And although the composition of the Corinthian krater is more elliptically referential in its approach to narration and not divided into two registers as on the Gemma, the present (the central moment) nevertheless is balanced between the past (to the left) and the future (to the right). Like the Gemma, then, the composition of the krater serves to bind together visually the past and the future.

In the case of the Gemma, the registrated scenes form a distinct temporal pyramid in which the present (with the most important cast of characters) stands at the apex and serves as the essential link between the past and the future. In effect, the Gemma is a visual "organigram" – to borrow a term from literary structualists,[97] that is, its imagistic construct forms a visual *schema* that enables the informed observer to grasp its temporal relationships in a hierarchically organized structure. At the same time, the historical events or situations of the Gemma are further bound together by genealogy, which itself acts to fuse the past, present, and future.[98]

82 Amphiaraos scene on a Corinthian krater. Berlin, Staaliche Museen Preussicher Kulturbesitz. After Schefold 1966.

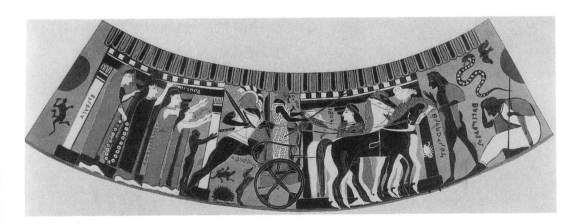

In the Gemma Augustea, the various narrative bits are united by the themes of dynastic *concordia* and *res gestae* (accomplishments) in the context of fate, fortune, and destiny. Serving as the focal point in the principal scene is the *lituus* in Augustus's right hand, symbolic of the military auspices under which members of his house have already won and will continue to win victories. And as noted, it is military success that guarantees the peace, stability, and *felicitas* of the entire Roman world, represented by the personifications and symbols surrounding Augustus. The nexus of messages embodied in the Gemma's referential symbols has paranarrative potential that enriches the figurative narrative. This paranarrative potential is particularly manifest in Augustus's cosmological badge, which appears between his head and that of the goddess Roma (for detail: Kähler 1968: pl. 12.1). Here Capricorn is inscribed on the multirayed solar disc (*nimbus*), not the *sidus Iulium* (comet of Julius Caesar), as some have thought.[99] In this highly charged, polysemous visual symbol allusions to Augustus's own past, present, and future in the context of fate and destiny are telescoped together. The interrelation of these temporal aspects governed by fate and destiny finds a literary analogue in a Vergilian passage in which the augur–god Apollo addresses the triumphant Iulus, son of Aeneas:

> *Macte nova virtute, puer: sic itur* [present] *ad astra,*
> *dis genite* [past] *et geniture deos* [future] (*Aen.* 9.641–2).

> A blessing on your young valor, my child! Thus *do you ascend* to the stars, you who *have sprung* from the gods and *will sire* gods (to be).

Capricorn and Sol are of great importance in Augustus's *Bildprogramm*. Already in 19–18 B.C., Capricorn and Sol (in anthropomorphic form) are found together on *denarii*.[100] Over a period of time, the Capricorn had accumulated a variety of meanings: It served to symbolize Augustus's defeat of Caesar's assassins, his conquest of Antony and Cleopatra, and his victory over the Parthians. These successes, which gave Augustus mastery over the world, were thought to have helped bring about the return of the prophesied Golden Age under the god Apollo. Because of these associations, Capricorn with globe, rudder, and cornucopia was also featured on *aurei* and *denarii* to celebrate the *Ludi Saeculares* (Secular Games) in 17 B.C. (*BMCRE* I, 62 [nos. 334–7], pl. 7.1–3). These games officially signaled the advent of the new age. When the barbarians of the North were threatening the stability of empire

in the latter part of Augustus's Principate, Capricorn again gained new meaning. As Pan had been set in heaven as a cosmic divinity in the form of Capricorn for assisting Zeus in saving the world from uncivilized forces as embodied in the monster Typhon, so Augustus would after his death attain his position in the stellar firmament of divinized heroes for saving the civilized world from barbarians. This simile complements and extends the narrative possibilities of the Gemma's figured scenes explicitly celebrating Augustus's victory over the barbarian world.

Capricorn and Sol are also closely connected with Augustus's birth and predestined apotheosis. Suetonius (*Aug.* 94.12) relates that Capricorn was Augustus's natal sign, although most scholars consider Suetonius mistaken on this point and take, instead, Capricorn as the sign of Augustus's conception. However, Suetonius was probably correct, because the moon was in Capricorn at the very hour of Augustus's birth. In his *Astronomica* (2.507–9), the Augustan writer Manilius described Capricorn at the time of Augustus's birth as *felix,* a word that we have seen is pregnant with meaning when associated with victorious leaders. The ideas of *felicitas* and *fecunditas* are related in representations of Capricorn and the cornucopia on a variety of Augustan coins.[101] At the same time, the association of Capricorn with Augustus's conception need not be dismissed, because Capricorn was the reigning sign 10 months prior to his birth on September 23 in the Julian Calendar.[102] According to some ancient astrologers, it was the constellation of an individual's conception, and not of his birth, that was decisive in determining his fate (Vitr. *De Arch.* 9.6.2). If it is also true that Augustus's actual date of birth in the pre-Julian calendar was December 17 (Radke 1972: esp. 261–2), when the Sun first entered Capricorn, then Capricorn would have been doubly favored by Augustus as his personal sign. Its dual significance may even have been implied in the representation of a bust of Augustus between two Capricorn protomes on a sardonyx cameo in the Metropolitan Museum in New York (Fig. 83).[103]

The far-ranging symbolism in the astral signs of Capricorn and the solar disc evokes a host of other similes and metaphors. Capricorn, for example, was considered to be the natal sign of the Sun, a fact that is of great consequence for the Gemma both visually and conceptually. The inscribing of Capricorn upon the solar *nimbus* serves as an allusion to solar kingship and immortality. In Hellenistic solar theology, Helios was regarded as the king of stars.[104] Those who wrote about kingship consequently likened the ruler of the ideal State to Helios, as well as to Zeus. Already in the *Somnium Scipionis* (*Rep.* 6.17), Cicero, influenced by the Stoics, referred to the Sun as *dux et princeps* ("guide and leader").[105] Au-

83 Sardonyx cameo of double Capricorns. New York, Metropolitan Museum of Art.

gustus had long been likened to the Sun, which in the Augustan age came to be closely associated with Apollo.[106] Augustus's father had dreamed that before his son was born the Sun rose from Atia's womb (Suet. *Aug.* 94.4). It was also rumored that Apollo, who appeared to Atia in the form of a snake, was Augustus's divine parent. On a glass cameo in Köln (Fig. 84),[107] the connection of Apollo and the Sun in the birth of Augustus is indicated by the representation of a snake coiled around an Apolline tripod with the solar rays inscribed within the *nimbus* of the Sun. On another occasion, Augustus's father dreamed that his son appeared to him wearing the Sun's radiate crown, dressed like Jupiter with the god's insignia, and driving a chariot drawn by white horses (Suet. *Aug.* 94.6). A little known relief in Vienne (Fig. 85)[108] represents Sol rising out of the sea with the solar disc and rays behind his head. His facial features look as though they have been assimilated to those of Augustus. Horace (*Carm.* 4.2.46–48) had already in effect equated Augustus and his earlier victorious return with the brilliant Sun:

> "*O Sol / pulcher, o Laudande!*" *canam recepto Caesare felix.*[109]

> Happy at Caesar's return I shall sing "O lovely Sun [= the coming of day], O one to be praised!"

84 Glass cameo with
snake and tripod of Apollo.
Köln, Röm.-Germ. Museum.

85 Relief of Sol. Vienne,
Musée Lapidaire. Photo:
Hachette.

According to Suetonius (*Aug.* 79.2), Augustus himself took special pride in thinking that the glance of his eyes was like the radiance of the Sun. In solar theology, Helios was a symbol of immortality because it was from the Sun that divine monarchs were thought to have descended to earth and to the Sun that they would return after their death to dwell as gods in the heavens (Vell. Pat. 2.123.2; Man. *Astron.* 1.799–804; cf., Cumont, 1912: 54). This concept, which itself is of eastern origin, is understandable in view of the fact that the sun was thought to "die" each day, only to be "reborn," or resurrected, on the morrow. Sunrise, as we have seen, was associated with the birth of Augustus, and an eclipse of the sun was linked with his passing (Cass. Dio 56.29.3), as it had been for great leaders before him (Weinstock 1971: 382–3). The metaphorical relationship of sunset and sunrise to a great leader is conveyed in the miraculous story of how as an infant Augustus disappeared one evening from his cradle on the ground floor only to be found the next day lying on a lofty tower facing the rising sun (Suet. *Aug.* 94.6).

The eagle that appears by the foot of Augustus has generally been regarded as the bird of Jupiter, as well as a symbol of the Roman Empire (cf., e.g., Kähler 1968: 24). The eagle in fact is a polysemous symbol, which like Augustus's personal badge also alludes to the past, present, and future. Like Horace's extended simile at the outset of ode 4 of book 4 of his *Carmina* in which Jupiter's eagle is likened to Augustus' stepson Drusus (Maior),[110] the eagle on the Gemma can allude to the "new eagle" Tiberius. Here, too, is the implication of the dynastic succession and the partitioning of power to carry out war against a foreign enemy. Overlooked also has been the eastern tradition that the eagle is the bird of the Sun and one of the chief vehicles of apotheosis.[111] The eagle on the Gemma would have alluded further to Augustus's inevitable deification.[112] Associated, too, with the theology of apotheosis and solar rebirth or resurrection was the belief that Capricorn leads the sun from the infernal regions to the heavens: *Capricornus ab infernis partibus ad supera solem reducens* (Macrob. *Sat.* 1.21.26). On the Gemma Augustea, therefore, the Capricorn superimposed on the solar disc alludes to Augustus's conception and birth, as well as to his predestined apotheosis and immortality.

This symbolism finds a visual analogue in the Solarium Augusti/Ara Pacis program, in which birth and immortality were brought into association with Augustus in a very personal way: The obelisk, symbolizing eternity and dedicated to the sun god for Augustus's victory over Egypt, cast a shadow toward the center of the Altar of Augustan Peace on September 23, the official birthday of Augustus in the Julian calendar (Buchner 1982). In fact,

the Gemma Augustea reiterates, only in the grandiloquent language of Hellenistic panegyric, many fundamental ideological concepts embodied in the more complex program of Augustan monuments of the northern Campus Martius. These structures make their greatest symbolic impact when observed synoptically from what I believe to have been the optimum view (Fig. 86; cf. Fig. 74).[113] In these and other Augustan monuments, there is generally present a strong dynastic construct in which references to the past, present, and future are interwoven as manifestations of fate, fortune, and destiny – concerns also prevalent in Augustan literature under the influence of contemporary Neo-Stoic philosophy (Pollini forthcoming: chap. 7).

FOR WHOM THE GEMMA AUGUSTEA WAS COMMISSIONED

Final matters of consideration are the function of the Gemma Augustea and the identity of its recipient. It seems likely that this magnificent work of art was presented to either Augustus or Tiberius, who are the only two whose zodiacal signs are depicted. If presented to Augustus, who after all is the principal protagonist, the Gemma might have served as a form of *consolatio* for the loss of Varus's legions.[114] By way of analogy, we know that literary *consolationes* and even statues were sometimes voted to an individual for a personal loss.[115] And literary sources tell us that Augustus was indeed devastated by the slaughter of Varus's legions, an event that was treated as a national tragedy that seriously jeopardized the security of Rome's northern frontier. As *Pater Patriae,* Augustus grieved the loss of the soldiers' lives as he would have the death of family members. For several months after the catastrophe, he is reported to have "cut neither his beard nor hair, and would sometimes bash his head against a door, crying out 'Quintilius Varus, return (my) legions!' And each year he observed the day of disaster as one of sorrow and mourning" (*barba capilloque sum-*

86 Optimum view of the Augustan monumental complex of the northern Campus Martius.
A. Solarium. B. Mausoleum. C. Ustrinum. D. Ara Pacis. Drawing: J. Pollini, after R. Reif.

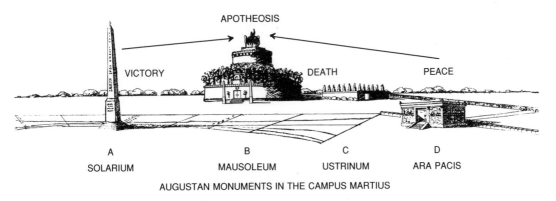

APOTHEOSIS

VICTORY — DEATH — PEACE

A
SOLARIUM

B
MAUSOLEUM

C
USTRINUM

D
ARA PACIS

AUGUSTAN MONUMENTS IN THE CAMPUS MARTIUS

285

*misso caput interdum foribus illideret vociferans: "Quintili Vare, legiones
redde!" diemque cladis quotannis maestum habuerit ac lugubrem)* (Suet.,
Aug. 23.2).

The relaxed, self-assured pose of Augustus on the Gemma and
the visual expression of future victory based on past successes ap-
pear to belie the gravity of the situation, perhaps with the intent
of imprinting upon the subconscious mind of the Gemma's re-
cipient an image of confidence and assured success. At the same
time, the magical properties believed inherent in the stone itself
would have served to ward off evil and ensure a successful out-
come in this period of crisis. In view of its propitious nature, the
Gemma would also have been a highly appropriate magical
"charm" for Tiberius, to whom Augustus now looks (with di-
rected gaze) to make the Germans atone for the lost legions of
Varus. But regardless of the identity of the recipient, it is clear
that the Gemma Augustea, celebrating imperial virtues and
achievements and the fate, fortune, and destiny of Augustus and
his house, could be read as a dynastic narrative by members of an
elite social class, well versed in the literary and rhetorical traditions
of Greco–Roman culture.

POSTSCRIPT

After I wrote the main text of this essay, there appeared two
studies on the Gemma Augustea that could not be fully taken into
consideration here, but will be discussed further in my book *The
Image of Augustus: Art, Ideology, and the Rhetoric of Leadership.* For
the present, the following observations are offered:

I. Megow (1987: 8–11, 155–63 (Cat. A 10), pls. 3; 4; 5.1–4, 6–
 7; 6.2, 3, 5–6): for a highly descriptive analysis with commen-
 tary on the Gemma.
II. Scherrer (1988).
 A. Scherrer's idea of a *iunctio dextrarum* (joining of right
 hands) and hence *concordia fratrum* (fraternal concord be-
 tween Tiberius and his dead brother Drusus), on which
 much of his argument is based, does not convince me.
 After checking both the original and my cast, I cannot
 see any remains of another hand in Tiberius's extended
 right hand. Although the torsion of Tiberius's foreshort-
 ened hand is awkward (hardly unknown in Roman glyp-
 tic art), the circular object held in his right hand appears
 to be nothing other than the end of the book scroll rep-
 resented in a foreshortened manner. Furthermore, al-
 though the *iunctio dextrarum* is attested in grave reliefs, the-

Gemma Augustea is not a gravestone! The mixing of the living and the dead in this way on a display cameo celebrating an important event in the life of Tiberius seems to me peculiar. Even on the Grand Cameo, the living and the dead are clearly represented on two different and separate planes: The divinized or heroic deceased members of the family are appropriately shown in heaven.

B. Scherrer identifies the bearded figure in the upper register as Saturn, although one would expect at least some attribute for him. An identification as Oceanus (who has no fixed attribute) still seems more likely to me, especially as part of the embodiment of the Augustan concept of *terra marique . . . parta victoriis pax* and as an indirect allusion to the Gigantomachy.

C. Scherrer proposed that Mars is represented in the lower register, assisting in raising the trophy. I find it difficult to believe that Mars would have appeared in the role of a divine *Gastarbeiter!* Compare, for example, how Mars is represented in Frieze A of the reliefs from the Palazzo della Cancelleria in the Vatican Museum: Magi (1945, pl. II). (See also my n. 57.) As for Mars being a *Repräsentant des "Draussen,"* it should be remembered that it was Augustus who "civilized" – or better "rehabilitated" – Mars by bringing him within the *pomerium* of Rome when he built the Temple of Mars in the Forum Augustum.

NOTES

To P. H. von Blanckenhagen, in memoriam.

1. The bibliography on these two monuments is massive. On the narrativity of the columns, see recently Brilliant (1984: 90–123) and Pollini (1986).

2. For the role of the "viewer–narrator": Brilliant (1984: esp. 15–20). See also the chapter entitled "How to Address Spectators: The Message and the Organizing of the Visual Narrative" in Leander Touati (1987: 29–37). For the question of reading important Augustan imagistic ensembles as "dynastic narratives" (not discussed by Brilliant), see the chapter entitled "The Rhetoric and Poetry of Visual Imagery and the Creation of Dynastic Narratives" in Pollini (forthcoming): chap. 7.

3. Although a certain amount of inference plays a part in any narrative, a true narrative does not depend heavily upon inference in order to be intelligible as a narrative. In other words, in a true narrative, an observer or reader does not need to know the story in order to fill in the missing events; he need only utilize ordinary logic based on life experience. For the role of inference in true narratives and "inferential narratives" (my term): Chatman (1975: esp. 303–15).

4. For the use of *dystaxie* (dystaxy) in the study of comparative linguistics:

Bally (1965). For its use in studies of narrative structure by literary critics: Barthes (1975: 266–9).

5. For examples of *hyperbaton: Rhet. Her.* 4.44.

6. For the importance of memorization in Greco–Roman education, see, in general, Marrou (1956) and Bonner (1977). For recent studies focusing on orally oriented cultures, see esp. Ong (1982); see also Clanchy (1979) and Camille (1985). For the question of literacy in the ancient world: Harris (1989).

7. See also Clarke (1963: 16) and Bonner (1977: esp. 254–62).

8. See also Bonner (1977: 262).

9. My term "dynastic narrative" might also be applied, for example, to the illustrated *Grandes Chroniques de France* of Charles V. For an interesting essay on the role of genealogy in this historical illustrated narrative: Hedeman (1985). For the relationship of time and narrative, see esp. Ricoeur (1984).

10. Cf. N. Marinatos's preliminary remarks (in this volume) about "combining principal images with signs."

11. Vienna, Kunsthistorisches Museum (AS-inv. IX A 79): h. 19 cm (7½"); w. 23 cm (9"). The fundamental work by Albert Rubens was updated by Kähler (1968). See also Pollini (1978: 173–254). For pertinent bibliography since 1978: Megow (1987) and Scherrer (1988).

12. For the importance of function in interpreting visual images, see Marinatos in this volume.

13. For the joint worship, including precedents and archaeological evidence: Nock (1972: 202–51); and more recently, Fayer (1976); Price (1984); Fishwick (1987); Hänlein-Schäfer (1985).

14. I believe that the Capitoline Jupiter was the direct inspiration even for the statue of Augustus in Herod's Temple of Roma and Augustus at Caesarea, a figure that supposedly was modeled on the Pheidian statue of Zeus at Olympia (Joseph. *BJ* 1.414; *AJ* 15.339, 16.136). Any influence of the Pheidian Zeus in my opinion, would have only been indirect; see further Pollini (forthcoming). Maderna (1988: 31), in a publication of which I was not aware at the time I prepared this chapter, also concludes that the majority of seated Jupiter types found in the provinces probably reflect the Capitoline Jupiter, although she does not call into question Josephus's comment on Herod's statue of Augustus. For the seated Jupiter type, employed for the *principes* of Rome, see further Krause (1983: 18–19); and more recently, Maderna (1988: 24–52).

15. *Denarius* of the Civil War period (A.D. 68) bearing the legend I.O.M.MAX.CAPITOLINVS: *BMCRE* I, 307 (no. 70), pl. 51.22; Kent (1978: pl. 62.215). Cf. also virtually the same image on the earlier coinage of Nero with the legend IVPPITER CVSTOS: *BMCRE* I, 209–211 (nos. 67–9), pls. 39.19–23; Kent (1978: pl. 56.194).

16. Inv. 97.22.8 (I thank Dr. E. Milleker for providing me with a new view of this statuette): Richter (1915: 110–11; no. 200). For the identification of the Capitoline Jupiter in this statuette, see further Nodelman (1987: 80–2, fig. 28). Cf. also the Marbury Hall Zeus in the Getty Museum: Vermeule (1977: 43–4, figs. 1–2).

17. It is difficult to say with certainty whether the pre-Domitianic cult image of Jupiter Optimus Maximus had a short section of his mantel draped over his left shoulder. If so, the omission of this detail would constitute a further modification of the Jupiter Capitoline type by the carver of the Gemma Augustea. Cf. also the Zeus type with totally nude torso appearing on the

reverses of coins minted by Alexander the Great and his successors: Kraay and Hirmer (1966: pl. 172, nos. 569, 570; pl. 173, no. 572; pl. 217, no. 769). See also Pollini (forthcoming).

18. For a more detailed discussion of individual figures and attributes: Pollini (1978: 173–254). Cf., however, Simon (1986a: 181–4), who argues for Tellus rather than Tellus Italiae, in part on the assumption that the children represented with her are two of the four Seasons. Although the child in the foreground holds ears of wheat, the child in the background has no attributes and therefore is unlikely to be one of the Seasons. In my opinion, the empty cornucopia held by the earth goddess signifies the famine in Italy at this time, and the ears of wheat held by the child allude to the hope of plenty as a result of victory and peace won by Augustus and his progeny. Simon (1986a: 183–4) also suggests that the bearded god standing beside Oikoumene would be Chronos-Saturnus, if he once held a sickle (*falx*). However, there is no indication that he held any attribute, nor are there any traces of recutting to remove a postulated attribute.

19. The phrase *terra marique* is commonly found in literary and epigraphic sources. For this expression: Momigliano (1942: 53–64).

20. A nude Augustus holds a ship's rudder and cornucopia and is flanked by two female figures personifying the realms of land and sea. See also Pollini (1992: 285–6, fig. 1).

21. On this matter, see further Onians (1979: 30–4).

22. For those who have held this view: Pollini (1978: 239, n. 69).

23. Cf. also Augustus on the Ara Pacis, where, as I have suggested, he originally appeared holding an augural *lituus,* again as mediator between gods and man: ibid., esp. 87–9 and 126–32.

24. On the day he was born, Augustus supposedly appeared to his father in a dream with the thunderbolt, scepter, and dress of Jupiter: Suet. *Aug.* 94.6.

25. Bare feet would be a sign of deification or heroization. Augustus's representation with sandals argues for his still being alive when the Gemma was created. I thank David Wright for reminding me that Augustus does not appear with bare feet on the Gemma.

26. The bronze statue of Augustus holding a thunderbolt from the "Basilica" at Herculaneum in the Museo Nazionale in Naples (inv. 5595) belongs to a group of statues set up at the time of Claudius; the statue in question therefore represents Divus Augustus: Niemeyer (1968: 32, 59, 104 [no. 82], pl. 27); see also Zanker (1978: 31–2 [no. 19], pls. 25–6).

27. For the significance of the *lituus* in this context and its various symbolic meanings, see further Pollini (1978, 190–2).

28. The concept of the *alter conditor* did not originate with Augustus; there was already a Republican tradition that had cast Camillus, for example, in the role of "Second Founder": Meslin (1981: 96–7). For this same idea, especially in connection with *denarii* showing a symbolic plowman, presumably Octavian, minted after the victory of Actium: *BMCRE* I, 104 (no. 638), pl. 15.17; Giard (1976: 72 [nos. 92–7], pl. IV). For the idea of the second founder in relation to this coinage: Liegle (1941: 106–8).

29. See also Cass. Dio 53.16.8. For the common etymology of *augur* and *Augustus:* Ernout (1946: 67–71) and Pollini (forthcoming).

30. For an excellent discussion of the meaning of the words in this Roman triumphal formula: Versnel (1978: 356–71).

31. For a further discussion: Meslin (1981: 98–106).

32. Cf. N. Marinatos' term "pictorial similes" in this volume.

33. As Horace says in ode 1.12.49 (cited in context supra), *gentis humanae pater*

atque custos. Jupiter also bears the epithet of *custos* on a Neronian coin that appears to represent the Sullan cult image in the temple of Jupiter Optimus Maximus; see further nn. 15–16.

34. For the dedication of the temple: Tac. *Hist.* 3.72.

35. As I suggested in support of the identification of the elderly, bearded god beside Oikoumene as Oceanus: Pollini (1978: 185–6).

36. In origin, his waters were sometimes associated with the "waters of chaos." In this regard, see further Fontenrose (1974: 225–39).

36a. I thank Diskin Clay for this observation.

37. As A. Stewart so eloquently reasserts in this volume. For the use of the gigantomachy theme in literature, especially in the *Aeneid,* see also Hardie (1986: 85–156). For the theme of the gigantomachy in Near Eastern and Greek culture and its metaphorical significance as the defeat of the forces of chaos: Fontenrose (1974: 239–47).

38. Indirect allusions to the gigantomachy allegory can also be found in Augustan literature, especially in the work of Vergil. See Hardie (1986: 85–186). For another literary parallel linking Augustus to the gigantomachy theme in an indirect manner: Horace, *Carm.* 3.4.37–80.

39. Among the works on the Grand Cameo, see Jucker (1976: 211–50, fig. 1a); Richter (1971: 104–5, no. 502 and fig. 502); most recently Megow (1987 with extensive bibliography: 80–1, 202–7 [Cat. A 85], pls. 32.5–10, 33). Somewhat analogous to the use of a line of demarcation between the ordered and the disordered is the low fence that marks the boundary between the neatly planted garden and the wild woodland beyond in the famous garden fresco of the underground room at Livia's Villa at Prima Porta; see most recently *Kaiser Augustus,* cat. 133 (B. Andreae).

40. An actual line of demarcation is not necessary to the division of these polarities. For a structural approach to this manner of representation: Leach (1985: esp. 20) and Bal and Bryson (1991: 192).

41. For a discussion of the modes of representing order/disorder in Greek and Roman reliefs, see Leander Touati (1987: 27–9). Although she does not deal with the divisional line, Leander Touati does note that the conquered enemy is usually relegated to the lower parts of battle scene compositions. In effect, the fallen bodies of "the enemy" often form an invisible line of demarcation between the victors and the conquered. See also Hardie (1986: 198). For Roman antithetical notions in general: Seel (1964: esp. 211–45, passim).

42. Cf. A. Stewart's observations on historically conscious styles, especially that of the Hellenistic Baroque in this volume. On parallel developments between "tragic" historiography and the pathos-filled conflicts represented in Hellenistic art: Hölscher (1987: 20–33).

43. Most of the other figures in the upper register are in three-quarter view, except for Oceanus (at the far right), whose head is almost in profile: Kähler (1968: pl. 11).

44. The bottom of Tiberius's scepter is visible next to the rim of the chariot's wheel (better seen in the plaster cast).

45. It is sometimes said that Tiberius is being helped down from his chariot: for example, recently T. Hölscher in *Kaiser Augustus,* 372. But surely a victor of the stature of Tiberius needs no help in descending from Victoria's chariot. Foreshortening accounts in part for the somewhat awkward appearance of Tiberius's hand, which holds a small *rotulus;* the knuckles have been partly cut away (cf., however, the incorrectly restored long *rotulus* in Rubens's sketch: Kähler [1968: pl. 2]). The shadowy line along

the upper part of Tiberius's arm is the result of the cutting back of the cameo at this point to eliminate the figure standing to the left of Tiberius, a feature that shows better in the plaster cast. For the short *rotulus:* Pollini (1987: 33–4). Note also the figure holding an unrestored short *rotulus* on the Ara Pacis: Pollini (1978: 244, n. 101 [no. N-30]).

46. This figure has recently been identified as Venus with a postulated Cupid to her right: Simon (1986a: 184–5, pl. 5, fig. 6 [with hypothetical reconstructions]). In detailed photos of the original cameo and of the plaster cast, however, it can be seen that this figure is togate: the curve of the toga's *sinus* appears just behind the upper part of the wheel's rim. Also, the contours of the missing figure's high left shoe are visible between the outer rim of the wheel and the spokes; the curve of the shoe, not straight falling folds of a long female dress, appears directly below Tiberius's right shoe (Kähler, 1968: pl. 4).

47. For the sculptural portraits of Germanicus: Fittschen (1977: 51–4); Bahnemann (1983: 15–20); and a collection of essays by different authors in *Germanico* (1987).

Best comparisons:

1. Bust in the British Museum (inv. 1883): Curtius (1948: 85, 94, pl. 32); Poulsen (1960: 29); Fink (1972: 281, pl. 1.1).

2. Head in the Ny Carlsberg Glyptothek (inv. 2648): Poulsen (1962: 88–9, pl. LXXXIX) and Fink (1972: 283, pl. 6.2 [caption of pl. 6.1 belongs with 6.2 and vice versa]).

A. Rubens was the first to identify the figure on the Gemma as Germanicus: Kähler (1968: 25–6, pl. 7). See also Pollini (1978: 177–82). This figure is sometimes incorrectly identified as Gaius, one of Augustus's adopted sons, as discussed in Pollini (1987: 44–5).

48. See also (independently) Möbius (1985: 78). The Genius Populi Romani and the personified Senate have also been proposed: for example, Eichler and Kris (1927: 55) and Kähler (1968: 25). These identifications seem rather unlikely to me, because these figures are generally found in state reliefs rather than in the private "court art" of cameos; cf. Simon (1986a: 184–5). Also Roma, who sits beside Augustus on the *bisellium,* is, after all, the embodiment of the Senatus Populusque Romanus: Pollini (1978: 211).

49. For the Temple of Concordia Augusta: Gasparri (1979: 26–7), following Rubens and Kähler, wrongly in my opinion assigns the event commemorated on the Gemma to January 16, A.D. 10, the date of the dedication of the Temple of Concordia. On the date of Tiberius's solemn entry: Pollini (1978: 223–5). The best reading of the date of the dedication of the Temple of Concordia in the Fasti Praenestini continues to be that of Degressi (1963: 114–15, 398–9). Cf., however, Gasparri (1979: 14 [no. 26]).

50. For a discussion of the historical point of reference: Pollini (1978: 196–203).

51. For various matters regarding the triumph: Versnel (1978). For Etruscan antecedents of the *toga picta,* cf. that worn by Vel Saties represented in the François Tomb: Holliday, Fig. 67.

52. For the awarding of the triumphal regalia as a result of his role in the Illyrian campaign of A.D. 9: Cass. Dio 56.17.2.

53. For this new dating: Pollini (1978: 175–6, 196–203, 223–5).

54. For the term: Verg. G. 2.145.

55. Cf. also the ominous horse head discovered on the site of what was to become Carthage, a *signum* itself of future war and prosperity (*Aen.* 1.441–5):

> *Lucus in urbe fuit media, laetissimus umbrae,*
> *quo primum iactati undis et turbine Poeni*
> *effodere loco signum, quod regia Iuno*
> *monstrarat, caput acris equi; sic nam fore bello*
> *egregiam et facilem victu per saecula gentem.*

> In the middle of the city was a grove of the most pleasant shade,
> where the Phoenicians, buffeted by wave and whirlwind, first exhumed
> a portent, the skull of a battle-keen horse, which regal Iuno revealed;
> for thus was the Carthaginian race to excel in war and to be bountiful
> in sustenance for centuries to come.

On this passage, see also Clay (1988: 196).

56. For several examples of this phraseology, see, for example, Livy 4.10.8; 6.18.9; 9.25.7; 22.23.3, 38.9.

57. Some have attempted to identify certain figures in this register as gods (infra). In Roman art, however, gods are not represented in such a subservient role. It is one thing for a Venus to inscribe a shield of victory, quite another for deities to "dirty" their hands in a manner not befitting their lofty divine status. Such labor is better left to personifications and/or ideal types. Gods are generally represented symbolically (e.g., a Mars *tropaeophorus* to symbolize victory) or presented in spirit, exemplifying divine favor/guidance. See also my comments on Scherrer's view in my postscipt (II. C.).

58. The only partly preserved seated figure at the left edge is apparently interpreted by Simon (1986a) as an eastern barbarian, because in her reconstruction (her pl. 5), he wears a Phrygianlike cap. However, the representation of a cap on this figure is incorrect: On close inspection (especially of the plaster cast: pl. 4), "wild" hair on the crown of the head can clearly be discerned. The bow and quiver in front of this figure are weapons associated with the Illyrian people. Simon also postulates a standing eastern type even farther to the left, although there is no evidence of any figure here. See further Pollini (1978: 206–7).

59. Following Will (1954: 599–603), Simon (1986a: 187–9) identifies the two figures wearing kiltlike loincloths as the Castores. When represented in art, however, Castor and Pollux have some distinctive attributes that these figures lack. They are usually shown nude or seminude, wearing on their heads a *pileus,* sometimes topped with a star, generally with spear and/or sword, and frequently with a horse: Lorenz (1976: 17–24, pls. 7–15). To make it clear that these two figures were not generic types, the engraver would surely have represented them with at least their most distinctive attribute, the *pileus.* Simon (1986a: 188) interprets the two armored figures as a doubling of Mars: *Da die römische Religion zwei Kriegsgötter kannte, Mars und Quirinus, war die Verdoppelung des Mars im gleichen Bildzusammenhang nichts Ungewohntes.* Other than the fact that both figures are military, I find nothing, iconographically speaking, that would suggest an identification as Mars or even Quirinus. I also do not agree with Simon's idea that these four figures have reference to the zodiacal sign (Gemini) and horoscope of Germanicus. The engraver, after all, used graphic signs of the zodiac for Augustus and Tiberius. Germanicus' sign is not represented because the Gemma was not directly related to him, but to Augustus and/or Tiberius.

60. For these types, see Connolly (1981: esp. 54–6, 72, 80, 97, 99–100, 110–12, 214, 229). For Roman cuirassed statues, see Stemmer (1978).

61. It would be tempting to see in these figures a reference to cohorts of newly created freedmen, whom Augustus designated the *cohortes voluntariae* (Macrob. *Sat.* 1.11.32). These freedmen units served in both the Illyrian and subsequent German campaigns (Vell. Pat. 2.111.1; Cass. Dio 55.31.1, 56.23.2). Although Augustus's official attitude toward slaves was a traditionally Roman one, he did honor them on occasion, as is evident from the fact that he set up a monument to a slave girl who produced quintuplets (Gell. *NA* 10.2.2). According to Suetonius (*Aug.* 25.2), freedmen served in their own units apart from those of free-born soldiers and were armed differently.

62. Previously suggested: Pollini (1978: 203–9) and infra.

63. For a parallel in Roman art of two separate and sequential events demarcated by two figures standing back to back within a single tableau, compared the two *pedites* to the left separating the scenes of *census* and *lustrum* on the "Altar of Gn. Domitius Ahenobarbus": Torelli (1982: 11–12). See also Kuttner in this volume.

64. For further discussion: Pollini (1978: 207–9).

65. Cf., however, Simon (1986a: 188–9), who attempts to make a case again for identifying this figure as Mercury. Despite the lack of baldric – presumably an oversight on the part of the carver – the shape and diagonal angle of the object on which the personification places his hand is not a moneybag (*marsupium*), but the hilt of his sword. His four fingers rest on the pommel of the sword (for a detail: Kähler, 1968: pl. 15). Furthermore, we would expect a more characteristic attribute of Mercury, such as the *caduceus,* winged hat, or winged sandals.

66. Simon (1986a: 188–9) attempts to support Will's idea (1954: 598–600) that this figure represents Diana, only Simon would call her Diana–Luna or a Diana–Bendis–Luna. Again, I am not convinced by her argument for such an identification. As Simon even admits (1986: 188–9, n. 39): *Darauf weisen das Lederkoller und die beiden Lanzen hin, die für die italische Diana ungewohnt sind.* A reference to a Diana–Bendis–Luna here would seem to me far too obscure.

67. Two spears are featured on *dupondii* from a mint in Spain presumably issued on the authority of Augustus for the Cantabrian Wars of 26–25 B.C.: *CNR* VII, 142 (nos. 1369–1369/2). For the iconography of Hispania: Arce (1980). Hispania also sometimes carries a round shield, which may have been omitted here so that she could pull the barbarian into submission. See also Zanker (1987), who follows my identification of this figure.

68. *BMCRE* I, 304 n., pl. 51.16; *CNR* IV, 100 (nos. 69, 69/1).

69. *Denarius* from mint at Tarraco: *BMCRE* I, 338 (no. 170).

70. See, for example, the figures of Hispania and Gallia flanking Parthus on the cuirass of the Augustus from Prima Porta: Pollini (1978: esp. 30–9 with further references).

71. The emptiness of the *cornucopia* has rarely been noted and never satisfactorily explained. See also my observation about the *cornucopia* on the Tazza Farnese: Pollini (1992: 293, pls. 1 and 4).

72. For the primary evidence: Pliny *HN* 7.149; Cass. Dio 55.22.3 (A.D. 5), 26.1, 27.1–3 (A.D. 6), 31.3–4 (A.D. 7), 33.4 (A.D. 8), 56.12.1 (A.D. 9).

73. For the possible apotropaic nature of such a gesture, see, in general, L'Orange (1953: 184–5). I do not agree with Simon that this baby is one of the four Seasons, because he holds no attribute: see n. 18.

74. In fact, the manpower shortage became so severe both before and after the Varan disaster that Augustus was compelled as a last resort to free slaves to serve in the army. Augustus's endeavors to increase the population is further stressed in two speeches to the unmarried and childless attributed to him in A.D. 9 by Cassius Dio (56.2.1–9.3).

75. See also Syme (1939: 449–54) who rightly notes (453), "It was not Rome alone but Italy, perhaps Italy more than Rome, that prevailed in the War of Actium. The Principate itself may, in a certain sense, be regarded as the triumph of Italy over Rome." For the doom of the old Roman nobility and the rise of the Italian municipal aristocracy: ibid.: 490–508. For the importance of Italia and the final resolution under Augustus of the old antithetical notion of Roma/Italia (*domi/foris*): Seel (1964: 367–415).

76. For the importance of Italy's wine production: Rostovzeff (1957: 67–70) and Pollini (1992: 292–3).

77. The form of the amulet, which is barely perceptible in photos, is best seen in the cast of the Gemma: Pollini (1978: 184 with n. 47). A reference to fertility may likewise be implied in the ivy-shaped amulets worn by female members of the Julio–Claudian house, because childbirth was an important female virtue in Augustus's program. For representations see, for example, a cameo in Vienna (Richter, 1971: 106–7 [no. 512]; Oberleitner, 1985: 58, fig. 40) and a cameo in Berlin (Vollenweider, 1966: 73–4 and n. 59, 120, pl. 84.2). Such an amulet is also worn by Ulpia Epigone in a funeral relief in the Lateran: Helbig[4] I, 741–2 (no. 1030). In a paper delivered at the annual meetings of the AIA and APA (December 1986), D'Ambra discussed (1987) the fertility aspects of this grave image as a reflection (in part) of the efficacy of Domitian's revival of the Augustan *Lex Iulia*.

78. For the *ius Italicum*, see Bleicken (1974: esp. 367–73) and Watkins (1979: 59–99). Bleicken (370) notes specifically, *Der konkrete Bezug auf ein fixiertes Gebiet wird also gerade durch die Übertragung des italischen Rechts, d.h. durch das "ius Italicum," gegeben. Diese Überlegung führt dahin, daß wir vor allem in dem "ius Italicum" einen stärkeren Bezug auf das Gebiet, und d.h. auf den Boden, sehen müssen als auf die Person.* For the implication of Italia in the term Tellus or Terra Mater: Gesztelyi (1981: esp. 440–4). For the idea that Italian and Roman colonies were regarded as of the same substance as the paternal land and treated as such in religious rites: Meslin (1981: 32).

79. See further Bleicken (1974: 384–8, 406–12) and Watkins (1979: 72–98).

80. These same concepts hold true in the back panels of the Ara Pacis for the composite female goddess on the left, identifiable in my opinion as Tellus Italiae, who serves as a pendant to the figure of Roma on the right. Augustan art, like the Principate itself, was in many respects still experimental, accounting thereby for some of the ambiguity of iconography, especially with regard to personifications. By the same token, ambiguity may have been intentional at times in a rhetoric that promised something for everyone. For flexibility in iconography, see esp. the comments of Hinks (1938: 111).

81. For example, Crawford (1974: 720) notes the use of the head of Mars and the eagle of Jupiter on thunderbolt on gold coinage of 211 B.C. to symbolize the "expected triumph of Roman arms." He also indicates (729) with regard to references to circus games and corn distributions on so-called "aedilician" types, "It is almost as if the moneyers concerned placed

on their coins an indication of what they would have provided if they had been elected Aediles."

82. See, for example, the *denarii serrati* of Q. Antonius Balbus: ibid., 379 (nos. 364/1a–e), 732.

83. More precisely, this form of sympathetic magic may be termed homoeo-pathic or mimetic/imitative magic; fundamental on this subject, as well as for comparative anthropological evidence: Frazer (1926: 52–174). See also Frazer (1929: 255). For the notion of an action as "predone" in connection with magic and the concept of the Latin *factura* as a magical "making": Harrison (1927: 43–5, 82). On the operative magical principle: Malinow-ski (1948: 79–84, 139–40) and O'Keefe (1982: esp. xv, xviii, 49–50, 267 with further literature). For an application of sympathetic magic in Roman sacrificial rites: Spaeth (1988: 8).

84. For other examples in Ovid, see, for example, Syme (1978: 53–4).

85. Museo Torlonia (inv. 414): Visconti (1885: 283, pl. 104). See also Cumont (1942: 337–8, pl. 37.2); Borghini (1980: 2–11, pls. 2–6 (best detailed photos); Kampen (1981a: 53–4). The desire to experience the future in a funereal context is also portrayed in Petronius's *Cena Trimalchionis*. See also in this volume: Whitehead.

86. Among those works on the Narmer palette: Frankfort (1948: 7–9, 172–3); Földes-Papp (1966: 51–3, 64, 70–4, 79–80, figs. 64–5, 90–2); Ridley (1973: 47–53); Gaballa (1976: 16–19); Janson (1991: 98–100, figs. 72–3). See now the chapter by Davis in this volume. I would also like to thank J. Baines for allowing me to read the unpublished manuscript of his paper, "The Origins of Kingship in Egypt."

The fourth century B.C. "Darius Krater" in the Naples Museum provides an example in Greek art of a composition in which historical and divine figures in a historical allegory are registrated in a hierarchical pyramid: Hinks (1939: 65–7, pl. 8). Here, the gods are arranged in the upper zone; the Persian King and others of importance, in the middle; and insignificant individuals of everyday life, at the bottom. Cf. also the paratactically displayed units of the great hierarchically arranged Apadana reliefs at Persepolis: Cool Root (1979: esp. 227–84, figs. 10–11).

87. As an analog for this hierarchic arrangement, see the central panel of the Apadana reliefs at Persepolis where the crown prince stands behind the Great King: Cool Root (1979: 88, fig. 11, pl. 17).

88. Compare also the Behistun relief with the third millennium Mesopotamian relief of Annubanini at Sar-i Pul: ibid., 196–202, pl. XLIX.

89. For a discussion of the existence of these cameos: Kyrieleis (1978: 121–2). For the Tazza Farnese: recently La Rocca (1984); Dwyer (1992); Pollini (1992). Like the Gemma Augustea, the Tazza Farnese is of sardonyx. On the eastern origin of this material, see further ibid., 5–6. I regard the Tazza Farnese as the product of a Greek gem engraver working first for the Ptolemies and then for Augustus and propose a new interpretation of the scene: Pollini (1992).

90. For a general discussion of gem engravers working for Augustus and members of his family: Vollenweider (1966: 47–80). It has often been postulated that the Gemma Augustea was the work of Dioskurides, the famous gem engraver of Augustus, who presumably came from Aigeai; see further Kähler (1968: 28 with n. 102). Although no signed work of his has been found in Egypt, might Dioskurides have once been in the service of the Ptolemaic court?

91. I use here the term "complementary" in the same sense that Wickhoff first employed "komplettierend" (Wickhoff 1900: 13).

92. Complementary narration has sometimes been called "simultaneous" or "synoptic"; however, these other two terms do not imply the subordination to a central scene of one or more other scenes or episodes, whether actually shown or only alluded to by some symbolic device(s). See further Himmelmann-Wildschutz (1967); Meyboom (1978); Snodgrass (1982).

93. Based on Wünsche's findings, this monument can now probably be safely associated with the victory and *census-lustrum* of M. Antonius, consul in 99 and censor in 97 B.C. See further Kuttner in this volume. Kuttner, however, does not note the temporally referential aspect of the *accensus* who carries the *vexillum* in the *lustrum* scene. Because the *accensus* leads off the lustrum procession, his appearance here alludes to the first part of the *lustrum,* which then culminates in the sacrifice to Mars by the censor.

94. The famous Battle of Marathon painted in the early Classical period and displayed in the Stoa Poikile shows the continuance of this synoptic manner of narration. Based on Pausanias's description of the painting (1.15.4), three distinct sequential moments of the battle were shown together in the large composition without the repetition of any one main character. Hanfmann (1957: 75) notes, "Rationalization and systematization of time was another scientific advance which might have affected Greek narration."

95. For a composition and mode of narration similar to that of the Amphiaraos scene, see Attic black-figure hydria in the Boston Museum of Fine Arts (inv. 63.473) dating ca. 510 B.C.: Vermeule (1965).

96. For the snake as a common chthonic index: Vermeule (1965: 45).

97. I have borrowed Barthes's term "organigram" (*organigramme*): Barthes, 1975: 269–70.

98. For an interesting example of a tableau in which the past, present, and future are interrelated in a genealogical framework, see the ceremonial miniature of the State Dinner of Charles V in the *Grandes Chroniques de France:* Hedeman (1985: 175–9, fig. 7).

99. For a discussion of the multivalent symbolism of this Augustan badge: Pollini (1978: 192–6, 221–2 with earlier references). Although I had considered the possibility of the disc behind the Capricorn and the star being the *mundus,* I am now convinced that the disc is the *nimbus* of the Sun. The engraver may have intended to represent seven rays, rather than the apparent eight rays behind the Capricorn (better seen in the cast). Seven was a sacred number and the usual (though not exclusive) number of rays of the solar disc. See, for example, the seven-rayed solar *nimbus* behind the head of the solar bird, the Phoenix, on a nearly contemporary liturgical garment from Egypt: Van den Broek (1972: 238–9, 426–7, pls. II–III). For other examples with or without disc/*nimbus:* ibid., 239–51. Solar rays are also shown delineated within the *nimbus* of the Sun on a glass cameo of the Augustan period in Köln (infra). Representations of Sol with rays inscribed within a solar *nimbus* appear too on *denarii* of Marc Antony dated to 42 B.C.: Crawford (1974: 512 [no. 496/1]). Some have considered the possibility that this might be the full moon, because we know that the moon was in Capricorn at the hour of Augustus's birth (infra), but in order to represent the moon as distinctly different from the sun, it was necessary in art to emphasize the moon's crescent shape. The moon as a half crescent and the sun in the form of a star, for example, appear together on *denarii* of 19 B.C. from the mint of Rome: Giard (1976: 78 [nos. 162–

6], pls. VII–VIII). Some have also interpreted the star inscribed on the disc as the *sidus Iulium*. Technically, this was a comet, which is often shown in art with its flamelike *cauda* (e.g., *BMCRE* I, 59 [nos. 323–8], pls. 6.6–8; 63 [no. 358], pl. 7.9). After Caesar's death, both a star and later a comet were used in association with *Divus Iulius*. For the *Caesaris astrum*: Weinstock (1971: 370–84) and Pollini (1978: 194–5). In antiquity, the star had several meanings: Besides being the star of Caesar's divine ancestress Venus and of his own divinity, it was the symbol of Helios, astral immorality, and the divinity of Hellenistic rulers. In any case, had the engraver of the Gemma intended to represent the *sidus Iulium* even without its *cauda*, it is unlikely that he would have employed the *nimbus*, which with the superimposed star can only refer to the sun. Furthermore, I know of no example in which the *sidus Iulium* is inscribed on a disc.

100. The connection of these *denarii* with the mint of Naumasus (Nimes) has recently been established by die-linkage: Giard (1976: 20, 198–9 [nos. 1357b–1360], pls. LV–LVI). Some have taken the naked figure hovering over Capricorn to be Sol, and others have suggested Aurora. The solar crown worn by the figure, the nudity, the lack of breasts, and the presence of what appears to be a penis in some examples argue for an identification as Sol: see, for example, ibid. (no. 1357c, pl. LV) and *CNR* IV, 218 (no. 264/2). The billowing mantle in this case is probably borrowed from Caelus, who appears on the breastplate of the Augustus from Prima Porta and the Belvedere altar: Kähler (1959: 16, pls. 6, 13). Even a nude Augustus appears with such a billowing mantle in a relief from the Sebasteion at Aphrodisias: Smith (1987: 104–6, pls. 6–7) and Pollini (1992: 285–6, fig. 1).

101. Among such examples: *BMCRE* I, 56 (nos. 305–8), pls. 5.15–16; 62 (nos. 344–50), pls. 7.1–5; 107 (no. 664), pl. 16.9; 113 (nos. 696, 698), pls. 17.8, 17.11.

102. Suetonius (*Aug.* 94.4) confirms that Augustus was born 10 months after his conception. In reckoning 10 months, the ancients counted the month of birth and that of conception in the total.

103. Inv. 29.175.4: Richter (1971: 101 [no. 482]). Octavian also appears to be represented on the back of Capricorn riding over the sea in an onyx cameo from the Beverley collection, a reference perhaps to his victory of Naulochus or Actium. For this cameo: Vollenweider (1966: 60, 62, nn. 78–9, 113, pls. 61.1–2).

104. For solar theology in Hellenistic and Roman times: Cumont (1912: 22–3, 55, 59, 69–75, 101, 103, 106–7); Warde Fowler (1914: 58–61); Weinstock (1971: 381–4). For the oriental tradition and its effect on Hellenistic thinking: Fears (1977: 76–7).

105. *Dux* in Latin also carries the specific meaning of a military leader; *princeps*, a preeminent civic leader.

106. For a comprehensive treatment of the role of Apollo in Augustan ideology: Gagé (1955: 411–12, 540–1, passim). For the role of Apollo in imperial ideology in general: Gagé (1981: 561–630).

107. Röm.-Germ. Museum (inv. 72.153). Other symbols on this glass cameo also refer to Augustus: Zanker (1988: 58, fig. 39).

108. Musée Lapidaire. The relief appears to be of Augustan or at least early imperial date. Cf. Espérandieu, 254 (no. 343), in which the figure is taken as Helios and dated to the first century A.D.

109. See further Weinstock (1971: 283) and recently Putnam (1986: 57).

110. I thank Michael Putnam and Nicholas Horsfall for reminding me of this passage. See the brilliant commentary on this passage in Putnam (1986: 81–100).

111. Among the principal works on this subject: Cumont (1912: 101–3; 1910: 119–64); and an expanded version: Cumont (1917: 35–118).

112. Not only was an eagle released from Augustus's funeral pyre (Cass. Dio 56.42.3) to symbolize the translation of his soul to the stars, but an eagle was also reported to have first circled above him when he was sacrificing in the Campus Martius and then to have perched above the first letter of Agrippa's name on the Pantheon – an ominous sign foretelling Augustus's imminent death and deification (Suet. *Aug.* 97.1).

113. I have restored the image atop Augustus's Mausoleum as a quadrigal statue rather than the usual *statua pedestris*. I have also restored the Mausoleum with oak trees, as suggested by Hesberg (1988b: 248), rather than the customary cypress trees. For my restoration and its significance in Augustus's *Bildprogamm:* Pollini (forthcoming): chap. 7.

114. Pollini (1978: 218–20) where I also suggest that Livia might have been the person who commissioned the work.

115. For the case of literary *consolationes* being written by Augustus's teachers for Octavia on the occasion of the death of her son Marcellus and for Livia on the death of her son Drusus: Bowersock (1965: 34). Livia was also voted statues by way of consoling her for the loss of Drusus (Cass. Dio 55.2.5). We know, too, of a case at Brixia (Brescia), where the town council decreed a gilded statue for a boy who died at the age of 6, in order to console his father: Friedländer (1908: 290). For the use of *imagines* for the purpose of *consolatio* see also Veyne (1958/9: 68–71).

THE "CENA TRIMALCHIONIS" AND BIOGRAPHICAL NARRATION IN ROMAN MIDDLE-CLASS ART

Jane Whitehead

> Now you must imagine you have been asked to a festival in honor of my past life. . . . Imagine that I am dead. Play something pretty.
> (*Sat.* 78)

At Trimalchio's command, the band strikes up such a dreadful noise that the fire department rushes in in alarm. So ends the outrageous dinner party of the *nouveau riche* freedman invented by the first century A.D. Latin author Petronius in his *Satyricon*.

The "Cena Trimalchionis" functions as a narrative unit within the *Satyricon* and one of Petronius's most biting social satires. The main object of his pungent wit, Trimalchio, is presented to the reader as a man obsessed with time and with his mark in life; we hear of these idiosyncrasies even before we encounter him. "Don't you know at whose house [the banquet] is today? Trimalchio, a very rich man – he has a clock and a uniformed trumpeter in his dining room, to keep telling him how much of his life is lost and gone" (*Sat.* 26). As Trimalchio sinks more deeply into his cups during the course of the dinner party, he becomes increasingly preoccupied with death.[1] He reads his will, commissions his tomb, relates his own biography so that the course of his life passes before our eyes, and, finally, asks to be anointed and wrapped in his shroud. Thus, the *Cena* flows like a life. We are reminded of one of Trimalchio's own metaphors, that wine is life (*Sat.* 34): After both, one is finally laid out cold.

Embedded within the narrative of the *Cena*, the narrative of Trimalchio's life is presented to us in numerous guises, among them anecdotes told by acquaintances and autobiographical details supplied by the freedman himself. Two of these embedded narratives are actually expressed semiotically, that is, they evoke artistic genres. The former of these occurs in the passage where the protagonists of the story first enter Trimalchio's house (*Sat.* 29); on the walls of his vestibule are painted scenes of his life, begin-

ning with the slave market and ending with the god Mercury sweeping him up to a high throne. The second is the section that most concerns this essay, that in which Trimalchio commissions his tomb and in its decoration epitomizes his biography for posterity (*Sat.* 41).[2] In the latter section, the satire is communicated through references to sculptural motifs, which would awaken recognition in the mind of the ancient reader. The goal of this study is, in part, to discover the responses that the description of these motifs would have stimulated.

The character of Trimalchio is perhaps the most carefully delineated of all Petronius's satirical figures. We know his origins, his story, his social class. The author plays constantly on the idea of freedom and freedmen – at one point in the dinner, for example, a boar is brought out wearing a cap of freedom (*Sat.* 41) – and he thus never allows the reader to forget Trimalchio's social status. As a result, the satire here has a deliberate specificity of social class and a fullness of detail not directed against the *Satyricon*'s other characters. The author has suggestively evoked the language of the lower classes, the *sermo plebeius,* and, as we shall see, has shown as subtle an eye for their artistic self-expression as well.

The idea that artistic taste might be class-determined was articulated by Bianchi Bandinelli in a discussion of this same passage of the *Cena*.[3] To fit his Marxist approach, he refined those theories that recognized two or more currents, alternating or simultaneous, in Roman art.[4] The Greek-influenced motifs with heroically proportioned figures and illusionistic treatment of volume and space, such as we see on the Ara Pacis or the Gemma Augustea (Pollini in this volume, Fig. 76), express the ideals of the politically powerful classes; Bianchi Bandinelli terms this style "court art" (*arte aulica*). The other style,[5] an anti-Classical, antiideal expression, he terms "plebeian," thus connecting it with a specific social context in which there is, as one sees imitated in the *Satyricon,* a linguistic parallel.

The notion of only two strands in Roman art, however, now appears unworkably simplistic; furthermore, the fact that patrons of "plebeian" art are, like Trimalchio, freedmen with foreign cognomina disproves Bianchi Bandinelli's theory that lower-class style derives from an indigenous *romanitas* (Zimmer 1982: 89). Nonetheless, the relationship of social class to artistic taste does bear examining more fully. Much recent scholarship, in fact, has sought to isolate genres and motifs that are exclusively plebeian.[6] And it is in the choice of genre and motif, perhaps more than in the style, that the taste of the working class expresses itself (Zimmer 1982: 91.)

The patterns of choice open to the patrons – choice of motif and of the style in which it was depicted – are subtle ones to trace. The aesthetic preferences for form that Bianchi Bandinelli termed plebeian[7] were used by Roman artists to interpret motifs that derive from, and have parallels in, the court repertoire. Among these are scenes that appear to have descended from the Imperial audience, or *congiarium* motif.[8] There are themes, however, that do seem to originate in "plebeian" workshops and are not expressed in the court style; these are frequently drawn from daily life, and claim to represent the patron in his life's activities. As one looks at the motifs Trimachio chooses for his tomb, one is led to ask whether it is not primarily his obsession with the representation of his own life that is being satirized as a mark of plebeian taste. Throughout the *Cena*, his pleasure in his own accomplishments goes hand in hand with his interest in the biographies of his fellow self-made freedmen and contrasts sharply with his ignorance of mythology. It is logical to suppose that the traditional mythological expressions of heroism and virtue were associated with the upper classes, and that freedmen would have replaced these symbols with their own iconography, namely, scenes from their own lives (Kampen 1981b: 135–6; Zimmer 1982: 60; Whitehead 1984: 318).

Taste, however, is also a qualitative judgment; good taste is separated from bad by subtle parameters, invisible to the uninitiated. As he commissions his tomb, Trimalchio continually oversteps boundaries and commingles things that have no place together. He begins by elevating his reeking cook to the status of a guest.[9] He then reads from his will a list of bequests to his slaves; this is an attempt to experience, while still alive, his household's grief for his death.[10] Likewise, he wishes to savor after his death the joys of his life. The commissioning of his tomb is a move toward that end: The motifs he chooses perpetuate the pleasures and accomplishments of his life. Seen this way, his biography is a form of apotheosis. It is ironic, then, that every scene he commissions is a standard one. Furthermore, he seems unaware that the motifs are as old as funerary art itself; he appears to take the symbolism too literally.

In order to analyze the thrust of the satire in this passage, we trace the standard motifs evoked, both for their origins and for the style in which they were depicted, in examples from Roman art. This approach illuminates the connotations of social class inherent in Trimalchio's taste. We must consider as well the character of the biographical narrative, both literary and sculptural, as the many strands of narrative fiction intertwine.

Then, looking at Habinnas, he said, "What do you say, my very dear friend: are you going to build a monument just as I have ordered you? I ask you sincerely to put right at the foot of my statue a puppy and wreaths, and unguents and all Petraites' fights, so that with your help I can live after death; furthermore let there be one hundred feet of frontage and two hundred feet of length. For I want there to be every kind of fruit around my ashes, and lots of vines. For clearly it is wrong for someone to care for his house while he is alive, and not to bother about the one where we must all live for a longer time. And above all, I want added, "This monument does not descend to my heir." However, I'll take care to provide in my will against any injury being done to me when I am dead. I'll appoint one of my freedmen as a guard for my tomb, to prevent the common people from running up and crapping on my monument. I ask you also to put ships departing under full sail on the [. . .] of the monument, and me sitting on the tribunal in my toga praetexta with five gold rings, pouring coins out of a bag in public; for you know that I threw a two-denarius banquet. Let the banquet rooms be shown, too, if it seems appropriate to you. And show all the people having a good time. At my right put a statue of my Fortunata holding a dove, and let her be leading a puppy with a leash on its collar: and my young boy, and amphorae sealed with lots of gypsum, so that they don't let the wine run out. And then I'll have you carve a broken urn and a boy weeping over it. A sundial in the middle, so that whoever looks at the time, whether he wants to or not, will read my name. And the inscription, too – see whether this seems appropriate to you: "Here lies Gaius Pompeius Trimalchio Maecenatianus. He was decreed a *sevir* in his absence. While he could have been in all the decuries in Rome, he refused. Upright, heroic, reliable, he grew from little, left thirty million sesterces, and never listened to a philosopher. Farewell to him: you, too, passerby." (*Sat.* 41)

Trimalchio first commands his sculptor *ut secundum pedes statuae meae catellam ponas.* Exactly what he means by a *statua* and where he intends it to be placed are unclear. Here, again, the problem is one of boundaries: Does he mean it to be placed on the outside or the inside of the monument? Analogies to a formal portrait of the deceased, standing and probably togate, either inside or on the exterior of tombs, are mostly in relief; these are characteristic commissions of freedmen (Kleiner 1977). Petronius's description calls to mind the high-relief portraits set into an exterior niche on the tomb of the baker Eurysaces, a monument standing prominently just outside the Claudian gate when this satire was written.[11]

Free-standing portraits also occur on tomb exteriors, but not on tomb types commissioned by freedmen. C. Poplicius Bibulus probably housed his statue in a tall central window in the façade of his Late-Republican tomb in Rome (Lugli 1938: 262–4 and fig. 56; Toynbee 1971: 127). "Base-and-canopy" tombs sheltered standing portraits of the deceased on the top of the monument

under a conical-roofed colonnade.[12] Such a structure would be more squarish in its base proportions than Trimalchio has requested, however.

Tomb interiors also held free-standing statues. The Claudian period portrait, tentatively identified as the freedman and *sevir* C. Lusius Storax from Chieti, probably was a seated figure (Giuliano 1963–4: 124–5). Trimalchio later in the passage asks to be depicted seated in his role as *sevir,* but that request is difficult to reconcile with his requirements here.

For full-length standing portraits placed on the interior of the tomb, Wrede has documented a second-century A.D. parallel in the sculptural ensemble from a mausoleum on the Via Appia in Rome, that of Claudia Semne, a freedwoman (1971: 125–66). The statues placed in her tomb included some statuettes based on prototypes of deities and heroes; Claudia Semne's portrait statuette was based on a Spes type. Trimalchio has already shown a similar tendency to link himself with deities in his vestibule paintings (*Sat.* 29). In one painted scene, he is shown as Mercury, long-haired and holding a caduceus; in another, Minerva leads him by the hand into Rome, as she led Hercules to Olympus. Recent studies[13] have shown that, while deification of freedmen through their portrait types does not occur on any scale until the second century, it had already been a conceit for the upper classes since the Late Republic (Kleiner 1987: 85). Trimalchio may be avant-garde here (or merely pretentious) in his usurping of an upper-class portrait mode.

The motifs to be carved in conjunction with Trimalchio's *statua,* on the other hand, suggest instead the low-relief carvings of the numerous, often disparate, scenes juxtaposed in bands or panels on tombs. The majority of these occur on the exterior of the buildings. Several examples of this type of monument have been found in the area of Naples (Figs. 88 to 91), and, as shown in what follows, may have served as a model for Petronius's description.

Trimalchio requests that a puppy be depicted at his feet. The dog is an integral part of two ancient funerary motifs, the hunt and the banquet. From the same mausoleum of Claudia Semne in Rome is documented a standing portrait of her son as Meleager,[14] set in a standard pose derived from sarcophagus reliefs; he has a small dog at his feet. The hunt motif has no role in Trimalchio's iconography, however. On the other hand, the figure of a small dog almost always appears in funeral banquet scenes at the foot of the deceased's couch[15]; this tradition leads one to ask whether Trimalchio might not be requesting a reclining portrait. If he intends his portrait to be free-standing, he could be commissioning

a *kline* monument, a type that always portrays the deceased re-
clining on the lid as if on a couch. *Kline* monuments are almost
exclusively the commissions of freedmen, and became common
in the first century A.D. (Wrede 1977). If, on the other hand,
Trimalchio's image is to be in relief, it would fit with the huge
banquet scene that he requests later in the passage.

The dog, however, is not limited to these motifs, but is fre-
quently used more generally as a symbol for faithfulness. One part
of an elaborate sarcophagus lid in the Capitoline Museum, for
example, depicts a couple seated upright on a couch in an affec-
tionate embrace, their dog beside them (Stuart Jones 1912: 313–
14, pl. 78). The imagery of faithfulness imparted by a dog is not
compositionally standardized in funerary monuments, but it does
appear in various guises. It seems to be the message of the first-
century altar of Gaius Julius Philetus in the Vatican,[16] on which
one relief-carved face depicts the deceased, a recently freed slave,
playing with a dog. Dogs often recline with the deceased woman
or child on *kline* monuments; one example in Copenhagen (Fig.
87)[17] depicts a man reclining with a cup of wine, a garland, and
a dog. Although the Copenhagen example may not symbolize per
se the fidelity of the deceased, but rather a more general symposial
virtue such as friendship,[18] it may yet be close to the image Tri-

87 *Kline* monument of a
man and his dog, second
century A.D. Copenhagen,
Ny Carlsberg Glyptotek n.
777. Photo: Ny Carlsberg
Glyptotek.

malchio's request would have evoked. Still, the notion of fidelity must be Petronius's intention here, given the reuse of the symbol later in the passage beside the wife's portrait, where, ironically, her dog wears a leash.

Also for the foot of his portrait, Trimalchio requests *et coronas et unguenta et Petraitis omnes pugnas*. This is a comic jumbling together of motifs, hard to imagine in its execution. Garlands are an extremely common funerary motif: In *kline* or funeral banquet scenes, the deceased often holds one[19]; as a separate motif, they are frequently depicted in tomb paintings or reliefs, whether on the tomb door or on the walls,[20] and are carried over as well onto "garland" sarcophagi (Koch and Sichtermann 1982). J.-M. Dentzer (1962: 533–94) analyzes the painted motifs in the tomb of C. Vestorius Priscus at Pompeii (Figs. 88 to 90), in which are depicted both the garlands and the perfume vessels, as well as some of the other motifs that Trimalchio requests. The tomb is one of several around Naples whose motifs bear an uncanny resemblance to those chosen by Trimalchio. Dentzer traces the depiction of fine vases such as perfume vessels in funerary art to tombs in Etruria and southern Italy as early as the fourth century B.C.; he associates the theme with the funeral banquet and tomb gifts (1962: 542–7).

88 Painted tomb of Vestorius Priscus, Pompeii, first century A.D. View of the east face of the tomb and surrounding precinct wall: Vestorius rendering justice; gladiators; grapes and wine pitcher. Drawing: J. Whitehead.

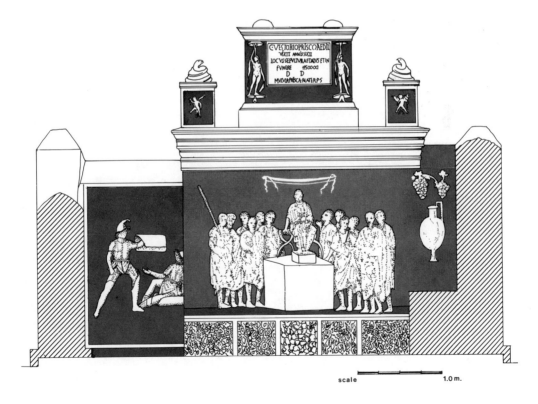

scale 1.0 m.

Trimalchio, however, has already been enjoying these enter-
tainments – his dog, garlands for celebrating, and spikenard – dur-
ing his *cena*. This is further evidence that his *statua* might be
regarded as part of a funeral banquet setting. It is also another
example of his blurring the boundaries between life and death,
that is, between the narrative of his monument, which is the story
of his life as if ended, and the narrative setting, the *Cena*. There
is constant echoing between these realms throughout the passage.

The third motif for the foot of his portrait, gladiators in combat,
also appears in the tomb of Vestorius Priscus (Fig. 88). Dentzer
(1962: 560), following Heurgon (1961: 262), attributes the estab-
lishment of this kind of gladiatorial show in funerary decoration
in the Naples area to Etruscan influence on Samnite art; its con-
nection with death derives from the origin of gladiatorial sports
in funerary games. The literary parallels he adduces for this theme
(1962: 590) further attest to the antiquity of the motif and confirm
that it also exists on its own, apart from the sculptural tradition.

Among the many other examples of gladiators in tomb art,[21]
the first-century tomb of C. Lusius Storax in Chieti (Fig. 91)[22]
offers an especially striking comparison to Trimalchio's commis-
sion; here, numerous combats are depicted in horizontal bands
below an interior pedimental area in which magistrates are por-
trayed in review. Storax, like Trimalchio, was a freedman and

89 Painted tomb of
Vestorius Priscus, Pompeii.
View of west face of tomb
and surrounding precinct:
Vestorius at his door with
slave boy and garlands;
peacock; garden plants.
Drawing: J. Whitehead.

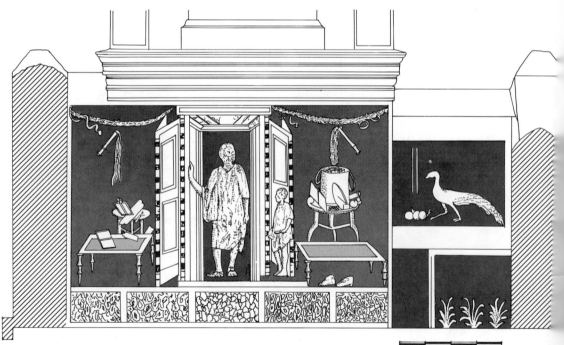

scale ▬▬▬▬▬ 1.0 m.

sevir, and, in that capacity, funded gladiatorial games. His monument offers a geographic parallel to Trimalchio's in its Naples-area location,[23] as well as a parallel for the social class and choice of motifs of the deceased.

Storax's monument depicts the deceased in a seated pose; a model for the reclining format with the gladiatorial fights, however, comes from an unexpected quarter: the life of the emperor Nero. Suetonius tells us (*Nero,* XII.3) that the emperor reclined on a couch on the podium of the amphitheater and was sometimes bloodied as a result.

Rather irrationally, Trimalchio appends to these requests his specifications for the tomb's dimensions. If these dimensions are intended for the structure itself, they are outrageously large (about 100 times the average documented area at Ostia: Cébeillac 1971: 104), but Trimalchio does, as he says, expect to be living there after death. He wants his tomb appointed with all the necessities (i.e., pleasures) of his life. He also wishes it decorated similarly to his house; one is again reminded of the protagonists' first view of the vestibule painted with scenes of Trimalchio's life.

If the requested dimensions apply to the plot on which the tomb is to rest, however, they are not so excessive. In effect, the *enim* in the following sentence ("For I want there to be every kind of fruit . . .") would suggest that Trimalchio wants the

90 Painted tomb of Vestorius Priscus, Pompeii. View of south face of tomb and precinct wall on eastern side: Banquet, ships with pygmies; table laden with silver vessels. Drawing: J. Whitehead.

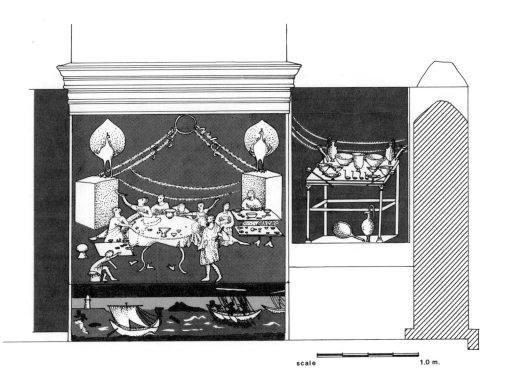

scale 1.0 m.

20,000 sq. ft for his garden. The idea to plant fruit trees and vines has its basis in actual practice; it was common for cemeteries to have gardens to soothe the living visitors (Jashemski 1970–1: 97–115; 1979: 143–53; Toynbee 1971: 94–100; D'Ambra 1988: n. 86). The produce from these plantings was often used to honor the deceased, either in the form of tomb offerings and funeral meal celebrations, or by generating income for the tomb's maintenance. Jashemski (1970–1: 101) notes a tomb garden that was even larger than Trimalchio's: the tomb of Aquilia, wife of Caricenus of Lavinia, 98 × 230 Roman feet. This fortuitously provides us with another Campanian parallel.

Trimalchio's mind then skips to the first of his inscriptions, which specifies that the monument not descend to his heirs. This request is stated in a formula frequently seen in abbreviated form on Roman monuments.[24] Such a stipulation would only have been needed if the heirs of the deceased were not his descendants. Trimalchio had no children and, unlike members of the ruling elite, no extended family connections. In spite of all the expense he is lavishing on his tomb, he has not attained the *ius imaginum,*

91 Tomb of Lusius Storax, Chieti, first century A.D. Photo: DAI neg. 62.1068.

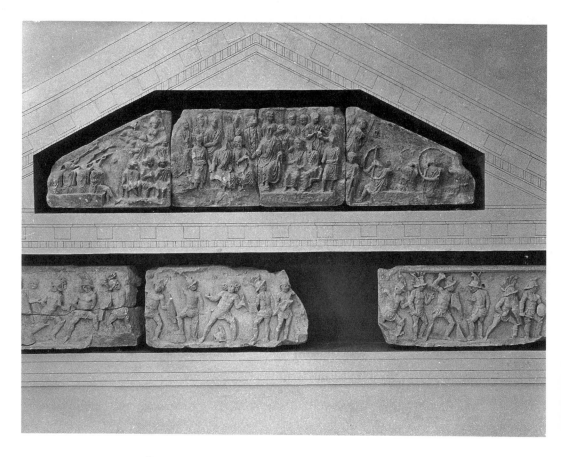

and none of his descendants would have the right to keep his portrait on display in their homes (Nista 1989: 33–9). Petronius thus stresses the upstart quality of the wealthy freedman.

Trimalchio next requests that ships be shown *plenis velis euntes*. If one has read the *Cena* to the end, one knows that Trimalchio made his vast fortune through shipping. One is encouraged to think that he is requesting a biographical detail here; in the next clause, he does commission a scene of his life, his tenure in the office of *sevir*. But we do not know the details of his biography yet. Thus, we are forced to read the ship motif as a standard one. Its relevance to his life then comes as a surprise later (*Sat.* 76); and it comes as a further surprise when we learn that the ship with which Trimalchio made his first millions was carrying several commodities that he commissioned as motifs for his tomb: wine, perfume, and slaves.

Ships are a very common funerary figure, regardless of which way they are heading. *Venientes,* they convey a soterial image: death as a return to a safe port, to a place of eternal rest.[25] They are thus analogous to the literary theme of the course of life as that of a sailing vessel.[26] The tomb of Vestorius carries this motif as well[27]: On the South wall, a scene of pygmies sailing through the Bay of Naples is painted below one of a *sigma* banquet (Fig. 90). Ships setting out, on the other hand, are one of several funerary symbols that treat death as a departure. A sarcophagus in the Praetextatus Museum (Fig. 92) showing departing ships laden with amphorae, flanking a lighthouse, bears the latter meaning, as might the ships on the funerary monument of the freedwoman Naevoleia Tyche and her husband C. Munatius Faustus in Pompeii.[28] It is not surprising that the ship motif was especially popular in the cemeteries of port cities. Thus, one of the most important details of Trimalchio's life translates into visual form as a funerary cliché, and one particularly popular in the coastal area around

92 Sarcophagus depicting ships flanking a lighthouse. Rome, Praetextatus Catacomb, fourth century A.D. Photo: DAI neg. 68.1007.

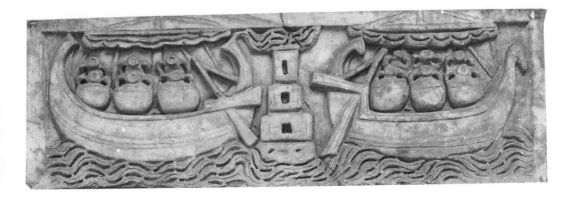

Naples, which is the setting of the *Cena*. Furthermore, we read the motif as a standard cliché at first because his biography is still not revealed to us.

Trimalchio then asks his sculptor to depict him in his role as *sevir Augustalis,* seated on a throne, distributing money out of a bag, and wearing symbols of his office, five gold rings and a toga praetexta. Once out of office, Trimalchio was no longer entitled to these trappings because they were the marks of a higher social rank. He thus wishes to perpetuate this status, which in his life was temporary. Petronius cynically refers here to the eternalizing power of art; this reflects, of course, upon the author himself as well. Expressed by a man who is thought to be the *arbiter elegantiae* of Nero's court,[29] his view of art and the purposes to which it might be put must be self-reflective.

Trimalchio wishes to inflate his image for posterity. Even in his role as *sevir,* he probably did not distribute money freely; he fulfilled his duty instead, as he says, by giving a banquet. The distribution of money (although Trimalchio does not request to be shown distributing money, but merely pouring it out of a bag in public) and the inordinate exaltation of the deceased here would call to mind Imperial audience scenes, such as that on the Anaglypha Traiani.[30] To usurp for oneself the iconography of the emperor is great *hybris,* but *hybris* is standard practice for Trimalchio: One thinks of the painted scenes in his vestibule, in which he is deified by Mercury.

Parallels to this overexpression occur, however, in several monuments contemporary with that of Trimalchio. The tendency to inflate and perpetuate one's role is visible on the monument of Vestorius Priscus, where, although only an aedile, the deceased is shown as a judge dispensing justice (Fig. 88).[31] He is elevated on a high podium and seated frontally toward the viewer in a composition drawn from Imperial iconography.[32] Similarly, in the tomb of Lusius Storax in Chieti, the deceased is shown seated, again frontally, surrounded by his retinue, and presiding over the gladiatorial games that he funded (Fig. 91). This parallel is especially striking, because the bands of gladiatorial combats on Storax's tomb were placed beneath a gable field in which was carved the relief of the deceased and his magisterial retinue; as Trimalchio requested for his *statua,* the games were set at the *sevir's* feet. Another striking parallel is a second-century funerary relief from a tomb in Brescia that depicts an Asiatic freedman, M. Valerius Anteros Asiaticus, *sevir,* entering the forum with two lictors and then seated on a podium with a bag of money in his hand (Fig. 93).[33] These three examples offer both geographical and social-class par-

allels: Two of them come from the area of Naples and two were commissioned by freedmen who were *seviri*.

Trimalchio then requests that the public banquet he gave as part of his duties as *sevir* be shown as well. Another banquet; this gives us three referential layers to distinguish: the narrative context (the *Cena*), the biographical datum (the *sevir* banquet), and the funerary symbol. Thus, in execution, this scene would look just like the standard banquet scenes of very ancient lineage that appear so frequently on funerary monuments.[34] This motif, too, occurs in Vestorius's tomb, where it hosts a modest nine persons (Fig. 90). Trimalchio thus continues to confound his biographical message in standard funerary scenes.

Yet, in his language here, beginning with the ship scene commission, our freedman expresses a nervous concern. Petronius seems to mock the pompous posturing of a tasteless patron toward his "artiste." Numerous direct addresses to Habinnas occur: *"Te rogo . . . scis enim . . . si tibi videtur . . . facias. . . . "* Here where his chosen images are intended to reflect most directly his life's accomplishments, he appears most concerned that they be understood. When he seems, however, to appeal to the discretion of his sculptor (*"si tibi videtur"*), when he seems concerned that the scene be within his sculptor's range of expression, the motif he requests is particularly standardized and common. Here again, Petronius may be self-reflective; he calls our attention to the way in which any narrative, literary or artistic, is delineated and read: that is, through a series of commonplaces juxtaposed. Petronius again identifies his own role with that of Habinnas, acknowledging that they both draw from their stores of stock scenes or characters as they generate a narrative. Thus, we find in this *ekphrasis* an incisive comment on the defining of taste.

93 Monument of Aneros Asiaticus, second century A.D. Brescia, Civici Musei.

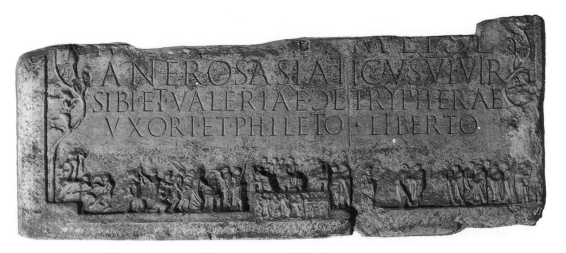

The decorative scheme that follows makes explicit the mixing together of *sevir* banquet and funeral banquet themes, and draws the reader back into the context of this anecdote, the *Cena* itself. Fortunata, Trimalchio's wife, is to be depicted on his right, holding a dove and leading a small dog on a leash. As noted before, the dog is at home here if we read this as still part of the banquet scene. With the same banqueting pose retained, the convention of depicting the deceased holding a small bird is a common one on *kline* monuments; although this detail is one usually reserved for children,[35] a *kline* relief in Geneva from the late first century A.D. depicts a woman reclining with both a dog and a bird (Wrede 1977: 429, fig. 115).

The text here, however, reads *ducat,* suggesting that Fortunata is *leading* a small dog. Such a description might indicate simply that she is to be shown holding the dog on a lead, or, more explicitly, that she is to be depicted as entering, and thus standing. The second-century sarcophagus of T. Aelius Evangelus, a wool dealer (Fig. 94), provides parallels for a number of motifs here.[36] Though later, it draws on very old images in the same way that Trimalchio's does. On the façade, which is all that remains of the chest, the freedman Evangelus reclines, holding a bunch of grapes in his outstretched right hand toward a cock perched on his toe. His wife, Gaudenia Nicene, stands at the foot of his couch with a small goat, instead of a dog, at her feet; she extends a drinking cup to her husband in her right hand and holds a garland in her left. This central grouping of husband and wife is then flanked by two scenes on either side that depict the occupation of the deceased. As on Trimalchio's tomb, emblems and vignettes of a biographical nature are juxtaposed to funerary tropes, some of which the two monuments share: funeral banquet couch, wine, garlands, bird (cock), dog (goat), reclining husband, and standing wife. It increasingly appears that the majority of monuments that can be adduced as parallels for Trimalchio's, especially those that share with it a number of motifs, are commissions of freedmen.

94 Relief of T. Aelius Evangelus, ca. A.D. 180. Malibu, J. Paul Getty Museum. Courtesy: Getty Museum.

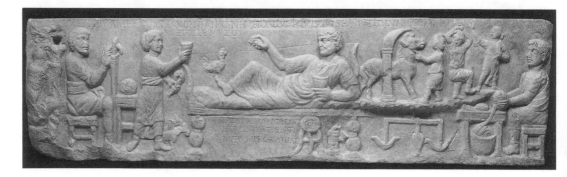

Trimalchio next requests *cicaronem meum, et amphoras copiosas gypsatas, ne effluant vinum.* A small boy and gypsum-sealed amphorae can easily be viewed as part of the funeral banquet as well, and we have already seen their use in Trimalchio's life, earlier in the *Cena.*[37] The chronological range of these as standard motifs extends from their use in Etruscan tomb paintings from the sixth century B.C.; in these versions, such as, for example, the Golini II Tomb at Orvieto, a slave stands beside the amphorae preparing to decant them for the banquet (del Chiaro 1971: fig. 3; Steingräber 1984, cat. no. 33). Trimalchio's request here denotes no relationship between the two motifs, however, and it is thus that they occur in Vestorius's tomb (Figs. 89 and 90). On the West wall, a slave boy stands beside his master at the entrance to a house; an amphora stands upright on a table depicted on the East wall. It is also significant that Trimalchio requests the amphorae to be depicted sealed. We return to his "wine is life" metaphor, which he carries further in his next request. Here the sealed amphorae remind us of his reluctance to give up life, even after death. Drawing on the same symbolism, Vestorius's tomb painting shows the amphora amid other symbols of paradise: a garden, and a peacock pecking at pomegranates.

The boy-with-amphora motif is then extended: Trimalchio commissions the image of a broken urn with a boy weeping over it. This theme does not seem to find a direct parallel in funerary art,[38] but is probably related to a number of literary motifs. As the broken urn symbolizes the human body out of which life has flowed, it is no doubt connected with the tradition of the Adonis garden for which there is a great body of literary evidence.[39] This tradition involved planting in the shell of a broken pottery vessel a fast-growing plant that would live only a short season. The shared metaphor is evident: The pot is the human body that in the latter motif is reinvested with life. On his tomb, then, Trimalchio's metaphor "wine is life" is given explicit visual form. The weeping boy adds a strong touch of pathos to the motif. Mommsen, relating this detail to funerary inscriptions, states that all inscriptional formulas in which a tone of pathos rings are plebeian commissions.[40]

This motif, of course, like all those on Trimalchio's monument can be read on another level: Transferring it from the funereal to the comic realm of the *Cena,* we see the boy weeping because he clumsily broke the urn and will be punished. It is in the multiple layers of an image's meaning that the humor lies.

The last sculptural decoration that Trimalchio requests is a clock, to be set in the center of the monument, so that whenever a passerby should want to read the time, he would be obliged to

read Trimalchio's name as well. A parallel for this kind of trick
occurs at the very end of this passage and will be treated later.
The motif itself, the sundial, is a common element of certain sar-
cophagus themes. It is found, for example, in the background of
a common sarcophagus lid motif, the funeral wagon scene (Fig.
95), which depicts the deceased riding with a companion in an
open coach.[41] There it seems to signal that the deceased's "time
has come." In such scenes, the *horologium* is often placed on a mile
marker, symbolizing the point at which the carriage passes beyond
life and time. Antecedents for the funeral wagon theme appear on
Etruscan ash urns,[42] and the sundial is found in these versions as
well. One also finds this detail in compositions of the Seven Sages;
the sarcophagus of Pullus Peregrinus provides a later example.[43]
We are also reminded of our first word-of-mouth introduction to
Trimalchio and his obsession with the passage of time (*Sat.* 26).
With this sundial trick, he again attempts to control from the dead
the elemental qualities of life, in this case, time.

For all his obsession with time and with the accomplishments
of his life, however, our freedman does not fuse the two to create

95 Funeral wagon scene,
fourth century A.D. Photo:
DAI neg. 78.1927.

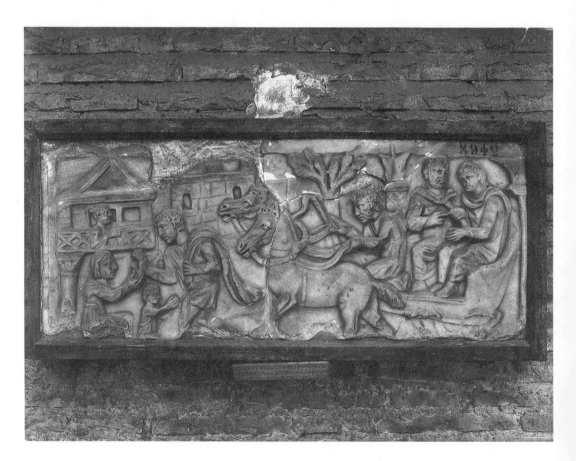

a chronological biography in his monument. With the request of
the sundial, Trimalchio returns to the exterior-built elements of
the monument. It becomes apparent now that Petronius has struc-
tured this episode, the commissioning of the tomb, in a mirror
(or, perhaps more properly, a two-ply) composition.[44] The episode
opens with his request for a portrait; this is matched at midpoint
by a return to his own image among biographical details: the ships,
the sevirate, and the banquet. The joys of his life – his dog,
wreaths, and unguents – and then his gladiator are matched later
(in reverse order) by the image of his wife and then by more joys
of his life, his boy, and wine jars. His demands for the size of the
structure, followed by the platitude that the tomb is a house, are
mirrored by the pathetic image of the broken urn evoking the
platitude that wine is life, and the request for the sundial structure.
Each half is then concluded by an inscription. Thus, the course
of his life has been turned back upon itself; it has been translated
into a series of emblems and recomposed in an achronological
pattern. Time is emblematized.

The finishing touch on the tomb, then, is the second inscrip-
tion, which provides another pithy summation of his life.[45] The
information provided is as emblematic in its literary way as were
the sculptural references to his life above. The inscription draws
similarly on standard funerary formulas. In fact, it reflects some of
the tropes of the sculptural medium and thus illuminates the na-
ture of the satire; we see more clearly how Petronius uses stere-
otypes for comic effect. His chosen epitaph is packed with joking
references and *double entendres*. As we have seen before whenever
he was requesting the most banal of motifs, Trimalchio here again
shows nervous concern about the appropriateness of his request:
"Inscriptio quoque vide diligenter si haec satis idonea tibi videtur."

He first gives all his names in a standard formula. Although he
does not state that he is a freedman – and the use of the abbre-
viation L in the freedman name was generally out of fashion at
this date[46] – his cognomina retain the history of his servitude. The
Ciceronian rhythm and measure of his name, then, have an iron-
ically disennobling effect. His name also juxtaposes the *nomina* of
two famous Roman personages, Pompey and Maecenas; the in-
congruity of the two together would have caused some
merriment.

Trimalchio boasts that he was decreed a *sevir* in his absence;
one might conclude that few people wanted the honor. In fact,
the office of *sevir* required the holder to expend great amounts
from his personal fortune for the benefit of the community. In-
scriptional evidence shows that the sevirate was almost exclusively
held by wealthy freedmen (Taylor 1914: 231). The expression

absenti decretus est would have reminded the reader of other instances in which offices were conferred in the absence of the conferee, notably, of Marius's election to the consulship (Mommsen 1878: 119), or, closer to hand, the consulships of Nero (Rose 1971: 78). Yet there is a world of difference in prestige and power between Marius's and Nero's consulships and Trimalchio's sevirate.

D'Arms (1981: 110) suggests that this phrase would also have called to mind Cicero's defense of the eques M. Caelius Rufus, who during his absence was elected by his townsmen to his local Senate, the *decuriones,* an office he had not sought (*Pro Caelio* II.5). That Caelius may be Trimalchio's role model here is reinforced by his *recusatio,* later in the inscription, of a position on the decuries in Rome, an honor that it is not certain he was explicitly offered. With his refusal, Trimalchio has also rejected the idea of living in the capital, which participation in the decuries would have required; he displays a provincial's disdain for the big city as well as a desire to imitate and outdo his betters. His posturing here accentuates both his provincialism and his low birth; the offices to which Caelius was elected were not open to Trimalchio, and the status of men from whom a formal *recusatio* would have been expected if they were not seeking office is still far above that of a freedman.

The expression *decretus est* also calls to mind formulas, which are common on the tombs of freedmen, that state that the tomb or land on which it rests was granted to the deceased by the decuries. Various versions occur, many including the abbreviation DD, for *decurionum decreto;* Vestorius Priscus's tomb carries this, as does the tomb of Umbricius Scaurus (Spano 1943: 242), who, though not a freedman, exhibits very similar taste in funerary motifs.

A list of Trimalchio's qualities follows in rhythmic crescendo, a dignity unsuited to the message. The qualities, furthermore, are drawn from names of Roman regiments,[47] and are in hilarious contrast to Trimalchio's unmilitary character. The list builds toward a *double entendre: ex parvo crevit.* The intended sense is, of course, that his fortune grew from very little, but the shorthand manner of expression leaves Trimalchio as subject. Here again the inscriptional joke parallels the sculptural. Again Trimalchio communicates an accomplishment of his life in such standard terms that he appears just like everyone else: Everyone grows up from very small.

Nec umquam philosophum audivit satirizes the arriviste's uneducated, provincial narrowness of mind. It also suggests that the *Cena* is in part a parody of Plato's *Symposium.* On the other hand,

this may be another reference to Nero, who, Suetonius tells us, was dissuaded by his mother from studying philosophy (*Nero* LII.1).

The final goodbyes expressed in the epitaph – *"Vale." "Et tu."* – like the sundial gimmick discussed before, would have succeeded because the ancient Romans never read silently. One sees commonly on Roman funerary inscriptions a final *vale,* to be uttered by the passerby (*CIL* V.4887 and 7838; Mommsen 1878: 121). Trimalchio, always wishing to have the last word, adds a response that the visitor to his tomb would also have voiced: a *reductio ad absurdum* of a standard formula.

In a sense, then, the epitaph carries in its kernel satirical tropes similar to those used in the sculptural decoration. The epitaph, the tomb, and Trimalchio himself are all formulas constructed of formulas; and each of the three in this list serves as a building block for the one that follows it. Petronius has constructed a stereotype of a freedman's artistic taste: It remains still to identify the components of that taste.

To ascertain "the typicality of Trimalchio," D'Arms (1981: 97–120) studies the inscription that the *libertus* commissions for his monument and determines that he is striving to convey the impression of belonging to the equestrian class. If one assumes that Trimalchio's class aspirations are so specifically aimed, does it follow that the sculptural decoration is chosen to the same effect and that all these formulas are therefore to be associated with the *equites?* While the decorative program of Trimalchio's tomb resembles that of the painted tomb of the aedile C. Vestorius Priscus in Pompeii,[48] it is also quite similar to the relief carving on the monuments of the *sevir* C. Lusius Storax in Chieti and of the *sevir* M. Valerius Anteros Asiaticus of Brescia, among others. Because the *seviri* were almost always freedmen, these motifs were clearly not reserved for the knights alone. The sheer frequency of these themes would argue against any exclusivity. The fact that the origins of many of them can be traced back to the Etruscans or even earlier further suggests that they are commonplaces, not reflective of any particular social class. In striking number, these ancient motifs are carried over into sarcophagus decoration as well; this is both a proof of the strength of tradition in funerary art and an indication as well that Petronius may not be satirizing the motifs themselves here, but rather the manner in which they are used. It is this manner of use, then, that defines taste.

It is specifically the freedman taste that Petronius is satirizing, and it is noteworthy that the archaeological record confirms his insights. One component of that taste, as Petronius presents it, is the freedman's tendency to excess, garishness, overstatement. In

fact, of the tombs catalogued by Calza in Ostia and Portus, the
most expensive and extensive – if one discounts those of the ruling
class – were those of the *seviri Augustales* (D'Ambra 1988: 86, n.
12). This social group was clearly identified in antiquity by its
public display of newly acquired wealth. Furthermore, the ten-
dency to overstate personal accomplishments and virtues (often
the mark of self-made men) resulted in the second century A.D.
in several forms of portraiture, exclusive commissions of freedmen
(Kleiner 1978; Wrede 1971), that depict the individual as a deity.
One is again reminded of Trimalchio's avant garde vestibule paint-
ings, in which his self-deification is more explicit as well as earlier
in date than the second-century statuary forms.

Petronius depicts Trimalchio as rather naïve and overly literal
in his understanding of ancient funerary symbolism, for example,
in the metaphor of tomb as house. It is difficult to determine
whether this is a characteristic of freedmen or merely the mark of
any Roman of bad taste, because it is impossible to know exactly
how any patron understood the motifs he commissioned. One can
see, however, tomb forms and accoutrements similar to Trimal-
chio's actually built by members of his social class. Likewise the
elements of his inscriptions find actual parallels.[49] Recent studies
of sculptural ensembles from tombs have suggested that freedmen
tended to choose even mythological scenes on the basis of rather
concrete and prosaic elements and that they cared less for their
symbolic or religious significance.[50]

Inasmuch a psychological as an artistic characterization, Petro-
nius depicts Trimalchio's tendency to skip illogically from one
motif to another; the resulting monument would display an irra-
tional juxtaposition of scenes. Nevertheless, one finds a similar,
though less eccentric, juxtaposition of motifs on several tombs in
the area of Trimalchio's Cumae: those of Vestorius and of A.
Umbricius Scaurus (Mazois 1824–38: 49, pl. XXXII; Kelsey and
Mau 1899: 418; Spano 1943) in Pompeii, and of Storax in Chieti,
among others. It seems that the odd mélange of funerary deco-
ration, perhaps perceived by the Romans as garish, may be a pro-
vincial quality. In fact, Trimalchio's monument appears to make
a direct reference to the tomb of Eurysaces in Rome, the deco-
ration of which depends on a single theme, the baking of bread,
and to claim its own superiority.

Regrettably lacking from the written narrative is a sense of how
Petronius envisioned these motifs depicted, specifically their style
of carving, the proportions of the figures, and the treatment of
spatial illusion. Thus, it is especially illuminating to trace the actual
appearance of these motifs in Roman art. The very antiquity of
many of them, the fact that their use antedates the period of the

Late Republic, when Hellenistic Greek motifs were adopted to express an emerging Imperial ideal, renders the term "court" irrelevant, at least with respect to the origin of the composition. The stylistic interpretation of these compositions, however, was the choice of the artisans trained in the traditions of a given workshop. When one looks at the examples adduced here, one is struck by their range of style and quality. Plebeian blends into court style so that one cannot draw a clean line between them. The seated magistrate composition on private monuments flattens an Imperial theme into a frontal and hierarchical emblem (Fig. 88). The gladiator scenes likewise simplify the spatial depth and shorten the figures, yet display musculature and details rendered with subtle sculptural technique (Fig. 91). The most evident anti-Classicism is reserved for those motifs, such as the ships and the funeral banquet (Figs. 90 and 92) that are furthest from Imperial themes. It appears that the choice of style is to a large extent bound to the genre of the monument for which it was intended and, thus, to the workshops that specialized in that genre. Yet the blending of court and plebeian characteristics on a single monument suggests that style is also the result of conscious aesthetic preferences; it is not determined merely by the quality of the carving or by how much the patron was willing to pay. It is part of the monument's message.

The most striking element of Trimalchio's taste, as Petronius depicts it, is his desire to communicate details and facts of his life. That the preference for biography was a trait of freedmen can be seen in all the genres of funerary art that the freedmen commonly commissioned, such as funerary altars with portraits (Kleiner 1987), sarcophagi (Zimmer 1982: 60; Whitehead 1984: 398), tomb *lastrae* and *loculus* plaques (Kampen 1981a: 135–6; Zimmer 1982a; D'Ambra 1988: 311). One sees this tendency also in the funerary ensembles adduced here as parallels for Trimalchio's tomb; these examples occur not only around the Naples area, but also in Rome, Brescia, and elsewhere.

In their desire for personalized decoration, freedmen sought out workshops that would oblige: workshops that could adapt, or renounce altogether, the traditional mythological and allegorizing motifs favored by the ruling classes. In creating new themes that expressed the more prosaic, but real, accomplishments of their patrons, these workshops formed new *topoi*, new standard compositions. As the call for such scenes increased in the second and third centuries A.D., the compositions became increasingly standardized; at this time, scenes of baking, milling, money changing, commercial transactions, and artisanal activities (in which only the tools and finished products differ from one to another) crystalized

into reproducible forms. Where possible, *topoi* of the court style were given more concrete meaning to fit the needs of the commission. The *mousikos aner,* or philosopher motif, was reused for the teacher or doctor; allegorical figures representative of the deceased's occupation came to serve as attendants in *dextrarum iunctio* and funeral banquet scenes. By the third century, artisans and bakers could buy ready-made sarcophagi, complete with scenes depicting various aspects of their occupations; all that was required to personalize the commission was to sit for the portrait, which was carved from a "blank" left in the proper place. This practice had already been in force for themes derived from Imperial iconography such as the battle, the clement or pious general, the hunt, and the *dextrarum iunctio.*

Petronius seems to hint with some cynicism here that any life, no matter how unusual, can be reduced to a series of standardized vignettes. This had long been the practice, in fact, in the literary genres. The upper-class genre of literary biography had always been quite formulaic in the nature of the information communicated.[51] In the more public forms of commemoration of the individual, such as the *res gestae* and the funeral eulogy, *laudatio funebris,* the same was true. The earliest literary biographies are presented in a chronological manner; by the second century A.D., they become typological, that is, they display a greater interest in virtues and character traits than in the *cursus honorum* of a life. This literary change is contemporary with the appearance and popularity of "career" sarcophagi, whose façades were decorated with four scenes from the life of a general, each scene symbolic of one of the Roman cardinal virtues.[52] The antichronological character of Trimalchio's monument, the tendency to turn life's events into emblems, appears precocious, but Petronius seems to identify an emerging trend in both literary and artistic taste.

The parallels between the literary and artistic biographies bring us once again to the identification of Petronius the author with Habinnas the sculptor. The author creates a comical stereotype of a nouveau-riche freedman in the same way that the fictitious sculptor is to create the stereotype of the freedman's monument: through a series of commonplaces or formulas. Read this way, the Cena becomes a satire against the limitations of art. It satirizes as well the limitations of the reader's understanding. Petronius draws on the fact that one best reads ancient narrative, whether literary or artistic, whether relating the exploits of a freedman or an emperor, through icons or standardized tropes; similarly, one best perceives social differences through stereotypes. Thus, even in depicting his anomalous character, Petronius is dependent on commonplaces.[53] For the modern reader, who rankles at being

pigeon-holed and categorized, this passage presents a useful exercise. Trimalchio makes us acutely aware of the tremendous gulf between event and narrative, and suspicious of the truth of both.

NOTES

1. Toward the beginning of the banquet, a silver skeleton with moveable limbs is brought in, and inspires Trimalchio to poetical reflections on the nature of human life. Dunbabin (1986: 195) cites much evidence from art and domestic contexts to suggest that this was, in fact, a common practice at banquets "in certain circles." She finds that the popularity of the death theme at dinner parties was at its peak in the first century A.D. but faded out toward the end of that century.

2. The tomb-as-house idea, implicit in the comparison of these two passages, is an underlying theme of the *Cena*. It relates to the idea that life after death can be attained through art, an idea that Trimalchio interprets rather too literally throughout. The pairing of these two passages is, furthermore, a clue to the structure of the *Satyricon* as a whole. Hubbard (1986) detects a rigid ring composition to the narrative; he confronts the mural *ekphrasis* of the young Trimalchio in his home with the sculptural *ekphrasis* of the mature Trimalchio in his tomb, each artistic evocation followed by inscriptions.

3. Bianchi Bandinelli (1963–4: introduction) states his belief that certain provincial monuments from the area of Naples retain a pre-Hellenistic style that can also be tied to the anti-Hellenistic element, that is, the "plebeian" element, in the capital. See also Bianchi Bandinelli (1967).

4. These theories of Roman art, which serve as antecedents to that of Bianchi Bandinelli, are discussed in Brendel (1953).

5. This "plebeian" style is quite varied and is, in fact, as multifaceted as the social stratum from which Bianchi Bandinelli has drawn its name. It is unified only in its avoidance of Hellenistic-inspired canons and techniques. In general, the proportions of the figures in plebeian-style reliefs are squat and childlike. The relief is shallow with little modeling, the details conveyed by simple lines. A kind of didacticism, a drive for legibility and clarity of detail, pervades the composition. Spatial relationships are simplified; the overlapping of forms and perspectival recession into depth tend to be avoided. Horizontal planes are frequently tipped up to the vertical. Scale is manipulated subjectively. One perceives an overall tendency to emblematize, to present information in the form of flattened symbols.

6. Some corpora of individual plebeian genres have been published, notably Kleiner's treatment of funerary monuments of freedmen in Rome (1977, 1987), and the same author's analysis of second-century mythological portrait groups (1978); and Wrede's compilation of *kline* monuments (1977). Increasingly, study has been initiated on plebeian motifs and their possible prototypes. Kampen has discussed two, the return of the sailor and the serving girls at the funerary banquet, in connection with a third-century sarcophagus from Ostia (1977–8). Genre scenes on the pre-Antonine *kline* monument from the Via Portuense have been traced by Kampen (1981a); and by Berczelly (1978). Discussing only sarcophagus decoration, Himmelmann (1973) has traced several compositions that are frequently or exclusively presented in the plebeian style: the *Wagenfahrt* motif, the *kline* and *sigma* banquets, and

the procession of togate figures. The *Wagenfahrt* on sarcophagus lids and *lastrae* has been further discussed in a monograph by Weber (1978); and the theme of circus games, by Gabelmann (1980). Wernicke treated the episodes in the life of a child as juxtaposed on sarcophagi; and the monument of the baker Eurysaces has been analyzed in a monograph by Ciancio Rossetto (1973). Scenes of Roman craftsmen and laborers have been collected by Zimmer (1982) (n. 6), and Zimmer (1985), and by Kampen (1981b).

7. These have been regarded by some scholars as simply the result of lower artistic quality obtained from cheaper workshops: Zimmer (1982: 90).

8. Such as one finds on the Anaglypha Traiani; for an illustration, see Torelli (1982: pl. IV.7).

9. This is paralleled by the passage in which he reduces his guests to the position of slaves by concealing from them any route of exit (*Sat.* 72): Hubbard. The social-class reversals may be a satirical reference to the emperor Nero, who brought many freedmen into positions of power. Trimalchio may be using the emperor as his role model, particularly in the excesses of his life style: Rose (1971: 78). If so, the knowledge that Petronius filters references to the emperor through the artistic expression of the freedman class adds a new dimension to the satire.

10. Lists of bequests to slaves were also marks of status; I thank Judith Ginsberg for this observation.

11. The monument of the baker Eurysaces has been analyzed in a monograph by Ciancio Rossetto (1973); illustrates the high-relief portraits of the baker and his wife Atistia.

12. The largest example at Pompeii is the tomb of the Istacidii: Toynbee (1971: 126) and Kockel (1983: 60–7, fig. 3ff., pls. 1a; 9a; 10c–e; 11–14).

13. Both Wrede (1971: 154) and Kleiner (1978) have isolated portrait types based on statuary prototypes of deities; these are commissioned only by freedmen.

14. Wrede (1971: 138); for a bibliography of the statue and its illustrations, see his n. 58, p. 138.

15. The presence of the dog dates from the use of the funeral-banquet motif in Sumerian art, where, Marvin Pope has conjectured in a conversation with me, it may have originally been a reference to ritual incest. In Greek art and in art thereafter, a different interpretation has been offered by Dentzer, "Le motif du banquet couché dans le Proche-Orient et le monde Grec du VIIe au IVe siècle avant J.-C.," Dentzer (1982): 442; there it is a "chien de table," a household pet and an element of aristocratic life. He cites Theognis of Megara (II.1249, 1253–4) who quotes Solon.

16. Kleiner (1987: cat. no. 11) dates it to A.D. 54–5. She interprets it as meaning that one of the deceased's duties was to care for the family's pet dog; this interpretation is a likely one as well.

17. Copenhagen, Ny Carlsberg Glyptotek 777; Wrede (1977: 423, fig. 108); Koch and Sichtermann (1982: pl. 65). All date it to the Trajanic period.

18. I owe this suggestion to John Van Sickle.

19. This detail occurs very early, dating at least from the Etruscan treatment of the funeral-banquet motif.

20. Only one of innumerable examples is the Tomb of the Garlands in Pompeii: Kockel (1983: pl. 41); DAI Neg. 77.2120.

21. Dentzer (1962: 555, n. 5). Another example from outside the Stabian Gate at Pompeii is a triple-banded relief depicting gladiatorial events. It probably

came from a large tomb. Ward-Perkins and Claridge, *Pompeii, A.D. 79* (Boston, Museum of Fine Arts: 1978) 90; Bianchi Bandinelli (1963–4: pl. XL, figs. 97–105).

22. See Bianchi Bandinelli (1963–4: 61ff.) for illustrations and further bibliography. Also Bianchi Bandinelli (1970: 60–1, pls. 62–4); Ryberg (1955: pls. 31–2, figs. 47–8b); Ghislanzoni (1908: 541–614, pl. III); and Felletti-Maj (1977: figs. 189a–90d).

23. Another striking example is the exterior stucco relief, arranged in bands depicting gladiatorial combats and hunts, or *venationes,* on the tomb of Umbricius Scaurus in the necropolis by the Herculanean gate at Pompeii; Bianchi Bandinelli (1963–4: figs. 106–9). Although a geographical parallel to Trimalchio's tomb, the monument is not that of a freedman. On the other hand, the second-century monument of the *sevir* Anteros Asiaticus in Brescia (see p. 311), which is often adduced as an illustration of Trimalchio's tomb, is thought by Hübner (1878: 421–2) to display the gladiator theme as well. The scene in question, however, looks more like one of Dionysiac dancing to me.

24. These are H.M.H.N.S. Mommsen (1878: 116 and n. 1) discusses the reading of this phrase and its parallels.

25. The most explicit rendering of the symbolism can be found in the mosaic pavement scene from Tomb 43 at Isola Sacra; this pavement depicts two ships flanking the lighthouse, accompanied by the Greek inscription ΩΔΕ-ΠΑΥΣΙΛΥΠΟΣ ("Here is the end of our toil"). Calza (1940: 169, fig. 83).

26. Seneca, *Ep.* VIII, 70.2: *praenagavimus, Lucili, vitam.* Cicero, *Cato* XIX.71, *"maturitas mihi tam iucunda est, ut quo propius ad mortem accedam, quasi terram videre videar aliquandoque in portum ex longa navigatione esse venturus."*

27. Dentzer (1962: 549) gives other uses of the theme also. Zimmer (1982: 208–11, nos. 156–62) illustrates several other examples probably relating, as here, to the occupation of the deceased as well as to a general funerary image.

28. Zimmer (1982: no. 157) reads this scene as one of return; the sailors, however, can be read as unfurling the sail equally well as the opposite.

29. The arguments are weighed by Mommsen (1878: 106–7, n. 2). The most conclusive evidence that the author and the *arbiter* are the same Petronius has been compiled by Rose (1971).

30. See Torelli (1982); also H. Rudiger, "Die Anaglypha Hadriani," *Antike Plastik* 12 (1973: 161–72).

31. Dentzer (1962: 576); for other parallels, ibid., 578ff.

32. Spano (1943) draws parallels for Vestorius's composition from the Augustan period Boscoreale treasure to scenes of Christ in judgment.

33. Hübner (1878: 414–22) finds several other parallels for Trimalchio's monument in this: gladiators, emblematic scenes of the deceased's source of wealth, including shipping, and a statue of Mercury. I am not entirely convinced by his identifications, however.

34. Bianchi Bandinelli (1963–4) illustrates several parallels for communal banquets on funerary monuments: from Amiternum, Este, Ancona, and Carthage (pls. XIII–XVIII, figs. 31–45).

35. See Wrede (1977: 417) for an example from Ariccia.

36. Malibu, J. Paul Getty Museum, inv. no. 86.AA.701. Whitehead (1984: 51–2, no. 3); Koch (1988: 24–7, no. 9).

37. *Sat.* 34, when Trimalchio produces a bottle of wine sealed with gypsum

100 years before. Gypsum sealing was apparently an attempt to arrest the further aging of a fine vintage.

38. An open amphora, turned on its side, appears on a funerary altar, now lost, from Ligorio on the Via Appia. It dates between the midfirst to the late second century A.D.; its inscription in Greek and Latin commemorates the freedman L. Aurelius Sabinus Doliarius, who Zimmer believes may have been a potter: Zimmer (1982: 201, no. 146). If Zimmer is right, the overlapping of biographical and funerary imagery on the altar is similar to that commissioned by Trimalchio.

39. Lehmann (1953: 125–8, for the bibliography).

40. Mommsen (1878: 118). "*Hic requiescit* ist, wie all Formeln, die ein Pathos in sich tragen, plebejisch."

41. Wilpert (1924–5; 1930: 26) distinguishes the Christian from pagan uses of the motif, and believes the sundial to signify that "the hour of excellence has come." Weber (1978) also recognizes two versions of the motif in Roman art and distinguishes them as "individualized" and "typical." The "typical" version she reads as a metaphor for the *cursus vitae:* It is thus analogous to the voyage motif, in her opinion. It appears to me, however, that the milestone depicted in these scenes is a clue that something has been passed, that is, the boundary between life and death; it does not merely refer to the course of life. The theme, then, becomes one of departure. See discussion of this motif in Whitehead (1984: 327).

42. Hausenstein (1922) illustrates examples from the Museo Guarnacci in Volterra. The Etruscan versions also fall into two compositional types, one more honorific or magisterial, the other funerary.

43. Rome, Torlonia Museum, Inv. no. 424; Rodenwaldt (1936: 82, pl. 5). The sundial is visible in the background just in front of the sage farthest to the right.

44. He has structured the *Cena* as a symmetrical whole: Hubbard (n. 2).

45. Roman inscriptional parallels for Trimalchio's epitaph are treated by Mommsen (1878: 116–21).

46. Kleiner (1987b: 85); Taylor (1961: 121–2; 1931: 219–21).

47. Mommsen (1878: 120). Claudius named two legions *piae fideles,* Trajan a third, *fortis.*

48. Dentzer (1962: 592), following Schultze (1904: no. 254), traces the name Vestorius to an ancient Campanian family and thus believes that the choice of painted motifs is from a repertoire long used in that family tradition.

49. Bianchi Bandinelli (1963–4: 19–20), in his discussion of this episode from the *Cena,* cites an inscription from Germania Superior (*CIL* XIII, 5708) as a parallel. The inscription makes specific stipulations for a tomb, among them, that all the deceased's hunting gear be cremated with him. One cannot be certain, however, whether the man who commissioned this inscription thought he would thus be able to use the gear in the afterlife or whether he merely wanted to prevent his descendants from using it.

50. D'Ambra (1988) concludes that a smith selected a Meleager scene for his sarcophagus because its composition stressed tools and weapons.

51. N. Kampen (1981a: 49) draws parallels between literary and sculptural biography in relation to an Antonine sarcophagus from the via Portuensis.

52. See ibid., 51, nn. 29–32 for a bibliography.

53. Far from commonplace, on the other hand, is the helpful criticism I have received on this chapter from colleagues, professors, and friends. I would like to thank Jerome Pollitt, who first suggested that this section of my

dissertation be published separately, and my other insightful readers, Diana E. E. Kleiner, John Clarke, and Sarah Morris. Colleagues whose suggestions along the way have stimulated important alterations include Fred Ahl, Jacqueline Clinton, Judith Ginsburg, Peter Holliday, David Mankin, Alan Nussbaum, and John van Sickle. Michael Hopcroft helped with computer graphics expertise. It would be uncharitable of me to blame them for any deficiencies or inaccuracies remaining here.

ABBREVIATIONS

AA = *Archäologischer Anzeiger*

AbhGött = *Abhandlungen der Akademie der Wissenschaften zu Göttingen*

AbhHeid = *Abhandlungen der Heidelberger Akademie der Wissenschaften*

AbhMainz = *Abhandlungen der Geistes- und Sozialwissenschaftliche Klasse, Akademie der Wissenschaften und der Literatur in Mainz*

ABV = J. D. Beazley. *Attic Black-Figure Vase-Painters*. Oxford: Oxford University Press, 1956

ActaArch = *Acta Archaeologica*

AF = *Archäologische Forschungen*

AJA = *American Journal of Archaeology*

AJAH = *American Journal of Ancient History*

AJP = *American Journal of Philology*

AnalRom = *Analecta romana Instituti Danici*

ANRW = H. Temporini, ed., *Aufstieg und Niedergang der römischen Welt*. Berlin: De Gruyter, 1972–

AntK = *Antike Kunst*

AntK-BA = *Antike Kunst. Beiheft*

AntW = *Antike Welt. Zeitschrift für Archäologie und Kulturgeschichte*

ArchCl = *Archeologia classica*

ArchEspArq = *Archivo español de arqueología*

ArtB = *The Art Bulletin*

ARV² = J. D. Beazley. *Attic Red-Figure Vase-Painters*, 2d ed. Oxford: Oxford University Press, 1963

AZ = *Archäologische Zeitung*

BABesch = *Bulletin antieke beschaving. Annual Papers on Classical Antiquity*

BCH = *Bulletin de correspondance hellénique*

BEFAR = *Bibliothèque des Écoles françaises d'Athènes*

BICS = *Bulletin of the Institute of Classical Studies of the University of London*

BMCRE I = *Coins of the Roman Empire in the British Museum* (London, 1923)

BMFA = *Bulletin of the Museum of Fine Arts, Boston*

BMMA = *Bulletin of the Metropolitan Museum of Art, New York*

BSA = *Annual of the British School at Athens*

BullComm = *Bullettino della Commissione archeologica comunale di Roma*

CAH = *Cambridge Ancient History*

CahByrsa = *Cahiers de Byrsa*

CIL = *Corpus inscriptionum latinarum*

CJ = *Classical Journal*

ClAnt = *Classical Antiquity*

ABBREVIATIONS

CNR = A. Banti, and L. Simonetti, 1972. *Corpus nummorum Romanorum*. Florence: A. Banti and L. Simonetti

CollLatomus = *Collection Latomus*

CP = *Classical Philology*

CQ = *Classical Quarterly*

CRAI = *Comptes rendues des séances de l'Académie des inscriptions et belles-lettres* (Paris)

CVA = *Corpus vasorum antiquorum*

DialArch = *Diologhi di archeologia*

EAA = *Enciclopedia dell'arte antica, classica e orientale*

Germanico, 1987 = *Germanico: la persona, la personalità, il personaggio*. Università degli studi di Macerata 39, Atti di Convegni 4. Rome: Giorgio Bretschneider

GettyMusJ = *The J. Paul Getty Museum Journal*

GRBS = *Greek, Roman and Byzantine Studies*

Helbig⁴ = W. Helbig: *Führer durch die öffentlichen Sammlungen klassicher Altertümer in Rom*, 4th ed. Tübingen: Ernst Wasmuth, 1963–72

HSCP = *Harvard Studies for Classical Philology*

IstMitt-BH = *Istanbuler Mitteilungen. Beiheft*

JARCE = *Journal of the American Research Center in Egypt*

JdI = *Jahrbuch des Deutschen Archäologischen Instituts*

JHS = *Journal of Hellenic Studies*

JNES = *Journal of Near Eastern Studies*

JRA = *The Journal of Roman Archaeology*

JRS = *Journal of Roman Studies*

JSAH = *Journal of the Society of Architectural Historians*

JWalt = *Journal of the Walters Art Gallery*

JWarb = *Journal of the Warburg and Courtauld Institutes*

Latmous = *Latomus. Revue d'études latines*

LIMC = *Lexicon Iconographicum Mythologiae Classicae*. Zurich and Munich: 1974–

MAAR = *Memoirs of the American Academy in Rome*

MdI = *Mitteilungen des Deutschen Archäologischen Instituts*

Meded = *Mededeelingen van het Nederlands Historisch Instituut te Rome*

MEFRA = *Mélanges d'archéologie et d'histoire de l'École française de Rome, Antiquité*

MemLinc = *Memorie. Atti della Accademia nazionale dei Lincei, Classe di scienze morali, storiche e filologiche*

MonAnt = *Monumenti antichi*

NewLitHist = *New Literary History*

NumAntCl = *Numismatica e antichità classiche. Quaderni ticinesi*

ÖJh = *Jahreshefte des Österreichischen Archäologischen Instituts in Wien*

OpRom = *Opuscula romana*

PAAR = *American Academy in Rome. Paper and Monographs*

Paralipomena = J. D. Beazley. *Paralipomena*. Oxford: Oxford University Press, 1971

PBSR = *Papers of the British School at Rome*

RA = *Revue archéologique*

REL = *Revue des études latines*

RendPontAcc = *Atti della Pontificia Accademia romana di archeologia. Rendiconti*

RHR = *Revue de l'histoire des religions*

RM = *Mitteilungen des Deutschen Archäologischen Instituts, Römische Abteilung*

RVAp = A. D. Trendall and A. Cambitoglou. *The Red-figured Vases of Apulia*. Oxford: Oxford University Press, 1978

328

SAK = *Studien zur altägyptischen Kultur*
StEtr = *Studi etruschi*
StMisc = *Studi miscellanei. Seminario di archeologia e storia dell'arte greca e romana dell'Università de Roma*
TAPA = *Transactions of the American Philological Association*
TAPS = *Transactions of the American Philological Society*
WS = *Weiner Studien*
ZÄS = *Zeitschrift für ägyptische Sprache und Altertumskunde*
ZPE = *Zeitschrift für Papyrologie und Epigraphik*

REFERENCES

Abrams, M. H. 1953. *The Mirror and the Lamp. Romantic Theory and the Critical Tradition.* New York: Oxford University Press.

Adams, B. 1974. *Ancient Hierakonpolis.* Warminster: Aris and Phillips.

1975. *Ancient Hierakonpolis Supplement.* Warminster: Aris and Phillips.

Agache, S. 1987. "L'actualité de la Villa Publica en 55–54 av. J.-C." In *L'urbs, espace urbain et histoire,* edited by C. Pietri, pp. 210–34. Rome: Ecole française de Rome.

Aldred, C. 1973. *Akhenaten and Nefertiti.* New York: Brooklyn Museum of Art and Viking.

Alföldi, A. 1956. "The main aspects of political propaganda on the coinage of the Roman republic." In *Essays in Roman Coinage Presented to Harold Mattingly,* edited by R. A. G. Carson and C. H. V. Sutherland, pp. 63–95. Oxford: Oxford University Press.

1957. *Die trojanischen Urahnen der Römer.* Basel: Friedrich Reinhardt.

1965. *Early Rome and the Latins.* Ann Arbor: University of Michigan Press.

1973. *Die zwei Lorbeerbaume des Augustus.* Bonn: R. Habelt.

1976. *Römische Frühgeschichte.* Heidelberg: C. Winter.

Allen, R. E. 1983. *The Attalid Kingdom. A Constitutional History.* Oxford: Oxford University Press.

Alpers, S. 1983. "Interpretation without representation or, the viewing of *Las Meninas.*" *Representations* 1: 31–42.

1988. *Rembrandt's Enterprise.* Chicago: University of Chicago Press.

Anderson, W. S. 1966. "Horace, *Carm.* 1.14: What kind of ship?" *CP* 61: 84–97.

André, J.-M. 1966. *L'otium dans le vie morale et intellectuelle romaine.* Recherches 30. Paris: Publications de la Faculté des lettres et sciences humaines de Paris.

Andreae, B. 1973. *The Art of Rome.* New York: Abrams.

1988. "Gartensaal aus der Villa der Livia bei Prima Porta." In *Kaiser Augustus und die verlorene Republic,* edited by M. Hofter, pp. 283–6. Berlin: Philipp von Zabern.

(ed.). 1990. *Phyromachosprobleme.* Mainz: Philipp von Zabern.

Arce, J. 1980. "La iconografia de 'Hispania' en epoca romana." *ArchEspArq* 53: 77–102.

Asselberghs, H. 1961. *Chaos en beheersing: Documenten uit aeneolithisch Egypte.* Documenta et monumenta orientis antiqui 8. Leiden: E. J. Brill.

The Assyrian Dictionary of the Oriental Institute of the University of Chicago, N. 1980. Edited by Erica Reiner and Robert D. Biggs, Vol. II, pt. 2. Chicago: Oriental Institute.

Atherton, C. 1989. "Hand over fist: The failure of stoic rhetoric." *CQ* 38: 392–427.

Bahnemann, R. 1983. "Germanicus?" *Hefte des archäologischen Seminars der Universität Bern* 9: 15–20.

Baines, J. 1989. "Communication and display: The integration of early Egyptian art and writing." *Antiquity* 63: 471–82.

Bakhtin, M. M. 1981. *The Dialogic Imagination,* edited by and translated by C. Emerson and M. Holquist. Austin: University of Texas Press.

Bal, M. 1983. "The narrating and the focalizing: A theory of agents in narrative." *Style* 17: 234–69.

1985. *Narratology: Introduction to the Theory of Narrative,* translated by C. van Boheemen. Toronto: University of Toronto Press.

1988. *Dissymmetry: The Politics of Coherence in the Book of Judges.* Chicago: University of Chicago Press.

1991. *Reading "Rembrandt": Beyond the Word–Image Opposition.* Cambridge: Cambridge University Press.

Bal, M., and N. Bryson. 1991. "Semiotics and art history." *ArtBull* 73: 174–208.

Bally, C. 1965. *Linguistique générale et linguistique française.* 4th ed. Berne: Francke.

Banfield, A. 1982. *Unspeakable Sentences.* London: Routledge & Kegan Paul.

Banti, A., and L. Simonetti, 1972. *Corpus numorum Romanorum.* Florence: A. Banti and L. Simonetti.

Baratte, F., and C. Metzger. 1985. *Musée du Louvre. Sarcophages au pierre d'époques romaine et paléochrétienne.* Paris: Musée du Louvre.

Barnett, R. D. 1958. "The siege of Lachisch." *Israel Exploration Journal* 8: 161–4.

Barth, J. 1969. "Life-story." In *Lost in the Funhouse,* pp. 113–26. New York: Bantam.

Barthes, R. 1961. "Le message photographique." *Communications* 1: 127–38. (Reprinted in *Image–Music–Text,* by R. Barthes, translated by R. Howard. London: Hill & Wang, pp. 15–31.)

1964. "Rhétorique de l'image." *Communications* 4: 40–51. (Reprinted in *Image–Music–Text,* by R. Barthes, translated by R. Howard. London: Hill & Wang, pp. 32–51.)

1975. "An introduction to the structural analysis of narrative," translated by L. Duisit. *NewLitHist* 6: 237–72.

1977a. "The photographic message." In *Image, Music, Text,* translated by S. Heath, pp. 15–31. New York: Hill & Wang. (Originally "Le message photographique." *Communications* 1, 1961.)

1977b. "Rhetoric of the image." In *Image, Music, Text,* translated by S. Heath, pp. 32–51. New York: Hill & Wang. (Originally "Rhetorique de l'image." *Communications* 4, 1964.)

1977c. *Image–Music–Text,* translated by R. Howard. London: Hill & Wang.

1986. "On reading." In *The Rustle of Language,* translated by R. Howard, pp. 33–43. New York: Hill & Wang.

Bartman, E. 1988. "Decor et duplicatio: pendants in Roman sculptural display." *AJA* 92: 211–25.

Baumgartel, E. J. 1955. *The Cultures of Prehistoric Egypt. I.* 2d ed. Oxford: Oxford University Press.

1960. *The Cultures of Prehistoric Egypt, II.* Oxford: Oxford University Press.

Baxandall, M. 1985. *Patterns of Intention.* New Haven: Yale University Press.

Beazley, J. D. 1922. "Citharoedos." *JHS* 42: 70–98.

1947. *Etruscan Vase-Painting.* Oxford: Oxford University Press.

1956. *Attic Black-Figure Vase-Painters.* Oxford: Oxford University Press.

1963. *Attic Red-Figure Vase-Painters.* 2d ed. Oxford: Oxford University Press.

1971. *Paralipomena.* Oxford: Oxford University Press.

REFERENCES Bek, L. 1985. "*Venustas species,* a Hellenistic rhetorical concept as the aesthetic principle in Roman townscape." *AnalRom* 14: 139–48.

Bell, E. 1977. *The Attic Black-Figured Vases at the Hearst Monument, San Simeon.* Ph.D. dissertation, University of California, Berkeley.

Bellinger, A. R. 1962. *Victory as a Coin Type.* Numismatic Notes and Monographs 149. New York: American Numismatic Society.

Bérard, C. 1983. "Iconographie, iconologie, iconologique." *Études de Lettres* 4: 5–37.

Bérard, C., C. Bron, and A. Pomari. 1985. *La cité des images: Religion et société en Grèce antique.* Paris: Fernand Nathan. (Also in *The City of Images: Religion and Society in Ancient Greece,* translated by D. Lyons. Princeton: Princeton University Press.)

 1987. *Images et société en Grèce ancienne.* Actes du Colloque International, Lausanne 8–11 Février 1984. Laussane: Institut d'Archéologie et d'Histoire Ancienne, Université de Laussane.

Berczelly, L. 1978. "A sepulchral monument from via Portuense." *ActaArch* 8: 49–74.

Bersani, L., and U. Dutoit. 1985. *The Forms of Violence. Narrative in Assyrian Art and Modern Culture.* New York: Schocken.

Bianchi Bandinelli, R. 1950. *Storicità dell'arte classica.* Florence: Electa.

 1961. "Sulla formazione del ritratto romano." In *Archeologia e cultura,* pp. 172–88. Milan: R. Ricciardi.

 1967. "Arte plebea." *DialArch* 1: 7–19.

 1970. *Rome: The Center of Power.* New York: George Braziller.

 1982. *L'arte etrusca.* Rome: Riuniti.

 (ed.). 1963–4. *Sculture municipali dell'area sabellica tra l'età di Cesare e quella di Nerone. StMisc* 10.

Bianchi Bandinelli, R., and A. Giuliano. 1973. *Etruschi e Italici prima del domino di Roma.* Milan: Rizzoli.

Bickerman, E. J. 1952. "Origines gentium." *CP* 47: 65–81.

Bieber, M. 1961. *The Sculpture of the Hellenistic Age.* 2d ed. New York: Columbia University Press.

Black, M. 1962. *Models and Metaphors.* Ithaca: Cornell University Press.

Blanck, H., and C. Weber-Lehmann. 1987. *Malerei der Etrusker in Zeichnungen des 19. Jahrhunderts.* Mainz: Philipp von Zabern.

Bleicken, J. 1974. "*In provinciali solo dominium populi Romani est vel Caesaris:* Zur Kolonisationspolitik der ausgehenden Republik und frühen Kaiserzeit." *Chiron* 4: 359–414.

Bloch, R. 1958. "Une tombe villanovienne près de Bolsena et la danse guerrière dans l'Italie primitive." *MEFRA* 70: 7–37.

Blum, H. 1969. *Die antike Mnemotecknik.* Hildesheim: Georg Olms.

Boardman, J. 1972. "Herakles, Peisistratos and sons." *RA:* 57–72.

 1975a. *Athenian Red Figure Vases: The Archaic Period.* New York: Oxford University Press.

 1975b. "Herakles, Peisistratos and Eleusis." *JHS* 95: 1–12.

 1976. "The Kleophrades Painter at Troy." *AntK* 19: 3–18.

 1978a. *Greek Sculpture. The Archaic Period.* New York: Thames & Hudson.

 1978b. "Herakles, Delphi and Kleisthenes of Sikyon." *RA:* 227–34.

 1985. "Image and politics in sixth century Athens." In *Ancient Greek and Related Pottery: Proceedings of the International Vase Symposium in Amsterdam, 12–15 April 1984,* edited by H. A. G. Bridjder, pp. 239–47. Amsterdam: Allard Pierson.

Boatwright, M. T. 1985. "The Ara Ditis-Ustrinum of Hadrian." *AJA* 89: 485–97.

1987. *Hadrian and the city of Rome*. Princeton: Princeton University Press.

Boehmer, R. M. 1974. "Orientalische Einflüsse auf verzeirten Messergriffen aus dem prädynastischen Ägypten." *Archäologichen Mitteilungen aus Iran (DAI Teheran)* n.s. 7: 15–50.

1975. "Das Rollsiegel im prädynastischen Ägypten." *AA* 4: 495–514.

Boëthius, A. 1978. *Etruscan and Early Roman Architecture*. Harmondsworth: Penguin.

Böhr, E. 1982. *Der Schauckelmaler*. Mainz: Philipp von Zabern.

Boissac, M.-F. 1988. "Sceaux Déliens." *RA* 2: 307–40.

Boitani, F. 1986. *Pittura Etrusca*. Rome: Quasar.

Bömer, F. 1951. *Rom und Troia*. Baden-Baden: Verlag für Kunst und Wissenschaft.

Bonfante, L. 1978. "Historical art: Etruscan and early Roman." *AJAH* 3: 136–62.

1989. "Nudity as a costume in classical art." *AJA* 93: 543–70.

Bonfante Warren, L. 1970. "Roman triumphs and Etruscan kings: The changing face of the triumph." *JRS* 60: 49–66.

1973. "Roman costumes. A glossary and some Etruscan derivations." *ANRW* 1(4): 584–614.

Bonner, S. F. 1977. *Education in Ancient Rome*. Berkeley: University of California Press.

Borger, R. 1979. *Babylonisch–Assyrische Lesestücke*. 2d ed. (1st ed., 1963). 2 vols. Analecta Orientalia 54. Rome: Pontificium Institutum Biblicum.

Borghini, A. 1980. "*Elogia puerorum:* testi, immagini e modelli anthropologici." *Prospettiva* 22: 2–11.

Börker, C. 1986. "Menekrates und die Künstler des farnesischen Stieres." *ZPE* 64: 41–9.

Botta, P. E., and E. Flandin. 1849–50. *Monument de Ninive*. 5 vols. Paris: Imprimerie Nationale.

Bowersock, G. W. 1965. *Augustus in the Greek World*. Oxford: Oxford University Press.

1990. "The pontificate of Augustus." In *Between Republic and Empire, Interpretations of Augustus and his Principate,* edited by K. Raaflaub and M. Toher, pp. 380–94. Berkeley: University of California Press.

Brendel, O. J. 1953. "Prolegomena to a book on Roman art." *MAAR* 21: 1–73. (Revised and reprinted in *Prolegomena to the Study of Roman Art,* introduction by J. J. Pollitt. New Haven: Yale University Press.)

1978. *Etruscan Art*. Harmondsworth: Penguin.

Brilliant, R. 1984. *Visual Narratives. Storytelling in Etruscan and Roman Art*. Ithaca: Cornell University Press.

1988. "Roman art and Roman imperial policy." *JRA* 1: 110–14.

Brommer, F. 1979. *The Sculptures of the Parthenon,* translated by Mary Whitall. London: Thames & Hudson.

Broughton, T. R. S. 1951, 1986. *Magistrates of the Roman Republic I, II* (1951), *III* (1986). New York: American Philological Association.

Brulé, P. 1987. *La fille a'Athenes*. Centre de Recherches de'Histoire Ancienne 76. Paris: Annales Littéraires de l'Université de Besançon.

Bruneau, P., and J. Ducat. 1983. *Guide de Délos*. Paris: De Boccard.

Brunn, H. 1905. *Kleine Schriften*. Leipzig: Teubner.

Brunt, P. A., and J. M. Moore. 1967. *Res Gestae Divi Augusti*. London: Oxford University Press.

Bryson, N. 1983. *Tradition and Desire: From David to Delacroix*. Cambridge: Cambridge University Press.

1990. *Looking at the Overlooked*. Cambridge, MA: Harvard University Press.

REFERENCES Buchner, E. 1982. *Die Sonnenuhr des Augustus*. Mainz: Philipp von Zabern.

 1988. "Horologium solarium Augusti." In *Kaiser Augustus und die verlorene Republic,* edited by M. Hofter, pp. 240–5. Berlin: Philipp von Zabern.

Buranelli, F. (ed.). 1987. *La tomba François di Vulci*. Rome: Quasar.

Burn, L. 1987. *The Meidias Painter*. Oxford: Oxford University Press.

Cairns, F. 1972. *Generic Composition in Greek and Latin Poetry*. Edinburgh: Edinburgh University Press.

Callaghan, P. J. 1981. "On the date of the Great Altar of Zeus at Pergamon." *BICS* 28: 115–21.

Calza, G. 1940. *Le necropoli del porto di Roma nell'Isola Sacra*. Rome: Libreria dello Stato.

Camille, M. 1985. "Seeing and reading: Some visual implications of medieval literacy and illiteracy." *Art History* 8: 26–49.

Capart, J. 1905. *Primitive Art in Egypt,* translated by A. S. Griffiths. London: Grevel.

Carandini, A. (ed.). 1985. *La romanizzazione del'Etruria: il territorio di Vulci*. Milan: Electa.

Carcopino, J. 1971. *Daily life in Ancient Rome*. 16th ed., edited by H. Rowell and translated by E. O. Lorimer. New York: Bantam.

Carpenter, R. 1960. *Greek Sculpture*. Chicago: University of Chicago Press.

Casson, L. 1971. *Ships and Seamanship in the Ancient World*. Princeton: Princeton University Press.

Castagnoli, F. 1945. "Il Campo Marzio nell'antichitá." *MemLinc* 8(1): 93–193.

Cébeillac, M. 1971. "Quelques inscriptions inédites d'Ostie: de la république à l'empire." *MEFRA* 83: 39–125.

Chamay, J., and D. von Bothmer. 1987. "Ajax et Cassandre par le Peintre de Princeton." *AntK* 30: 58–68.

Charbonneaux, J. 1952. "La main droite de la Victoire du Samothrace." *Hesperia* 21: 44–6.

Chatman, S. 1975. "Towards a theory of narrative." *NewLitHist* 6: 294–318.

 1978. *Story and Discourse: Narrative Structure in Fiction and Film*. Ithaca: Cornell University Press.

Cheesman, G. 1914. *The Auxilia of the Roman Imperial Army*. Oxford: Oxford University Press.

Christie, Manson, and Woods, Ltd. 1975. *Greek and Etruscan Vases from Nostell Priory*. Auction catalogue. London.

Ciancio Rossetto, P. 1973. *Il sepolcro del fornaio Marco Virgilio Eurisace a Porta Maggiore*. Rome: Istituto di Studi Romani.

Clanchy, M. T. 1979. *From Memory to Written Record: England 1066–1307*. Cambridge, MA: Harvard University Press.

Claridge, A., and J. B. Ward Perkins. 1978. *Pompeii, A.D. 79*. Boston: Museum of Fine Arts.

Clark, T. J. 1990. "Jackson Pollock's abstraction." In *Reconstructing Modernism: Art in New York, Paris, and Montreal 1945–1964,* edited by S. Guilbaut, 172–243. Cambridge, MA: MIT Press.

Clarke, M. L. 1963. *Rhetoric at Rome*. New York: Barnes & Noble.

Clay, D. 1988. "The archaeology of the Temple to Juno in Carthage (*Aeneid* 1.446–93)." *CP* 83: 195–205.

Clay, G. 1973. *Close-Up: How to Read the American City*. New York: Praeger.

Clement, P. 1958. "The recovery of Helen." *Hesperia* 27: 47–73.

Coarelli, F. 1965–7. "Il Tempio di Bellona." *BullCom* 80: 61–6.

 1968a. "Il tempio di Diana in Circo Flaminio e alcuni problemi connessi." *DialArch* 2: 191–243.

1968b. "L'ara di Domizio Ahenobarbo e la cultura artistica in Roma nel II sec. AC." *DialArch* 2: 302–68.

1968c. "L'identificazione dell'Area sacra dell'Argentina." *Palatino* 12(4): 365–73.

1970–1. "Classe dirigente romana e arti figurative." *DialArch* 4–5: 241–76.

1972. "Il sepolcro degli Scipioni." *DialArch* 6(1): 36–106.

1976a. "Architettura e arti figurative in Rome: 150–50 a.c." In *Hellenismus in Mittelitalien,* edited by P. Zanker, pp. 38–51. *AbhGött* 97.

1976b. "Frammento di affresco dall'Esquilino con scena storica." In *Affreschi romani dalle raccolte dell'Antiquarium comunale,* edited by R. E. Filippi, pp. 13–21. Rome: Palazzo Braschi.

1977. "Il Campo Marzio occidentale. Storia e topografia." *MEFRA* 89: 807–46.

1980a. *Guida archeologia di Roma.* 2d ed. Rome: Arnoldo Mondadori Editore.

1980b. *Roma.* Bari: Laterza.

1983a. "Il Pantheon, ll'apoteosi di Augusto e l'apoteosi di Romolo." *Cittá e architettura nella Roma imperiale. AnalRom Suppl.* 10: 41–6.

1983b. "Le pitture della tomba François a Vulci: una proposta di lettura." *DialArch* 3: 43–69.

1984. *Roma sepolta.* Rome: Armando Curcio Editore.

1987. *I santuario del Lazio in età repubblicana.* Studi archeologia 7. Rome: Nuova Italia Scientifica.

Connelly, J. B. 1988. *Votive Sculpture of Hellenistic Cyprus.* Nicosia: Department of Antiquities of Cyprus and New York: New York University Press.

Connolly, P. 1981. *Greece and Rome at War.* London: Macdonald.

Cool Root, M. 1979. *The King and Kingship in Achaemenid Art.* Acta Iranica, Textes et Mémoires 9. Leiden: E. J. Brill.

Cornell, T. 1977. "Aeneas' arrival in Italy." *Liverpool Classical Monthly* 2: 77–83.

Coste, D. 1989. *Narrative as Communication,* introduction by Wlad Godzich. Minneapolis: University of Minnesota Press.

Crawford, M. 1974. *Roman Republican Coinage.* Cambridge: Cambridge University Press.

Cristofani, M. 1967. "Ricerche sulle pitture della tomba François di Vulci. I fregi decorativi." *DialArch* 1: 186–219.

1990. *La grande Roma dei Tarquini.* Rome: "L'Erma" di Bretschneider.

Cros, E. 1988. *Theory and Practice of Sociocriticism,* translated by J. Schwartz, introduction by J. Link and U. Link-Heer. Minneapolis: University of Minnesota Press.

Cullen, G. 1961. *The Concise Townscape.* London: Van Nostrand Reinhold.

Culler, J. 1988. *Framing the Sign: Criticism and its Institutions.* Norman: University of Oklahoma Press.

Cumont, F. 1910. "L'aigle funéraire des Syriens et l'apothéose des empereurs." *RHR* 62: 119–64.

1912. *Astrology and Religion Among the Greeks and Romans.* New York: Dover.

1917. "L'aigle funéraire d'Hiérapolis et l'apothéose des empereurs." In *Études syriennes,* edited by A. Picard, pp. 35–118. Paris: Auguste Picard.

1942. *Recherches sur le symbolisme funéraire des romains.* Bibliothèque archéologique et historique 35. Paris: P. Geuthner.

Curtius, L. 1948. "Ikonographische Beiträge zum Porträt der römischen Republik und der julisch-claudischen Familie." *MdI* 1: 53–94.

D'Ambra, E. 1987. "*Palades artis:* The Arachne myth and the frieze from the

REFERENCES Forum Transitorium." *AJA* 91: 279 (abstract).

 1988. "A myth for a smith: A Meleager sarcophagus from a tomb in Ostia." *AJA* 92: 85–99.

D'Arms, J. 1981. *Commerce and Social Standing in Ancient Rome.* Cambridge, MA: Harvard University Press.

Davies, M. 1978. "Sailing, rowing, and sporting in one's cups on the wine-dark sea." In *Athens Comes of Age,* edited by W. A. P. Childs, pp. 72–95. Princeton: Princeton University Press.

Davis, W. 1979. "Two compositional tendencies in Amarna relief." *AJA* 82: 287–94.

 1983. "Artists and patrons in predynastic and early dynastic Egypt." *SAK* 10: 119–39.

 1989. *The Canonical Tradition in Ancient Egyptian Art.* New York: Cambridge University Press.

 1990. Review of Preziosi 1989. *ArtBull* 72: 156–66.

 1992. *Masking the Blow: The Scene of Representation in Late Prehistoric Egyptian Art.* Berkeley: University of California Press.

Davreux, J. 1942. *La légende de la prophetesse Cassandre.* Liège: Bibliothèque de la Faculté de Philosophie et Lettres de l'Université de Liège, Fasc. 94.

De Angelis Bertolotti, R. 1985. "Materiali dell'Ara Pacis presso il Museo Nazionale Romano." *RM* 92: 221–34.

de Fine Licht, K. 1968. *The Rotunda in Rome. A Study of Hadrain's Pantheon.* Copenhagen: Gyldendal.

de Francisci, P. 1959. *Primordia civitatis.* Rome: Apollinaris.

de Garis Davies, N. 1943. *The tomb of Rekh-mi-Re at* Thebes. 2 vols. New York: Plantin Press.

Degrassi, A. 1963. *Inscriptiones Italiae XIII.2.* Florence: La nuova Italia.

de Kuyper, E., and E. Poppe. 1981. "Voir et regarder." *Communications* 34: 85–96.

del Chiaro, M. 1971. *Re-exhumed Etruscan Bronzes.* Santa Barbara: University of California, Santa Barbara University Museum.

Demargne, P. 1984. "Athena." *LIMC* II: 969.

Dennis, G. 1883. *The Cities and Cemeteries of Etruria.* 3d ed. London: J. Murray.

Dentzer, J. M. 1962. "La tombe de C. Vestorius dans la tradition de la peinture italique." *MEFRA* 74: 533–94.

 1982. *Le motif du banquet couché dans le Proche-Orient et le monde Grece du VIIe au IVe siècle avant J.-C.* Paris: De Boccard.

Derrida, J. 1982. *Dissemination,* translated with an introduction by B. Johnson. Chicago: University of Chicago Press.

 1988. *Limited, Inc.,* translated by S. Weber. Evanston, IL: Northwestern University Press.

Detienne, M. 1989. "The violence of wellborn ladies: Women in the Thesmophoria." In *The Cuisine of Sacrifice Among the Greeks,* edited by M. Detienne and J.-P. Vernant, pp. 129–47. Chicago: University of Chicago Press.

Deubner, O. 1979. "Der Gott mit dem Bogen." *JdI* 94: 223–44.

Dilke, O. A. W. 1985. *Greek and Roman Maps.* Ithaca: Cornell University Press.

Dohrn, T. 1972. "Wandgemälde aus der Tomba François." In Helbig⁴ IV, pp. 204–17.

 1976. "Totenklage im frühen Etrurien." *MdI* 83: 195–205.

Donderer, M. 1988. "Nicht Praxiteles, sondern Pasiteles." *ZPE* 73: 63–8.

Dowden, K. 1989. *Death and the Maiden: Girl's Initiation Rites in Greek Mythology.* London: Routledge.

Duell, P., et al. 1938. *The Mastaba of Mereruka I.* Chicago: University of Chicago Press.

Dugas, C., J. Berchmans, and M. Clemmensen. 1924. *Le sanctuaire d'Alèa Athéna à Tégée.* Paris: P. Geuthner.

Dunbabin, K. M. D. 1986. "*Sic erimus cuncti* . . . the skeleton in Greco-Roman art." *JdI* 101: 185–255.

Duncan, H. D. 1968. *Symbols in Society.* Oxford: Oxford University Press.

Dwyer, E. 1992. "The temporal allegory of the Tazza Farnese." *AJA* 96: 255–82.

Eck, W. 1984a. "*CIL* VI 1508 (Moretti, *IGUR* 71) und die Gestaltung senatorischer Ehrenmonumente." *Chiron* 14: 201–17.

——— 1984b. "Senatorial self-representation: Developments in the Augustan period." In *Caesar Augustus. Seven Aspects,* edited by F. Millar and E. Segal, pp. 129–67. Oxford: Oxford University Press.

Eco, U. 1990. *The Limits of Interpretation.* Bloomington: Indiana University Press.

Edwards, I. E. S. 1972. "The early dynastic period in Egypt." In *CAH,* edited by I. E. S. Edwards et al., Vol. I, Pt. 2, pp. 1–70. Cambridge: Cambridge University Press.

Ehrenberg, V., and A. H. M. Jones. 1976. *Documents Illustrating the Reigns of Augustus and Tiberius.* 2d ed. Oxford: Oxford University Press.

Eichler, F., and E. Kris. 1927. *Die Kameen im Kunsthistorischen Museum.* Vienna: Anton Schroll.

Eisner, M. 1979. "Zur Typologie der Mausoleen des Augustus und des Hadrian." *RM* 86: 319–24.

Ernout, A. 1946. "*Augur, Augustus.*" *Philologica* I: 67–71.

Espérandieu, E. 1947. *Recueil Général des Bas-Reliefs de la Gaule Romaine I.* Paris: Imprimerie Nationale.

Evans, A. J. 1921. *The Palace of Minos at Knossos I.* London: Macmillan.

——— 1930. *The Palace of Minos at Knossos III.* London: Macmillan.

Fairservis, W. 1991. "A revised view of the Na'rmr Palette." *JARCE* 28: 1–20.

Falkener, M. 1946. "Asianos zelos under Pergamon-Fries." *OJh* 36: 1–45.

Favro, D. 1989. "Was man the measure?" In *Architects' People,* edited by R. Ellis and D. Cuff, pp. 13–43. Oxford: Oxford University Press.

——— 1992. "Pater urbis: Augustus as city father of Rome." *JSAH* 51: 61–84.

Fayer, C. 1976. *Il culto della dea Roma: origine e diffusione nell'impero.* Chieti: Trimestre Pescara.

Fears, J. R. 1977. *Princeps a diis electus: The Divine Election of the Emperor as a Political Concept at Rome. PAAR* 26.

Felletti Maj, B. M. 1977. *La tradizione italica nell'arte romana.* Archeologica 3. Rome: G. Bretschneider.

Ferrari, O., E. Pozzi et al. 1986. *Le collezioni del M. N. di Napoli. I mosaici, le pitture.* Rome: De Luca.

Fidenzoni, P. 1970. *Il Teatro di Marcello.* Rome: Liber.

Fink, J. 1972. "Germanicus-Porträt." In *Antike und Universalgeschichte. Festschrift Hans Erich Stier,* pp. 180–8. Münster: Aschendorff.

Finkenstaedt, E. 1984. "Violence and kingship: The evidence of the palettes." *ZÄS* 111: 107–10.

Fishwick, D. 1987. *The Imperial Cult in the Latin West.* Études préliminaires aux religions orientals dans l'empire romain 108. Leiden: E. J. Brill.

Fittschen, K. 1969. *Untersuchungen zum Beginn der Sagedarstellungen bei der Griechen.* Berlin: Verlag Bruno Hessling.

——— 1977. *Katalog der antiken Skulpturen in Schloss Erbach.* Archäologische Forschungen 3. Berlin: Gebr. Mann.

REFERENCES Fletcher, A. 1964. *Allegory: The Theory of a Symbolic Mode*. Ithaca: Cornell University Press.

Földes-Papp, K. 1966. *Vom Feldbild zum Alphabet: Die Geschichte der Schrift von ihren frühesten Vorstufen bis zur modernen Lateinischen Schreibschrift*. Stuttgart: Belser.

Fontenrose, J. 1974. *Python: A Study of Delphic Myth and Its Origin*. New York: Biblio & Tannen.

Forster, E. M. 1927. *Aspects of the Novel*. New York: Harcourt, Brace.

Foucault, M. 1973. *The Order of Things*, translated by A. Sheridan. New York: Vintage.

1975. *The Archaeology of Knowledge*, translated by A. M. Sheridan Smith. New York: Harper & Row.

François, A. 1857. *Bullettino dell'Instituto di Corrispondenza Archeologica* 29: 98–104.

Fränkel, M. 1890. *Die Inschriften von Pergamon*. Berlin: Spemann.

Frankfort, H. 1948. *Kingship and the Gods*. Chicago: University of Chicago Press.

Fraser, P. M. 1960. *Samothrace, Vol. 2, Part 1: The Inscriptions on Stone*, edited by K. Lehmann. Princeton: Princeton University Press.

Frazer, J. 1926. *The Golden Bough: A Study in Magic and Religion*. 3rd ed. London: Macmillan.

1929. *Publii Ovidii Nasonis fastorum libri sex: The fasti of Ovid II*, edited with translation and commentary. London: Macmillan.

Fried, M. 1980. *Absorption and Theatricality: Painting and Beholder in the Age of Diderot*. Berkeley: University of California Press.

Friedländer, L. 1908. *Roman Life and Manners under the Early Principate II*. London: Routledge & Kegan Paul.

Friss-Johansen, K. 1967. *The Iliad in Early Greek Art*. Copenhagen: Munskgaard.

Froning, H. 1988. "Anfänge der Kontinvierenden Bilderzählung in der griechischen Kunst." *JdI* 103: 169–99.

Furtwängler, A. 1890. *Olympia IV, Die Bronzen*. Berlin: De Gruyter.

Furtwängler, A., and C. Reichhold. 1904. *Griechischen Vasenmalerei*. Munich: Verlagsanstalt F. Bruckmann A.-G.

Gaballa, G. A. 1976. *Narrative in Egyptian Art*. Mainz: Phillip von Zabern.

Gabba, E. 1982. "Political and cultural aspects of the classicistic revival in the Augustan age." *ClAnt* 1: 43–65.

Gabelmann, H. 1980. "Circusspiele in der spätantiken Repräsentationskunst." *AntW* 11(4): 25–38.

Gagé, J. 1955. *Apollon Romain, essai sur le culte d'Apollon et le développement du "ritus Graecus" à Rome des origines à Auguste*. Paris: De Boccard.

1976. "Comment Énée est devenu l'ancêtre des Silvii Albains." *MEFRA* 88: 7–30.

1981. "Apollon impérial, gerant des 'fata romana.'" *ANRW* 2.17.2: 561–630.

Galinsky, G. K. 1969. *Aeneas, Sicily and Rome*. Princeton: Princeton University Press.

Gantz, T. N. 1975. "The Tarquin dynasty." *Historia* 24: 539–54 [1976].

Garrard, M. D. 1982. "Artemisia and Susanna." In *Feminism and Art History: Questioning the Litany*, edited by N. Broude and M. D. Garrard, pp. 147–71. New York: Harper & Row.

Gasparri, C. 1979. *Aedes Concordiae Augustae*. I monumenti Romani 8. Rome: Instituto di Studi Romani.

Gatti, G. 1937. "I Saepta Iulia nel Campo Marzio." *L'urbe* 2(9): 8–23.

1943–4. "Topografia dell'Iseo Campense." *RendPontAcc* 20: 117–63.

1979. "Il Teatro e la Cryta di Balbo." *MEFRA* 91: 237–313.

338

Genette, G. 1976. "Boundaries of narrative." *NewLitHist* 8: 1–13.

 1988. *Narrative Discourse Revisited,* translated by J. E. Lewin. Ithaca: Cornell University Press.

Germanico: la persona, la personalità, il personaggio. 1987. Università degli studi di Macerata 39, Atti di Convegni 4. Rome: G. Bretschneider.

Gesztelyi, T. 1981. "Tellus-Terra Mater in der Zeit des Principats." *ANRW* 2.17.1: 429–56.

Ghislanzoni, E. 1908. "Il rilievo gladiatorio dei Chieti." *MonAnt* 19: 541–614.

Giard, J. B. 1976. *Catalogue des monnaies de l'empire romain I. Auguste.* Paris: Bibliothèque Nationale.

Gilbert, P. 1949. "Fauves au long cou communs à l'art égyptien et à l'art sumérien." *Chronique d'Égypte* 22: 38–41.

Girard, J. L. 1981. "Domitien et Minerve: une predilection imperiale." *ANRW* 2.17.1: 233–45.

Giuliano, A. 1963–4. "Il supposto rittrato di C. Lusius Storax." *StMisc* 10: 100–2.

 (ed). 1979. *Museo Nazionale Romano. Le sculture I.1.* Rome: De Luca.

Goidanich, P. 1935. "Rapporti culturali e linguistici fra Roma e gl'Italici. Del dipinto Vulcente di Vel Saties e Arnza." *StEtr* 9: 107–18.

Goldschmidt, V. 1978. "Remarques sur l'origine épicurienne de la prénotion (prolepsis)." In *Les Stoïciens et leur logique,* pp. 155–69. Paris: Vrin.

Gombrich, E. 1961. *Art and Illusion: A Study in the Psychology of Pictorial Representation.* 2d, rev. ed. Princeton: Princeton University Press.

 1982. "Action and expression in Western art." In *The Image and the Eye.* Oxford: Phaidon.

Goodlett, V. C. 1991. "Rhodian sculpture workshops." *AJA* 95: 669–81.

Goodman, N. 1949. "On likeness of meaning." *Analysis* 1: 231–8.

 1971. *Languages of Art: Approach to a Theory of Symbols.* Indianapolis: Bobbs-Merrill.

 1978. *Ways of Worldmaking.* Indianapolis: Bobbs-Merrill.

Gottdiener, M., and A. Lagopoulos. 1986. *The City and the Sign.* New York: Columbia University Press.

Grabar, O. 1979. "Are pictures signs yet?" *Semiotica* 25: 185–8.

Graef, B., and E. Langlotz. 1937. *Die antiken Vasen von der Akropolis zu Athen.* Berlin: De Gruyter.

Groenewegen-Frankfort, H. A. 1951. *Arrest and Movement: An Essay on Space and Time in the Representational Art of the Ancient Near East.* London: Faber & Faber.

 1970. " 'Narratives' in ancient Egypt." *Art News Annual* 36: 112–21.

Gruen, E. S. 1984. *The Hellenistic World and the Coming of Rome.* Berkeley: University of California Press.

 (forthcoming). *Culture and National Identity in Republican Rome.* Ithaca: Cornell University Press.

Hafner, G. 1987. "Drei Gemälde im Tempel der Bellona." *RM* 94: 241–60.

Hall, E. S. 1988. *The Pharaoh Smites His Enemies.* Münchner Ägyptologische Studien 46. Munich: Münchner Ägyptologische Studien.

Hamilton, R. 1985. "Euripidean priests." *HSCP* 89: 53–73.

Hanfmann, G. M. A. 1952. "Observations on Roman portraiture." *Latomus* 11: 203–15, 337–47, 454–65.

 1957. "Narration in Greek art." *AJA* 61: 71–8.

 1975a. *Roman Art. A Modern Survey of the Art of Imperial Rome.* New York: Norton.

 1975b. *From Croesus to Constantine. The Cities of Western Asia Minor and their Arts in Greek and Roman Times.* Ann Arbor: University of Michigan Press.

REFERENCES Hänlein-Schäfer, H. 1985. *Veneratio Augusti: Eine Studien zu den Tempeln des ersten römischen Kaisers.* Rome: G. Bretschneider.

Hannestad, N. 1986. *Roman Art and Imperial Policy,* translated by P. J. Crabb. Jutland Archaeological Society Publications 19. Moesgard: Aarhus University Press.

Hansen, E. V. 1971. *The Attalids of Pergamon.* 2d ed. Ithaca: Cornell University Press.

Hardie, P. 1986. *Vergil's Aeneid: Cosmos and Imperium.* Oxford: Oxford University Press.

Hardy, E. G. 1911. *Six Roman Laws.* Oxford: Clarendon.

Harris, W. V. 1978. *War and Imperialism in Republican Rome 327–70 B.C.* Oxford: Oxford University Press.

 1989. *Ancient Literacy.* Cambridge, MA: Harvard University Press.

Harrison, E. B. 1972. "The south frieze of the Nike Temple and the Marathon Painting in the Painted Stoa." *AJA* 76: 353–78.

 1982. "Two Pheidian heads: Nike and Amazon." In *The Eye of Greece. Studies in the Art of Athens,* edited by D. Kurtz and B. Sparkes, pp. 53–88. Cambridge: Cambridge University Press.

Harrison, Jane E. 1927. *Themis: A Study of the Social Origins of Greek Religion.* New York: The World Publishing Company.

Hart, M. 1991. "Athens and Troy: The Iliupersis in Attic vase-painting." *AJA* 95: 323.

Hartigan, K. 1979. *The Poets and the Cities.* Meisenheim am Glan: Hain.

Haslam, M. 1976. *The Oxyrhynchus papyri.* London: British Academy for the Egypt Exploration Society.

Hausenstein, W. 1922. *Das Bild. Atlanten zur Kunst 2: Die Bildnerei der Etrusker.* Munich: Piper.

Havelock, C. M. 1981. *Hellenistic Art.* 2d ed. New York: Norton.

Haynes, D. E. L. 1972. "Alte Funde neu entdeckt." *AA:* 731–42.

Hedeman, A. D. 1985. "Restructuring the narrative: The function of ceremonial in Charles V's *Grandes Chroniques de France.*" In *Pictorial Narrative in the Antiquity and the Middle Ages,* edited by H. L. Kessler and M. S. Simpson, pp. 171–81. Studies in the History of Art 16. Washington, D.C.: National Gallery of Art.

Hedrick, C. W., Jr. 1988. "The temple and cult of Apollo Patros in Athens." *AJA* 92: 185–210.

Hellenismus in Mittelitalien. 1976. Edited by Paul Zanker. *AbhGött* 97.

Herbert, C. 1991. *Culture and Anomie.* Chicago: University of Chicago Press.

Herdejürgen, H. 1989. "Beobachtungen an den Lünettenreliefs hadrianischer Girlandsarkophage." *AntK* 1: 17–26.

Herington, C. J. 1955. *Athena Parthenos and Athena Polias.* Manchester: Manchester University Press.

Heurgon, J. 1961. *La vie quotidienne chez les Étrusques.* Paris: Hachette.

 1969. *Rome et la Méditerranée occidentale.* Paris: Presses universitaires de France.

Himmelmann, N. 1973. *Typologische Untersuchungen an römischen Sarkophagreliefs des 3. und 4. Jahrhunderten n. Chr.* Mainz: Verlag der Akademie der Wissenschaften und der Literatur.

Himmelmann-Wildschutz, N. 1967. "Erzählung und Figur in der archaischen Kunst." *AbhMainz* 2: 73–101.

Hinks, R.P. 1939. *Myth and Allegory in Ancient Art.* Studies of the Warburg Institute 6. Reprinted in 1969. Nendeln, Liechtenstein: Kraus.

Höckmann, U. 1982. "Nestor und Phönix in der Tomba François in Vulci." *Boreas* 5: 78–87.

Hoffman, M. 1979. *Egypt Before the Pharaohs*. New York: Knopf.

Hofter, M. 1988. *Kaiser Augustus und die verlorene Republic*. Berlin: Philipp von Zabern.

Holliday, P. J. 1980. "*Ad triumphum excolendum:* The political significance of Roman historical painting." *Oxford Art Journal* 3: 3–10.

1990a. "Processional imagery in late Etruscan funerary art." *AJA* 94: 73–93.

1990b. "Time, history, and ritual on the Ara Pacis Augustae." *ArtB* 72: 542–57.

Hölscher, T. 1979. "Beobachtungen zu römischen historischen Denkmälern. 1. Censoredenkmal München-Paris. 2. Das Schiffsrelief aus Praeneste im Vatikan." *AA* 1979: 337–48.

1984. *Staatsdenkmal und Publikum. Vom Untergang der Republik bis zur Festigung des Kaisertums in Rom*. Xenia 9. Kostanz: Universitätsverlag Kostanz.

1987. *Römische Bildsprache als semantisches System. AbhHeid*.

1988a. "Gemma Augustea." In *Kaiser Augustus und die verlorene Republic*, edited by M. Hofter, pp. 371–3. Berlin: Philipp von Zabern.

1988b. "Historische Reliefs." In *Kaiser Augustus und die verlorene Republic*, by M. Hofter, pp. 351–400. Berlin: Philipp von Zabern.

Homo, L. 1971. *Rome impériale et l'urbanisme dans l'antiquité*. Paris: Michel.

Hood, S. 1978. *The Arts in Prehistoric Greece*. Harmondsworth: Penguin.

Hubaux, J. 1945. *Les grands mythes de Rome*. Paris: Presses universitaires de France.

Hubbard, T. K. 1986. "The narrative architecture of Petronius' *Satyricon*." *ArchCl* 55: 190–212.

Hübner, E. 1878. "Zum Denkmal des Trimalchio." *Hermes* 13: 413–22.

Huelsen, C. 1910. *Die Thermen des Agrippa*. Rome: Loescher.

The Human Figure in Early Greek Art. 1988. Washington, D.C.: National Gallery of Art.

Hurwit, J. M. 1985. *The Art and Culture of Early Greece, 1100–480 B.C.* Ithaca: Cornell University Press.

Iser, W. 1978. *The Act of Reading: A Theory of Aesthetic Response*. Baltimore: Johns Hopkins University Press.

Jacoby, F. 1923–58. *Die Fragmente der griechischen Historiker*. Berlin: Weidemann; and Leiden: E. J. Brill.

Janson, H. W. 1991. *History of Art*. 4th ed., Vol. I. Edited by A. F. Janson. New York: Prentice Hall and Abrams.

Jashemski, W. 1970–1. "Two gardens at Pompeii." *CJ* 66: 97–115.

1979. *The Gardens of Pomepeii, Herculaneum, and the Villas Destroyed by Vesuvius*. New Rochelle: Caratzas.

Jeffrey, L. H. 1965. " 'The battle of Oinoe in the Stoa Poikile.' A problem in Greek art and history." *BSA* 60: 42–57.

Johnson, M. 1987. *The Body in the Mind: The Bodily Basis of Meaning, Imagination, and Reasoning*. Chicago: University of Chicago Press.

Jucker, H. 1976. "Der grosse Pariser Kameo." *JdI* 91: 211–50.

Kahil, L. 1955. *Les enlevements et le retour d'Helene*. Paris: De Boccard.

1963. "Quelques vases du Santuaire d'Artemis a Brauron." *AntK-BH* 1: 5–29.

1965. "Autour de l'Artemis attique." *AntK* 8: 20–33.

1977. "L'Artemis de Brauron: rites et mystere." *AntK* 20: 86–98.

1981. "Le 'Craterique' d'Artemis et le Brauronia de l'acropole." *Hesperia* 50: 253–63.

Kähler, H. 1948. *Der grosse Fries von Pergamon*. Berlin: Gebr. Mann.

1959. *Die Augustusstatue von Primaporta (Monumentum Artis Romane 1)*. Köln: M. DuMont Schauberg.

1966. *Seethiasos und Census.* Monumenta Artis Romanae 6. Berlin: Gebr. Mann.

1968. *Alberti Rubeni Dissertatio de Gemma Augustea.* Monumenta Artis Romanae 9. Berlin: Gebr. Mann.

Kahlmeyer, J. 1934. *Seestrum und Schiffbruch als Bild im antiken Schifttum.* Dissertation, University of Greifswald.

Kaiser, W. 1956. "Stand und Probleme der ägyptischen Vorgeschichtsforschung." *ZAS* 81: 87–109.

1957. "Zur inneren Chronologie der Naqadakultur." *Archaeologia Geographica* 6: 69–77.

1964. "Einige Bemerkungen zur ägyptischen Frühzeit, III: Die Reichseinigung." *ZAS* 91: 86–125.

Kampen, N. B. 1977–8. "Meaning and social analysis of a late antique sarcophagus." *BABesch* 52–3: 221–2.

1981a. "Biographical narration and Roman funerary art." *AJA* 85: 47–58.

1981b. *Image and Status: Roman Working Women in Ostia.* Berlin: Gebr. Mann.

Kantor, H. J. 1965. "The relative chronology of Egypt and its foreign correlations before the late Bronze Age." In *Chronologies in Old World Archaeology,* edited by R. W. Ehrich, pp. 1–46. Chicago: University of Chicago Press.

Kaplony, P. 1966. *Kleine Beiträge zu den Inschriften der ägyptischen Frühzeit.* Eiesbaden: Harrassowitz.

Kebric, R. B. 1983. *The Paintings in the Cnidian Lesche at Delphi and their Historical Context.* Leiden: E. J. Brill.

Keel, O. 1978. *The Symbolism of the Biblical World.* New York: Crossroad Publishing.

Kellum, B. 1985. "Sculptural programs and propaganda in Augustan Rome: The Temple of Apollo on the Palatine." In *The Age of Augustus,* edited by R. Winkes, pp. 169–76. Archaeologia Transatlantica 5.

Kelsey, F. W., and A. Mau. 1899. *Pompeii, Its Life and Art.* New York: Macmillan. (Reprinted in 1982 in New Rochelle: Caratzas Bros.)

Kemp, B. 1989. *Ancient Egypt: Anatomy of a Civilisation.* London: Routledge.

Kemp, W. 1983. *Der Anteil des Betrachters: Rezeptionsästhetische Studien zur Malerei des 19. Jahrhunderts.* Munich: Maeander.

1985. "Death at work: A case study on constitutive blanks in nineteenth-century painting." *Representations* 10: 102–23.

Kennedy, G. 1963. *The Art of Persuasion in Greece.* Princeton: Princeton University Press.

Kent, J. P. C. 1978. *Roman Coins.* New York: Abrams.

Kessler, H. and M. S. Simpson (eds.). 1985. *Pictorial Narrative in Antiquity and the Middle Ages.* Studies in the History of Art 16. Washington, D.C.: National Gallery of Art.

Keuls, E. 1978. "Rhetoric and visual aids in Greece and Rome." In *Communication Arts in the Ancient World,* edited by E. A. Havelock and J. P. Hershbell, pp. 121–34. New York: Hastings House.

Klaus, P. 1982. "Description and event in narrative." *Orbis Litterarum* 37: 201–16.

Kleiner, D. E. E. 1977. *Roman Group Portraiture: The Funerary Reliefs of the Late Republic and Early Empire.* New York: Garland.

1978. "Second century mythological portraiture. Mars and Venus." *Latomus* 40: 512–44.

1987. *Roman Imperial Funerary Altars with Portraits.* Rome: G. Bretschneider.

Kleiner, F. 1983. "The sacrifice in armor in Roman art." *Latomus* 42: 287–301.

Koch, G. 1984. *Roman Funerary Sculpture. Catalogue of the Collections.* Malibu: J. Paul Getty Museum.

Koch, G., and H. Sichtermann. 1982. *Römische sarkophage.* Munich: C. H. Beck.

Kockel, V. 1983. *Die Grabbauten vor dem Kerkulaner Tor in Pompeji.* Mainz: Philipp von Zabern.

Körte, A. 1897. "Ein Wandgemälde von Vulci als Document zur römischen Königsgeschichte." *JdI* 12: 57–80.

Kraay, C. M. 1976. *Archaic and Classical Greek Coins.* Berkeley: University of California Press.

Kraay, C. M., and M. Hirmer. 1966. *Greek Coins.* New York: Abrams.

Kraeling, C. H. 1957: "Narration in ancient art: Introduction." *AJA* 61: 43.

Kraft, K. 1967. "Der Sinn des Mausoleums des Augustus." *Historia* 16: 189–95.

Kraus, T. 1967. *Das römische Weltreich.* Berlin: Propylaen Verlag.

Krause, B. H. 1983. *Iuppiter Optimus Saturnus.* Trierer Winckelmannsprogramme 3. Mainz: Philipp von Zabern.

Kroll, J. 1982. "The ancient image of Athena Polias." *Hesperia, Suppl. 20,* 65–76.

Kubler, G. 1961. *The Shape of Time: Remarks on the History of Things.* New Haven: Yale University Press.

Kunze, E. 1950. *Archaische Schildbander.* Olympische Forschungen II. Berlin: De Gruyter.

Kunze, M. 1990. "Neue Beobachtungen zum Pergamonaltar." In *Phyromachosprobleme,* edited by B. Andreae, pp. 123–39. Mainz: Philipp von Zabern.

Kurtz, D. 1985. "Beazley and the connoisseurship of Greek vases." *Greek Vases* 2: 237–50. (Occasional Papers of the J. Paul Getty Museum, Antiquities 3. Malibu: J. Paul Getty Museum.)

Kuttner, A. 1991. "A Latin *census* on a third c. Praenestine cist: Villa Giulia 13 133 and the "Ara Domitii Ahenobarbi.'" *RM* 98: 141–61.

(forthcoming). *Dynasty and Empire in the Age of Augustus: The Boscoreale cups.* Berkeley: University of California Press.

Kyrieleis, H. 1978. Response to D. Burr Thompson, "The Tazza Farnese reconsidered." In *Das ptolemäische Ägypten,* pp. 121–2. Akten des internationalen Symposions, September 27–9, 1976, Berlin. Mainz: Philipp von Zabern.

Laffineur, R. 1984. "The Mycenaeans at Thera – further evidence?" In *Minoan Thalassocracy: Myth and Reality,* edited by R. Hägg and N. Marinatos, pp. 133–9. Stockholm: Svneska Institutet i Athen.

Lakoff, G., and M. Johnson. 1980. *Metaphors We Live By.* Chicago: University of Chicago Press.

Lambrechts, P. 1956. *Augustus en de egyptische Godsdient.* Brussels: AWLSK.

Langlotz, E. 1937. *Die Antiken Vasen von der Akropolis zu Athen II.* Berlin: Georg Reimer.

La Rocca, E. 1976. *Guida archeologica di Pompei.* Rome: Arnoldo Mondadori Editore.

1984. *L'età d'oro di Cleopatra. Indagine sulla Tazza Farnese.* Documenti e recerche d'arte alessandrina 5. Rome: "L'Erma" di Bretschneider.

1985a. *Amazzonomachia. Le sculture frontali del tempio di Apollo Sosiano.* Rome: De Luca.

1985b. "Fabio o Fannio. L'affresco medio-reppublicana dell'Esquilino come riflesso dell-arte 'rappresentativa' e come espressione di mobilità sociale." In *Ricerche di pittura ellenistica. Lettura e interpretazione della produzione pittorica dal IV. secolo a.C. all'ellenismo. Quad. DialArch* 1: 169–91.

1986. "Il lusso come expressione di potere." In *Le tranquille dimore degli dei.*

343

REFERENCES *La residenza imperiale degli horti Lamiani,* edited by M. Cima and E. La Rocca, pp. 3–52. Venice: Cataloghi Marsilio.

 1988. "Der Apollo-Sosianus Tempel." In *Kaiser Augustus und die verlorene Republic,* by M. Hofter, pp. 121–36. Berlin: Philip von Zabern.

Lattimore, S. 1976. *The Marine Thiasos in Greek Sculpture.* Monographs of the Archaeological Institute of America 9. Monumenta archeologica 3. Los Angeles: UCLA Institute of Archaeology.

Lauter-Bufe, H. 1982. "Zur Fassade des Scipiongrabes." *RM* 89: 35–46.

Lawrence, A. W. 1972. *Greek and Roman Sculpture.* London: Jonathan Cape.

Layard, Austen H. 1853. *Discoveries in the Ruins of Nineveh and Babylon.* London: John Murray.

Leach, E. 1985. "Michelangelo's Genesis: A structuralist interpretation of the central panels of the Sistine Chapel ceiling." *Semiotics* 56: 1–30.

Leach, Eleanor. 1988. *The Rhetoric of Space. Literary and Artistic Representations of Landscape in Republican and Augustan Rome.* Princeton: Princeton University Press.

Leander Touati, A.-M. 1987. *The Great Trajanic Frieze.* Skrifter Utgivna au Svenska Institutet I Rom 45. Stockholm: Paul Aaströms.

Lee, E. N. 1978. "The sense of an object: Epicurus on seeing and hearing." In *Studies in Perception: Interrelationships in the History of Philosophy and Science,* edited by M. A. Caws, pp. 27–59. Columbus: Ohio State University Press.

Lehmann, K. 1973. *Samothracian Reflections.* Princeton: Princeton University Press.

 1975. *Samothrace: A Guide to the Excavations and Museum.* 4th ed. Locust Valley, NY: Institute of Fine Arts.

Lehmann, P. 1953. *Roman Wall Paintings from Boscroeale in the Metropolitan Museum of Art.* Cambridge, MA: Harvard University Press.

Lewis, N. 1958. *Samothrace, Vol. 1: The Ancient Literary Sources,* edited by K. Lehmann. Princeton: Princeton University Press.

Lezzi-Hafter, A. 1988. *Der Eretria Maler.* Mainz: Philipp von Zabern.

Liegle, J. 1941. "Die Münzprägung Octavians nach dem Siege von Actium und die Augusteische Kunst." *JdI* 56: 91–119.

Ling, R. 1984. *CAH VII.1. The Hellenistic World to the Coming of Rome. Plates.* Cambridge: Cambridge University Press.

Lissarague, F. 1987a. "Dionysos s'en va-t-en guerre." In *Images et société en Grèce ancienne,* edited by C. Bérard, C. Bron et al., pp. 111–20. Lausanne: Institut d'Archéologie et d'Histoire Ancienne, Université de Laussane.

 1987b. "Voyages d'image: Iconographie et aires culturelles." *Revue des Etudes Anciennes* 89: 261–9.

Lissarague, F., and F. Thélamon. 1983. *Image et céramique grecque.* Actes du Colloque de Rouen, 25–6 Novembre 1982. Rouen: Publications de l'Université de Rouen.

Liverani, M. 1979. "The ideology of the Assyrian empire." In *Power and Propaganda.* Mesopotamia 7. Edited by M. T. Larsen, pp. 297–317. Copenhagen: Akademisk Forlag.

Lloyd, R. B. 1979. "The Aqua Virgo, Euripus and Pons Agrippae." *AJA* 83: 193–204.

Lloyd-Jones, H. 1968. "The Cologne fragment of Alcaeus." *GRBS* 9: 125–39.

 1991. *Greek Epic, Lyric and Tragedy. The Academic Papers of Sir Hugh Lloyd-Jones.* Oxford: Oxford University Press.

Loerke, W. 1982. "Georges Chédanne and the Pantheon." *Modulus* 15: 40–55.

Long, A. A. 1986. *Hellenistic Philosophy.* Berkeley: University of California Press.

 1992. "Stoic readings of Homer." In *Homer's Ancient Readers: The Herme-*

neutics of Greek Epic's Earliest Exegetes, edited by R. Lamberton and J. H. Keaney, pp. 41–66. Princeton: Princeton University Press.

Long, A. A., and D. Sedley. 1987. *The Hellenistic Philosophers.* Cambridge: Cambridge University Press.

Long, C. 1978. "The Lashti Dagger." *AJA* 82: 35–46.

L'Orange, H. P. 1953. *The Iconography of Cosmic Kingship in the Ancient World.* Institutet for Sammenlingnende Kulturforskning 23. Oslo: Aschehoug.

Lorenz, T. 1976. "Die Dioskuren in der römischen Plastik." *Meded* 38: 17–26.

Lotman, J. 1975. "The discrete text and the iconic text." *NewLitHist* 6: 333–8.

Lucas, D. W. 1968. *Aristotle's Poetics.* Oxford: Oxford University Press.

Luckenbill, D. D. 1924. *The Annals of Sennacherib.* Oriental Institute Publications 2. Chicago: University of Chicago Press.

Lugli, G. 1938. *I monumenti antichi di Roma e suburbio III.* Rome: G. Bardi.

Lynch, K. 1960. *The Image of the City.* Cambridge, MA: MIT Press.

MacDonald, W. L. 1976. *The Pantheon. Design, Meaning and Progeny.* Cambridge, MA: Harvard University Press.

1986. *The Architecture of the Roman Empire, Volume II: An Urban Appraisal.* New Haven: Yale University Press.

Maderna, C. 1988. *Iuppiter Diomedes und Merkur als Vorbild für römische Bildnisstatuen.* Archäologie und Geschichte I. Heidelberg: Archäologie und Geschichte.

Magi, F. 1945. *I rilievi flavi del Palazzo della Cancelleria.* Rome: Dott. Giovanni Bardi.

Malinowski, B. 1948. *Magic, Science, and Religion.* Boston: Beacon Press.

Manacorda, D. 1982. *Archeologia urbana a Roma: il progetto della crypta Balbi.* Florence: All'insegna del Giglio.

Mansfield, J. 1985. The Robe of Athena and the Panathenaic " 'Peplos.' " Ph.D. dissertation, University of California, Berkeley.

Mansuelli, G. A. 1968. "Individuazione e rappresentazione storica nell'arte etrusca." *StEtr* 36: 3–19.

Marin, L. 1980. "Toward a theory of reading in the visual arts: Poussin's *The Arcadian Shepherds.*" Reprinted in *Calligram,* edited by N. Bryson, pp. 63–90. Cambridge: Cambridge University Press.

Marinatos, N. 1984. *Art and Religion in Thera.* Athens: D. & I. Mathioulakis.

1989. "Man and animal in Creto-Mycenaean art." In *Philia Epe,* pp. 19–24. Festschrift G. Mylonas. Athens: Biblioteke tes en Athenais Archaiologiskes Hetaireias 103.

Marinatos, S. 1974. *Excavations at Thera VI.* Athens: Biblioteke tes en Athenais Archaiologiskes Hetaireias 65.

Markle, M. M. 1982. "Macedonian arms and tactics under Alexander the Great." In *Macedonia and Greece in Late Classical and Early Hellenistic Times,* edited by B. Barr-Sharrar and E. N. Borza, pp. 87–111. Studies in the History of Art 10. Washington, D.C.: National Gallery of Art.

Marmor, M. 1990. Review of Preziosi 1989. *Art Documentation* 9: 22–5.

Marrou, H. I. 1956. *A History of Education in Antiquity,* translated by George Lamb. Madison: University of Wisconsin Press.

Martin, J.-P. 1982. *Providentia deorum. Aspects religieux du pouvoir romain.* Rome: Collection de l'École française de Rome 61.

Marzi, M. G. 1980. "La scoperta." *Materiali per servire alla storia del vaso François* (Bolletino d'arte special series): 27–50.

Massa Pairault, F. H. 1985. "La divination en Etrurie. Le IV siècle, periode critique." *Caesarodunum* (Bulletin de Institut d'Études Latines et du Centre de Rechereches A. Piganiol, Suppl. 52) 66: 77–82.

345

REFERENCES

Matheson, S. B. 1986. "Polygnotos: An Iliupersis scene at the Getty Museum." *Greek Vases in the J. Paul Getty Museum*, 101–14. Occasional Papers on Antiquities 2, vol. 3. Malibu: J. Paul Getty Museum.

Mattingly, H. 1960. *Roman Coins*. 2d ed. London: Methuen.

Matz, F. 1968. *Die Dionysischen Sarkophage I, II*. Berlin: Gebr. Mann.

1975. *Die Dionysischen Sarkophage IV*. Berlin: Gebr. Mann.

Mazois, F. 1824–38. *Les ruines de Pompei*. Paris: Didot.

Megow, W.-R. 1987. *Kameen von Augustus bis Alexander Severus*. Antike Münzen und geschnittene Steine 11. Berlin: De Gruyter.

Merkelbach, R. 1967. *ZPE* 1: 81.

Meslin, M. 1981. *L'uomo romano: uno studio di anthropologia,* translated from the French. Milan: Arnoldo Mondadori.

Messerschmidt, F., and A. von Gerkan. 1930. *Nekropolen von Vulci*. JdI Ergänzungsheft 12: 62–163.

Meyboom, P. G. P. 1978. "Some observations on narration in Greek art." *Meded* 40: 55–72.

Meyer, H. 1982. "Vulcan und Isis in der Sala Rotunda: Ein Beitrag zur Kunst un Pompeius der Grosse." *RendPontAcc* 53/54: 241–71.

Kunst und Geschichte. Vier Untersuchungen zur antiken Historienkunst. Munich: W. Fink.

Millar, F., and E. Segal (eds.). 1984. *Caesar Augustus. Seven Aspects*. Oxford: Oxford University Press.

Millet, N. B. 1990. "The Narmer macehead and related objects." *JARCE* 27: 53–9.

Möbius, H. 1985. "Zweck und Typen der römischen Kaiserkameen." *ANRW* 2.12.3: 32–88.

Momigliano, A. 1932. *L'opera dell'imperatore Claudio*. Florence: Valecchi.

1934. *Claudius. The Emperor and His Achievements*. Oxford: Oxford University Press.

1942. "Terra marique." *JRS* 32: 53–64.

1966. "Time in ancient history." *History and Theory, Suppl. 6:* 1–23.

Mommsen, T. 1878. "Trimalchios Heimath und Grabschrift." *Hermes* 13: 106–21.

Moon, W. G., and L. Berge. 1979. *Greek Vase Painting in Midwestern Collections*. Chicago: Art Institute of Chicago.

Moret, J. M. 1975. *L'Ilioupersis dans la ceramique italiote*. Bibliotheca Helvetica Romana 14. Rome: Institut Suisse de Rome.

Moretti, G. 1938. *Ara Pacis Augustae*. Rome: Libreria dello Stato.

Moretti, M. 1982. *Vulci*. Novara: Istituto Geografico de Agostini.

Moretti, M., and G. Maetzka. 1970. *The Art of the Etruscans*. New York: Abrams.

Morgan, L. 1988. *The Miniature Wall-Paintings from Thera*. Cambridge: Cambridge University Press.

Morgan, M. B. 1973. "Villa Publica and Magna Mater." *Klio* 55: 216–22.

Mørkholm, O. 1991. *Early Hellenistic Coinage, from the Accession of Alexander to the Peace of Apamea (336–188 B.C.)*. Cambridge: Cambridge University Press.

Moynihan, R. 1985. "Geographical mythology and Roman imperial ideology." In *The Age of Augustus,* edited by R. Winkes, pp. 149–62. Archaeologia Transatlantica 5.

Murray, W. M., and P. M. Petsas. 1989. *Octavian's Campsite Memorial for the Actian War*. Philadelphia: American Philosophical Association.

Mylonas, G., 1955. "The figured Mycenaean stelai." *AJA* 55: 134–47.

1972. *Ho taphikos kylos V ton Mykenon*. Athens: Biblioteke tes en Athenais Archaiologiskes Hetaireias 73.

Na'aman, N. 1979. "Sennacherib's campaign to Judah and the date of the *LMLK* stamps." *Vetus Testamentum* 29: 61–86.

Nash, E. 1968. *Pictorial Dictionary of Ancient Rome*. Vol. 1. London: Praeger.

Neumann, G. 1965. *Gesten und Gebärden in der griechischen Kunst*. Berlin: De Gruyter.

Newberry, P. 1908. "The petty-kingdom of the harpoon and Egypt's earliest port." *Liverpool Annals of Archaeology and Anthropology* 1: 17–22.

Newell, E. T. 1921. *The octobols of Histiaea*. Museum Notes and Monographs 2. New York: American Numismatic Society.

——— 1927. *The Coinages of Demetrios Poliorcetes*. London: Oxford University Press.

The New English Bible with the Apocrypha, 1971. New York: Oxford University Press.

Niemeyer, H. G. 1968. *Studien zur statuarischen Darstellung der römischen Kaiser*. Monumenta Artis Romanae 7. Berlin: Gebr. Mann.

Nims, C. F., et al. 1978. *The Tomb of Kkeruef*. University of Chicago, Oriental Institute Publications, Vol. 102. Chicago: University of Chicago Press.

Nista, L. 1989. "Ius imaginum and public portraiture." In *Roman Portraits in Context*, edited by M. Anderson, pp. 33–39. Atlanta: Emory University Museum of Art and Archeology.

Nock, A. D. 1972. "ΣΥΝΝΑΟΣ ΘΕΟΣ." *Essays on Religion and the Ancient World I*, pp. 202–51. Oxford: Oxford University Press. (Reprint of article in *HSCP* 41 [1930]: 1–62.)

Nodelman, S. 1987. "The portrait of Brutus the tyrannicide." In *Ancient Portraits in the J. Paul Getty Museum*, pp. 41–86. Occasional Papers of the J. Paul Getty Museum I. Malibu: J. Paul Getty Museum.

Noël des Vergers, A. 1862–4. *L'Étrurie et les Étrusques ou dix ans de fouilles dans les Maremmes toscanes II*. Paris: Didot.

Norden, E. 1958. *Die antike Kunstprosa*. 5th ed. Stuttgart: Teubner.

Oberleitner, W. 1985. *Geschnittene Steine: Die Prunkkameen der Weiner Antiken-sammulung*. Vienna: Hermann Böhlaus Nachf.

O'Keefe, D. L. 1982. *Stolen Lightning: The Social Theory of Magic*. New York: Continuum.

Olinder, B. 1974. *Porticus Octavia in Circo Flaminio. Topographical Studies in the Campus Region of Rome*. Svenska Institutet Skriften 8.ii. Rome: P. Aastroems Foerlag.

Oliver, J. H. 1932. "The Augustan pomerium." *MAAR* 10: 145–82.

Ong, W. J. 1982. *Orality and Literacy: The Technologizing of the World*. London: Methuen.

Onians, J. 1979. *Art and Thought in the Hellenistic Age*. London: Thames & Hudson.

Otis, B. 1970. *Ovid as an Epic Poet*. 2d ed. Cambridge: Cambridge University Press.

Page, D. L. 1950. *Select Papyri 3. Literary Papyri: Poetry*. Loeb Classical Library. Cambridge, MA: Harvard University Press.

Pallottino, M. 1952. *Etruscan Painting*. Geneva: Skira.

——— 1978. *The Etruscans*. Harmondsworth: Penguin.

——— 1987. "Il fregio dei Vebenna e le sue implicazioni storiche." In *La tomba François di Vulci*, edited by F. Buranelli, pp. 225–33. Rome: Quasar.

Palmer, R. E. A. 1990. "Studies of the northern Campus Martius in ancient Rome." *TAPS* 80(2): 1–64.

Panofsky, E. 1939. *Studies in Iconology*. Oxford: Oxford University Press.

——— 1953. *Early Netherlandish Painting*. 2 vols. Cambridge, MA: Harvard University Press.

REFERENCES 1960. *Renaissance and Renascences in Western Art*. Stockholm: Almquist and Wiskell.

Pape, M. 1975. *Griechische Kunstwerke aus Kriegsbeute und ihr öffentliche Aufstellung in Rom: von der Eroberung von Syrakus bis augusteische Zeit*. Ph.D. dissertation, University of Hamburg.

Parker, H. M. D. 1958. *The Roman Legions*. Cambridge: Cambridge University Press.

Parker, R. 1990. "Myths of early Athens." In *Interpretations of Greek Mythology*, edited by J. Bremmer, pp. 187–214. London: Routledge.

Parpola, S. 1980. "The murderer of Sennacherib." In *Death in Mesopotamia*, pp. 171–82. Mesopotamia 8. Edited by B. Alster. Copenhagen: Akademisk Forlag.

Pearson, A. C. 1917. *Fragments of Sophocles*. Cambridge: Cambridge University Press.

Peirce, C. S. 1932. *Elements of Logic*, edited by C. Hartshorne and P. Weiss. Collected Papers of Charles Sanders Pierce 2. Cambridge, MA: Harvard University Press.

Pensabene, P. 1982. "Su un fregio fittile e un ritratto marmoreo da Palestrina nel Museo Nazionale Romano." In *Miscellanea archaeologica Tobias Dohrn dedicata*, edited by H. Blanck and S. Steingräber, pp. 73–88. Rome: G. Bretschneider.

Perdrizet, P. 1908. *Fouilles de Delphes V*. Paris: École française d'Athènes.

Perret, J. 1971. "Rome et les Troyens." *REL* 49: 39–52.

Petersen, E. 1899. "Caele Vibenna und Mastarna." *JdI* 14: 43–9.

Petrie, W. M. F. 1920. *Prehistoric Egypt*. London: Egyptian Research Council.

 1921. *Prehistoric Egypt Corpus*. London: Egyptian Research Council.

 1953. *Ceremonial Slate Palettes and Corpus of Protodynastic Pottery*. London: Egyptian Research Council.

Petrie, W. M. F., and J. E. Quibell. 1896. *Nagada and Ballas*. London: Bernard Quaritch.

Petrounias, E. 1976. *Funktion und Thematik der Bilder bei Aischylos*. Hypomnemata 48. Göttingen: Vandenhoek und Ruprecht.

Pfanner, M. 1979. "Bemerkungen zur Komposition und Interpretation des grossen Friezes von Pergamon." *AA*: 46–57.

 1983. *Der Titusbogen*. Mainz: Philipp von Zabern.

Pfeiffer, R. 1968. *A History of Classical Scholarship*. Oxford: Oxford University Press.

Pfiffig, A. 1975. *Religio etrusca*. Graz: Academ. Druck-u. Verlagsanst.

Pfuhl, E. 1923. *Malerei und Zeichnung der Griechen*. Munich: F. Bruckmann.

Pietilä-Castren, L. 1987. *Magnificentia publica. The victory monuments of the Roman generals in the era of the Punic Wars*. Commentationes humanarum litterarum 84. Helsinki: Societas Scientiarum Fennica.

Pietri, C. (ed.). 1987. *L'urbs, espace urbain et histoire*. Rome: École française de Rome.

Pinney, G. F. 1988. "Pallas and Panathenaia." In *International Vase Symposium: Proceedings of the 3rd Symposium on Ancient Greek and Related Pottery, August 31–September 4, 1987*, edited by J. Christiansen and T. Melander, pp. 465–77. Copenhagen: Ny Carlsberg Glyptotek and Thorvaldsens Museum.

Platner, S., and T. Ashby. 1929. *A Topographical Dictionary of Ancient Rome*. London: Oxford University Press.

Podro, M. 1982. *The Critical Historians of Art*. New Haven: Yale University Press.

Pollini, J. 1978. "Studies in Augustan 'Historical' Reliefs." Ph.D. dissertation, University of California, Berkeley.

1983. Review of Torelli 1982. *AJA* 87: 572–3.

1986. Review of Brilliant 1984. *AJP* 107: 523–7.

1987. *The Portraiture of Gaius and Lucius Caesar.* New York: Fordham University Press.

1989. "Man or god: Divine assimilation and imitation in the late republic and early principate." In *Between Republic and Empire, Interpretations of Augustus and His Principate,* edited by K. Raaflaub and M. Toher, pp. 333–63. Berkeley: University of California Press.

1992. "The Tazza Farnese: *principe augusto 'redeunt Saturnia regna!'* " *AJA* 96: 283–300.

(forthcoming). *The Image of Augustus: Art, Ideology, and the Rhetoric of Leadership.*

Pollitt, J. J. 1974. *The Ancient View of Greek Art.* New Haven: Yale University Press.

1983. *The Art of Rome c. 753 BC–AD 337. Sources and Documents.* Cambridge: Cambridge University Press.

1986. *Art in the Hellenistic Age.* Cambridge: Cambridge University Press.

Porter, J. I. 1989. "Philodemos on material difference." *Cronache Ercolanesi* 19: 149–78.

Pöschl, V. 1964. *Bibliographie zur antiken Bildersprache.* Heidelberg: C. Winter.

Postgate, J. N. 1973. "URU.Š E = *kapru*." *Archiv für Orientforschung* 24: 77.

Poulsen, F. 1922. *Etruscan Tomb Paintings. Their Subjects and Significance.* Oxford: Oxford University Press.

Poulsen, V. 1962. *Les portraits romains I.* Copenhagen: F. Hendriksen's Eft.

1968. *Claudische Prinzen.* Baden-Baden: Bruno Grimm.

Poursat, J.-C. 1968. "Les représentations de danse armée dans la céramique attique." *BCH* 92: 550–615.

1977. *Catalogue des ivoires mycéniens du musée national d'Athènes.* Paris: Bibliothèque des écoles françaises d'Athènes et de Rome 230.

Prayon, F. 1974. "Zum ursprünglichen Aussehen und zur Deutung des Kultraumes in der Tomba delle Cinque Sedie bei Cerveteri." *Marburger Winckelmann-Program* 12: 1–15.

1975. *Frühetruskische Grab- und Hausarchitektur.* MDI Ergänzungsheft 22.

1982. "Projektierte Bauten auf römischen Münzen." In *Praestant Interna: Festschrift für Ulrich Hausmann,* edited by G. von Freytag and B. von Loeringhoff, pp. 319–30. Tübingen: Ernst Wasmuth.

Preziosi, D. 1989. *Rethinking Art History: Meditations on a Coy Science.* New Haven: Yale University Press.

Price, S. R. F. 1984. *Rituals of Power: The Roman Imperial Cult in Asia Minor.* Cambridge: Cambridge University Press.

Prince, G. 1982. *Narratology: The Form and Functioning of Narrative.* Ithaca: Cornell University Press.

Purcell, N. 1987. "Town in country and country in town." In *Ancient Roman Villa Gardens,* edited by E. B. MacDougall, pp. 185–203. Dumbarton Oaks Colloquium on the History of Landscape Architecture 10. Washington, D.C.: Dumbarton Oaks.

Putnam, M. C. J. 1986. *Artifices of Eternity: Horace's Fourth Book of Odes.* Ithaca: Cornell University Press.

Quibell, J. E., and F. W. Green. 1900–1. *Hierakonpolis.* 2 vols. London: Egypt Exploration Fund.

Radke, G. 1972. "Augustus und das Göttliche." In *Antike und Universalgeschichte. Festschrift für Hans Stier und G. Lehmann,* pp. 257–79. Münster: Aschendorff.

1974. "Etrurien – ein Produkt politischer, sozialer und kultureller Spannung." *Klio* 56: 29–53.

Radt, S. 1977. *Tragicorum Graecorum fragmenta 4: Sophocles.* Göttingen: Vandenhoek and Ruprecht.

Radt, W. 1981. "Der Alexanderkopf in Istanbul. Ein Kopf aus dem grossen Fries des Pergamonaltäres." *AA:* 583–96.

1988. *Pergamon. Geschichte und Bauten, Funde und Erforschungen einer antiken Metropole.* Cologne: DuMont Buchverlag.

Rallo, A. 1974. *Lasa. Iconografia e esegesi.* Florence: Sansoni.

Reade, J. E. 1980. "Space, scale, and significance in Assyrian art." *Baghdader Mitteilungen* 11: 71–4.

1985. "Texts and sculptures from the north-west palace, Nimrud." *Iraq* 47: 203–14.

1986. "Foundation records from the south-west palace, Nineveh." *Annual Review of the Royal Inscriptions of Mesopotamia Project* 4: 33–4.

Rebuffat, D., and R. Rebuffat. 1978. "De Sidoine Apollinaire à la Tombe François." *Latomus* 37: 88–104.

Reynolds, J. 1981a. "Roman inscriptions of 1976–80." *JRS* 71: 121–43.

1981b. "New evidence for the imperial cult in Julio–Claudian Aphrodisias." *ZPE* 43: 317–27.

Richards, I. A. 1936. *The Philosophy of Rhetoric.* Oxford: Oxford University Press.

Richardson, E. 1964. *The Etruscans.* Chicago: University of Chicago Press.

Richter, G. M. A. 1915. *The Metropolitan Museum of Art. Greek, Etruscan and Roman Bronzes.* New York: Gilliss.

1968. *Korai.* London: Phaidon.

1971. *Engraved Gems of the Romans.* London: Phaidon.

Ricouer, P. 1977. *The Rule of Metaphor.* Buffalo: University of Toronto Press.

1983. *Time and Narrative,* translated by K. McLaughlin and D. Pellauer. 2 vols. Chicago: University of Chicago Press.

Ridgway, B. S. 1977. "The Peplos Kore, Akropolis 679." *JWalt* 36: 49–61.

1990. "Birds, 'meniskoi' and head attributes in archaic Greece." *AJA* 94: 583–612.

Ridley, R. T. 1973. *The Unification of Egypt.* Deception Bay: Shield Press.

1975. "The enigma of Servius Tullius." *Klio* 57: 147–77.

Riegl, A. 1902. *Das holländische Gruppenporträt,* edited by K. M. Swoboda. Vienna: Oesterreichische Staatsdruckerei.

Robertson, M. 1975. *A History of Greek Art.* Cambridge: Cambridge University Press.

1981. *A Shorter History of Greek Art.* Cambridge: Cambridge University Press.

Roddaz, J. M. 1984. *Marcus Agrippa.* BEFAR 253.

Rodenwaldt, G. 1936. "Zur Kunstgeschichte der Jahre 220 bis 270." *JdI* 51: 82–113.

1943. *Kunst um Augustus.* (Reprinted 1988.) Berlin: De Gruyter.

Rohde, E. 1982. *Pergamon: Burgberg und Altar.* Berlin: Henschelverlag Kunst und Gesellschaft.

Roma medio-repubblicana. Aspetti culturali di Roma e del Lazio nei secoli IV e III A.C. 1973. Rome: Antiquarium.

Ronzitti-Orsolini, G. 1971. *Il mito dei Sette a Tebe nelle urne volterrane.* Florence: La Nuova.

Rose, K. F. C. 1971. *The Date and Author of the Satyricon.* Mnemosyne, Suppl. 16. Leiden: E. J. Brill.

Rosenmeyer, T. G. (forthcoming). "Apollonius Lyricus." In *Transactions of the*

IXth Congress of the International Federation of Classics Studies. Studi Italiani di Filologia Classica.

Rostovzeff, M. 1957. *The Social and Economic History of the Roman Empire*. Oxford: Oxford University Press.

Rudiger, H. 1973. "Die Anaglypha Hadriani." *Antike Plastik* 12: 161–72.

Russell, D. A., and N. G. Wilson (eds.). 1969. *Menander Rhetor*. Oxford: Oxford University Press.

Russell, J. M., 1991. *Sennacherib's Palace Without Rival at Nineveh*. Chicago: University of Chicago Press.

Ryberg, I. S. 1920. "Early Roman traditions in the light of archaeology." *MAAR* 7: 71–89.

———. 1949. "The procession of the Ara Pacis." *MAAR* 19: 79–101.

———. 1955. *Rites of the State Religion in Roman Art*. *MAAR* 20.

Sakellariou, A. 1985. "L'identité minoenne, l'indentité mycenienne à travers compositions figuratives." In *L'iconographie minoenne. Actes de la table ronde d'Athènes 1983*, edited by P. Darcque and J.-C. Poursat, pp. 293–309. *BCH*, Suppl. XI.

Sartre, J.-P. 1949. *Psychology of the Imagination*, translated by H. E. Barnes. New York: Free Press.

Sauron, G. 1987. "Le complex pompéien du Champ de Mars: Nouveauté urbanistique à finalité idéologique." In *L'urbs, espace urbain et histoire*, edited by C. Pietri, pp. 457–73. Rome: École française de Rome.

Schäfer, H. 1957. "Das Niederschlagen der Feinde." *Wiener Zeitschrift fur die Kunde des Morgenlandes* 54: 168–76.

———. 1974. *Principles of Egyptian art*. 4th ed. Edited by E. Brunner-Traut and translated by J. R. Baines. Oxford: Oxford University Press.

Schäfer, T. 1989. *Imperii insignia. Sella curulis und Fasces. Zur Repräsentation römischer Magistrate*. RM Ergänzungsheft 29. Mainz: Philipp von Zabern.

Schefold, K. 1952. *Pompejanische Malerei: Sinn und Ideengeschichte*. Basel: B. Schwabe.

———. 1962. *Vergessenes Pompeji*. Berne: Francke.

———. 1966. *Myth and Legend in Early Greek Art*, translated by A. Hicks. New York: Abrams.

———. 1972. *La peinture pompéienne. Essai sur l'évolution de sa signification*, revised and translated by J.-M. Croisille. Brussels: Latomus.

Scheid, J. 1975. *Les frères arvales*. Paris: Presses universitaires de France.

Scherrer, P. 1988. "*Saeculum Augustum – Concordia Fratrum*: Gedanken zum Programm der Gemma Augustea." *OJh* 58: 115–28.

Schissel von Fleschenberg, O. 1913. "Die Technik des Bildeinsatzes." *Philologus* 72: 83–114.

Schmidt, K. 1931. "Die Namen der attischen Kriegsschiffe." Dissertation, University of Leipzig.

Schmidt, T.-M. 1990. "Zum Beginn und Abbruch der Arbeiten am Pergamonaltar." In *Phyromachasprobleme*, edited by B. Andreae, pp. 141–62. Mainz: Philipp von Zabern.

Schnapp, A. 1988. "Why did the Greeks need images?" In *International Vase Symposium: Proceedings of the 3rd Symposium on Ancient Greek and Related Pottery, August 31–September 4, 1987*, edited by J. Christiansen and T. Melander, pp. 568–74. Copenhagen: Ny Carlsberg Glyptotek and Thorvaldsens Museum.

Schofer, P., and D. Rice. 1977. "Metaphor, metonymy, and synecdoche revis(it)ed." *Semiotica* 21: 121–49.

Schott, S. 1950. *Hieroglyphen: Untersuchungen zum Ursprung der Schrift*. Akademie

REFERENCES

der Wissenschaften, Geistes- und Sozialwissenschaftliche Klasse 24. Wiesbaden: Akademie der Wissenschaften.

Schultze, W. 1904. *Zur Geschichte der Lateinischen Eigennahmen. AbhGött* 5.

Scott, R. T. 1982. "Providentia Aug." *Historia* 31: 436–59.

Searle, J., 1980. "*Las Meninas* and the paradoxes of pictorial representation." *Critical Inquiry* 6: 477–88.

Seel, O. 1964. *Römertum und Latinität.* Stuttgart: Ernst Klett.

Seton-Williams, M. V. 1980. *Tutankhamun: der Pharo, das Grab, der Goldschatz.* Frankfurt: W. Krüger Verlag.

Settis, S. 1970–1. "Poseidon Aristeromachos? La transmissione di un modello pittorico alla c.d. Ara di Domizio Enobarbo." *Studi Classici e Orientali* 19–20: 146–64.

 1988. "Die Ara Pacis." In *Kaiser Augustus und die verlorene Republic,* edited by M. Hofter, pp. 400–26. Berlin: Philipp von Zabern.

Shapiro, H. A. 1977. "Personification of Abstract Concepts in Greek Art and Literature to the End of the Fifth Century B.C." Ph.D. dissertation, Princeton University.

 1989. *Art and Cult Under the Tyrants in Athens.* Mainz: Philipp von Zabern.

 1990. "Old and new heroes: Narrative, composition and subject in Attic black-figure." *ClAnt* 9: 114–48.

Shapiro, K. D. 1988. "The Berlin Dancer completed: A bronze auletris in Santa Barbara." *AJA* 92: 509–28.

Sherwin-White, A. N. 1976. "Rome, Pamphylia and Cilicia 133–70 BC." *JRS* 66: 1–14.

Shipley, F. W. 1933. *Agrippa's Building Activities in Rome.* St. Louis: Washington University Press.

Silk, M. S. 1974. *Interaction in Poetic Imagery.* Cambridge: Cambridge University Press.

Simon, E. 1967. *Ara Pacis Augustae.* Greenwich, CT: New York Graphic Society.

 1969. *Die Gotter der Griechen.* Munich: Hirmer Verlag.

 1975. *Pergamon und Hesiod.* Mainz: Philipp von Zabern.

 1983. *Festivals of Attica.* Madison: University of Wisconsin Press.

 1986a. "Die drei Horoscope der Gemma Augustea." *NumAntCl* 15: 179–90.

 1986b. *Augustus: Kunst und Leben in Rom um die Zeitenwende.* Munich: Hirmer.

Slater, W. J. 1976. "Symposium at sea." *HSCP* 80: 161–70.

Small, J. P. 1974. "Aeneas and Turnus on late Etruscan funerary urns." *AJA* 78: 49–50.

 1987. "Left, right, and center. Direction in Etruscan art." *OpRom* 16: 125–35.

Smith, R. R. R. 1987. "The imperial reliefs from the Sebasteion at Aphrodisias." *JRS* 77: 88–138.

 1988. "*Simulacra gentium:* The *ethne* from the Sebasteion at Aphrodisias." *JRS* 78: 50–77.

 1991. *Hellenistic Sculpture.* London: Thames & Hudson.

Smith, W. S. 1965. *Interconnections in the Ancient Near East.* New Haven: Yale University Press.

 1981. *The Art and Architecture of Ancient Egypt.* Harmondsworth: Penguin.

Snodgrass, A. M. 1982. *Narration and Allusion in Archaic Greek Art.* The Eleventh J. L. Myres Memorial Lecture, New College, Oxford. London: Leopard's Head.

1987. *An Archaeology of Greece.* Berkeley: University of California Press.

Sordi, M. 1972. "L'idea di crisi e di rinnovamento nella concezione romano-etrusca della storia." *ANRW* 1(2): 781–93.

Sourvinou-Inwood, C. 1979. *Theseus as Son and Stepson.* Institute of Classical Studies Bulletin, Suppl. 40. London: Institute of Classical Studies.

1987a. "A series of erotic pursuits: Images and meanings." *JHS* 107: 131–53.

1987b. "Menace and pursuit: Differentiation and the creation of meaning." In *Images et société en Grèce ancienne,* edited by C. Bérard, C. Bron et al., pp. 41–58. Actes du Colloque International, Lausanne 8–11 Février 1984. Laussane: Institut d'Archéologie et d'Histoire Ancienne, Université de Laussane.

1988. *Studies in Girls' Transitions.* Athens: Kardamitsa.

Spaeth, B. 1988. "The Goddess Ceres: A Study in Roman Religious Ideology." Ph.D. dissertation, Johns Hopkins University, Baltimore.

Spano, G. 1943. "La tomba del'edile C. Vestorio Prisco in Pompeii." *Atti della Reale Accademia d'Italia. Memorie della classe Scienze Morale e Storiche, series* 7(3): 289–315.

Sprenger, M., and G. Bartoloni. 1983. *The Etruscans. Their History, Art, and Architecture.* New York: Abrams.

Stähler, K. 1972. "Zur Rekonstruktion und Datierung des Gigantomachi giebels von der Akropolis." In *Antike und Universalgeschichte. Festschrift für Hans Stier und G. Lehmann,* pp. 101–12. Münster: Aschendorff.

1978. "Uberlegungen zur architektonischen Gestalt des Pergamonaltäres." In *Stüdien zur Religion und Kultur Kleinasiens. Festschrift für F.K. Dörner,* edited by S, Sahin, E. Schwertheim, and J. Wagner, pp. 638–57. Leyden: E. J. Brill.

Stambaugh, J. 1988. *The Ancient Roman City.* Baltimore: John Hopkins University Press.

Stansbury-O'Donnell, M. D. 1989. "Polygnotos' *Ilioupersis:* A new reconstruction." *AJA* 93: 203–15.

Steingräber, S. 1984. *Catalogo ragionato della pittura etrusca.* Milan: Editoriale Jaca.

Stemmer, K. 1978. *Untersuchungen zur Typologie, Chronologie und Ikonographie der Panzerstatuen.* AF 4. Berlin: Gebr. Mann.

Stewart, A. F. 1977. *Skopas of Paros.* Park Ridge, NJ: Noyes Press.

1979. *Attika: Studies in Athenian Sculpture of the Hellenistic Age.* Journal of Hellenic Studies, Suppl. Paper 14. London: Society for the Promotion of Hellenic Studies.

1990. *Greek Sculpture: An Exploration.* New Haven: Yale University Press.

Stewart, Anne. 1984. "A study in the iconography of Demetrios Poliorketes." Masters thesis, University of California, Berkeley.

Storoni Mazzolani, Lidia, 1972. *The Idea of the City in Roman Thought.* Bloomington: Indiana University Press.

Strong, D. 1988. *Roman Art.* 2d ed. Edited by R. Ling. Harmondsworth: Penguin.

Strong, D. E. 1968. "The administration of public building in Rome during the late republic and early empire." *BICS* 15: 97–109.

Stuart Jones, H. 1912. *The Sculptures of the Museo Capitolino.* Oxford: Clarendon Press.

Sutton, D. F. 1984. *The Lost Sophocles.* Lanham, MD: University Press of America.

Syme, R. 1939. *The Roman Revolution.* Oxford: The Clarendon Press.

1978. *History in Ovid.* Oxford: Oxford University Press.

REFERENCES

Taylor, L. R. 1914. "Augustales, Seviri Augustales, and seviri: A chronological study." *TAPA* 45: 231–53.

———. 1931. *The Divinity of the Roman Emperor*. Middletown, CT: American Philological Association.

———. 1961. "Freemen and freeborn in the epitaphs of imperial Rome." *AJP* 82: 113–32.

Teissier, B. 1987. "Glyptic evidence for a connection between Iran, Syro-Palestine, and Egypt in the fourth and third millennia." *Iran* 25: 27–53.

Tersini, N. 1987. "Unifying themes in the sculpture of the Temple of Zeus at Olympia." *ClAnt* 6: 139–59.

Thiersch, H. 1931. "Die Nike von Samothrake: ein rhodisches Werk und Anathem." In *Nachrichten von der Gesellschaft der Wissenschaften zu Göttingen*, pp. 336–78. Philologische-historische Klass, Heft 3.

Thompson, M. L. 1961. "The monumental and literary evidence for programmatic painting in antiquity." *Marsyas* 9: 36–77.

Thomsen, R. 1980. *King Servius Tullius*. Copenhagen: Gyldendal.

Todorov, T. 1969. "Structural analysis of narrative." *Novel* 3: 70–6.

Torelli, M. 1975. *Elogia Tarquiniensia*. Florence: Sansoni.

———. 1981. *Storia degli Etruschi*. Rome: Laterza.

———. 1982. *Typology and Structure of Roman Historical Reliefs*. Ann Arbor: University of Michigan Press.

———. 1983. "Ideologia e rappresentazione nelle tombe Tarquiniesi dell'Orco I e II." *DialArch* 1(2): 7–17.

Touchefeu, O. 1981. "Aias II." *LIMC* I: 336–51.

Toynbee, J. M. C. 1971. *Death and Burial in the Roman World*. Ithaca: Cornell University Press.

Tréheux, J. 1987. "Sur le Néorion de Délos." *CRAI*: 168–84.

Trendall, A. D. 1967. *Red-Figured Vases of Lucania, Campania, and Sicily*. Oxford: Oxford University Press.

———. 1980. "Three recently-acquired Greek vases." *Art Bulletin of Victoria* 19: 3–11.

Trendall, A. D., and A. Cambitoglou. 1978. *The Red-Figured Vases of Apulia*. Oxford: Oxford University Press.

Trendelenburg, A. 1876. "Die Gegenstüke campanischen Wandmalerei." *AZ* 34: 1–8, 79–93.

Trigger, B. 1983. "The rise of Egyptian civilisation." In B. G. Trigger, B. J. Kemp, D. O'Connor, and A. B. Lloyd, *Ancient Egypt: A Social History*, pp. 1–70, 349–52, 365–71. Cambridge: Cambridge University Press.

Trimpi, W. 1973. "The meaning of Horace's *ut pictura poesis*." *JWarb* 36: 1–34.

Tuchelt, K. 1979. *Frühe Denkmäler Roms in Kleinasien I. Roma und Promagisträte*. IstMitt-BH 23. Mainz: Philipp von Zabern.

Ungnad, A. 1938. "Eponymen." In *Reallexicon der Assyriologie 2*, pp. 412–57. Berlin: De Gruyter.

Ussishkin, D. 1982. *The Conquest of Lachish by Sennacherib*. Publications of the Institute of Archaeology, Tel Aviv University 6. Tel Aviv: Tel Aviv University, Institute of Archaeology.

Van Deman, E. B. 1922. "The Sullan Forum." *JRS* 12: 1–31.

Van den Broek, R. 1972. *The Myth of the Phoenix According to Classical and Early Christian Traditions*. Leiden: E. J. Brill.

Vandier, J. 1952. *Manuel d'archéologie égyptienne*. 2 vols. Vol. 1, *Les époques de formation*. Paris: Picard.

Van Nes, D. 1963. "Die Maritime Bildersprache des Aischylos." Ph.D. dissertation, University of Utrecht.

354

Vergers, A. Noël des. 1862–4. *L'Etrurie et les Etrusques*. Paris: Firmin Didot frères.

Vermeule, C. C. 1977. "The heroic Graeco–Roman Zeus from the Villa d'Este and Marbury Hall: A cult image created after a major hellenistic (Pergamene) prototype." *GettyMusJ* 5: 43–4.

Vermeule, E. 1965. "The vengeance of Achilles: The dragging of Hektor at Troy." *BMFA* 63: 34–52.

Vernant, J.-P., and P. Vidal-Naquet. 1972. *Myth et tragedie en Grece ancienne*. Paris: F. Maspero.

Versnel, H. S. 1978. *Triumphus: An Inquiry into the Origin, Development and Meaning of the Roman Triumph*. Leiden: E. J. Brill.

Vessberg, O. 1941. *Studien zur Kunstgeschichte der römischen Republik*. Lund: C. W. K. Gleerup.

Veyne, P. 1958/9. "Tenir un buste." *CahByrsa* 8: 61–78.

Vian, F., and M. B. Moore. 1988. "Gigantes." *LIMC* IV: 218–26.

Viscogliosi, A. 1988. "Die Architektur-Dekoration der Cella des Apollo-Sosianus-Tempels." In *Kaiser Augustus und die verlorene Republic,* by M. Hofter, pp. 136–48. Berlin: Philipp von Zabern.

Visconti, C. L. 1884. *I monumenti del Museo Torlonia*. Rome: Imprimerie Tiberina.

Vitoux, P. 1982. "Le jeu de la focalisation." *Poétique* 51: 359–68.

Vogel, L. 1973. *The Column of Antoninus Pius*. Cambridge, MA: Harvard University Press.

Vollenweider, M.-L. 1966. *Die Steinschneidekunst und ihre Künstler in spätrepublikanischer und Augusteischer Zeit*. Baden-Baden: Bruno Grimm.

von Arnim, J. 1903–5. *Stoicorum Veterum Fragmenta*. Leipzig: Teubner.

Von Blanckenhagen, P. H. 1940. *Flavische Architektur und ihre dekoration, untersuch am Nervaforum*. Berlin: Gebr. Mann.

1957. "Narration in hellenistic and Roman art." *AJA* 61: 78–83.

Von Bothmer, D. 1953–4. "A Panathenaic amphora." *MMAB* 11: 52–56.

Von Bothmer, D., et al. 1983. *Wealth of the Ancient World. The Nelson Bunker Hunt and William Herbert Hunt collections*. Fort Worth: Kimbell Art Museum, published in association with Summa Publications.

von Hesberg, H. 1988a. "Bildsyntax und Erzählungsweise in der hellenistiche Flächenkunst." *JdI* 103: 309–65.

1988b. "Das Mausoleum des Augustus." In *Kaiser Augustus und die verlorene Republic,* edited by M. Hofter, pp. 245–51. Berlin: Philipp von Zabern.

von Wilamowitz-Moellendorf, U. 1900. "Asianismus und Attizismus." *Hermes* 35: 1–52.

Waelkins, M. 1987. "The adoption of Roman building techniques in Asia Minor." In *Roman Architects in the Greek World,* edited by S. Macready and F. H. Thompson, pp. 94–105. London: Society of Antiquaries.

Walton, K. 1990. *Mimesis as Make-Believe: On the Foundations of the Representational Arts*. Cambridge, MA: Harvard University Press.

Warde Fowler, F. 1914. *Roman Ideas of Divinity*. London: Macmillan.

Wardman, A. 1976. *Rome's Debt to Greece*. London: P. Elek.

Ward-Perkins, J. B., and A. Claridge. 1978. *Pompeii, A.D. 79*. Boston: Museum of Fine Arts.

Warmington, E. H. 1935. *Remains of Old Latin I. Ennius and Caecilius*. Loeb Classical Library. Cambridge, MA: Harvard University Press.

Watkins, T. H. 1979. "Roman citizen colonies and Italic right." *CollLatomus* 164(1): 59–99.

Weber, E. 1972. "Die trojanische Abstammung der Römer als politisches Argument." *WS* 85: 213–25.

Weber, W. 1978. *Die Darstellungen einer Wagenfahrt auf römischen Sarkophagdeckeln*

und Loculusplatten des 3. und 4. Jahrhunderten n. Chr. Rome: G. Bretschneider.

Webster, G. 1969. *The Roman Imperial Army.* London: Adam & Charles Black.

Webster, T. B. L. 1954. "Personification as a mode of Greek thought." *JWarb* 17: 10–21.

———. 1967. *Monuments Illustrating Tragedy and Satyr Play 2.* Institute of Classical Studies Bulletin, Suppl. 20. London: Institute of Classical Studies.

Weinstock, S. 1971. *Divus Iulius.* Oxford: Oxford University Press.

Weitzmann, K. 1970. *Illustration in Roll and Codex: A Study of the Origin and Method of Text Illustration.* Princeton: Princeton University Press.

Wenning, R. 1979. Review of Simon 1975. *Gnomon* 51: 355–61.

Wernicke, K. 1885. "Lebenslauf eines Kindes in Sarkophagdarstellungen." *AZ* 43: 209–22.

Westcoat, B. D. 1987. *Poets and Heroes: Scenes of the Trojan War.* Atlanta: Emory University Museum of Art and Archaeology.

White, H. 1973. *Metahistory.* Baltimore: Johns Hopkins University Press.

Whitehead, J. K. 1984. "Roman Biographical Sarcophagi: Style and Social Class." Ph.D. dissertation, Yale University, New Haven.

Wickhoff, F. 1900. *Roman Art,* translated by E. Strong. London: Heinemann.

Will, E. 1954. "Sur quelques figures de la Gemma Augustea." *Latomus* 13: 597–603.

Williams, B. 1988. *Decorated Pottery and the Art of Nagada III.* Münchner Agyptologische Studien 45. Munich: Münchner Agyptologische Studien.

Williams, B., and T. J. Logan. 1987. "The Metropolitan Museum knife handle and aspects of pharaonic imagery before Narmer." *JNES* 46: 245–84.

Wilpert, J. 1924–5. "L'ultimo viaggio nell'arte sepulcrale classico–romana." *RendPontAcc* 3: 171–91.

———. 1930. *Sarcophagi cristiani antichi I.* Rome: Pontificio istituto di archeologia cristiana.

Winkes, R. (ed.). 1985. *The Age of Augustus.* Archaeologia Transatlantica 5.

Winnefeld, H. 1910. *Die Friese des Groszen Altars. Altertümer von Pergamon,* Vol. 3, Part 2. Berlin: Georg Reimer.

Winter, I. J. 1981. "Royal rhetoric and the development of historical narrative in Neo-Assyrian reliefs." *Studies in Visual Communication* 7(2): 2–38.

———. 1985. "After the battle is over: The Stele of the Vutures and the beginning of historical narrative in the art of the ancient Near East." In *Pictorial Narrative in the Antiquity and the Middle Ages,* edited by H. L. Kessler and M. S. Simpson, pp. 11–32. Studies in the History of Art 16. Washington, D.C.: National Gallery of Art.

Wiseman, T. P. 1970. "The definition of 'eques Romanus' in the late republic and early empire." *Historia* 19: 67–83. (Reprinted in T. P. Wiseman, *Roman Studies Literary and Historical,* pp. 57–73. Oxford: Oxford University Press, 1987.)

———. 1974. "Legendary genealogies in late republican Rome." *Greece and Rome* 21: 153–64. (Reprinted in T. P. Wiseman, *Roman Studies Literary and Historical,* pp. 207–18. Oxford: Oxford University Press, 1987.)

———. 1976. "Two questions on the Circus Flaminius." *PBSR* 44: 44–7. (Reprinted in T. P. Wiseman, *Roman Studies Literary and Historical,* pp. 157–60. Oxford: Oxford University Press, 1987.)

———. 1979. "Strabo on the Campus Martius: 5.3.8, C235." *Liverpool Classical Monthly* 4(7): 129–34.

———. 1987. *Roman Studies: Literary and Historical.* Oxford: Oxford University Press.

Wollheim, R. 1987. *Painting as an Art.* Princeton: Princeton University Press.

Wolterstorff, N. 1981. *Works and Worlds of Art.* Oxford: Clarendon.

Wrede, H. 1971. "Das Mausoleum der Claudia Semne und die burgerliche Plastik der Kaiserzeit." *RM* 78: 125–66.

1977. "Städtrömische Monumente, Urnen und Sarkophage des Klinentypus in den beiden ersten Jahrhunderten n. Chr." *AA:* 395–431.

Wünsche, R., et al. 1985. *Ein griechischer Traum. Leo von Klenze der Archäologe. Ausstellung vom 6 Dez. 1985–9 Feb. 1986. Staatliche Antikensammlungen und Glyptothek München.* Munich: Staatliche Antikensammlungen und Glyptothek.

Wycherley, R. E. 1957. *The Athenian Agora III: Literary and Epigraphical Testimonia.* Princeton: Princeton University Press.

Yates, F. 1966. *The Art of Memory.* Chicago: University of Chicago Press.

Yurco, F. J., 1980. "Sennacherib's third campaign and the coregency of Shabaka and Shebitku." *Serapis* 6: 221–40.

Zadoks Jitta, A. N. 1938. "Juppiter Capitolinus." *JRS* 28: 50–5.

Zadoks Josephus Jitta, A. N. 1932. *Ancestral portraiture in Rome.* Amsterdam: N. V. Noord Hollandsche Uitgeners-mij.

Zanker, P. 1978. *Studien zu den Augustus–Porträts I. Der Actium-Typus.* 2d ed. *AbhGött* 85.

1988. *The Power of Images in the Age of Augustus.* Ann Arbor: University of Michigan Press.

(ed). 1976. *Hellenismus in Mittelitalien. AbhGött* 97.

Zevi, F. 1970. "Considerazioni sull'elogio di Scipione Barbato." In *Omaggio a R. Bianchi Bandinelli,* pp. 63–73. Rome: De Luca.

1976. "L'identità del tempio sotto S. Salvatore in Campo." In *Hellenismus in Mittelitalien,* edited by P. Zanker, pp. 34–6. *AbhGött* 97.

Zimmer, G. 1982. *Römische Berufsdarstellungen. AF* 12.

1985. "Römische Handwerker." *ANRW* 2.12.3: 205–28.

Ziolkowski, A. 1988. "Mummius' Temple of Heracles Victor and the Round Temple on the Tiber." *Phoenix* 42–44: 309–33.

357

INDEX